Goya

TRUTH AND FANTASY

The Small Paintings

MUSEO DEL PRADO, MADRID, 18 NOVEMBER 1993 – 27 FEBRUARY 1994

ROYAL ACADEMY OF ARTS, LONDON, 17 MARCH–12 JUNE 1994

THE ART INSTITUTE OF CHICAGO, 16 JULY–16 OCTOBER 1994

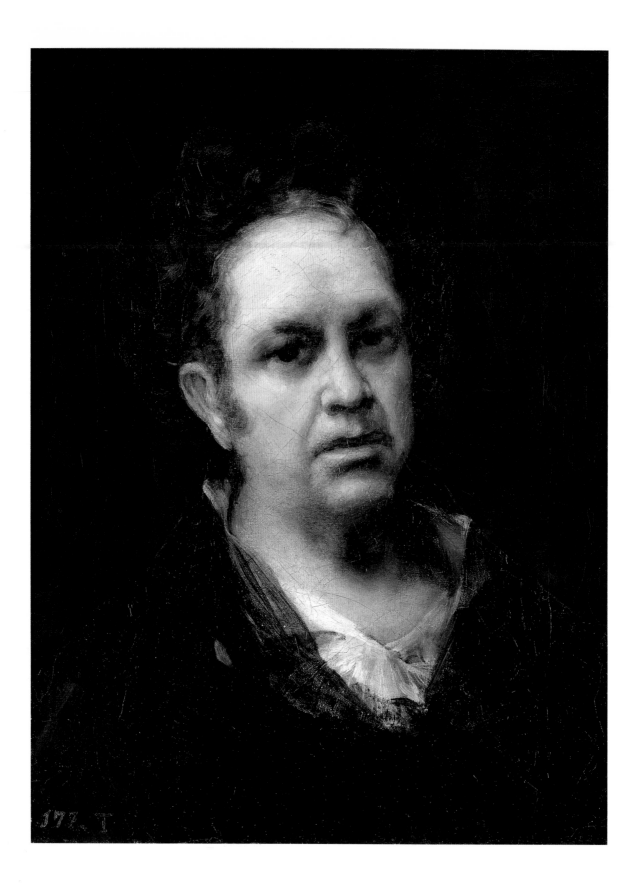

Goya

TRUTH AND FANTASY

The Small Paintings

EXHIBITION CURATED BY

JULIET WILSON-BAREAU

MANUELA B. MENA MARQUÉS

MUSEO DEL PRADO, MADRID
ROYAL ACADEMY OF ARTS, LONDON
THE ART INSTITUTE OF CHICAGO

Catalogue published in association with
Yale University Press · New Haven and London

First published on the occasion of the exhibition
'Goya: Truth and Fantasy, The Small Paintings'
Royal Academy of Arts, London, 17 March–12 June 1994
The Art Institute of Chicago, 16 July–16 October 1994

In London the exhibition was organised in association with
THE TIMES and CLASSIC *f*M

In London the exhibition is part of the Spanish Arts Festival

The Chicago showing of the exhibition is made possible by
Sara Lee Corporation.

With the support of *IBERIA*

The Royal Academy of Arts is grateful to Her Majesty's Government for its
help in agreeing to indemnify the exhibition under the National Heritage Act
1980, and to the Museums and Galleries Commission for their help in
arranging this indemnity.

ISBN 0 300 05863 2 (cloth)
 0 300 05864 0 (p/b)

Library of Congress Catalog Card Number 94–60248

DL M-4874-1994

Production by Ediciones El Viso, S.A., Madrid
Typeset in Monophoto Garamond by
Servis Filmsetting Ltd, Manchester
Printed in Spain by Julio Soto, Impresor, S.A.

FRONTISPIECE: *Self-portrait*, Museo del Prado, Madrid.
Inscribed *Frᶜᵒ Goya Pintor / Aragonés / Por el mismo / 1815*.

UNDER THE HIGH PATRONAGE OF
Their Majesties The King and Queen of Spain

CONTENTS

TRUTH AND FANTASY
The Small Paintings
JULIET WILSON-BAREAU

FOREWORD

The Museo del Prado in Madrid, the Royal Academy of Arts in London and The Art Institute of Chicago have together organised this exhibition of the small works of Francisco Goya which, it is hoped, will reveal fundamental new aspects of his work and affect current studies of one of the greatest artists of all time. Goya's work is extensive, and constitutes an inexhaustible fund of material for research. In past exhibitions dedicated to the many facets of his output, the large paintings, portraits and historical and religious compositions, were often shown with works, which although smaller, were of captivating expressive power. These smaller works were usually relegated to second place beside the large-scale paintings. Yet, two museums in Madrid, that of the Real Academia de San Fernando and the Lázaro Galdiano, each own a significant group of small paintings and have shown them in such a way that the large canvases did not overwhelm the intensity and delicacy of the smaller.

It seemed that an exhibition that gathered together these small paintings by Goya could be a revelation, and bring out aspects of his art which, until now, have been little studied, as well as encouraging a more profound understanding of his work in general. The more the possibilities of this idea were explored, the more it became evident that it would open a way to a fresh examination of his works as well as being an event of the highest aesthetic value, both for the many Goya specialists and for the general public.

Once the theme of the exhibition had been established, the three institutions began to plan the research, which turned out to be complex and difficult. Goya's work is currently dispersed throughout many countries, in public and private collections whose guardians jealously protect their delicate paintings. The whereabouts of some of them were unknown; the condition of others was difficult to assess, either because of the fragility of the support or because of the presence of dirt and old varnish; hardly any of them had been examined technically.

First it was necessary to make a series of journeys to study all the small paintings at first hand. Then it was essential to compare as many of possible of the works to each other, and in some cases preliminary conservation work had to be undertaken. Many museums, including those that have lent works to this exhibition, generously helped to make these investigations possible. Given the necessity of examining the works in the best conditions, the Museo del Prado, with the enthusiastic support of its specialist staff, decided to complete the work in its own laboratories. Rarely has such intensive study been possible in the preparation of an exhibition.

In referring to his small, free and imaginative works, Goya used the phrase 'fantasy and invention': this has become the *leitmotiv* of the exhibition. Here we have gathered together the *bocetos* and sketches for the great decorative frescoes, altarpieces and tapestry cartoons, in which the artist freely expressed his first compositional ideas – as he was later to do for the series of paintings for private rooms, made without the constraints of a commission – the intimate portraits of himself, his friends and family and the miniatures dating from his final years in Bordeaux.

The idea for the exhibition was proposed in 1989 by Norman Rosenthal of the Royal Academy to Alfonso E. Pérez Sánchez, then director of the Prado, who welcomed it with enthusiasm. Juliet Wilson-Bareau, who had begun her scholarly career working on Goya, was chosen to undertake the research for the exhibition; her inexhaustible determination and energy, and her visual and scholarly acuity and subtlety ideally suited her for the task. In this task she has been staunchly supported by Manuela Mena Marqués and by the Departments of Restoration and Technical Documentation of the Prado and their laboratory. For the difficult task of coordinating the exhibition the efficiency of those who have working in the three institutions has been indispensable: we are grateful to Teresa Posada Kubissa, Emeline Max and Martha Wolff.

A Consultative Committee, consisting of Jeannine Baticle, Valeriano Bozal, Enriqueta Harris Frankfort, Julián Gállego, Nigel Glendinning, William B. Jordan, Priscilla E. Muller, Alfonso E. Pérez Sánchez, José Manuel Pita Andrade and Eleanor A. Sayre, has generously contributed its collective knowledge, moral support and invaluable advice. Our thanks also go to Felipe Vicente Garín Llombart, former director of the Museo del Prado who actively encouraged the project.

The generosity of private collectors, public institutions and colleagues from all over the world has been indispensable. At the Prado Museum the exhibition has been sponsored by the Banco Central Hispanoamericano, whose support has been essential in realising the project; the Royal Academy of Arts has benefited from the generosity of a private foundation which wishes to remain anonymous and from valuable media support from *The Times* and Classic FM. The Chicago showing of the exhibition is made possible by Sara Lee Corporation. The organisers are also grateful for the collaboration of the airline company Iberia in the transportation of works of art. Thanks to the support of the Spanish Ministry of Culture the exhibition has been included as part of the Spanish Festival in London in Spring 1994. The important exhibition *Goya and the Spirit of Enlightenment* was shown in Boston, New York and Madrid in 1989; now in the summer of 1994 Chicago will once again reinforce the collaboration between Spain and North America over the study of the art of Goya.

Francisco Calvo Serraller
DIRECTOR
MUSEO DEL PRADO

Sir Philip Dowson CBE
PRESIDENT
ROYAL ACADEMY OF ARTS

James N. Wood
DIRECTOR AND PRESIDENT
THE ART INSTITUTE OF CHICAGO

LENDERS TO THE EXHIBITION

GERMANY
Dresden
Staatliche Kunstsammlungen, Kupferstichkabinett

ARGENTINA
Buenos Aires
Museo Nacional de Bellas Artes

SPAIN
Madrid
BANCO INVERSION-AGEPASA
Biblioteca Nacional
E. Gutiérrez de Calderón
Casilda-Ghisla Guerrero Burgos y Fernández de Córdoba
Paloma Mac-Crohon Garay
L. Maldonado
Museo Lázaro Galdiano
Museo del Prado
Museo de la Real Academia de Bellas Artes de San Fernando
Conde de Orgaz
Marqués de la Romana
Marquesa de Santa Cruz
Baron Thyssen-Bornemisza
Thyssen-Bornemisza Foundation
Conde de Villagonzalo

Oviedo
Masaveu Collection

Saragossa
Museo Pilarista, El Pilar
Museo de Zaragoza

UNITED STATES
Boston, Massachusetts
Museum of Fine Arts

Chicago, Illinois
The Art Institute of Chicago

Dallas, Texas
Meadows Museum, Southern Methodist University

Flint, Michigan
Flint Institute of Arts

Los Angeles, California
The Armand Hammer Museum of Art and Cultural Center

Malibu, California
The J. Paul Getty Museum

Pasadena, California
The Norton Simon Foundation

Providence, Rhode Island
Museum of Art, Rhode Island School of Design

Williamstown, Massachusetts
Sterling and Francine Clark Art Institute

FRANCE
Agen
Musée d'Agen

Besançon
Musée des Beaux-Arts et d'Archéologie

Bordeaux
Musée des Beaux-Arts

GREAT BRITAIN
Barnard Castle, County Durham
The Bowes Museum

London
British Rail Pension Trustee Company
The Trustees of the National Gallery

HUNGARY
Budapest
Szépmüvészeti Múzeum

ITALY
Florence
Galleria degli Uffizi

SWEDEN
Stockholm
Nationalmuseum

OTHER COLLECTIONS
Jaime Ortiz-Patiño
S. Sebba

ACKNOWLEDGEMENTS

The organisers wish to thank those lenders who wished to remain anonymous and all the staff of the Museo del Prado, the Royal Academy of Arts and The Art Institute of Chicago. In particular the Committee would like to thank the following:

Javier Aguado
Javier Agudo
Mercedes Agulló
Santiago Alcolea
Jesusmaría Alía Plana
Isabel de Alzaga
Gregorio de Andrés
Gonzalo Anes Alvarez de Castrillón
Plácido Arango Arias
Evaristo Arce
Inés Argüelles
Rocío Arnáez
Pamela K. Askew
José María de Azcárate
Leticia Azcue
Reynold Bailey
Istzván Barkóczi
Esperanza Barreda Maldonado
Rosario Bartolomé
Pablo Benavides Orgaz
Félix Benítez de Lugo
Huguette Berès
Knut Berg
David Bindman
George Bisacca
Zacarías Blanco Gago
David Bomford
Annette Bradshaw
Sylvie Brame
Robert Bruce-Gardner
José Buces
Duncan Bull
José Ignacio Calvo Ruata
María Luisa Cancela
Marina Cano
Tracie Costantino
José Capa
Juan Carrete Parrondo
Condesa de Carvajal
Görel Cavalli-Björkman
María Concepción Contell
Bryan Crossling
Christiane Décaillet
Xavière Desparmet Fitz-Gerald
The Marquess of Douro
Douglas Druick

Adrian Eeles
Caroline Elam
Walter Feilchenfeldt
María Teresa Fernández de Bobadilla
Carmen Fernández Lascoiti
Gabriele Finaldi
Carmen Font
Jaime and Beatriz Fraser Luckie
Jesús Gaite
Klaus Gallwitz
Nigel Glendinning
Richard Godfrey
George Goldner
Joaquín Gómez Espinosa
José María González-García
Ana Gudiol Corominas
Montserrat Gudiol Corominas
María Angeles Gutiérrez Fraile
Ronne Hartfield
María Cruz Hermida
Christoph Heilmann
Johann Georg, Prinz von Hohenzollern
Wolfgang Holler
Luis Jiménez-Clavería Iglesias
Claude Keisch
François Lachenal
Julio Laguardia
Román Ledesma
Gregory Martin
Jane Martineau
Ana Martínez de Aguilar
Alvaro Martínez-Novillo
Katharina Mayer Haunton
Ian MacClure
Paolo Erasmo Mangiante
Marco Miele
Jacques Minassian
Jennifer Montagu
Mary Mulhern
Angel Navarro
Juana María Navarro
Alan Newman
Eva Nierges
Anne Norton
George Ortiz
Carmen Ortueta de Salas
Angela Osorio de Moscoso

Sandra Osorio de Moscoso y Sanchez
Félix Palacios
Edmund Peel
María Pemán
Paloma Pérez de Armiñán
Roy Perkinson
Leif Einar Plahter
Carmen Rallo
Claudie Ressort
Piers Rodgers
Alfonso Rodríguez G. de Ceballos
María Teresa Rodríguez Torres
Concepcíon Romero
Pierre Rosenberg
Daniel Rosenfeld
Isadora Rose-de Viejo
Ruth Rubinstein
Enrique Ruspoli Morenés
Martina von Sales
Duque de San Carlos
Elena de Santiago
Duque de Segorbe
Barbara Stern Shapiro
Julietta Scharf
Dorothy Schroeder
David Scrase
Mary Solt
Duque de Soria
Stephanie Stepanek
Julien Stock
Anna Stoll
Margret Stuffmann
Peter Sutton
Gary Tinterow
Federico Torralba Soriano
Federico Torrelló
Guillermo Tovar de Teresa
Nicholas Turner
José Antonio Urbina
Marqués de Valdeolmos
José Luis Várez Fisa
Zahira Véliz
Françoise Viatte
Peter Waldeis
Christopher R. Young
Josě Luis Yuste
Frank Zuccari

PREFACE

Much of the time spent in preparing this exhibition and catalogue has been devoted to analysing – and in some cases to first tracing and rediscovering – the large number of works that were studied. It was decided to make the publicaion into a selective 'mini-corpus' of the small-format pictures, sketches and miniatures, and to include lost or unlocated works that form part of complete groups or series, as well as paintings that for one reason or another could not be shown in the three venues of the exhibition. The presentation of so wide and complete a selection of groups of works from among Goya's small paintings was made possible thanks to the close collaboration of the many people and institutions who agreed to and frequently participated actively in the examination of works in their collections.

This study owes a great deal to earlier art historians and connoisseurs. Elías Tormo, followed by the late Enrique Lafuente Ferrari, devoted much time and energy to looking at (and often worrying about) the Goyas that they saw over many years, combining an acute analysis of the works with a broad view of their cultural context. The paintings presented here were discussed in detail with Norman Rosenthal and studied continuously over many months with Manuela Mena, who was an essential contributor to the project. Eleanor A. Sayre took time from her own Goya project to provide invaluable notes on pictures and share her opinions with us, and Alfonso E. Pérez Sánchez was a constant source of encouragement and information. We also received invaluable assistance from Jeannine Baticle, Enriqueta Harris Frankfort and Nigel Glendinning, as well as Jesús Urrea in the Prado Museum, whose recent discovery and publication of Goya's remarkable competition picture for the Parma Academy complements the discovery of Goya's Italian Notebook and throws additional light on the sketch that introduces the exhibition.

The emphasis in the texts that follow is on the works themselves, and the circumstances of their creation. Many of the paintings were carefully restored and cleaned in the Prado Museum in preparation for the exhibition, and most are now in optimum physical condition. I owe a special debt to the Prado restorers for an immeasurably enhanced understanding of Goya's techniques and changing style as a result of their observations as they worked on the paintings. Enrique Quintana, who coordinated the technical documentation, also contributed illuminating analyses of the significance of the paintings and the development of Goya's *œuvre*. María del Carmen Garrido and her staff in the Gabinete Técnico in the Prado added greatly to our understanding of the works through x-radiographs and infrared reflectography examination, as did technical and conservation departments in many other institutions.

The organisation of the project, both in terms of research and the setting up of the exhibition, was carried out in collaboration with Emeline Max at the Royal Academy of Arts, Martha Wolff at the Art Institute of Chicago, and Teresa Posada Kubissa and Montserrat Sabán in the Prado. Belén Bartolomé Francia was a willing and delightful research assistant, who helped to gather an

enormous amount of documentary material and compile the bibliography.

Santiago Saavedra, who coordinated the publication in Spain, ensured that many requests for unusual reference illustrations – particularly of church interiors – could be included and, with John Nicoll of Yale University Press, closely supervised the production of the catalogue. This English-language edition owes much to the editorial coordination, tact and skills of Jane Martineau, Sally Salvesen and Robert Williams, and to the translations of Goya's and other Spanish texts by Philip Deacon.

It is hoped that this exploration of the small paintings will pave the way for further study of the works themselves and a more fundamental consideration of Goya's *œuvre* as a whole.

JULIET WILSON-BAREAU

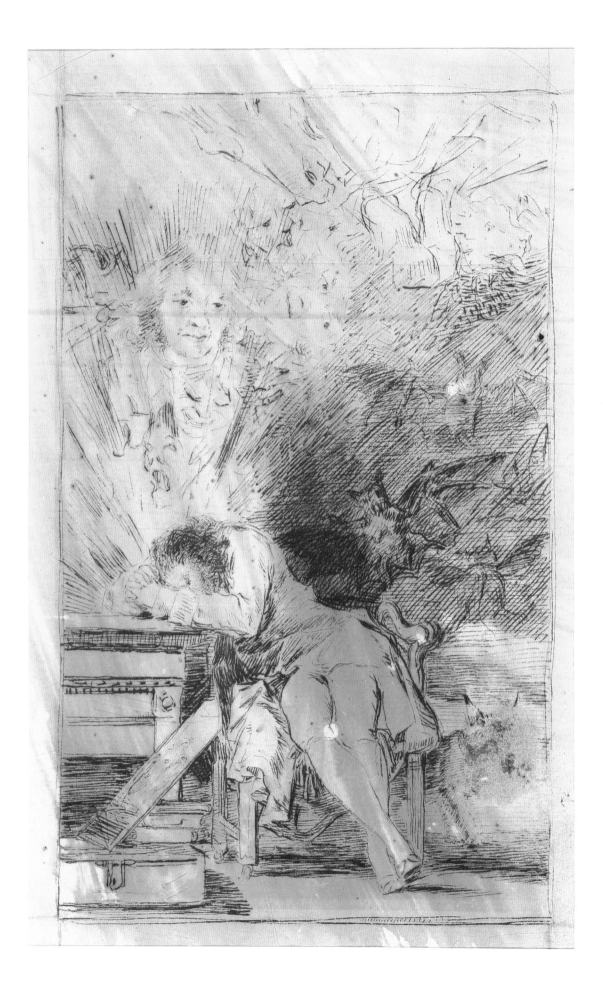

MUST IT BE SO? IT MUST BE SO!

Manuela B. Mena Marqués

Work out for yourself a way to catch this old god.
I am afraid he might see me first, or know I am there, and keep away.
It is difficult for a mortal man to win against a god.

(Homer, *Odyssey*, IV, 395–7)

*I*n the potent energy and variety of his art, Goya, like Beethoven, can be likened to the ancient sea-god Proteus, whose divine force and changing appearance – which made him invincible and able to deceive mortals – were described by Homer. The art of the great masters also possesses that divine quality; strong and changeable yet, for mere mortals, unattainable. Goya's first idea for the frontispiece of the *Caprichos*, published in 1799 (fig. 1), shows the fire of imagination issuing from the head of the sleeping artist in a changing, turbulent and powerful form like the 'old god'. The drawing emphasises the variety of his art, which combined exquisite technique and refined 18th-century forms with a darker, more dramatic amalgam originating in the mind of the painter, which would subsequently be interpreted as the quintessence of the Romantic spirit and, in the present century, as evidence of the hidden realms of the unconscious and as an anticipation of Surrealism.

Every age has to interpret great artists according to its own ideals and feelings, its preoccupations and fears, in tune with prevailing cultural affinities between present and past, emphasising what is interesting and ignoring what does not stir current passions. Artists who are not of the first rank are only mediocre witnesses of their age. Geniuses are the exceptional witnesses of the human soul; so relentless in their desires and passions that they not only define their age but create and inform it. Beethoven, with his question and assertive reply written at the head of the final

Fig. 2 *Self portrait*, c. 1795–7
brush and indian ink, 22.3 × 14.4 cm
The Metropolitan Museum of Art, New York

movement of his string quartet in F Major (opus 135) of 1826, 'Must it be so? It must be so!', summarises and defines his age. In this he was at one with his contemporary Goya: both appear to define the idea of art and the existential enterprise of the artist. Both 'invented' the art of the 19th century, and the

Fig. 1 Preparatory drawing for
'*The dream of reason produces monsters*', pl. 43 of *Los Caprichos*.
1797–8 (see fig. 31)
pen and ink, 23 × 15.5 cm
Museo del Prado, Madrid

mark they left on their contemporaries made them into emblematic figures. Beethoven's phrase captures the essence of liberty that both artists, the one in music the other in painting, held to be the most powerful spring of their art, the contribution that they made to their own age and bequeathed to posterity.

The essential characteristic of Goya, revealed in many different ways, was freedom of artistic expression. A freedom which undoubtedly derived from his strength of character: 'everyone, from the King and Queen down, knows me, and I cannot limit my genius as easily as others perhaps would do', he wrote (20 February 1790) to his friend Zapater (fig. 3). And slightly earlier he expressed the same force of character when referring to the malice of his enemies at court: 'but they only come up against an edge of porphyry. Against a b–t, g— who will break into a thousand pieces before they make him yield an inch' (December 1789?). The *Self-portrait* of *c.* 1795 (fig. 2) illustrates Goya's characteristic manner, and establishes the parallel with Beethoven. The painter looks straight ahead; his lowered chin accentuates the power of his gaze and the indomitable expression of his dark eyes; the tense mouth with the protruding lower lip reveals the obstinacy of his character; and the wild, long hair frames his face and can be seen as a symbol of the creative freedom that emanates from his brain – artistic freedom born out of the inner conviction of the abundance of his imagination, deriving from an assessment of his own strength. 'Give up opera and all the rest, write only in your own manner', Beethoven jotted in one of his notebooks in 1816. 'There are no rules in painting', said Goya (Report to the Royal Academy of San Fernando, 14 October 1792), adding later: 'Finally, Sir, I do not see any other more effective way of advancing the Arts, nor do I believe there is one, than to reward and protect the young artist of exceptional talent, render due respect to the master, give free reign to the spirit of students who wish to

learn, without stifling it, and without imposing methods that would warp the inclination they show'. Operating against well-established rules, Goya forged a way forward to the new, which, without entirely breaking with the present, transcended the aesthetic ideas of the age in which he lived.

The freedom of Goya's art was not the chaotic expression of uncontrollable creative forces nor the 'unbridled contravention of the law', in this case, the laws of art; it was the intelligent choice of that which enabled him to express his ideas in the most appropriate form, imposing his own criteria, without subjecting himself to rules that did not interest him. Even in his earliest works Goya's artistic personality is unmistakable. Only the bad state of conservation of some of his paintings has led to doubts being raised about their author-ship and, in the same way as his writings vividly reveal his personality, so too the brushstrokes, light and shade, colours and even those parts of paintings which appear hidden, like the support and the preparation, are unmistakably his own.

Already at the outset of his artistic career, Goya demonstrated an exceptional know-ledge of the art of the past. Evidently he had studied the methods and artistic practices established in 16th-century Italy which had even filtered down to the modest workshop of José Luzán, his first teacher in Saragossa. He encountered the same rigorous tradition during his first stay in Madrid when he worked in the studio of Francisco Bayeu. While there he undoubtedly visited the royal collections; and shortly afterwards studied the works of Antiquity and of the great masters of the Renaissance and the Baroque during his time in Italy. These studies bore fruit in his excep-tional draughtsmanship, his knowledge of anatomy, the beauty of his form and monu-mentality and harmony of his figures and compositions. Even before the recent dramatic discovery of his Italian Notebook (p.92), which provided proof for what had

Fig. 3 *Martin Zapater*, 1797
oil on canvas, 83 × 64 cm
Museum of Fine Arts, Bilbao

previously only been guessed at, Goya subtly incorporated elements gleaned from the art of the past into his works. In order to achieve this he used drawing, which for him was not a question of using line or outline but of capturing and structuring form by means of light and shade.

The paucity of drawings dating from Goya's first period had previously led scholars to think that he did not use them to study nature or form or to work out his compositions. Goya never conformed to the romantic idea which visualised him and other Spanish artists painting straight onto the canvas without preliminary studies. The few known drawings from his early years – the studies of a woman's head in the Prado Museum (fig. 78–80) or some impressive sketches of figures for the tapestry cartoons dating from somewhat later (fig. 40) – provide evidence of such competence and subtlety in technique and structure that they show the young Goya to have been a masterful and powerful draughtsman. In the light of the Italian Notebook (fig. 38, 60–69, 72, 75, 81, 84, 86, 102, 148), one can appreciate his rigorous training and the working methods that provided him from his early years with the profound awareness of the structures that determine form and composition; to this was added his stunning use of chiaroscuro and his unsurpassed intelligence in the application of colour.

There is another element which goes into the making of Goya's art: reality. Yet, for Goya, even in his youth, reality was not the simple depiction of customs and manners (*costumbrismo* in Spanish), but rather the capturing of the essence of Spanish life, the local colour of a society which was to disappear for ever with the invasion by the French and with war, the nationalistic traditions (*casticismo*) of the common people and of the aristocracy (fig. 8, 9), which in Goya is the genuine expression of the concept of Spanishness. For this reason the tapestry cartoons and their preliminary sketches can be defined as archetypal examples of 'Spanish caprice'.

Although the fellow artists who worked on the project for the Royal Tapestry Factory – Francisco and Ramón Bayeu, Maella, González Velázquez, José del Castillo (fig. 133) and others – used the same or similar themes to those painted by Goya – life in Madrid, scenes of rural picnics and street-sellers, in the manner of Italian or French paintings and prints – they were unable to go beyond the creation of pleasant genre scenes, similar to those being produced by other European artists of the time. Stereotyped and without any individual characterisation, the sketches and cartoons of these painters never rose above the merely decorative. Goya, however, went beyond the anecdotal and the fleeing experience of the moment to create symbols of specific social classes, of the grace and deceptiveness of women, and of childhood. What mysterious compositional factors explain their transformation into unforgettable images, some of them masterpieces of European painting?

Goya imposed classical compositions on his scenes and borrowed poses from the Antique for his characters, the *majos* and *majas* of Madrid in their contemporary clothes. (fig. 4, 139). But Goya himself claimed, through his son's biography, that Velázquez, Rembrandt and Nature had been his masters, and this, in conjunction with other factors, is certainly true. The free brushwork and sobriety of colour of Velázquez is combined with the varied and individualised expression of character of Rembrandt. Goya had also studied nature, in the broadest sense of the term. In the report to the Academy of San Fernando, Goya revealed his concept of nature: 'what a profound and impenetrable mystery is contained in the imitation of divine nature, without which there is nothing good, not only in painting (which has no other task than its exact imitation) but also in the other sciences!' Goya abandons the rhetoric of the official report

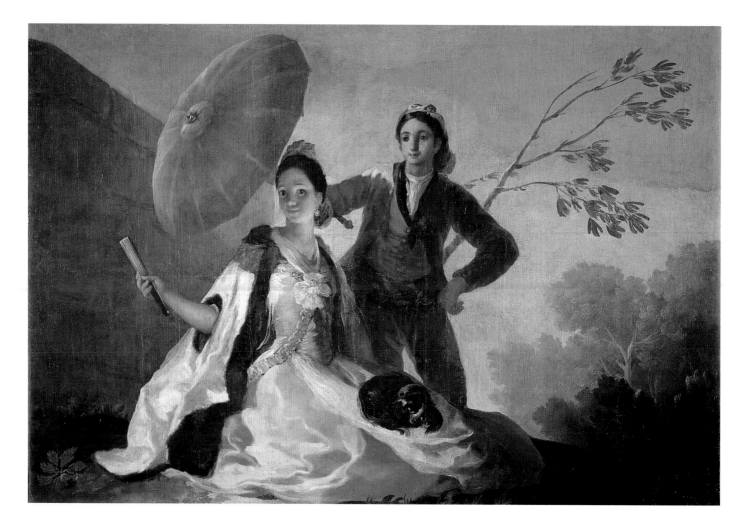

Fig. 4 Tapestry cartoon, *The Parasol*, 1777
oil on canvas, 104 × 152 cm
Museo del Prado, Madrid

when he exclaims: 'What statue or cast exists that is not copied from divine nature? As excellent as the artist may be who copied it, he can but proclaim that, placed side by side, one is the work of God, and the other of our miserable hands.' In his imitation of nature Goya reveals vitality, not cold, rational analysis. His words reverberate with his delight in the world that surrounds him, the colour of the sky, the capturing of light and atmosphere, the form of clouds, trees and mountains. This is evident in his letters in which he speaks of hunting: 'we went off to the mountains which are seven leagues away from Madrid' (to Zapater, 6 October 1781); 'go on, why not come; together we will go to a few places where we can bag a bird or two' (to Zapater, 6 June 1787; see fig. 49).

In 1825 Goya wrote a letter to his friend Ferrer from Bordeaux that reveals certain aspects of his artistic personality (see cat. 99–111), and which also demonstrates his 'youthful' old age. The artist rebels against the idea that his *Caprichos* of 1799 should be reprinted, claiming that now he has better things to do than he did twenty years before. He tells Ferrer how he has painted a series of more than '40 experiments, original miniatures that I have never seen the like of before because the whole is made up of points and things which look more like Velázquez's brushwork than that of Mengs'. The quotation reveals Goya's attitude to his art and the awareness he had of its originality and novelty; but even more is revealed: Goya underlines the fact that it was Velázquez's technique that provides the modernity. It was this profound understanding of the latter's paintings that made Goya a revolutionary painter, perhaps the first modern artist.

It is evident that Goya did not only study the external aspects of Velázquez's work, which had always inspired realist Spanish artists to some degree, he also understood the way in which his predecessor's art had broken with all traditional models. It is not difficult to

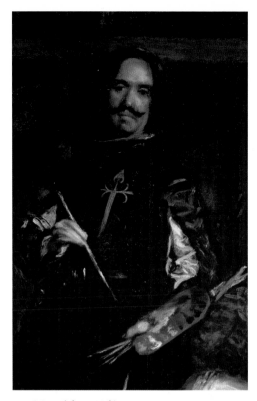

Fig. 5 Detail from Velázquez, *Las Meninas*, 1656 oil on canvas, 318 × 276 cm Museo del Prado, Madrid

Fig. 6 *Self-portrait*, 1783 oil on canvas, 86 × 60 cm Musée d'Agen

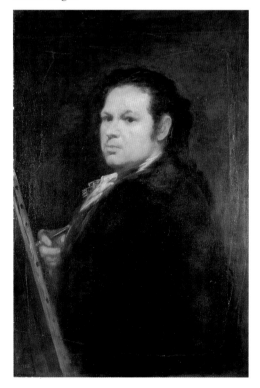

23

imagine Goya's surprise on studying the manner in which the great Spanish painter of the 17th century had treated the inviolate idealised world of classical mythology in such works as *The Forge of Vulcan*, *Bacchus* or *The Topers* and even the *Rokeby Venus*. The same transformation is evident in Velázquez's personal approach to religious subjects, such as *Christ Crucified* or *The Flagellated Christ*.

Goya's admiration for the variety of portraits by Velázquez he could see in the royal collections (fig. 5, 6) must also have been considerable. The realism, expressive force, subtle nuances of character and position – power, pride, beauty or stupidity – acted as fundamentally important examples for Goya. But another aspect of Velázquez's art was also significant, and impelled Goya to break with tradition in his maturity: the presence in Velázquez's works of a world of ugliness, of beings with a deformed, sometimes almost monstrous appearance; the acceptance of what was less than human. The palace dwarfs and fools can be regarded as the precursors of Goya's audaciously original subjects, the basis of his essential modernity.

Goya delved deeply into the mysterious side of humanity which determines man's actions: 'and what now? I'll have you know I'm not afraid of witches, spirits, phantoms, boastful giants, rogues, knaves, etc., nor do I fear any other kind of beings except human ones'. He fears humans because he has made the acquaintance of every possible type: 'they not only scratch and fight, they bite and spit, sting and pierce; on these other fatter ones feed, and they are worse. For these no better protection has been discovered but the earth, and that is not because they [the monsters] pardon the dead. Even when dead they do not cease to be offensive because their cruel behaviour extends even to neighbouring corpses; there is no remedy except knowing how to put yourself beyond the reach of their cruelty' (letter to Zapater, 19 February 1785). Goya describes evil and envy with humour, his vivid

imagination made it possible for him to describe symbolically in painting the character of 'humans'. But it was not always evil that attracted him. In all Goya's surviving letters, including the letters to Zapater, there are many examples of his cheerfulness and optimism, of his good heart and wish to amuse himself, of his loyalty and love for family and friends: 'I forgot to tell you that my sister-in-law, our Maria, got married and that I was the instrument or begetter of the marriage since it was to a friend of mine.... The handsome bridegroom is falling apart and at only 24 years of age' (to Zapater, January 1783). This human, heartfelt comment about the 'handsome bridegroom' and 'our Maria' seem to prefigure the central figures of the 'loving couple' in the sketch of 1788 for the *Hermitage of San Isidro* (cat. 25).

Goya's interest in and knowledge of mankind made him one of the great portrait painters in the history of art. The vast majority are full size, but he also executed some exquisite, small-scale portraits of the highest quality, among them his self-portraits (cat. 62, 63) and the equestrian portraits of Godoy (cat. 61), of which he said, 'I assure you that it is one of the most difficult subjects one could propose to a painter' (to Zapater, 2 August 1794), and the miniatures of his son Javier and his in-laws (cat. 67–73), in which he achieves the same incisive naturalism and insight into the psychology of the sitter as in his large commissioned portraits.

The study of Antiquity and of the portraits of Titian and Velázquez which he could see in the Spanish royal collections and elsewhere, and his own talent to capture reality are all revealed in his portraits. As in his religious or genre compositions, in his portraits Goya created images of a profound symbolic value that transcend the mere copying of physical appearance of a particular person and become representative of the human spirit (fig. 8, 41, 48). The painter's writings reveal his agility in capturing the psychology, actions and gestures

Fig. 7 A Letter from Goya to Zapater,
'*Londres 2 de agosto de 1800*' [i.e. 1794]
Museo de Prado, Madrid

of men, with an undercurrent of humour that at times borders on satire. He gave a lively description of Carlos IV after he had delivered a painting to the King: '... and I have had the good fortune to please him a great deal, so that not only through the manifestations of his mouth has he praised me but also with his hands, on my shoulders, half-embracing me, as he spoke ill of the Aragonese and of Saragossa' (20 February 1790). This perfectly describes the King's affable manner as he joked with the artist about his native town and his fellow countryman, perhaps Francisco Bayeu. More revealing is the letter to Zapater in which, after a long separation, Goya questions his friend, in a mood of curiosity mixed with melancholy: 'I should like to know if you are elegant, distinguished or dishevelled, if you have grown a beard and if you have all your own teeth, if your nose has grown, if you wear glasses, walk with a stoop, if you have gone grey anywhere, and if time has gone by for you as quickly has it has for me. I have become old and wrinkled, you would not know me except for my snub nose and sunken eyes ... what cannot be denied is that I am very conscious of my 41 years and you perhaps look as young as you did in Father Joaquín's school' (28 November 1787). Although the letter is lost, and is known only in a German translation (the language in which it was originally published), it shows Goya's mastery in giving penetrating descriptions using a couple of words as easily as strokes of the brush. Whether on a large or small scale his accounts provoke a smile in the spectator.

Goya's capacity to make himself the master of the changing reality of mankind is evident in his portraits, and in the figures to be found in his paintings, drawings or prints. He manages to individualise figures with an impressive economy of means. This is the case especially in his caricature, both in the figures or scenes in his drawings and prints, and also in the few portrait caricatures that have survived. Perhaps the most significant is the celebrated self-

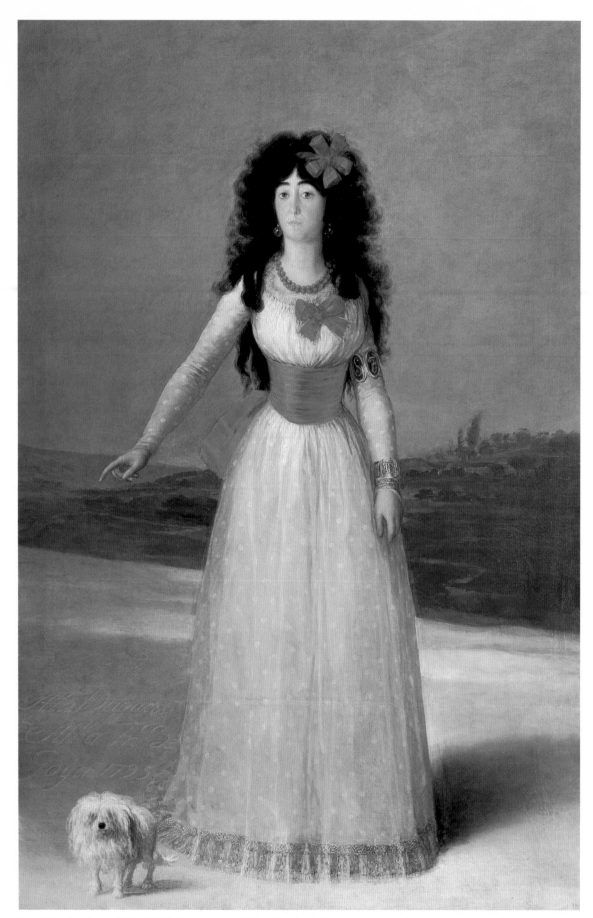

Fig. 8 *The Duchess of Alba*, 1795, oil on canvas, 194 × 130 cm, Collection of the Duke and Duchess of Alba, Madrid

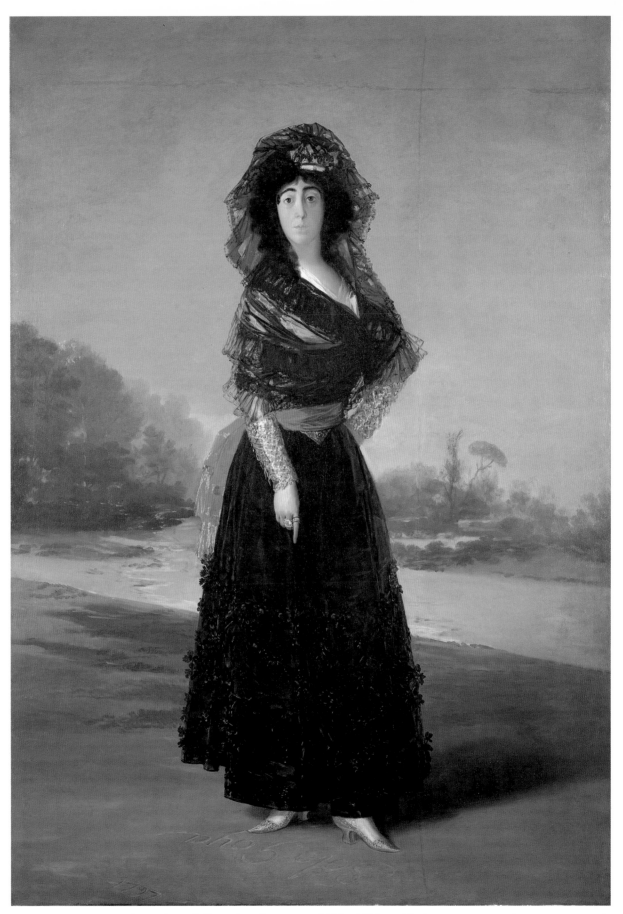

Fig. 9 *The Duchess of Alba*, 1797, oil on canvas, 210.2 × 149.3 cm, The Hispanic Society of America, New York

portrait in the letter to Zapater of 1794, written at the time of Goya's relationship with the Duchess of Alba, when the artist was already deaf. With a few lines from his pen he shows himself seated, in profile, with his chin sticking out – perhaps just after taking measures to alleviate an aching tooth – with his snub nose and sunken eyes, delicately accentuating the well-known features of his face: 'this is how I am', he tells his friend (fig. 7).

Since the first caricatures, made towards the end of the 16th century by Annibale Carracci – who was admiringly referred to by Goya in the report to the Academy – masters of the portrait have been also masters of caricature. Caricature is a rapid and simple form of art; it has an instantaneous effect, immediately provoking the viewer to laugh or smile. Whereas portraiture seeks to discover the character of man in an heroic sense, caricature brings out its defects, and through distortion pins down the spirit and essence of a personality, reflecting the inner life, not the physical appearance, of the individual. The masters of caricature, such as Annibale Carracci, Bernini or Goya, each brings sharp mental faculties and the capacity to observe, which enable them to enter another mind and disclose the hidden disharmony of the personality, and to fix it with a few strokes on paper or canvas. The alteration of the physical features and gestures can be extreme, and its roots lie in a long tradition of probing and analysing the individual. Goya also appropriated an idea of Giacomo della Porta, who transposed human characteristics, such as haughtiness, pride, vigour or stupidity, to the features of birds or animals. In Goya's work the most deep-rooted human vices were suggested through alteration of the facial features, which border on the bestial (fig. 14). But such an extreme degree of deformity was not always necessary; Goya is a master of subtlety. The essence of caricature, the revelation of the spirit by means of slight alterations in the physical appearance of someone, is present in all his portraits, although in many of

them it may now be hidden from our eyes, since we are unable to compare the portrait with the original.

In Goya's caricatures the psychology of the subject is revealed in a subtle way. Some are cruel; others friendly. The viewer unconsciously sides with the artist, shares his feelings, trusts the eyes that have uncovered the defects hidden beneath the shining silks, or laid bare the sweetness, fear or intelligence beneath the simplicity or loyalty of a character. This arrogant confidence of Goya, who trusted his own powers, the openness with which he undertook every action in his life, can also be read in his portraits, to the extent that we now recognise the people of his time through his portraits. In order to achieve that supreme mastery in the representation of the individual, Goya, as he himself affirmed, had only to skip all the rules: the rules of Court art, which demand adulation and servitude, the rules of the depiction of colour and light, and the rules governing technique.

Each of Goya's two great self-portraits exemplifies this. It is equally illuminating to compare the various known portraits of the Duchess of Alba, because the artist's link with her gives them a greater expressive potential. In the small portrait in the Prado, the Duchess is seen from behind, with her beautiful mop of black hair and slim figure, frightening her servant, 'the pious woman' (cat. 64). The forcefulness of her gesture and her abundant curled hair are used to convey the impulsive character of the Duchess, as it is known from contemporary sources. This tiny canvas, dated 1795, has all the characteristics of a caprice, but in the same year Goya was to paint one of the most beautiful portraits of her (fig. 8). Standing erect, facing forward, dressed in white, the Duchess has something of the appearance of a *kore*, an archaic Greek statue of a woman. Her red sash and bows are the subtle means by which Goya transmits something of her passionate, capricious character, but the features are serene. The arm extends in

a calm gesture that indicates the artist's dedication (written on the ground), her white gauze dress is a symbol of the harmony of her person in relationship to the serene, bare landscape of greenish and grey tones, and the world around her. The painter straightforwardly and unreservedly admires the delicate, vibrant beauty of the young woman. The portrait seems to reflect the calm period before the French Revolution, when the Age of Enlightenment was coming to an end, when Reason would no longer hold sway. In the portrait of the Duchess of 1797 (fig. 9) everything has changed. The white gauzes have become black lace, red continues to be the colour of the decoration on her dress, but now seen in momentary flashes beneath the mantilla, like sparks from a bonfire, whose reflected glow touches the face of the woman. The hieratic pose of the earlier portrait is now transformed by the haughty carriage of the Duchess, emphasised by her left arm resting on her hip and the right arm, whose hand points imperiously towards the artist's inscription, 'Only Goya' traced in the ground at her feet. A river flows in the background, symbolic of the flux of existence, heralding the arrival of a new century that Goya anticipated and invented before anyone else. It is a portrait *par excellence* of a character, not of her features – Goya kept the portrait like a prized talisman to the end of his days – in which every line, every gesture, every movement is laden, as in caricatures, with content and meaning (the Italian word for 'caricature' derives from the verb 'to load'). One senses the veiled contempt of the indomitable Duchess.

Goya delighted in spectacle and street scenes: there are many references to amusing situations in his letters to Zapater, such as his fall from a new carriage 'in the English style and built there, so light that it leaves everyone else behind, with its ironwork excellently gilded and shiny, what a beauty: even here people stop to look at it'; but, 'going at a gallop along the wide street which, although it was wide, was not sufficiently so: imagine what [the driver] did, for on executing the turn we ended up, carriage, horse and the two of us, turning somersaults, and thank God it was no more than that' (1 August 1786). Or the account of intimate family festivities: 'we have got excited to the point that our joy has become almost uncontrolled. What toasts! What a succession of bottles! What coffee and encores of coffee! What bottles! What glasses in the air!' (December 1797). Such descriptions give an idea of Goya's eye for detail and for the essential qualities in any scene. 'Yesterday the King went to Atocha at five o'clock in the afternoon, very happy, with the Prince on his left and the Princess and Carlota facing backwards, the Infantes behind in another carriage that was followed the Infanta and all the royal retinue, it made a fine sight (and I remembered you, since in all my greatest pleasures that is what I usually do). The light was good and the plaza Mayor looked better than on other occasions, both in my opinion and that of others' (30 March 1785).

Any subject is suitable for Goya: he knows how to handle not only individuals but also groups or crowds and the relationship between them and the individual. The colour, liveliness and sense of activity come through in his compositions; one can almost hear voices, noise and music: 'Tonight they are putting on excellent music for the King and Queen performed by the musicians of the opera company and the theatres, at nine a very large number of people will attend, how I wish I could go with you …', adding in a postscript, 'now that I have heard the music, I can assure you it was magnificent, there were more than a hundred musicians' (letter to Zapater, 23 June 1789). The artist makes use of the world around him for the new art he is creating, but he still appears to have doubts about his own capabilities. In some of his sketches for the tapestry cartoons he feels unsure of himself because 'the subjects are so difficult and require so much effort, like the Meadow of San

Isidro on the Saint's day itself, with all the hustle and bustle there usually is there; I assure you, in confidence, that I feel ill at ease' (31 May 1788). Imitating nature rather than making a servile copy of it, the *Meadow of San Isidro* (cat. 26) combines artistic acuity and imagination to create a vivid sensation of reality.

It was in the 'sketches' (cat. 7, 19–31) for the tapestry cartoons that Goya began to express, on a small scale, new ideas that broke with traditional iconography. Until then he had been able to derive his inspiration for religious subjects more or less directly from existing compositions. The determining factor was the new concept of freedom that he perceived in those final years of the 18th century, the prelude to the new age. In his earliest years, Goya had sometimes worked in collaboration with other artists, in particular with Francisco Bayeu. ('The little sketch you have was conceived by Francisco and executed by me and the end product isn't worth three sous, it doesn't matter whether it's mine or yours nor is it worth the canvas it's drawn on', he wrote to Zapater, 9 January 1779). At that date he was apparently unaware of the possibilities that the small sketch was going to hold for him.

The little stories that Goya invented narrate comical or satirical events; they are linked to one another, and are the first works of his career to be planned as a series. Goya was aware of the difficulty of the task: 'If [only] I hadn't been given orders from above to have the designs done for the bedroom of the most serene Infantas in time for the arrival of the Court here. It is something I am working on with great dedication and annoyance since time is short and it is something the King will see' (31 May 1788; see cat. 25–29). As a result, the technique employed for these small works was very elaborate, since Goya had to submit them to the King for his approval; this is true of all the sketches for the later series of tapestry cartoons. From the preparation of the canvases to the final glaze, the care and refinement of his technique is evident: all these sketches,

once they had fulfilled their role as models for the monarch, were regarded as works in their own right with a value of their own. It is therefore not surprising that for many years, indeed until x-rays recently revealed changes in compositions, some of them, such as those acquired at an early date by the Duke and Duchess of Osuna (see cat. 25–29), were assumed to be not preparatory sketches for the cartoons, but highly finished, repeat versions of the compositions.

The grace and beauty of these subjects, and the exquisite care with which they were executed, won them admiration from connoisseurs at an early date. In his letters, Goya discusses these small works: 'Sabatini tackled me about some fine sketches which I had, and which had already been dispatched; you didn't come off too badly and I have been left bare. The old one which I had of the dance, if you like you can put it in a corner, because as it was unusable, it remained ...' (letter to Zapater, December 1778). Given as presents, or sold to his friends and patrons as 'cabinet paintings', their immediate, sketch-like character that captured everyday reality became a new form of expression for the artist. They provided him with the opportunity of giving free reign to his imagination for 'caprice and invention', and with the bonus of being able to sell them to a clientele that had not commissioned the works, and which had not influenced his creative imagination: 'I work with the same sense of honour, which gives me pleasure, without having to deal with my enemies, abasing myself to no one' (to Zapater, 25 March 1786). In 1794 Goya made some independent paintings, or cabinet pictures, for the first time. These are the pictures on tinplate (cat. 32–43) that he presented to the Royal Academy of San Fernando, sending them with a letter to Bernardo de Iriarte in which he explained how he had worked on them with freedom and imagination. The Italian tradition for *capricci* (caprices) was still alive at the end of the 18th century: Goya wished his compo-

Fig. 10 G. B. Tiepolo,
*Polichinela Talking to
Two Magicians* and *Six People
Watching a Snake*,
plates 9 and 12 of the *Scherzi di Fantasia*,
c. 1760

sitions to be associated with it. In 1799 he published the engravings of 'scenes of capricious subjects', known as *Caprichos*. The genre, whose greatest practitioner in the second half of the 18th century was Giambattista Tiepolo, had enjoyed great popularity both in Italy and in Spain (see Hoffman, pp. 47ff.). Tiepolo's small fantasy scenes were sometimes of a satirical character, and sometimes included magical or oriental allusions. They are distinct from Goya's but have the same spirit of freedom and imagination. Tiepolo's engravings, known originally as *Capricci*, although years later his son Domenico divided them into *Capricci* and *Scherzi*, can be dated between 1735 and 1770, the last ones being almost contemporary with the beginning of Goya's career. The popularity of these works by Tiepolo certainly had something to do with Goya's devotion to this curious genre. Both *capriccio* and *scherzo* are musical terms, and from the beginning of the

17th century were used to categorise small works of a playful nature, composed of short musical phrases and bright, gracious rhythms, in which certain liberties denied to more solemn music were allowed.

The essence of Tiepolo's *capricci* lies in the enigmatic nature of their subject-matter, and the evocative power of their expressive effects. No scene has an exact historical moment: the characters, their dress and the decorative elements are haphazardly combined from the worlds of Antiquity and of the Orient, linking magic with literary references and illustrating themes taken from the *commedia dell'arte*. Death, the ephemeral nature of existence and pleasure, and the yearning for the past lie beneath these scenes, as in the last series of *Scherzi* (fig. 10), possibly executed as late as 1770. Goya evidently knew these works; perhaps he saw them in Madrid, since it is likely that he had links with Giambattista's son Domenico, who was somewhat older than

him. Alternatively, he may have seen them in Italy, where they were appreciated by collectors. Tiepolo, like Goya, was an artist whose series of prints and sets of decorative works were based not so much on traditional sources and iconography – although he might make use of them – as on his own vision.

The 1790s mark the beginning of a new attitude in Goya: the 'preliminary sketch' became an accepted part of his artistic expression, not merely as part of the preparation for larger paintings but as a work of art in its own right. Unless other works are discovered in the future, it seems that the first '*caprichos*' must have been the tinplates presented to the Academy in January 1794 (cat. 32–43), although Goya's serious illness at the end of 1792 and beginning of 1793 is usually taken as the starting-point for the new genre and for his new creative independence. From the middle of the previous decade, when he was made a Court Painter, the artist already enjoyed financial security thanks to his hard work and thrift. On 1 August 1786 he wrote to Zapater: 'I had already established for myself an enviable way of life, I didn't go begging to anyone, anyone who wanted me sought me out, I was more sought after, and if it wasn't for a very important person or at a friend's insistence, I didn't work for anyone'. A few days later, on the 23rd, he tells him: 'I walk, eat and drink well and I enjoy myself all I can', but by the next year Goya appears to have found his profession more onerous: 'My friend, I work a lot, almost nothing amuses me' (28 February 1787); expressions such as 'Good-bye, I have no more time' (10 March 1787), 'I can tell you nothing about all the things which are happening to me because I am always in a hurry' (23 June 1787), and 'I am so laden down with work that if they do not give me a couple of months…I won't be able to carry them out' (19 March 1788) become more and more frequent in the subsequent years. Goya enjoyed a stable, comfortable position, but work piled up and he resented it, wishing to enjoy a freedom he appeared to have lost: 'I do wish they would not remember me, so that I can live in greater tranquility and to be able to carry out the works I am required to do; so that I can use the time left over for my own pleasure, which is what I miss' (2 July 1788). In April 1789 he was appointed Painter to the King and inevitably his duties and work increased: 'I could not reply to you by the previous post because of the many duties I have' (11 November 1789). These letters to his dear friend Zapater give the impression that Goya had no free time since he had to work for the Court, the Academy and for the public. This would seem to confirm the suggestion that until that time he could not have begun the cabinet paintings and independent pictures. Overwork and other duties increased; this may have been the cause of Goya's mysterious illness. It was probably true, when in describing to Zapater his duties and the spirit of envy that surrounded him, he wrote 'I have the misfortune to have a difficult path ahead' (25 April 1789). For some years he had tried to avoid commissions, responsibilities and rivalries, and at the end of 1792 Goya left for Andalusia and Cadiz, having finally managed to obtain permission from the King to leave the Court; it was there that he fell ill.

After 1793, back in Madrid, having recovered from the most dangerous stage of the illness, Goya's correspondence with his friend took on a complaining, aggrieved tone that contrasts markedly with his healthy and cheerful spirit of the previous years. At the end of 1792, during his stay in Cadiz and shortly before falling ill, perhaps in the company of friends, Goya began to think about and execute some of these first works of the series of plates for the Academy. These lighthearted scenes of bullfights recall some of the inventions for the tapestry cartoons, and their technique is very close to that of the earlier sketches (see cat. 32–37); even in *Strolling Players* (cat. 38), which is reminiscent of 18th-century pictures of popular entertainments,

like some of the small-scale canvases of Giambattista Tiepolo, Goya's healthy and extrovert character still seems intact. But the painter turned to his childhood friend for the support he appeared unable to find around him during the bitter days of convalescence: 'My dearest friend, I am standing up, but feel so ill that I am not sure my head is on my shoulders, and I have no wish for food, or anything else. Only your letters and you alone, to the exclusion of all else, gives me pleasure. I do not know what is happening to me, wretched as I am, since I have lost you, lost you.' (letter to Zapater, 1793). Goya no longer had the strength to work: 'I have still not begun to work, nor have I been spirited enough to do so with my ills, I will begin, God willing, next week' (letter to Zapater, 1793), and shortly afterwards he wrote that 'as concerns my health, I am the same as before, at times raging with a spirit that I cannot stand, at other times calm, like now when I have picked up my pen to write to you, and now I get tired, all I will say is that on Monday, God willing, I will go to see the bullfight and I would like you to accompany me' (to Zapater, 23 April 1794). The letter sent to Iriarte with the series of plates also revealed the artist's gloomy mood, and it was probably true when he told Iriarte that he had painted them 'to occupy my imagination which is mortified contemplating my ills' (4 January 1794). The delight and amusement evident in the anecdotes of the earlier years were replaced by the anguish of a man at a loss in the face of the elements, of destiny and of the blackness of his own illusions. In the last works of the series the drama begins: death and madness, like premonitions of the times that are looming, prefigure the subjects that would occupy the artist. Of these works, the *Fire at Night*, *Attack by Robbers*, *Shipwreck*, *Interior of a Prison* and the *Yard with Lunatics* (cat. 39–43) bear witness to the gloom and sadness of the artist, and to the solitude and isolation that were the result of his illness and deafness.

It was during the 1790s, in particular the years between 1794 and 1800, that Goya produced many of his greatest independent works; it was also the time that his fully developed artistic personality emerged. Around 1796 he appears to have recovered his strength and spirit; this is borne out in the few letters of this period to his friend Zapater, and in the many commissions he carried out. It was the time of his greatest large-scale commissioned portraits, and, as well as the small cabinet pictures, Goya used drawing and etching for the full expression of his ideas. Whereas earlier he had no free time for his independent work, now he found time, as he had to abandon social engagements and give up teaching at the Academy because of his deafness.

His studio, with its work-table, was now his refuge. In 1796 he spent some time on the estate of the Duchess of Alba at Sanlúcar de Barrameda; the so-called Sanlúcar Album, recording scenes of life in the Duchess's palace dates from this period (fig. 11, 188, 189). The small, delicate drawings of the Album are essential for an understanding of Goya's evolution. It contains, among other subjects, the first ideas for one of the works that has brought him most fame: *The Naked Maja* (fig. 12). A cabinet picture *par excellence*, perhaps painted for Godoy, in whose palace it was housed in 1800 according to the accounts of Pedro Gonzáles de Sepúlveda and Agustin Ceán Bermúdez, placed alongside other female nudes of a mythological character. In contrast with these, for the first time in the history of European art, the nude does not rely on a mythological subject: it is not Venus, but a woman who hides her identity behind a deceitful smiling mask. It is the ultimate caprice: in her nudity the woman is simultaneously prostitute, victim, Venus and enchantress, one who signals the end of the 18th century and opens the way to the new era in which all the liberties of Romanticism would

find a place. The painting, whose mystery has still not been fully explained, is a work of intimacy, 'an enlargement' of a cabinet painting, an ambiguous, enigmatic caprice, the concern of inquisitions of all ages: 'Let the said Goya be ordered to appear before this tribunal in order to identify [the *majas*] and state whether they are his work, for what reason he did them, at whose request and what intention guided him' (Judgement for the Tribunal of the Holy Office, 16 March 1815).

Goya's art had already encompassed subjects that had rarely been treated before: asylums, prisons and isolation hospitals. These were years of political and social criticism, also evident in the *Caprichos*, violent satires in which reality and imagination are combined,

paralleling the satirical spirit which was sweeping through the rest of Europe in these years (fig. 19–23). Throughout this period of exceptional creative activity, Goya consciously abandoned the norms of 18th-century art. The final years of the century also witnessed the definitive establishment of the themes that define the image of Goya up to the present day. As has been pointed out already, it was only after he became ill and deaf that dramatic subjects and obscure scenes of witchcraft appeared in his paintings. Perhaps the fundamental series is that of the eight canvases in the Marquess de la Romana's collection (cat. 74–81), in which the 'capricious subjects' emphasise tragic, violent and frightening aspects of reality. Is it the painter's predilection for drama? That cannot

Fig. 11 *Young Woman Washing at a Fountain*, page d of the Sanlúcar Album, 1796
brush and indian ink,
17.1 × 10.1 cm
Biblioteca Nacional, Madrid

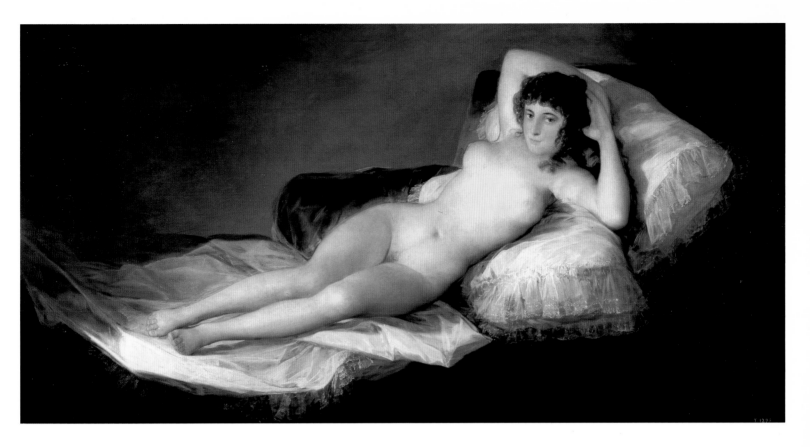

Fig. 12 *The Naked Maja*, before 1800
oil on canvas, 97 × 190 cm
Museo del Prado, Madrid

be the whole reason. During the gloomy years of his illness Goya developed a taste for death and the dramatic, and the pictures that follow the promptings of his own ideas and experiences, like the series of the *Caprichos* or the albums of drawings, present the satirical vision of reality that his mordant spirit possessed, his lack of faith in human beings. He created scenes of supreme tragedy with no room for hope: the hospital as a place of death where there is no possibility of a cure; killings, assassinations and rape, in which the victims have no way of escape; situations in which men or women cannot find relief from their torturers, hells in which all hope has been abandoned.

These works, steeped in violence, in physical and mental torture (fig. 176, 196), seem to be a premonition of the war that Goya, with his acute sensibility, was able to anticipate. It is not surprising that the canvases belonging to the Marquess de la Romana were initially dated during the period of the War of Independence: their scenes evoke, even before they had occurred, the searing visions of the *Disasters of War* and of its drawings (fig. 201, 202, 205). But they were not works for himself, to keep and pore over in the solitude of the studio, or to be shown to trusted friends, as some of the drawings of this decade and those of a few years later might have been; they were, rather, produced in order to be sold. There was a

market of buyers interested in acquiring such scenes for the decoration of their private rooms; the atrocities that the masses demanded in traditional and popular vignettes and blind-men's ballads were now read as a kind of proclamation of the freedom of an enlightened society, which included the right to criticise. And, alongside death and fanaticism, appear the witches (cat. 44–49) and the *Sueños* or *Caprichos*, caprices into which Goya appears to escape: 'Come, come when I have set up the room where we will live together and sleep (a remedy I rely on when my sadness afflicts me)' (letter to Zapater, 1793). Is the painter sleeping or dreaming in his art? Are his experiences of sadness expressed and sublimated in those canvases depicting atrocities? Who is the man who 'amorously' murders the naked woman (cat. 78)?

Goya would go on 'listening' to reality, but from now on 'caprice and invention' were expressed with greater force, even in the great painting, *Carlos IV and his Family*, of 1800 (fig. 13). Preliminary sketches in the Prado show how carefully he based the portrait on reality; the family is grouped, however, according to the artist's conception. The scene is both solemn and natural, because of the reassuring presence of children, but also contains the fantasy in which the artist, in the manner of Velázquez, includes himself on the great canvas in a new 'caprice' of his imagination.

If one compares the painting of Goya in this period with that of his exact French contemporary Jacques-Louis David, it is possible to grasp the radically opposed attitudes that animated each painter. David, the purest representative of Neoclassicism, was politically committed to revolution. Reality did not exist for him unless united to Antiquity, which he considered to be a model of perfection. Napoleon, another great figure who foreshadowed the 19th century like Beethoven or Goya, became the painter's ideal hero. In David's painting of 1800 in Vienna's Kunsthistorisches Museum, in which Napoleon appears crossing the Alps like a new Hannibal – painted the same year as the *Carlos IV and his Family* – the dynamism and heroism that David introduces into the portrait of the hero capable of conquering the whole of Europe is a telling contrast to Goya's picture. In his portrait, Goya encapsulates the decadence and moral corruption of a whole age. Unlike David, Goya had no wish to idealise his sitters; he was not, like David, a painter of a specific period but the precursor of a whole new epoch, in political and social terms and also in terms of the expression of humanity, which 20th-century psychology has only begun to discover. Goya's approach was almost unthinkable in his own age. When in 1822 Stendhal, in *De l'amour*, stated that 'in 1922 psychology will give us the description of the physical side of man where this phenomenon (love) resides', he was subjecting mankind to an analysis similar to that of Goya, who doubted appearances and the ability of men to understand one another. The supremacy of Reason and people's trust in it had collapsed.

Before 1808 the Spanish world in which Goya lived had yet to be shaken to its foundations. Traditional ideas, consolidated over centuries without any idea of change, were kept in place by a rigid political power structure (cat. 60. 61) and by the Church, an equally rigid and stable institution (cat. 97 and fig. 219, 220), which extended its control over the whole of society. The spirit of renewal that might have arisen in literature or in the universities was strictly controlled by the Inquisition, but it was only at the end of the 18th century that Spanish intellectuals, impatient for change and progress in their country, and influenced by French thought, via the *philosophes* and, later, by the spread of Revolutionary ideas, brought about the transformation of the entire social and political structure of Spain. The fall of Carlos IV and his family and the invasion of Spain by Napoleon's troops plunged the country into turmoil.

From 1800 until his death in Bordeaux in

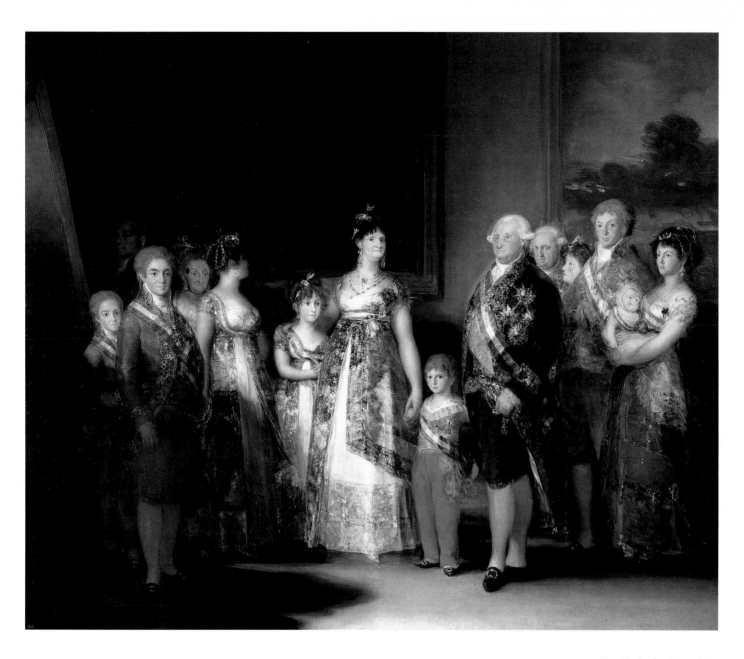

Fig. 13 *Carlos IV and his Family*, 1800–1
oil on canvas,
280 × 336 cm
Museo del Prado, Madrid

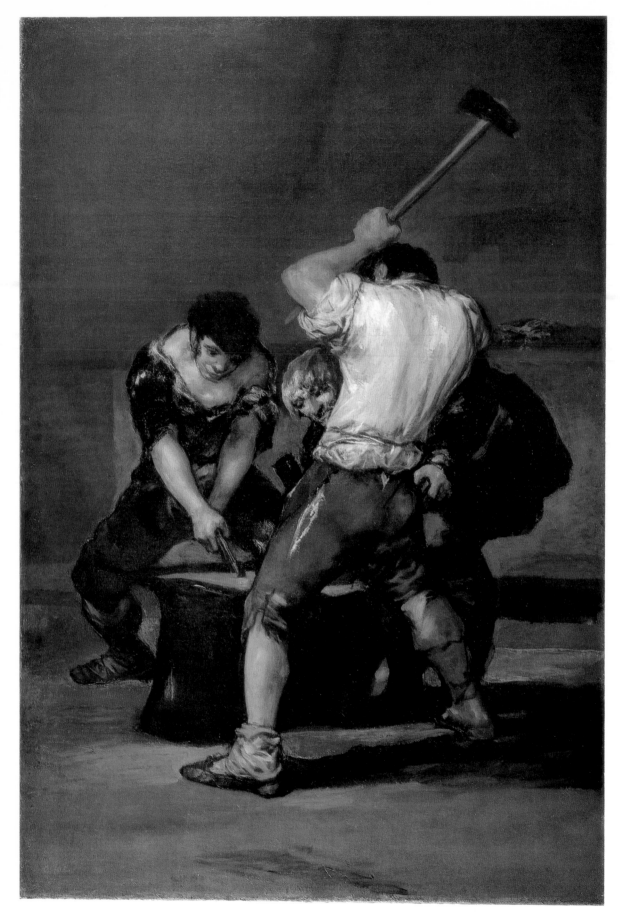

Fig. 14 *The Forge, c.* 1812–16, oil on canvas, 181.6 × 125 cm, The Frick Collection, New York

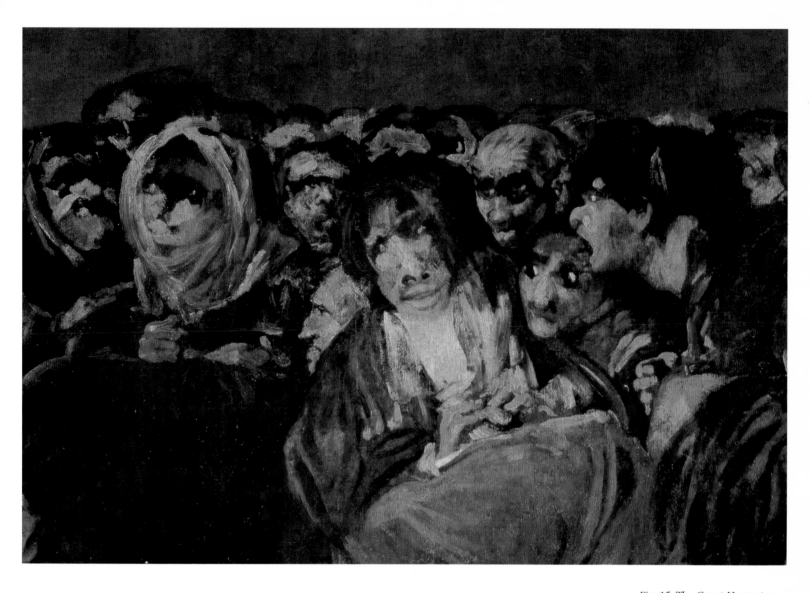

Fig. 15 *The Great He-goat*, a
detail from the Black Paintings,
1820–23
wall painting applied to canvas
Museo del Prado, Madrid

1828 Goya created for himself a world of his own. In dramatic force and feeling for the inner nature of mankind it utterly surpassed the vision of his contemporaries, including Delacroix and even Gericault, artists who also created their own imaginative world. It is that inner reality of Goya, based on his understanding of nature and of man, that is expressed in his works and led the way to modernity. After 1808 people are increasingly important in Goya's painting. Some are simple and patriotic, passionately hoping for change, as in the two great canvases of the *Second of May* and the *Third of May*, or in the small, masterly paintings of the *Knife-grinder* and the *Water-Carrier* (cat. 92, 93) or in *The Forge* (fig. 14). Others are ignorant, fanatical and superstitious, as in the pictures in the Academy (cat. 95–8); yet others are phantasmagorical, echoing terrors and frustrations of the past, as do the bewitched figures of the Black Paintings

(fig. 15). In spite of everything, Goya's vision developed in new subjects that transcend historical facts to lead us into a mysterious, ambiguous world of human motivations. Goya himself changed from the joyful, unconcerned youth shown in his early self-portraits to the weary man with the gaping mouth that seems to express the profound doubts and ill-disguised contempt of his late maturity (see Frontispiece). Pictures, such as the ones of savages now in Besançon (cat. 82, 83), the group of paintings in the Academy of San Fernando, with bulls, madmen, flagellants and scenes of the Inquisition (cat. 95–8), can be linked with the extraordinary drawings in the albums and the etchings of that period. The *Tauromaquia*, the *Disasters of War*, the *Disparates* and later the Black Paintings, unfortunately helped to create a stereotyped image of the painter and forged a legend that would be difficult to erase, encouraged by the

Fig. 16 *Lunatic Skates*,
page 32 of Album G, 1824–8
black chalk, 19.2 × 15.1 cm
Museum of Fine Arts, Boston

imitations and 'Goyesque caprices' of artists like Eugenio Lucas, or the sombre portrayals of popular manners and behaviour by José Alenza, rather than the profound works of Goya himself. For Goya was not only a revolutionary and political artist, the explorer of the unconscious and the witness of the events of his time, but also a painter with a masterly technique, with energetic, vibrant brushstrokes and fluent mysterious washes, the painter of shadow and, above all, of light, of the magic of atmosphere. Only when one is acquainted with the entire range of his work, including paintings dating from the very end of his life, is it possible to comprehend the infinite variety of Goya's art. Clarity of form and clarity of space defined the art of his time, for Neoclassicism affected Spanish painting as it did the whole of Europe. But that crystalline clarity of paint allied to the analytical drawing of reality was the antithesis of Goya's universe, which lay primarily in the subtle play of chiaroscuro.

Now that they can be studied together, the small pictures of Goya, the sketches and the independent works conceived as thematic series and miniatures, prove to be, together with the drawings and prints, the best starting point for an understanding of Goya's art. In all these works, technique, colour, truth to life, fantasy and invention are expressed with absolute freedom. They are the touchstones against which all possible new identifications and attributions should be compared. Goya's work needs to be stripped of the accretions of time and history that obscure his marvellous compositions. *Lunatic Skates* (fig. 16), dating from his final years in Bordeaux, leaves us with an expressive symbol of what might occur if one takes novelty and progress with excessive insouciance, if knowledge is not based on sound foundations.

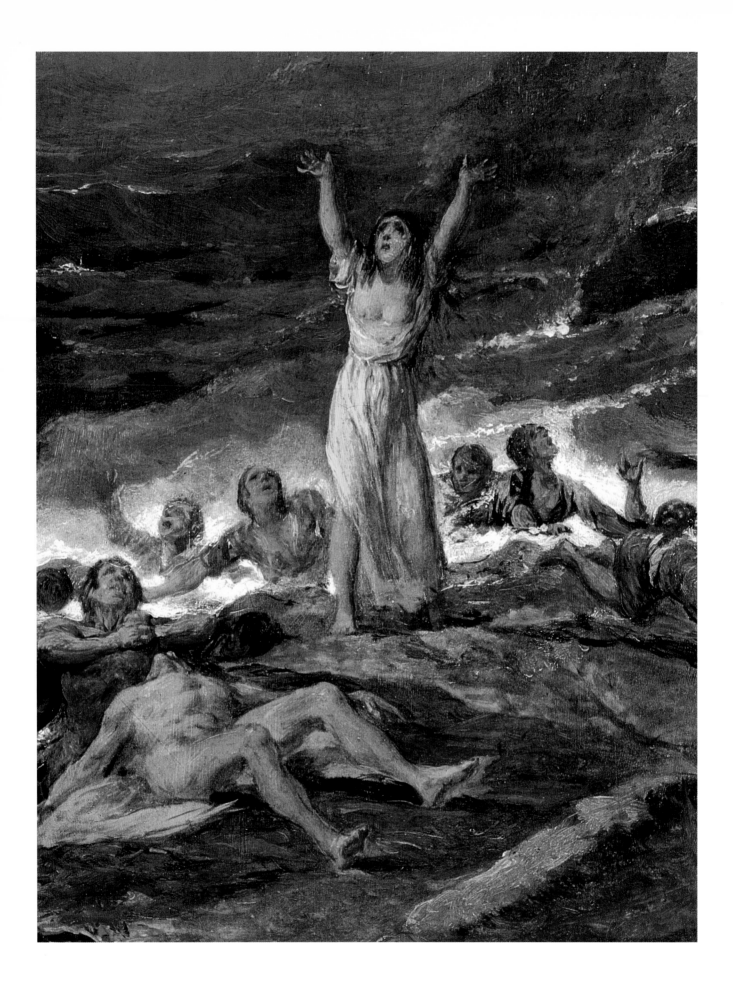

UNENDING SHIPWRECK

Werner Hofmann

Feel I not wroth with those who bade me dwell
In this vast lazar-house of many woes?
Where laughter is not mirth, nor thought the mind,
Nor words a language, nor ev'n men mankind;
Where cries reply to curses, shrieks to blows,
And each is tortured in his separate hell –
For we are crowded in our solitudes –
Many, but each divided by the wall,
Which echoes Madness in her babbling moods . . .

(Byron, from *The Lament of Tasso*, 1817)

I

No hay reglas en la Pintura: 'There are no rules in painting'. An artist who says this speaks for the subjectivity on which Modernism bases its revolutionary claims. To this day, Goya's reputation is that of a revolutionary who broke with tradition.

Goya's rebuttal of all 'rules' in his art is to be found in a Memorandum[1] of an address he made on 14 October 1792 to the Royal Academy of San Fernando, of which he had been a member since 1780 and Deputy Director since 1785. The subject of the Memorandum was the Academy's call for a debate on the reform of the teaching curriculum of art. Goya seized his opportunity. He addressed his proposals to his friend Bernardo de Iriarte, the Vice-Protector of the Academy, who was a member of the city's *ilustrados*, a circle influenced by the rationalist theories of the 18th-century Enlightenment.

Goya's arguments reveal his own ideas on the nature and potential scope of the painter's profession. Twice he demands precise imita-

tion ('*puntual imitación*'): in one case the imitation of divine nature ('*divina naturaleza*'), and in the other that of Truth ('*verdad*'). In other words, nature is Truth; and this truth takes precedence over the truth of art. Goya inveighs against those to whom Greek statues are more important than divine nature, and blames them for the current decadence of the arts. Here, he is referring to the 18th century's adulation of the Antique, the art of the classical world, as championed by J.J. Winckelmann, Anton Raphael Mengs and others. Mengs, of course, had been Court Painter in Madrid from 1761 to 1775, and it was through him that Goya had gained his first commissions for cartoons for the Madrid Tapestry Factory. In these paintings he showed himself already fascinated by nature, even if – amid the hurly-burly of the popular amusements they illustrate – it lacks the epithet 'divine'.

At the end of his Memorandum, Goya makes a plea for tolerance: may everyone be allowed to develop his individual talents freely. He urges the Academy's teachers to allow their

Fig. 17 Detail from *Shipwreck* (cat. 41)

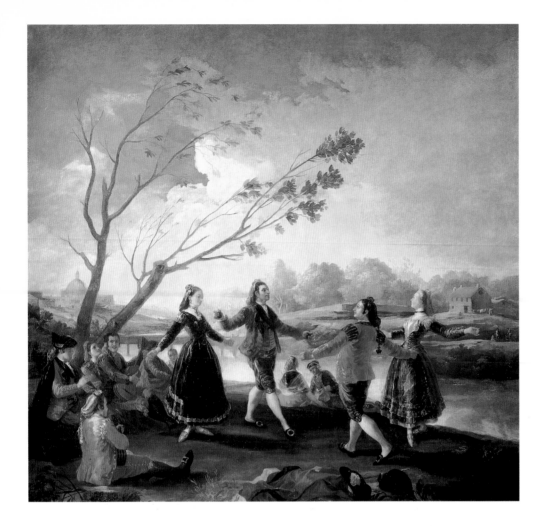

Fig. 18 *Dance on the Bank of the River Manzanares*, 1777
oil on canvas, 272 × 295 cm
Museo del Prado, Madrid

students a free choice of artistic exemplars, rather than exerting their utmost to warp such inclinations as their students may have towards one or another style of painting. This is generous advice indeed, but it should not be seen in isolation. Goya empowered the artist to assume his autonomy, but placed that autonomy in the service of Truth. However, there is not one, but several truths, just as there are various ways in which the artist can communicate them. This we learn from another, hitherto undiscussed, passage in the Memorandum. In it, Goya poses a question, one to which he frankly admits he has no answer: 'How comes it about that one has perhaps been happier in a less careful work than in one done with greater application? The two categories of work to which Goya here refers are clearly these: the sketch, and the finished painting.

This discrimination of degree in painting goes back to the sixteenth century, when artists first ventured to give free rein to their individuality, dashing down the *prima idea* for a work; and even then, as Giorgio Vasari tells us, many found it hard to prevent the 'fire of inspiration' from being quenched in the course of execution. The resulting oil sketches were evaluated, and collected, as art; but they remained inferior in status to the finished work. This attitude gradually changed as new criteria of taste came to the fore: witness Sir Joshua Reynolds's praise of Thomas Gainsborough, just after Gainsborough's death in 1788, in his fourteenth Academy Discourse. Unlike painters such as Pompeo Batoni ('who finished his historical pictures part after part'), Gainsborough painted everything at once, always with an eye to 'the Tune': 'the whole going on at the same time, in the same manner

as nature creates her works'. The painter does not copy nature; he imitates her process of creation. Reynolds concedes that such spontaneity strikes many critics as crude, chaotic, uncoordinated; but Gainsborough, he says, is a painter who can arrange matters so that everything has its place and combines harmoniously. Through 'a kind of Magick', chaos acquires shape; Gainsborough's 'undetermined, general manner' leaves it to our imagination to complete and to interpret the forms that are perceived.

In his youth Goethe experienced this same joy in decipherment on first encountering the works of art in his grandfather's collection: 'Bold brushstrokes, vigorous washes, all that was forceful delighted me; even when a figure was no more than a hieroglyph of a few strokes, I contrived to read it, and I valued it excessively'. In his maturity, however, Goethe would have no more truck with such 'chaos'. He wrote in 1799, in *Der Sammler und die Seinigen*: 'Fine art demands plain, clearly defined representations'.

Such was the contemporary context of Goya's own remarks. These leave us in no doubt that the painter was 'happier' in the sketch because in it he did not need to fetter his spontaneity. But this is exactly what he must do in the final execution, which demands discipline and carefully considered arrangement. Only in the sketch, then, can the artist deploy his talents in 'total freedom' ('*plena libertad*').

Goya spoke from experience. In the large religious compositions to which he owed his contemporary fame, he had been forced to submit to academic discipline; the resulting constraints are visible even in the small oil sketches. From his tapestry cartoons he had learnt just how much artistic individuality was lost in the transfer to weaving – or rather, how little of his individual handiwork came through. As a successful portrait painter, too, he was expected to provide evidence of 'greater application'. One notable instance was

that of the large altarpiece, apparently commissioned for the sacristy of Toledo Cathedral in 1789 but not delivered until ten years later. In it, I imagine, Goya found himself engaged in a dialogue with El Greco's *Disrobing of Christ* (fig. 174) which hangs in the same sacristy. But that was not the only reason for the delay. Goya was clearly having difficulties in transferring his *prima idea* (cat. 55) into the larger format (fig. 175).

The pictorial idea of Goya's *Taking of Christ* shows how the traditional religious theme is undermined by more general, human references. By the time he completed the work, he was already working on the etchings of *Los Caprichos*. This led to one remarkable parallel across the sacred-secular divide. Compare the figure of the captive Redeemer with *Capricho* pl. 2: '*They say "Yes" and give their hands to the first comer*' (fig. 21). The young woman shipped off into marriage is both victim and accomplice. She is selling herself, and will be revenged for it; at the same time, she is a mere object in a society in which women are at the disposal of men. The scene looks like a sideshow; the lively spectators look very much like the crowd that flocks to see the victims of the Inquisition (cat. 97, fig. 219, 220). We recognise the themes of the *Ecce homo* and the *Taking of Christ*. In the painting, as in the etching, there is a public spectacle of abuse and maltreatment.

The categorisation of work into two classes, discussed in Goya's Memorandum, recurs in the celebrated letter that he wrote to Iriarte on 4 January 1794 to announce the impending arrival of eleven 'cabinet pictures' ('*quadros de gabinete*'), in which he explained their origins as follows: 'In order to occupy my imagination, which has been depressed through dwelling on my misfortunes, and to compensate at least in part for some of the considerable expenses I have incurred, I set myself to painting a series of cabinet pictures in which I have been able to depict themes that cannot usually be addressed in commissioned

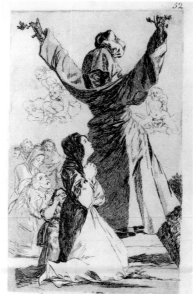

Fig. 19 '*Ups and downs*', pl. 56 of
Los Caprichos, 1797–8
etching and aquatint,
21.7 × 15.1 cm
Museo del Prado, Madrid

Fig. 20 '*What a tailor can do!*',
pl. 52 of *Los Caprichos*, 1797–8
etching and aquatint,
21.7 × 15.2 cm
Museo del Prado, Madrid

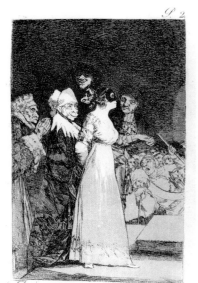

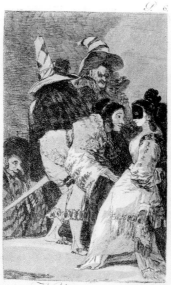

Fig. 21 '*They say "yes" and give
their hand to the first that
comes*', pl. 52 of *Los Caprichos*,
1797–8
etching and aquatint,
21.7 × 15.2 cm
Museo del Prado, Madrid

Fig. 22 '*Nobody knows anybody*',
pl. 6 of *Los Caprichos*, 1797–8
etching and aquatint,
21.8 × 15.3 cm
Museo del Prado, Madrid

Fig. 23 '*Here comes the Bogeyman*', pl. 3 of *Los Caprichos*, 1797–8
etching and aquatint,
21.7 × 15.3 cm
Museo del Prado, Madrid

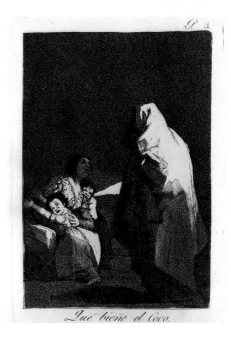

works, where *capricho* and invention have little part to play.'

No doubt about it: having said in his Memorandum that he has often had more success with a less careful work than with one more elaborately done, the painter has now isolated another factor that limits his 'full liberty': commissions. Patrons not only insisted that he put all his technical skill into his paintings; they even prescribed the content. He thus felt doubly constrained. And so he claimed the right to give rein to his 'caprice and invention' ('*capricho y invención*') by turning to the small cabinet picture: in this he was free, and had no need to look over his shoulder, as he did with commissioned works.

II

In that letter of 1794 Goya used the word *capricho*. Some years later he was to use the same word as a generic name for a collection of 80 etchings. How can 'caprice' be reconciled with one's duty to the truth? What part does 'invention' play in all this? These questions are best considered in the light of one of the eleven cabinet pictures that Goya – despite his high status and his self-confidence – submitted to the Academy for its approbation: the *Yard with Lunatics* (cat. 43), now in Dallas. Goya mentions it in a letter to Iriarte

written on 7 January 1794, three days after the passage quoted above: 'a yard with lunatics, and two naked figures fighting while their keeper beats them, and others [dressed] in sacks; it is a scene that I once saw in Saragossa'. It is as if Goya were trying to exonerate himself of the suspicion of exercising caprice and invention by presenting himself as an objective witness of a cruel, but real, event. '*I saw this*' ('*Yo lo vi*'), he was later to inscribe on plate 44 of the *Disasters of War*, an etching whose formal weakness possibly stems from the fact that 'caprice and invention' played so small a part in it (fig. 202). Goya was eager for authenticity. But what he witnessed in Saragossa was at most the spur to the *Yard with Lunatics*, no more: Goya was no passive eyewitness. His works are summations, not mere additions of perceptual impressions. What he saw was simply the raw material, and *capricho* and *invención* served to deepen its expression.

Seen in this way, the *Yard with Lunatics* is the *capricho* without equal: its artistic content is identical with the content of the life of the helpless creatures who people it. Each of them is a flesh and blood *capricho*. These twelve errant 'disciples' recall David's *Death of Socrates* (fig. 24), an encoded, Republican Last Supper, in which the Redeemer leaves his disciples in a state of disarray.

The genre, and the word *capriccio* originated in Italy. The *capriccio* was a hybrid, and as such eminently suited to Goya's vision. He endowed it with a new intensity of form and of content, while at the same time exploiting its inherent ambivalence. The *capriccio* stands for artistic freedom, art unfettered by rules and norms; but from the beginning it has always had a dark side, and its earliest definitions read like the symptoms of a disease. For F. Alunno in the 16th century, *capriccio* meant a sudden and unreasoned appetite; for H. Estienne (in 1578), *caprice* conveyed the desire to do something that can suddenly, and without reason, overwhelm one. Here, already, reason

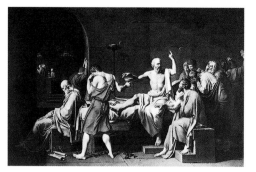

Fig. 24 Jacques-Louis David, *The Death of Socrates*, Salon of 1787 oil on canvas, 130 × 196 cm The Metropolitan Museum of Art, New York

and liberty are contrasted. The emotions aroused by the artistic *capriccio* are said to include 'fear' and 'horror'. It might be put this way: there is a caprice that liberates, and a caprice that oppresses. Baldinucci, in his *Notizie* (1681), assigned to it marginal figures such as drunkards, mountebanks and plebeians (we think here of Goya's *Yard with Lunatics*), but also things that inspire terror: wraiths, spirits, and infernal and diabolical scenes. Again we are reminded of the *Yard with Lunatics*, and realise that it is a hell on earth.

In 1734 the Jesuit lexicographers of Trévoux pronounced a judgement entirely in keeping with the Age of the Enlightenment: they dismissively listed a 'capriccio' as a 'mental derangement' ('*dérèglement d'esprit*'). In his treatise *Parere sull'architettura* (1765), Giovanni Battista Piranesi, creator of the *Grotteschi*, stages a debate between an adherent and an opponent of the rules of architecture. The adherent scorns 'the crazy freedom to work on caprice' and calls for continued observance of the classicist norms defined by Vitruvius and maintained by Palladio. *Capriccio* becomes an insult. (Piranesi, a divided personality, supports both parties to the argument, thus arguing in both cases against his own *alter ego*.)

In 1797, when F. Milizia published his

Fig. 25 Detail from *Yard with Lunatics* (cat. 43)

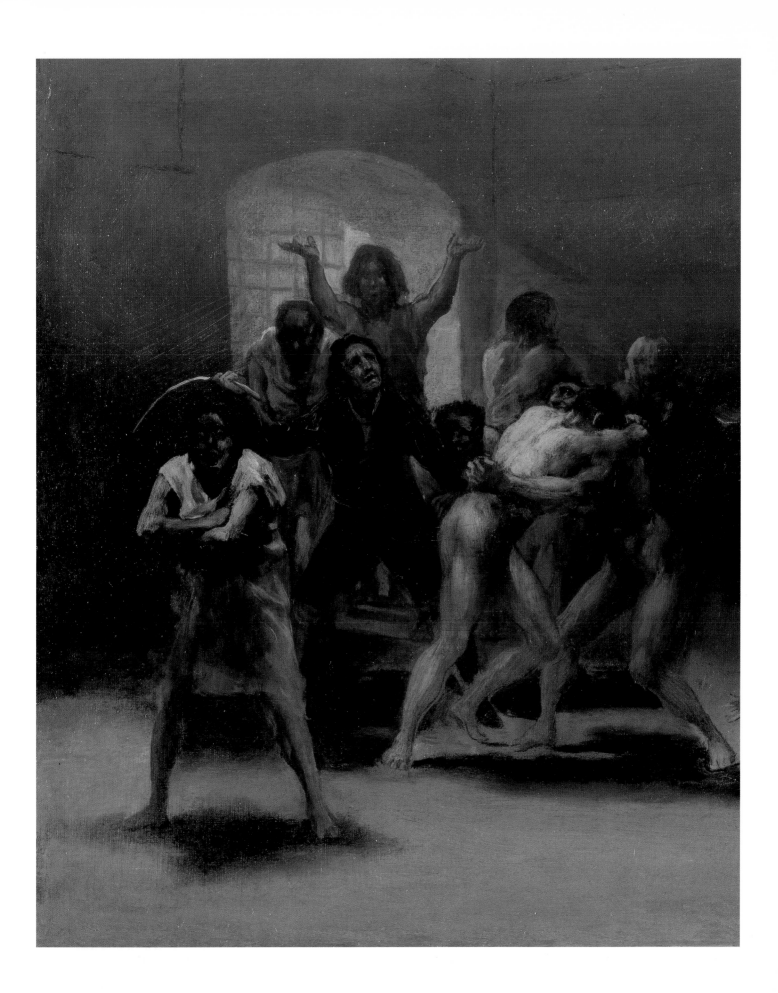

Dizionario delle Belle Arti, Goya was already working on his *Caprichos*. The Italian encyclopædist demanded obedience to the rules. His response to the *capriccio* was to use its bizarre-ness of form as a basis for a diagnosis of mental illness. Its restless, fitful changes from one form to another – seen at its most extreme in the 'deliriums' of the 17th-century architect Francesco Borromini – corresponds to 'the fickleness of the patient who shifts from one place to another in the hope of feeling better, and feels worse'. To all this there is only one 'antidote': sanity. Milizia articulates the rationalist fear that the *capriccio* may release too many safety valves. The same refusal is implicit in Goethe's apodeictic diagnosis: 'The classical', he said to Eckermann on 2 April 1829, 'I call the healthy, and the romantic the sick.' In our own century in Germany, so-called 'Degenerate Art' (*entartete Kunst*) was to suffer for this intransigence.

What was the attitude to the *capriccio* in Spain? *The Diccionario de autoridades* (Madrid, 1726) lays down no hard and fast categories. On the contrary, where painting is concerned, the Spanish word *capricho* means the same as 'conception' or 'conceit'. At the same time, however, it exists 'outside ordinary, common rules'; and so the 'singular ideas' with which it surprises us are no mere aberrations. This author is trying to square the circle; and Goya makes the same attempt in his advertisement of 1799 for his forthcoming *Caprichos.* In the very first sentence Goya arouses curiosity as to the 'matters of caprice' or 'of fantasy' ('*asuntos caprichosos*') with which he intends to entertain and edify the public. He derives these ideas from the follies ('*extravagancias*') of human nature, and from common impostures ('*embustes vulgares*') and 'ignorance', always with the purpose of producing 'perfect works'. Imitation and invention are inseparable: the painter takes the diverse, discrete forms of nature and recombines them into the ideal creations of his own imagination. For which reason, Goya proudly concludes, he

merits the title of inventor and not that of slavish copyist ('*el título de inventor y no de copiante servil*').

Goya is doing what the classical Greek painter Zeuxis, in a celebrated anecdote, is said to have done – but he is doing it *à rebours*, against the grain. Zeuxis engaged the five loveliest maidens of Crotona to model for his figure of Helen of Troy; Goya combines what he finds scattered in reality into a unified whole that embodies not beauty and regularity but the very opposite.

What Goya invented, a synthesis of rule-defying *extravagancias* and *embustes vulgares*, was an affront to the ideal of beauty that had hitherto represented the supreme formal value. This was a revolutionary step indeed. It had already been anticipated by none other than Winckelmann, in a tongue-in-cheek conceit that reveals this strict preceptor as another divided personality. Hardly had Winckelmann published his *Reflections on the Imitation of Greek Works in Painting and Sculpture* (1755–6), in which the celebrated phrase 'noble simplicity and still grandeur' occurs, when he switched to a precisely antithetical position and composed an anonymous 'epistle', in which he spoke up for all that he had just condemned. And so, assuming the mantle of devil's advocate, Winckelmann wrote the first apologia for caricature. His argument – and this is important in the present context – passes by way of nature: 'In art, nothing is petty or insignificant; and perhaps there is some advantage to be drawn even from the so-called Dutch forms and figures. It was thus that Bernini used caricatures; we are told that these exaggerated figures furnished him with one of the prime requisites of art, namely the freedom of his hand. Since I read this, I have begun to think differently of caricatures; I believe that the artist who achieves proficiency in caricature has taken a great step forward in the practice of his art. The author cites it among the virtues of the ancient artists that they went beyond the bounds of common nature; do not

our own masters do precisely this in caricatures? And no one admires them for it.'

If we subtract the irony from this, it points directly to the expressive intention for which Goya argues in his advertisement in the newspaper *Diario de Madrid*. What was still blasphemy to Winckelmann could be proclaimed by Goya, half a century later, as something noble.

The inventor of the *Caprichos* is no 'slavish copyist': nor is the painter of the earlier *Yard with Lunatics*. If he had been, he would have contented himself with the scene of two men wrestling in Saragossa. He takes this *capricho*, which is no more than a trivial anecdote, or *fait divers*, and adds his own invention to turn it into a kind of parable. His contemporaries seem to have taken very little notice. The Academy of San Fernando categorised the eleven cabinet pictures, euphemistically, as 'representations of popular amusements'. This is true enough of some of them, although the borderlines are hard to draw, in keeping with the ephemeral character of the *capricho*. *The Manikin* (cat. 31), painted just before Goya's illness, certainly is a popular amusement, but it is also a macabre, paradoxical play on the helplessness of many living persons. Seen in one way, man is the plaything of women and their whims; alternatively, he is an empty mask, who does not fulfil desires, but only disappoints. When he falls into a woman's arms, she embraces only a lifeless doll.

This popular amusement belongs to a tradition that goes back to the classics of Spanish literature: '*Nobody knows anybody*', Goya's commentary for *Capricho* pl. 6 (fig. 22) is borrowed from the playwright Lope de Vega. All the world's a stage, peopled by Goya with a cast that represents all estates, classes, occupations and ages. Even the child is trained up to live by lies and deceit (e.g. *Capricho* pl. 3: '*Here comes the Bogeyman*; fig. 23); and thus begins a lifelong dance of deception. The child is deceived by its mother; she is deceived by her husband; the mistress dupes her lover; the monk or priest dupes the believer (the *Appearance of St Isidore* (cat. 56), for example, might be a stage illusion or a scarecrow). The superstitious can be fooled by a fetish: *Capricho* pl. 52, '*What a tailor can do!*' (fig. 20). Ugliness becomes its own victim: *Capricho* pl. 55, '*Till Death*'. The struggle for political power degenerates into ceaseless '*Ups and downs*' (*Capricho* pl. 56; fig. 19). Someone is always left out in the cold; the criminal is always his own victim. All this ambivalence means that different expressive registers are always clashing and overlapping. High emotion turns to self-mockery; pain is held at bay by sarcasm; death becomes a farce. Innocence is not believable – in *Capricho* pl. 32, '*Because She was susceptible*' (fig. 196), the convict is a husband-killer (cat. 74, 75). Violence becomes mere high spirits; a masquerade turns out to be a dance of death; a nursery bogeyman becomes a real nightmare. The sublime is always turning into the ridiculous, the ridiculous into the sublime.

The social metaphor for these constant ups and downs is *Blind Man's Buff* (fig. 26), a pantomimic dance of deception based on constant role-shifting: if the blindfolded person catches another player, he or she is rewarded with the gift of sight, and the other puts on the blindfold. Darting around, she who has been recognised must now recognise herself. But in this chain of pursuit and flight, longing and concealment, an outsider may suddenly appear – such as the woman who stands aloof from the other players and faces the viewer rigidly and frontally. Her isolation anticipates that of the man in the left foreground of the *Yard with Lunatics*. We see that the patterns of this innocuous party game already contain those of the *Yard with Lunatics*: separation, union, flight, confusion.

This is not to say that the game played in the *Yard with Lunatics* is merely some new and radical form of blind-man's buff. It is, in fact, what Samuel Beckett calls an Endgame. The players *are* the roles they play for us; the

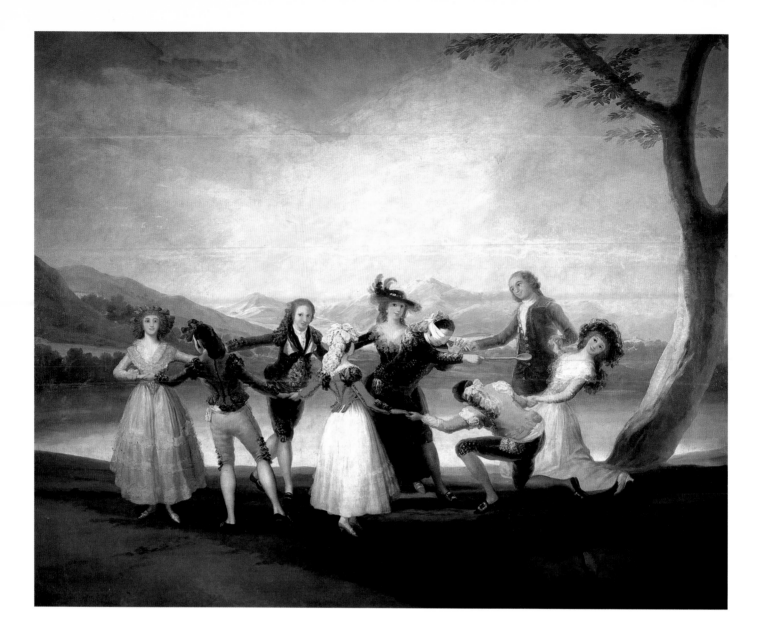

Fig. 26 Tapestry cartoon, *Blind
Man's Buff*, 1788–9
oil on canvas, 269 × 350 cm
Museo del Prado, Madrid

aesthetic gloss has vanished; the masquerade is over. And yet there is still an ambivalence about these human creatures. On one hand they are outcasts, with whom society will have nothing more to do; offensive blemishes on the face of normality. On the other they have escaped from the disguises and constraints with which this same society builds its golden cage, its own prison. In his perplexity, reduced to his own devices, 'natural' man confronts the 'artificial' man (Diderot) who wields the lash: naked Being asserts itself in face of Seeming (Rousseau). The lunatics are oblivious of the keeper's whip, banished to a submarine seclusion filled with a pale, dead light that matches the aching void behind all the painting's action.

This Endgame can also be seen as the *ne plus ultra* of the whole *capricho* idea: as a nonstop caprice that constantly weaves these wretched, obsessive lives into new and fantastic forms. No rule holds them in check; society cannot curb them; they know no shame and no remorse. Dread and concupiscence, horror and rage, have no limits. Nevertheless, this dangerous liberty of theirs cannot and must not find fulfilment except in protective custody, in confinement.

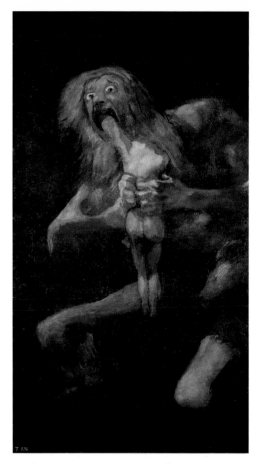

Fig. 27 *Saturn Devouring one of his Sons*, a detail from the Black Paintings, 1820–23
wall painting transferred to canvas, 146 × 83 cm
Museo del Prado, Madrid

III

To set impulses and instincts free, there must be an extreme situation. This is why Goya, in his cabinet pictures, continually harps on catastrophes. He takes commonplace ones – shipwreck, conflagration, highway robbery, and the 'disasters' of war – and turns them into paradigms of human existence. At the same time, all these are also paraphrases of the *Yard with Lunatics*, for they, too, are predicaments from which there is no escape. The works inhabit a sequestered space, a '*Huis clos*', in which, sooner or later, every man will be at his neighbour's throat.

Homo homini lupus: man is to man a wolf. In the 18th century, the theme of human self-destruction was frequently projected onto a figure who, centuries earlier, had been 'ennobled' by Dante: Count Ugolino. In Canto 33 of Dante's *Inferno* we meet Ugolino and his sons, starving in prison and resorting to cannibalism. Goya painted the violation of this same taboo in his figure of *Saturn Devouring his Children* (fig. 27), one of the so-called Black Paintings. In this work, Goya followed Rubens, but went far beyond his source in the expression of bestial rage. Minus the literary

distancing process, the same took place on the raft that carried the survivors of the *Medusa*. Gericault painted this aftermath of a shipwreck in 1819, three years after the event that had so shocked the French public (fig. 28). His Michelangelesque composition holds the balance between despair and hope. We ask ourselves: Will those on the raft be rescued by the frigate that has just sailed into view – in precisely the direction in which the wind is *not* driving the shipwrecked mariners?

The central figure in Goya's *Shipwreck* (cat. 41) is a woman with upraised arms. Her gesture might mean one of several things. It could be that of a worshipper, an *orans*. Goya uses it elsewhere in various contexts, and in a number of different expressive registers. The upraised arms of a dummy in *Capricho* pl. 52 (fig. 20) are a mockery of superstition; in the background of the *Yard with Lunatics* the same gesture becomes an appeal. In the painted cupola of San Antonio de la Florida it serves to mark incredulous amazement, and in the *Third of May*, a fatalistic readiness to die.

These shifts (Aby Warburg called them 'inversions'[2]) of meaning illustrate the way in which Goya uses the licence of the *capriccio* – the mingling of different kinds of art (genre, satire, infernal vision, human document) and registers of expression – to create multiple layers of meaning. And these multiple layers of meaning in his art emerge at the junction of the sacred and the profane.

Where does Goya stand in the tradition of religious painting? As the artistic offensive of the Counter-Reformation got under way, the art of Spain was second only to that of Italy in its zealous observance of the directives of the Council of Trent (1545–63). The Roman Catholic Church set out to win believers through a direct appeal to the emotions. The result was pictorial propaganda based on the twin themes of triumph and suffering. The martyrdom of those who had laid down their lives for the Christian faith was often presented

Fig. 28 Gericault,
The Raft of the 'Medusa', 1819
oil on canvas, 491 × 716 cm
Musée du Louvre, Paris

with disconcerting vividness; Spanish artists were particularly active in this area.

Goya painted few martyrs. However, the *Taking of Christ* and *Christ on the Mount of Olives* show the original of all martyrs, not those who followed him. The huge compositions that the young Goya painted for Saragossa (El Pilar) belong to the tradition of the apotheosis of the Church Triumphant.

He broke with that tradition in the frescoes that he painted for San Antonio de la Florida (1798). Contemporary with the *Caprichos*, these relate a miracle, but one that looks like some popular amusement. The everyday meets the supernatural: another *capricho*. St Antony of Padua resurrects a murdered man to testify to the innocence of Antony's father, who has been accused of the murder (cat. 53). By showing solidarity with his father, the Saint tells us that even the poor, the common people, can expect justice if they have a convincing advocate. The miracle is embedded in a busy scene that serves to cover the hasty escape of the real murderer – a situation that can arise on any day, on any street corner in any large town. Goya neither unmasks nor judges the murderer; he lets him get as clean away as if he were hand in glove with him.

St Antony of Padua enjoys great popularity

to this day. Two hundred years ago he would have been revered as an exemplary individual who, although well-born, enjoyed the trust of the common people. Such a servant of God might well earn the approbation of Goya, especially as he fought so hard for the cause of justice. Another fighter was Friar Pedro, who did battle with the bandit El Maragato, and vanquished him. Goya recorded this real-life incident in a kind of film-strip that shows the Friar as a popular hero (cat. 84–9). Friar Pedro embodied the alliance between religion and populism that was to reveal its ambivalence in the struggle against the French a few years later; for the warlike patriotism of the lower clergy had reactionary features that were not lost on Goya, as the *Disasters* show.

Be that as it may, in immortalising St Antony's miraculous feat, in the cupola of a modest church in a Madrid suburb, Goya was keeping his distance from an established Church that was using its alliance with the throne to perpetuate the abuse of power that we know as the Inquisition. In the *Caprichos*, and in a number of paintings, Goya – who seems to have been an atheistic kind of Catholic – revealed this institution for what it was: a cynical instrument of ideological terror that mobilized the basest instincts of the masses. He showed the clergy, both pastoral and parasitical (monastic), as the epitome of stupidity and vice. Goya's martyrs come from the opposing camp: they are the victims of the Inquisition.

In this connection he invented a new form of history painting, which bears all the distinguishing marks of the *capriccio* as we know it. This new form represents a mixture of caprice and terror – the kind of terror that Edmund Burke, in his *Enquiry* of 1757, described as the emotion that is aroused by experiences of the Sublime. We see this in the eight cabinet pictures now in the collection of the Marquess of la Romana (cat. 74–81). All show secular 'saints' suffering abuse and

humiliation. The first two 'episodes' still bear a relation to the *Caprichos*, with their hooded, spectral figures and the prison cell in which – as in the *Yard with Lunatics* – everyone is alone with himself. The pensive seated figure (cat. 75) has some of the contemplative dignity of the Redeemer who waits for his tormentors, as if this were Goya's conception of a scene absent from the Gospels. The paintings that follow are variations on forms of physical menace and destruction. The woman seized by a brigand (an expert of caprice and terror!) is a naked Truth, a *Nuda veritas* (cat. 77). In one sense she is a successor to the figure of Truth whom Goya had united with Time and History in an allegorical tableau (cat. 50); in another sense the brigand is putting her on show, like the young women on the streets of Madrid who are obligingly displayed to potential clients by an old woman. The victim as potential sex object: an ambivalence reminiscent of the Marquis de Sade. The same applies to the sex murder (cat. 78) and to *Shooting in a Military Camp* (cat. 81), an act of male power with erotic undertones; there is no need to enlist the symbolic alphabet of psychoanalysis to see the guns in terms of phallic aggression.

Two scenes without action – the *Plague Hospital* (cat. 80) and *Vagabonds, or Gypsies Resting in a Cave* (cat. 79) – also have their multiple layers of meaning. Their clumps of figures recall the *Last Supper* that Goya painted in 1796–7 for the Santa Cueva in Cadiz (cat. 51). In this he abandons decorum and shows the Apostles as an untidy heap of bodies, their physical weight relieved only by the radiant figure of the Saviour. The profane and the sacred are thrown together.

To connect plague victims and bandits with a Last Supper is not to accuse Goya of using ambiguity as a cover for blasphemy. I mean only to show the breadth of his vision of the human condition. The result is a sense of brotherhood that expressly includes society's

Fig. 30 '*This is the truth*', pl. 82 of
The Disasters of War, c. 1815–20
drawing, 17.5 × 22 cm
Biblioteca Nacional, Madrid

Fig. 29 *St Isidore*, 1775–8
etching, 23 × 16.8 cm
Biblioteca Nacional, Madrid

outsiders – an idea that anticipates Dostoevsky. The art historian, of course, looks to the past and associates Goya's secular saints and martyrs with the tradition of Caravaggio, who, much to the annoyance of his decorous critics, showed the Apostles as real men, and rough ones at that. Goya had done the same ever since his early etching of *St Isidore* (fig. 29), in which, although the ploughman-saint wears the costume of a nobleman, his facial features betray his lowly origins. I have an idea that Goya showed St Isidore once more, but now entirely as a peasant, in the last etching of the *Disasters*: '*This is the truth*' (fig. 30).

If a saint can look like a peasant, then insane, sick or shipwrecked human beings have every right to their own exemplary significance: that is to say, they can serve as metaphors of life on the edge, life as an ordeal that cries out for a Redeemer. Do criminals have a place in this company of outsiders and outcasts? Nietzsche gives one answer (which might as easily have come from Byron or Rimbaud) in section 45 of *The Twilight of the Idols* (1889): 'The criminal type is the type of the strong man in adverse conditions; he is a strong man made sick. What he needs is the wilderness; he needs a freer and more perilous form of nature and existence, in which the strong man's instinctive weapons of self-defence have their rightful place. His virtues have been outlawed by society; his liveliest impulses, which are his by nature, are choked with a rank growth of suspicion, of fear, of dishonour.'

The criminal is a marginal figure, too. As such, the 19th century made a hero of him; I need only cite Byron. C.G. Jung (as Anthony Blunt pointed out[3]) saw the criminal as a redeemer: through his crime, he frees us from the burden of evil by taking it upon himself. The crucified Christ between the two thieves is thus the key to the different levels on which

Goya depicts the human being: acting and suffering, abusing and abused.

What of the artist: where does he belong in all this? Goethe (1749–1832), Goya's younger contemporary, once resignedly remarked that the artist is too closely involved with the action on the world's stage to set himself up as a judge of it. This closeness he blamed on the imagination, on which the artist depends, and which stands for the 'irrepressible craving for the absurd that asserts itself in the most cultivated person; in defiance of all civilisation, it revives the instinctive brutality of leering savages in the midst of the decent world'.

Goethe wrote these words (in *Tag- und Jahreshefte*) in 1805; at very much the same time, Goya was painting what has been identified as the hideous martyrdom of two French missionaries at the hands of the Iroquois (cat. 82, 83). Nor were the 'leering savages' (*fratzenliebende Wilden*) of the far-off Americas alone in acting out the craving for the absurd. It was on display in Europe, too, 'in the midst of the decent world', and most inhumanly so in the war between the Spaniards and the occupying French.

Goya concentrated the horrors of that war into the 82 etchings of the *Disasters of War*, maintaining the strict, and at times chilly, formal detachment that alone could justify the use of such atrocities for the purposes of art. For these horrors do not involve the perpetrators alone: the artist and his imagination are accessories after the fact. Jung's insight can be transferred to the relationship between the artist and his public: the cruelty devised by the painter allows the viewer to see his or her own 'irrepressible cravings' displayed in effigy.

IV

The artist as a figure of convergence, in whom the criminal meets the redeemer: does this tally with the identity that Goya outlined for himself when he placed his *Caprichos* in the service of 'enlightenment' (*la ilustración*)? Such an objective would seem to be closer to the principles laid down by Mengs, which Goya certainly knew, for they were part of the intellectual baggage of all the Spanish artists of his day. According to Mengs, the work of art must be such as to be seen in all circumstances as the work of an enlightened person; for, wherever reason does not hold sway, art is the work of 'mere chance'. This is the same argument that Goya uses on a drawing for '*The dream of reason brings forth monsters*' (*Capricho* pl. 43; fig. 32), where he defines his own art as a 'universal language', and in the advertisement for the *Caprichos*, where he declares his intention of remedying the general lack of enlightenment ('*falta de ilustración*'). In Goya's commentary (in the Prado Musuem) on the same image (fig. 32), he issues a warning, and invokes a synthesis, that might have been devised by Mengs: 'Imagination abandoned by Reason produces impossible monsters; united with her, she is the mother of the arts and the source of their marvels'.

In all these statements we suspect a defensive strategy on Goya's part; these are self-protective utterances, whereby the King's principal Court Painter appoints himself the custodian of received tradition and seeks to divert the attention of his public from the 'impossible monsters' that spring from his own imagination. Had not Mengs, too, warned against the irrationality of chimerical creatures that could not possibly exist?

As an artist who marries *capricho* with *invención*, Goya rides roughshod over his own stated principles. What makes this possible (and profoundly distinguishes him from Mengs) is the archetype of nature, to which he

attaches the epithet 'divine' in order to divert the suspicions of the censors. As an artist, he can handle the irrational only by raising it to the highest power; he can show the savageries of war only by making them the *ne plus ultra* of perverted desire. By draping a tree with shattered corpses and severed limbs (*Disasters* pl. 39; fig. 205), he makes mutilation into a 'work of art' that forms an alliance between caprice and terror, but also between *capricho* and *invención*.

'It is no crime to depict the bizarre desires that nature inspires', we read in *La Nouvelle Justine* (1797). De Sade seeks to justify himself by pleading for an expanded concept of nature that will accommodate his own inventions in all their unremitting monstrosity ('*monstruosité intégrale*'). He performs an act of total liberation, designed to put the human being in control of all his own destructive potential. He liquidates boundaries in order to 'restore to civilised man the strength of his inherited instincts', as Paul Eluard put it from a Surrealist point of view. (This is precisely what the *Yard with Lunatics* is all about.)

De Sade's revolutionary protest/indictment goes even deeper, in two ways that reveal his position to be a kind of atheistic counterpart of Christianity. First, his destructive contempt for the body fits into the tradition of Christian antisensualism – which he stylises, not of course into asceticism, but into unremitting excess. Second, de Sadeian liberation, which leads to *monstruosité intégrale*, culminates in a return to prescriptive control, for it can be realised only in an all-embracing utopia of evil. In this, says P. Klossowski in *Sade mon prochain* (1947), de Sade finds the fulfilment of his 'vision of a society in an unbroken state of criminality.... This paradoxical utopia virtually corresponds to the state of our own modern society.'

De Sade thus carries the Fall of Man to its ultimate conclusion – which led Flaubert to remark that *Sadism* was 'Catholicism's last word' (recorded by the Goncourt brothers in their *Journal*, 29 January 1860). As Flaubert explained, 'This is the spirit of the Inquisition, the spirit of torture, the spirit of the medieval Church, the horror of nature. There is not one tree in de Sade, nor one animal.' What would Flaubert have said about Goya? (The Goncourts do not tell us.)

Klossowski defined the work of the 'Divine Marquis' as an Anti-Church. It is an image that chimes with the totality of Goya's endeavour to create his own world of anti-reason. He too invents a *monstruosité intégrale* and entwines *capricho* with *invención*. But the obsessive terrors that grip him are not acted out in the privacy and seclusion of some mental laboratory. These are not the strenuous exercises of a brain that finds no escape from its self-created labyrinth of sexual acrobatics; nor do they address themselves to the voyeur who is hungry for imaginary excesses. Here is the crucial distinction: both de Sade and Goya justify 'bizarre desires' by reference to an expanded concept of nature; but de Sade turns them into elaborate, collective, artificial figures, while Goya projects unfettered nature onto the Spanish present, its perpetrators and its victims.

It is a Pandæmonium with Goya himself at its centre, not as a diabolical Master of the Revels but as a detached contemporary observer who converts what he sees into parables, ultimately concentrating them into visions, with eyes closed, trusting only in his own instinct for formal creation. In '*The dream of reason*', Goya shows himself as a blind seer. His artistic contemporaries, when they wanted to show the intensity of a blind man's inner vision, took a detour by way of Oedipus, Homer or Milton; both Caspar David Friedrich ('close thy bodily eye') and John Constable ('it is the soul that sees') directly invoked the power of the inner eye.[4] Goya, in his self-portrait as a dreamer/sleeper, adopted a different approach, based on experiences crucial to his understanding of himself as an artist.

Fig. 31 '*The author dreaming*'
a drawing for pl. 43 of *Los
Caprichos*, 1797,
pen and iron-gall ink over black
chalk, 21.6 × 15.2 cm
Museo del Prado, Madrid

Fig. 32 '*The dream of reason
produces monsters*',
pl. 43 of *Los Caprichos*, 1797–8
etching and aquatint,
21.6 × 15.2 cm
Museo del Prado, Madrid

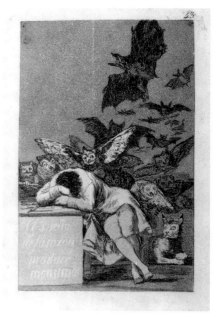

The dream, as a borderline experience that expands insight, has a tradition in Spain as it has nowhere else in Europe: one has only to think of the playwright Calderón de la Barca (*Life's a Dream*) and the poet Quevedo y Villegas (*Los sueños*, 'sleep', or 'visions'). The dream can threaten; it can reveal what is hidden; it can also confirm a noble resolution, as in Murillo's *Dream of Patricio Juan* (Prado).

The fact that the same Spanish word, *sueño*, can also mean 'sleep' has led to a misleading interpretation of *Capricho* pl. 43 as 'The Sleep of Reason', a view that ignores not only the dual meaning of the Spanish word but also the fact that Goya was originally planning a series to be called *Sueños*. What we know as *Capricho* pl. 43 was first intended to be *Sueño* pl. 1 (fig. 31). The man who buries his head in his arms is plagued by nightmares. To fend off these self-created onslaughts is the function of his art, which conjures and exorcises terror by giving it a shape. In this way it serves the purpose of *ilustración*, in the highest sense of that word: it casts light.

Goya was an *ilustrado* not because he worshipped reason and dipped his brush in pure intellect; and not because he stood up for the abused and the humiliated: but because he widened the scope of his art to reveal the conditions under which unfreedom is created. He returned art to its first function by undertaking to confront the eye with unheard-of, unfathomable horrors in order to 'release it from gazing into the terror of the night' (Nietzsche, *The Birth of Tragedy*, 1872, ch. 19). Goya reflects the 'dialectic of the Enlightenment' and carries it to the conclusion pointed

out this century by Theodor Adorno and Max Horkheimer: 'Enlightenment is mythic anxiety, turned radical.'

The work of art as an apotropaic (exorcising) act affords a wider and deeper perspective than Kant's retreat to the idea of 'disinterested pleasure': though supposedly the first modern definition of art, this has nothing to do with Goya. Nor, indeed, has irony, the form of paradox that Friedrich Schlegel, for instance, employed to disrupt the rigid categories of rationalism – even though the cryptic titles and commentaries of the *Caprichos* can be read as guileful exercises in distancing through wit.

The genesis of Goya's obsessions does not lie in the soaring, autonomous intellect but in the magical origins of artistic activity. *Capricho* pl. 43 has its links with the Counter-Reformation. The disordering of the senses that befalls the dreamer/sleeper has its origin in the temptations to which the Catholic knows himself to be exposed. Christian doctrine and pastoral practice had two answers to this: the person tempted was punished, or was forgiven. In 1788 Goya painted *St Francis Borgia and the Dying Impenitent* (cat. 17). A comparison of this sketch with the huge completed painting in Valencia Cathedral (fig. 119) confirms what was said at the outset: in the small format, Goya enjoys the 'total freedom' that he must later deny himself.

The sketch was preceded in its turn by a drawing (fig. 118), in which we see Goya looking for his pictorial idea. The work was commissioned in honour of Francisco de Borja (1510–72), who entered the Society of Jesus in 1536 and performed charitable work, notably for the sick and the dying. In the drawing, the Jesuit holds up a crucifix to the dying man with a gesture that is both admonitory and pleading. This seems to be having its effect, for already Heaven's winged emissaries are arriving to carry the redeemed soul aloft, while 'a winged demon', according to one commentator (F. Nordström), 'is about to leave the room'. This winged creature contains the formal germ of those *monstruos imposibles* that have a central function in Goya's work as embodiments of evil.

By the next stage, in the oil sketch, the single demon has multiplied and acquired a menacing degree of power. Far from quitting the scene, the birds of night have taken possession of the deathbed. We can assume that two considerations (or rather, impulses) prompted this change of emphasis: first, the realisation that the composition needed more drama, and second, Goya's own fascination with the horrific and the frightful. In the crowd of demonic figures in the oil sketch, Goya for the first time satisfied the demand that he was to raise some ten years later in the advertisement for the *Caprichos*: to unite 'in a single fantastic personage' ('*en un solo personage fantástico*') what appears in nature only in scattered form or else exists only in the imagination.

The end pursued by the Saint is also the end proclaimed, years later, by the deviser of the *Caprichos*. We can apply to both what Goya wrote on the drawing for *Capricho* pl. 43 ('*Ydioma universal*'): both set out 'to banish vulgar prejudices and perpetuate, through this work of *caprichos*, the solid testimony of truth'. But in the course of the ten years that elapsed between the *Impenitent* and the *Caprichos*, the idea of 'truth' in Goya's work underwent a crucial semantic shift. Not only did it quit the sphere of monopolistic religion: it became so thoroughly secularised as to oppose religion in the name of reason. The verities of faith have been perverted into superstition; not that this inhibits Goya in the least from joining in the process of perversion with the aid of *capricho* and *invención*.

The Borgia painting is the earliest evidence for our assertion that Goya regarded art as an apotropaic action, prompted by terror. In '*The dream of reason*', a Saint's dialogue with a dying man is replaced by a dialogue within the artist himself. He is simultaneously the impenitent and the exorcist who saves him. Or, to put

it another way, he is an impenitent, since the demons and monsters give him pleasure which he converts into pictorial signs by means of *capricho* and *invención*; but in so doing he also does the work of St Francis Borgia, in his own way, by rationalising his temptations: he exorcises them by drawing and painting. Unlike the Saint, of course, he does not perform this apotropaic act in order to save anyone's soul. Inasmuch as it causes us to see and to be aware, the work of art takes the place of the promised redemption.

V

At San Antonio de la Florida, Goya shows a miracle as it takes place in the midst of popular merrymaking. Above it, the celestial dome does not (as was the case with Tiepolo) open into the supernatural realm: Goya has painted sky, not heaven. In the apse of the same church, however, the *Adoration of the Trinity* takes place against a firmament of a very different kind (fig. 173). The angels are the very same young women who, in the dome, witness the miraculous resurrection of the Saint's dead father. The critics' accusations of profanity do not go to the heart of the problem. Goya is making a distinction between a miracle that owes its credibility to its everyday surroundings, and the glorification of an abstract emblem (a dogma!) that has no such credibility, even though the attendant angels look like flesh and blood. It is, indeed, their sensual worldliness that casts doubt on what it is they are supposed to be doing.

There is a similar disparity between the Boston oil sketch for the allegory of *Time, Truth and History* (cat. 50) and the finished allegory in Stockholm (fig. 162). In the sketch, the figure of Truth – Eleanor Sayre (see Bibliography) relates her to the liberal Cadiz Constitution – is a buxom village maiden whom we have already met in the figure of the young woman who stands aloof from the game

of *Blind Man's Buff* (fig. 26). There she stands, unclothed, and her look and her attitude are disarming in their ingenuousness. In the large painting in Stockholm she is transformed: the guileless country girl has become a white-clad, self-assured lady, frozen into a practised studio pose. In the oil sketch she was the embodiment of Spain; later she becomes its representative emblem.

This shift of emphasis reflects the same tension between small and large formats that Goya addressed in his Memorandum on the reform of art studies. Behind it lies a symptom of the age: the loss of credibility suffered by two traditional themes, allegory and miracle. These had become vessels that the painter found it difficult to fill with anything substantial or worth looking at. The Protestant sceptic G.W.F. Hegel was not the only one to point out (with some satisfaction, in his case) that we no longer bend the knee to the images of the saints (*Aesthetik*, 1.2: 'The Position of Art in Relation to Religion and Philosophy'). Even the Catholic German mystic Novalis had his doubts on the subject. In Novalis's posthumously published novel *Heinrich von Ofterdingen* (1802), the father of the eponymous hero bemoans the loss of spirituality: 'Gone is the time when divine visions came in dreams; and we never shall or can understand the feelings of those chosen individuals of whom we read in the Bible. Dreams must have been very different in those days, and so must all human concerns.'

This is confirmed by the dream in *Capricho* pl. 43, in which there is definitely no room for 'divine visions'. Heinrich's father continues: 'In the age of the world in which we live, there is no longer any direct intercourse with heaven.' Not even the work of artists can alter this: 'Our miraculous images today have never greatly edified me, and I have never credited those great feats that our clergy ascribe to them.'

This credibility gap leads Goethe to the same conclusion as Goya: he transposes biblical characters into the here and now. In

the opening chapters of *Wilhelm Meisters Wanderjahre* (1807–10, published 1829), Wilhelm is on his travels when he meets a Holy Family. The chapter titles are unequivocal: The Flight into Egypt; St Joseph the Second; The Temptation. It all takes place in the ruins of a monastery in a remote valley. What is left of the building now serves the Christianity of Good Works, *which needs no church*: 'our traveller found himself in a very neat and well-preserved chapel, which was, however, furnished for the domestic purposes of daily life'.

The Imitation of Christ is now to be found in ordinary existence: neither in the glorification of a dogma, nor in pilgrimages such as those that Goya mocks in the Black Paintings, nor in a dance round a statue of the Madonna (*Procession of Flagellants*; cat. 96). We find it, instead, in *The Water-carrier* (cat. 93) and *The Knife-grinder* (cat. 92). The young woman with the jar of water is the culmination of a series of variations on the theme of 'loving kindness' and 'charity' in Goya's sketchbooks. In the early 1790s, when he painted the *Girls with Water-jars* (fig. 136), the result was a genre painting in the tradition of galleries of urban types and occupations ('Street Cries', and the like). He now gave *The Water-carrier* a monumental weight and rhythm; it is no accident that her outline is the same as that of *St Barbara* (cat. 6). With ease and dignity, she proclaims an inward freedom that is also an appeal to the viewer; and this makes her into a 'real allegory' (*allégorie réelle*: the oxymoronic subtitle that Gustave Courbet coined for his vast painting of *The Artist in His Studio*).

The sacralisation of the profane (which incorporates a secularisation of religious themes) also has some light to throw on Goya's two 'Mason' paintings. *The Drunken Mason* (cat. 24) was painted in 1786 as a sketch for a tapestry for the banqueting hall of the palace of El Pardo. In the course of scaling up his design, Goya modified the pictorial idea: the drunken mason became *The Wounded Mason* (fig. 130). This radical change of

meaning is revealed by the two men carrying their stricken workmate. In the sketch, their broad grins reveal a trace of *Schadenfreude*, and of cheerful complicity; in the final version they are straight-faced, but indifferent rather than sympathetic. How is anyone to tell whether the drunken mason is not also wounded?

Edith Helman (see Bibliography) explains the theme by referring to an edict of Charles III, repeatedly published from 1778 onwards, concerning unsafe scaffolding on building sites. The tapestry would thus have been a monument to the monarch's social conscience, and at the same time a discreet reminder from Goya the sceptic that edicts are not always observed – or perhaps that, with the best precautions in the world, accidents cannot always be avoided. With this is linked the verdict that runs through Goya's 'universal language' like a leitmotiv: 'All will fall' (the title of *Capricho* pl. 19). Both paintings thus become complementary parables. If man is perennially riding for a fall, it does not really matter whether he is drunk or sober; his fate is the same. Both images coincide in a single *topos* of Christian iconography. This becomes clear if they are compared with Goya's early *Descent from the Cross* (fig. 34), which makes Christ the prototype of the helpless, defenceless human creature.

VI

Goya's work stands within several art-historical frames of reference. This artist who cast his eye on the grandeur and the misery of the marginal figures in society – the poor, the sick, the workers – was a Court painter, employed, in turn, not only by three Spanish kings but by the nobility and the bourgeoisie. To put it rather too neatly: Goya stood between the victims and the victimizers. His self-portraits are variations on this Janus-faced quality: they show him between compliance and self-

assertion. He is compliant when he appears, in the attitude of a servant, on the periphery of ceremonious portraits (fig. 13, 35, 41); he asserts himself when he is alone and looking the viewer straight in the eye (cat. 62, 63, fig. 6, 36). Different from both these self-images is the confession of faith that he gives in '*The dream of reason*'. This shows him under physical threat; but the bats and other creatures that assail him are reified metaphors of his own inner unease. They foreshadow the overthrow of the mind. This is what makes this etching (together with the drawings for it) into a parable of the fate of the modern artist as we know it.

This parable has an analogy in the *angst* and desolation of the hero of Goethe's *Torquato Tasso* (1790). Cast off by his princely patron, the poet believes himself to be on the edge of an abyss; like the dreaming Goya, he hears about his head the wingbeats of 'Those hideous, uncanny, feathered things, The horrid retinue of ancient Night'. A quarter of a century later, Byron found still stronger tones for the distracted poet. The process of radicalisation may be outlined as follows: the dreamer Goya is beset by fiends at his worktable; Goethe's Tasso is alone with his despair; Byron's Tasso is banished to a 'lazar-house' and suffers a collective fate. With both Goya

Fig. 33 '*There's a lot of this, but one doesn't see it*', page 67 of Album C, *c*. 1814–23 brush and iron-gall ink, 20.6 × 14.3 cm Museo del Prado, Madrid

Fig. 34 *Descent from the Cross,*
c. 1770–72
wall painting transferred to canvas,
130 × 95 cm
Lázaro Galdiano Museo, Madrid

patronage, to which Goya laid claim in his cabinet pictures, was carried to its logical extreme towards the end of his life in the Black Paintings that he painted in 1820–23 for the walls of his own country house, the Quinta del Sordo: a logical extreme, because in these works self-emancipation gives way to a self-imposed incarceration. These paintings are simultaneously a menace and a shield; Goya painted them as a kind of bulwark. In the *Yard with Lunatics* he was the observer who comes in from outside; here he stands and lives at the centre of a hell on earth, a Pandæmonium that is entirely of this world, with no hope of any world beyond.

and Goethe, nightbirds are heralds of affliction; in Byron's poem, abuse and menace are internalised, and each individual, 'tortured in his separate hell', is simultaneously perpetrator and victim.

The step from Goethe's drama to Byron's poem marks the abandonment of those traditional metaphors (drawn from religious iconography) that stood for sinful, animal nature. Goya took the same step. The *Yard with Lunatics* already foreshadows Byron's lazar-house. Here everyone, and not only the artist, falls prey to distraction.

The independence of commissions and

References

[1] See J. Held, 'Goya's Akademiekritik', *Münchener Jahrbuch für bildende Kunst*, XVII (1966), p. 214.

[2] In E. Gombrich, *Aby Warburg: An Intellectual Biography* (London, 1970).

[3] A. Blunt, 'The Criminal-King in the Nineteenth-century Novel', *Journal of the Warburg and Courtauld Institutes* (1937), p. 249.

[4] For Friedrich, see the collection of writings in S. Hinz, ed., *Caspar David Friedrich in Briefen und Bekenntnissen* (Munich, 1974), p. 92; for Constable, the couplet he cited (from George Crabbe's 'The Lover's Journey' in *Tales*, 1812) in his lecture of 1836 can be found in C.R. Leslie, *Memoirs of the Life of John Constable* (London, 1951), p. 318, where its source is not given.

Fig. 35 *Count of Floridablanca y Goya*, 1783
oil on canvas, 262 × 166 cm
Collection of the Bank of Spain, Madrid

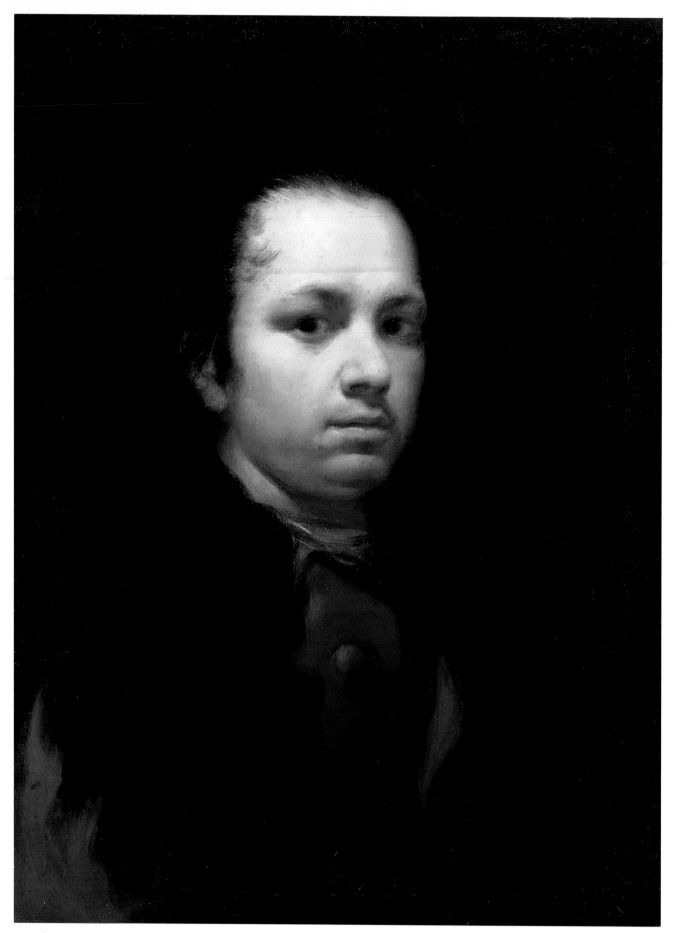

Fig. 36 *Self-portrait, c.* 1770–75, oil on canvas, 58 × 44 cm, Private Collection, Madrid

'FRANCISCO GOYA Y LUCIENTES, PINTOR'

Juliet Wilson-Bareau

'Don Francisco de Goya y Lucientes was born in Fuendetodos, in the kingdom of Aragon, on 31 March 1746. He was baptised Francisco José' (Beroqui, 1927). This is how Goya's son began a brief account of his celebrated father's life, written at the request of the Royal Academy of San Fernando in 1831, just three years after Goya's death in Bordeaux at the age of 82. The artist's earliest self-portrait (fig. 36) shows him as a young man, at the start of a career that was to carry him through the last quarter of the 18th century; while in another, much later one (see Frontispiece), he appears as a mature artist whose hopes of a rebirth of his country, after victory over the hated French invaders in 1813, had been extinguished on the return of the tyrannical Fernando VII as absolute ruler of Spain. In the early portrait, the head, with its deep-set eyes and double chin, is set firmly on the thick neck, and the gaze is steady and penetrating; long, dark locks spread over the shoulders, and the curving coat-lapel that catches the light directs the spectator's eye towards the strong but sensitive mouth and the alert and serious expression on the artist's face. The eyes remain in shadow, and impasto touches on the forehead give a sense of almost tangible relief to the head, increased by the slight halation in the background that suggests atmosphere and space. It looks like the portrait of a very young man, and could have been painted as a souvenir for his parents, before he set out for Italy in 1769 or 1770, in his early twenties.

The later portrait was painted in 1815, when Goya was in his seventieth year. Although the style has evolved and the artist himself has aged greatly and bears the marks of illness and suffering, the personality is the same. Indeed, the later portrait, in a style that combines both the realism and spirituality of Rembrandt with an already romantic expression of the artist's personality, confirms the impression of seriousness in the younger man, of self-assurance and an impressive inner harmony. The construction of the portraits is also inseparable from the effect they produce in the spectator: that of the young man, upright and full of contained, youthful energy, directly confronting his own image and the spectator's gaze; and that of the old man half-turned towards the spectator, in a pose suggesting the weariness of a life-long struggle but also the indomitability of a man who was to live through another revolutionary period before going into self-imposed exile in France; brooding, contemplative, the head is set off by the negligent attire, with surprisingly delicate and voluptuous textures in the open-necked shirt, half-veiled by a transparent black shawl, while the freely brushed background complements the delicate treatment of the hair. Now barely legible, the inscription is a statement: '*Fr.co Goya Pintor[?] / Aragonés / por el mismo / 1815*', recording the profession, proud origin, authorship and date of this moving self-portrait. The constant, unchanging character of the artist and his way of seeing

himself and the world is confirmed by other self-portraits of various dates (fig. 1, 2, 6, 7, 13, 35, 41, 105, 186; cat. 62, 63), suggesting that his style will prove to be equally marked by his strong, immutable personality.

The early self-portrait has a 'Mengsian' air about it, appropriate to the work of a young artist who had probably already spent several years in Madrid, working in the studio of Francisco Bayeu. Bayeu, to whom Goya was to become intimately linked through his work with him and his younger brother Ramón, and his marriage in 1773 to their sister Josefa, was the principal Spanish follower of the celebrated artist of Bohemian origin, Anton Raphael Mengs, who was called from Rome in 1761 by Carlos III to work for the Court, together with Giambattista Tiepolo and his two sons, Domenico and Lorenzo. Mengs's theories of art, firmly grounded in neo-classical principles, paid homage to the splendour of ancient Greek sculpture known in Italy through Roman copies, but he also admired works by Rembrandt and prized the art of Velázquez as the finest example of what he defined as 'the natural style, or style based on nature', considering that 'if Titian surpassed him as a colourist, Velázquez was much farther ahead than he in his understanding of light and shade and aerial perspective' (Ponz, 1947, pp. 569–70). Goya's son, in the biography already cited, wrote of his father: 'Observing Velázquez and Rembrandt with veneration, he devoted himself only to the study and contemplation of nature, which he described as his guide and mentor', and these qualities of 'naturalness' and the impression conveyed of figures existing in space and animated by light are a constant in his art from the earliest years. Light, above all, is the feature that emerges as the essential element in his work, in whatever medium he used, and the sensitivity with which he analyses its action on his own features provides a touchstone for the appreciation of all his paintings.

Of Goya's journey to Italy and what he saw and learnt there, little was hitherto known, in spite of much speculation. However, detailed study of the Italian Notebook recently acquired by the Museo del Prado (see p. 92), and a new appreciation and understanding of the nature of his participation in the Parma competition (see cat. 1), will undoubtedly clarify much that has remained obscure and suggest what really interested him in Italy. Goya himself emphasised that he went to Rome 'at his own expense', and Valentín Carderera, in 1838, noted that his stay in Rome as a 'poor student, full of passion and enthusiasm', was undertaken in very different circumstances from those who went 'as the holder of one of His Majesty's imposing scholarships', who spent their time copying and imitating 'the works of Conca, Trevisani and Benefiali which were then in vogue' (Glendinning, 1977, p. 291; 1982, p. 298). He evidently stayed in Rome for a considerable period of time, and travelled quite extensively, particularly along the Adriatic coast and in the north. On his return to Spain he was offered his first major commission, to paint a fresco decoration on the vault of the *coreto*, or little choir, in the great church of El Pilar in Saragossa (fig. 37, cat. 2). The large sketch for this fresco, which Goya executed with very few changes, was extensively altered as he worked out the design on the canvas, as is seen in the striking x-ray image (fig. 77). This shows the artist working with effects of light to convey the symbolic radiance of the *gloria*, and underlines his remarkable assurance of touch in the modelling of heads or wings or adding the single strokes that indicate the fingers of a hand. The figures have a classical strength and solidity that speak of Goya's recent Italian experience, and are also evident in the cycle of monumental mural paintings in the Charterhouse of Aula Dei, near Saragossa, painted a year or two later (fig. 88).

'We left Saragossa for Madrid on 3 January

Fig. 37 *Gloria*, 1772, fresco, 6.5 × 12.5 metres, vault of the Little Choir, El Pilar, Saragossa

1775. And arrived on the 10th'. The entry in Goya's Notebook (fig. 65) records the start of his young family's new life and his future career in Madrid. He had married Josefa Bayeu in 1773, and the following year a son was born in Saragossa (fig. 68, see p. 126, cat. 8, 9), the first of seven children recorded and baptised, of whom only one, Javier, would survive (fig. 48, cat. 69). In a memorial sent to the King some years later, when he was soliciting his nomination as Court Painter, Goya wrote that 'having practised this Art in Saragossa, his native city, and in Rome, . . . he was summoned by Don Anton Raphael Mengs to continue it in

Your Majesty's Royal Works' (Sambricio, 1946, doc. 56). From 1775 to 1780, and again from 1786 to 1792, Goya was employed as a designer for the Royal Tapestry Factory of Santa Barbara. According to the Factory's accounts, during the earlier period he executed over thirty tapestry cartoons, more than any of the other painters attached to the Factory, and during the 1780s, another fifteen (Cruzada Villaamil, 1870, pp. xxi, 147). Many of them are very large, and Goya's son recorded what his father must have told him, that they were seen and approved by Mengs, 'who was amazed by the great facility with

which he made them'. He presented them as paintings 'of my own invention' (fig. 18, 39, 91), and prepared them with great care, making detailed studies from the live model for the figures (fig. 40) and sketches – some of them in his Notebook – for the landscape settings (fig. 38). From the very first of these 'original' compositions, Goya was concerned to construct a harmonious and interesting design, taking into account the destination of the tapestries and their relationship one to another. From the earlier series, only one sketch has survived (cat. 7), but all the artists had to provide finished models for approval by Mengs and the King, before starting to paint the full-scale versions from which the weavers would work.

The tapestry cartoons provided Goya with the 'bread and butter' for his family in the early years of his life in Madrid, and enabled him to explore a wide range of genre subjects that drew on his everyday experiences. They reveal his interest in every aspect of life in the city and his enjoyment of everything connected with the countryside, which he combined with references to a whole repertory of classical and contemporary allusions and iconographical conceits evidently intended to entertain and intrigue the more or less sophisticated viewer of his work. Through their large numbers and

Fig. 38 Page 34 verso of Goya's 'Italian Notebook' Museo del Prado, Madrid

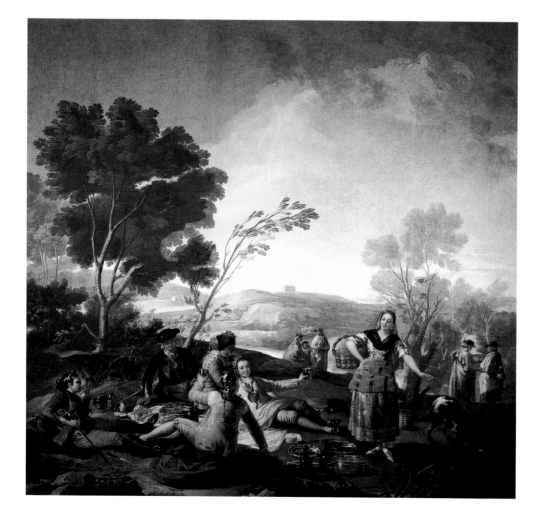

Fig. 39 Tapestry cartoon, *The Picnic*, 1776 oil on canvas, 272 × 295 cm Museo del Prado, Madrid

Fig. 40 Study for *The Picnic*, 1776 black chalk heightened with white, on blue paper, 19 × 24.5 cm Instituto Valencia de Don Juan, Madrid

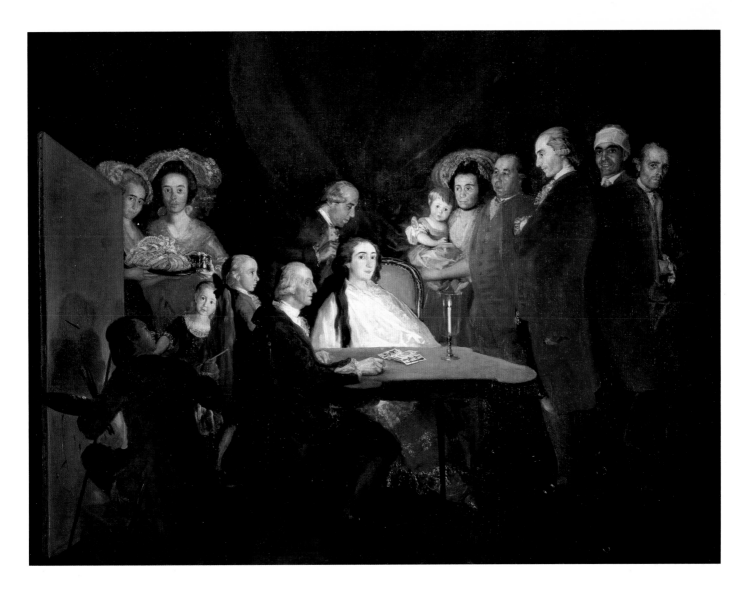

Fig. 41 *Infante Don Luis and his Family*, 1784
oil on canvas, 248 × 330 cm
Magnani-Rocca, Corte di Mamiano
Foundation, Parma

the variety of their compositions, the tapestry cartoons present an inexhaustible field of study, and the restoration of these much abused canvases (which remained rolled in the palace basement for many years, before their transfer to the Prado in 1897) will one day reveal them in something close to their original splendour, as a demonstration of Goya's powers of pictorial invention, on a level with those of Raphael or Rubens.

The commissions for tapestry cartoons were interrupted for economic reasons between 1780 and 1783, during the period of Spain's war with Britain, but Francisco Bayeu arranged that Goya and his own brother, Ramón Bayeu, who also regularly worked for the Tapestry Factory, should paint some of the ceilings on which he was engaged in El Pilar in Saragossa. This was to prove an unhappy experience, and led to bitter quarrels with his brother-in-law and the chapter of El Pilar. Goya was indignant at the criticism of his work and outraged by the suggestion that he should submit to its correction by his brother-in-law,

Francisco Bayeu, and after various exchanges he wrote a tremendous epistle to the Building Committee, giving his version of the events and justifying his conduct. He went as far as to state that Francisco had accused him 'although indirectly, of being high-handed, proud, indocile and vain', and that he had 'borne with resignation the insulting attacks on his honour' (Viñaza, 1887, pp. 168–73). The dispute was eventually resolved through the intervention of the archpriest Don Matías Allué, but the incident reflects the artist's confidence in his own abilities and his impatience with the kind of criticism that paid attention to details of style and ignored the overall effect of his work. He was accused of painting too fast, of a lack of 'finish' and decorum in his work, and those with a traditionalist or neo-classical view of art could not come to terms with the expansive energy of his style and broad technique.

Even his painting for the Parma Academy competition was criticised for its unreal colour and failure to keep to the subject, although it is clear from the preparatory sketch that the composition was very carefully planned in relation to his chosen theme (cat. 1). The same degree of attention is evident in his painting for San Francisco el Grande, a 'competition' among seven of the most prominent artists at the Court to provide altarpieces for the newly completed church. Goya made at least two sketches (cat. 11, 12) and explained his ideas in a letter to the Prime Minister, Count Floridablanca, who had commissioned the pictures. The relative success of Goya's very large religious painting and of his ambitious portrait of the minister (fig. 35) was followed by contacts with important private patrons, and particularly the King's brother, the Infante Don Luis. Goya went twice to stay at the Infante's palace at Arenas de San Pedro, in 1783 and 1784, and apart from painting a series of splendid portraits of the Infante's family (fig. 41, see cat. 59), he was much admired by the Infante as a fellow hunting enthusiast. For a while Goya lived with a somewhat heady mixture of success and the machinations of jealous colleagues, and in 1783 his brother Camilo was worried enough to write to Martín Zapater about 'Francho's' problems: 'although God has blessed him with ability he is persecuted for it with such force that although they can no longer conceal it (since this town is not like Saragossa) they make him lose patience with what this one and that one has said, and twisting everything with their lies as much as they can, so that I am writing this in a state of great agitation; ... the worst of it is that they leave him disgusted with painting, and being unable to take away his ability, they succeed in ensuring that he will not carry on, or at least is in danger of it; since they cannot bear that he should be so highly praised or should be so highly regarded compared with the rest' (*Diplomatario*, 1981, p. 430). However, within two years, Goya was so far ahead of the pack that he had no real need to fear the activities of those whom he always qualified as '*los hombres viles*'.

His success in the 'competition' of the San Francisco el Grande altarpieces led to further commissions for religious paintings during the 1780s, of which one of the most impressive is the painting that crowned a magnificent new altarpiece (*retablo*) in the church of San Antonio del Prado in Madrid. From the tiny '*borrón*' that shows the composition with the angel on the left and God the Father with cherubs above (cat. 14), Goya developed a monumental painting, executed with little reference to the actual space in which the scene takes place, but creating an effect of light that envelops the figures, which are painted in a technique very similar to that of Velázquez. The perfect geometry of their relationship is marked out by bold areas of strong white impasto which describe and define their silhouettes, giving the composition a strength and balance that fully express the mystery that is taking place, without the need for any other elements (fig. 42). The majestic power of the angel, the force of the enormous, pointing

Fig. 42 *Annunciation*, 1785 oil on canvas, 300.5 × 180.5 cm Collection of the Duchess of Osuna, Seville

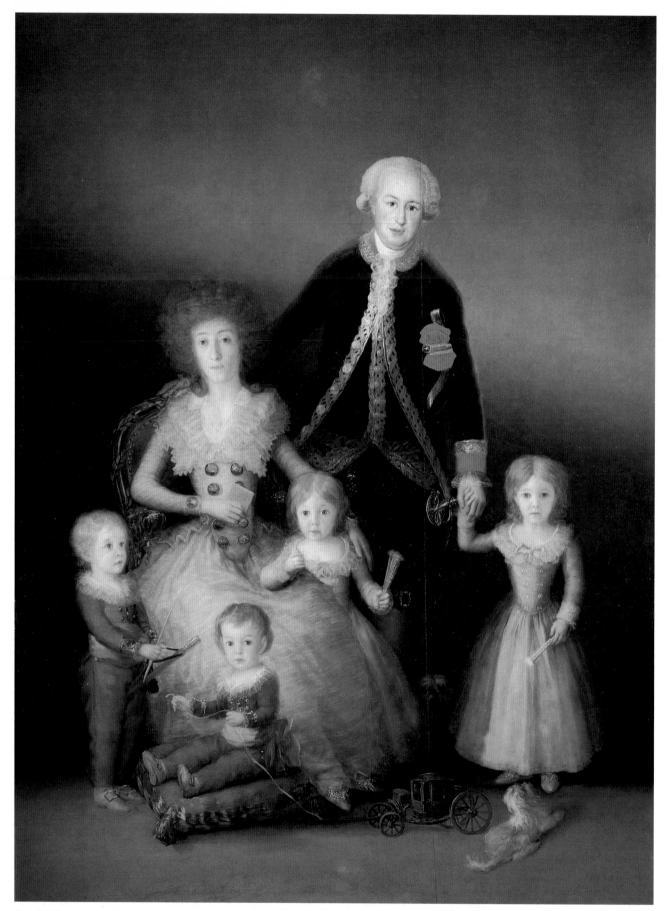

Fig. 43 *The Duke and Duchess of Osuna and their Family*, 1788, oil on canvas, 225 × 174 cm, Museo del Prado, Madrid

Fig. 44 *'The Alameda'*, *the Palace of the Dukes of Osuna*, an engraving after Yriarte published in Charles Yriarte, *Goya*, Paris 1867, page 79

finger and the classical beauty of the features suggest Antique sources that are also evident, although in a very different way, in Jacques-Louis David's *Death of Socrates* (fig. 24), indicating the degree to which Goya's inherent classicism lay beyond the Neoclassical currents of his day.

Although the Infante don Luis, Goya's first important patron, died in 1785, he gained new protectors in the future Duke and Duchess of Osuna, a young couple who commissioned their portraits that year and then the exquisitely 'French rococo' family portrait (fig. 43) in which Goya outdid himself in the delicacy of handling and sense of light and atmosphere, even though the very complexity of the group with the four children, two dogs, a toy carriage and variety of sticks and fans resulted in a somewhat naively posed group. The Osunas brought up their children on enlightened principles in the beautiful setting of their country palace and gardens known as 'El Capricho' at La Alameda, just to the north of

Madrid (fig. 44). Goya painted for them a set of seven decorative canvases that were set into the walls of one of the principal salons, in which he used the most refined painterly technique to create works intended to be seen and appreciated as paintings, rather than translated into the medium of tapestry.

These large and elegant *asuntos de campo* (country scenes) are masterpieces of design, in which buildings and trees and figures are combined in a variety of interesting groupings and poses and actions, while obeying an underlying geometrical order that binds each scene into a perfectly structured whole, and in which the expression of the space within the picture is assimilated to the lines of force of the composition. In the largest and most impressive of the compositions, *Sorting the Bulls* (fig. 45), figures and animals, landscape and buildings and even the sky are structured on a complex, interlinking pattern of diagonals that mark out the perspective of the scene with absolute clarity, and at the same time gather

Fig. 45 *Sorting the Bulls*, 1786–7
oil on canvas, 165 × 285 cm
Whereabouts unknown

every element of the composition into a superbly organised pattern on the surface of the canvas, anticipating the way in which the foreground designs of *The Hermitage* and *The Meadow of San Isidro* cradle the compositions and open up the space behind. This magnificent work, which disappeared after the Second World War, anticipates the much smaller, more subtly structured scene that Goya painted as part of the series on tinplate in 1793 (cat. 32), and probably served as a model, directly or indirectly, for the transformation of the equestrian portrait of Godoy into a '*garrochista*' (cat. 60).

In another of the larger scenes, the force of verticals and diagonals again expresses the meaning of the scene, as their interplay underlines the 'gravity' of the various elements – stones, straining oxen and wounded man – expressed with a reticence and dignity that is echoed not in the sketch (cat. 24) but in the tapestry cartoon of *The Wounded Mason* (fig. 131). In these scenes, in which Goya certainly gave free rein to his imagination, he established a type of composition that would be perfected and refined but remained virtually unchanged until the end of his life, and is found in paintings such as *The Shipwreck* of 1793–4 (cat. 41), *The Last Supper* (cat. 51), *The Friar's Visit* (cat. 74), or *The Making of Powder* of *c.* 1810–14 (cat. 90).

The period from 1785 to 1795 was perhaps

Fig. 46 *Transporting a Stone Block*, 1786–7
oil on canvas, 169 × 127 cm
Private Collection

Fig. 47. *Javier Goya*, 1805–6
oil on canvas, 192 × 115 cm
Private Collection

Fig. 48 *Mariano Goya*, 1809–10
oil on canvas, 113 × 78 cm
Private Collection

the happiest of Goya's life, although inter-rupted by moments of tragedy and the drama of his illness in 1792–3. Josefa continued to give birth to children who died in their infancy, and two more were born to the couple in 1780 and 1782 of whom, like the earlier four, nothing is known except their names and the date of their birth and baptism, and the names of their godparents. Goya was undoubtedly deeply affected by these infant deaths, and the tenderness with which he paints children indicates the depth of his feeling for them. In the beautiful sketch for *The Immaculate Conception*, painted in 1783–4 (cat. 13), the cherub at lower right is so like a real child that it could be a 'portrait' of little Ermenegilda Francisca de Paula, born 13 April 1782. In 1784 the couple's last child, Francisco Javier, was

born, the only one who survived. He married in 1805 and gave Goya a grandson, Mariano, the following year; and both son and grandson were apples of the artist's eye and the objects of his painterly attentions (fig. 47, 48; see cat. 67–73). However, neither came to any good, and Javier, who claimed to be an 'artist', had sold most of his father's important paintings within a few years of his death, while Mariano was a spendthrift eccentric, more interested in acquiring a title than conserving his inheritance.

It was not in his home but out with the hunt that Goya found his greatest happiness. His letters to Zapater are full of accounts of shooting parties he has just enjoyed or is looking forward to, and there is much about dogs and their health and behaviour. In 1781

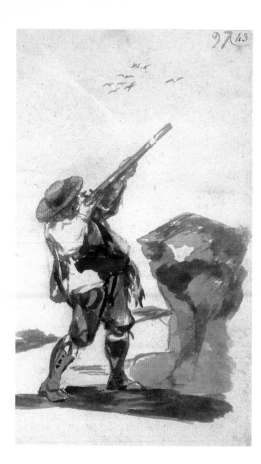

Fig. 49 *A Hunter Shooting at Birds*,
page 97 of Album F, *c.* 1812–23
brush and iron-gall ink, 20.4 × 14 cm
Museum Boymans-van Beuningen,
Rotterdam

he wrote to Zapater about a shoot: 'as far as I am concerned there is no better entertainment in all the world, and though I've only been out once here no one did better than I did, since with 19 shots I bagged 18 items, as follows: 2 hares, a rabbit, 4 young partridge, 1 old one, and 10 quail', and after his first visit to Arenas de San Pedro in September 1783, 'I went out hunting twice with His Highness, who is a very good shot, and on the last afternoon he said after I had brought down a rabbit: "this rotten dauber is even more passionate about hunting than I am"' (*Cartas a Zapater*, 1982, nos. 26, 49). A series of drawings from a much later period graphically expresses what Goya found in the sport (fig. 49), in which total coordination is required, with the body braced to take the recoil of the gun and tensed to swing round at a fresh sighting of the game. Goya must have enjoyed the physical and mental

thrill of a good shoot, as well as the stimulus of knowing that he was an excellent shot. He undoubtedly felt the same response to the *seguidillas* (popular songs) to which he referred with enthusiasm on several occasions until the letter to Zapater, probably written in 1792, in which he mentioned 'the *seguidillas* that are enclosed, which you will listen to with such pleasure, but I haven't heard them and probably won't since I don't go any more to the places where I could listen to them, simply because I took it into my head to stick to a certain irrational idea and keep up a certain dignity that I heard you say to yourself one ought to have, and with which you can imagine I'm not particularly pleased' (*Cartas a Zapater*, 1982, no. 125). Goya's pictures are full of the rhythms and vitality of a man who loved hunting, popular songs and dances but also fine music, and whose handwriting swung

Fig. 50 The Reliquary in the Church of Fuendetodos, *c.* 1762 (destroyed)

from exquisite italic script to powerful scrawl. These rhythms are an essential part of his art, but even more important is his passionate relationship with light and his need to make it a part of his paintings.

In Goya's earliest known work, the doors of a reliquary in the church at Fuendetodos (fig. 50, 51), decorated with an image of the Virgin and St James, which he painted when he was perhaps seventeen, the complicated design was probably taken from an engraving, and the large, rather wooden, figures are treated with great slabs of light applied flat onto the forms.

The same is true of the figures of a *Virgin of Carmen* and *St Francis of Paola* (fig. 51) on the inner side of the doors, although these are more simplified, recalling in their strong, rudimentary forms the powerful abstraction of the Saint's head and robe in *The Death of St Francis Xavier* (cat. 5), and the long, strong fingers that are marked by touches of light in the later painting. However, the lesson of Italy was the understanding of human form – sculptural, Antique form – and the action of light as it simultaneously creates form and gives it significance. In a little etching, perhaps

Fig. 51 Details of the destroyed Reliquary at Fuendetodos showing (centre) the *Appearance of the Virgin of the Pillar to St James* on the outside of the door-panels, which opened to reveal *The Virgin of Carmen* (left) and *St Francis of Paola* (right)

Fig. 52 Detail from *Sorting the Bulls,* or *Bulls by a Stream* (cat. 32)

made in Italy or soon after Goya's return to Spain (fig. 53), the simple, sculptural shapes of the robed figures are lit in such a way that they confer gravity and a sense of calm protection, enfolding the Christ-child within a zone of shadow. There is a certain rigidity in the print, with its simple oppositions between areas of light and areas of shadow. A detail from Goya's *St Barbara* (fig. 54), with the martyrdom of the Saint at her father's hands, shows a much more subtle approach to the treatment of light: over the reddish ground that is apparent everywhere in the picture, the brush is handled with great freedom and precision to mark with a single stroke the flashing blade of the knife, describe the fingers of the executioner's two hands, 'model' the three-dimensional, ribbon-like flash of lightning with single strokes, and touch with light the bared shoulder and bowed head of the victim, and to express, by means of agitated brushstrokes with no precise function on the Saint's dress, the drama of the scene.

The early preoccupation with defining a form by means of touches or patches of light along its edges, as in the *Hannibal* (cat. 1), is a constant in Goya's early paintings. These touches tend to form small, independent spaces that delimit from the outside the forms that they surround, as with the horse's legs. Later, in the *Appearance of the Virgin of the Pillar to St James* (cat. 10), light takes on a more complex function, and areas of bold, white impasto are applied in the final stages around the edges of the forms to accentuate their volume, as in the case of the Virgin and the little image. Apart from these larger, form-enhancing areas of impasto, small touches of white are used here in several places, such as the outstretched arms of the disciple running towards the Saint, creating a sense of movement through an expressive graphic language.

From the 1790s and the series of paintings on tinplate, Goya abandoned effects of light that were more in keeping with an earlier Baroque tradition, and brought to his paintings a natural light that illuminates the whole scene. In *Sorting the Bulls* (fig. 52, cat. 32),

Fig. 53 *The Flight into Egypt*, c. 1771–3
etching, 13 × 9.5 cm
Staatliche Museen Preussischer Kulturbesitz, Berlin

Fig. 54 Detail from *St Barbara* (cat. 6)

Fig. 55 '*La Beata*', a detail from *The Duchess of Alba and 'La Beata'* (cat. 64)

light was added when the composition was already completed, and applied with broad, richly empasted brushstrokes that lie along the horizon, bordering the edges of the scene with a luminous band that reflects light throughout the picture and throws the distant figures into relief. The density and concentration of the brush strokes create the luminous vibration that is necessary to give life to the whole picture, from the distant crowd to those specific areas within the composition that pick up and reflect the unifying light of the sky. Goya's handling of his brush is so masterly that he retains complete control, and even when working on a tiny scale, as in the small *capricho* of *The Duchess of Alba and 'la Beata'* (fig. 55,

Fig. 56 Detail from *Bandit Murdering a Woman* (cat. 78)

cat. 64), is able to describe forms and express shades of meaning through the spontaneity, unforced dexterity and variety of his brushwork.

Perhaps through the experience of his drawings in brush and indian ink on the pages of the Madrid Album in 1796–7 (fig. 197, 198), and his development of the most delicate or dramatic effects obtained by aquatint in the plates of *Los Caprichos*, Goya invented a new style of painting, combining every kind of handling from thick impasto to the thinnest washes of colour, reinforced by black lines applied with the point of the brush. If there were no other proof of their date, the eight canvases of the Marquess of la Romana would have to be placed in the period of the *Caprichos* on technical grounds. In the detail of the *Bandit Murdering a Woman*, fig. 56, cat. 78), the black, zigzag outline reinforcing the murderer's chest and belly evokes the violence of his act, an outline that is contrasted with the soft, smooth outlines of the victim's naked body. While already thinner and more transparent in technique, this series still retains painterly effects and makes striking use of impasto to express the light of a lantern or the daylight outside a cave (cat. 75, 77).

The development towards an ever more transparent, fluid use of colour is seen in the panels of the *Cannibals* (fig. 57, cat. 83), where the backgrounds lose the realistic effect that was important in earlier compositions. In the panels of the Academy of San Fernando (cat. 95–98), there is no directional light, no real depth or picture space. The two bull-

Fig. 57 Detail from *Cannibals Contemplating Human Remains* (cat. 83)

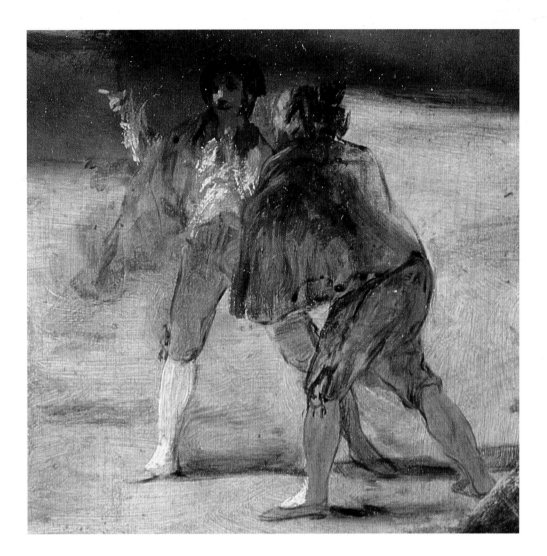

Fig. 58 Detail from *A Bullfight* (cat. 95)

fighters dressed in red, yellow and blue (fig. 58) have lost their consistency and no longer reflect light but absorb it into the intensity of the colour, while the background has blurred and lost its form. The final stage of this process is seen in the late *Bullfight* painted in France (cat. 112), in which the background is a barely indicated monochrome wash, and all interest is concentrated in the foreground, where the most important elements are accented by a very free use of texture and colour. The study of Goya's work that follows shows his style and technique in constant evolution, developing with each new series of works that reflect his changing relationship with the world around him. To follow this evolution is to gain some understanding of a man who was able to express all his ideas through his art.

TRUTH AND FANTASY

The Small Paintings

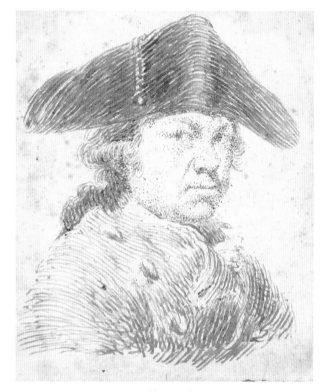

Self-portrait
pen and iron-gall ink
Metropolitan Museum of Art, New York
Robert Lehman Collection, 1975

The illustrated catalogue which follows does not include documentary, bibliographical
and technical information. This appears in the section starting on p. 341.

1746 30 March: Francisco Goya born at Fuendetodos, 40 km south-west of Saragossa. Fourth of six children of José Goya, a master gilder, and Gracia Lucientes, from a family of minor Aragonese aristocrats.

1748 Birth of the future Carlos IV.

1750s Educated in Saragossa at the Escuelas Pías, possibly Martin Zapater was his childhood friend.

1760 Ventura Rodriguez remodels the church of El Pilar. Carlos II becomes king. Goya sudies with José Luzán for four years, learning by copying the prints in his master's collection.

1761 Anton Raphael Mengs arrives in Madrid as court painter, followed in 1762 by Giambattista Tiepolo and his 2 sons.

1763 January: Francisco Bayeu called to Madrid by Mengs and establishes a studio with his brother, Ramón, in which Goya also works.

 December: Goya enters a drawing competition, organised by the Royal Academy of San Fernando, without success.

1766 Second unsuccessful participation in a competition organised by the Academy of San Fernando.

1769 February: Mengs leaves Madrid to return to Italy.

1770 March: Giambattista Tiepolo dies in Madrid and Domenico returns to Venice. Goya travels to Italy (the exact dates and itinerary are unknown). Lives in the Palazzo Tomati, home of Taddeo Kuntz and Piranesi. Notes and sketches are recorded in the Italian Notebook (fig. 59–68).

1771 April: enters a competition at the Royal Academy of Fine Arts, Parma, submitting a history painting (cat. 1), which was unsuccessful, but praised by the judges.

 October: commissioned to paint a fresco (cat. 2) in a ceiling of the church of El Pilar, Saragossa.

1773 25 July: marriage to María Josefa, sister of Francisco Bayeu, in the church of Santa María, Madrid.

1774 Series of eleven paintings on the walls of the Charterhouse of Aula Dei near Saragossa completed.

 29 August: birth of first child, Antonio Juan Ramón y Carlos, in Saragossa.

1775 Goya and his family leave Saragossa, arriving in Madrid a week later, in order to work under Mengs and Bayeu as a painter of cartoons for the Royal Tapestry Factory (cat. 7).

 December: birth of Eusebio Ramón.

1777 21 January: birth of Vincente Anastasio.

1779 9 October: birth of María del Pilar Dionisia. Death of Mengs in Rome.

1780 May: elected to the Royal Academy of San Fernando. Returns to Saragossa to decorate the cupolas in El Pilar (cat. 8, 9).

 22 August: birth of Francisco de Paula Hipolito Antonio Benito.

1781 May: the building committee of El Pílar rejects Goya's sketches for the pendentives. He completes his fresco decoration and is back in Madrid in July.

 July: commission to paint one of seven altarpieces for San Francisco el Grande, Madrid (cat. 11, 12).

1782 13 April: birth of Hermenegilda Francisca de Paula.

1783 Goya resumes work for the Royal Tapestry Factory. Portrait of Prime Minister Floridablanca (fig. 35). Visit to the Infante Don Luis, the King's brother, at Arena de San Pedro (fig. 41).

 6 December: inauguration of San Francisco el Grande. Goya's success leads to further major commissions for religious paintings (see cat. 13–17).

1784 October: birth of the future Fernando VII.

 2 December: birth of Francisco Javier Pedro.

1785 18 March: appointed Assistant Director of Painting at the Academy of San Fernando.

 First commission for the future Duke and Duchess of Osuna (fig. 43).

1786 25 June: appointed Painter to the King.

 Autumn: presents sketches for tapestry cartoons for the dining-room of the Prince and Princess of Asturias (cat. 19–24), completed 1787.

1787 April: seven decorative canvases completed for the Osunas' country house (fig. 45, 46).

1788 May: working on sketches for tapestry cartoons to decorate the bedchamber of the Infantas (cat. 25–29); series abandoned on the death of Carlos III in December.

Carlos IV nominates Goya as Court Painter; he executes royal portraits, and works on his last series of tapestry cartoons (cat. 30, 31).

1791 Rise of Godoy, who becomes Duke of Alcudia and Protector of the Academy of San Fernando (cat. 60).

1792 14 October: Goya's report to the Academy on the teaching of art.

Falls ill in Madrid.

1793 January: obtains official leave of absence to go to Andalusia. Falls seriously ill in Seville and by March is in the care of Sebastian Martínez in Cadiz.

11 July: attends a meeting of the Academy in Madrid.

1794 5 January: eleven cabinet pictures, painted during Goya's convalescence, shown to the members of the Academy, who respond favourably; a twelfth, the *Yard with Lunatics*, is added to complete the series (cat. 32–43).

1795 Equestrian portrait of Godoy (cat. 61), portraits of the Duke and Duchess of Alba (fig. 8, see cat. 64, 65). Appointed Director of Painting at the Academy of San Fernando.

1796 Spends much of the year in Andalusia and visits the Duchess of Alba at Sanlúcar de Barrameda (fig. 9). Paintings for the Santa Cueva in Cadiz planned and perhaps executed (see cat. 51, 52).

1797 Working hard on the *Sueños* prints and drawings (fig. 31), that develop into *Los Caprichios*, published 1799.

November: Godoy appoints a liberal government that includes Jovellanos, Saavedra and Meléndez Valdés.

1798 March: Godoy temporarily removed from power and replaced by Saavedra.

6 June: six witchcraft pictures sold to the Osunas (cat. 44–9). Commission for fresco decoration of San Antonio de la Florida, Madrid (cat. 53, 54).

16 August: Jovellanos replaced by Caballero as Minister of Justice.

1799 6 January: *The Taking of Christ* (cat. 55) presented to the San Fernando academicians before its installation in the sacristy of Toledo Cathedral.

6 February: publication of *Los Caprichos* announced in the *Diario de Madrid*.

31 October: appointed First Court Painter: equestrian portraits of María Luisa and the king, the *Family of Carlos IV* (1800).

1803 Goya presents the plates and 240 unsold sets of *Los Caprichos* to the King, who grants Javier Goya a pension.

1805 8 July: Javier Goya marries Gumersinda de Goicoechea y Galarza, daughter of a Madrid merchant.

1806 11 July: birth of Pío Mariano, Goya's only grandson.

1808 French troops in Spain. Demonstration at Aranjuez against Godoy. Carlos IV abdicates in favour of Fernando VII.

April: Spanish royal family in Bayonne relinquish crown to Napoleon.

2 May: Madrid uprising against the French followed by executions of 3 May. Start of War of Independence.

June–August: first siege of Saragossa. Goya's visit to depict the heroic resistance (see cat. 91–3).

1810 Begins *The Disasters of War* series of etchings.

1811 19 March: awarded the Order of Spain by Joseph Bonaparte.

1812 19 March: adoption of the Constitution of Cadiz.

12 June: Goya's wife, Josefa dies.

1813 June: final defeat of French and flight of Joseph (José I).

1814 6 January: Council of Regency established in Madrid.

24 Feburary: Goya petitions Regency for a grant to paint the heroic scenes of *The Second* and *Third of May 1808* (Prado Museum).

1815 16 March: the Inquisition threatens to summon Goya on account of two 'obscene' paintings of a *Maja* (fig. 12).

1816 October: publication of *La Tauromaquia* etchings.

1817 Paints a large altarpiece for the sacristy of Seville Cathedral (see cat. 94).

1819 27 February: acquires the Quinta del Sordo, on the outskirts of Madrid.

27 August: altarpiece for the Escuelas Pías is unveiled.

Winter: survives a near-fatal illness.

November: inauguration of the Royal Prado Museum, with Goya's equestrian portraits of Carlos IV and María Luisa.

1820 Begins the Black Paintings on the walls of the Quinta (fig. 15). Working on the *Disparates* etchings.

9 March: Fernando VII forced to abide by Constitution of 1812, after General Riego's uprising.

1823 French troops restore Fernando to absolute power.

17 September: Goya gives the Quinta to Mariano.

30 September: Spanish Cortes surrenders to French at Cadiz.

13 November: Fernando VII enters Madrid, after imprisonment and execution of many Liberals.

1824 January–April: Goya in hiding.

1 May: general amnesty declared.

2 May: petitions the King to be allowed to travel to France for health reasons. Permission is granted on 30 May. Goya travels through Bayonne to Bordeaux, where he stays with his old friend Leandro Fernández de Moratín.

30 June: arrives in Paris; paints portraits of Joaquín María Ferrer and his wife, and a *Bullfight* (cat.112). Returns to Bordeaux, where he sets up home with Doña Leocadia Zorrilla and her daughter – probably his child.

Continues to paint, draw and make lithographs. Executes many miniatures during the winter (cat. 99–111).

1825 Publishes *The Bulls of Bordeaux* (cat. 115–18) series of lithographs.

1826 May–June: visits Madrid, his request to retire on a full pension is granted.

1827 Summer: final visit to Madrid.

1828 16 April: dies at 2 am; buried in Bordeaux beside Martín Miguel de Goicoechea. Exhumed in 1901, his remains were transferred to Madrid and finally interred in San Antonio de la Florida in 1929.

Italy and Spain: The Early Years

c.1770–1773

The catalogue of the Prado Museum published in 1828, the year of Goya's death in Bordeaux, included three of his works (see cat. 60) and a biographical note 'provided by [the artist] himself'. In fifteen short lines, Goya summed up his career and gave an account of his early training: 'He was a pupil of Don José Luzán in Saragossa, who taught him the principles of drawing by giving him the best prints in his collection to copy; he spent four years with him, and had begun to paint original compositions by the time he went to Rome; he has had no teacher other than his own observation of the celebrated artists and pictures in Rome and in Spain, from which he has gained the greatest advantage.'

Goya's son, Javier, also compiled biographical notes from which, in spite of possible inaccuracies, further details emerge: Goya studied drawing from the age of thirteen under Luzán's direction in the (then unofficial) Academy in Saragossa, 'and after having acquired some knowledge of painting in oils, he went to Rome where he studied, not as a scholar or someone supported by the Court of Madrid, of which there were several at that time, but with the application appropriate to one who was solely maintained by his family', adding that 'the blind devotion he always felt towards his parents prompted him to return home all the more speedily'.

While the date of Goya's departure for Italy is unknown, his return to Spain is documented by a letter concerning the repatriation of the picture that he had sent in April to a competition at the Academy of Fine Arts in Parma (cat. 1). Goya had already entered works, unsuccessfully, for competitions held by the Academy of San Fernando in Madrid in 1763 and 1766, and after the first of these, in which he obtained not a single vote from the jury, he may have remained in Madrid, studying with Francisco Bayeu, a highly competent artist working in the currently fashionable neo-classical style, who was assistant to the celebrated Court Painter Anton Raphael Mengs. The Bayeu and Goya families certainly knew each other in Saragossa, and in 1773, not long after his return from Italy, Goya married Josefa, one of the Bayeu sisters, in Madrid. Goya's relationship with Francisco Bayeu was always a difficult one, with the younger but infinitely more gifted artist chafing at his brother-in-law's position of authority and supervision of his work (see cat. 8, 9), but although he very rarely acknowledged his debt to Bayeu, he made judicious use of his relationship with this established Court artist, presenting himself in the Parma competition as the 'pupil of Signor Francisco Bayeu, Court Painter to His Catholic Majesty'.

Although it won no prize, Goya's entry in the Parma competition received a special mention, and in October 1771, soon after his return to Spain, he was commissioned to decorate a vault in the church of El Pilar in Saragossa (fig. 37, see cat. 2). His surviving early works are virtually all on religious themes (see cat. 2–6), and are full of allusions to the '*cuadros célebres de Roma*' seen and admired on his visit to Italy.

Fig. 59 Detail from *Hannibal* (cat. 1)

THE ITALIAN NOTEBOOK, *c.*1770–1785

A small notebook of fine Italian paper, stitched and bound into a parchment cover, has recently been acquired by the Museo del Prado (fig. 60). Its worn and much-handled binding still shows faint traces of the names *Goya* and *Zaragoza* written in pen and ink, which also recur sporadically throughout its pages, and it includes a wide variety of sketches and written notes. The origin of the Notebook is attested by the beautiful, strong paper with the star and anchor watermark and initial *F* of the famous paper manufacturer Fabriano, and with a bird and initial *N* that probably indicate the name of the actual papermaker.

On the very first page, Goya's handwriting – already strong and fully formed, with its individual characteristics and rhythms – is combined with a vigorous drawing of an allegorical figure, perhaps Minerva (fig. 61). This chalk drawing is retouched with pen and ink, and the surrounding notes include a reference to the number of popes – '*los Papas son 253. el año 1771*', and a list, written partly in shaky Italian, of various items, including '*estampas*' (prints) and artist's supplies.

This page is followed by figure studies, adaptations or copies of things seen in churches and collections, including copies after the Antique, as well as works of imagination, drawn in a variety of media: black and red chalk, and pen and iron-gall ink. The handling is spirited and confident, free yet precise, and in spite of a certain orthodoxy in the shading – acquired, no doubt, through copying engravings in Luzán's studio in Saragossa – and some uncertainties in the modelling of complex passages, Goya's remarkable ability to inscribe

The Italian Notebook,
c. 1770–85
(figs. 38, 60–69, 72, 75, 81, 84, 86, 102, 148)
Parchment binding 19.5 × 13.5 cm, with 83 extant pages 18.6 × 12.8 cm
Drawings and annotations in pen and ink, red and black chalk
Museo del Prado, Madrid

Fig. 60 Goya's 'Italian Notebook'

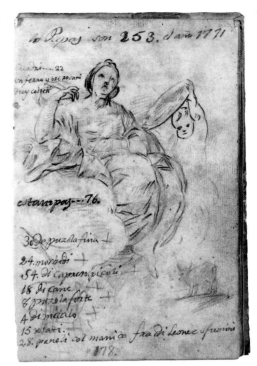

Fig. 61 Goya's 'Italian Notebook',
page 1 recto

an outline that gives life to the form within it (fig. 64, 66), and to evoke the solidity and energy of a figure (fig. 63), is already evident.

The Notebook contains drawings for several works long attributed to Goya (cat. 4–6), and has served as the basis for the selection of early paintings presented here. Thanks to the emergence of this hitherto unknown document, it is now possible to reconstruct Goya's early career and assess his work on the basis of incontrovertible stylistic evidence. The Notebook (published in a facsimile edition in 1994), shows Goya's range of interests, and even lists the places he visited in Italy; when studied in detail, it will reveal more about the the artistic affinities that are reflected throughout his later work.

The Notebook was evidently used for artis-tic purposes until some time in the mid- to late 1770s, although Goya turned to it from time to time, even years later, for inspiration (see cat. 38, 92). Thereafter it continued to serve as a repository for important personal records. The baptisms of all save his youngest child, Javier, are recorded, including a first, hitherto unknown, son born in Saragossa on 29 August 1774, whose godfather was Carlos Salas, the sculptor who worked in El Pilar (fig. 68). Other pages record his wedding – 'on 25 July 1773, and it was a Sunday' (fig. 67) – and the family's departure for Madrid on 3 January 1775 (fig. 65). It is not known when the Notebook left Goya's hands, or those of his family, and since it was never referred to in documents or in any related literature, its existence remained unsuspected until very recently.

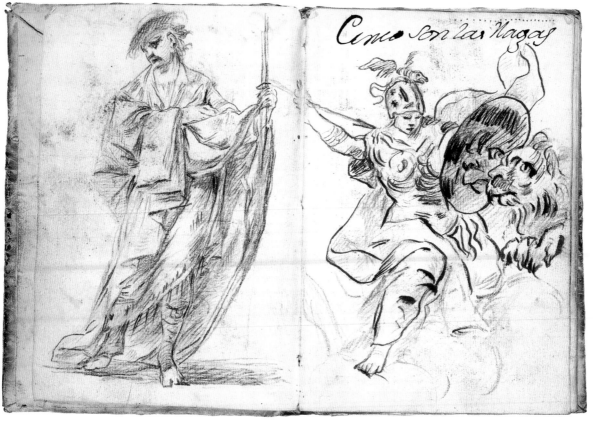

Fig. 62 Goya's 'Italian Notebook'
pages 1 verso, 2 recto

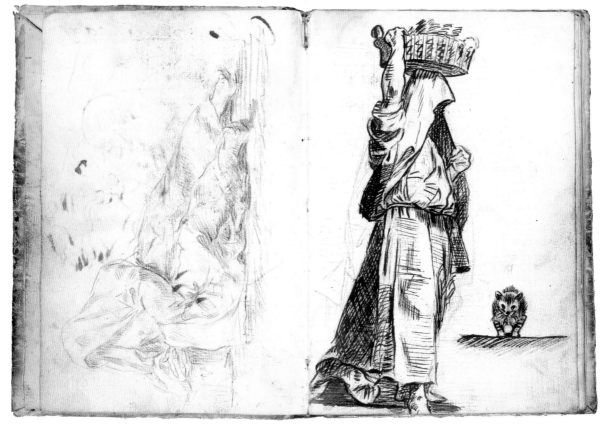

Fig. 63 Goya's 'Italian Notebook'
pages 2 verso, 3 recto

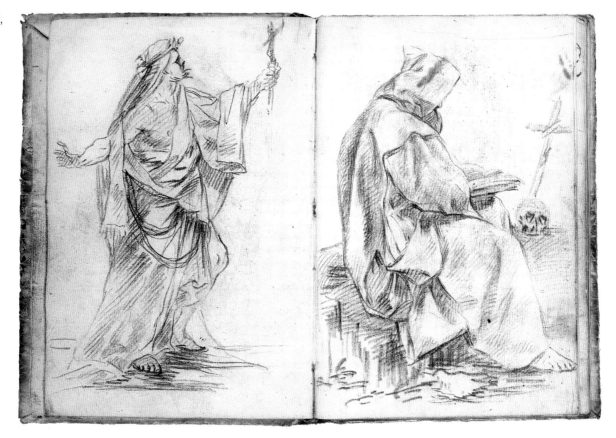

Fig. 64 Goya's 'Italian Notebook',
pages 6 verso, 7 recto

Fig. 65 Goya's 'Italian Notebook',
pages 20 verso, 21 recto

Fig. 66 Goya's 'Italian Notebook'
pages 26 verso, 27 recto

Fig. 67 Goya's 'Italian Notebook'
pages 41 verso, 42 recto

fig. 68 Goya's 'Italian Notebook', pages 53 verso, 54 recto

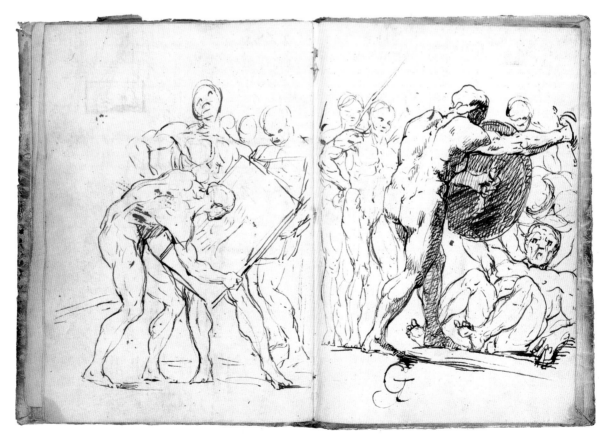

fig. 69 Goya's 'Italian Notebook', pages 79 verso, 80 recto

THE PARMA ACADEMY COMPETITION, 1771

In May 1770, the Academy of Fine Arts in Parma announced the subject of its painting competition to be held the following year. The theme was Hannibal's triumphant arrival on the Alpine slopes of Italy, and the Academy laid down the details of the picture to be painted by the competitors: 'Hannibal should be shown raising the visor of his helmet and turning towards a Genius, who takes him by the hand as he points towards the beautiful lands of Italy in the distance, expressing with his eyes and whole bearing his inner joy and noble confidence in the victories to come'. This was a homage to the late Abate Frugoni, poet and first Secretary of the Academy, for the subject was inspired by one of his sonnets.

Goya evidently wrote to the Academy announcing his intention to participate in the competition, and a further letter, dated Rome, 20 April 1771, was addressed to Count Rezzonico, the Academy's Permanent Secretary. In it Goya stated that he was writing 'further to inform you that my painting has been handed in to the Post in order that it should reach your hands. The device with which I have distinguished it, according to the Academy's rules, is a verse from Virgil's *Aeneid*, in Book Six, which reads *And finally we reach the shores of fugitive Italy*' (fig. 70). Comparison with Goya's handwriting, whether in the Italian Notebook or in other documents, and the 'Italianate' spelling of his name (with a *j* instead of a *y*), suggest that this letter is perhaps not in his own hand, and raises the interesting possibility that Goya left Rome as soon as his painting was finished, and before it was sent on to Parma. This would have given him the opportunity to visit as many places in Italy as possible in the time left to him, since his 'blind devotion...towards his parents prompted him to return home all the more speedily', according to his son's later account.

The circumstances of Goya's visit to Italy are still veiled in mystery. In 1826 (in his formal

Ferocemente la visiera bruna
Alzò sull'Alpe l'African Guerriero
Cui la vittrice militar fortuna
Splendea negli atti del sembiante altero.

Rimirò Italia, e qual chi in petto aduna
Il giurato sull'ara odio primiero
Maligno rise, non credendo alcuna
Parte secura del nimico Impero.

Indi col forte immaginar rivolto
Alle venture memorande imprese,
Tacito, e tutto in suoi pensier raccolto,

Seguendo il Genio, che per man lo prese,
Coll'ire ultrici, e le minacce in volto,
Terror d'Ausonia, e del Tarpeo discese.
(Abbot Frugoni, died 1770)

Fig. 70 A letter from Goya to Count Rezzonico, dated Rome, 20 April 1771 Academy of Fine Arts, Parma

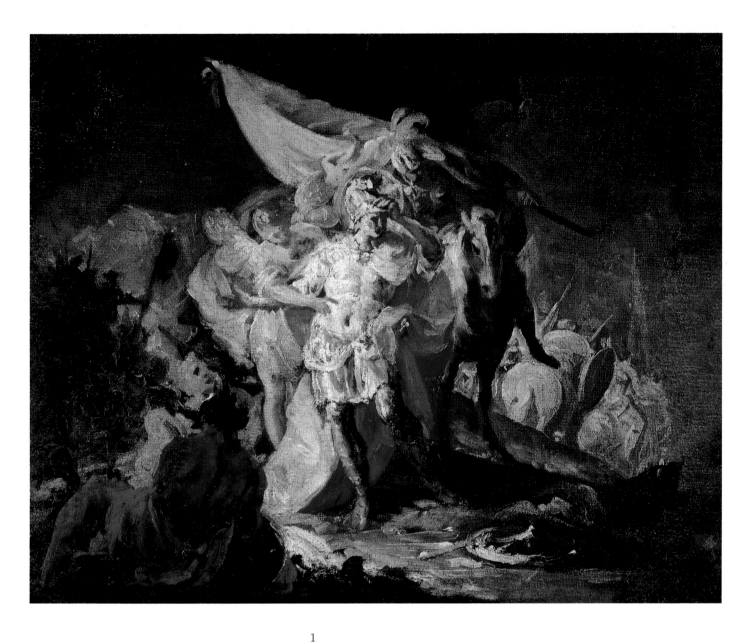

1
Sketch for *Hannibal the Conqueror, Viewing Italy for the First Time from the Alps*,
1771
oil on canvas, 30.6 × 38.5 cm
Private Collection, Madrid

request to retire as Court Painter), Goya himself stated that 'Mengs asked me to return from Rome', and it is possible that he was then in contact with Mengs, the artist whom, back in 1761, Carlos III had called to Madrid to be his principal Court Painter, along with Tiepolo. Mengs had left Spain in 1769, arriving back in Rome early in 1771, and returned to Madrid in 1774. Perhaps more pertinently, after Giambattista Tiepolo's death in Madrid in March 1770, his son Domenico, with whom Goya was certainly in close contact, returned to Venice that same year, and it is not impossible that Goya may have travelled with him, at least as far as Genoa. That Rome was Goya's goal and principal place of stay in Italy there is no doubt, to the extent that he was qualified as 'Romano' in the Academy's report on the competition in Parma, and always insisted on the importance of his visit to Rome in subsequent letters and biographical notes. It appears that Goya stayed in Rome as a guest of the Polish artist Taddeus Kuntz, in an apartment in the Palazzo Tomati on Strada Felice, now via Sistina, where Piranesi was also living, near Trinità de' Monti. If further information emerges about the circumstances of Goya's stay there, it may be possible to assess more precisely the influences that shaped the one composition he is known to have painted in Rome.

Goya's recently rediscovered competition picture, not seen since it was sent from Parma back to Spain, more than 220 years ago, was clearly prepared with all possible care and due attention to the Academy's guidelines. Goya must have researched the historical background to the given theme, and consulted classical authors, relevant examples of Antique sculpture and more recent sources, such as Cesare Ripa's *Iconologia*, in order to prepare his picture. No fewer than four pages of the Italian Notebook are devoted to composition sketches and studies for the painting, and these confirm the authenticity of the damaged, but now carefully restored, sketch whose initial identification and publication in 1984 were greeted with considerable scepticism.

Comparison of the oil sketch and the principal composition study in red chalk (fig. 72) shows that Goya originally formulated his picture in a vertical format, designed in the shape of a St Andrew's Cross, with the banner, high above the figure of Hannibal, pointing to the skies top-left, and balanced by the diagonal rising from the reclining river god at lower-left to the outline of the Alps, over which the Carthaginian leader had marched with his army. However, the size and format of the competition canvas was dictated by the Academy, and Goya was bound to employ a

Fig. 71 *Apollo Belvedere*, Roman copy, early 2nd century AD, after a Greek original, marble, 224 cm high Vatican Museums, Rome

Fig. 72 Goya's 'Italian Notebook', pages 15 verso, 16 recto, 1771
Museo del Prado, Madrid

landscape format measuring 88 × 142 cm: thus, the chalk drawing's horizontal lines that cut across the banner and the right-hand peak and the ground beneath the figures alter the format of the drawing, anticipating that of the oil sketch. As it turned out, the competition was actually won by Paolo Borroni, with a composition in which Hannibal and the winged Genius appear in the middle distance, seen from behind. The commentary at the official prize-giving gave Borroni's picture rather cool praise, and went on to refer in warmer terms to Goya's painting: 'The Picture which was countersigned with a line from Virgil, "And finally we reach the shores of fugitive Italy", received six votes. The jury appreciated the fluent handling of the brush,

the warmth of expression in Hannibal's countenance and the grandiose character of his whole demeanour, and if the colouring had been truer to life and the composition had followed the set theme more closely, it would have raised doubts about the award of the palm carried off by the winner'.

The scene, in fact, follows the Academy's dictates very closely. Hannibal's pose is one of elegant arrest, apparently inspired by that of the *Apollo Belvedere* (fig. 71), but with a more pronounced *contrapposto* movement as Hannibal steps forward on the sloping ground, raises his visor and gazes down on the plains of Lombardy that the winged Genius points out to him. Hannibal's right hand is extended in a gesture of wonder, while his standard-bearer,

astride a long-suffering mount, leans towards him to catch a glimpse of the view, the great banner now dipped to conform with the new format, and a shield forming a 'halo' behind Hannibal's head. Soldiers on horseback are seen moving away down the slopes to the right, while in the distance on the left there is the suggestion of a cavalry skirmish, with swords raised and banners flying. In the foreground, acting as a dark *repoussoir* for the composition, an allegorical figure of the River Po – with a horned bull's head, just as he appears in Ripa's illustration of *Lombardia* (fig. 73) – reclines on his water-jar, the source from which the River flows. His dark, reddish form sets off the blond figure of a vanquished barbarian who gazes up at the conquering hero, while on the ground to the right lie a barbarian shield and banner.

On another page in the Notebook (fig. 75), Goya twice sketched the figure of Hannibal in red chalk, and then retouched one in pen and ink, completing his costume of plumed helmet, greaves and voluminous cloak. On the facing page is a study of Roman armour,

probably sketched from an Antique trophy (see fig. 74). The figures and armour, and the rhythms of their grouping in the oil sketch, suggest study of classical models such as the reliefs on the Arch of Constantine in Rome, and carved sarcophagi. Other drawings in the Notebook also reveal Goya's feeling for the energy of figures in movement or suspended animation, and his grasp of anatomy and gesture (figs. 62, 65, 69), and the precision and clarity of the forms, indicate his interest in Antique sculpture.

The recent restoration of the oil sketch has revealed the brio of Goya's handling, and although the vivid effect of the touches of impasto is no longer what it was, especially on the figure of Hannibal (who should stand out almost literally in relief) as the protagonist, much of the picture's strength and delicacy has been recovered. Swift, sure brushstrokes are apparent everywhere, particularly in the heads and hands and in the impasto touches along the outlines of Hannibal's raised arm, and in spite of the over-pronounced texture of the canvas, the modelling can be seen to be subtle

Fig. 73 *Victory, with Trophies and a Defeated Barbarian*, Roman marble relief Boboli Gardens, Florence

LOMBARDIA

Fig. 74 '*Lombardia*', an allegorical figure from Cesare Ripa's *Nova Iconologia*, Padua, 1618

Fig. 75 Goya's 'Italian Notebook',
pages 18 verso, 19 recto, 1771
Museo del Prado, Madrid

and firm. Even from this sketch, which Goya painted simply as a guide for himself, one could deduce the effect now seen in the larger competition picture. The style is very close to that of Goya's *St Barbara* (cat. 6), where a majestic figure standing firmly on the ground is set off by billowing draperies handled, as in the rediscovered *Hannibal*, to marvellous effect, with highlights on the folds leading the eye to the most significant parts of the composition. The horsemen and banners, and the raised arm with a dagger, in the *St Barbara*, and even the foreground with its suggestion of a steeply sloping landscape, establish a relationship so close to the Parma picture that it may have been painted immediately on Goya's return to Spain.

The competition picture was, in fact, sent back to Spain from Parma in circumstances that provide an intriguing introduction to Goya's own return home. The correspon-dence of the Marquis du Tillot (first referred to in 1928, but without quoting from the documents), the First Minister of Parma and Director of its Academy, shows that he arranged for the shipment of Goya's painting back to Spain in the second half of 1771, but had to halt the crate in Genoa and change the destination address from Valencia to Saragossa, since the artist had meanwhile returned to the latter city. This raises the question why Goya had first wanted his picture to be returned to Valencia. Did he himself return there, rather than 'more speedily' rejoin his parents in Saragossa, because of a commission arranged in Italy? Or had he arranged to present his competition picture at the Academy of San Carlos in Valencia? At all events, the first certain news of Goya's return to Spain was the commission, in October that year, to paint sketches for the fresco decoration of a vault in the basilica of El Pilar (cat. 2).

Paintings on Religious Themes

1771–1775

*D*uring the period that began with his return to Spain in the summer of 1771 and ended with his departure for Madrid early in 1775 to work for the Royal Tapestry Factory, Goya's activity is principally documented in Saragossa. From October 1771 until July of the following year he was working on the preparatory sketch and the frescoes of the *coreto* (little choir) in the basilica of El Pilar (cat. 2). Shortly after the completion of this major project, he made an offer to the Building Committee to paint the adjoining ceilings, in a letter written in 'Saragossa on 22 November 1772', in which he describes himself as 'Professor of Painting [i.e., a practising artist] in this City'.

In 1773 Goya married the sister of Francisco Bayeu, in whose Madrid studio he had worked before travelling to Italy. The parish register records his wedding to María Josefa Bayeu in the church of Santa María, Madrid, on 25 July 1773, and five months later he recorded this event in a page of the Italian Notebook: 'I was married on the twenty-fifth of July in the year 1773. And it was a Sunday. Today is 15 December' (fig. 67). The couple returned to live in Saragossa, where their first child, a son, was born on 29 August 1774. The baptism of Antonio Juan Ramón Carlos that same day in the parish church of San Miguel de los Navarros is recorded both in the parish register and once again in the Italian Notebook, where the names of the couple's other children also appear (fig. 68). The fact that the godfather of this son and heir was Carlos Salas, the sculptor who supervised the stucco decoration for El Pilar, suggests a close connection between him and Goya's family, probably reflecting professional relationships and ties of friendship with Goya's father, a master gilder who would have worked with Salas in churches in and around Saragossa.

By the time of his first child's birth in August 1774, Goya had completed his remarkable series of eleven scenes from the life of the Virgin, painted in oils on the walls of the church in the monastery known as the Aula Dei Charterhouse, just to the north of Saragossa. After the infinite, celestial spaces painted *al fresco* on the vault of the little choir in El Pilar (fig. 37, cat. 2), the Aula Dei murals are conceived as monumental reliefs, with friezes of figures and groups of figures standing on steps or terraces (fig. 88). They are spaced along the walls, above the choir-stalls that line the church interior, and for those fortunate enough to have seen them their effect is extraordinarily impressive.

In these paintings, as in the *St Barbara* (cat. 6), Goya drew on his experience of classical art in Rome and the 16th- and 17th-century Italian artists whose work most closely reflects this monumental, classicizing tendency. Another example of Goya's close study of both Antique and contemporary sculpture in Italy is the *Baptism of Christ* (cat. 3), while two devotional pictures (cat. 4, 5), probably painted for his parents, and sketched on facing pages of the Italian Notebook (fig. 84), are less sophisticated in conception and more closely related to the work of his master, José Luzán, and to Goya's lost paintings on the reliquary in the church at Fuendetodos (fig. 50, 51). These smaller works cannot be dated with precision, but were probably all painted before Goya and his family left Saragossa for Madrid in 1775.

Fig. 76 Detail from the *Gloria* (cat. 2)

CHOIR OF THE BASILICA OF EL PILAR, SARAGOSSA
1771–1772

Fig. 77 *Head of an Angel*, 1772
red chalk, 43.5 × 34 cm
Museo del Prado

Goya returned to Saragossa after his experiences in Italy and succeeded in carrying off a major commission almost immediately. The Building Committee for the Reconstruction of El Pilar, in its session of 21 October 1771, recorded that 'Goya is to make sketches for the painting of the vault of the *coreto* (little choir), corresponding with the area indicated on Don Ventura's drawing, and if they are approved by the Royal Academy, terms will be agreed'. This decorative project formed part of the plans to remodel the huge 17th-century basilica that incorporated the miraculous Pillar that had remained on the same spot, beside the River Ebro, since the traditional date of the Virgin's appearance to St James the Great (see cat. 4, 10). The primitive chapel built to protect the Pillar and the image of the Virgin was replaced in time by more elaborate constructions: a

Romanesque, then a Gothic-Mudéjar church, and finally the 17th-century temple whose plans and decoration were revised by Francisco de Herrera the Younger; and then, in the 18th century, Ventura Rodríguez gave the building its neo-classical appearance.

The church of El Pilar is a vast space regulated by weighty but simple architectural elements. Four cupolas are clustered around the central dome, painted in fresco by Antonio González Velázquez in 1752–3, before the construction of Ventura Rodríguez's magnificent chapel of the Virgin that virtually fills the space below. The choir faces the chapel of the Virgin, in the centre of the east end that Ventura Rodríguez had originally intended as the principal entrance to the church but which was finally made into a small choir for liturgical purposes. This was the area for which Goya

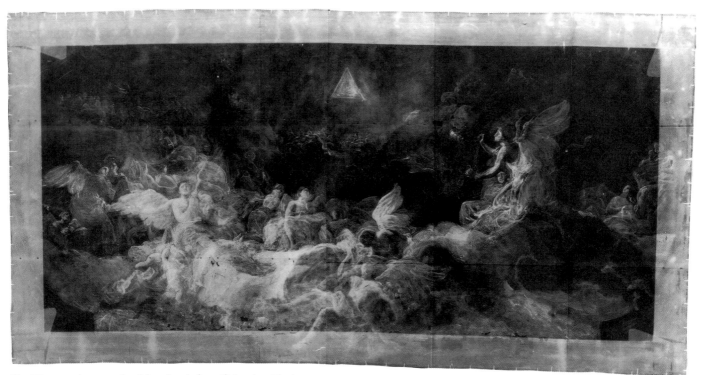

Fig. 78 x-ray photograph of the sketch (cat. 2) for the *Gloria*

Fig. 79 *Head of an Angel*, 1772
red chalk, formerly
Carderara Collection, Madrid

Fig. 80 *Head of an Angel*, 1772
red chalk, 46.5 × 35 cm
Musée du Louvre, Paris

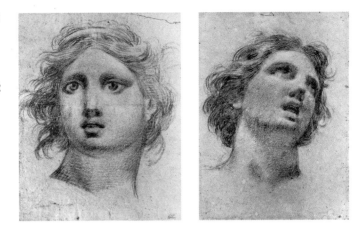

was invited by the Committee to provide sketches for a fresco decoration. Three weeks later, on 11 November 1771, the Committee was informed that Goya 'has done a painting in fresco as a sample, and as proof that he is experienced in this technique, and it has met with the approval of expert opinion'. The Administrator went on to report that Goya was prepared to undertake the fresco for 15,000 *reales*, including the expenses of a labourer and materials, whereas Antonio González Velázquez was asking 25,000 *reales*. The Committee therefore decided that it would 'accept Goya's proposal, but in order to follow correct, sure procedure, he must make several sketches representing the *Gloria* and send them to the Academy in Madrid for approval; and when that has been obtained, terms will be agreed and the contract signed'.

Goya went to work on his sketches, or more probably on his one large sketch, since the x-ray image of the canvas (fig. 78) reveals a large number of major alterations, many of which are also partially visible to the naked eye. The long, rectangular surface of the ceiling, with rounded and slightly curved ends, is high above the floor of the choir. Goya was therefore faced with the need to paint a *Gloria* that would be legible from the ground and that could incorporate a sense of infinite space

within the relatively narrow area between the exterior wall, with its window, and the stuccoed arch that separates the choir's vault from adjoining ones.

The x-ray shows that Goya's original design included three additional large figures in the foreground, whose outlines can still be seen beneath the overpainting on the canvas. Whether he made preparatory drawings and smaller sketches is unknown, but he evidently worked out the composition directly on this canvas, painting and repainting until he was satisfied with the result. The elimination of the large figures that had created an almost unbroken chain across the foreground opened up the vista, so that the spectator's eye is led into limitless space, with the angels in pairs or groups, disposed on their clouds in such a way that they recede in ever more golden tones towards the glowing symbolic triangle on which lines, gestures and gazes converge. The spectacular x-ray image confirms the brio and freedom with which Goya painted his picture, but it also reveals very clearly his difficulties in working out the composition.

The choir below was equipped with an organ and choir-stalls, and Goya's angels in glory hold sheets of music as they sing or play on a variety of instruments: violins, lutes and a

horn. The music-making groups extend back into the golden aura, delicately painted, and rendered in natural, individualised poses. The colour scheme is dominated by the golden yellow light, with vivid red and blue accents that underline the central presence of the Name of God in the triangle, which in the sketch remains unlettered.

The structure of Goya's composition is not unlike that of González Velázquez's earlier sketch for the part of his cupola showing the *Apparition of the Virgin of the Pillar* (his sketches had remained with the Chapter since they were painted). It shows the earthly and heavenly realms linked together, with the Virgin descending on a cloud towards St James. Although the earthly sphere is not visible in Goya's *Gloria*, the heads that appear below the dark clouds, near the lower edge of the sketch, and in the fresco, suggest that the scene is viewed from the ground, not somewhere in the sky, while his impressively classical angels, for which he made red-chalk studies (figs. 78–80), and his solid little *angelitos* (baby angels), all of them modelled with vivid touches of colour, look forward to the saints and martyrs he was to paint a decade later in one of the cupolas (see cat. 8, 9).

On 27 January 1772, Goya presented his sketch, of which it was stated that 'the members were already aware that it was well executed and in particularly good taste; it was approved by the Committee, and in spite of the decision in the previous meeting that it should be submitted to the Royal Academy for approval, they decreed that work should start immediately'. The contract was signed the following day, and on 31 January Goya received an initial payment. The final payment was made on 31 July 1772, and with this fresco Goya established his reputation as an artist well able to handle large-scale decorative works.

The frescoed vault in El Pilar, Saragossa (see fig. 37)

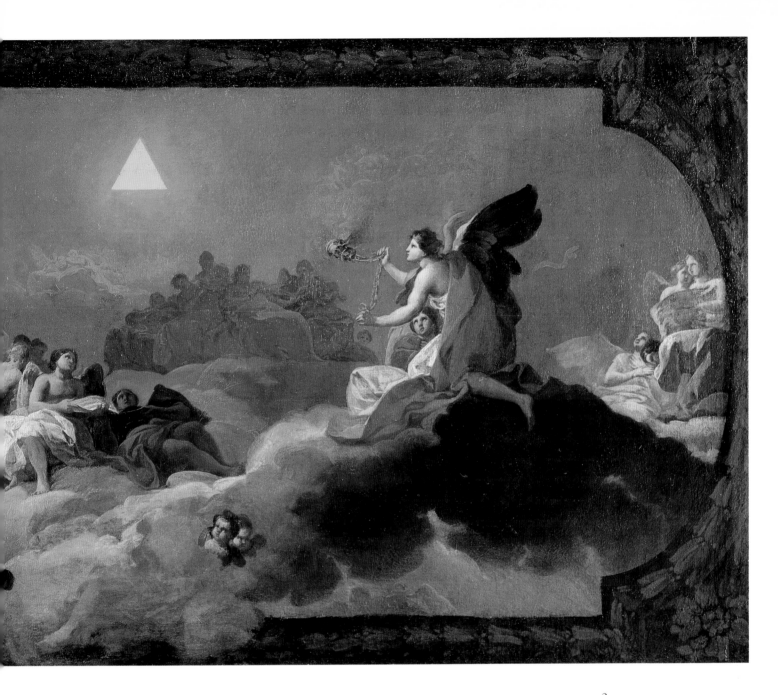

2
Sketch for the *Gloria*, 1771–2
oil on canvas, 76 × 151 cm
Private Collection, Barcelona

SCENE FROM THE LIFE OF CHRIST, *c.* 1771–1775

This small devotional picture belonged to Don Juan Martín de Goicoechea, the friend of Martín Zapater and Goya in Saragossa. Its references to Antique and Italian Renaissance art are so strong that it may even have been sent by Goya to Spain from Italy, a possibility supported by the fact that the figure of Christ is very closely related to a drawing near the beginning of the Italian Notebook (fig. 81). However, it was more probably painted on Goya's return to Saragossa and given as a mark of esteem for his friend or in gratitude for favours received.

St Mark's account of the Baptism describes how 'Jesus came from Nazareth of Galilee, and was baptised by John in the Jordan. And when he came up out of the water, immediately he saw the heavens opened and the Spirit descending upon him like a dove; and a voice came from heaven, "Thou art my beloved Son; with thee I am well pleased"'. Goya's representation of the *Baptism* enshrines all these elements at once: Jesus moves forward into the Jordan's shallows and St John pours water onto his bowed head, while the Holy Spirit illuminates the mystery of this act through the strong shaft of light emanating from the dove's beak. The perfection of the semi-nude bodies recalls Italian Renaissance versions of the Baptism that served as a pretext for studies of ideal male figures. However, Goya's composition is much more closely in tune with the spirit of the Counter-Reformation, emphasising the spiritual, sacramental nature of the scene, in which the humility of Christ is here an essential element.

An earlier idea for the composition, revealed by the x-ray image of the canvas (fig. 82), includes Christ kneeling before St John with his hands clasped in front of him, in a relationship that recalls that of the figures in Algardi's celebrated sculpture of the *Beheading of St Paul* behind the main altar of the church of S. Paolo Maggiore in Bologna (fig. 83), and anticipates that of the Virgin and the angel of the Annunciation in Goya's own later paintings (see fig. 42, cat. 14). The figures are also markedly influenced by Antique sculpture in the chiselled purity of their forms, and besides revealing the changes in the composition, the x-ray also draws attention to the precision of Goya's brushwork and the way in which forms are modelled with light that catches the outlines of hands or legs or Christ's ear.

In the work's almost atemporal setting, with just a hint of water, rocks and vegetation, the dove emerges with naturalistic clarity from the golden heavens, discharging an unearthly light whose focused beam shapes the compositional idea, while its diffused effects model the sensitively observed forms of the figures and their draperies. The quiet but profound spirituality of this encounter by Christ and the Baptist parallels that of Joseph's relationship with Mary and the Christ-child in Goya's earliest etching (fig. 53), and is full of the intense emotions and calm classicism that pervade the great Aula Dei cycle of 1774 on the Life of the Virgin (fig. 88).

Fig. 81 Goya's 'Italian Notebook' page 12 recto

Fig. 82 x-ray photograph of *The Baptism of Christ* (cat. 3)

Fig. 83 Alessandro Algardi, *The Beheading of St Paul*, 1641–7, marble, 282 cm high S. Paolo Maggiore, Bologna

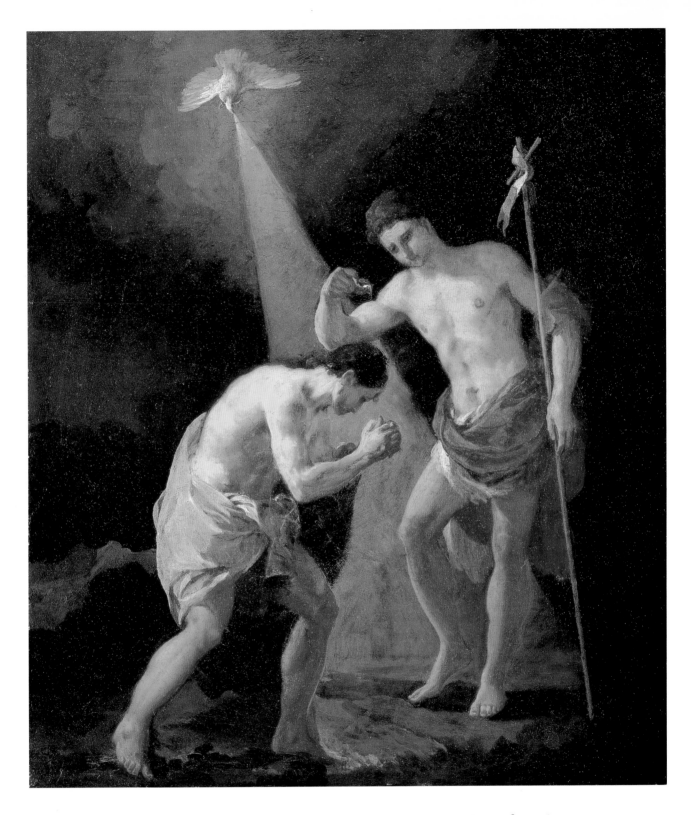

3
The Baptism of Christ, c. 1771–5
oil on canvas, 45.4 × 39.4 cm
Count Orgaz, Madrid

TWO DEVOTIONAL PICTURES, *c.* 1771–1775

On two facing pages of his Italian Notebook, Goya lightly sketched in black chalk his ideas for a pair of compositions (fig. 84). On the left a 'Virgin of the Pillar', with the Virgin, in glory, surrounded by little angels, and on the right-hand page a saint gazing at the crucifix held in his hand and reclining beneath a leafy bower that identifies him as the Jesuit St Francis Xavier. The sketches correspond with the pair of paintings (cat. 4, 5) whose acquisition was discussed at a Committee meeting held on 11 April 1926 in the Academy of St Luke in Saragossa. The Minutes of this meeting refer to 'two sketches whose provenance is known to be the family of the celebrated Don Francisco Goya y Lucientes…and whose colouring and draughtsmanship, whose demonstrable strokes of genius, whose bold-

ness and very faults, and even whose state of conservation, suggest to us that they are two estimable works by the Aragonese artist; and although their value represents a sacrifice for the Academy, we believe that it should find the means to acquire them, thereby demonstrating its admiration in homage to the undying glory of the Painter from Fuendetodos'.

The two paintings acquired by the Academy from Doña Francisca Lucientes were no doubt painted by Goya for his parents, probably soon after his return from Italy in the summer of 1771, to judge from the simplicity of their style. The first represents the image of the Virgin that is preserved in the Santa Capilla (Holy Chapel) in El Pilar, a tiny statue of carved, unpainted wood on a column of semi-precious stone, to whom the faithful pray

Fig. 84 Goya's 'Italian Notebook', pages 64 verso, 65 recto

Fig. 85 *The Death of St Francis Xavier*, engraving after the painting by L. Giminiani, published in P. Crozat's *Recueil*, Paris, 1729 Biblioteca Nacional, Madrid

before going to kiss the miraculous column through a special window at the rear of Ventura Rodríguez's chapel. Although in Goya's rendition, the graceful, but rather squat, Early Gothic carving of the Virgin has been elongated and made to coincide with the width of the pillar, it is evident that he studied the figure carefully, since he reproduces the way the Virgin holds the Christ-child and the folds of her cloak, while the Child's gestures are also conveyed with precision. The sketch in the Notebook shows many more young angels playing on clouds around the Virgin and Child. In the painting, they are reduced to three *angelitos* with absurdly small, butterfly wings, like those in the sketch for the choir (cat. 2). They hover in front of the Pillar, holding red and blue draperies, and are set off against rich brownish clouds, while cherubim surround the *gloria* against which the Virgin is silhouetted. The effect is both natural and naive, and Goya's intention was evidently to produce a devotional picture that had the directness and simplicity of a popular print.

The *Death of St Francis Xavier* is a more sophisticated but still traditional composition whose iconography was well-established (see fig. 85). The most outstanding of the Jesuit saints after Ignatius Loyola, St Francis was canonised in 1622. He was the Order's great missionary, apostle to the Indies and Japan, in the course of which he met his death: abandoned by the Portuguese, he was left by a merchant ship on an island off the coast of China, where he died in 1552 under a shelter of boughs and foliage, holding the crucifix he had received from Ignatius. In his summary black-chalk sketch (fig. 84), Goya shows St Francis turning on his side in order to gaze on his crucifix. In the painting, however, he lies on his back and looks up in the direction of one of two *angelitos* that hover over the roof of the hut, and who indicates the *gloria* to which the Saint's soul will rise, while beyond can be glimpsed sea and ships.

The canvas, which has suffered considerably, is nevertheless impressive for the simplified, schematic construction of its elements. The rich red ground is used to great effect, and Goya built his almost abstract forms with colour and impasted touches of light. The powerfully modelled head, with its serene and trusting expression, remains largely intact, and the strong hands that grasp the crucifix recall those of St Francis of Paola on the right-hand door-panel of the Fuendetodos reliquary (fig. 51). But while the general effect is of a strongly, simply constructed image, the brushstrokes that describe the foliage on the roof of the hut are as soft and subtle as those on the costume of St Barbara (cat. 6).

The dates of these early canvases are difficult to determine, given that Goya undoubtedly modified his style to suit his particular purpose in painting them, but they nevertheless reveal a striking unity, from his earliest attributed work on the reliquary to the documented choir fresco and the Aula Dei murals that span the first half of the 1770s.

4
The Virgin of the Pillar,
c. 1771–5
oil on canvas, 56 × 42.5 cm
Museo de Zaragoza, Saragossa

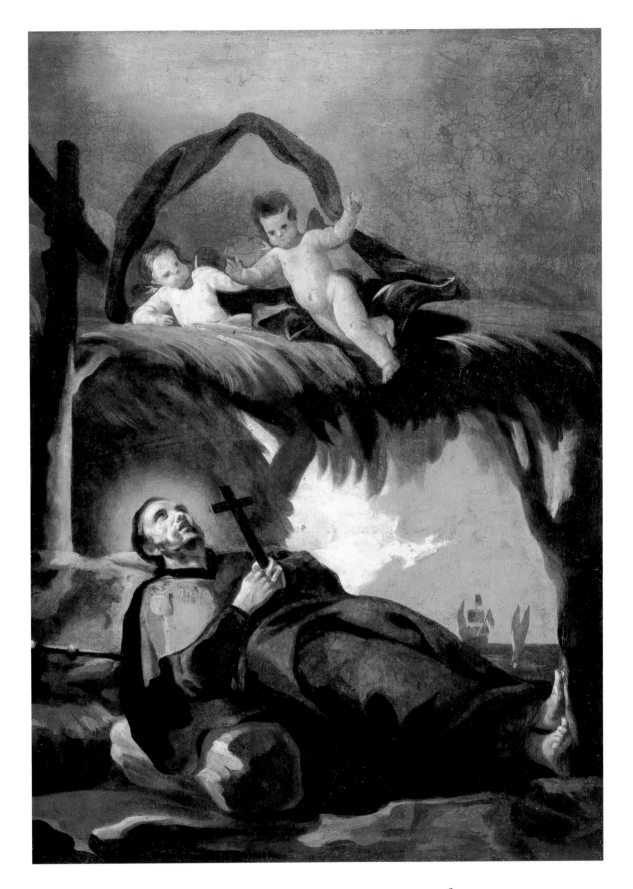

5
The Death of St Francis Xavier,
c. 1771–5
oil on canvas, 56.5 × 42.2 cm
Museo de Zaragoza, Saragossa

A SAINT AND MARTYR, *c.* 1771–1775

Goya's impressive *St Barbara* is painted in the classicising style of the murals in the Aula Dei Charterhouse (fig. 88). These were completed by the end of 1774, and Goya recorded his departure, with his family, from Saragossa on 3 January 1775, and their arrival in Madrid a week later (fig. 65). He moved to Madrid in order to work for the Royal Tapestry Factory of Santa Barbara, and it is not impossible that this image of the Saint was in some way connected with the new phase of his career. Nothing is known of the painting's early history, but it shows strong stylistic links both with the Parma competition picture of 1771 (cat. 1) and with the Aula Dei murals of three years later, and could have been painted at any time during this period.

St Barbara, a legendary saint from Asia Minor who became popular throughout Europe, was said to be the daughter of a pagan nobleman named Dioscorus. He protected her virtue and shielded her from contact with the Christian religion by building a tower in which she had to live. She nevertheless became an ardent convert and made her convictions known by piercing a third window, to symbolise the Trinity, in her tower. She escaped from her angry father, who pursued and denounced her. Dragged before a Roman judge, she was tortured and condemned to death by decapitation. The sentence was carried out by her own father on the summit of a mountain, and divine retribution came in the form of the lightning that killed him as he returned home. In Spain, St Barbara is invoked as protection against thunder and lightning, and against sudden death and the danger of dying without the sacraments.

Goya has compressed all these elements within the harmonious oval of his composition, placing the Saint on a prominence, with her attribute of the monstrance with the Host,

Fig. 86 Goya's 'Italian Notebook', page 29 recto

Fig. 87 *Cesi Juno*, Hellenistic copy, before BC 150, of a Pergamene original
marble, 228 cm high
Capitoline Museum, Rome

Fig. 88 Detail from *The Betrothal of the Virgin*, 1774, mural, Charterhouse of Aula Dei, Saragossa

as well as her martyr's crown and palm. In the background to the right looms her crenellated tower, against which the scene of the martyrdom appears, with her father raising a flashing blue blade and a jagged ribbon of lightning already appearing from an angry red cloud. To the left, horsemen and banners similar to those of Hannibal's army (cat. 1) may represent the Roman troops present at her execution, while also symbolising St Barbara's patronage of soldiers and armourers. She appears in the form of a sketch in the Italian Notebook, on the page that faces Goya's note of his wedding in July 1773 (fig. 67), and the figure is clearly related to antique sculptures, such as the *Cesi Juno* (fig. 87), admired by Michelangelo as 'the most beautiful thing there is in all of Rome', and copied by Goya on another page of the Notebook (fig. 86). In the painting, the Saint stands out against a very dark background, with a remarkable sense of movement in her pose, as if the monstrance were drawing her forward. Diagonal rhythms lead the eye from her feet through the folds of her splendid, billowing garments, to the palm and monstrance grasped firmly in her hands and thence to the beautiful head half-turned to greet the beholder.

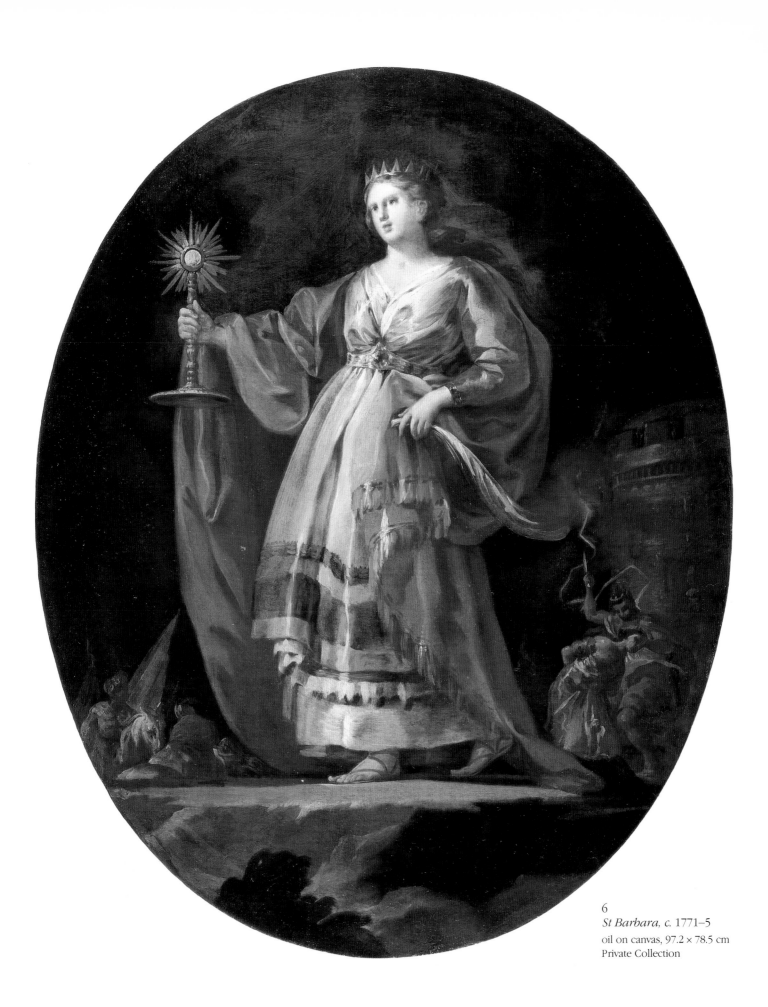

6
St Barbara, c. 1771–5
oil on canvas, 97.2 × 78.5 cm
Private Collection

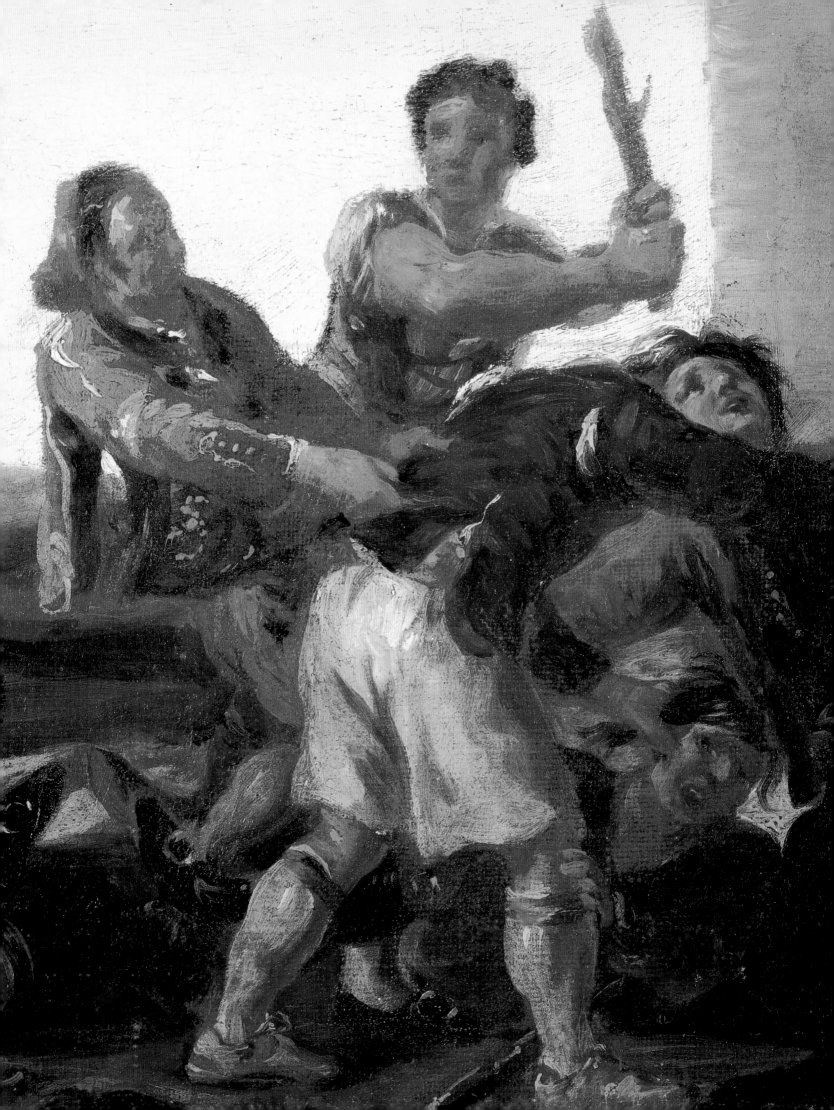

The Royal Tapestry Factory of Santa Barbara

1776–1778

*G*oya's note of the week-long journey from Saragossa to Madrid undertaken in January 1775 (fig. 65) marked the start of his career as a painter of cartoons for the Royal Tapestry Factory. Years later, in a letter to Fernando VII, he wrote that 'Mengs asked me to return from Rome', and his son recorded that 'the first works that revealed his genius in painting were the pictures he made for the Royal Tapestry Factory, which were assessed and approved by *caballero* Mengs, who was astonished by the great facility with which he made them'.

A series of cartoons on hunting themes was carried out under the direction of his brother-in-law Francisco Bayeu, and completed during 1775. A year later, Goya signed his account for 'a picture that I, Francisco Goya, have painted (of my own invention)', describing the subject of *The Picnic* (fig. 39). This was followed by his accounts for 'a dance on the bank of the River Manzanares' (fig. 18) and, on 12 August 1776, for the cartoon known as *The Brawl at the New Inn* (fig. 91). Seven other cartoons were also made for the 'tapestries that are to decorate the room in which their Most Serene Highnesses the Prince and Princess [of Asturias] dine, in the Royal Palace at El Pardo'.

The Palace at El Pardo, to the north of Madrid, served as the official Court residence (*Real Sitio*) during the first three months of each year. It was the setting for which Goya designed all except the first and last of his series of tapestry cartoons, beginning with *The Picnic*, which he delivered to the Factory in October 1776. These decorative compositions, intended for a room used by the heir to the throne and his young bride, María Luisa of

Parma, offered a change from the traditional subjects for tapestries. The fact that they illustrated 'entertainments and dress of the present time' was noted by the historian Antonio Ponz in the volume of his *Viage de España* published that year, and Goya's lengthy descriptions in his invoices give details of their themes.

All new designs for tapestries had to be approved by the King, and the artists who worked for the Royal Tapestry Factory presented their finished sketches as models. Of the 25 principal cartoons painted by Goya in the 1770s, not counting the many subsidiary designs and overdoor panels, only this one sketch (cat. 7) can be firmly attributed to him. All his other sketches belong to the 1780s, and owe their survival mainly to the fact that Goya sold a substantial group to his patron the Duke of Osuna in 1798 (cat. 19–31).

The young artist's claim that the tapestry designs were 'of my own invention' is borne out by the originality of his compositions and their vivid brushwork, and although the painting of cartoons intended for use by weavers was a lowly form of art, Goya took advantage of the opportunity to work on contemporary themes on a large scale. From the finished sketches prepared for these series of cartoons, in which he had constantly to keep in mind the relationship between the different compositions in each group, came a lifelong habit of creating harmonious and interesting works that could be enjoyed singly or as part of an integrated whole – a characteristic that came to be of great importance in his later series of 'cabinet pictures'.

Fig. 89 Detail from *The Brawl at the Cock Inn* (cat. 7)

DINING-ROOM OF THE PRINCE AND PRINCESS OF ASTURIAS, PALACE OF EL PARDO, 1777

This appears to be Goya's only surviving sketch from his three early series of tapestry cartoons. He delivered the huge canvas (fig. 91), together with three others, to the Royal Tapestry Factory with an account dated 12 August 1777, in which the cartoon is described thus: 'An inn at which coachmen and muleteers from various provinces of Spain have arrived, and after resting they began to play cards and a dispute about the game arose, and a man from Murcia is stirring up bad feelings between two men, another in order to break it up is pulling at a jacket and ripping it around the lower part. Another with the same purpose is threatening them with the branch of a tree in his hands. This first group has five figures. There are two others wrestling on the ground at almost the same distance and another who is not so bold who has a rock in his hand, as if about to flee. At the door of the inn stand various people; the inn-keeper is picking up the money and there is someone else with a pistol who is about to dismount from a horse. The whole composition of this painting has thirteen figures and some others who can be seen in the distance.'

Goya's price for this very large cartoon, measuring over four metres wide, was 10,000 *reales*, twice the price of the *Promenade in Andalusia* (Museo del Prado) which includes only five principal figures. The Court Painter Andrés de la Calleja was responsible for valuing the cartoons, and in the case of the cartoon derived from this sketch he reduced Goya's price by 1,000 *reales*. He nevertheless gave a very sympathetic account of the artist's work, and otherwise agreed with his prices, 'considering the size, type of work and the fact that it is of the artist's own invention, as a result of which he will have had to devote much more time than is apparent to little preliminary sketches, and designs from nature for which he will also have incurred certain expenditure.'

Fig. 90 Part of Goya's account, dated 12 August 1777
Palace Archives, Madrid

Fig. 91 Tapestry cartoon, *The Brawl at the New Inn*, 1777
oil on canvas, 275 × 414 cm
Museo del Prado, Madrid

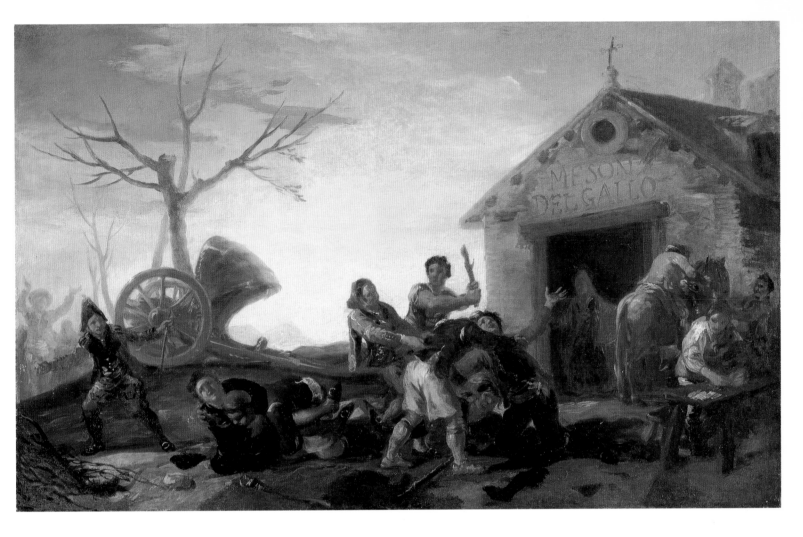

7
Sketch for *The Brawl at the Cock Inn*, 1777
oil on canvas, 41.9 × 67.3 cm
Private Collection

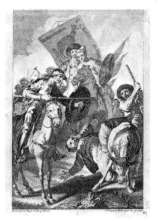

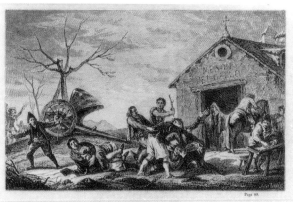

LA MAISON DU COQ

Fig. 92 Projected illustration by Goya for an edition of *Don Quixote*, 1780 engraving by Fabregat Biblioteca Nacional, Madrid

Fig. 93 *The Cock Inn*, engraving after a drawing by Jules Lavée, published in C. Iriarte, *Goya*, Paris 1867, page 99

None of Goya's '*borroncillos*', probably a reference to preliminary oil sketches, are known to have survived, nor have his drawings from the live model, apart from a few studies for the earlier *Dance* and *Picnic* compositions (figs. 18, 38). In the case of *A Brawl at the New Inn*, the surviving '*borrón*' provides the only known example from this period of the finished sketches that were presented for approval to the King. It was acquired by the French writer and art historian Charles Yriarte before 1867, the year in which it was reproduced in his biography and catalogue of Goya's work (fig. 93).

Comparison of the sketch and large cartoon shows that Goya made few but significant changes. The sketch is very boldly and vigorously brushed, and the dark red 'ground' that was applied to the whole canvas has been left bare in many places and used for areas of shadow or unifying patches of colour. The lively brushstrokes help to create an impression of violent action through touches of bold impasto, and light catches the swiftly modelled forms at strategic points. Goya conceived his composition as a frieze of figures arranged in the same plane, from the stone-throwing coachman on the left to the innkeeper at the table on the right. Although the subject concerns a vulgar brawl over a game of cards, the whole scene has been composed like an Antique relief, and there is a sense of tragedy appropriate to a higher form of art in the upturned, bloodstained face of the man attacked by the Murcian (a stock character of proverbially unsound character) at the centre of the composition, whose expression of suffering is reinforced by the despairing gesture of his outflung hand. The head and torso of the figure behind him, wielding a club-like branch of wood in his muscular arms, recalls the sword-bearing hero of one of the most famous Antique reliefs, that of the Orestes sarcophagus, which Goya could have seen in Rome or else studied in Bellori's engraving of it (fig. 95). The dramatic gesture of Goya's principal victim and the pose of the figure on the far left, 'who is standing with a stone in his hand as if about to flee', both suggest a reference to another celebrated figure, the so-called Pedagogue from the Niobe Group (fig. 94). However, the deliberate crudeness of the faces and figures of the men fighting on the ground, and the picturesque gaiters and shorts of the Murcian, turn the classical references to burlesque effect. The cartoon sketch is also related to Goya's projected illustration for 'The Braying Adventure' in the 1780 edition of *Don Quixote* (fig. 92).

Fig. 94 '*The Pedagogue*', one of the 'Niobe Group', a collection of Roman marble statues after Greek originals Uffizi Gallery, Florence

The ambiguity of the composition and its mixture of comedy and tragedy extend to the setting, in which the bare branches of the trees echo the outflung arms of the foreground figures and others in the distance, and the figures and delicately painted carriage are silhouetted against a radiant sky. The sketch has a concentrated, classical unity of action, with the drama of the frieze-like figures echoed in the stark landscape elements, and effects of light and colour, with vivid reds, emphasising the action and underlining the expression of fear and rage and furtive greed. The name of the inn in the sketch, 'MESON DEL GALLO' (The Cock Tavern), painted above the entrance to the modest building, has been altered in the cartoon to 'VENTA NUEBA' (New Inn), painted on a sign, and many other changes can be observed. The composition of the cartoon has been expanded in all directions to create a much more decorative effect. The figures now appear spread out over a wider expanse of ground, or are silhouetted in a carefully calculated pattern against the sky. Two dogs add light relief and fill blank spaces between the figures, while the inn, a larger and more substantial building, appears more distant; on the left, the bare branches and suggestion of distant hills in the sketch have been transformed in the cartoon into leafy and more numerous trees that give way to an agreeable prospect of landscape and sierra.

While Goya, probably in consultation with the director of the Tapestry Factory, must have been responsible for the important changes in design in the cartoon, one difference may prove to be a later alteration. The character of the brushstrokes in the massed foliage above the central group, and the fact that it interferes with the balance of the design, suggest that this may have been added by another hand to ease the weavers' task in translating unrelieved areas of sky.

Goya's descriptions of this and other cartoons in his first original series give no hint of any intention other than to illustrate with a certain degree of humour 'entertainments and clothing of the present time', although, being of his own invention, they no doubt contain all kinds of personal allusions and meanings. The composition of the *Brawl* has been seen as an allegory of Ira, or Wrath, one of the Seven Deadly Sins, and has been considered as a visual parallel to Ramón de la Cruz's theatrical satire of the classical melodramas approved by enlightened intellectuals. The layers of meaning and allusion in this and Goya's other tapestry cartoons are a fertile ground for analysis and debate. But whether the subjects are seen as wider allegories or more focused references to contemporary life in Madrid, the 'high art' allusions within these supposedly comic and light-hearted themes suggest the extent of Goya's ambition and personal involvement in the making of these remarkable compositions for the Spanish Court.

Fig. 95 Engraving of a relief on the *'Orestes' Sarcophagus* published in J. P. Bellori's *Admiranda Romanarum Antiquitatum*, 1963

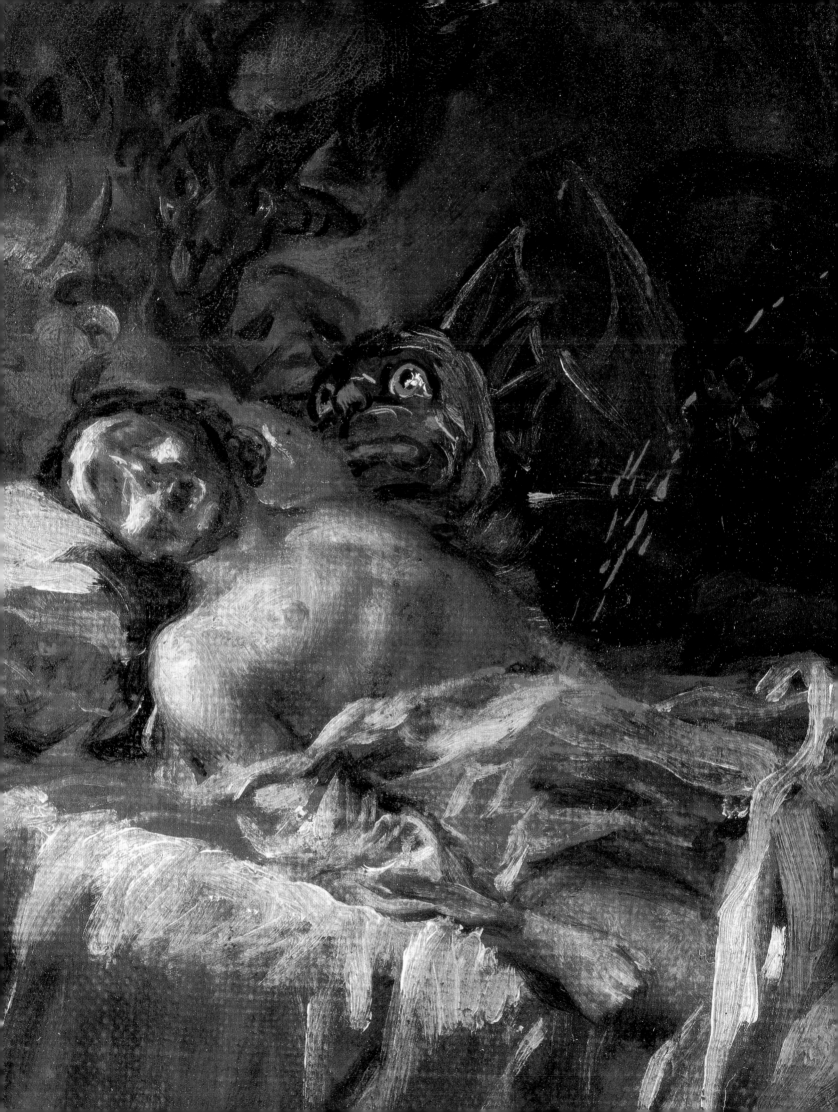

Paintings on Religious Themes

1780–1788

*I*n May 1780, at the age of 34, Goya was elected to the Royal Academy of San Fernando, on presentation of his *Christ on the Cross* (Museo del Prado, Madrid), painted in a manner acceptably close to that of Mengs and of his brother-in-law Francisco Bayeu. Shortly afterwards, the Building Committee of El Pilar in Saragossa agreed that while Bayeu was painting his ceilings in the church, his brother Ramón and Goya should paint the four cupolas that surround the chapel of the Virgin. During this decade Goya was occupied, first in Saragossa and then in Madrid, with two of his most important religious projects, followed by further commissions for altarpieces in Salamanca, Madrid, Valladolid and Valencia.

The fresco decoration of one of the cupola's in El Pilar should have been a triumph for the artist, but it led to bitter wrangling with the church authorities and clashes with his brother-in-law. It nevertheless remains one of his most remarkable works, for which the two preparatory sketches have survived (cat. 8, 9).

On his return to Madrid, Goya was nominated as one of seven artists who were to paint altarpieces for the newly built church of San Francisco el Grande. Two sketches are known (cat. 11, 12), and Goya's correspondence provides insights into the development of this important project, completed in 1784.

Although the four paintings in the collegiate church of Calatrava, in Salamanca, were destroyed during the War of Independence (1808–14), the sketch for *The Immaculate Conception* above the high altar has survived (cat. 13), and the church interior helps to explain its particular, Mengsian, characteristics. In the case of Goya's *Annunciation*,

painted in 1785 for the Capuchin monks of San Antonio del Prado, the church itself has been destroyed, but the magnificent canvas that crowned the complex altarpiece and its remarkable preparatory sketch are known (fig. 42, cat. 14).

For the nuns of the royal convent of Santa Ana in Valladolid, Goya and Ramón Bayeu each painted three altarpieces, and Goya's sole surviving sketch (cat. 15) is another notable example of the verve and spontaneity of his initial invention, and the care with which he elaborated his large paintings. The last religious commission in the 1780s was for two paintings of scenes from the life of the Spanish Jesuit St Francis Borgia, to hang in the family chapel in the cathedral at Valencia. Goya's two preparatory sketches (cat. 16, 17) are works of intensely vivid imagination, keyed in rich, sombre tones, and in the second of which monsters and demons make their first appearance in his art, prefiguring the witchcraft scenes of ten years later (cat. 44–9).

Fig. 96 Detail from *St Francis Attending a Dying Impenitent* (cat. 17)

CUPOLA OF THE BASILICA OF EL PILAR, SARAGOSSA, 1781–1782

After completing his fresco in the little choir of El Pilar (cat. 2), Goya had offered to paint the adjacent ceilings. However, the Committee had already begun negotiations with Francisco Bayeu for the eight ceilings and cupolas around the chapel of the Virgin. Carlos Salas, the sculptor responsible for all the stucco decoration, suggested the theme of the Loretan Litany invocations to the Virgin as '*Regina*', or Queen, rather than scenes from her earthly life that Bayeu had been considering.

In July 1773, Goya had married Francisco Bayeu's sister Josefa in Madrid, and the following year Salas acted as godfather to their first child, born in Saragossa while Goya was working in the monastery of Aula Dei. In March 1775, Goya wrote to the Chairman of the Pilar Building Committee to inform him that his brother-in-law was working 'on Sundays and feast days and until ten o'clock at nights' on his sketches for the frescoed ceilings next to Goya's and immediately behind the chapel of the Virgin.

These ceilings were completed a year later, in 1776, but further long delays seem to have led Goya's supporters in Saragossa to intervene on his behalf. In a letter to Zapater dated January 1778 he wrote to say that 'I'm going to tell you the truth about the offer of sketches to Salas, and the fact is that Don Martín Goicoechea and Salas want me to send something to show to the canons, because they want to see whether it would be possible for me to do the work and I have great respect for them as you know, this is in secret …'. The secret negotiations evidently came to nothing, but in May 1780 Francisco Bayeu proposed that his brother Ramón and Goya should paint the four cupolas while he was completing his ceilings and thereafter under his regular supervision.

From that month onwards, Goya's letters are full of plans concerning his return to Saragossa, where his friend Martín Zapater made arrangements for his family's stay. On 9 August 1780, Goya announced to Zapater that 'I've finished the first sketch for one of the cupolas', and on 5 October the Minutes of the Building Committee in Saragossa record that he and Ramón presented their sketches, together with those of Francisco Bayeu, for all the ceilings, and that 'after the gentlemen of the Committee had looked at them attentively and with great pleasure, they instructed Don Francisco Goya and Don Ramón Bayeu, who were present, to return to their lodgings with a view to starting work at once'.

With the exception of Goya's sketch for the little choir (cat. 2), most of the preparatory sketches for the Pilar ceilings are now displayed in a small museum in the church. Apart from the splendid earlier designs by Antonio González Velázquez for the central cupola over the chapel of the Virgin, the vigour and inventiveness of those by Goya – for the only cupola he was ultimately allowed to paint – are enough to suggest the differences in temperament and talent between him and his brothers-in-law. Friction over Francisco's supervision of Goya's work led to dissentions, recorded in detail in the Pilar Archives, which finally exploded in March 1781. The Committee, already upset by adverse criticism of Goya's cupola, rejected his sketches for the pendentives, particularly the representation of 'Charity' for its alleged indecency, and insisted that he present new sketches approved by his brother-in-law. Goya responded in a long and very emotional memorial to the Committee, and threatened to leave Saragossa on the spot. He was persuaded to complete the work, but the Committee would have nothing more to

do with him, even refusing the customary gifts to the artist's wife, and Goya's letters to Zapater, after his return to Madrid, show how deeply the whole affair had hurt him. In July he wrote that 'when I think about Saragossa and painting, my blood boils'.

Since the sketches for the cupolas in El Pilar – painted in the traditional way as pairs of lunettes – had to be presented to the Committee for approval, they are relatively 'finished' works. Francisco Bayeu approved the designs and also decided, apparently against Goya's judgement, on the orientation of all the ceiling frescoes in El Pilar. The Virgin appears as the central motif when they are viewed from the far, west end, of the basilica, an orientation that conflicts with the movement of the faithful, who progress from the side entrances at the east end to the chapel of the Virgin, and thence down into the body of the building.

Goya's cupola, on the north side nearest the river, is lit by the diffused light from the central lantern and by a small window in the north wall, below the dome. The immense height of the building, the relative obscurity of the cupola, and the clean but heavy classical style of Ventura Rodríguez's architecture, called for a design of great clarity and vigour, and it is this aspect of Goya's work that contrasts so markedly with the sketches and frescoes by his brothers-in-law. As he wrote in his memorial to the Committee, 'the sketches show the whole work complete and finished, with the same figures, colouring and disposition in which they should be located', and they give a very clear idea of the fresco design. The Virgin appears in glory, surrounded by angels and presiding over an assembly of martyrs, many bearing palms and also crowns of laurel that were not included in the fresco.

Some thirty to thirty-five figures appear in

Fig. 97 The interior of the cupola, with Goya's fresco of the *Queen of Martyrs*, in the basilica of El Pilar, Saragossa

each half, and Goya has disposed them in well-organised groups, on clouds that are mainly white and gold-tinged around the Virgin, generally darker and more thunderous in the sketch for the opposite side. Those in Francisco Bayeu's sketches resemble the smooth, stuccoed clouds into which they often merge in the ceilings (while Ramón's look more like twisted cotton wool), but Goya's clouds offer comfortable, natural support to the various figures and instruments of their martyrdom. Immediately below the Virgin, Saints Peter and Paul intercede on behalf of the Aragonese martyrs, with St Vincent with his millstone on the left and, to the right, St Laurence kneeling beside his grid-iron and St Engracia holding her hammer and a fearsome nail. Farther along, a figure reclines (as if in a tapestry cartoon), the pose half-echoed on the far left by St Simon, prostrated over his sharp-toothed saw.

Fig. 98 A view of the cupola showing the Virgin in Goya's *Queen of Martyrs* fresco in El Pilar, Saragossa

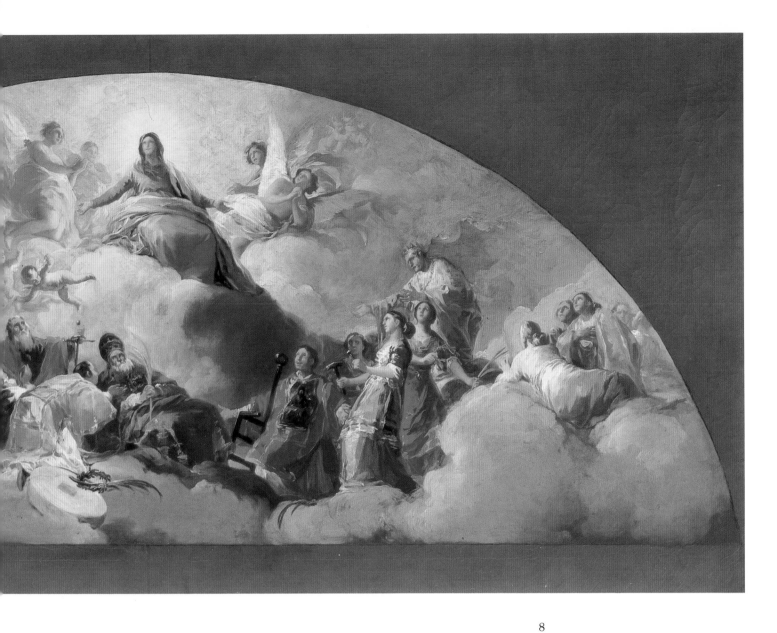

8
Queen of Martyrs, Sketch with the Virgin,
1781
oil on canvas, 85 × 165 cm
Museo Pilarista, El Pilar, Saragossa

In the sketch for the opposite side of the cupola (cat. 9), St Lambert stands with his decapitated head in his hands, St Catherine, above her spiked wheel, sits like a lively school-teacher beside the child-saints Justin and Pastor, with their alphabet. To the right, dark clouds support the weight of St Sebastian, recumbent on a tree-trunk, St Barbara on the crenellations of her tower, St George, patron saint of Aragon, with his banner, and St Stephen kneeling beside some heavy stones.

The figures are painted on a rich red ground that is left uncovered in many areas. The deft and rapid brushstrokes and the sumptuous and subtle colour, thin and fluid or richly empasted, describe the forms through the play of light. The source of light is the Virgin herself, and the entire composition, as constructed in Goya's two sketches and executed in the cupola, is unified by her presence. The scheme is fundamentally unreal, a Baroque invention, but Goya has invested it with a naturalness that years later was to lead to the revolutionary treatment of the cupola in San Antonio de la Florida in Madrid (cat. 53, 54), in which the 'earthly' events take place in the cupola, while angels and cherubim occupy the space below. Goya's concern to create a believable reality, even in the heavenly spheres, is reflected in these early sketches for El Pilar, as well as his skill and confidence in the handling of a complex, brilliant composition.

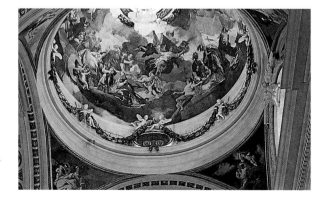

Fig. 99 The Banner displayed in Goya's *Queen of Martyrs* fresco in El Pilar, Saragossa

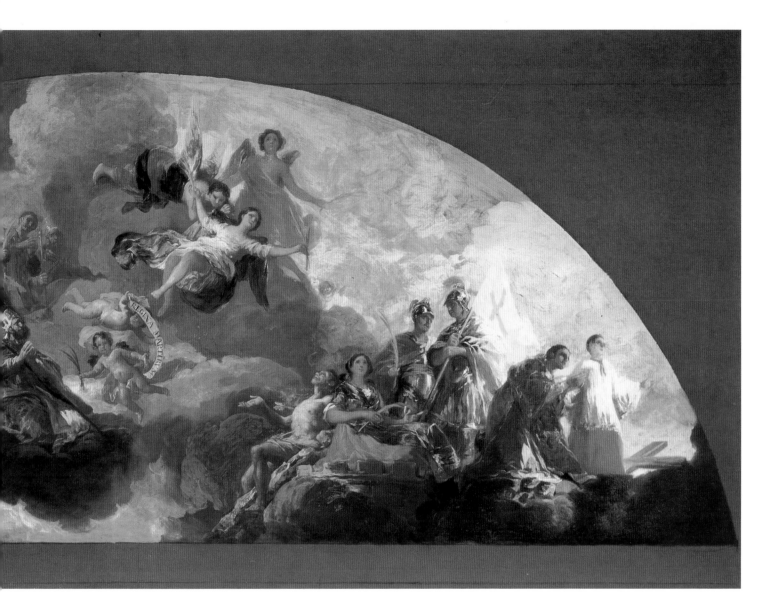

9
Queen of Martyrs, Sketch with the Banner,
1781

oil on canvas, 85 × 165 cm
Museo Pilarista, El Pilar, Saragossa

CHURCH OF SAN PEDRO, URREA DE GAÉN (TERUEL), 1782–1783

'When the Apostle James was praying one night with his disciples beside the River Ebro, near the walls of the city of Saragossa and not far from the bridge, the Virgin Mary, Mother of God, who was then still living, appeared to him surrounded by choirs of angels, on a marble column; she left him an image of herself, and there the apostle built a chapel.' This is the story, at its simplest, of the apparition of the Virgin to St James the Great, at the Roman town of Caesaraugustus (Saragossa) in the year AD 40.

Goya had already painted the image of Our Lady of the Pillar (cat. 4), and some ten years later he expanded the theme into an altarpiece for the church at Urrea de Gaén in the province of Teruel, south of Saragossa. Nothing is known about the commission, and no documents have been published, although Goya's correspondence records a payment of 3000 *reales* by the Duke of Híjar in 1783. In a description of the church published in 1788, Antonio Ponz referred to other paintings, including a *St Blaise* by Goya, but not to this work. All the paintings disappeared in 1936, during the Spanish Civil War, though some of them are recorded in photographs (fig. 100).

Goya's very free, preliminary sketch gives an idea of the effect of the lost altarpiece. The rich, yet soft, colours and impulsive swirling brush-strokes express the excitement of the scene, and touches of white model the figures with light and establish a sense of perspective. A disciple runs forward with arms outspread – a gesture constantly used by Goya to express wonder or dismay – at the sight of St James in

ecstasy before the vision of the Virgin, who indicates the image brought with her and points commandingly towards the Saint. Bare, wintry branches in the foreground recall the traditional date of her appearance, 2 January.

A page in Goya's Italian Notebook (fig. 102) shows God the Father appearing to an almost identical figure. If this were Abraham, then God's charge to him to build an altar on the land given to him and his descendants would find a parallel in the Virgin's encouragement to St James to establish the Christian church in Spain and build a sanctuary to enshrine her image. For unknown reasons, the composition was reversed for the actual altarpiece (fig. 100), and therefore another, more finished, sketch must have been made. The strong, simple design is more rationally organised in the large painting, in which the living Virgin descends more convincingly towards St James, and the altarpiece must have been admirably suited to the rural Aragonese community, as originally seen in the spacious and luminous church interior designed by Agustín Sanz for the Duke of Híjar, completed in 1782 (fig. 101).

Fig. 101 Interior view of the Church at Urrea de Gaén, Teruel

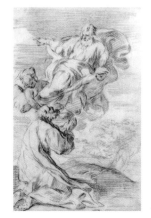

Fig. 102 Goya's 'Italian Notebook', drawing in red chalk on page 14 recto

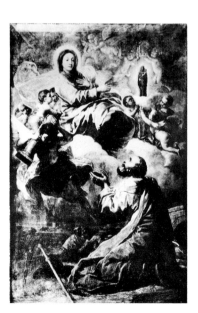

Fig. 100 *Appearance of the Virgin of the Pillar to St James,* *c* 1782–3 (destroyed), formerly in the church of Urrea de Gaén

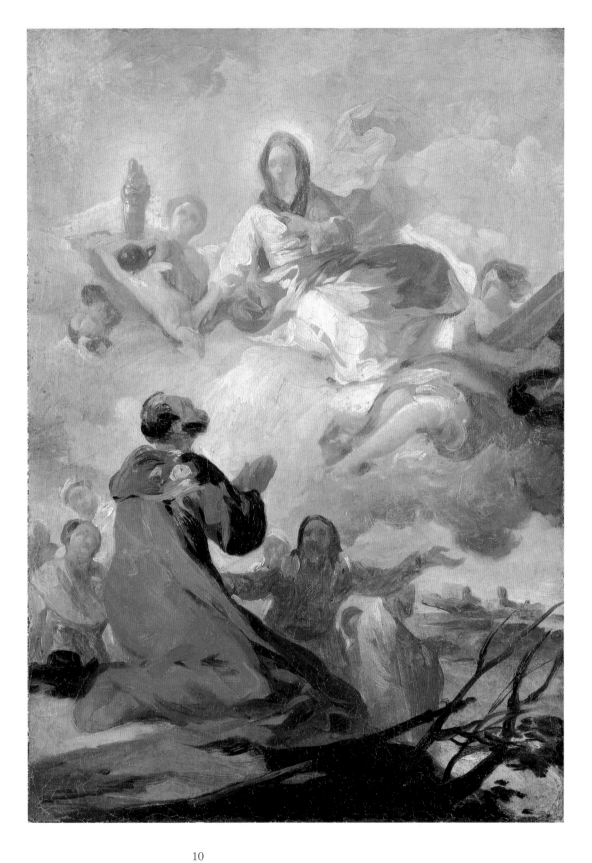

10
Sketch for *The Appearance of the Virgin of the Pillar to St James the Great*,
1782–3

oil on canvas, 46.7 × 33 cm
Private Collection

SAN FRANCISCO EL GRANDE, MADRID, 1781–1784

In July 1781, soon after his return from the Pilar fiasco in Saragossa (cat. 8, 9), Goya wrote to Zapater to announce that he had been nominated to paint one of seven altarpieces for the newly completed church of San Francisco el Grande in Madrid, and had sent the letter from Count Floridablanca, conveying the royal command, to his patron Don Juan Martín de Goicoechea, 'so that he can show it to those vile people who showed so little confidence in my ability'. Referring to the project as 'a formal competition', in which 'the great Bayeu is to do a painting', Goya rejoiced that Ramón, his colleague at the Royal Tapestry Factory, had evidently been forgotten.

The rebuilding of the church and convent had begun in 1761. By 1770 the vast cupola had been completed, but work then ceased for several years. The great dome appears in the background of Goya's tapestry cartoon, completed in March 1777 and described as 'A dance beside the River Manzanares…in the distance, a bit of Madrid around San Francisco is visible' (fig. 18). In the 1782 edition of his guide to Madrid, Antonio Ponz referred to the project to paint the altarpieces, which were not unveiled until some two years later. Goya had received the royal order on 20 July 1781, and by early August was promising to send Zapater 'one of the *borroncillos*' (little sketches) of his picture. Three weeks later he was working 'on the *borron* for San Francisco', probably a reference to the sketch that he sent to Count Floridablanca on 22 September, accompanied by a remarkable explanatory letter:

'Your Excellency, With due regard for His Majesty's esteemed command, communicated to me by Your Excellency on 20 July, nominating me to paint one of the six paintings for the new Temple of San Francisco de Asis in this city, and leaving it to my judgement to decide which of the events from the life of St Bernardino of Siena appeared most suitable, I have painted a *borroncito* [little sketch] of the size given to me (as to all the others) of the Miracle that occurred when the Saint was preaching in a wide, flat plain (because the crowd was too great for the streets and squares) near the Aquiline City in the presence of Renato, King of Sicily, and a multitude of people; as he was exalting the coronation of the Queen of Angels, the notable congregation was utterly amazed to see the most brilliant star descend from Heaven and hover over His Head, bathing him in Divine Light. A subject that gives sufficient opportunity to enrich the composition, in spite of the limitations imposed by the narrow format of the picture, since Your Excellency's enlightened understanding, will appreciate that, given the necessity for a pyramidal construction that must follow a serpentine pattern in order to achieve the best decorative effect, it is inevitable that the representation of the plain will lack to some extent the spaciousness to which I have made allusion.'

Royal approval of the sketches was evidently forthcoming, and on 23 December Goya received 6,000 *reales*, on account 'and until further arrangement', and began work on his painting. There is no further news until January 1783, when he regaled Zapater with an account of Bayeu's humiliation at Court over his picture for the high altar, and sent his friend 'one of the *boradores* [i.e., sketches] of the painting', adding that 'obviously it is very much a *borron* and the original has changed, but at least it will give you an idea'.

The sketch Zapater received could be the earlier of the two that have survived (cat. 11),

Fig. 103 Interior of the church of San Francesco el Grande in a print of 1785, from *Seminario Pintoresco Español*, December 1847

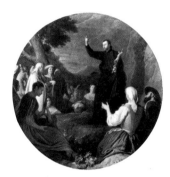

Fig. 104 Michel-Ange Houasse, *The Prediction of St Francis*, c. 1722
Museo del Prado

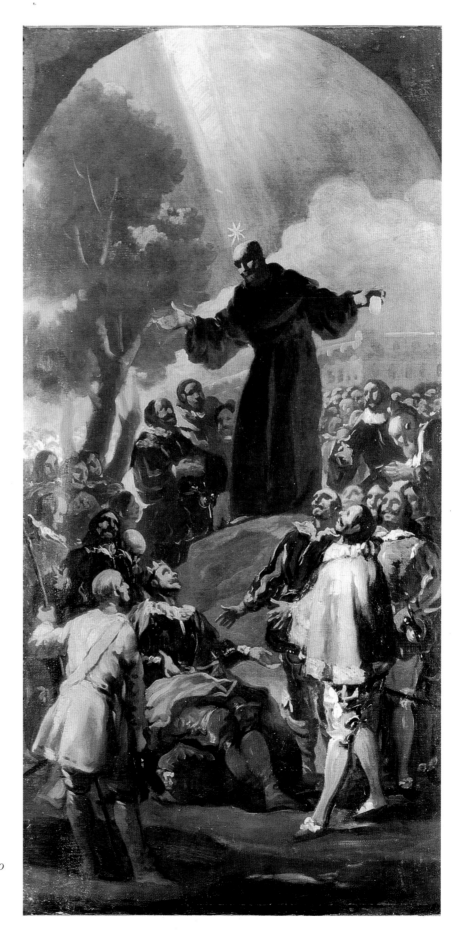

11
*St Bernardino of Siena
Preaching before King Alfonso
of Aragon*, 1781 (first sketch)
oil on canvas, 62 × 31 cm
Private Collection

with a composition possibly based on a painting by Michel-Ange Houasse that Goya could have seen (fig. 104). St Bernardino, with the miraculous star over his head, is standing on a hillock surrounded by a crowd of figures, and leaning forward towards the King, who is seated below him with legs extended and hands outspread in wonder. From the monochrome reproduction of this picture (which has almost never been seen in public), the handling appears simple and direct, with the composition articulated by touches of light on the figures, trees and distant buildings.

A second sketch (with the same provenance and equally unknown) is much closer to the large altarpiece, and may be the '*borroncito*' that was presented to the King (cat. 12). Here Goya has clarified the composition, emphasising its serpentine rhythms, increasing the sense of verticality, and resolving many conflicting elements that led the eye out of the picture or away from the central theme. The figures on the left combine with the trees to form a powerful vertical thrust, and also surround and support the King, now kneeling before the ecstatic, swaying figure of the Saint, in a pose recalling that of a drawing of St Isidore (fig. 106). In the painting, the heads, limbs and weapons have been adjusted to concentrate attention on the King and St Bernardino, who holds aloft his tablet inscribed with the monogram of Christ's name. In this sketch, Goya introduced a self-portrait, the figure to be seen at the right edge staring out at us.

In the finished altarpiece (fig. 105), nearly five metres high and painted with the strong, simplified brushwork of the tapestry cartoons, the 'serpentine' organisation is even more impressive, and every element serves to highlight the devotion of the kneeling monarch. The crucifix now grasped by the Saint strengthens the upward movement of the whole, and in the original vast and empty interior of the church of San Francisco el Grande (fig. 103), Goya's painting must have contrasted strik-

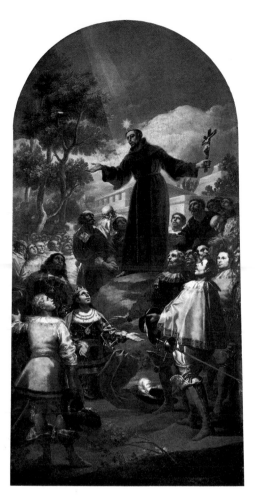

Fig. 105 St *Bernardino of Siena Preaching*, 1782–4
oil on canvas, 480 × 300 cm
San Francisco el Grande, Madrid

Fig. 106 *St Isidero*,
c. 1778–84
red chalk, 23 × 19.2 cm
Private Collection

ingly with the old-fashioned Baroque or vaguely Neoclassical compositions of his academic colleagues.

The altarpieces were unveiled at the beginning of November, and in December Goya was able to inform Zapater, 'I have certainly found favour in respect of informed opinion and of the public in general...since everyone is for me, without any question'. His participation in the San Francisco competition marked the real start of his career as an independent artist at the Court of Madrid.

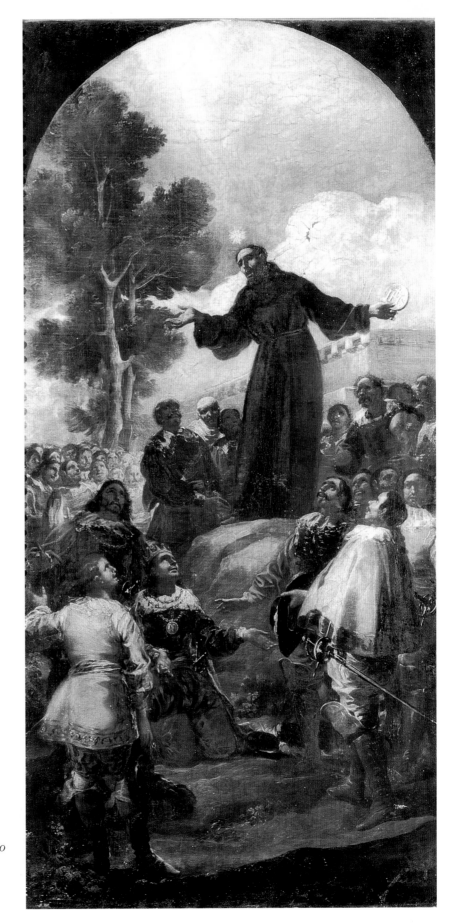

12
*St Bernardino of Siena
Preaching before King Alfonso
of Aragon*, 1781 (second
sketch)
oil on canvas 62 × 33 cm
Private Collection

COLLEGE OF CALATRAVA, SALAMANCA, 1783–1784

On 10 October 1784, Goya addressed a note (fig. 108) in the following terms to Don Gaspar Melchor de Jovellanos as President of the Council of Military Orders which included that of Calatrava:

'Sir, Don Francisco Goya, Academician '*de mérito*' of the Royal Academy of San Fernando, hereby informs you that he has completed the four paintings that were commissioned from him last year for the Church of the College of Calatrava in Salamanca. The first … represents the mystery of the Conception of the Most Holy Virgin surrounded by Angels in glory with the Eternal Father; the second, St Raymond of Fitero being knighted at the siege of Calatrava in a landscape…; the third and fourth are pendants … and one represents St Benedict Abbot destroying idols, and the other St Bernard embracing a cross, all larger than life-size figures, and painted by him. The artist has attempted to combine the observation of nature with every artistic device in order to achieve the best result.'

Although these paintings disappeared in 1810–12 during the war against the French, a description of the interior of the church in Salamanca, made shortly before it was opened for public worship in July 1790, describes the magnificent architectural settings for Goya's paintings, designed by Pedro Arnal, Director of Architecture at the Royal Academy of San Fernando. Of the original elements, only the pairs of Corinthian columns that framed the *Immaculate Conception* over the high altar are still in place (fig. 107). The effect must have been at once rich and severe, with mouldings of black marble veined with white around the *Immaculate Conception,* and of red marble around the *St Raymond* above it, and around the paintings over the side-altars.

Apart from the written descriptions, these four large paintings are known only through the surviving sketch for the *Immaculate Conception* (cat. 13). As one of Goya's most beautiful finished sketches for a large work, it was no doubt presented to the Council for approval, following the commission to paint the altarpieces in April 1783, and was probably given to Jovellanos by Goya in gratitude for his patronage. Its double-square proportions are perfectly harmonious, and the simple, graceful figure of the Virgin, in her robes of white and rich, translucent blue, would have related perfectly to the tall, narrow space between the paired columns in the church. She is surrounded by a luminous *gloria* in the upper half, in which the figure of God the Father, marvellously depicted, emerges to protect and bless her. She stands on the globe and Crescent, attended by cherubim and little angels. An alert little serpent, with the apple of Original Sin in its jaws, appears at the Virgin's feet, and her porcelain features, with downcast eyes, and gentle, elongated hands, surely made her an ideal devotional image for the College students.

Fig. 107 Interior of the College church of Calatrava, Salamanca

Fig. 108 Letter from Goya to Jovellanos, dated 10 October 1784 National Historic Archives, Madrid

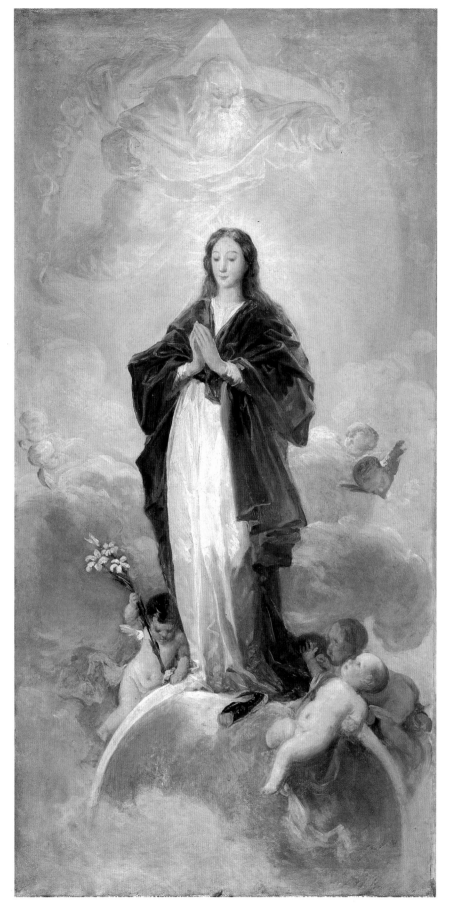

13
Sketch for *The Immaculate
Conception*, 1783–4
oil on canvas, 80.2 × 41.1 cm
Museo del Prado, Madrid

SAN ANTONIO DEL PRADO, MADRID, 1784–1785

The chapel of San Antonio del Prado, built in 1716 for the Capuchin fathers, stood in the plazuela del Duque de Medinaceli (now plaza de las Cortes). Its principal ornament was a complex Baroque altarpiece, which fell into such a dilapidated condition that Ventura Rodríguez recommended its destruction. In 1785 the Duke of Medinaceli commissioned the Court architect, Francisco Sabatini, to design a new altarpiece. Constructed in the latest neo-classical style by the best sculptors and craftsmen in Madrid, it included a single painting, an *Annunciation* by Goya (fig. 42, 110). This majestic canvas, just over three metres high, crowned the whole altarpiece, its curved top rising to meet the vault. Its theme is the mystery of the Incarnation of the Son of God, expressed through a superbly structured composition that must have created an awe-inspiring effect in its original position high up near the roof of the chapel.

Like all Goya's major paintings, it was no doubt preceded by a number of sketches of which only one, probably the earliest, has survived (cat. 14). Goya seems to have used graphite to rough out his design on the prepared canvas, before brushing on the rich, soft colours with impulsive strokes that barely cover the beige preparation. The handling is as free as in the sketch for Urrea de Gaén (cat. 10), with playful, whirling baby angels and God the Father swooping forward, in the same attitude as in the much more carefully worked *Immaculate Conception* (cat. 13). The composition is full of dramatic diagonals, expressing the coming of the Godhead, the descent of the Holy Spirit, and the movement of the angel towards the Virgin. All these motifs appear in the large, unfinished *Annunciation* by Mengs that hung, by order of the King, in the Royal Academy in Madrid from 1780 (fig. 109).

However, any connection between the two compositions disappeared when Goya eliminated all these 'baroque' elements from his large picture.

In the sketch, the Virgin kneels before a lectern supporting a Bible, her head silhouetted against the shaft of divine light. An alteration to the outline of her cloak sets her apart from the angel, in line with the shaft of light, and the setting is left undefined. The composition is largely conceived in terms of the light that floods in from upper left, probably corresponding with the southern side of the cupola, and illuminates the figures of the angel and kneeling Virgin. In the larger finished painting, Goya made sweeping changes, reversing the composition, raising the height of the steps, and moving the angel towards the centre of the scene and the Virgin away from it. A doorway on the left and a covered basket suggest a temporal setting, but the symbolic lily and 'Hebraic' scroll indicate a more profound interpretation. The whole colour scheme becomes purer and cooler, and Goya plays an extraordinarily delicate scale of greys, mauves and blues against the rich yellow-gold of the angel's stole. Through the geometrical perfection of the composition and the magnificent, commanding gesture of the angel, like that of some Antique winged Victory, the story of the Annunciation to Mary in the sketch is transformed into an expression of the mystery of the Incarnation of the Son of God.

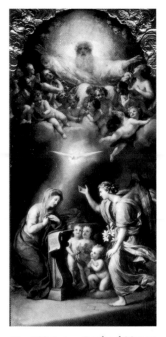

Fig. 109 Anton Raphael Mengs, *Annunciation*, 1779 Palacio Real, Madrid

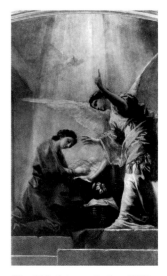

Fig. 110 *Annunciation*, 1785 (see fig. 42)

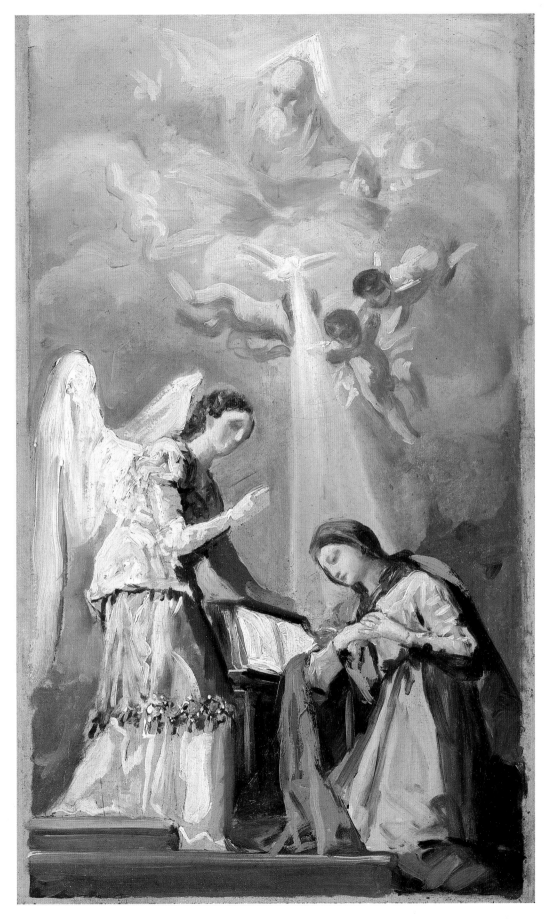

14
Sketch for *The Annunciation*,
1785
oil on canvas, 42 × 26 cm
Museum of Fine Arts, Boston,
William Francis Warden Fund

ROYAL CONVENT OF SANTA ANA, VALLADOLID, 1787

'Three paintings with life-size figures have to be ready and installed by St Anne's Day, one of them representing the death of St Joseph, another St Bernard and another St Ludgarda, and I haven't yet begun to think about it, and it has to be done because the King has ordered it, so you can imagine how pleased I'm feeling.' Goya's letter to Zapater, dated 6 June 1787 (fig. 112), suggests that he had only just received the royal command for three of the six large paintings, to be completed by 26 July, for the altars in the new church of the Royal Monastery of Bernadine nuns of Santa Ana in Valladolid. The convent had been completely rebuilt during the preceding years, to plans by Francisco Sabatini. In the same letter to Zapater, Goya responded to a question from Don Juan Martín de Goicoechea with the information that 'what is practised now here is the Architectonic style', and this new, Neoclassical style is perfectly illustrated in the church at Valladolid, with its oval interior, impressive high-altar and six side-altars of marbled and gilded wood (fig. 113). In March that same year, the nuns had lamented the delay in providing 'the paintings that are to be placed in the empty spaces in the altarpieces in the Church', adding that 'these paintings are the principal element in the altarpieces and an essential part of the whole design of the Church'. The following month, Sabatini recommended that, if the King were willing, 'the six that are required could be ordered from the painters Don Ramón Bayeu and Don Francisco Goya, since they are salaried and I am confident of their ability, and as soon as they have been given the order, I will give them the dimensions and information they will need for its execution'. In June of the previous year, Ramón Bayeu and Goya had each been nominated to the post of Painter to the King, in order to paint cartoons for the

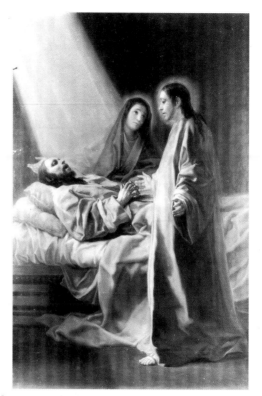

Fig. 111 *The Death of St Joseph*, 1787
oil on canvas, 220 × 160 cm
Royal Convent of Santa Ana, Valladolid

Royal Tapestry Factory 'and whatever else is required of them for the royal service'. The altarpieces for the Royal Convent in Valladolid were therefore part and parcel of the artists' functions as Court painters.

Goya's three paintings harmonise perfectly with the church interior and the simple, classical form of the altars. They also relate to the sources of light from the lantern and oval windows above the altars, in the cupola, and from a window high in the south-facing wall of the presbytery. Pacific and serene in their monumentality, the altarpieces are painted in creamy beige and brown tonalities, with the central *Death of St Joseph* adding notes of blue (in the Virgin's mantle) and salmon pink (in Joseph's gown).

Fig. 112 Letter from Goya to
Zapater, dated 6 June 1787
Museo del Prado, Madrid

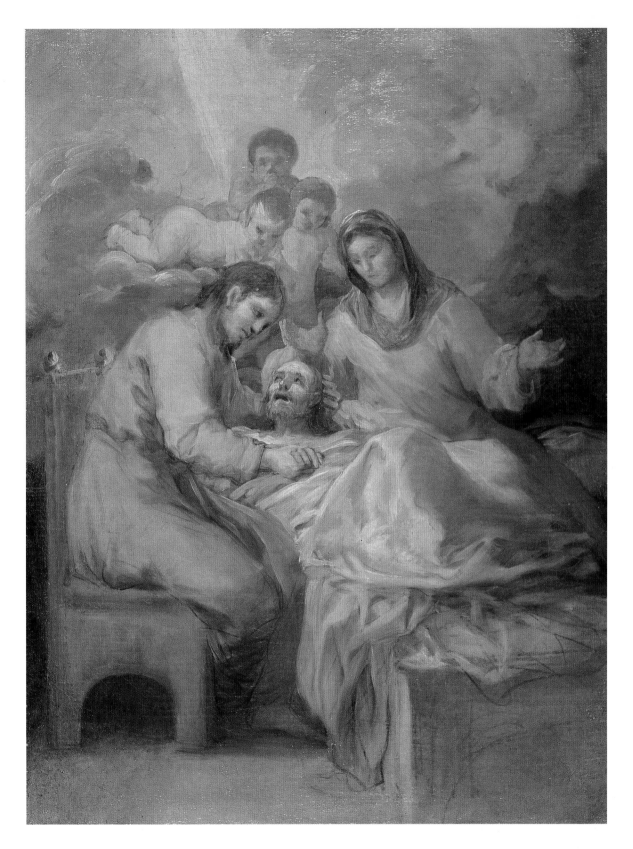

15
Sketch for *The Death of St Joseph*, 1787
oil on canvas, 54.5 × 41.1 cm
Flint Institute of Arts, Flint, Michigan,
Gift of Mr and Mrs William L. Richards
through the Viola E. Bray Charitable Trust

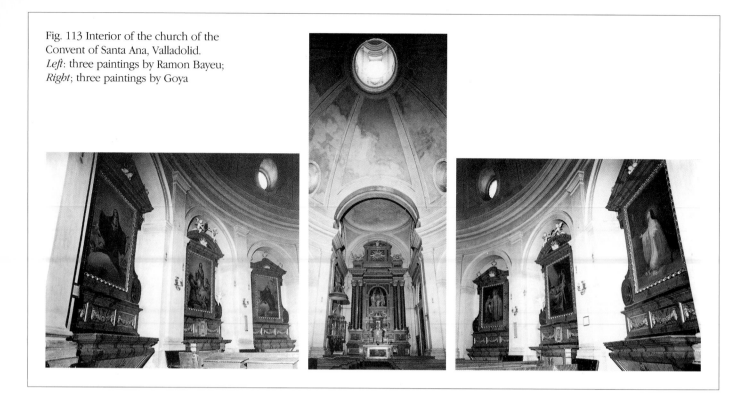

Fig. 113 Interior of the church of the Convent of Santa Ana, Valladolid. *Left*: three paintings by Ramon Bayeu; *Right*; three paintings by Goya

The terms of Sabatini's letter suggest that the artists worked from architectural drawings and sketches, and although the nuns did not finally take possession of their new convent until September, Goya must have been under considerable pressure to complete his pictures in time. Only one sketch has survived (cat. 15), so different from the final image (fig. 111) that it must be a first idea, but it provides a vivid example of the way in which Goya developed his compositions. The sketch for the *Death of St Joseph* presents an intimate and very human scene. It follows 17th-century representations of an apocryphal, medieval account of Joseph's death, told as if by Jesus himself, and it centres on the dying Joseph's extraordinarily expressive head. Jesus sits informally by the bedside, comforting his earthly father as he gazes with steadfast tenderness into his eyes, cradling his head and holding his hand at the moment of supreme agony and anxiety. Mary looks on with a gesture of resignation, while three cherubs,

who resemble real children, crowd forward on clouds to watch.

Goya first sketched the scene in graphite on the prepared canvas, and his impulsive drawing strokes are apparent everywhere, especially at the end of the bed and in the figure of Christ. Colours were applied very freely, and mixed on the canvas, as in the sketch for the *Apparition of the Virgin of the Pillar* (cat. 10), although they are much thinner here, and leave some areas of the surface uncovered. In its simplicity and directness, the *Death of St Joseph* is also related to the earlier *Death of St Francis Xavier* (cat. 5), where cherubs watch over the recumbent Saint.

In Goya's finished painting (fig. 111), clouds and cherubs have disappeared, and the composition has been reversed and restructured. Christ now stands in profile, facing the light, like the angel of the *Annunciation* (fig. 42), while St Joseph lies still and quiet, his eyes apparently open, suggesting that this is the

very moment of death, rather than its fearful anticipation. The Virgin, now at the centre of the composition, as befits an altarpiece for nuns, gazes at her Son while indicating her dying husband, here illuminated by a great shaft of light from on high. There is no longer any physical contact between the figures, but a powerful spiritual unity, symbolised by the pattern of their hands.

In November 1781 Goya had written to Zapater on the death of his friend's sister, and shortly before the death of his own father. The letter seems to parallel, if not to explain, his involvement in the subject of the *Death of St Joseph*: 'My dear Martin, I was very sad to hear about your sister and have commended her spirit to God, but I was consoled by the idea I have that she was very good and will have won herself a fair share of glory, while we who have been such knockabouts need to amend our ways in the time that is left to us. . . . I similarly am expecting the sad news that my father has died any day now because they have written to say there is very little hope . . . my only regret is that I can't be there, to have at least that comfort.' The emotional intensity of Goya's sketch for the painting in Valladolid is a vivid example of the extent to which his art sprang from his own feelings and experiences, however much he later elaborated and refined their expression. The large altarpieces for the convent church in Valladolid have sometimes been judged cold and devoid of religious feeling. Looking at the paintings in their original setting, and in the light of this sketch, reveals that the very opposite is true.

CHAPEL OF ST FRANCIS BORGIA, VALENCIA CATHEDRAL, 1787–1788

'Madrid 16 October 1788. Don Francisco de Goya, Painter. His invoice for two pictures he has painted showing scenes from the life of St Francis Borgia for the new Chapel provided by Her Excellency in the Cathedral Church of Valencia. 30,000 *reales.*' Goya's account, addressed to the Marchioness of Peñafiel, Countess Duchess of Benavente and Gandía, in Madrid, was paid on 22 May 1789 and debited to the Gandía estate, which lay to the south of Valencia. The two pictures were painted for the chapel dedicated to the illustrious ancestor of the Duchess of Gandía for whom Goya had been working since 1785, when he painted portraits of her and her husband (who became 9th Duke of Osuna in 1787), and in 1786–7 made the set of large, decorative landscapes for their country house at La Alameda, just outside Madrid (figs. 45, 46). While the energetic and enlightened

Countess Duchess led an active life in Madrid, she also looked after her Valencian interests. The chapel of San Francisco de Borja in Valencia Cathedral had been renovated in 1755, and in 1786 she commissioned new paintings for it; two years later she agreed to improvements in one of the palace chapels at Gandía.

The subjects of Goya's paintings were no doubt chosen by the Countess Duchess, and the setting of the Saint's leave-taking from his family appears to be the grand staircase in the palace courtyard at Gandía (fig. 116), with some artistic licence in respect of the background. In 1539 Francis Borgia, Marquess of Lombay, was commanded, as the Emperor Charles V's most trusted courtier, to bring the mortal remains of the famously beautiful Empress Isabel to Granada. There, in the Chapel of the Kings, the dreadful sight of her

Fig. 114 *St Francis Borgia Saying Farewell to his Family,* 1788
white chalk on blue-grey paper, 29 × 21.5 cm
Museo del Prado, Madrid

Fig. 115 *St Francis Borgia Saying Farewell to his Family,* 1788
oil on canvas, 350 × 300 cm
Valencia Cathedral

Fig. 116 View of the Palace courtyard, Gandía, Valencia, the home of the Dukes of Gandía

decomposed corpse led to his resolve to abandon the vanities of this world and devote his life to God. This, the moment of his conversion, was the subject painted by Maella during the late summer of 1786, for the main altar in the chapel. Since the noble convert was married, with young children, it was not until after the death of his wife and the majority of his eldest son, in 1551, that the Emperor granted him leave to renounce his estates and titles.

In the scene painted by Goya for the left wall of the chapel, which is illuminated by light from a cupola, the father embraces his heir on the courtyard steps and prepares to leave home, accompanied by his second son, Don Juan, who waits in the foreground. This may represent Francis Borgia's departure for Rome in 1550, after he had settled his affairs in Gandía and been awarded a doctorate by its University. However, it is more probably a fictional representation of the renunciation of his estates and family, since he received the Emperor's licence in Oñate, in the Basque country, after his visit to Rome. The scene as painted by Goya enabled his patroness to centre the incident on the family home and to show her saintly forbear surrounded by the children from whom she traced her descent.

A preliminary drawing, sketched in chalk on blue-grey paper (fig. 114), shows the leave-taking with the principal figures in profile. In the oil sketch (cat. 16), father and son again clasp one another around the neck, but are swung round into almost frontal poses, their feet facing the flight of steps down which the father is about to walk towards his new life in the service of the Church. The composition is formed on two axes, the pyramidal and perspectival arrangement of figures and architectural elements in the foreground, and the frieze of weeping women – possibly the three Borgia daughters – and male attendants against the rhythms of the architecture in the background. The sketch is painted on a rich red ground, with a free yet precise rendering of

heads and hands, ruffs and rich brocades. The expressions and gestures, full of emotional intensity, are all centred on the future saint, who stands booted and garbed for his journey, and ready to descend the steps. Don Carlos, as the heir and new head of the family, stands firm in his sorrow, linked through his light costume and the descending lines of his father's arm and sword, to the child, perhaps the youngest son, Don Alonso, weeping bitterly, with one arm on the balustrade.

In the large finished painting for the chapel (fig. 115), the immediate, dramatic intensity of the sketch is replaced by greater frontality and monumentality. The descending balustrade has been realigned to reduce its perspectival pull, and the child's gestures have been altered accordingly, while Don Juan is now seen in strict profile in the foreground, with only his head turned towards his father. The sequence of arches and classical pilasters in the sketch has been replaced by a single arch decorated with a broad band of galloping knights carved in relief. The large-scale figures are now more distinctly defined, and the woman with clasped hands, on the right of the sketch (perhaps the daughter who entered a convent), has been replaced by a man, whose upward gaze draws attention to the halo over the Marquess's head. The poses and expressions of him and his son and heir are more harmonious, and less suggestive of the wrench of their impending separation than the rhythms that link them together in the sketch.

The 'leave-taking' scene, conceived in the grand Venetian manner, is an example of the kind of historical biography that became fashionable in France and Germany in the 1760s and 1770s. The scene of the miracle, painted for the opposite wall of the chapel, was one in which Goya could more easily exercise his fantasy. Where the initial drawing for the leave-taking is executed in a traditional, almost academic, manner in chalk on coloured paper, the preparatory study for the Saint at the death-bed of an impenitent is freely drawn in

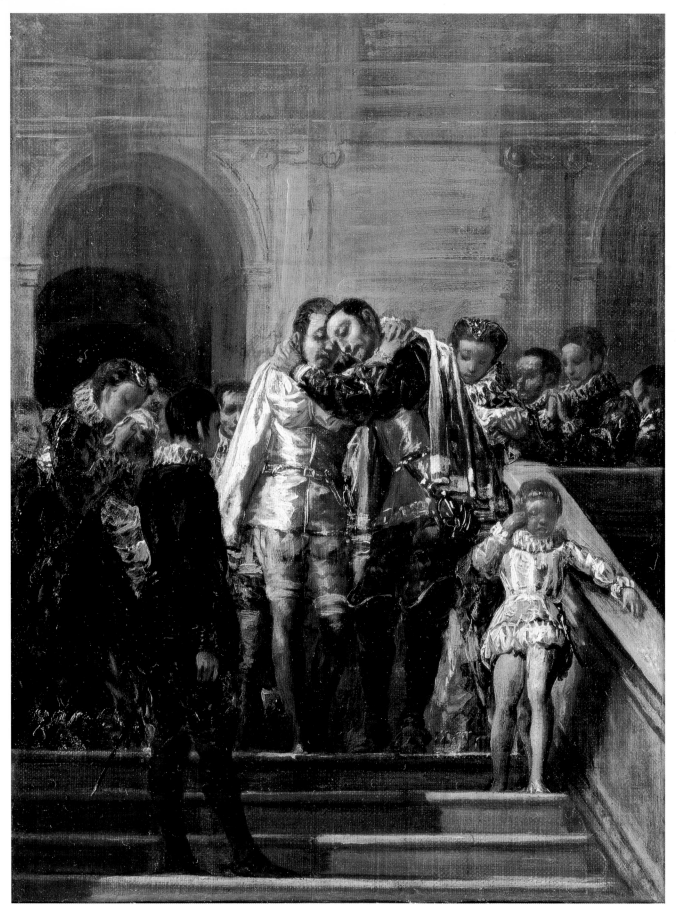

16 Sketch for *St Francis Borgia Taking Leave of his Family*, 1787–8
oil on canvas, 38 × 29.3 cm, Marquesa de Santa Cruz, Madrid

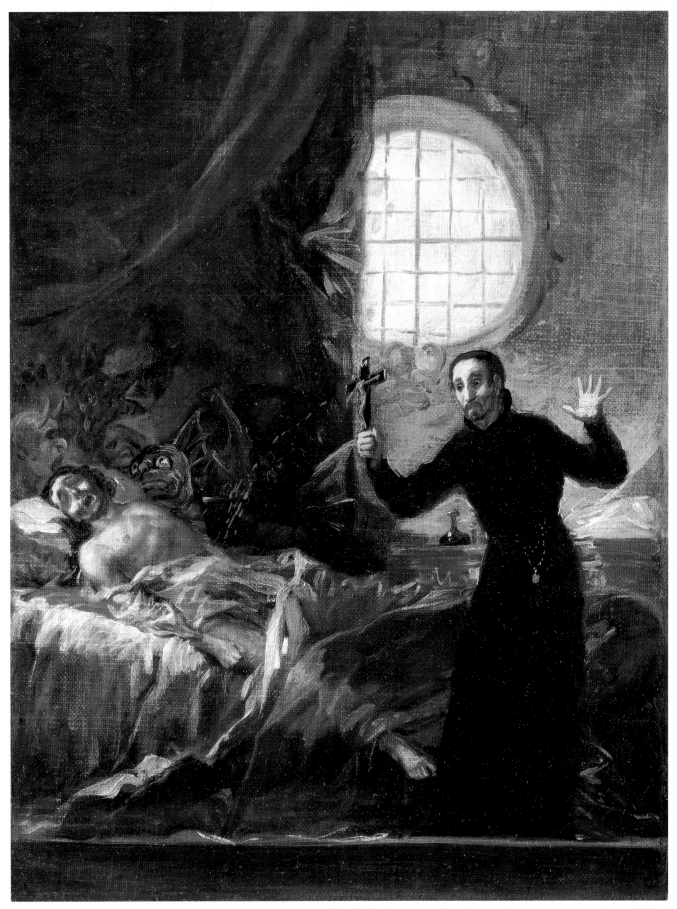

17 Sketch for *St Francis Borgia Attending a Dying Impenitent*, 1787–8
oil on canvas, 38 × 29.3 cm, Marquesa de Santa Cruz, Madrid

soft graphite or chalk to create effects of light, and shows visible alterations in the design (fig. 118). The Saint, in his simple priest's habit, stands in profile beside the bed, with his crucifix held above the dying man, whose bare chest and right foot emerge from the bedclothes. In the background, a winged devil flees, while three lightly sketched cherub heads hover over the man whom the Saint is about to save.

In the oil sketch (cat. 17), Goya has already eliminated the Baroque elements of cherubs and clouds, but replaces the fleeing devil by a group of monsters, drawn from the traditions of Spanish medieval art, that lurk in the shadows behind the bed. The picture is divided almost exactly into two: in the right half, a large round window with stucco decoration is seen beyond a table on which a glass flask is prominently displayed, probably containing the holy oil for administering Extreme Unction, with a suggestion of white linen, perhaps for the shroud. The Saint, silhouetted in black against the bluish wall, stands in an almost frontal pose, his habit just in contact with the dying man's foot. He grasps the crucifix in one hand, while his expression and the extended fingers of the other hand express awe and wonder at the miracle that is occurring: the right arm of the little image of Christ is detached from the cross and points in the direction of the figure on the bed, sending drops of blood spurting towards the impenitent, spattering his nightshirt and the edge of the sheet. In the left half, darkened by the green draperies of the bed, the dying man lies against the pillows, with his chest thrust out and mouth open in fear and agony. The downward thrust of his arm and clenched fist, half-bared leg and foot express extreme pain and tension as the miraculous blood touches the body possessed by the Devil.

This sketch is already closer to the flat, relief-like effect of the final version of the leave-taking, and its suggestion of a dais below the bed echoes the horizontal accent of the steps in the first composition. Here, the red ground on the canvas is even more apparent, much of it left uncovered, but the swift brushwork is just as precise and effective in describing forms, detailing expressions and constructing the brilliant light effects. The monsters, much heralded by art historians as the first in Goya's work, are at once naive and powerful. Next to a horned demon, seen in profile at the left edge, is a goat's head, followed by a monstrous creature with great red eyes, and another figure behind these two; the rest of the space is filled by a dark, bat-winged demon whose black-clawed paw rests threateningly on the bed.

The tense excitement of the scene in the sketch gives way to much suaver treatment in the large finished painting (fig. 119). Here, the half-naked figure of the possessed impenitent recalls the heroes and victims of David's classicising compositions, while the spirituality of the Saint is emphasised by his mystical expression and the full halo around his head. He is placed farther off and reduced in size, so that he appears slimmer and more elongated, and occupies less space within the composition. In this final version, the blood sprays out from the hand of Christ towards the dying man's head, and although the monsters, now slightly more 'human' in appearance, still gloat in anticipation of their prey, the dying man is already receiving, or is about to receive, the miraculous transfusion: his hand, no longer clenched, unfolds over the bedclothes, his body is softly shrouded, and the vivid touches of light that suggested his out-thrust left leg in the sketch have been eliminated here.

In the sketch, there is an emotional, 'earthly' immediacy, but an irrational construction. Standing forward of the bed, the Saint could not, and does not, actually look at the recumbent figure, nor could the blood from the crucifix fall where it does. For the chapel in the Cathedral, Goya created a composition of great elegance and rationality as well as power, and in a discourse to the Valencian Academy in

Fig. 117 Michel-Ange Houasse, *Appearance of St Francis,* *c.* 1722
Institute of San Isidro, Madrid (on loan to the Prado, Madrid)

1796, Don Pedro de Silva praised it for the natural effects that would enable even the ignorant to understand the picture's meaning.

At the end of the 1780s, Goya was still eliminating angels and clouds of glory from his religious compositions, and giving them a more naturalistic appearance, but he was not afraid to introduce into them the darkness and demons that were to play so prominent a role in his work of the following decade.

Fig. 118 *St Francis Attending a Dying Impenitent*, 1788
charcoal, 32 × 25 cm
Museo del Prado, Madrid

Fig. 119 *St Francis Attending a Dying Impenitent*, 1788
oil on canvas, 350 × 300 cm
Valencia Cathedral

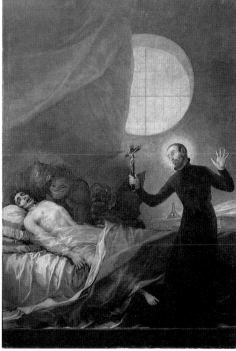

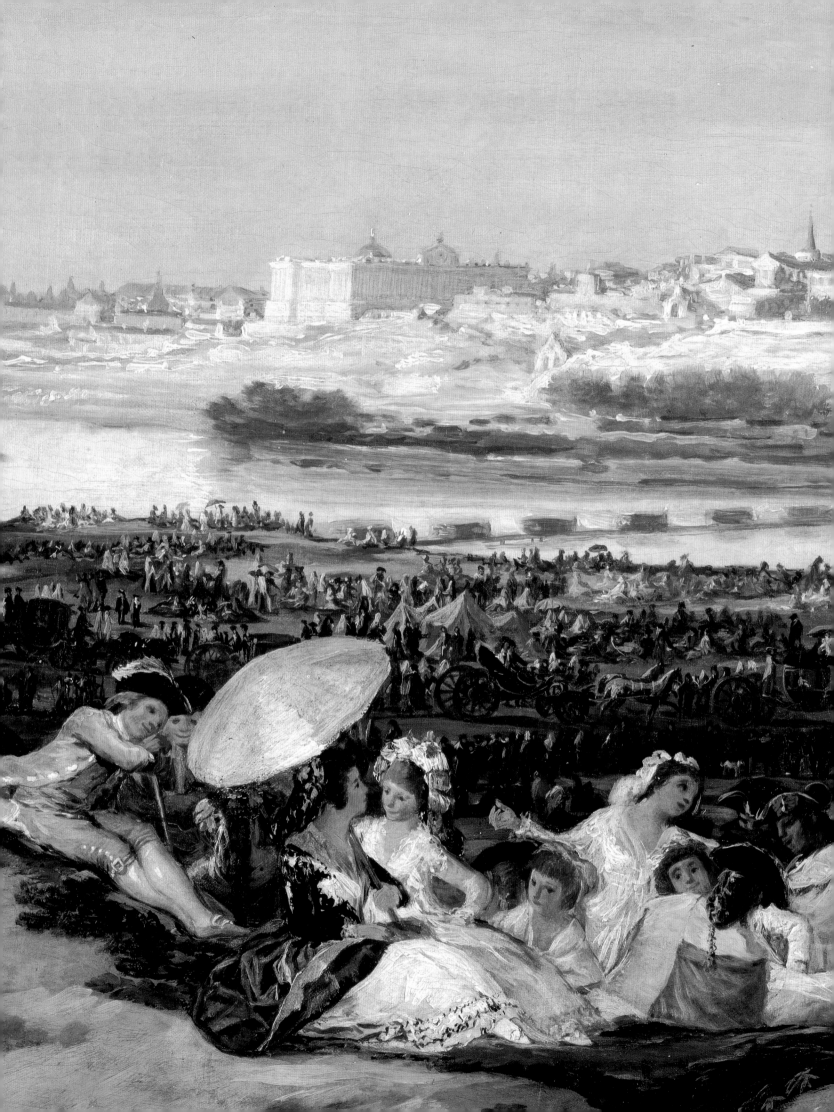

Allegory and Genre: Tapestry Cartoons

1784–1792

*I*n the 1780s, Goya's commissions for religious paintings consolidated his reputation in Madrid, after his success in 1784 in the important 'contest' of the altarpieces for San Francisco el Grande (cat. 11, 12). The earlier years of the decade were spent working on the Pilar frescoes and his painting for San Francisco el Grande, and in spite of a commission to paint a major, full-length portrait of the Prime Minister, Count Floridablanca (fig. 35), Goya's letters to Zapater reflect his anxiety about commissions and their remuneration. Thereafter, in spite of the apparent fiasco in Saragossa (cat. 8, 9), his growing fame in Madrid led to commissions for Salamanca, Valladolid and Valencia.

Although work for the Royal Tapestry Factory resumed in 1783, Goya made no further cartoons until his appointment as Painter to the King in June 1786. However, in 1783 he began working for the Infante Don Luis, the King's brother, who lived in semi-exile with his wife, Doña María Teresa de Vallabriga (cat. 59), and their three children at Arenas de San Pedro, near the Sierra de Gredos. Goya stayed there on two occasions, in 1783 and 1784, painting bust and full-length portraits, and a great family group with thirteen figures and the artist himself at his easel in the corner (fig. 41). Although the Infante died soon afterwards, more patrons came forward, among them the Duke and Duchess of Osuna (fig. 43), for whom Goya painted the first of a series of portraits in 1785. The Duchess of Osuna, or

Marchioness of Peñafiel and Countess Duchess of Benavente and Gandía as she then was, spent much of her time on the family's property at La Alameda, just outside Madrid. Called 'El Capricho', this elegant country house reflected her own and her husband's advanced and refined tastes, and Goya painted a set of beautiful, decorative canvases for one of the rooms there. These 'country pictures' (figs. 45, 46) are very similar in spirit to the tapestry cartoons painted at the same period (see cat. 19–24), and they reflect a certain mischievous irony as well as more sober themes.

These new patrons and new commissions, his success at Court, even the jealousy of his rivals, gave Goya's work a new impetus and a new spirit of modernity and innovation in the second half of the 1780s. His evident delight at his good relations with the King and the Prince of Asturias, with ministers and the nobility, as well as his friendship with cultured intellectuals such as Jovellanos and Ceán Bermúdez, gave him the freedom and confidence to work in a variety of styles and seek intelligent solutions to the artistic and intellectual problems posed by his various commissions. This particularly fruitful phase in his work was to lead to his ultimate dissatisfaction with painting tapestry cartoons, and friction over this issue with the palace bureaucracy may have added to the stresses that contributed to the serious breakdown of his health in the closing months of 1792.

Fig. 120 Detail from *The Meadow of San Isidro* (cat. 26)

A MYTHOLOGICAL ALLEGORY, 1784

Although this is one of the very few works, apart from portraits, that Goya signed and dated, nothing is known about its origins. The artist's name and the date are prominently inscribed, as if engraved, on the blade of the great sword at the centre of the composition, and the scene suggests a sophisticated joke, a puzzle picture painted to amuse a patron, or perhaps the artist himself.

Its traditional title is a reference to the Greek myth of Omphale, Queen of Lydia, who purchased Hercules as a slave, a condition to which he had been temporarily condemned by the Delphic oracle. Surrounded by luxury in Omphale's palace, Hercules adopted feminine ways, and lived in thrall to his royal mistress. In Goya's picture, he appears in the guise of a 16th-century knight in full armour, seated on a low stool before a lively young woman who has a work-box on her lap. From it comes the thread that Hercules is attempting to insert into the eye of a needle. Behind the two, Omphale holds the sword with Goya's name, her fur-trimmed gown perhaps alluding to the lion's skin taken in jest from Hercules. The great sword penetrates the space between the hero's busy hands and the young woman's work-box, and disappears behind the rich red fabric – Hercules' cape? – lying over her knees. Is she one of Omphale's 'lascivious Ionian maidens'? In a *décolleté* gown and plumed hat, she leans back with an amused expression, apparently contemplating the wriggling, gilded dragon on Hercules' helmet, lifted from the Italian Notebook (fig. 62). The work-box rests on her lap, and her slightly parted legs and slippered feet form alternating, interpenetrating patterns with the armoured legs of the needle-threading warrior, recalling Omphale's legendary beating of her lover with her golden slipper. A pet dog stares out at some unseen observer, perhaps the one who 'illuminates' the scene, since no source of light is visible within the picture.

The picture's meaning for Goya and his circle may never be unravelled, but certain other works are suggestive. In the same year, 1784, Goya painted the very large family portrait (fig. 41) in which the Infante Don Luis, already old at 56, plays patience beside his beautiful young wife, who had been portrayed on horseback the previous year (see cat. 59). It seems not impossible that Goya's *Hercules and Omphale* alludes to the circumstances of their marriage of convenience, arranged by the King (fig. 116), and to some amorous intrigue within their circle. The picture's sexual symbolism is also reflected in a print from *Los Caprichos* (fig. 121). An old man with a skein of yarn over his arms is linked by a thread to a young girl standing with legs apart and with the ball she should be winding suggestively held in front of her.

This brilliant composition, freely yet precisely brushed over the rich red ground, with sumptuous colours and subtle modelling, confirms the mastery that made Goya the most accomplished, most envied and most intrigued-against artist at the Court of Carlos III in the 1780s.

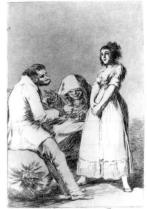

Fig. 121 '*It is better to be lazy*', pl. 73 of *Los Caprichos*, 1797–8
etching and aquatint, 21.7 × 15.2 cm
Museo del Prado, Madrid

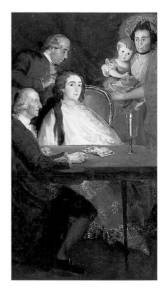

Fig. 122 Detail from *Infante Don Luis and his Family* (fig. 41)

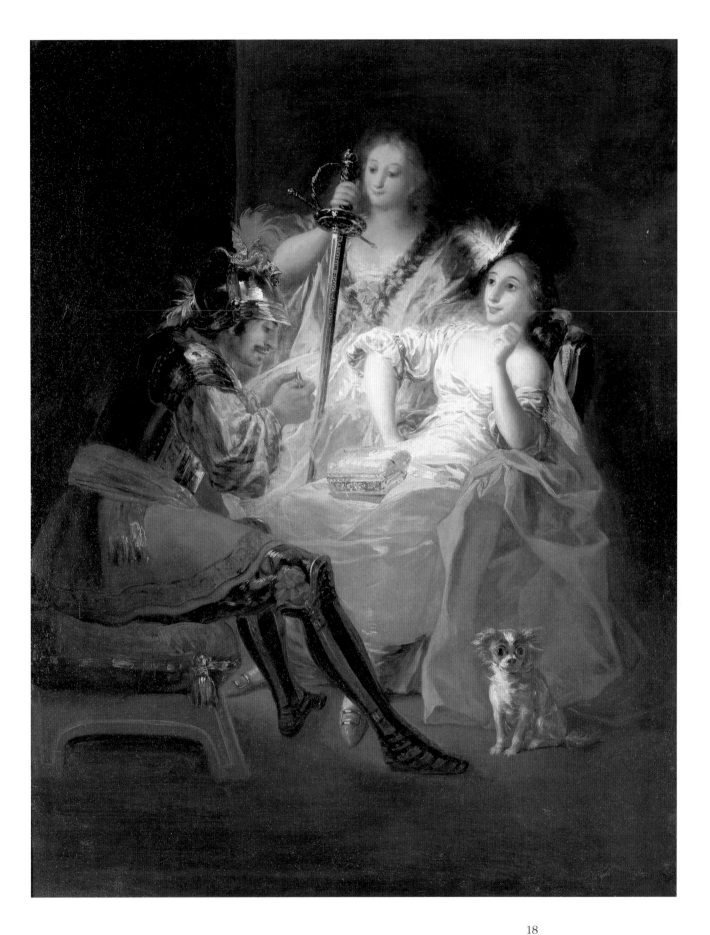

18
Hercules and Omphale, 1784
oil on canvas, 81 × 64.5 cm
Signed and dated on the sword-
blade: '*FRANCISCO DE GOYA AÑO 1784*'
Private Collection

TAPESTRY CARTOONS, 1786–1792

On 25 June 1786, at the Palace of Aranjuez, Don Pedro de Lerena, the King's principal major-domo, signed a Royal Order to the effect that 'The King has been pleased to nominate Don Ramón Bayeu and Don Francisco Goya, so that under the supervision of His Majesty's artists, Don Francisco Bayeu and Don Mariano Maella, they should paint the designs to be woven in the Royal Factory, and whatever else is required of them for the royal service, granting to each of them fifteen thousand *reales* a year'.

The dry terms of the official document contrast with the excited and triumphant tones of the letter that Goya penned to his close friend Zapater in Saragossa:

'My dear Martín, I am now Painter to the King with fifteen thousand *reales* and although I've no time I must let you know how the King sent an order to Bayeu and Maella to search out the two best painters that could be found to paint the cartoons for tapestries and whatever the Palace might need, in fresco or in oils. Bayeu proposed his brother, and Maella proposed me. Their advice was put before the King and the favour was done, and I had no idea what was happening to me.

I have thanked the King and the Prince and the rest of the notables, and Bayeu because he said it was thanks to him that Maella proposed me, and Maella because he proposed me.'

The letter, dated 7 July and signed with a characteristic mixture of intimacy and dignity, 'Yours and yours again, Francisco de Goya', marks the start of a period of intense artistic activity and the production of some of Goya's most beautiful works. From 1786 until the death of Carlos III in December 1788, Goya was painting portraits for the Banco Nacional de San Carlos and a growing clientele among the nobility (fig. 43), altarpieces for Valladolid and Valencia (cat. 15–17), a major group of decorative paintings for La Alameda commissioned by the Osuna family (figs. 45, 46), as well as his sketches and cartoons for the Royal Tapestry Factory. The first of the new series of cartoons included the largest canvas he ever painted, and although the second series was abandoned after only one cartoon had been executed, it was preceded by the preparation of exquisitely detailed sketches (cat. 25–9).

On the accession of Carlos IV and María Luisa, Goya was nominated to the post of Court Painter, which led to his numerous official portraits of the monarchs; and in February 1790 he was to comment on his position 'as someone who is so well known that from the King and Queen down, everyone knows me'. However, Goya's confirmation as the most notable Court artist was accompanied by a sudden personal distaste for painting tapestry cartoons, perhaps because of the pleasures of making 'fancy pictures' for the Osunas and the brilliantly inventive sketches for *The Meadow of San Isidro* and others in the series whose translation into full-size cartoons was cancelled on the death of Carlos III. A new series of cartoons, ordered for the Escorial in April 1790, was still incomplete by mid-1792. At the end of that year, Goya suffered the nearly fatal illness that left him profoundly deaf, bringing changes in his way of life that allowed him to give fuller rein to '*capricho* and invention' in his art.

DINING-ROOM OF THE PRINCE AND PRINCESSS OF ASTURIAS, PALACE OF EL PARDO, 1786–1787

Following his nomination as Painter to the King in June 1786, mentioned to Zapater in Goya's letter of 7 July, he wrote again to Zapater on 12 September, commenting on a new project for tapestry cartoons: 'I'm now very busy making sketches for a room in which the Prince dines'. With his new appointment, Goya became a Court employee, salaried to paint cartoons for the Tapestry Factory and any other works ordered by the King, such as the altarpieces for the convent in Valladolid (cat. 15). He therefore no longer presented invoices with detailed descriptions of the cartoons, as he had done with the earlier series (cat. 7), but accounts and receipts for the expenses he was entitled to claim: for his colour-grinder, for stretchers and canvases, for colours and other supplies, including suspiciously large quantities of paint brushes.

The sketches on which Goya was working in September 1786 were for tapestries to decorate the dining-room, or 'conversation room', of the heir to the throne, Carlos, Prince of Asturias, and Princess María Luisa, in the Pardo palace. Carlos III had requested 'paintings of pleasant, light-hearted subjects that are needed for that palace', and Goya was given the measurements for six principal panels, a cornerpiece and six overdoors. His accounts included payment for 'a coach to the Royal Palace of El Escorial to present to His Majesty (whom God preserve) the sketches for the dining-room at El Pardo', and this event probably took place in November or December 1786. In a letter dated 16 December, Goya replied to Zapater's reproaches for his silence by protesting that he had far too much to do, and would prefer less success and a quiet life with his friend, 'rather than be lauded and applauded by the King and the Prince and Princess, and have so many worries'.

The designs for the dining-room are among the finest of Goya's cartoons, and they include the largest work he ever painted (fig. 126). Over fifty metres of canvas were invoiced on 26 October, and the carpenter was paid for the stretchers on 17 November, while further supplies of artists' materials were invoiced up to 25 April 1787. In the end, as a consequence of the death of Carlos III the following year, the tapestries woven from Goya's designs were never hung in El Pardo, but his cartoons, and their preparatory sketches, reveal the freshness and originality of Goya's 'inventions'.

The principal theme of these 'pleasant, light-hearted subjects' is the Four Seasons, and the designs incorporate much traditional imagery and draw on Goya's rich pictorial culture culled from a wide variety of sources, including the works of art in the royal collections. However, his approach was entirely original, and each image is built around a particular incident and tells its own story. Small but revealing differences between the sketches and the final cartoons, as well as changes visible within the works themselves, show how thoroughly Goya worked to clarify his ideas and improve his compositions. He must have taken into account not only each individual tapestry that was to follow, but also their relationship and their sequence within the room. Although the dining-room itself is no longer identifiable, a tentative reconstruction (see fig. 124) suggests that the huge tapestry of *Summer* may have hung on a long wall facing the windows, *Spring* and *Autumn* opposite each other on the shorter walls, while *Winter* would have occupied the indirectly lit wall

Fig. 123 The tapestry sketches (cat. 19–24) in a sequence according to the likely arrangement of the finished tapestries
in the dining-room of the Palace of El Pardo

Fig. 124 Hypothetical reconstruction of the arrangement of the tapestries in the dining-room in the Palace of El Pardo, including overdoors

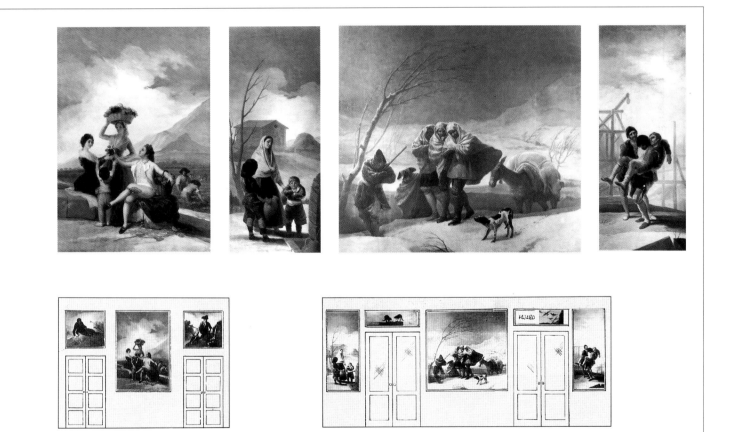

between the windows, with the two narrower panels on either side (cat. 23, 24).

The sketches that Goya presented to the King evidently remained his own property, and were later bought by the Duke and Duchess of Osuna, together with those for other cartoons (cat. 25–28), for the Duchess's study at La Alameda. They remained together, with one exception, until their sale by auction at the end of the 19th century, and are now widely scattered. Studying them and comparing them with the cartoons (all of which are in the Prado Museum) is like watching the artist at work in his studio, sketching, correcting and altering his compositions as his ideas developed around each particular subject or picture.

Two in the series – *Spring* and *Autumn* – illustrate pleasant pastoral amusements; *Summer* shows peasant workers and their families resting from their labours during the harvest, while *Winter* offers a momentary encounter between rich and poor in a chill and desolate landscape. While the main theme is the Four Seasons, an underlying motif of four of the six principal compositions is the nature and behaviour of children, closely and lovingly observed. In the autumn of 1786, when Goya was working on his tapestry designs for the Prince and Princess of Asturias, the couple already had three daughters, and their first son, the future Fernando VII, was just two years old. Fernando was born in October 1784, two months before Goya's own son, Francisco Javier, who was the only one of his seven baptised children – five boys and two girls – to survive. The artist was also painting the three young children of the Duke and Duchess of Osuna at this time (a group portrait now lost), and in 1788 he painted them again, in the enchanting family portrait that also included the fourth and youngest child (fig. 43). Other portraits suggest that children were very much a preoccupation at this time, and Goya painted them with unsurpassed skill and great affection.

In *Spring*, also known as *The Flower Girl*

(cat. 19), a country girl kneels in an open landscape, offering flowers to a woman out walking with a prettily dressed little girl. Behind them, a rustic with his finger to his lips holds up a little rabbit with which to startle the woman, cautioning the viewer not to give his game away. In the sketch, the little girl holds some brightly coloured flowers tightly in both fists and leans forward to look at the flower-girl, while her mother grasps her firmly by the wrist as she accepts a long-stemmed rose. The decorative nature of the scene, with its note of simple humour, is expressed with great verve and built on diagonal movements within the group that also integrates it within the land-scape setting.

In the cartoon (fig. 125), Goya has clarified the composition. The rabbit is clearly now the centre of the story: held upright, it faces towards the unsuspecting young woman whose head is bent towards the flower-girl. The child now holds her mother's hand, and behind her back looks up expectantly at the rabbit, awaiting the next move with obvious interest. The landscape helps to reinforce the story, bringing the focus constantly back to the rabbit as the eye is guided along the flowing

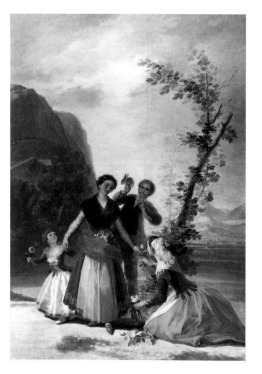

Fig. 125 *Spring* or *The Flower Girl*, tapestry cartoon, 1786–7 oil on canvas, 277 × 192 cm Museo del Prado, Madrid

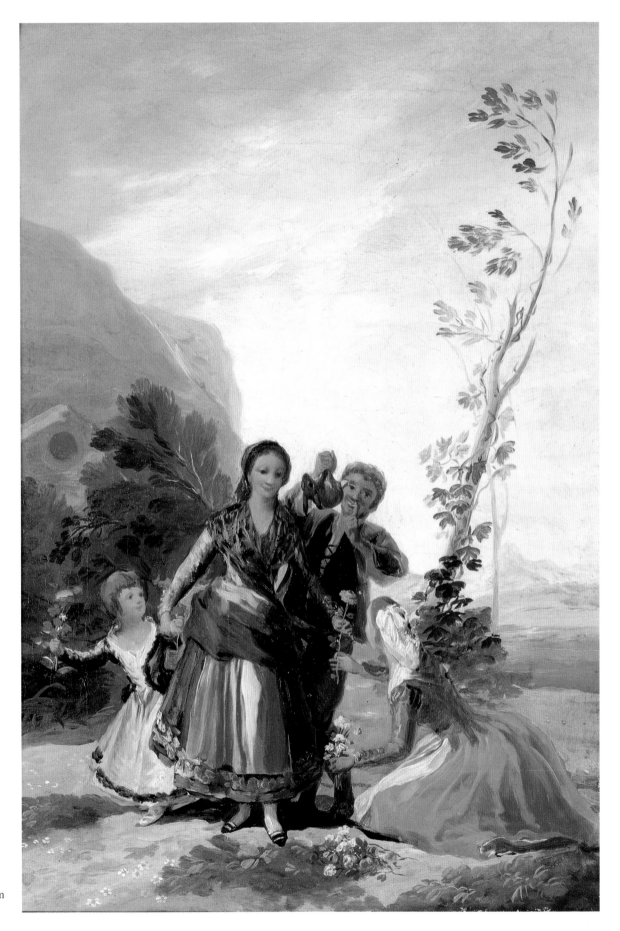

19
Sketch for *Spring* or
The Flower Girl, 1786
oil on canvas, 34.2 × 23.9 cm
Private Collection, Madrid

lines of the composition. Goya's many altera-
tions all relate to the telling of the amusing little
incident through which he represented his
allegory of *Spring*.

Perhaps because of its enormous size, just
short of three metres high by six and a half
wide, Goya's cartoon representing *Summer*,
or *The Harvest* (fig. 126), differs relatively little
from the preparatory sketch (cat. 20). The
design was first roughed out in graphite on the
prepared canvas, and the quick, free strokes
are visible in many areas. The composition is
conceived, like the much earlier *Brawl at the
Cock Inn* (cat. 7), as a frieze of figures, with an
even more markedly triangular grouping in the
centre. From the stone roller on the threshing-
ground to the left, the eye moves to the group
of merry peasants who are exchanging flail and
rake for a bottle and glass, and making a
ragged companion drunk. A mother, feeding
her protesting toddler, links the four figures to
two men laughing and talking together in the
centre. Behind them, another figure leaning on
the straw leads the viewer's eye up to the cart,
on which three little boys are romping. The
almost cinematic sequence of their poses and
movements suggest their imminent fall, and a
woman behind the cart raises her hands in
alarm. Nearby, a man plays with his child, while
another man lies snoring, mouth open and
chest bared.

Two horses are also enjoying the rest, a bay
standing to forage for grain and a gentle grey
mare lying on the straw. The centre of the
composition is marked by the sickle, symbol
of the men's labours on the estate that is
dominated by the castle in the background.
And to remind his viewers that this 'idyllic'
scene is a moment of respite in a life of toil, an
anonymous peasant works on beside the
mounting stacks of straw on the right. In the
cartoon (fig. 126), Goya introduced further
refinements, simplifying the composition
while emphasising and defining details, the
figure of the young simpleton whose glass is
being filled, for example, who in the final

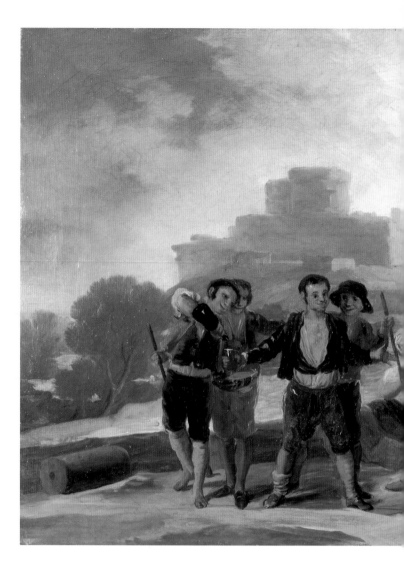

Fig. 126 *Summer* or *The Harvest*,
tapestry cartoon, 1786–7
oil on canvas, 276 × 641 cm
Museo del Prado, Madrid

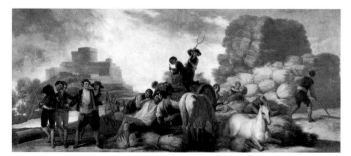

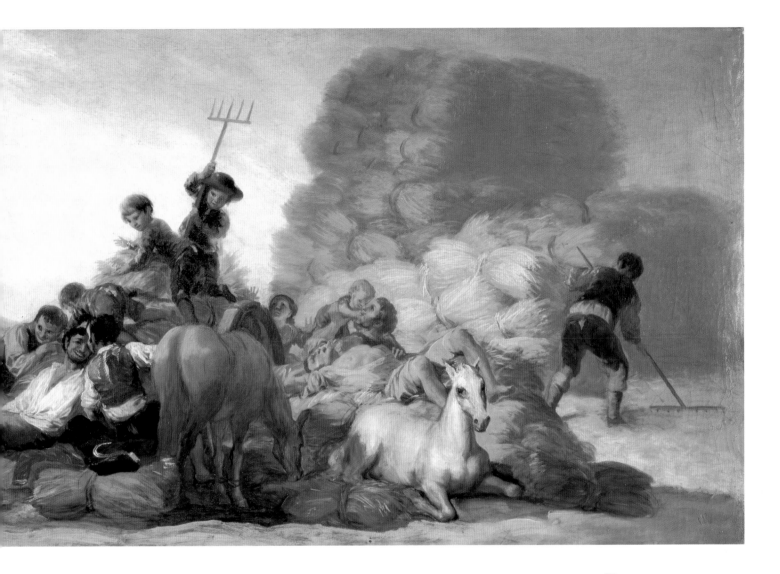

20
Sketch for *Summer* or
Harvesting, 1786
oil on canvas, 33.5 × 79.5 cm
Museo Lázaro Galdiano, Madrid

design is clearly presented as the village idiot, now pitilessly mocked by everyone.

As in the two preceding compositions, Goya's allegory of *Autumn* (cat. 21) is expressed in a contemporary Spanish idiom, and resists interpretation on more than a superficial iconographical level. The two seated figures have usually been seen as the aristocratic parents of the beautifully dressed little boy. But in spite of the nonchalantly familiar pose of the man, apparently the 'lord' of these vineyards, his dress and *redecilla* (hair-net) – clearly seen in the cartoon – identify him as a *majo*, and he is seated on a noticeably lower level than the lady. Is Goya, like Velázquez, presenting 'a pretence Bacchus' ('*un Baco fingido*') in the person of this attractive young *majo* in his clothes of yellow silk? In the sketch, he is seated on a wine barrel covered by his cloak, with vine leaves and branches strewn at his feet, in front of the vineyards that spread into the distance and in which two men toil. One hand rests on a basket full of grapes, and with the other he holds up a magnificent bunch of grapes as an offering to the elegant lady in black, carefully seated on a cloth on the low stone wall. The 'comedy' in this instance centres on the little boy who jumps up and down, reaching for the grapes that are just beyond his grasp, while a handsome young woman with a great basket of grapes on her head crowns the group as a personification of Autumn.

In the cartoon (fig. 127), the lady appears even more clearly as the mistress of the estate, receiving the gifts of nature as she looks at the young man with an air of wonder and takes the bunch with a gentle gesture. Her young son, now quieter, stands straight with arms outstretched towards the grapes, and leading the spectator's eye towards the girl with the basket.

The sketch is one of the liveliest in the series, full of pencil underdrawing and pentimenti in the painted design, and the country girl with her basket recalls a sturdy figure from Goya's Italian Notebook (fig. 63); in the cartoon she is a young woman of extraordinary beauty, seen in a glow of reflected light, and intimately linked through line and colour to the figure of the grape-bearing Bacchus-*majo*.

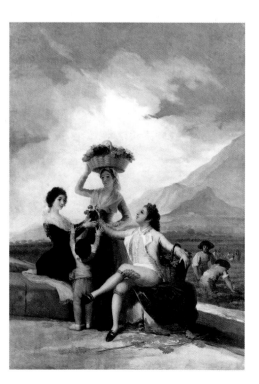

Fig. 127 *Autumn* or *The Grape Harvest*, tapestry cartoon, 1786–7 oil on canvas, 275 × 190 cm Museo del Prado, Madrid

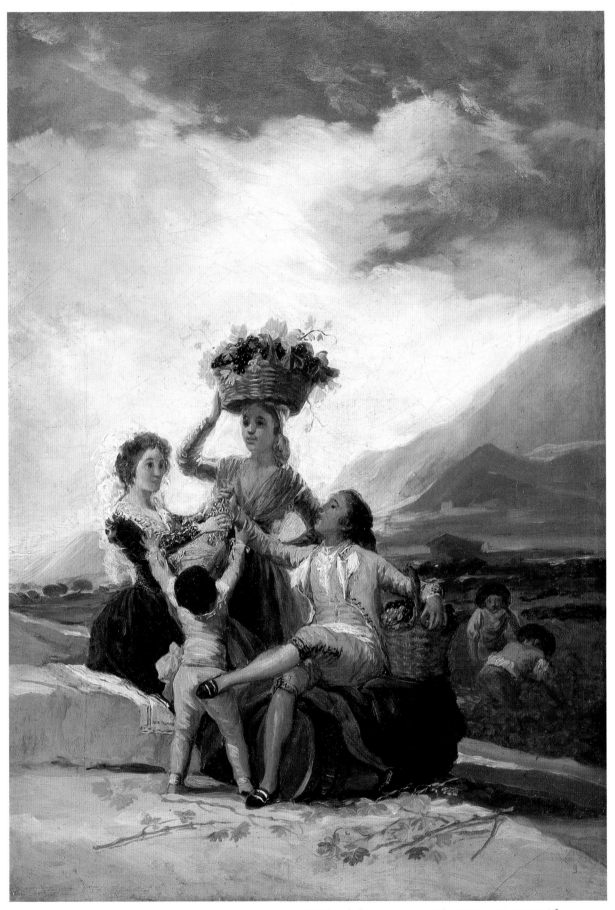

21 Sketch for *Autumn* or *The Grape Harvest*, 1786
oil on canvas, 33.8 × 24 cm, Sterling and Francine Clark Art Institute,
Williamstown, Massachussetts

In contrast to the previous Seasons, *Winter*, or *The Snowstorm* (cat. 22), introduces a more sombre mood, and the sketch is one of Goya's most impressive small-scale works. It shows three poor peasants in a snowstorm, walking in step with left foot forward, and huddled under a single blanket pulled round their heads and shoulders, revealing their inadequate clothing. Their faces express profound despair, and they are so sunk in their misery that they have not seen two men who approach from behind, and are about to collide with the first as he turns into their path.

The first approaching man appears to be a servant, well-wrapped in a hooded greatcoat with red trimmings. His follower, in a cape and hat, leads a mule laden with the gutted carcass of a pig. Buildings in the background suggest that all the men have come from a nearby farm or village. The biting wind tears at the blanket of the three unfortunates, revealing money-bags on the belt of the nearest man. Goya seems to imply that the three poor men had between them insufficient money to buy a pig for their families, while the rich will have plenty and to spare. The scene is both sad and comic, with the men from two different classes, unaware of each other and about to collide, with only the dog, already stopped in its tracks, aware of the impending encounter.

In the cartoon (fig. 128), Goya eliminates the comic element and allows the serious theme to dominate. The setting is expanded to create a much more desolate winter landscape: the buildings have disappeared and trees bend violently in the wind, while the well-dressed servant, who has lost his rich red armpieces, now carries a gun, the crucial new element. The three poor peasants here each have a blanket, but one of them now raises his eyes, drawing the spectator's attention to their wretched condition, while even their dog seems more frightened and submissive under threat from the gun. Such significant changes in the final design intended for the royal palace invite analysis of the precise meaning of the composition in both sketch and cartoon.

In 1794 a tapestry woven from one of Goya's cartoons was described as 'a woman and two lads who are fetching water from the fountain', and the sketch for this design was described in a sale catalogue of 1896 as 'A woman and two children by a fountain'. But when the catalogue of Goya's tapestry cartoons was published by Cruzada Villaamil in 1870, soon after their rediscovery, it appeared with the title *Poor People* (*Los Pobres*) and the description 'A poor woman, shivering with cold near a fountain, accompanied by two children, waits for a pitcher placed under the spout to fill with water. Snowy landscape background.' This misreading of the subject was later reinforced by a comparison with similar figures in an *Allegory of Winter* by the Catalan painter Antonio Viladomat, with the result that Goya's *A Woman and Two Children by a Fountain* has been seen and interpreted, for over a century, as a variation on *Winter*.

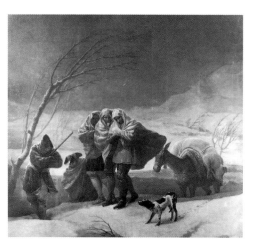

Fig. 128 *Winter* or *The Snowstorm*, tapestry cartoon, 1786–7
oil on canvas, 275 × 293 cm
Museo del Prado, Madrid

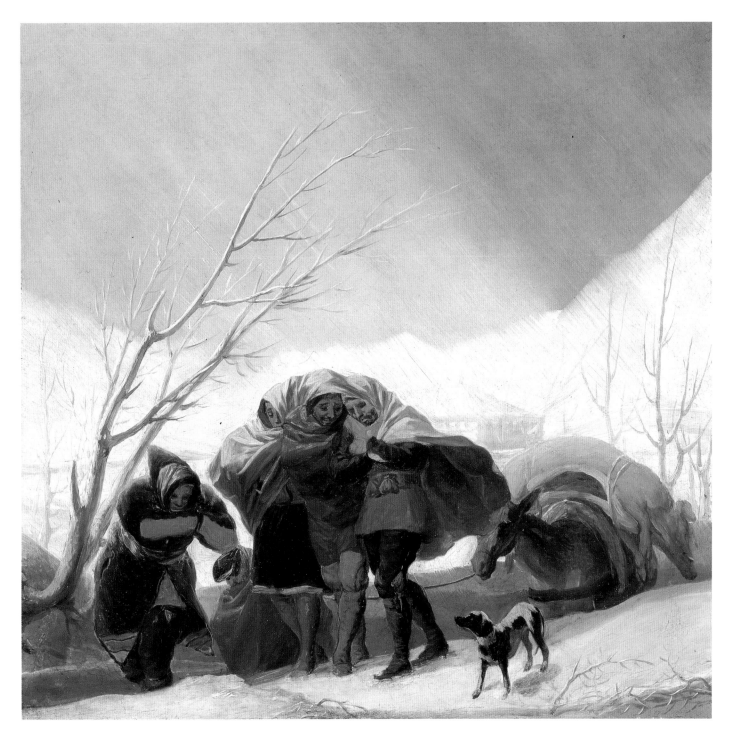

22
Sketch for *Winter* or *The Snowstorm*, 1786
oil on canvas, 31.7 × 33 cm
The Art Institute of Chicago,
Bequest of Verde C. Graff

Goya's sketch (cat. 23) shows a young woman with two children by a fountain at which a pitcher is filling slowly, while another stands on the ground. The older boy holds a small pitcher and faces his younger brother who stands with arms folded and shoulders hunched, a furious expression on his face. His mother has a hand on his shoulder and is pushing him forward, gesturing with her right hand towards the jar in the fountain. All three appear warm and well-dressed, and there is nothing to suggest a wintry scene. Green rushes flourish and the ground recedes into a hazy, blue-pink landscape with a farm building, perhaps the family's home, while placid white clouds give way to blue sky at the top of the picture. What is the source of the little boy's rage? Probably that he has not been allowed to carry a pitcher to the fountain, like his elder brother, so his mother teasingly tells him to take the one that is filling.

In the cartoon (fig. 129), slight but significant changes and the introduction of the bare tree (probably responsible for the identification of the 'winter scene') serve to clarify the story. Mother and elder brother now both hold pitchers, and with no other jar standing on the ground it is clear that the small boy has come to the fountain empty-handed. The curving lines of the tree echo the gentle inclination of the mother's head, as she looks at her furious little son, but no longer encourages him to carry the full pitcher. The child's expression, emphasised by his 'pudding-basin' haircut and posture, hunched up and rooted to the ground, is marvellously observed. If further proof were needed of the family's status, the mother wears excellent, buckled shoes in the cartoon, and the little boy's boots are tied with bows. The simple comedy of the sketch is here converted into an example of maternal patience.

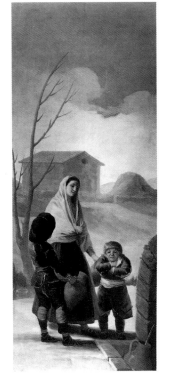

Fig. 129 *A Woman and Two Children by a Fountain*, 1786–7 oil on canvas, 277 × 110 cm Museo del Prado, Madrid

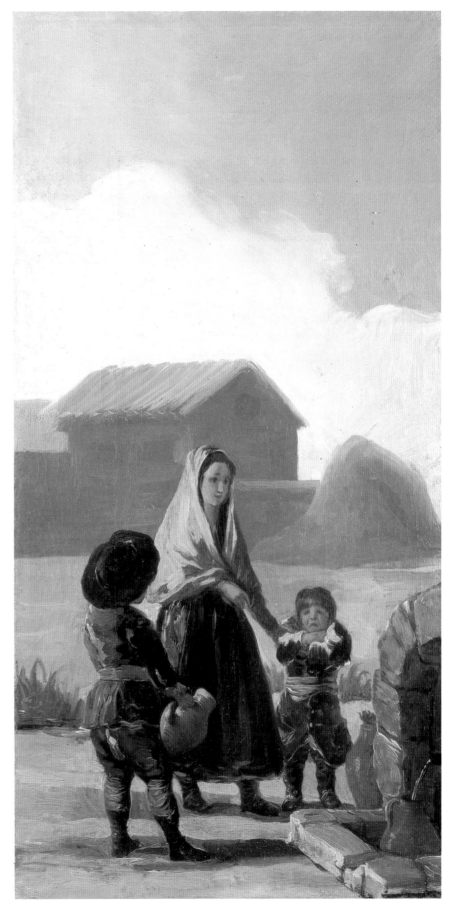

23
Sketch for *A Woman and Two Children by a Fountain*, 1786
oil on canvas, 35.4 × 18.4 cm
Private Collection, Madrid

If the bare tree in the *Woman and Two Children by a Fountain* suggests that it was intended to harmonise with *Winter*, the height of the straw-stack also links it with *Autumn*. Its pendant (cat. 24), whose seasonal significance is left unclear, also began as a 'comic sketch'. Goya's *Drunken Mason* shows two men carrying a injured companion. Blood runs down his cheek and stains his shirt, and the whole pose, from limply flopping legs to inert hand, suggest, though with considerable ambiguity, that he has passed out from pain rather than from drinking too much wine. However, the scaffolding in the background and the implied tragedy in the pose do not explain the knowing glances and grins of the two men carrying him. Their expressions may relate to the injured man's undress, in a shirt without his breeches, a state in which he also appears in the cartoon (fig. 131), where his companions are more neatly dressed and their expressions are more appropriate to the gravity of the scene, even though the blood that indicates that an accident had occurred has disappeared.

What kind of 'accident' has befallen the victim? What meaning was Goya conveying in the 'comic sketch' and then in the cartoon that is so different, and in which the group has all the gravity of a *Descent from the Cross* (see fig. 34)? The ostensible subject of the cartoon has been related to enlightened concern for the well-being of workmen and to a decree of Carlos III that sought to protect them against negligence and accidents on building-sites. But nothing in the sketch or in the cartoon indicates what really is happening, and in spite of the expressive force of the scenes it is difficult to grasp the full significance of Goya's invention.

This group of sketches for the dining-room at El Pardo is characterised by very freely pencilled underdrawing, fluid paint and touches of impasto that simultaneously create light and depth and the rhythm of the work. Full of pentimenti, the sketches provide evidence of Goya's remarkable inventive energy, illuminating the final designs of the more carefully organised and decorative cartoons that, although now dulled by time, constitute some of his most beautiful and complex paintings.

With the originality that is found in all his work, he kept to no rigid iconographical programme but composed these subjects with great freedom, around simple little comedies or scenes in which he slips from comedy in the sketches into the more serious themes that herald the subjects of the following decade.

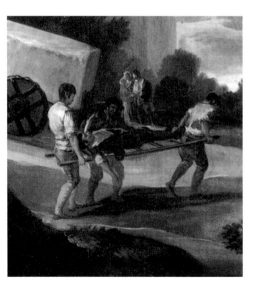

Fig. 130 Detail from *Transporting a Stone Block* (fig. 46)

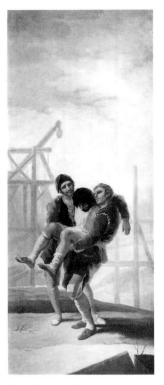

Fig. 131 *The Wounded Mason*,
1786–7
oil on canvas, 268 × 110 cm
Museo del Prado, Madrid

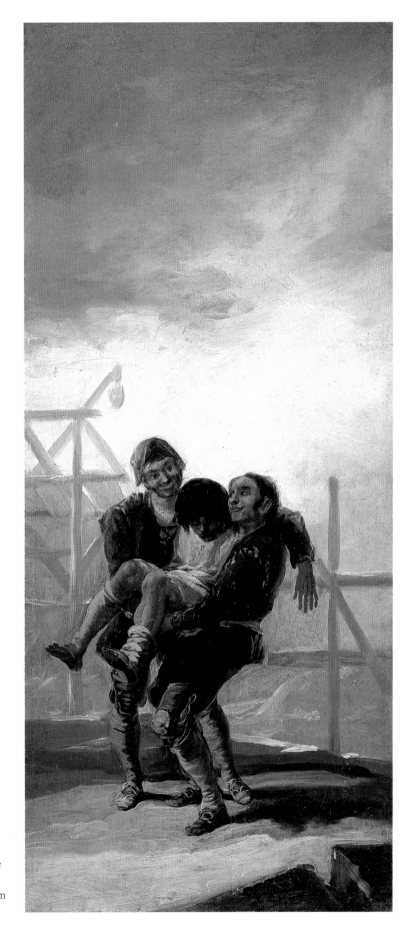

24
Sketch for *The Drunken
Mason*, 1786
oil on canvas, 34.9 × 15.3 cm
Museo del Prado, Madrid

THE BEDCHAMBER OF THE INFANTAS IN THE PALACE OF EL PARDO, 1788

Goya completed his cartoons for the dining-room of the Prince and Princess of Asturias (cat. 19–24) in the course of 1787, and from June to October of that year also painted the three altarpieces for the Royal Convent of Santa Ana in Valladolid (see cat. 15), in execution of his duties as Painter to the King. It was a particularly busy year, and in November he wrote to Zapater that 'I've grown old with so many wrinkles that you wouldn't recognise me except for my snub nose and deep-set eyes … and I'm beginnning to feel my 41 years in no uncertain way…'.

At the beginning of 1788 orders were given for a new series of tapestries for the palace of El Pardo, this time to decorate the bed-chamber of the Infantas, the sisters of the young Prince of Asturias. From Goya's accounts, we know that on 12 February he took delivery of 'five stretchers with their canvases for the designs for tapestries', in other words, the canvases for his preparatory sketches, and that by 10 April, over eighty metres of canvas as well as four large and four smaller stretchers had been supplied to him. However, Goya delayed getting down to work and it was not until 31 May, in a letter to Zapater, that he first referred to this new commission. He apologised, not for the first time, for failing to paint a promised image of Our Lady of Carmel, which he would have done 'if I hadn't had orders from on high to have the compositions for the bedchamber of the Most Serene Infantas ready for when the Court returns here, which I am struggling as hard as I can with, given the lack of time and the fact that the King and the Prince and Princess, etc. have to see them; besides which, the subjects are very difficult and need a lot of work, like the *Meadow of San Isidro* [see cat. 26] on the Saint's feast day, with all the commotion that usually accompanies it…'.

Fig. 132 The tapestry sketches (cat. 25–9) arranged as for the bedchamber of the Infantas, in the Palace of El Pardo

 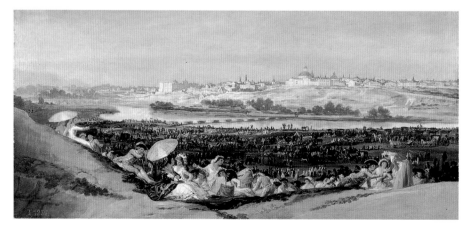

The new series of tapestries was intended for the bedroom of the three young daughters of the Prince and Princess of Asturias, the granddaughters of the old King, who were thirteen, nine and six years old. Goya's lively theme was the games and pastimes enjoyed by the people of Madrid, with the time-honoured pilgrimage (*romería*) to the hermitage of St Isidore (Isidro) as the principal feature. Over the preceding two to three years, José del Castillo had designed cartoons for the bedroom of the baby Infante Don Fernando, including a scene in the park at El Pardo and a very large view of the *Meadow of San Isidro* (fig. 133). When Goya painted similar themes for the bedroom of the Infante's sisters, he inevitably outshone Castillo's decorative, but rather mannered style and imagery.

Goya's letter to Zapater of 31 May suggests that he had about one month in which to complete his sketches, before the Court returned from its spring visit (*jornada*) to Aranjuez. Five canvases for sketches were listed in the accounts on 12 February, and five sketches are known and presumed to be connected with this commission. Although the project was abandoned on the death of the King in December, and only one cartoon was finally painted, the sketches suggest a possible order underlying the decorative scheme. The *Meadow of San Isidro* 'on the Saint's feast day' was clearly the dominant composition, but the sketch representing the *Hermitage of San Isidro* reveals what lies at the heart of the festival (cat. 25). St Isidore is the patron saint of Madrid, and every year on his feast day, 15 May, the people of the city crossed the River Manzanares by the Puente de Segovia, below the royal palace, followed the River south and climbed the steep hill to a hermitage above the low-lying meadows (now covered by buildings). There one can still drink the water from the fountain that is said to have flowed when St Isidore, an eleventh-century labourer who worked on a farm near Madrid, struck the soil with his hoe and brought forth water for his thirsty lord and master. A hermitage was first erected beside the fountain by the Empress Isabel, 'as a thanksgiving for having cured her husband, the Emperor Charles V, and her son, Prince Felipe, after they had drunk from the miraculous fountain', according to the inscrip-

tion on the present hermitage, rebuilt in a classical style in 1724. Although its surroundings have changed considerably, the building itself is still very much as Goya painted it, with its entrance porch and characteristic dome and spire.

In Goya's sketch, the bells are ringing and swinging on either side of the image of the Saint, high above the entrance porch, where crowds have gathered. In the background to the right, people are queuing, under the control of two uniformed guards, in order to fill their jugs and pitchers from the fountain on the hermitage wall, below the balconies. Everyone is dressed for the *fiesta*, the women in white mantillas and most of the men in capes and three-cornered hats, *majo*-style. Three women are seated in the foreground, while a group of men stands a little farther off, watching a fellow who has evidently come running with his jug from the fountain and is offering a glass of water to the young woman seated directly below the chapel spire. In his haste, he has left his cloak and sword on the ground, and is the only man in the picture wearing a jacket. Is Goya simply illustrating the

traditional fetching of water from the miraculous fountain? Or is he constructing a narrative? The whole composition centres on the young couple and the figures around them, suggesting a scene from a play. The afternoon sunlight catches the hermitage, leaving much of the building in shadow, and Goya creates a wonderfully atmospheric effect with fluid, parallel brushstrokes that barely cover the beige preparation on the canvas. The figures are treated with a combination of freedom and precision, and the whole scene vibrates with life and atmosphere.

Today, when turning from the hermitage towards the river that lies below the hillside and beyond what used to be meadows, one sees, in spite of the intrusive urbanisation, the view that was Goya's in the *Meadow of San Isidro* (cat. 26): the great dome of San Francisco el Grande, with other churches nearby, and over to the left the foreshortened west façade of the royal palace, gleaming in the late afternoon sun. The sun also illuminates the figures on the high ground near the hermitage, while evening shadows are spreading across the low-lying meadows. Crowds of

Fig. 133 José del Castillo, *The Meadow of San Isidro*, 1785 Municipal Museum, Madrid (on loan from the Prado, Madrid)

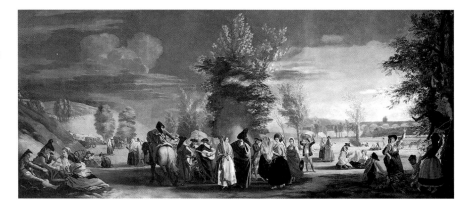

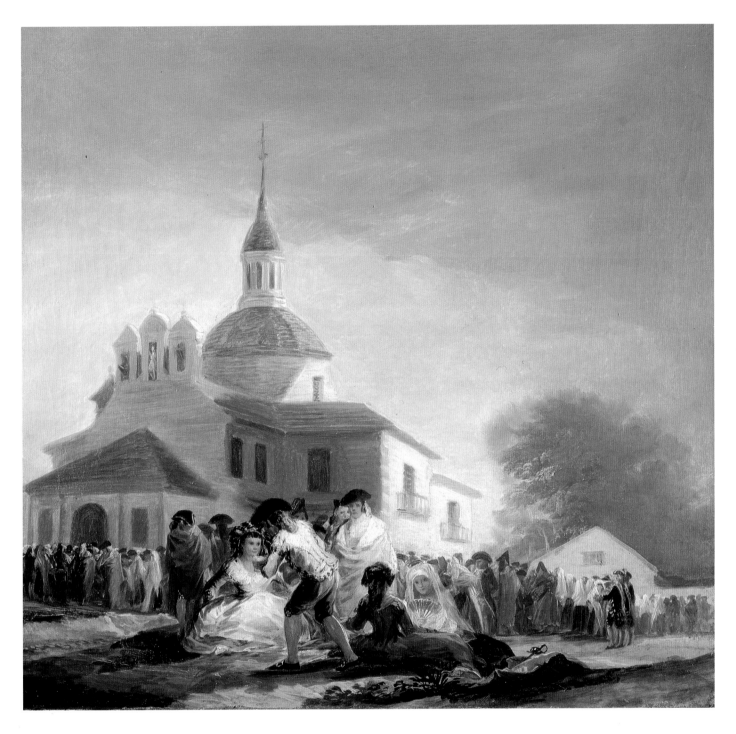

25
Sketch for *The Hermitage of San Isidro*, 1788
oil on canvas, 41.8 × 43.8 cm
Museo del Prado, Madrid

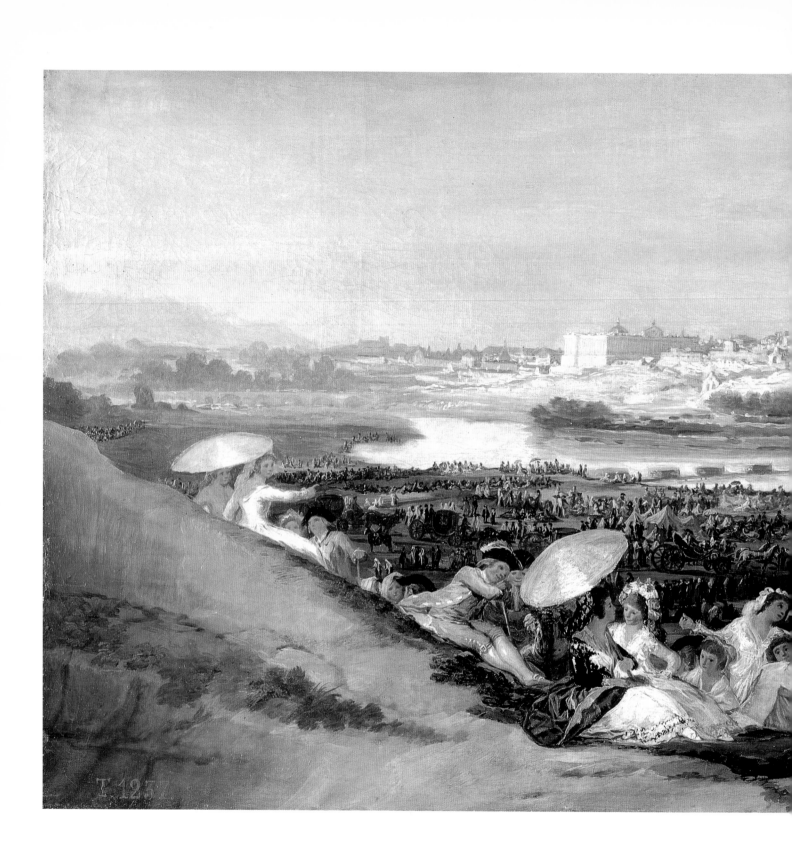

T 123

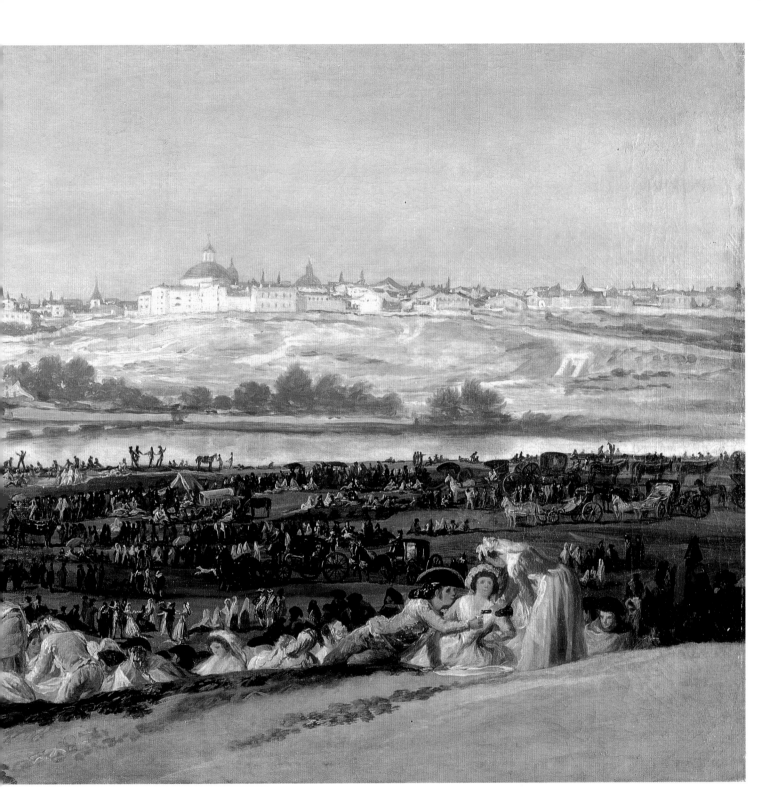

26
Sketch for *The Meadow of San Isidro*, 1788
oil on canvas, 41.9 × 90.8 cm
Museo del Prado, Madrid

tiny figures are moving to and from the Segovia bridge far away to the left below the royal palace, while others use the wooden San Isidro bridge whose pontoons appear in the centre of the picture.

Goya's sketch combines a precise topographical view, in the tradition of Houasse and Joli, with a brilliant evocation of the atmosphere and activities of the pilgrimage, 'with all the commotion that usually accompanies it' for the *fiesta* of St Isidore. The nearest figures follow the lie of the land, as if suspended on a slack rope, and at its lowest point the two girls with a sunshade break through into the foreground, inviting the spectator to join in the *fiesta*. The shape of the empty, almost unpainted foreground, with its delicate diagonal rhythms, cradles the throngs of people and sets off the distant view of Madrid. The figures talk and flirt, picnic and promenade, drink and dance, right down to the water's edge, and are depicted with Goya's precise, swift strokes of the brush so that every one, however distant, is characterised and individualised. Their parallel ranks create a sense of recession, and the whole commotion of people and dogs, horses and carriages, is skilfully organised so that the eye is led from group to group, discovering each to be a perfect little vignette of varied activities. The distant view of the city is thinly painted in soft, liquid tones, through which the preparatory pencil drawing is clearly seen in the topographical details of the palace. In this vast and magical view, Goya embraced the Madrid that he knew and loved, and the *Meadow of San Isidro* is a masterpiece of its kind.

Although it is impossible to guess at the planned sequence of images for the tapestries, one can imagine the *Hermitage of San Isidro* linked with the more aristocratic figures on the higher ground to the left of the *Meadow*. Those to the right in the *Meadow* are of a different type: a girl pours wine for a young man, and groups of *majos* wrapped in their capes appear lower down the hill. The *majos*

and *majas* from the lower social classes in Madrid, celebrated for their picturesque dress and bold manners, and much imitated by the aristocracy at this time, introduce a distinctly less elevated 'tone' on this side of the picture, linking it with another sketch in the series. In *The Picnic* (cat. 27), Goya presents an incident at the *fiesta*, and not a very edifying one at that. An elegantly dressed young couple has been picnicking from a basket, with plates and bottles of wine on a cloth spread out on the ground. Nearby, and illustrating the mixture of classes that characterised the *fiesta*, is a group of rough-looking *majos*. One lies half-asleep on the grass, two others, with a girl between them, appear in the background, while the ringleader sits in the centre. He has helped himself to a glass of wine and is probably responsible for the condition of the young man lying beside an empty bottle with his head in his hands. The *majo* is easing himself forward towards the young woman, showing a handsome, stockinged calf that mocks the useless limbs of the prostrate *beau*. Legs and bottle converge on the *majo*'s leering expression as he looks at the befuddled girl. She can still sit upright, but will clearly be unable to defend herself against the *majo*'s advances, and her pose contrasts, through its very similarity, with that of the girl being offered water from the sacred fountain in the *Hermitage of San Isidro*. Exquisitely painted, this little 'pastorale' evokes the enchanted world of Watteau, but with a sharply ironic, very Spanish flavour. Was the scene intended as a moral lesson for the young Infantas, or as a *divertissement* for their parents? How would they have seen this Madrilenian ruffian who gets the better of his elegant superiors, to the evident delight of the peering, mocking pair in the background?

From Goya's five sketches for the Infantas' bedchamber, only one cartoon was finally painted. This was a game of *Blind Man's Buff* (cat. 28), played by young people beside a river, against a distant prospect of hills. Like the

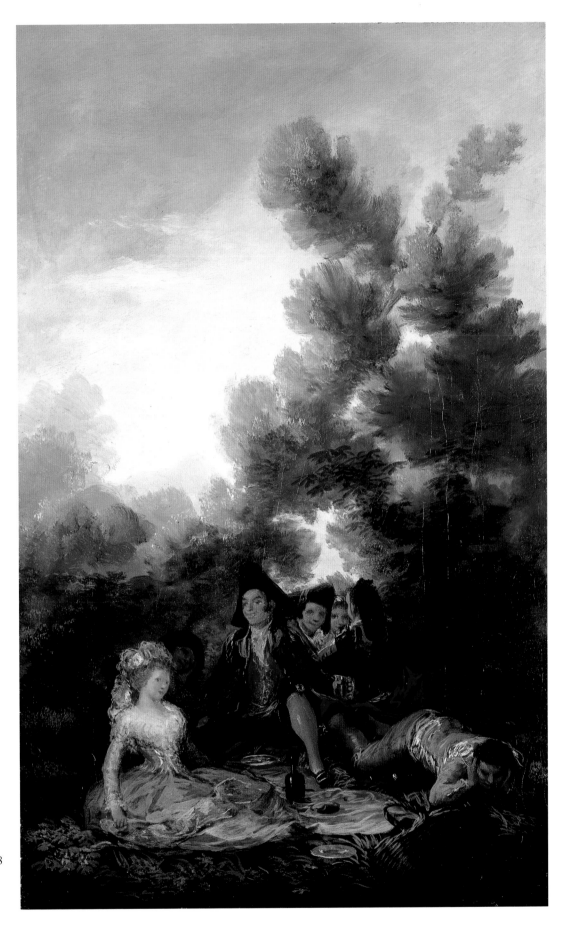

27
Sketch for *The Picnic*, 1788
oil on canvas, 41.3 × 25.8 cm
The Trustees of The National
Gallery, London

picnic, it offers an isolated incident from the myriad activities seen in the *Meadow of San Isidro*, where groups of dancing figures are also seen. In the *Blind Man's Buff* sketch, eight ladies and their *beaux* have linked hands and are dancing and ducking around a blindfolded man clutching a long wooden spoon. He is lunging towards a young women who leans away, with a smile half-directed towards the spectator. The game, a favourite one in the French *fête galante* repertory, is less straightforward than it seems. The blindfolded man is no doubt hoping to encounter his girlfriend, but the girl he is seeking is surely the one outside the circle, seen peeping over the shoulder of a young lady in a plumed hat, who makes sure that the blind man cannot get near her.

The sketch is exquisitely composed and painted over a vigorous underlying graphite sketch that surfaces in many areas. The finely detailed foreground figures are set off by the serpentine lines of the tree, and crowds of tiny figures are seen on the opposite bank of the river. In the cartoon (fig. 134), which has lost its upper part, much of this detail was omitted, and probably in order to clarify the design and simplify the story rather than for reasons of propriety, the peeping girl does not appear – or rather, she was included and then painted out, since her face is clearly visible under a layer of paint on the canvas.

Although *Blind Man's Buff* was the only large cartoon that Goya finally painted, the carpenter's account lists stretchers for four main panels and four smaller overdoors. The first corresponds with the format of the *Meadow of San Isidro*, the second, inexplicably, with both the *Hermitage of San Isidro* and *Blind Man's Buff*, the third with *The Picnic* and the fourth with a sketch of identical height and very similar style and technique to the *Blind Man's Buff*. Known as *The Cat at Bay* (cat. 29), it must have been intended for a narrow tapestry panel beside a door or window, and it too could be another scene at

Fig. 134 *Blind Man's Buff*, tapestry cartoon (see fig. 26)

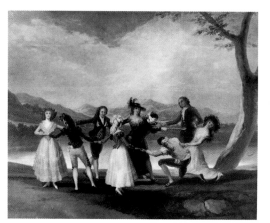

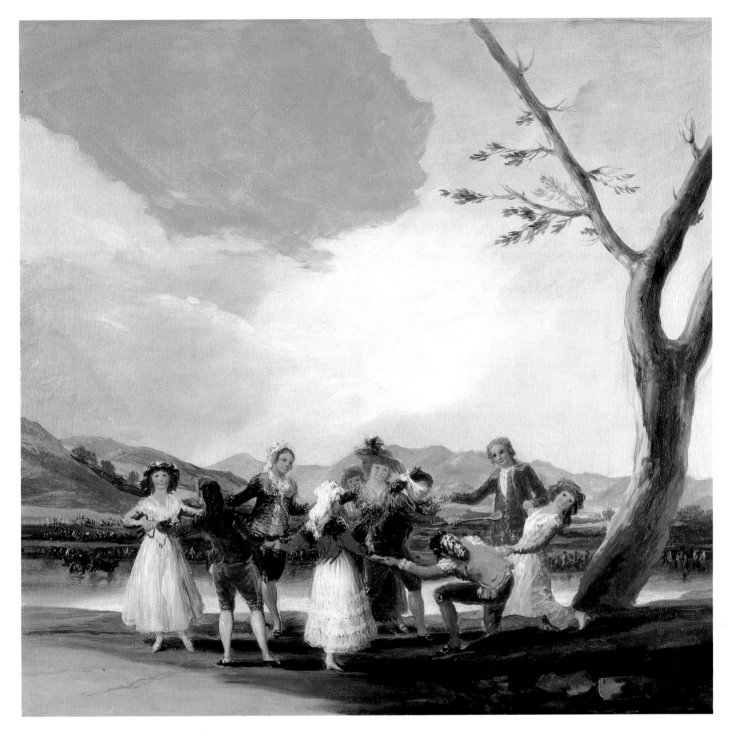

28
Blind Man's Buff, cartoon, 1788
oil on canvas, 41.6 × 43.9 cm
Museo del Prado, Madrid

Fig. 135 Detail of Goya's tapestry
cartoon *Fighting Cats*,
oil on canvas,
Museo del Prado

the pilgrimage site of San Isidro. A youth and a man are trying to dislodge a terrified cat from a tree. Passers-by turn to see what is going on, while a man with a pitcher and glass – perhaps a water-vendor or pilgrim from the hermitage – continues on his way. Rising diagonals lead the eye from the dog jumping up and barking furiously, along the bare tree-trunk, grasped and shaken by the laughing men, to the cat. The creature is lodged with its back arched and fur on end, glaring balefully at its tormentors and trying to keep out of reach of the young man's stick. It recalls Goya's *Fighting Cats* (fig. 135), one of the overdoors from his previous series of tapestry designs, and the little creature penned on a page of his Italian Notebook (fig. 63).

Less highly finished than the larger compositions, the *Cat at Bay* is distinguished by the soft *contre-jour* effect of the youth, and the swift, sure strokes that describe a hand and give expression to a face, or add the touches of impasto that create both space and light. The rhythm and vitality of the poses and gestures, recalling the laughing men in *The Drunken Mason* (cat. 24), characterise all Goya's work at this period, and animate the slightest of his sketches.

In painting his designs for the bedchamber of the Infantas as highly finished and sophisticated little pictures, Goya came closer to the notion of the small independent cabinet picture that he was soon to claim as his own.

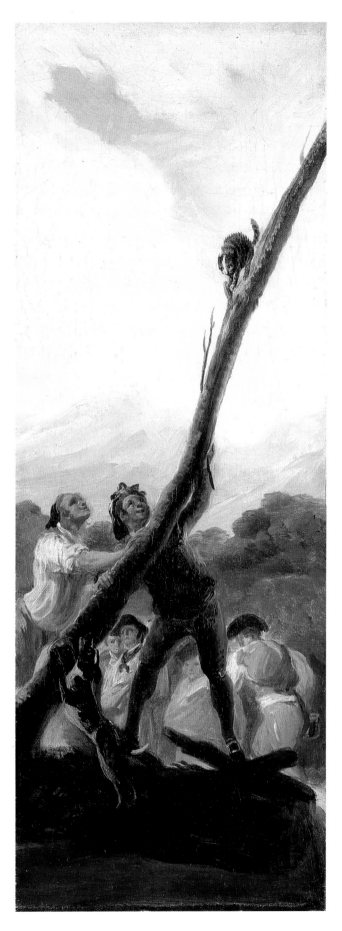

29
Sketch for *The Cat at Bay*, 1788
oil on canvas, 42 × 15.5 cm
Private Collection

THE KING'S STUDY, EL ESCORIAL, 1791–1792

Following the death of Carlos III in December 1788, Carlos IV and Queen María Luisa chose the palace at El Escorial in preference to El Pardo. All current projects for tapestries were cancelled, and Goya only completed one cartoon (fig. 134) from the sketches he had recently prepared (cat. 25–9). To keep the Tapestry Factory working, Carlos IV determined that 'designs should be made that are pleasing and are distinguished by good taste', and on 20 April 1790 the Court architect was informed that 'the King has deigned to determine the subjects on rustic and comic themes [*cosas campestres y jocosas*] that he wishes to be represented in the tapestries'.

Goya's recent appointment as Court Painter had given him a new sense of self-assurance, and he now refused to take instructions from Maella, who was responsible for Goya's work for the Tapestry Factory. Boasting of his friendly relationship with the new King, he told Zapater that 'I can't restrain my genius as easily as perhaps some others can', and a year later the director of the Tapestry Factory had to inform the King that in spite of being salaried to paint cartoons, Goya 'says that he is not painting and does not want to paint, now that he has been promoted to the position of Court Painter'. This letter apparently had the desired effect, for shortly afterwards Goya asked for the sizes of his tapestries and wrote a penitent letter to his brother-in-law Francisco Bayeu, informing him that the sketch for the largest cartoon was almost complete.

His change of heart was no doubt reinforced by the news that if he did not complete his sketches forthwith, his salary would be suspended, and the sketches were probably presented to the King before Goya took a month's leave of absence that autumn to visit Saragossa. Six principal cartoons and one overdoor panel are known for this series, and when Goya fell ill at the end of 1792, the series may have been left incomplete, since no fewer than thirteen stretchers had been delivered to his home. The subjects on 'rustic and comic themes', included a very large village wedding, with men on stilts, girls at a fountain, and women tossing a manikin.

If *The Wedding* (fig. 138) was the dominant composition, the cartoons painted from the two surviving preparatory sketches (cat. 30, 31) were probably the flanking subjects for the shorter walls. The wedding of the pretty, young village girl to a fat and ugly, but moneyed, bridegroom would thus be accompanied by 'before' and 'after' images of feminine guile and domination. In the sketch for *Girls with Water-jars*, two young women in colourful costumes and with jars on their heads stand eyeing a spectator beyond the picture, and their postures and glances suggest they are well aware of themselves as objects of desire.

The sketch is delicately painted over a lightly pencilled design, but Goya made radical alterations while working on the cartoon (fig. 136). He painted over the woman in the background, who is nevertheless still visible on the canvas itself and very clearly revealed in the x-ray (fig. 137). And while the girl on the right remains largely unchanged, her handsome companion is now seen almost in profile, looking straight ahead as she listens to the '*bellos consejos*' (good advice) of the Celestina-like figure who stands beside her, apparently appraising an interested spectator. Much play is made with open and closed vessels, and the young boy – a close relation to the lad from the earlier series (cat. 23) – holds one of each type as he faces the viewer. The ball-capped pillar was also painted out in the

Fig. 136 *Girls with Water-jars*, tapestry cartoon, 1791–2 oil on canvas, 267 × 160 cm Museo del Prado, Madrid

Fig. 137 x-ray photograph of a detail of the tapestry cartoon, *Girls with Water-jars*

cartoon, and instead of employing its rather obvious symbolism and distracting vertical emphasis, the final composition is built around an intricate network of diagonals that draws the viewer in towards the sirens waiting by the fountain.

In *The Straw Manikin* (cat. 31), the girls have 'caught' their man and are tossing him high. The figures in the sketch are more down to earth than the alluring young women at the fountain. They stand pulling on the blanket from which the manikin springs, as if he was running while looking at the viewer from over his shoulder. A visible alteration to his left leg increases the sense of upward movement that is followed by the delighted glances of the girls. Like the *Girls with Water-jars* sketch, this one is swiftly painted with fluid brush-strokes and quick flicks of impasto. Thin, transparent white enlivens the dress of the young women and is washed over the fore-ground, helping to 'lift' the manikin into a pink and blue sky. The massive architectural feature in the sketch disappears in the cartoon (fig. 139), where the girls are more refined and doll-like, as is the manikin caught in a pose that suggests both its rise and fall, isolated against a background of softly painted trees.

Goya's representations of enticement and dangerous equilibrium, marriage processions and the mocking of men, have been seen as emblems of fortune and images of the Ages of Man, and also as reflections of the political instability of those years. Between 1789 and 1792, against the background of the French Revolution and an increasingly conservative regime in Spain, ministers rose and fell, while the fortunes of Manuel Godoy, the young favourite of the Queen, impelled him upwards until he became Duke of Alcudia (cat. 61) and, finally, Prime Minister of Spain in November 1792. If these events are reflected in Goya's last tapestry designs, the medium was ill-suited to such purposes. His nearly fatal illness at the end of 1792, and the profound deafness that resulted from it, heralded a break with the old order and a concentration in the following years on small-scale works that more appro-priately expressed his personal vision of the world.

Fig. 138 *The Wedding*, tapestry cartoon, 1791–2
oil on canvas, 267 × 293 cm
Museo del Prado, Madrid

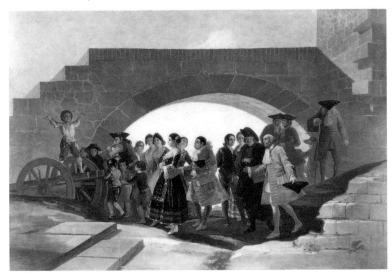

Fig. 139 *The Straw Manikin*, tapestry cartoon, 1791–2
oil on canvas, 267 × 160 cm
Museo del Prado, Madrid

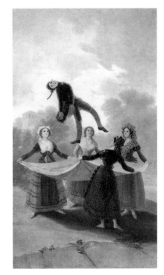

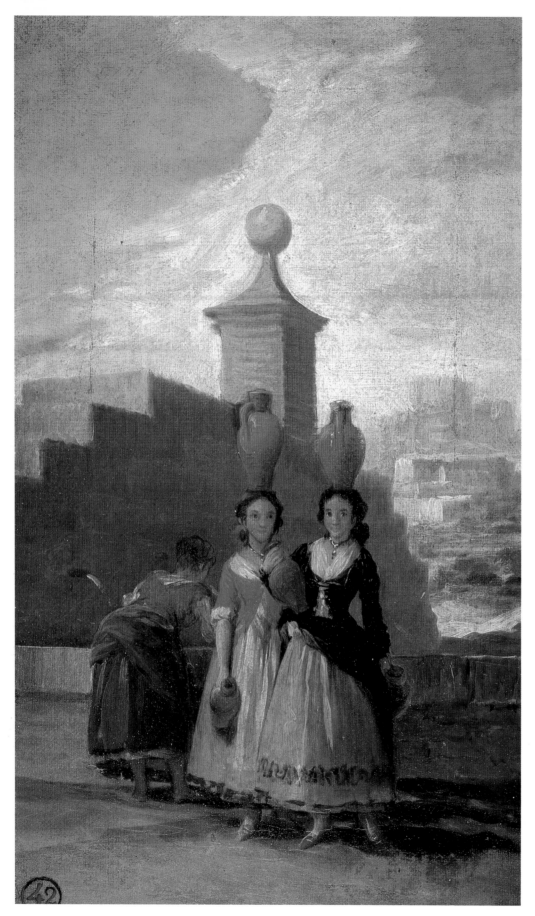

30
Sketch for *Girls with Water-
jars*, 1791
oil on canvas, 34.4 × 21.5 cm
Paloma Mac-Crohon Garay
Collection, Madrid

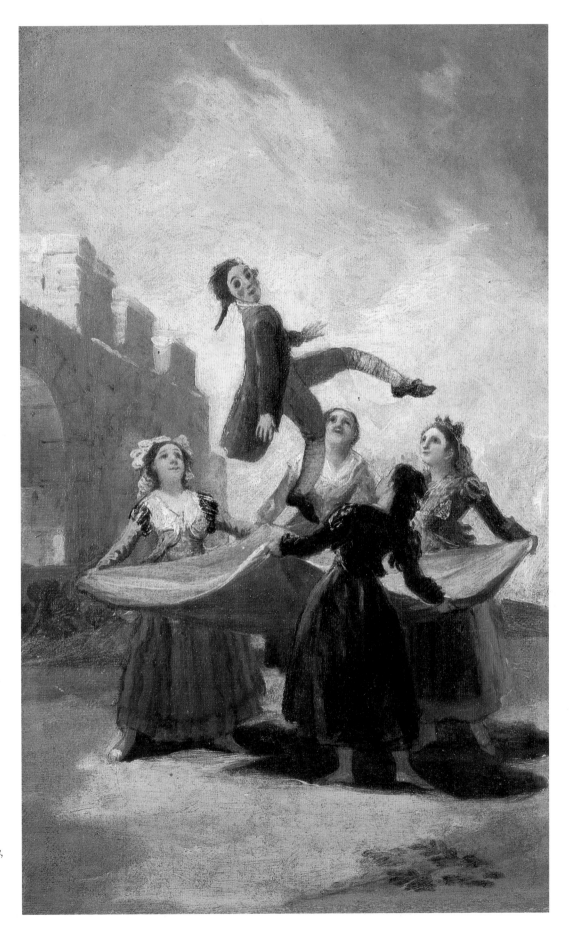

31
Sketch for *The Straw Manikin*,
1791
oil on canvas, 35.6 × 23.2 cm
The Armand Hammer Collection,
Los Angeles

Cabinet Pictures: 'Capricho and Invention'

1793–1794

*T*owards the end of 1792, Goya appears to have left Madrid without requesting an official leave of absence. He signed and dated a report to the Academy on the teaching of art on 14 October, and then there is silence until news of the artist's ill health began to emerge in the new year. A letter to the Osuna family's administrator, apparently written by Goya and dated Madrid, 17 January 1793, said that he had been ill in bed for two months and was taking leave of absence to go to Seville and Cadiz. However, although the leave of absence, arranged by Francisco Bayeu, was granted in January, it seems that Goya had in fact fallen ill in Andalusia some time earlier.

On 19 January Zapater replied to a letter from Sebastián Martínez, a prosperous and cultivated gentleman who lived in Cadiz and whose portrait Goya had recently painted in Madrid. The artist had been taken to Martínez's home, and referring to an earlier letter of 5 January, Zapater wrote that the latest news left him just as anxious, since 'his malady is of the gravest nature'. By 29 March Martínez was able to inform him that 'our Goya is getting on slowly but there is some improvement.... The noise in his head and his deafness are just the same, but his sight is much better and he is no longer affected by the dizziness that made him lose his balance. He is already going up and down stairs very well and in fact is doing things that he could not do before'. At the same time, one of Goya's colleagues referred to the artist as absent from Madrid, 'struck down with paralysis', and an intriguing allusion to the cause of his condition comes in a letter from Zapater to Bayeu, with the comment 'As I told you, Goya brought this on himself through his own thoughtlessness', although this may refer to nothing more than his rash decision to leave Madrid without permission, after completing the tapestry cartoons he had not wanted to paint (see cat. 30, 31).

Goya left Cadiz by 4 June, and on 11 July 1793 he attended a meeting of the Academy, but there is then no further news of him until six months later, when he wrote to Bernardo de Iriarte, the Academy's Deputy, on 4 January 1794: 'In order to occupy my imagination which has been depressed through dwelling on my misfortunes, and to compensate at least in part for some of the considerable expenses I have incurred, I set myself to painting a series of cabinet pictures in which I have been able to

Fig. 141 Letter from Goya to Iriarte, 4 January 1794, British Library, London

depict themes that cannot usually be addressed in commissioned works, where *capricho* and invention have little part to play. I thought of sending them to the Academy, since your Excellency knows the advantages I might expect to derive from submitting my work to the artists' criticism. . .'. The following day, the members of the Academy were shown the 'eleven pictures painted by him on various themes of national pastimes, and the assembly looked at them with great pleasure, praising their merit and that of Señor Goya' (Glendinning, *Critics*, pp. 46–7).

Goya's letter and the Minutes of the Academy meeting are generally agreed to refer to a series of twelve paintings on tinplate, also identifiable with a group of works acquired by a Madrid picture dealer before 1805. These were listed as 'Fourteen sketches on panel that represent various stages in the bullfight, shipwrecks, attack by robbers, fires, a blaze at night, etc.' (the tinplate supports being mis-

taken for wood panel). These pictures were therefore painted during Goya's convalescence and in the first months of his deafness, and were presented to the Academicians to demonstrate that he had lost nothing of his artistic touch. The consummate skill and unfolding imaginative power of these small images mark the start of Goya's transition from the still luminous, 18th-century world of the tapestry cartoons to the dark visions and *caprichos* that were to predominate in his work from the turn of the century through to the end of his life.

BULLS AND BULLFIGHTING, 1793

The writer of the Minutes that record the presentation of Goya's eleven 'cabinet pictures' in the San Fernando Academy on 5 January 1794, referred to them as 'various subjects of national pastimes'. Since this hardly applies to the scenes of human and natural disaster and despair that were also included (cat. 39–42), the brief description no doubt evoked the scenes with bulls which were the most numerous within the group. If any of the Academicians present at the meeting were *aficionados* of the bullfight, they may have been surprised to see scenes that are indirect allusions rather than the didactic depictions seen in the paintings and engravings of an artist like Carnicero.

Besides his passion for hunting, Goya was himself an *aficionado*, and there are references to bullfights in his letters to Zapater. He devoted a series of etchings to *La Tauromaquia* (the art of bullfighting) in 1815 (figs. 144, 145), and in Bordeaux in 1825 his friend Moratín recorded that 'Goya says he has fought bulls in his day, and that with the sword in his hand he fears no one'. Goya's observation of the attitudes and expressions of bulls and horses is extraordinarily acute and often more sympathetic than his treatment of the bullfighters themselves. The bullfight scenes on tinplate are brilliant little fantasies on this theme, and of the six that were probably included in the group sent to the Academy, three take place outside and three inside the bullring. In one, bulls are seen gathered in a valley, perhaps at La Muñoza or in the Arroyo Abroñigal near the old bullring (cat. 32). A herd of 24 bulls and oxen, grouped in apparent disorder, are in fact placed in relationships that conceal a marvellously calculated spatial geometry, revealing the animals from every angle and leading the spectator's eye from foreground to the luminous distance. At the top of the nearest slope looms the menace of which the animals, some bellowing nervously, are clearly aware, two mounted *garrochistas* with a very visible *pique*, painted with great vivacity (see fig. 52). Behind them is the crowd, controlled by mounted guards, and on the far bank is a multitude of smaller figures, who have come on foot or by carriage to see the bulls. They recede into a more atmospheric distance than in the *Meadow of San Isidro* (cat. 26), but still retain a sense of individual identity.

Fig. 142 After Goya, *Bulls by a Stream*, drawn for Bocourt, engraved for *Histoire de peintres*, c. 1850

Fig. 143 After Goya, *Death of a Picador*, drawn for Bocourt, engraved for *Histoire de peintres*, c. 1850

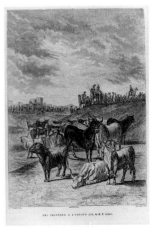

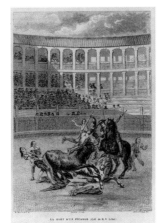

In another scene (cat. 33), four consecutive moments in a classic *suerte de banderillas* are enacted by four *toreros* in an arena-like space limited by walls: in front is the top of the barrier from which the spectator views the scene, and at the back a wall with a high, barred gate, where lively groups of *majos* wearing capes and sombreros or *gorros* (tall caps) are talking or watching the action. A softly painted landscape with buildings recedes into the distance and a luminous sky arches over the whole scene. Figures and landscape recall the sketches for tapestry cartoons (cat. 19–31), and are painted with broad or finely detailed touches that combine freedom and precision to express the turn of a body, hands grasping the banderillas, or a buckle on a shoe.

In a third scene (cat. 34), men with a roped bull on the outskirts of a town are restraining the animal, who stands with head raised to avoid the attacking dogs. In the middle distance, a spectator raises his arms in the gesture to be seen in so many of Goya's works (e.g., cat. 7), and the group of observers links the foreground to a delicately painted townscape, where a crowd around a greasy pole being climbed indicates a *fiesta*. As in *Banderillas in the Countryside*, a soft light falling from the left illuminates and unifies the scene, inviting the eye, through vivid, impasted touches, to explore the space within the picture.

The three bullring scenes (cat. 35–37) are variations on the '*sol y sombra*' – sun and shade – theme. The arena has been variously identified as the bullring at Madrid, at Cadiz, and elsewhere, but does not correspond exactly with any of them; if not imaginary, the setting perhaps most closely resembles the ring at Madrid. In two of the three scenes (cat. 35, 36), the roof, balconies and stands are drawn in paint with geometrical precision yet sketchy delicacy, revealing the stands running continuously beneath the figures. The sunlight casts strong shadows within the covered balconies, and vivid touches of impasto flicker over the spectators in the sun, creating effects

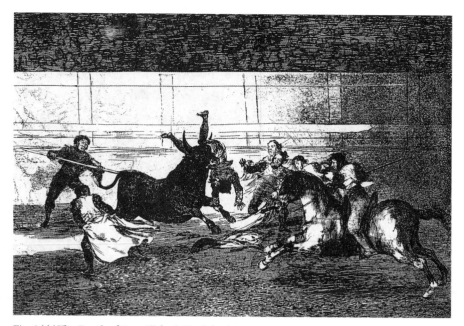

Fig. 144 '*The Death of Pepe Illo*', pl. E. of the *Tauromaquia*, 1815 etching and aquatint, 25 × 35 cm Biblioteca Nacional, Madrid

of brilliant animation, while the movements of the crowd in the shade are expressed through touches of thinner colour and the rhythmical notation of the black hats. The *Death of a Picador* is the most vividly realistic of these scenes, in which a group of animals and men in violent movement is set against the bare barrier and empty sunlit stands (*tendidos*) to the right. The scene prefigures one of Goya's dramatic renderings of the *Death of Pepe Illo* (fig. 144), an event which occurred in 1801 and is illustrated in the *Tauromaquia* etchings of 1815.

In each of the other two paintings, Goya evokes various incidents and stages (*suertes*) in the *corrida*. In one, a dignified and graceful bullfighter, painted with such definition and expression that suggests it may be a portrait of Pedro Romero (see fig. 146), plays the bull with the cape behind his back; farther off, bulls are being cleared from the ring by a picador

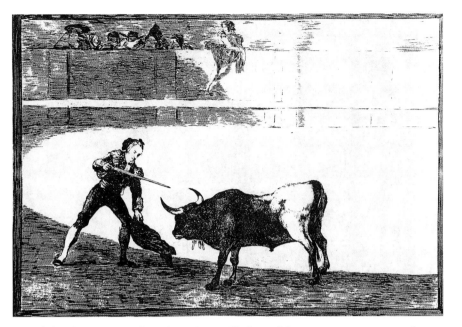

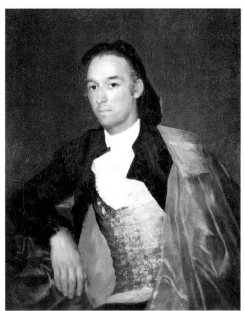

Fig. 145 *'Pedro Romero Killing the Halted Bull'* pl. 30 of the *Tauromaquia*, 1815–16
etching and aquatint, 24.5 × 35.5 cm
Biblioteca Nacional, Madrid

Fig. 146 *Pedro Romero*,
c. 1795–8, oil on canvas,
84.1 × 65 cm
Kimbell Art Museum, Fort Worth

and a lad with a lasso, and troop obediently towards the bull-pen (*toril*), while a massive creature gazes enquiringly at the picador. Curved shadows at the lower corners of the composition indicate the barrier in front of the spectator and complement the circular movements within the ring. Finally, with the ring and stands now almost completely in shadow, the ultimate act, seen in the *Matador Killing the Bull* (cat. 37), is combined, with the two preceding acts (*tercios*), into a single image: banderillas are suspended from the bull's neck and lie prominently in the foreground beside a *pique* and a picador's hat, while dying horses lie in the sand and another picador sits on his blindfolded mount in the centre. The eye is led along the curving shadow on the sand to the fallen horse to the left of the matador. With dignified bravura, the matador leads the bull on with a hat, rather than with the short cape (*muleta*), and prepares to plunge his sword into the lowered neck, as in the etching of

Pedro Romero Killing the Halted Bull that Goya made some twenty years later (fig. 145).

In all six scenes, the pinkish-beige preparation that covers the tinplate is visible in many areas, unifying the whole surface and softening the cool tones that are the hallmark of Goya's art. Space and light are brilliantly evoked, and every figure and animal is clearly situated and defined. Apart from the nobler 'portrait' figures in *Pass with the Cape* and the *Killing the Bull*), it is the bulls themselves who are the principal subjects, and of sympathetic interest. Massive and powerful but also lithe and intelligent, these creatures are carefully observed and drawn with the point of the brush. The artist's view of the bullfight is passionate yet detached, and these *caprichos* on bullfighting themes express the complex relationship between the people of Spain and the art of fighting bulls that was explored by Goya in later paintings and prints (see cat. 95, 112–18).

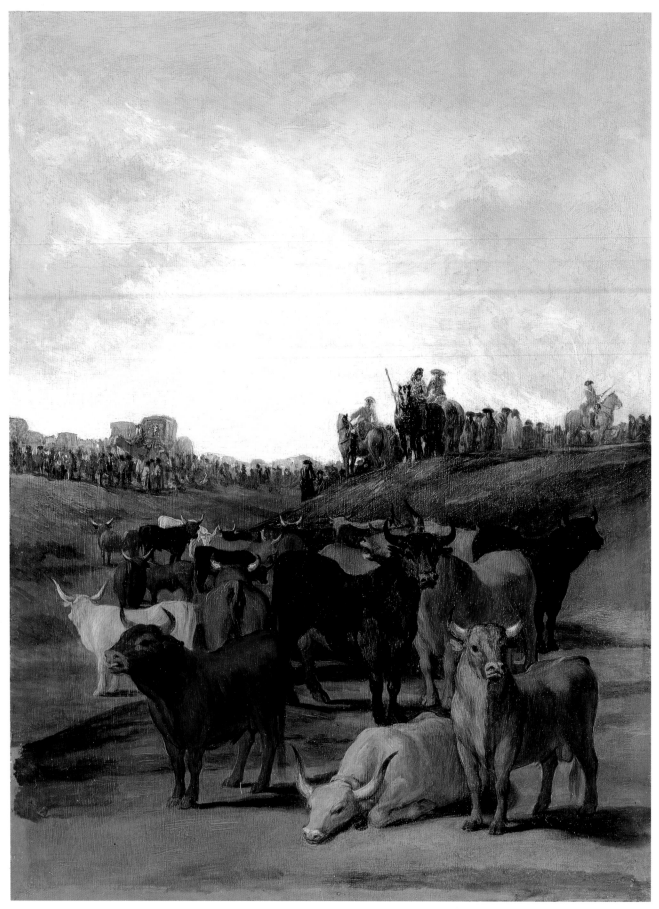

32 Sorting the Bulls, 1793

tinplate, 42.6 × 32 cm, Private Collection

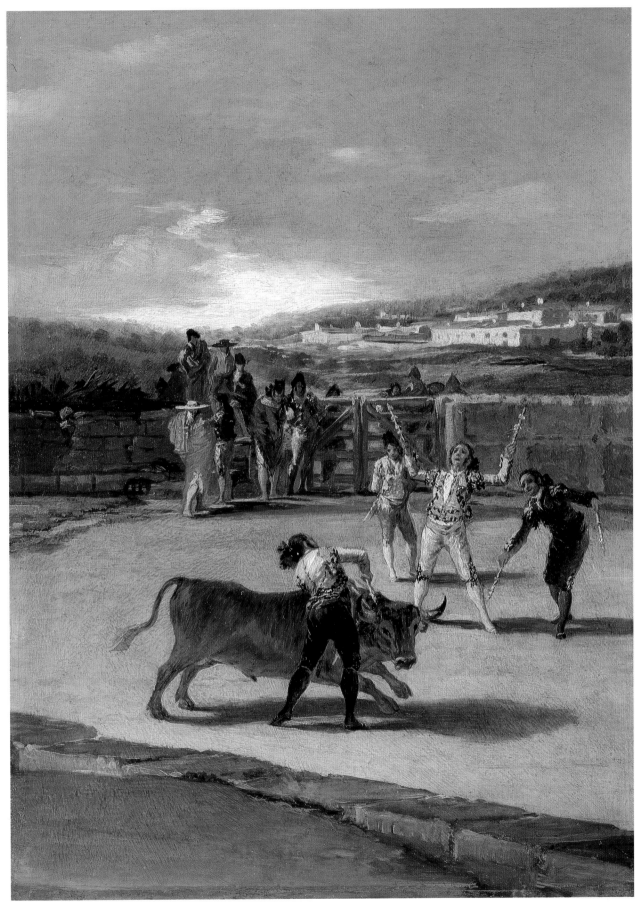

33 *Banderillas in the Countryside*, 1793
tinplate, 43.1 × 32 cm, Masaveu Collection, Oviedo

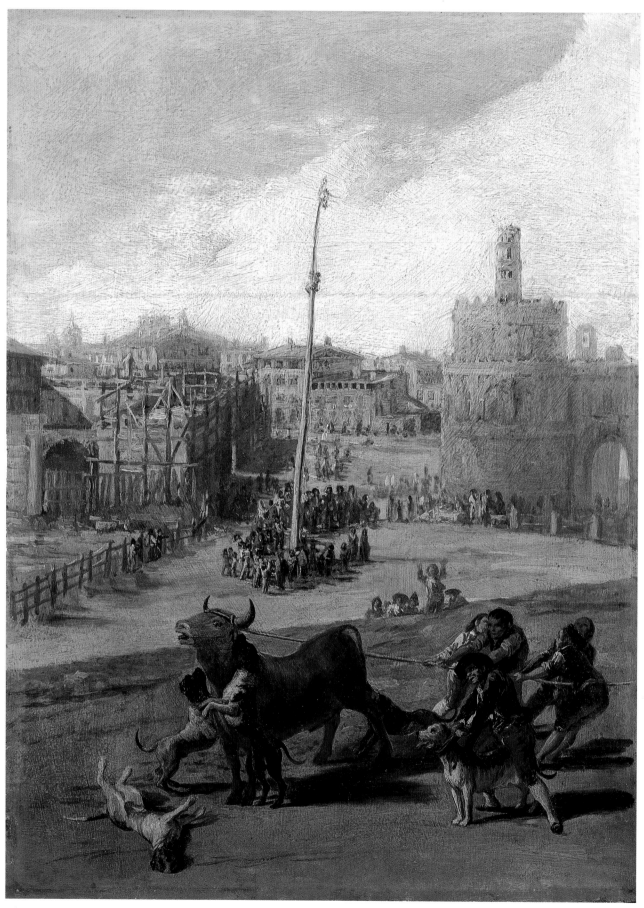

34 *Bull Held by a Cord*, 1793
tinplate, 42.9 × 31.6 cm, Private Collection

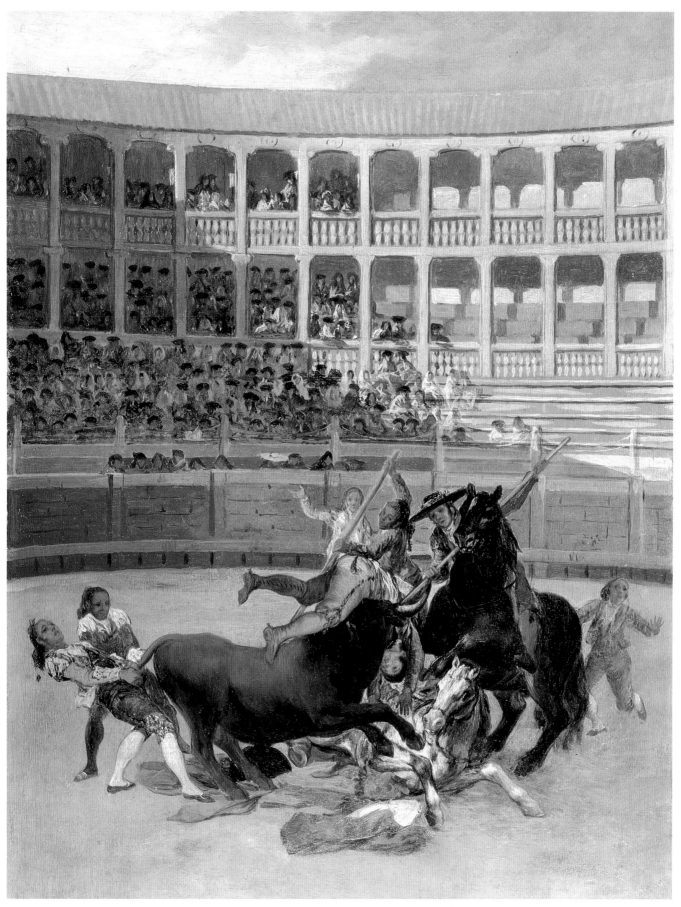

35 *Death of a Picador*, 1793
tinplate, 43 × 31.9 cm, British Rail Pension Trustee Co., London

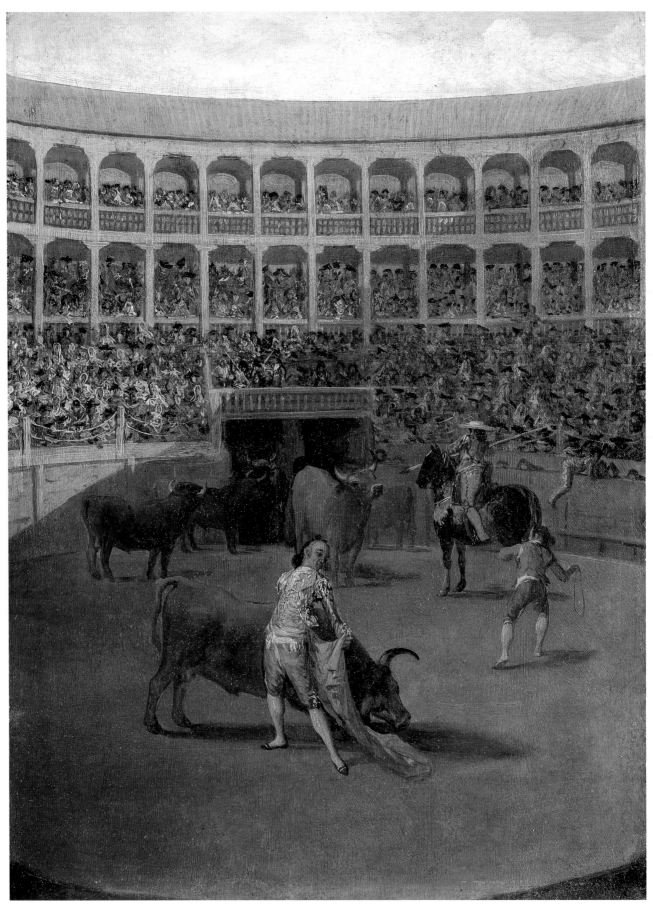

36 *Pass with the Cape*, 1793
tinplate, 43.1 × 32 cm, Conde de Villagonzalo, Madrid

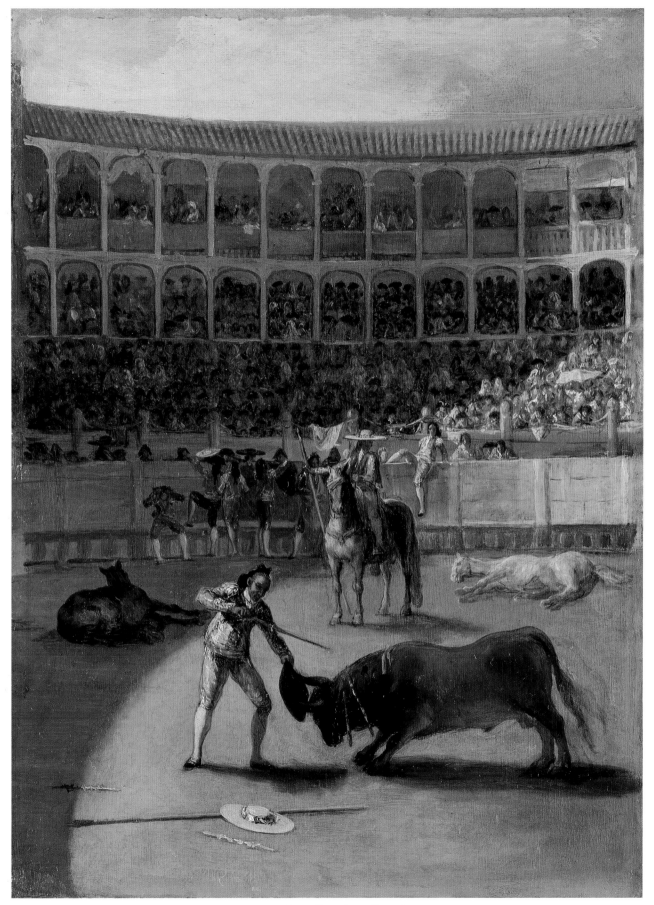

37 *Matador Killing the Bull*, 1793
tinplate, 43 × 31.9 cm, Casilda-Ghisla Guerrero Burgos y Fernández de Córdoba Collection

CAPRICHOS AND INVENTIONS, 1793–1794

The six pictures grouped here, together with six bullfight scenes (cat. 32–37), appear to make up the twelve '*caprichos*' that Goya is known to have painted during his convalescence in 1793. These were, by his own account, completely independent works, perhaps the first that he painted entirely to please himself rather than in response to a commission or a friend's request. Since the identification in 1967–8 of this group of twelve, it has been hailed as the first full demonstration of Goya's powers of imagination, and the start of a long series of works that were to spring from the depths of the artist's most intimate personal experience and vision of the world.

To the eleven pictures of 'national pastimes' (*diversiones nacionales*) shown to the Academicians on 5 January 1794, Goya added a twelfth on which he was already working when he wrote to Iriarte two days later. In his letter (fig. 147), dated 7 January, Goya thanked Iriarte and expressed his gratitude for the favourable reception given to his works by the Academicians and their sympathetic enquiries about his health. He added that the pictures could remain in Iriarte's home as long as he pleased, 'as well as a final one which I have already begun, which shows a yard with lunatics, and two naked figures fighting while the keeper beats them, and others in sacks (it is a scene I once saw in Saragossa). I will send it to Your Excellency in order to complete the series'.

Since the painting described by Goya as the last in the series is identifiable (cat. 43), it provides the one available clue to the order in which the series was painted, and helps to establish which other pictures formed part of it. The *Yard with Lunatics* is in fact one of the 'darker' subjects in the series, close in tonality and mood to the *Interior of a Prison* (cat. 42), which has usually been placed much later in Goya's *œuvre*, although technical examination now appears to confirm that it is part of

Fig. 147 Letter from Goya to Iriarte, dated 7 January 1794
British Library, London

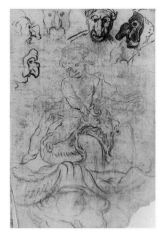

Fig. 148 Goya's 'Italian Notebook', page 11 recto

this earlier group. It is tempting to suppose that Goya began his set of twelve paintings on tinplate with the more agreeable and realistically painted subjects – the scenes with bulls (cat. 32–37) and the *Strolling Players* (cat. 38) – and that he gradually moved towards a more forceful and original style as the series developed. This possibility is supported by the evidence of Goya's etchings, in series such as *Los Caprichos*, where its earlier prints and preparatory drawings are handled in a lighter, more 'realistic' way (fig. 152, 156), while many of the later ones are images of tremendous power and symbolic darkness (fig. 23, 157). Although the order suggested here cannot claim to be definitive, it offers a possible basis for the series as a whole, from the bullfighting subjects that may have their origins in Goya's convalescence in Andalusia to intensely dramatic, even horrific scenes of disaster, degradation and despair.

In spite of considerable differences in the nature of the scenes, the unity of the series is emphasised by purely physical characteristics. All the paintings are on thin metal sheets plated with almost pure tin, scissor-cut and slightly uneven, but measuring about 43 × 32 cm and covered with a thickly brushed, beige-pink preparation over a thin red ground. The strong brushmarks in the preparation are clearly apparent under the thin, fluid layers of colour in the pictures, and its beige-pink tone is visible in many places where Goya did not paint to the limits of the forms or the edges of the tinplate. In the case of the *Strolling Players* the entire composition was freely sketched in pencil on the prepared surface, as Goya had been doing in the tapestry cartoon sketches of 1786–88 (cat. 19–29), and the graphite drawing is clearly apparent to the naked eye; the *Attack by Robbers* and the *Shipwreck* (cat. 40, 41) are executed with a combination of finely detailed or freely applied strokes, and brown-black line drawing done with the point of the brush; and in the darker paintings of the *Interior of a Prison* and the *Yard with*

Lunatics, thin layers of colour were dragged over the ridged surface of the preparation that was sometimes toned with grey or black, creating, with the dark brush drawing, a breathtakingly free but sure combination of line and colour. The technique itself, in its astonishingly free but assured combination of colour and line, expresses the mood and emotion of Goya's pictures, marking each one with a distinctive style.

Many interpretations have been proposed and many sources cited for these extraordinary small works, which call for the very close reading of the images themselves and their relationship to others within Goya's *œuvre*. In the *Strolling Players*, actors on the carpeted boards above the heads of the delighted crowd perform a 'Menandrean Allegory', according to the abbreviated lettering on a sign at the front of the stage. Menander, a classical Greek dramatist, was the author of satirical and moralising comedies very much in the spirit of those by dramatists of Goya's day.

The scene is closely related to the subject-matter of Goya's last sketches and cartoons for tapestries (cat. 30, 31), as well as the earliest drawings for *Los Caprichos* (fig. 152), with their themes of deceit and dangerous equilibrium; here, the relationship between Columbine, Pierrot and the overdressed aristocrat is symbolised by the juggling Harlequin's bottle and two glasses, while the ridiculously 'important' dwarf merrily raises his bottle in a gesture that links him to the girl, but with the other hand brandishes an empty glass. Above and behind him is a tree with lopped branches that supports the actors' tent. The *commedia dell'arte* theme is echoed in the three masks seen peering over the sign, which seem to have come straight from the Italian Notebook (fig. 143), while the grotesque mask of the observer who peeps through an aperture in the tent draws attention to the role of the actor-spectator in relation to this bitter-sweet, exquisitely painted comedy of life.

The paintings loosely referred to in the

Chopinot inventory as 'shipwrecks, attack by robbers, fires, a blaze at night' appear to be identifiable with the three tinplate subjects that correspond with these themes, suggesting elemental allegories of water, earth and air. The *Fire at Night* (cat. 39) shows a crowd of figures fleeing, which includes some carrying half-clothed bodies and a mother with her child in her arms, in an undefined, unreal space where only a broad, paved surface in the foreground is distinguishable in the confusion of smoke and flames. In the *Attack by Robbers* (cat. 40) that recalls Goya's earlier decorative canvas for the Osunas (fig. 149), a similar scene of carnage is taking place, but now in a desolate and rocky landscape that underlines the brutality of the action and the hopelessness of the sole survivor's plea; as the victims lie dead or dying, a cast-off shoe emphasises the diagonal structures of the composition and points a contrast with the sun-bathed peaks in the distance, beyond the barrel of a bandit's gun. Rocks, rather than murderous robbers, are the dangerous element in the *Shipwreck* (cat. 41), where a black hulk lists and sinks below the huge, menacing outcrop, and gulls fly over waves full of floating spars; in the foreground, figures battle to safety, collapsing or dying on a rocky shelf, while a wild figure raises her arms to hurl imprecations at the heavens. Recalling, yet far removed from the Romantic storms and shipwrecks of Vernet or Pillement, the tiny figures in Goya's picture are embodiments of terror, relief and despair, their pathos heightened by the touch of tender, anti-heroic realism in the woman pulled bare-bottomed from the waves.

These three paintings (cat. 39–41) present a vision of man's helplessness before the forces of nature or human wickedness, but there is still a certain theatricality in the detailed presentation and almost miniature-like treatment of the figures, set in the open air. In the remaining two pictures – one of them known to be the last in the series – the spectator is brought closer to figures that occupy an oppressive, almost monochrome world. The massive stone arch of the *Interior of a Prison* (cat. 42) rises above the cowed and broken forms of the prisoners, emphasising their impotence. Shackled and chained beyond the limits of punishment, they sit, stand or lie in a space where the light serves only to illuminate their despair, offering no comfort or suggestion of escape. Some fifteen years earlier, Goya had etched a similar figure in *The Garrotted Man* (fig. 151), and he returned to the theme in the *Caprichos* (fig. 150) and in many later prints. In the *Interior of a Prison*, the extraordinary sensitivity of Goya's brush, in touches of dragged and 'broken' paint or precise but tremulous drawing of the prisoners' limbs, suggests their physical suffering and communicates an impression of overwhelming despair.

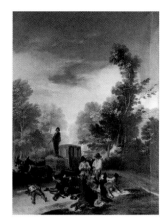

Fig. 149 *Attack on a Coach*, 1786–7
oil on canvas, 169 × 127 cm
Private Collection

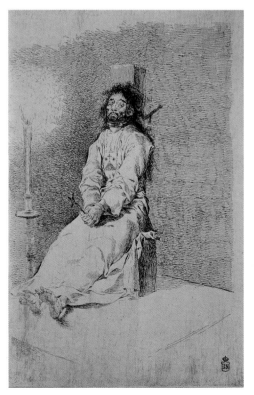

Fig. 150 *A Woman in Prison*, 1797–8
aquatint, 18.5 × 12.5 cm
Biblioteca Nacionale, Madrid

Fig. 151 *The Garotted Man*, c. 1778–80
etching, 33 × 21.5 cm
Biblioteca Nacionale, Madrid

Fig. 152 '*The ancient and modern origin of Pride*', *Sueño* no. 18, 1797
pen and iron-gall ink
24.4 × 18.5 cm
Museo del Prado, Madrid

Did Goya himself visit a prison in company with progressive legal friends like Jovellanos and Meléndez Valdés, who were concerned with penal reform? Did he visit the lunatic asylum in Saragossa, as he indicated to Iriarte, for similar reasons, or from the kind of interest that made of them almost places of public entertainment at that time? Or because, as seems possible, relatives from Fuendetodos on his mother's side were held in the hospital asylum at Saragossa? No doubt many aspects of these scenes originated in things seen and experienced by the artist, but they go far beyond simple commentary and reportage. Every figure in the composition of the *Yard with Lunatics* plays a part in the complex scene that revolves around the pair of naked madmen, locked in combat like Greco-Roman wrestlers, with limbs as precisely and delicately portrayed as the figures in a finely carved Antique relief (fig. 153), or in the pages of Goya's Italian Notebook (fig. 69). Madmen staring and gesticulating at the artist, with fearful or mocking expressions, seem to implicate him in their own condition, while in the background to the right a solitary figure faces the wall, paralleling the artist or spectator's position in front of the picture. The wall is the negation of all space and time, over which filters the bright light of day that only dimly illuminates the yard below. It is as if in these last paintings, at the very end of his convalescence, Goya came to a final, full understanding of his near escape from madness, or from death, and, too, an equal understanding of the wall of silence that would henceforth surround him.

Fig. 153 *The Rape of the Daughter of Leucippus*, Roman sarcophagus relief
Vatican Museums, Rome

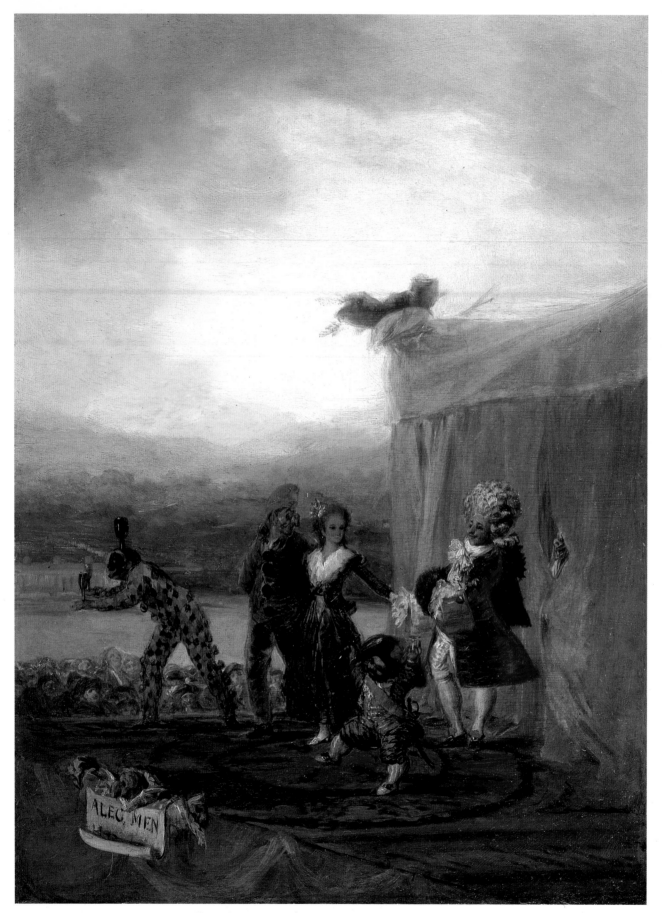

38 *Alegoria Menandrea* or *The Strolling Players*, 1793–4

tinplate, 42.5 × 31.7 cm, Inscribed lower left: *'ALEG[ORIA] MEN[ANDREA]'*

Museo del Prado, Madrid

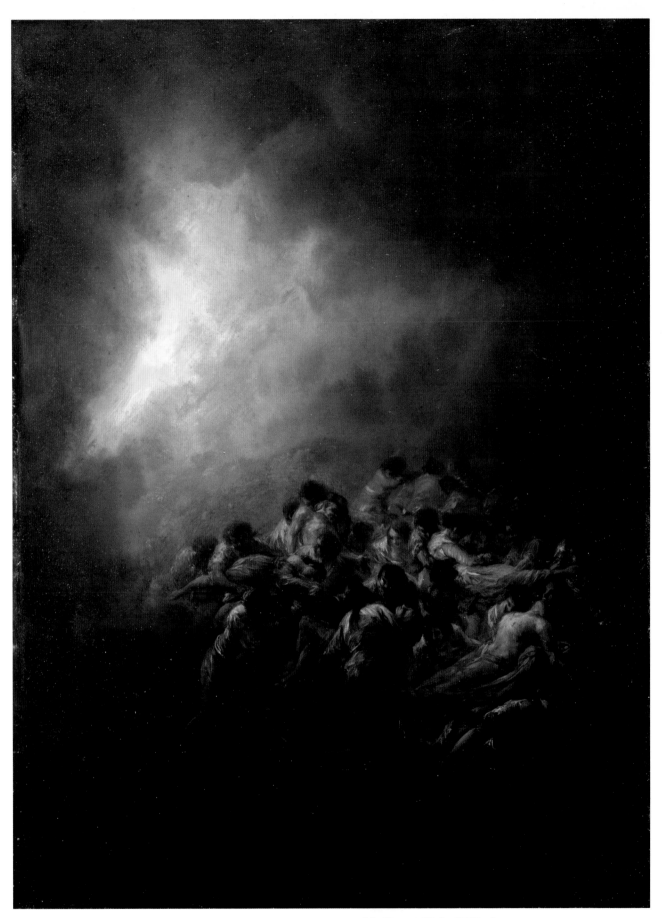

39 *Fire at Night,* 1793–4
tinplate, 43.2 × 32 cm, BANCO INVERSION-AGEPASA, Madrid

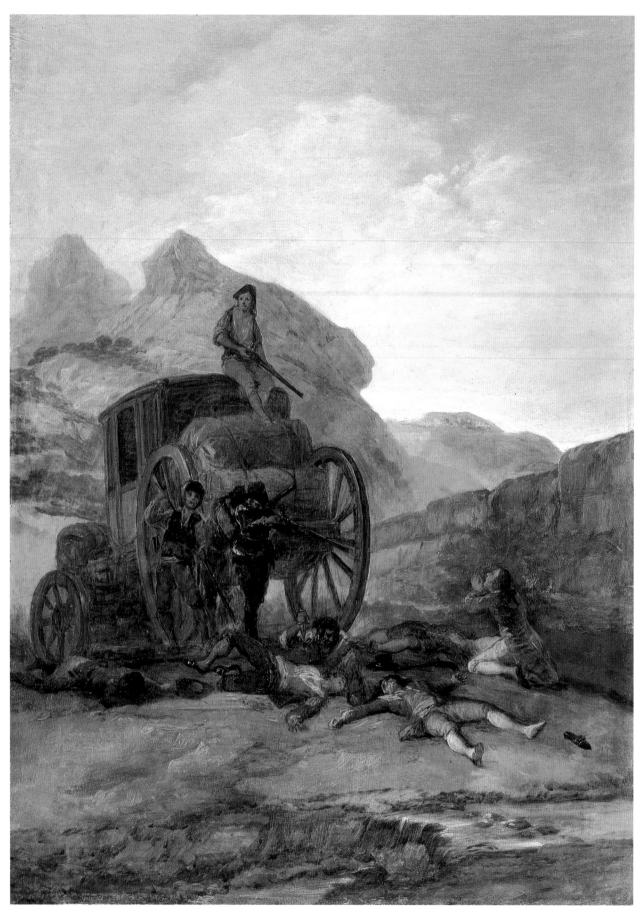

40 *Attack by Robbers*, 1793–4

tinplate, 42.7 × 31.7 cm, BANCO INVERSION-AGEPASA, Madrid

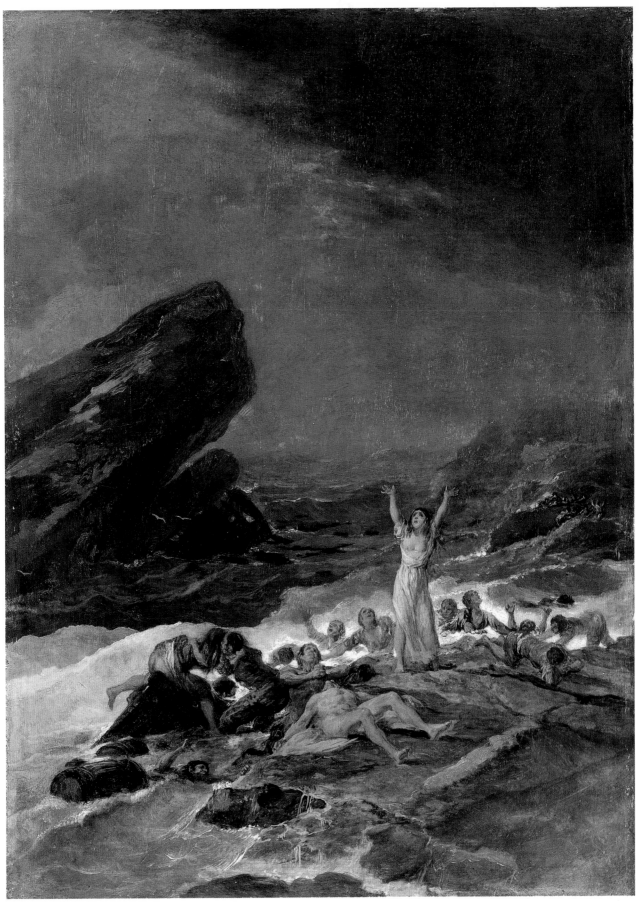

41 *Shipwreck*, 1793–4
tinplate, 43 × 31.8 cm, Private Collection

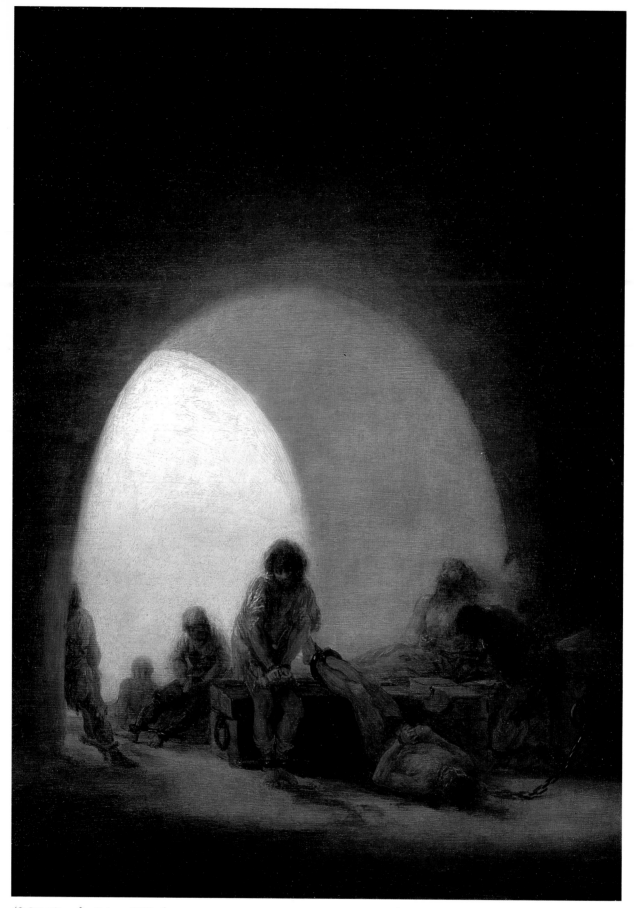

42 *Interior of a Prison*, 1793–4

tinplate, 42.9 × 31.7 cm

The Bowes Museum, Barnard Castle, County Durham

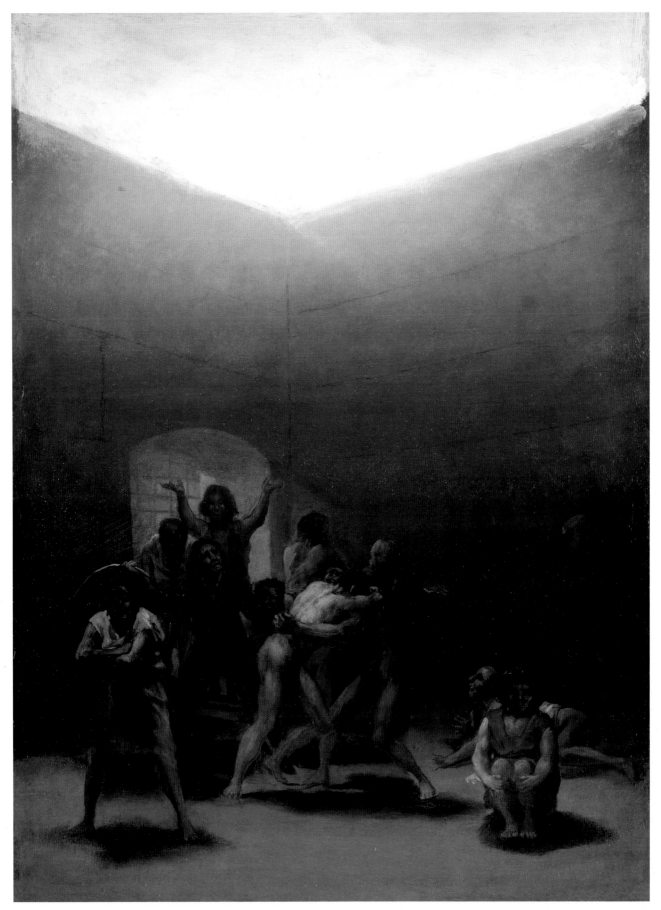

43 *Yard with Lunatics*, 1793–4
tinplate, 43.5 × 32.4 cm, Algur H. Meadows Collection,
Meadows Museum, Southern Methodist University, Dallas

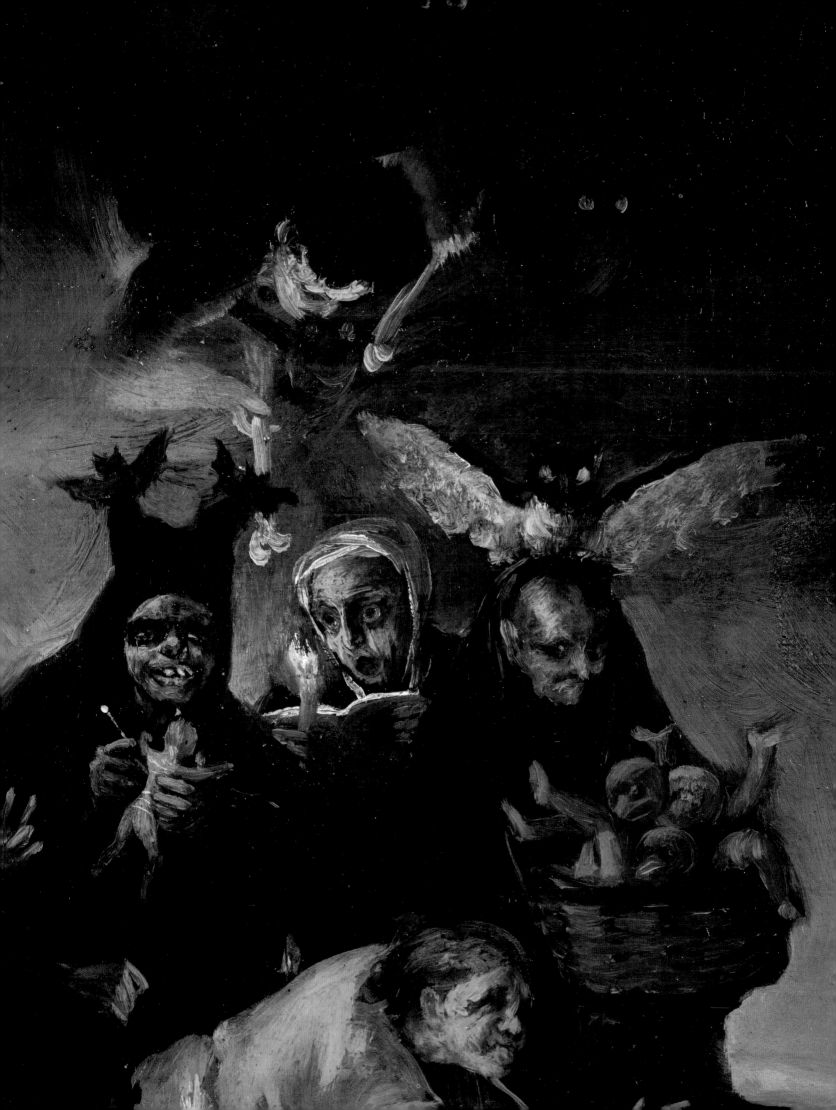

Witchcraft and Allegory

1797–1799

*G*oya's first experience with the pleasures of painting pictures dictated purely by fantasy and imagination soon led to further experiments. Those painted immediately after his illness, in 1793–4, were made with no other aims than to please himself and produce works that could subsequently be offered for sale (cat. 32–43). Over the next two years he resumed much of his normal activity, particularly as a portrait painter, which brought him a steady income. In 1795 his commissions to paint the Duke and Duchess of Alba took him to their palace, and he also made delightful little pictures of the capricious Duchess, Cayetana, and her entourage (cat. 64, 65), continuing the following year, during a visit to her estates in Andalusia, with drawings in the first of two celebrated albums, the so-called Sanlúcar Album. These he used not as he had the Italian Notebook, to make sketches for pictures, studies of figures, or lists and notes, but to construct sequences of images. Although based on reality, the drawings in these albums were an expression of his responses to and ideas about the world around him (figs. 188, 189). And out of these images, to which he began to add captions in the second, so-called Madrid Album (fig. 187), evolved the series of prints that he published at the beginning of 1799 with the title *Los Caprichos.*

Goya became known in Spain, and also abroad, through the dissemination of his etchings, his paintings, and his prints of 'caprichos', and was soon identified by his contemporaries with subjects that were strange, striking and fantastical, revealing the workings of a powerful and original mind. Besides his prints and drawings, he continued to create sets of small cabinet pictures, and the 'seis asuntos de brujas' (six witchcraft subjects), sold to the Duke and Duchess of Osuna in 1798, are a perfect example of this new genre (cat. 44–9). Acquired by them for the decoration of their country house, 'El Capricho', at La Alameda, these six cabinet pictures were the next link in the series of imaginative works that Goya would continue to paint, draw, etch and lithograph until the end of his life.

His very first purely imaginative picture seems to have been a mythological allegory, the *Hercules and Omphale* of 1784 (cat. 18). Judging from its style, a small allegorical sketch representing *Time, Truth and History* (cat. 50) was probably painted at much the same time as the witchcraft scenes, when Goya was working on the preparatory drawings and prints for *Los Caprichos.* The painting draws on the same iconographical elements and uses the same compositional structures, but while the witchcraft scenes have a mildly satirical edge to them, the significance of the allegory is more profound and general, and it may have been intended as a study for a large-scale work that was not painted until some fifteen years later (see fig. 162).

SIX WITCHCRAFT SUBJECTS, 1797–1798

On 27 June 1798, Goya signed and dated an 'Invoice for six pictures of Witchcraft scenes which are at la Lameda [*sic*, for 'Alameda'], six thousand *reales*' (fig. 155), and two days later the Duke of Osuna signed the order for payment for 'six Witchcraft scenes made by him for my country house at La Alameda'. It has usually been supposed that these paintings were specially commissioned for the Alameda and reflected the sophisticated tastes of the Duke and Duchess, but it seems more probable that they were painted, like the tinplate pictures of 1793–4 (cat. 32–43), as independently imagined *caprichos*, which Goya then offered to friends, patrons or dealers. In the same way, he sold to the Osunas a group of his earlier sketches for tapestry cartoons (cat. 19–28), which the order for payment records as having been painted 'for the Countess Duchess's Study', although this was clearly not the case.

That such pictures sprang straight from the artist's imagination and reflected personal preoccupations and ideas can be inferred from a remarkable (undated) letter that Goya wrote to Zapater. (This letter may have preceded his illness, but equally well could have been written at the time that he was working on *Los Caprichos* and painting these pictures that are so closely related to the witchcraft themes in the etchings and their preparatory drawings.) He claimed: 'There's plenty of energy in the last letter you sent me, and the truth is that you can find everything up your sleeve, just like me when I'm inventing in painting…', and after referring to financial worries that put him in a bad mood, he added: '…ya, ya, ya, I'm not afraid of witches, hobgoblins, apparitions, boastful giants, knaves or varlets, etc., nor indeed of any kind of beings except human beings…'.

Witches were very much in the air at the end of the 18th century. They intrigued and amused the educated classes, but were ridiculed and decried by Goya's enlightened friends, who saw all superstition as a threat to progress and the emancipation of the common man from harmful beliefs and the power of the clergy. Judging from Goya's texts and titles for *Los Caprichos*, he used witches and witchcraft for comic effect, but also, most importantly, as allegories of human behaviour, and the same seems to be true of these six paintings. Two of them have been identified as scenes from plays by Antonio Zamora (cat. 48, 49), and it is not impossible that others may derive from the theatre, although the source most usually suggested is the celebrated account of the *auto de fe* at Logroño in 1610, a Spanish equivalent of the Salem Witches' trials, that was annotated with a burlesque commentary by Goya's dramatist friend Leandro Fernández de Moratín. However, the inventions that Goya pulled out of his sleeve inevitably related to his own experience and to the human beings that he feared more than he did monstrous apparitions.

Fig. 156 '*Trials*',
pl. 60 of *Los Caprichos*, 1797–8
etching and aquatint,
21 × 16.6 cm
Museo del Prado, Madrid

Fig. 157 '*Blow*',
pl. 69 of *Los Caprichos*, 1797–8
etching and aquatint,
21.3 × 14.8 cm
Museo del Prado, Madrid

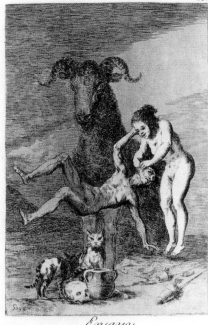

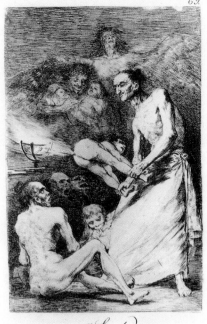

Fig. 155 Goya's invoice for his 'six
pictures of witches', 1798
Collection of Jaime Ortiz-Patiño

As with the pictures on tinplate, there is no way of telling in what order the paintings were made, but reference to the *Caprichos* prints and the *Sueños* preparatory drawings suggests some parallels. The *Witches' Kitchen* (cat. 44) is close to the more 'realistic' style of the drawings and prints made early on in the *Caprichos* series (figs. 156, 157). This subject, the transformation of men into goats, dogs and infernal beings, is one that Goya made into a satire on human behaviour in a characteristically bold, almost abstract, later plate, with the title '*Wait till you've been anointed*' (fig. 158). In the painting, hideous male figures, rubbing their limbs with unguent poured from a smoking jar, are turning themselves into animals. Human skulls lie on the floor, and from a rope tied to the rafters hang bones and an oil-lamp that throws its light over the grisly scene. The steep diagonal of the rope parallels the broomstick on which a fully transformed he-goat is taking off up the chimney to join the witches' sabbath.

Outside, in the dark night, two travellers, one running, the other having fallen, are in terror as three witches carry a screaming, naked figure through the air, sucking his blood as they go. Goya's *Flying Witches* (cat. 45) is far more sinister and frightening than the other three scenes of witches' activities, and strangely recalls the desolate landscape and blanketed figures of the *Winter* tapestry design (cat. 22). The flying figures are wearing *corozas*, tall conical head-dresses worn by penitents or prisoners of the Inquisition (cat. 96, 97). Here they are modified by a cleft that suggests a bishop's mitre, and links the figures to the anti-clerical prints and their related drawings in the *Caprichos*, in which witches in the form of old hags, friars and prelates suck their victims or expel noxious blasts of foul air (figs. 157, 159, 160). Using hands or a sheet, the two terrified men in Goya's *Flying Witches* stop up their ears and cover their eyes, while the standing figure also thrusts his thumbs between his fingers in the traditional gesture

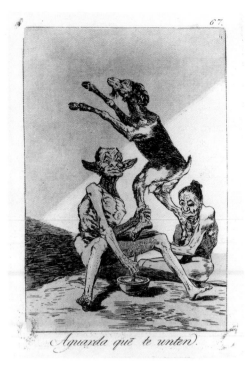

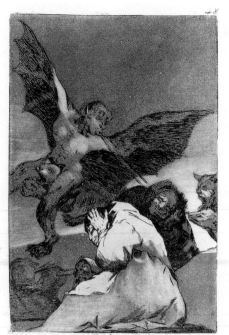

Fig. 158 '*Wait till you've been anointed*', pl. 67 of *Los Caprichos*, 1797–8, etching and aquatint, 21.7 × 15.1 cm
Museo del Prado, Madrid

Fig. 159 '*Tale-bearers, or Blasts of wind*', pl. 48 of *Los Caprichos*, 1797–8, etching and aquatint, 20.7 × 15.1 cm
Museo del Prado, Madrid

that is meant to conjure away evil. Only the ass is unmoved by the fearful apparition, and stands his ground.

The Witches' Sabbath and *The Spell* (cat. 46, 47) both illustrate the rituals of witchcraft. In one, the Devil in the form of a great he-goat, crowned with vine-leaves and with a wicked glint in his eye, sits at the centre of a circle of women who offer him foetuses, newborn babies or skeletal children. In the other, five hideous witches are casting a spell on a terrified man who, in his nightshirt, has been transported to this desolate place. While one chants from a book by the light of a candle, another holds a basket of babies, and a third sticks a huge pin into a foetus. In both pictures, and in many plates of the *Caprichos* (figs. 157, 160, 161), Goya dwells on the threat to young lives, born or unborn, from fate or wicked witches identifiable as procuresses who practise abortions. Given his tender attitude to children, revealed in so many portraits and

other works (cat. 19, 65), the fact that only one of Goya's seven baptised children survived beyond childhood, and the references in his letters to his wife's miscarriages, suggest a reason for the repetition of these images and the artist's obsession with this theme.

Of the six witchcraft subjects, two are clearly identifiable as scenes from the theatre, both taken from comedies by Antonio Zamora that were still very popular in Goya's day. Of the scene of Don Juan and the Knight Commander, from the third act of *El Convidado de piedra* (*The Stone Guest*), little can be said, for the picture has not been seen since the sale of the possessions of the bankrupt Osuna family in 1896. The stone figure advances towards the jaunty and defiant Don Juan, seated waiting for his guest, and the relationship of the two figures and Don Juan's nonchalant pose recall Goya's burlesque *Hercules and Omphale* of some fifteen years earlier (cat. 18).

The other theatre scene is identified by the

Fig. 160 '*The Witches'
Proclamation*', *Sueño* no. 6
pen and iron-gall ink,
23.1 × 15.3 cm
Museo del Prado, Madrid

Fig. 161 '*A gift for the master*', pl.
47 of *Los Caprichos*, 1797–8
etching and aquatint,
21.7 × 15 cm
Museo del Prado, Madrid

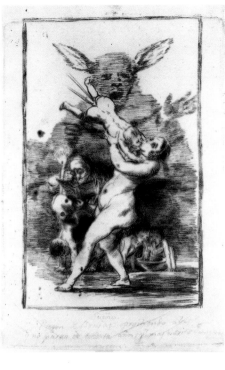

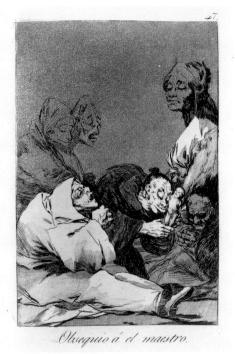

Obsequio á el maestro.

lettering on the book or prompter's sheet at lower right: 'LAM[PARA] DESCO[MUNAL]'. This is the first line of a speech by the ridiculously fearful and superstitious priest Don Claudio, who believes he has been bewitched and must keep the Devil's lamp alight in order to stay alive: 'Monstrous lamp / Whose vile light / As if I were a wick / Sucks up my life's oil'. The dancing donkeys, or asses, in the picture were also dimly discerned in the background by Don Claudio, and they link the painting to the satires on asses that appear in the *Caprichos* etchings and the album of drawings that preceded them.

This group of six pictures suggests an allegory or satire on the senses and the physical and spiritual nature of Man, from the moment of his conception until death. It is also a reflection on his vulnerability to evil forces that may or may not be beyond his control – perverse desires and mutations, 'witches' who take hold of his body and suck him dry, the passions and follies that lead Don Juan and Don Claudio astray. The scenes are 'staged' with the figures in close-up against a decor that could, in all of them, represent a painted backdrop. This unity is nevertheless enlivened by very varied handling in a relatively broad and free technique, and the canvases can be seen as pairs that form a harmonious whole. In January 1799 the Osunas acquired four copies of *Los Caprichos*, and in *tertulias* (gatherings) at La Alameda the significance of witches and demons could have been discussed with Goya's vivid depictions of these creatures to hand. In his later series of paintings, Goya eliminated these creatures of fantasy, concentrating on the dreadful actions of the human beings that were so much more to be feared, until the demons re-emerged years later, in the Black Paintings of the Quinta del Sordo.

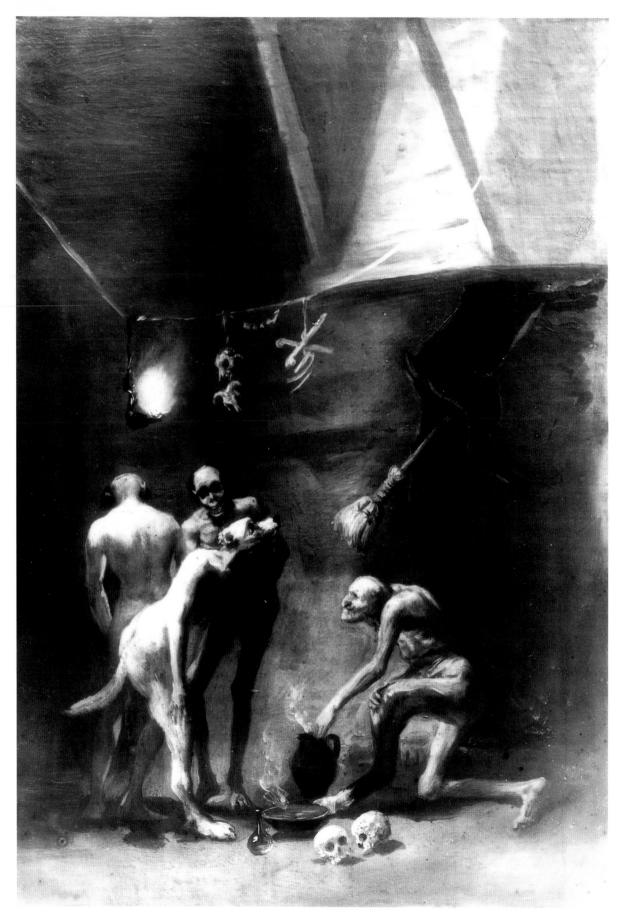

44 *The Witches' Kitchen*, 1797–8
oil on canvas, 45 × 32 cm, Private Collection

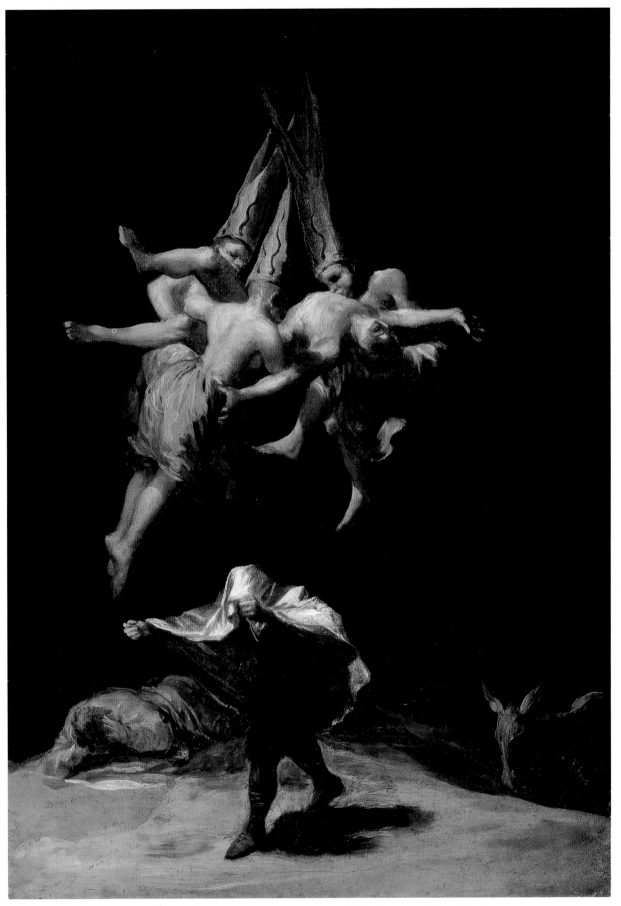

45 *Flying Witches*, 1797–8
oil on canvas, 43 × 30.5 cm, Jaime Ortiz-Patiño Collection

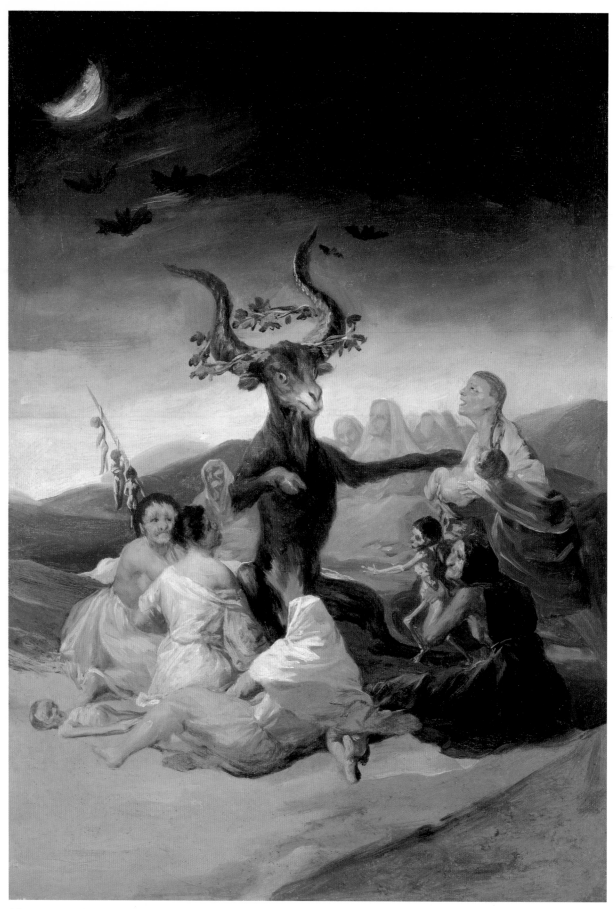

46 *The Witches' Sabbath*, 1797–8
oil on canvas, 43.3 × 30.5 cm, Museo Lázaro Galdiano, Madrid

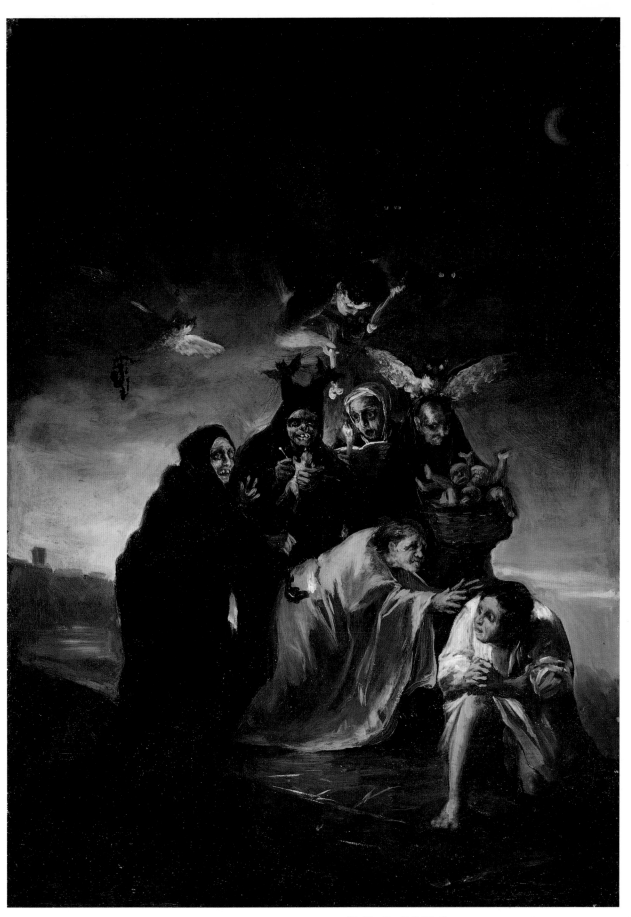

47 *The Spell*, 1797–8
oil on canvas, 43.5 × 30.5 cm, Museo Lázaro Galdiano, Madrid

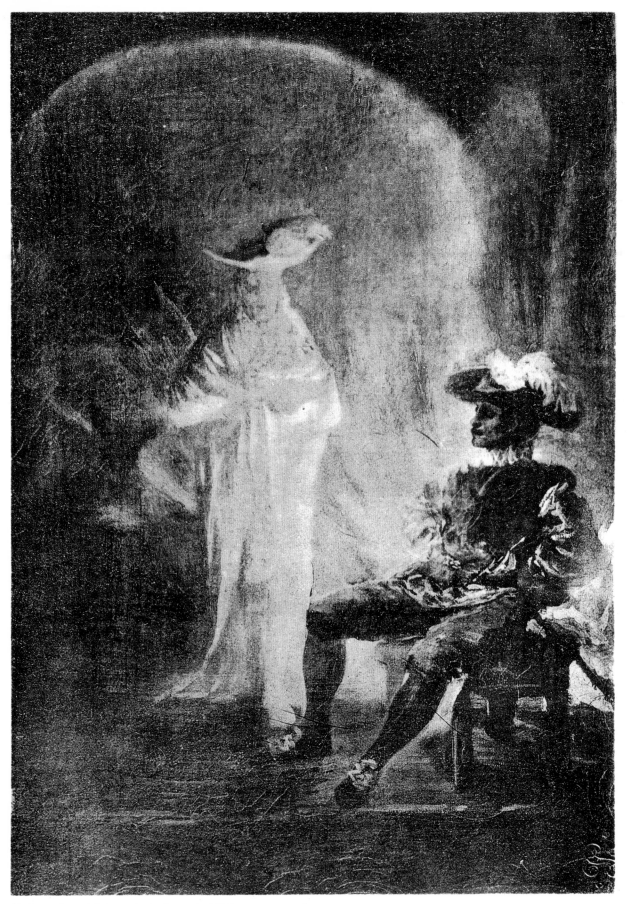

48 *Scene from 'El Convidado de Piedra' ('The Stone Guest'),* 1797–8
oil on canvas, 45 × 32 cm, Location unknown since 1896

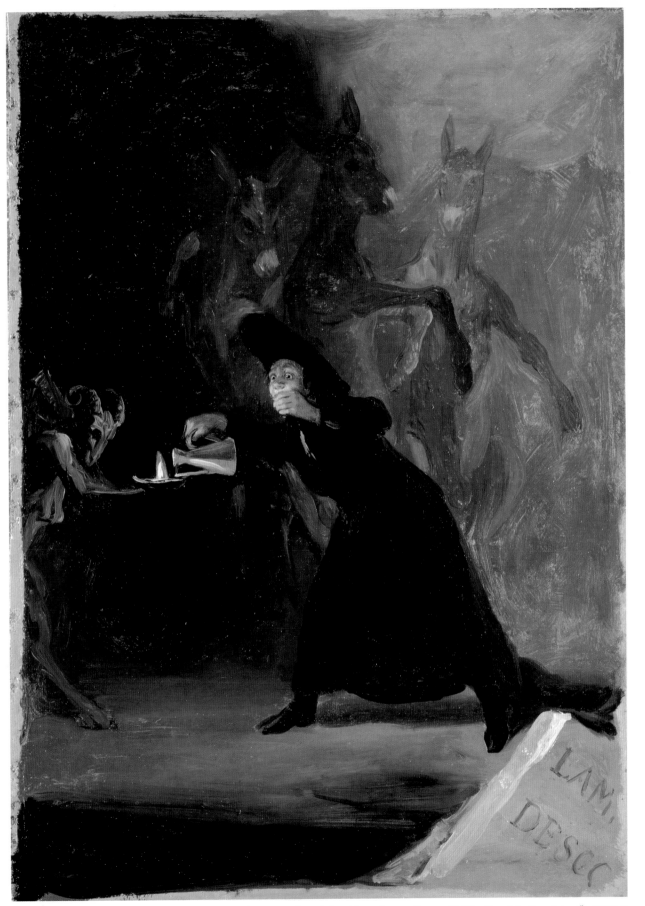

49 *Scene from 'El Hechizado por Fuerza' (The Forcibly Bewitched)*, 1797–8
oil on canvas, 42.5 × 30.8 cm, The Trustees of The National Gallery, London

ALLEGORY ON TIME, TRUTH AND HISTORY,
c. 1797–1799

This slight and sketchy composition is a study for one of Goya's largest paintings, in which the winged and bearded figure of Time draws forward into the light a beautiful woman with classical features (fig. 162). Clothed in a simple white dress, she displays a book and holds a sceptre. In the sketch, the young woman, identifiable as Truth, is naked, although if, as it appears, she is holding a small book in her hand, she could be an allegorical representation of Truth, or perhaps Philosophy, whom Goya depicted in a much later drawing (fig. 216). In front of her, History is seated on a stone that appears to be part of a column, and looks over her shoulder as she records the past in her open book. In the large painting, naked Truth is transformed by her dress and attributes, and has been seen as the figure of Philosophy, as depicted in Ripa's *Iconologia*, or of History, or, most recently, as a personification of the liberal Constitution of 1812. If the latest interpretation is correct, what was Goya representing in the sketch, and for what purpose did he paint it? Its date cannot be in doubt since it corresponds so closely with the *Caprichos* prints and their related drawings, and also with the six witchcraft paintings made at the same period (cat. 44–9).

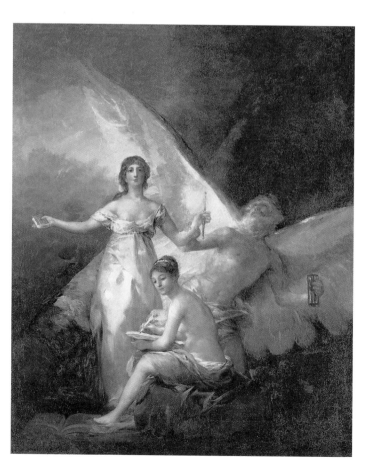

Fig. 162 *Truth, Time and History,*
1797–1800/?1812–14
oil on canvas, 294 × 244 cm
Nationalmuseum, Stockholm

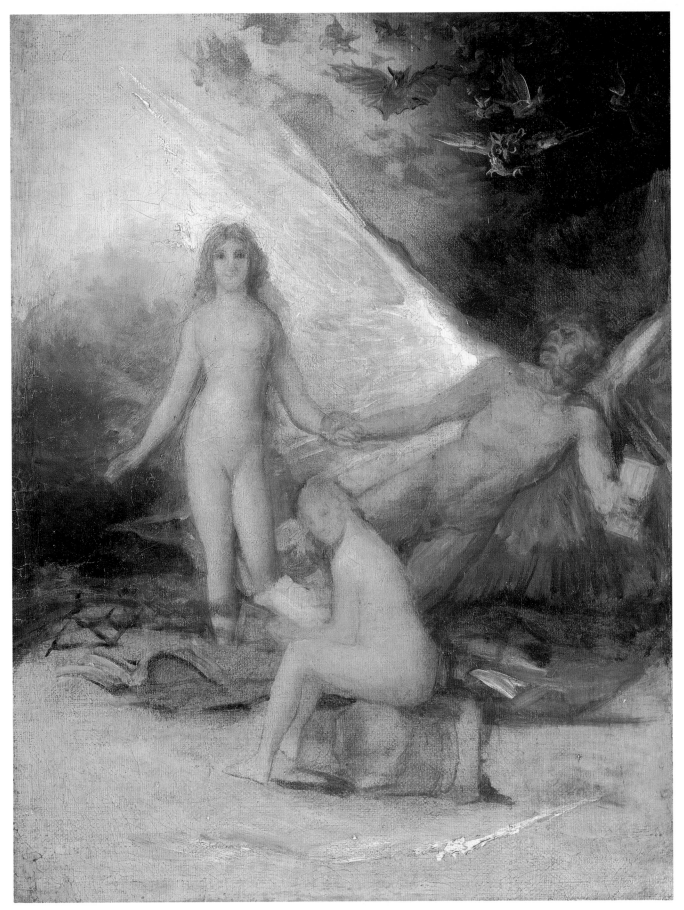

50 Sketch for *Time, Truth and History*, c. 1797–9
oil on canvas, 41.6 × 32.6 cm, Museum of Fine Arts, Boston,
Gift of Mrs Horatio Greenough Curtis in Memory of Horatio Greenough Curtis

The sketch has suffered: over the years the effects that Goya was interested in capturing, above all the effects of light, have been much reduced by the old relining that flattened the impasto. The figures, too, were abraded and partly restored long ago, and Truth's face, which Goya may have left almost blank, has been retouched. The figures of the two women are delicately drawn with the point of the brush, and they show traces of pentimenti, suggesting they may have been draped. The figure of Time, identified by his hour-glass, was also altered in the course of work, and his head is in any case strikingly different from that of the classic, grey-bearded figure in the large painting. In the sketch, he appears more saturnine and resembles the flying demons in some of the *Caprichos* prints (fig. 157). He grasps Truth by the wrist, pulling her forward so that she stands silhouetted against the light reflected in the great spread of his wing, and looking up anxiously at the flocks of owls and bats flying out from the darkness overhead. The position of his body and his advancing left arm suggest that he is about to take flight, bringing Truth away from the menacing nocturnal creatures, but there is a certain confusion in the movements and gestures that Goya eliminated in the final painting. In a drawing closely related to the *Caprichos*, showing Time flying with Truth (fig. 163), Time's head and the arm holding the hour-glass are much closer to their positions in the large picture, and the forward thrust of his left thigh gives the body a firm stance, rather than its floating or flying motion in the oil sketch.

The way in which the sketch was composed is also strikingly similar to that of the witchcraft pictures that Goya was painting at this time. Like *The Spell* (cat. 47), the allegory sets its three participants within a space that is given depth by the slight indication of the diagonals in the foreground. Was it an abandoned idea for the *Witchcraft* series? Or an independent sketch for a large allegory that was not painted – or completed – until later?

Fig. 163 *Time and Truth*, 1797–8
wash over red crayon, 30.5 × 20.6 cm
Museo del Prado, Madrid

If a grand allegory was planned but left incomplete in the period in which Goya was working on the *Caprichos* (in 1797–8), the most likely occasion would have been the nomination of Jovellanos as Minister of Grace and Justice in November 1797, and, even more important, as acting Prime Minister when Godoy was temporarily dismissed by the King in the following March. Three days before that happened, Goya had returned from Aranjuez, where he had painted a deeply sympathetic portrait of the Minister (Museo del Prado, Madrid), showing him seated at his work-table beneath a bronze statue of Minerva, goddess of wisdom and of the arts and crafts. If an allegorical painting was planned to herald a period of enlightened government led by

Goya's learned and high-minded patron (see cat. 13), its abandonment would be explained by Jovellanos's replacement a few months later (16 August 1798). This sketch would then have been used or the large painting, if begun, could have been completed for the brief triumph of liberalism when the Cortes proclaimed the Constitution in Cadiz in 1812.

Like the sketch, the large allegory has suffered over the years, and it is therefore difficult to judge its style and assess its date. However, its rational organisation and strongly classical forms suggest a relationship with Goya's allegorical and religious paintings of 1810–12. It is a grandly impressive picture that was no doubt appropriate to the setting and context for which it was painted. But the sketch that Goya painted in the last years of the 18th century, despite its lack of finish and some loss of quality, has a youthful freshness that reflects its creation at a time when optimism was still undimmed and it seemed that Truth and the 'philosophical' principles of the Enlightenment would prevail.

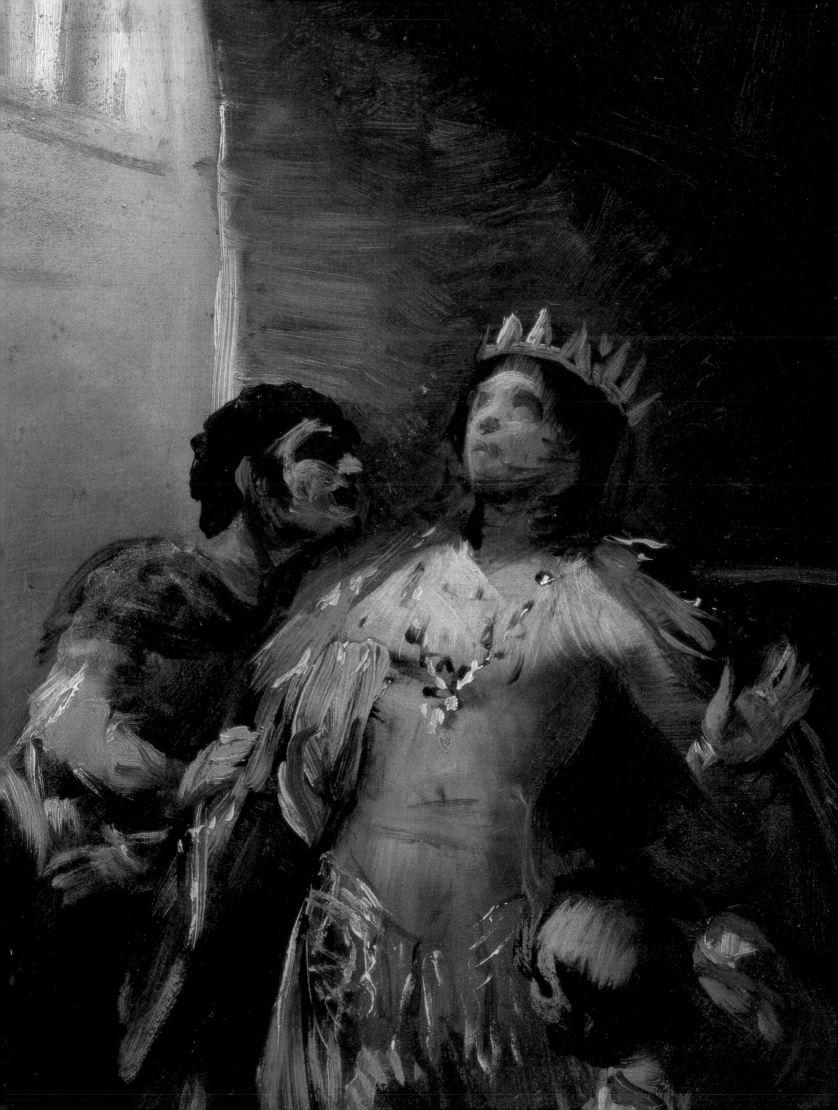

Paintings on Religious Themes

1796–1800

After intense activity in the field of religious paintings in the 1780s (cat. 8–17), it was not until the second half of the 1790s that Goya returned to these themes. The altarpieces painted in 1788 for the Duchess of Osuna, to adorn her ancestor's chapel in the Cathedral at Valencia, had been the last such works before Goya's illness, and during his convalescence he was evidently unable to take on large-scale works. Little is known about his activity during 1794, after his reappearance on the scene with the series of paintings shown to the Academy (cat. 32–43). By the end of March, he had evidently still not been seen at the Tapestry Factory, and its Director noted that since the death of Ramón Bayeu a year ago, Goya 'has not delivered a single painting…and from what I understand is absolutely incapable of painting as a result of a serious illness that he suffered'. Goya's deafness certainly complicated his more public activities, and in April he reported to the Secretary of the Academy that he was finding it very difficult to give classes and keep order among the students. However, he was evidently painting regularly, if on a reduced scale, mainly in the field of portraiture. At the end of that year, Don Ramón Posada, whose portrait Goya painted shortly thereafter, visited the artist at his home, recording the fact that 'I found him so totally deaf that it was necessary to communicate with him by writing'. But when Posada enquired about a painting commissioned by the Academy of San Carlos in Mexico, Goya indicated that he had not yet begun 'such an important and tiring commitment, without assurances as to its payment', which suggests that by late 1794 he was fully able to undertake large pictures if it was worth his while.

In the second half of the decade, Goya produced some of his most important works, including a magnificent series of portraits, major religious paintings, and his etchings of *Los Caprichos*, published in 1799. Although he was intimately linked with enlightened reformers like Jovellanos and Meléndez Valdés and evidently held many of the same views, he was certainly not the agnostic disbeliever, tainted by impious liberal ideas, that has sometimes been implied. His letters to Zapater confirm his continuing, uncomplicated faith, and his religious paintings of the 1790s are evidence, if such were needed, of his profound emotion before the mysteries of the Church and the miracles of its saints.

During these years he painted three lunettes for an oratory in Cadiz (cat. 51, 52), and then, in a burst of creative activity at the end of the decade, his 'Sistine ceiling' in the frescoes of San Antonio de la Florida on the outskirts of Madrid (cat. 53, 54), an extraordinary *Taking of Christ* for the Cathedral sacristy in Toledo (cat. 55) and three major altarpieces, lost in the War of Independence, for a church near Saragossa (see cat. 56–8). In each of these commissions he sought an ideal solution for the subject to be painted and its architectural context, and as always, the preparatory sketches reveal and illuminate the processes of his art.

Fig. 164 Detail from *St Hermengild in Prison* (cat. 58)

ORATORY OF THE SANTA CUEVA, CADIZ, *c.* 1796–1797

Three of Goya's least-known works are to be found in an oratory in Cadiz, next to the church of El Rosario and not far from the home of Sebastián Martínez, the friend who looked after him during his illness in 1792–3. They are lunette-shaped paintings on canvas, set high on the walls of the richly decorated, oval interior, in which columns of jasper support a soaring vault (fig. 167). The oratory, built above the original Santa Cueva (Holy Cave), a subterranean chapel for the meetings of a religious brotherhood, was intended for prayer and meditation on the Sacrament of the Eucharist. It was built in 1793–6 and consecrated in March 1796, and its decoration includes five paintings, one each by Zacarías González Velázquez and José Camarón, and three by Goya. All five are on themes connected with the Eucharist, in a carefully devised iconographical scheme that embraces the whole building, and Goya's three subjects included the principal scene of the *Last Supper*, as well as scenes relating to the Eucharist in the the *Miracle of the Loaves and Fishes* and the parable of the *Expulsion of the Guest without a Wedding Garment.*

No documents relating to the paintings have come to light, and it is not known where Goya painted them, whether in Cadiz or Madrid, or in which year. Of the two other paintings, Zacarías Velázquez's *Wedding at Cana* is signed and dated 1795, while Camarón's *Gathering the Manna* is undated. Since the oratory was consecrated in March 1796, it has been suggested that Goya may have sent his paintings from Madrid, or that he painted them during his extended stay in Andalusia that year, or even at some later date. A Palace document of 1798, referring to Goya's demands that he should be reimbursed for payments to his colour-grinder, said that he had done no work

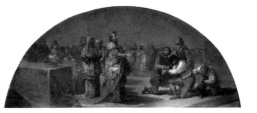

Fig. 165 *Invitation of the Father of the Family,*
c. 1796–7
oil on canvas, 146 × 340 cm
Oratory of Santa Cueva, Cadiz

for the Palace, 'least of all during the whole of 1796 when he was absent in Seville'. This was the year when Goya stayed with the Duchess of Alba (see figs. 8, 9) at Sanlúcar during the summer, but also visited Ceán Bermúdez in Seville, and by the end of the year was ill, once again, in Cadiz. Lacking documentary material, only study of the paintings themselves and their preparatory sketches will confirm the date of their execution. And of the two known sketches, the whereabouts of the one showing the *Miracle of the Loaves and Fishes* has been unknown since 1935.

The *Last Supper* (fig. 168), over the entrance to the oratory and facing the altar, is the focus of the pictorial scheme, and Goya devised a composition that is both profoundly original and also a perfect example of intelligent

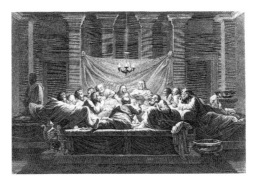

Fig. 166 *The Eucharist,*
after Nicolas Poussin,
engraved for *La Galerie*
du duc d'Orléans, 1786,
vol. II, no. 62
Biblioteca Nacional, Madrid

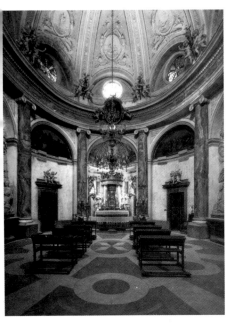

Fig. 167 View of the high altar in the Oratory of the Santa Cueva, Cadiz

plagiarism. It shows Christ among his disciples, not seated in the normal way, but reclining Roman-style around a low table of indeterminate shape. The connection with Poussin's *Eucharist* in the Seven Sacraments series (Ellesmere Collection, on loan to the National Gallery, Edinburgh) has long been noted, but that painting was inaccessible to Goya. However, it is now clear that he could have seen the engravings after Poussin's paintings in the inexhaustibly rich collection of prints and books that belonged to Sebastián Martínez (fig. 166).

The sketch for the *Last Supper* (cat. 51) is a rapid compositional study that establishes the elements of the design, the effects of light and, particularly, the rhythms of the picture, by means of expressive brushwork. Sketchily painted on a red ground that is left uncovered in many places, it is composed on a series of diagonals that lead the eye from the shadowy foreground figures across the vibrant touches on the table-cloth to the luminous figure of Christ and, above all, His hand raised to bless the chalice. Diagonals indicated in the foreground give depth to the composition and break the awkward angles of the lunette, transforming it into a fan shape. In the finished painting, the composition has been reorganised for greater legibility. St John moves from left to right of the figure of Christ, so that the blessing of the bread and wine is clearly the central motif. Figures standing behind the Apostles are moved away to the right, while an angle of wall now draws attention to the two most clearly defined Apostles apart from St John, perhaps SS Peter and Paul, and the gesture of wonder of the nearer of the two, also clearly indicated in the sketch, that leads the eye to the bread and wine on the table. The barely defined figures on the left of the sketch become the expressive group of three dis-

ciples, portrayed as simple men of blind, 'primitive' faith. Basing his composition on a classic, Poussinesque formula, Goya interpreted the mystery of the Eucharist through the powerful emotions of very real, ordinary people gazing at Christ, and at the bread and wine transformed through His gesture.

In the *Miracle of the Loaves and Fishes* (cat. 52) the sketch is more confused, and Goya made greater changes in the finished painting (fig. 169) in order to give prominence to the figure of Christ and to open up the background to the distant view of the multitude, organised in the same way, although on a very different scale, as in the *Meadow of San Isidro* (cat. 26). Goya's sketches and final canvases for the Santa Cueva are painted with great freedom, and in the latter the red ground shows through the very thin layers of colour, brushed swiftly over the surface and enlivened by bold touches of impasto. If Goya went to Cadiz in the early months of 1796, as it now seems he may have done, and knowing the remarkable speed with which he worked, it is not impossible that sketches and broadly brushed canvases were painted on the spot in March. The paintings are related both to his earlier work, in the more complex forms of the draperies or the theatrical types of gesture, and to the later, freer style in which forms drawn with the brush predominate, and faces and figures become more popular, more brutish even, but at the same time more powerfully expressive. Although his contacts with those responsible for the Santa Cueva almost certainly date from his earlier stay in Sebastián Martínez's home during his illness, for reasons of style and technique it seems likely that Goya's paintings were conceived and painted after his full recovery, either in Madrid in 1795–6 or in Cadiz, just in time for the consecration of the Santa Cueva oratory in March 1796.

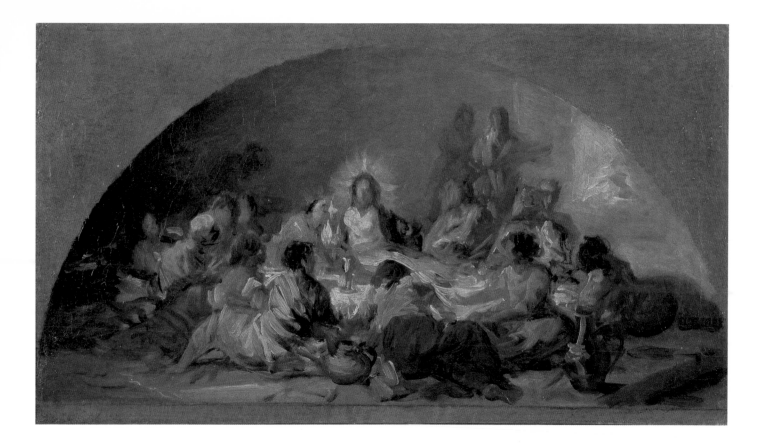

51
Sketch for *The Last Supper*, c. 1796–7
oil on canvas, 25 × 42 cm
Private Collection

Fig. 168 *The Last Supper*,
c. 1796–7
oil on canvas, 146 × 340 cm
Oratory of the Santa Cueva, Cadiz

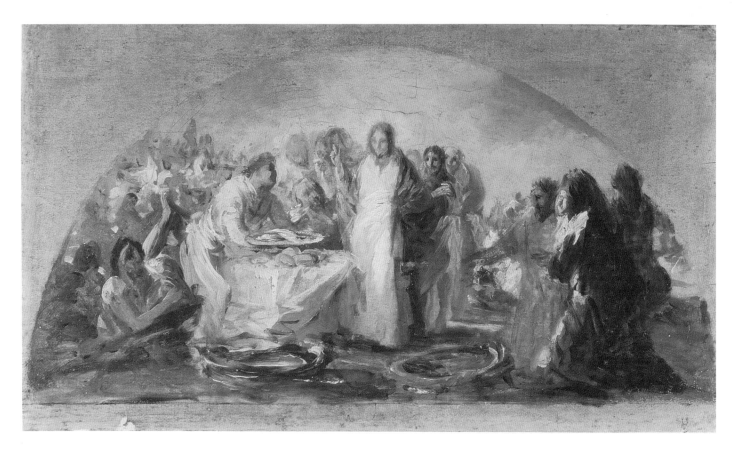

52
Sketch for *The Miracle of the Multiplication of Loaves and Fishes*, c. 1796–7
oil on canvas, 24.4 × 38.7 cm
Location unknown since 1936

Fig. 169 *The Miracle of the Loaves and Fishes*,
c. 1796–7
oil on canvas, 146 × 340 cm
Oratory of the Santa Cueva, Cadiz

SAN ANTONIO DE LA FLORIDA, MADRID, 1798

The view fom the Royal Palace in Madrid embraces two of the sites most cherished by the people of Madrid in Goya's day, and which are forever linked to his name: to the south-west, across the River Manzanares, the hermitage of San Isidro, painted by Goya in 1788 to show the festivities on the Saint's day on 15 May (cat. 25, 26); and to the northwest, adjoining the river, the hermitage of San Antonio de la Florida, now paired with the replica built for worship when the original chapel with its frescoes became a national monument. The latter hermitage was constructed when Carlos IV decided to enlarge his royal domains and include the pleasant estates of La Florida that lay beyond the city gates. This necessitated the destruction of a chapel designed by Sabatini, which was replaced by the present simple, elegant structure, built in 1792–8. The interior consists essentially of a central space just over five and a half metres square, surmounted by a cupola and lantern, and with windows in the walls below. Beyond this central space is a small choir and apse (fig. 170).

No official document concerning the order to paint the interior of the royal hermitage is known, perhaps because it was simply a part of Goya's duties as Court Painter, but an invoice records the materials supplied to him between 15 June and 22 October 1798 'for the work in the chapel of San Antonio de la Florida, which he has painted by royal order of His Majesty in this year 1798'. From the end of March until the middle of August 1798, Jovellanos was Minister of Justice and acting Prime Minister with his colleague Saavedra, the Minister of Finance, and he was no doubt largely responsible for the allocation of this project to Goya. The artist's multiple activities in this year included this representation of a miracle and of angels

in glory in fresco in a popular chapel, the painting of a series of pictures on the theme of witchcraft (cat. 44–9), portraits of the liberal ministers Jovellanos and Saavedra and of the French regicide Guillemardet, ambassador to the Court of Madrid, and the *Los Caprichos* etchings, a series of satires that attacked immorality and corruption in high and low places, and in particular the abuses of the Church, which were published early in 1799.

In San Antonio de la Florida, Goya found himself once again, as in El Pilar in Saragossa in 1782 (cat. 8, 9), although now on a much smaller scale, with a cupola and its pendentives, and all the upper architectural areas of the chapel, including the apse. For the hermitage dedicated to the cult of St Antony of Padua, the theme chosen for the cupola was one of his most striking miracles. St Antony was born in Lisbon to parents of noble descent who gave their son an excellent education. He chose to follow a religious vocation, and became famous as a preacher in Italy and the south of France. The subject of Goya's frescoes is an event recounted in Father Isla's translation of the *Christian Year* (*Año Cristiano*) of Father Croisset: '[The Saint] was in Padua when he received news that his father, who had been falsely accused of murder in Portugal, was in danger of being sentenced to death. He requests permission from his superior to leave for Portugal, and by a miracle finds himself immediately in Lisbon. He pays a visit to the judges and proclaims the innocence of his father, but realizing that his testimony has carried no weight with them he asks that the dead man's body be brought to the courtroom. The novelty of the case had attracted the whole city to the place; St Antony questions the dead man and orders him in the name of our Lord Jesus Christ to declare loudly and clearly

Fig. 170 Interior of San Antonio de la Florida, Madrid, engraving after Yriarte, published in C. Yriarte, *Goya*, Paris, 1867, p. 55

Fig. 171 View of the cupola, with the *Miracle of St Antony of Padua*, in San Antonio de la Florida, Madrid

whether his father was responsible for the murder which had been committed on his person; the corpse raised himself up, and publicly declared the innocence of the accused; and once the declaration was over he settled himself again in his coffin. The admiration and astonishment which the action caused in those present is easier to understand than to explain. Antony directed a fervent address to all his family exhorting them to virtue; and in an instant he found himself restored once again to his convent in Padua.'

It is not known whether Goya chose the particular miracle to be represented, but there is no doubt that of those recounted in the *Christian Year* it provided the richest source for his imagination at this time. The idea of St Antony transported through the air from Padua to Lisbon, but for saintly rather than devilish purposes, and the goodness and humility of the Saint of noble lineage who fought against 'licentious and disordered behaviour' was in harmony with his current preoccupations. He presumably began to think about the decorative scheme in May 1798, and Moratín's diary for 21 May records, in his curious coded language, '*cum Goya a San Plácido, vidi picturae*' – no doubt a reference to Goya's study of fresco decorations in one of several Madrid churches. The first materials for the frescoes were delivered on 15 June, and from 1 August a hired coach took him to the hermitage every day for one hundred and twenty days, until his work was completed on 29 November.

Of the two known preparatory sketches, and there may have been others that have not survived, one is a study for the northern half of the cupola (cat. 53), where the miracle takes place and which is seen by the visitor on entering the chapel (fig. 171). The sketch, swiftly, almost crudely, brushed, appears to be a first idea for the composition and, above all, a study of the effects of light that Goya was seeking. It shows the Saint in an open landscape, contradicting the reference to the

courtroom scene in the *Christian Year*, standing on or just behind the grey coffin from which the murdered man has been taken and unwrapped from his shroud. The naked figure appears to be dead, or just starting to resuscitate, half-supported by a woman wearing a red shawl who, like the group of figures farther away, is gazing at the Saint in awe and wonder as he leans forward with a gesture of blessing and command. To the left, a small boy with a very pink face and vivid yellow jacket has straddled the balcony in a pose that also directs the eye towards the Saint, so that the central group forms a triangle with the Saint's head at its apex.

There is, however, a competing focus of attention overhead, where angels are descending from the Heavens, holding up heavy draperies. On the left, a figure with his back to the balcony has raised his arms in wonder at the sight, while to the right of the composition, the barely defined figures seem to have no clear focus. The principal figures are thrown into relief by vigorous strokes of white paint added around the contours or in smaller, vivid touches that mark the rhythms of the figures along the balcony.

In the cupola itself (fig. 172), Goya reorganised the whole composition, replacing the celestial Heavens by a landscape and sky that open up to natural daylight from the lantern. By relegating the angels, cherubs and curtains to the lower areas, on the pendentives, arches and lateral walls around the windows, he was able to make his scene in the cupola an entirely real one. Here, there are no competing centres of interest, and the action around the balcony centres on the scene of the miracle. The Saint is now shown standing on a rock, rather like St Bernardino in the painting for San Francisco el Grande (cat. 11, 12), and is detached from the surrounding figures as he commands the murdered man to speak. Instead of the inert figure on the shroud, the livid figure of the murdered man sits up, hands stiffly joined in prayer, and appears to be answering the Saint.

The shroud, whose white accent in the sketch distracts attention from the Saint, has been moved to another part of the balcony, where it serves to break its continuity and draw attention to the coffin, placed exactly opposite the murdered man, on which a man who is probably the gravedigger, with a mound of earth behind him, stands with arms outstretched, gazing at the miracle ocurring on the other side.

The movements and expressions of the crowd around the balcony are extraordinarily varied, and as in the paintings for the Santa Cueva (cat. 51, 52), Goya has shown the reactions of simple people, from religious awe to excitement, curiosity or indifference, creat-ing a sense of the whole texture of society through the variety of people, costumes and gestures. In the figure of the Saint himself, sometimes qualified as expressionless, Goya perfectly captures the humility and goodness as well as the passionate, magnetic character of the young man. In the fresco, another child is clambering onto the balcony rail, and the figure with upraised arms in the sketch has been turned away from the now banished *gloria* and towards the Saint, while beside him a figure seen from the back, with his hat pulled down over his ears – probably the 'false accuser' – is fleeing from the figures harmoniously grouped about the Saint. Those that surround the murdered man to the right are

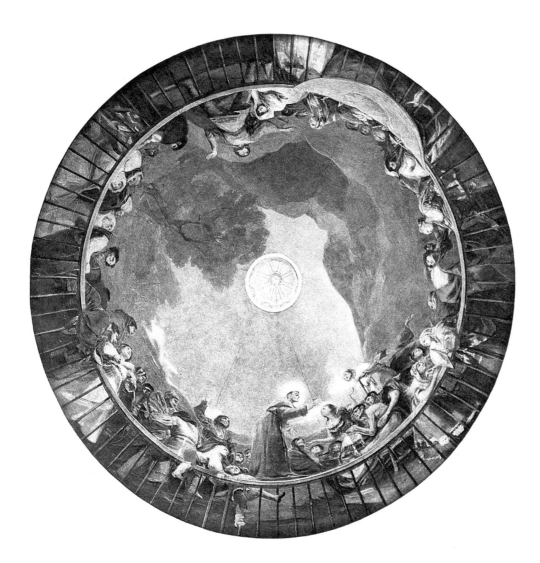

Fig. 172 The cupola in San Antonio de la Florida, Madrid

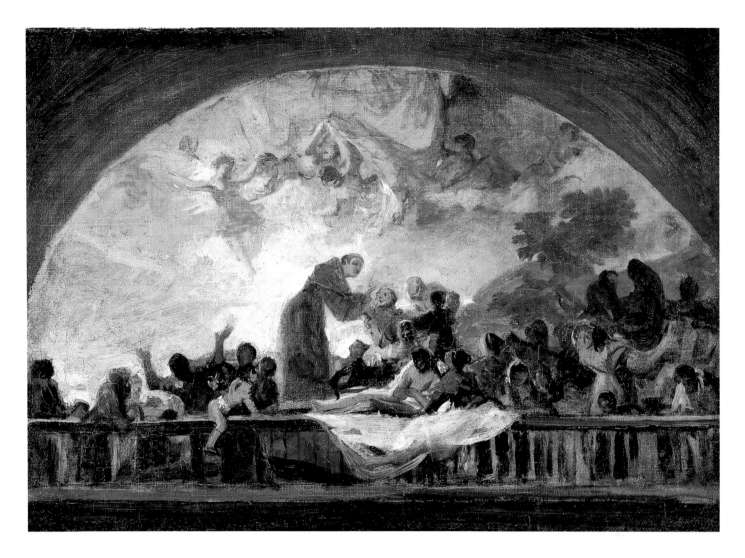

53
Sketch for *The Miracle of St Antony of Padua*, 1798
oil on canvas, 26 × 38 cm
L. Maldonado Collection, Madrid

complemented by the light accent of the woman gazing intensely at the miracle and holding a large white handkerchief, already indicated in the sketch, who recalls the emotional women in one of Goya's paintings for the Cathedral in Valencia (cat. 16).

The *gloria*, banished from the cupola, is represented on the curved apse of the church (fig. 173). It receives little natural light, and would have been illuminated principally by candles on the altar below. Goya's decoration consists of a host of angels adoring the Holy Trinity, which is represented in stucco, with rays of light emanating from the divine triangle. While the fresco is less original and effective than Goya's representation of angels in the other areas of the church, the sketch is an exquisitely composed and painted evocation of the effect he intended. The stucco triangle and rays of light are indicated at the centre, and around the symbolic image angels are drawn with the point of a brush and brown pigment and enlivened with the lightest touches and washes of colour – carmine, blue and yellow –

as they fly or float, recline or kneel, their varied movements and ecstatic mood expressed by fluid brushwork and dancing, glancing touches of impasted white.

Dancing rhythms characterise the brushwork in the frescoed angels on the arches and walls and pendentives that lead the eye towards the cupola. Recently restored, these angels have recaptured their former glory, and the natural light from the chapel windows and the lantern reveals the splendour of their majestic poses and richly decorated garments, and above all the subtlety of their modelling. The cupola, still much obscured by grime, will be revealed in all splendour only after cleaning. But comparison with the sketch shows that here, too, Goya used white to throw the principal figures into relief and to create harmonious rhythms in the figures around the balcony. Perhaps in no other case in Goya's work does the sketch reveal so clearly the richness of the artist's invention and the clarity of his thought and control of his artistic means in arriving at the final, pefect solution.

Fig. 173 View of the apse with the *Adoration of the Trinity* in San Antonio de la Florida, Madrid

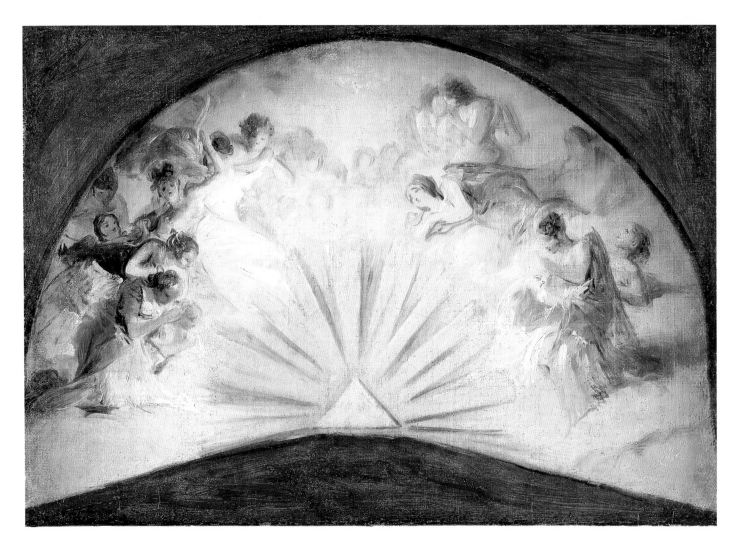

54
Sketch for *Adoration of the Trinity*, 1798
oil on canvas, 26.6 × 37.7 cm
L. Maldonado Collection, Madrid

SACRISTY OF TOLEDO CATHEDRAL, 1798

Goya's *Taking of Christ* (fig. 175) was painted for the Cathedral sacristy at Toledo, a long, rectangular room dominated by El Greco's magnificent *Disrobing of Christ* at the far end (fig. 174). The walls of the great chamber are lined with bays containing the chests for vestments, and are spanned by a very high, vaulted ceiling decorated by Luca Giordano, with small windows above the right-hand wall, through which very little light can penetrate. In 1797 the Cathedral chapter decided to re-install the Greco in a magnificent new altar setting and to add two further altars, one either side of the sacristy. Goya was commissioned to paint the altarpiece for the recessed bay on the right, which would have been lit by candlelight from below, and above all from the altar below the Greco, to its left. The *Taking of Christ* was presented to the Academicians in Madrid in January 1799, before being transported to Toledo. There it was joined by its pendant, a tamely classicising representation of the *Agony in the Garden* for the altar on the opposite wall by a fellow Court Painter, Francisco Ramos.

In the iconographical scheme for the altarpieces, Goya's sketch (cat. 55) followed Ramos's since it shows the moment in Christ's Passion when Christ was first delivered into the hands of his enemies, before the tumultuous events that led to his final humiliation, when he was disrobed before being nailed to the Cross. El Greco's *Disrobing* centres on the monumental figure of Christ, who stands barefoot in a rich red tunic, sorrowful but resigned, and held on a rope by a man whose looks and gestures express anxiety, even fear, as he prepares to pull off the robe. A knight in armour gazes calmly out at the spectator, and in the background figures are piled one above the other, staring, shouting and gesticulating,

while plumed helmets, halberds and staves thrust up to the top of the picture space.

The sketch for Goya's painting is so freely executed that it is probably a first sketch rather than the final design submitted to the Cathedral chapter. Its dramatic colours suggest that Goya was intending to match El Greco's picture, and his principal figures surrounding Christ are very similar to those in the *Disrobing*: the soldier in a bright yellow jacket leaning on a halberd combines El Greco's man in a yellow jerkin with the two others nearest to Christ, while El Greco's knight in armour corresponds with Goya's foreground soldier advancing towards Christ with ropes held out to bind him. The background in Goya's picture is filled, although not to the top, with dim figures and halberds that glint steely-blue in the light of lanterns and torches, and the figure

Fig. 174 Interior of the sacristy of Toledo Cathedral, with Goya's *Taking of Christ* (on the right) and El Greco's *Disrobing of Christ* (left, and see detail above)

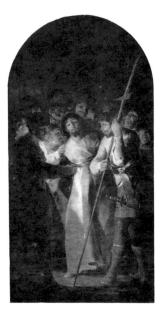

Fig. 175 *The Taking of Christ*,
1798 oil on canvas, 265 × 140 cm
Sacristy of Toledo Cathedral

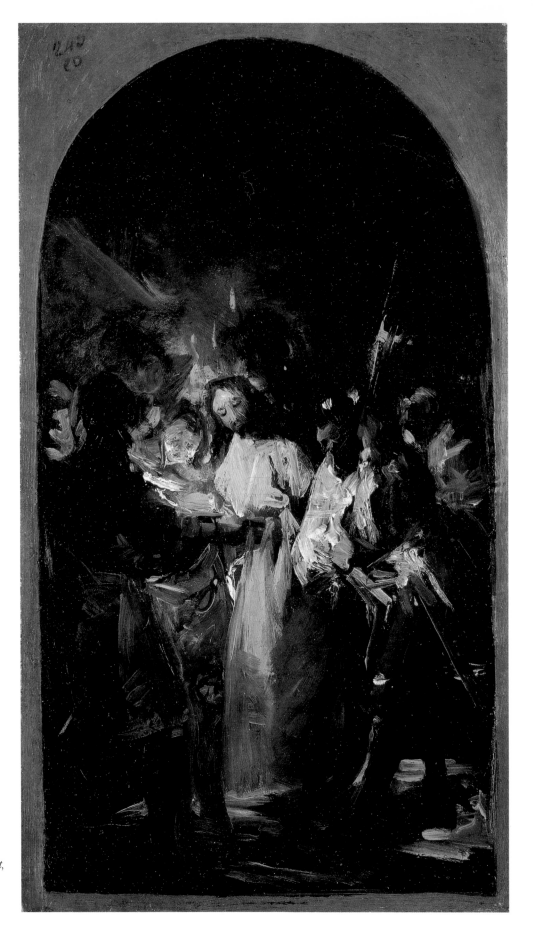

55
Sketch for *The Taking of Christ*,
1798
oil on canvas, 40.2 × 23.1 cm
Museo del Prado, Madrid

of Christ, with eyes closed and head inclined, his arms apparently forced behind his back, is moving – literally and figuratively – from the night scene in the Garden of Gethsemane in the direction of El Greco's Calvary.

Even in the boldly, impulsively brushed sketch, full of pentimenti, swords are in evidence as well as halberds, recalling the Gospel accounts of the Taking of Christ. Matthew speaks of a 'great crowd with swords and clubs, from the chief priests and the elders of the people', while Mark records a crowd armed 'with swords and clubs', and John describes how 'a band of soldiers and some officers from the chief priests and the Pharisees went there with lanterns and torches and weapons'. Matthew, Mark and Luke all refer to the kiss of Judas Iscariot, which is not clearly indicated in the sketch, suggesting that Goya may have been following the account in John, which is the only one that mentions lanterns.

In the sketch, as well as the painting in the sacristy, the light evidently comes from a lantern behind the foreground figure on the left, creating dramatic effects on the figures and ground. This hidden lantern simulates in the picture the actual candlelight in the sacristy that must have illuminated the *Disrobing*, and by this means, too, Goya linked his painting to El Greco's masterpiece, and gave it a 'natural' source of light. He also concentrated attention on the lower half of his picture, no doubt aware that the upper part would always be lost in darkness, and in the altarpiece the halberd held by the soldier in the foreground is the only element that rises to the rounded upper edge of the canvas.

In the sketch, the action centres on the soldier advancing to secure Christ with ropes, while the figure in yellow with a halberd looks

on; in the altarpiece, where the action is more complex, Christ's shoulder is held by a figure whose proximity suggests that he is Judas with the kiss of betrayal, while the foreground figure now turns to the soldier on the right with a commanding gesture that seems to evoke a startled, almost fearful, response, recalling the man carrying out the disrobing in El Greco's painting. Goya's crowd of figures, arching fan-shaped around the head of Christ, also correspond with those in the Greco, but are here taken to the limits of caricature, evoking the figures in later plates of *Los Caprichos* that he was currently etching or had recently completed: the crowd surging around the woman exposed to public shame in plate 24 (fig. 177), or the humiliation and maltreatment of a man in a nightgown who is about to be undressed and given an enema by a group of threatening, mocking friars in plate 58 (fig. 176).

While the colours in the large painting are much softer than those of El Greco's daylight scene at Calvary or of Goya's preparatory sketch, the compositional structure of the altarpiece builds on that of the sketch where, in spite of some confusion in the design, there is already a sense of the weight of bodies and the space they occupy on the ground. The work provides a cruel contrast with Ramos's *Agony in the Garden*, which shows no awareness of context in terms of its setting, lighting or the proximity of El Greco's masterpiece. As in his paintings for the Santa Cueva in Cadiz and the frescoes in San Antonio de la Florida, Goya started from a summary indication of the sense and rhythms of his subject in the sketch, and arrived at a deeply moving composition that is far removed from the works of his academic colleagues in its superbly structured, penetratingly intelligent design.

Fig. 176 '*Swallow it, dog*', pl. 58 of *Los Caprichos*, 1797–8 etching and aquatint, 21.7 × 15.1 cm Museo del Prado, Madrid

Fig. 177 '*Nothing could be done about it*', pl. 24 of *Los Caprichos*, 1797–8 etching and aquatint, 21.7 × 15.2 cm Museo del Prado, Madrid

SAN FERNANDO, MONTE TORRERO, SARAGOSSA
c. 1798–1800

When Goya went to Saragossa in 1810, between the two sieges of the city by Napoleon's troops, he probably made no attempt to see his three altarpieces, painted at the turn of the century for the church at Monte Torrero on the outskirts of the city. Jovellanos had seen them on his way to exile in Mallorca, noting in his diary on 7 April 1801: 'We went through the new town until we were brought to a halt by the fine facade of the church.... Inside it is a rotunda with a splendid cupola which because of its size deserves to belong to a larger place of worship. Two lunettes, one on each side, serve as chapels, and another deeper one opposite the presbytery. Inside them are three altars with three most beautiful paintings by Don Francisco Goya.... Admirable works not only because of their composition but also because of the strength of the chiaroscuro, the inimitable beauty of the colouring and a certain magic of light and hues where one would imagine no other brush could reach.'

The church, built by the authorities responsible for the great Canal de Aragón, was consecrated on 30 May 1802, but Goya's paintings disappeared during the War of Independence and have never been seen since. The architect who, in December 1813, reported on the condition of the church and the sums needed to repair it, stated that 'The interior of the church had suffered a great deal as a result of it having been used as a kitchen, the altar tables, which were of the finest jasper, had been burnt and broken, [...] having supported the three famous pictures painted by the celebrated Don Francisco Goya', and calculated the cost of the repairs, 'without including the cost of the paintings, which was 30,000 *reales*'. Jovellanos's earlier description of the paintings and Goya's three surviving

sketches, together with the allusion to the altars in the report of 1813, provide some indication of the effect of the altarpieces in Tiburcio del Caso's handsome, neo-classical church interior (fig. 178).

The sketches may be preliminary *borrones* rather than final studies, since they are so vigorously and broadly brushed, particularly the larger *Appearance of St Isidore* for the main altar (cat. 56). The composition shows the seventh-century Bishop of Seville appearing to King Ferdinand III, 'El Santo', in 1247 and exhorting him to renewed efforts to take the besieged city, the last stronghold of the Moors in Spain, whose mosque with its tall minaret, now the Cathedral tower known as the Giralda, is glimpsed in the background. St Fernando, grasping a sceptre, appears in front of his tent, while attendants offer him his crown and sword as he gazes up at the vision of St Isidore 'floating', as Jovellanos observed, above the King and his soldiers. Placed at the end of the deep and narrow apse (fig. 178), this image, with its strong diagonal thrusts and St Isidore seen as if flying towards the congregation with imperious gestures of command, must have created a remarkable effect, burlesqued by Goya in one of the later plates from the *Caprichos* showing flying friars pursuing a young woman (fig. 179).

For the altar on the left, Gospel side, Goya painted an episode in the life of St Elizabeth, Infanta of Aragon and Queen of Portugal, who was born at Saragossa in 1271. The sketch represents the saintly Queen tending a poor woman's horribly cancerous foot, which was later found to be cured (cat. 57). As with the design for the high altar, the image recalls a print from the *Caprichos* series that uses very much the same compositional scheme but to

Fig. 178 Interior view of the church of San Fernando, Monte Torrero, Saragossa

quite different ends (fig. 180). However, while Goya intended the girl in the satirical etching to be a prostitute, attended by a colleague and an old procuress, and took her from an even more explicit drawing in one of his albums, the figure of the 'good woman' in the sacred altarpiece became a new subject of scandal for the people of Saragossa. A letter to the King's chief major-domo from the director of the Canal Imperial de Aragon is dated 24 November 1801, and was therefore written after Jovellanos's visit to the church, but before its consecration. It enumerates the various works that remain to be completed, mainly in carpentry, and then refers to another outstanding problem (referring mistakenly to the deceased Francisco Bayeu instead of Goya): 'The picture of St Elizabeth which forms one of the three altars of the Church had proved quite shocking and there was excessive talk of it in the city because, apparently, in his painting the brush of Don Francisco [Goya] had shone at the expense of decency; for which reason the Vicar-General of the Reverend Bishop of Huesca told me that it was necessary to cover the breasts of the sick woman who the Saint was curing before consecrating it; but having had news that the afore-mentioned [Goya] would be coming to the city in the following spring it seemed to me best to await his presence in order for him to carry out the change himself, which he did.' As with his fresco of *Charity* on one of the pendentives in El Pilar some 20 years before (see cat. 8 and 9), Goya again offended the citizens of Saragossa with his robust representation of the female figure, but there is no record of whether he altered the final painting.

The third picture, for the altar on the Epistle side, represented *St Hermenegild in Prison*, and the preparatory sketch (cat. 58) is the most finished of the three. St Hermenegild was the son of the Visigoth King Leovigild, who gave him the governorship of Seville but took arms against him when he became a Christian convert. Abandoned by his Roman allies,

Hermenegild was eventually captured and thrown into prison. He suffered cruel treatment in an attempt to make him abjure his faith, and when he finally refused communion from an Aryan priest, his father ordered his decapitation. This took place on 13 April 586 AD, when Hermenegild was little more than 20 years of age. The church of his name in Seville claims to be the site of his imprisonment and martyrdom.

In Goya's sketch, St Hermenegild is seen dressed in armour with his royal robes and crown, standing in the darkness of a prison cell. Three menacing gaolers surround him, presumably threatening and attempting to persuade him to abjure, but the young Prince gazes steadfastly upwards, with an attitude of refusal, as the light streams in through the barred window of his cell and falls on his face and breast. The soft brushstrokes modelling the forms, and vivid touches of light on the Saint's costume and the kneeling foreground figure, create a mysteriously beautiful effect in the darkness. These three sketches convey so much of the richness and beauty of Goya's invention that the loss of the three altarpieces, like those in the College of Calatrava in Salamanca (cat. 13), serves to underline the barbarity of what the artist himself referred to as the 'bloody war in Spain with Bonaparte'.

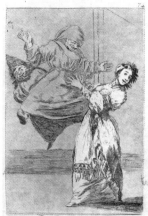

Fig. 179 '*Don't scream, stupid*', pl. 74 of *Los Caprichos*, 1797–8 etching and aquatint, 21.6 × 15 cm Museo del Prado, Madrid

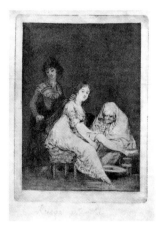

Fig. 180 '*She prays for her*', pl. 31 of *Los Caprichos*, 1797–8 etching and aquatint, artist's proof, 20.8 × 15.2 cm Museo del Prado, Madrid

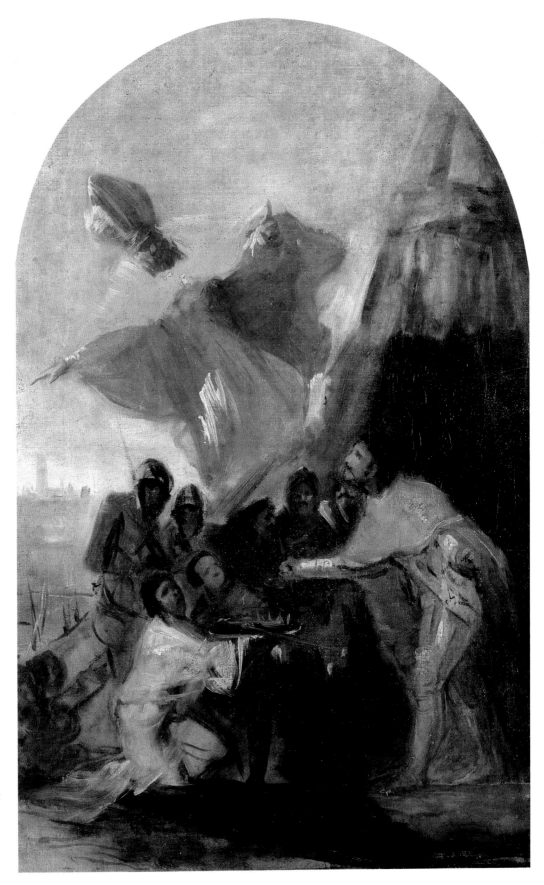

56
Sketch for *The Appearance of St Isidore to St Fernando*,
c. 1798–1800

oil on canvas, 46.5 × 31 cm
Museo Nacional de Bellas Artes,
Buenos Aires

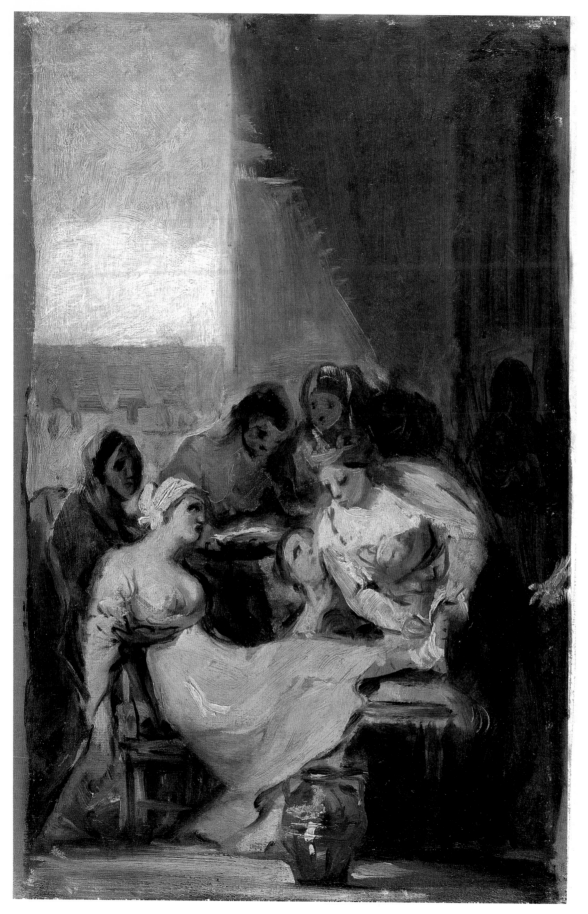

57
Sketch for *St Elizabeth Tending
a Sick Woman, c.* 1798–1800
oil on canvas, 33 × 23 cm
Museo Lázaro Galdiano, Madrid

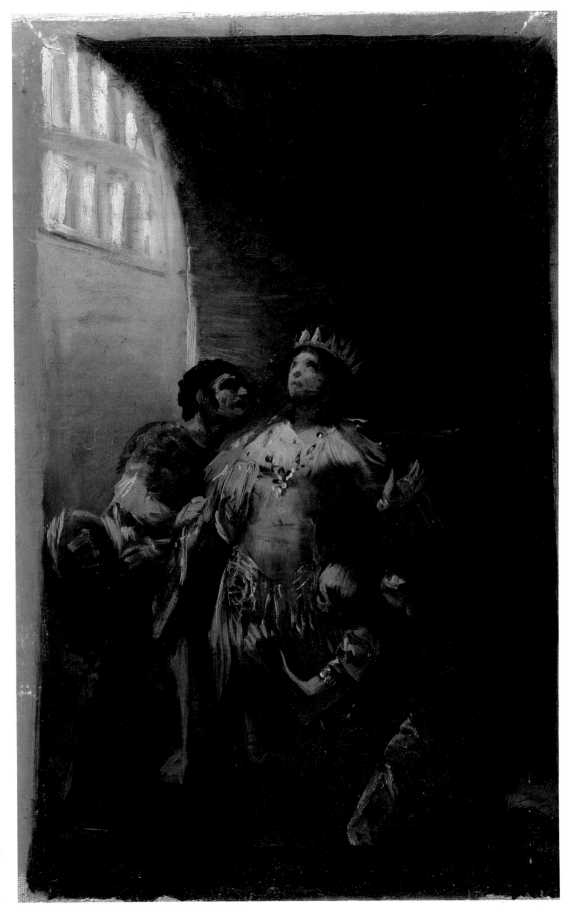

58
Sketch for *St Hermengild in Prison*, *c.* 1798–1800

oil on canvas, 33 × 23 cm
Museo Lázaro Galdiano, Madrid

Portraits

1783–1805

*G*oya's earliest known portrait is the compelling image of himself as a young man, probably painted around the time of his journey to Italy, when he was about twenty-five years old (fig. 36). It reveals the penetrating gaze of an artist who would spend a lifetime scrutinising those around him, and as a portraitist he had no equal in the Spain of his day.

His first documented portrait commissions date from 1783, when he painted a very grand and formal portrait of Carlos III's Prime Minister, Don José Moñino y Redondo, Count of Floridablanca, to whom he addressed his celebrated letter concerning the altarpiece for San Francisco el Grande (cat. 11, 12). That same year, Goya paid the first of two visits to the King's brother, the Infante Don Luis, at Arenas de San Pedro, where he painted several portraits of the Infante's family and a sketch for a large equestrian portrait of the Infante's wife (cat. 59). He had no doubt completed this by the time he returned to Arenas the following year, when the great family portrait was probably executed (fig. 41). This initial burst of activity and its successful results soon brought him further commissions and a first contact with the young couple who were to become his most important patrons, the Marquess and Marchioness of Peñafiel, future Duke and Duchess of Osuna (fig. 43).

However, the great majority of these portrait commissions were for life-size likenesses, and small-scale portraits are rare in Goya's *œuvre*.

Those that he did paint, whether as sketches for large paintings or as small intimate pictures for friends and family, fortunately cover much of his career, providing an insight into his approach and working methods, and a clear indication of his changing style over the years. They also touch on key relationships with the family of the Infante Don Luis (cat. 59), with Manuel Godoy and the royal family (cat. 60, 61), with Goya's image of himself (cat. 62, 63) at a crucial period of his life, following his illness, when he was very close to the Duchess of Alba and her entourage (cat. 64, 65). The brilliant image of his 'friend Asensi' (cat. 66), probably painted in San Antonio de la Florida, leads to the more bourgeois representations that characterise much of his 19th-century portraiture. In 1805 he painted a singular group of miniatures on copper, on the occasion of his son's marriage. They show Javier and his bride and the family in-laws (cat. 67–73), and are reunited here for the first time, revealing Goya's mastery in this unusual genre.

All these small-scale works show Goya's art of portraiture in 'close-up', at its freshest and most spontaneous, and provide insights into his brilliant technique and his gift of psychological penetration into his sitters' personalities and his own.

MARÍA TERESA DE VALLABRIGA ON HORSEBACK, 1783

On 20 September 1783, Goya wrote a breathless letter to Zapater about his month-long visit to the King's brother, the Infante Don Luis de Borbón, and his family at Arenas de San Pedro: 'My dear Son, I have just arrived very tired from Arenas. His Highness has paid me a thousand honours, I have done his portrait, and that of his wife and son and daughter with an applause which was unexpected since other artists had already been there and not made a success of it'; he added that his Highness was an excellent shot, and had been amused by the passionate enthusiasm of the '*pintamonas*' (wretched dauber) for hunting. The Infante lived in semi-exile with a beautiful young wife, Doña María Teresa de Vallabriga y Rozas, whom he married in 1776 when he was 50 years of age and she was only sixteen.

The Infante Don Luis, who had long since renounced the role of Cardinal, allotted him in childhood, had led a somewhat immoral life and been involved in scandals that this marriage was intended to resolve. Doña María Teresa had been selected by Carlos III as a suitable bride for his brother, since her relatively modest rank excluded her children from the succession to the throne, and she and they were furthermore barred from the Court. It was said by some that she treated her husband with scant respect, and her dominating role at the little court in Arenas may be reflected in Goya's intriguing allegory on the theme of Hercules and Omphale (cat. 18), painted in the year of his second visit to Arenas.

On 2 July 1784, Goya informed his 'Dearest Martín: I am thin and not working much, I have still not finished the portrait of the wife of the Infante on horseback but there is little left to do', promising to paint a *Virgin* for his friend 'on returning from Arenas'. This equestrian portrait, known only from Goya's letter and its summary description in an inventory, was evidently a pendant to an earlier portrait by Francesco Sasso of the Infante, on the scale of Goya's equestrian portraits of Queen María Luisa (fig. 185) and Carlos IV. Goya was

Fig. 182 After Velázquez,
Isabel de Borbón, 1783
etching, 38 × 31 cm
Biblioteca Nacional, Madrid

Fig. 183 *Mariá Teresa de Borbón and Vallabriga*, 1783
oil on canvas, 132.3 × 116.7 cm
National Gallery of Art,
Washington, DC

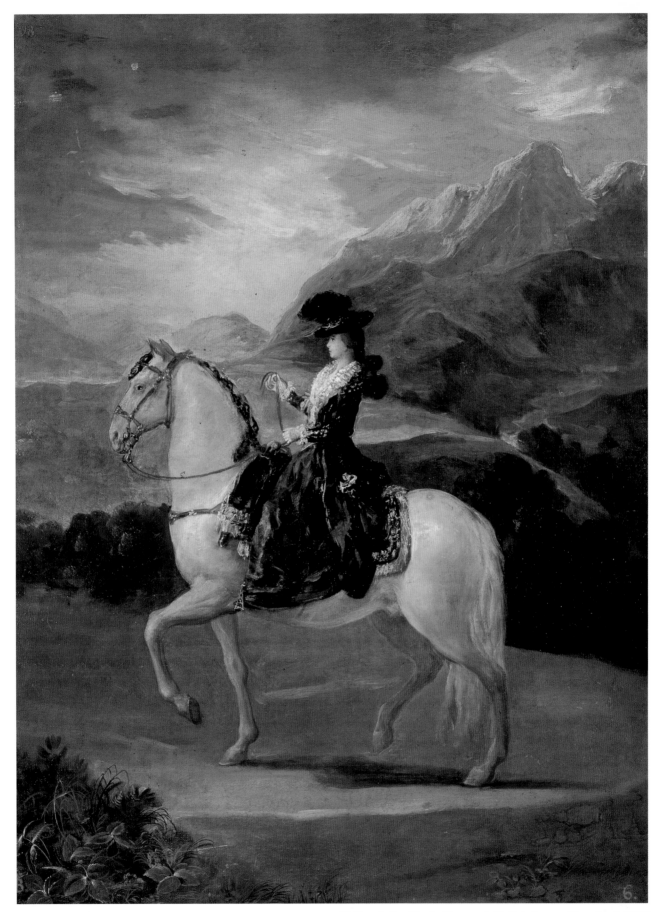

59 Sketch for *María Teresa de Vallabriga on Horseback*, 1783
oil on canvas, 82.5 × 61.7 cm
Galleria degli Uffizi, Florence

evidently trying to complete the large canvas to take with him to Arenas on his second visit, when he painted his celebrated group portrait of the whole family (fig. 41).

His equestrian portrait was based on the 'sketch of the portrait of Señora Doña María Teresa de Vallabriga on horseback', also described in the inventory and presumably painted on his previous visit to the Infante. The highly finished sketch shows Doña María Teresa in a magnificent blue riding habit and plumed hat, sitting astride her handsome mount and holding the reins in her right hand with an elegantly correct gesture. The pose recalls Velázquez's portrait of Isabel de Bor-

bón, copied by Goya in 1778 (fig. 182), and the landscape is composed, like those of his admired master, in a series of diagonal planes that recede into a distant prospect of the Sierra de Gredos. The setting and the exquisitely painted plants in the foreground relate this sketch to Goya's portrait of María Teresa's little daughter, the future Condesa de Chinchón (fig. 183), painted in the same year.

It was the success of his portraits for the Infante Don Luis, as well as his altarpiece for San Francisco el Grande (cat. 11, 12), that brought Goya to the attention of the Court and aristocracy, and launched him on his career as a portraitist.

EQUESTRIAN PORTRAITS:
A GARROCHISTA, *c.* 1791–1792, AND GODOY, 1794

The role of Manuel Godoy in the history of Spain and in the career of Goya continues to be a subject of speculation and conflicting opinions, and it is perhaps appropriate that Goya's first known portrait of him should be something of an enigma, and that his likeness should have remained hidden until very recently. In November 1819, the year in which Goya moved to the Quinta del Sordo, the Royal Prado Museum was inaugurated, with 311 paintings on display, including Goya's two grand equestrian portraits of Carlos IV and Queen María Luisa, the parents of the reigning monarch, Fernando VII. By 1821, another Goya, sent in a batch of pictures from the royal palace in August 1819, had been added to the display and was catalogued as *A Picador on Horseback*. In 1828 it appears as *Portrait of a Bullfighter on Horseback* in the first Prado catalogue to include a selection of Spanish pictures by living or recently deceased artists. This new edition included Goya's three paintings preceded by a biographical note contributed by Goya (see p. 91), who died in Bordeaux that same year.

While the two large equestrian portraits were clearly an appropriate choice for the Museum, it appears surprising that a small painting of a '*picador*' or '*torero*' should have formed part of the royal collection and been selected to hang in the Museum at this early date. However, technical examination in 1987 and the recent cleaning of the painting offer an answer to the first question. Beneath the '*picador*', or '*garrochista*', is concealed a portrait of the young Manuel Godoy, recognisable from his round face with chubby cheeks and straight nose in the x-ray image of the canvas (fig. 184), and whose three-cornered hat emerges into view in the painting itself. The repainting, which is crude and heavy-handed,

shows none of the precision and energy of Goya's brushwork, and seems very unlikely to be in his hand. It affects not only the figure, which is given a formless and inexpressive face, but also the horse, the whole of the sky and much of the background. Goya's finely detailed handling and vivid touches of impasto are visible in the x-ray and even to the eye beneath the repaint on the figure, while beneath the dull grey and blue overpainting of the sky, a light, almost translucent, grey has been found on the right, linking this area to the untouched and beautiful distant landscape on the left.

When was this small equestrian portrait of Godoy painted, and why was it crudely altered, not just to change the identity of the person represented but to transform the subject? Although the repainting makes it difficult to judge the effect of Goya's original and assess its probable date, it is clearly related to the portrait of María Teresa de Vallabriga of 1783 (cat. 59). The influence of Velázquez is still strong, but since the style of the 'Godoy-garrochista' appears considerably freer, a later date seems likely, and this would accord with the details of Godoy's career.

Don Manuel Godoy y Alvárez de Faria was born at Badajoz in 1767, to an impoverished noble family. His father was a Colonel in the army, who gave his sons an excellent, enlightened education. His elder brother went to Madrid to join the Royal Bodyguards, and seems to have had a liaison with María Luisa, the young Princess of Asturias, wife of the future Carlos IV. In 1784, when he was seventeen, Manuel followed his brother to the court and into the Bodyguards and the favours of María Luisa. Four years later, the death of Carlos III saw the start of the favourite's incredibly rapid rise to a position of power and

influence, culminating in 1792 in his ennoblement as Duke of Alcudia, his nomination as Spanish Grandee of the First Class, and his appointment as First Secretary of the Office and Commandant of the Royal Bodyguards.

In 1791, Godoy was promoted to Brigadier, and then Field Marshal, and on 25 August he was awarded the Order of Carlos III, whose sash is still visible beneath the *garrochista*'s shirt. The portrait was therefore painted after this date, and perhaps to celebrate the conferring of the dukedom in April 1792. The drastic transformation of the picture was probably carried out after the fall of Godoy in 1808, when portraits of the hated favourite are known to have been destroyed by the mob, and it remained in the royal palace until it was sent to the Prado in 1819.

The second portrait (cat. 61) is no doubt the one referred to in a celebrated letter (fig. 7), dated by Goya in jest from 'London 2 August 1800', but which on internal evidence was written in Madrid on 2 August 1794. In it he told Zapater that he was to paint the Duchess of Alba, who would come to sit for him. 'I had hardly finished a sketch which I am doing of the Duke of Alcudia on horseback, when he contacted me to say he would tell me when to come and would take care of my lodging at the Palace [of El Escorial], since I would need to be there longer than I thought. I assure you that it is one of the most difficult subjects a painter could be presented with.' He added that Francisco Bayeu was to have done it but was too tired and overworked (his brother-in-law died the following year). While Goya's sketch exists, there is no indication that he ever completed the large portrait whose existence is unrecorded.

The early history of the sketch is unclear. It has been tentatively identified with the 'sketch of a rider' in the inventory of Goya's studio made in 1812, and it is possible, although perhaps unlikely in view of its high degree of finish, that it remained in the artist's possession. It shows Manuel Godoy wearing virtually

Fig. 184 x-ray photograph of '*A Garrochista*' (cat. 60)

the same uniform as the one that can just be made out in the *Garrochista* portrait (cat. 60), that of Commandant of the Royal Bodyguards. However, whereas the Godoy who appears in the x-ray image beneath the *garrochista* is a lively, youthful-looking figure, the Duke of Alcudia of 1794, portrayed as a Captain-General of the Bodyguards, with the three regulation bands of '*entorchados*' on his red cuffs and on the red saddle-blanket, is an altogether more commanding and portentous presence. Holding the reins firmly in one hand, and with the other resting on his hip, he appears very much in command, as his horse

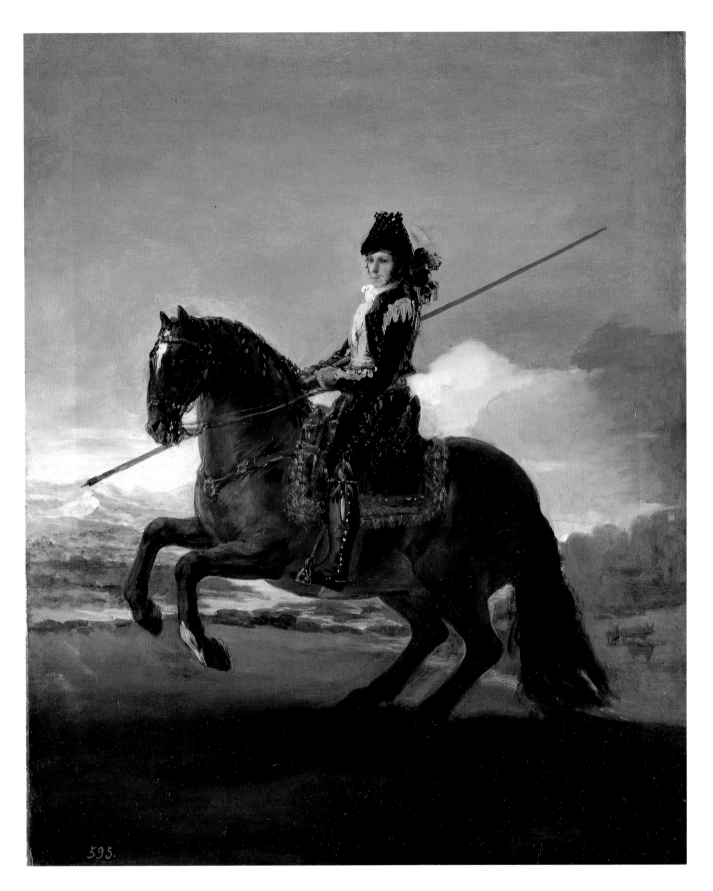

60
Equestrian Portrait, known as 'A Garrochista',
c. 1791–92 (repainted *c.* 1808)
oil on canvas, 57 × 47 cm
Museo del Prado, Madrid

performs a *levade* in front of a bare and misty landscape. The face is painted with great precision and economy, and succeeds in conveying a suitably classical image of the naturally rubicund and rotund features of the favourite. It is said that when José Beratón drew a portrait for an engraved frontispiece published in 1795, Godoy sent it back twice, the first time saying that he considered 'the left arm mis-shapen and the likeness is wrong'; and the second because 'the head is very bulky and the face is more sizeable than mine'.

If it were not for the uniform, which dates the portrait between May 1793 and March 1795, the subtle, almost abstract, background, in which the succeeding folds of the landscape merge gently into the white light of the sky, might suggest an even later date for this portrait, closer to that of Queen María Luisa in 1799 (fig. 185). However, it also recalls the spare, luminous background behind the *Marchioness of Solana, Countess of Carpio* (Musée du Louvre, Paris), painted in 1794–5, while the

handling of the ornaments on Godoy's costume, in vivid and assured little touches that give form to the body, is very close to that of other portraits of this period (cat. 63–5). In these two works, now revealed in a new light, the figure of Godoy is seen advancing towards his apotheosis as Prince of the Peace. What Goya really thought of the man who was an enlightened patron and reformer but of whose private life he could hardly approve has been much debated. A radical contemporary, Bartolomé José Gallardo, recounted how Goya would draw caricatures in sand tipped from his friends' writing materials, and that 'the main subject, repeated with all kinds of variations, was Godoy, for whom he expressed a particular dislike', and caricatures of Godoy have been identified in several of the satirical plates of *Los Caprichos*. But in these equestrian portraits and other images of the all-powerful favourite, Goya found a formula that pleased the sitter while leaving the spectator free to interpret the artist's feelings towards his sitter.

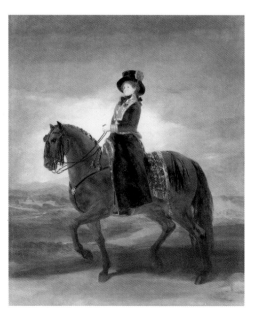

Fig. 185 *María Luisa on Horseback*, 1799 oil on canvas, 335 × 279 cm Museo del Prado

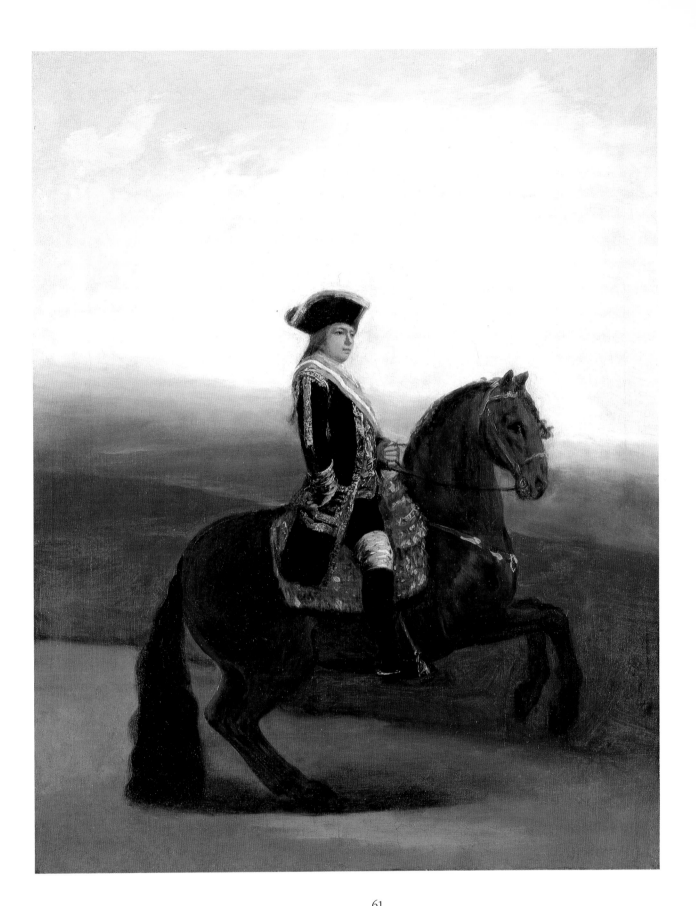

61
Sketch for the *Equestrian Portrait of Don Manuel Godoy, Duke of Alcudia,* 1794
oil on canvas, 55.7 × 44.5 cm
Private Collection

SELF-PORTRAITS, *c.* 1794–1797

Goya confronted his own gaze on a number of occasions, committing around a dozen images of himself to canvas, paper or an etching plate in the course of his long life. Some of these self-portraits are direct representations of his image seen in a mirror: a sardonic three-quarters view with sidelong glance introduces the prints of *Los Caprichos* (fig. 186), and for Zapater he penned a caricature of himself in 1794 (fig. 7). Two early works show him as an artist, presenting a picture to the minister Floridablanca or painting a family portrait (figs. 35, 41), while in the drawings for the frontispiece originally designed for *Los Caprichos*, he appears as 'The author dreaming', seated in an artist's chair in a corner of his studio (fig. 1, 31).

The earlier of the two small self-portraits in oils is the only one in which Goya shows himself at work in his studio. He stands before a large canvas placed on an easel, as if he were painting a full-length portrait of himself in a mirror, or one of the spectator 'posing' in front of him. In the 1780s and 1790s Goya was living at no. 1 calle del Desengaño, not far from the Puerta del Sol, and probably had his studio in the same building. It must have been a space large enough to accommodate huge tapestry cartoons and equestrian portraits, but this view, probably painted in an area reserved for portraiture, includes only a glimpse of the floor between his easel and the wall, with a small writing-table behind him. Light – the essential element in all his paintings – floods in through a huge window, picking out the papers and writing materials on the table and eating the contours around the subject seen against the light. Holding a brush in his right hand (so 'correcting' the image seen in the mirror) and the palette in his left, the artist is

Fig. 186 '*Francisco Goya y Lucientes, Painter*', pl. 1 of *Los Caprichos*, 1797–8
etching and aquatint, 21.9 × 15.2 cm
Museo del Prado, Madrid

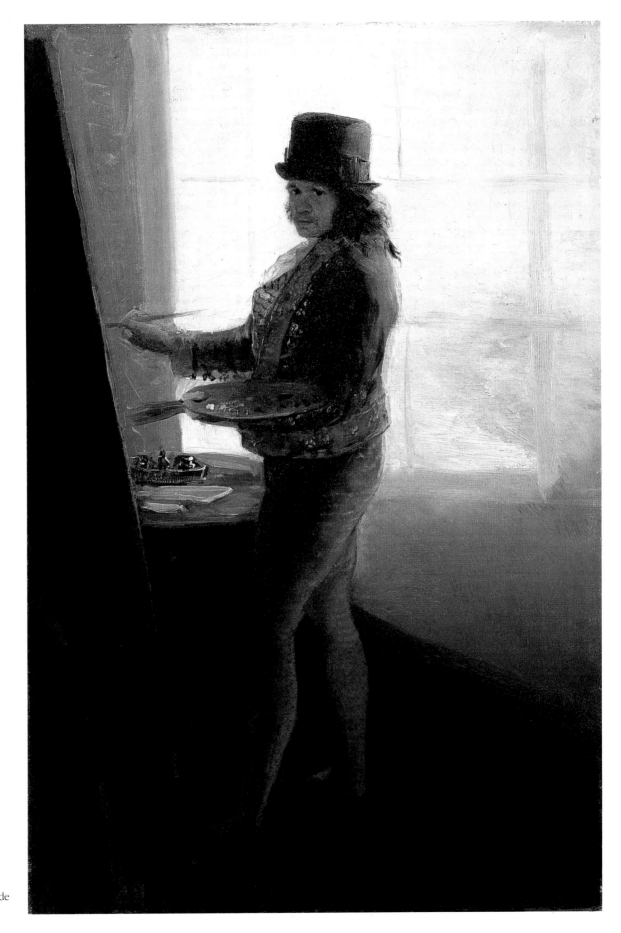

62
Self-portrait in the Studio,
c. 1794–5

oil on canvas, 42 × 28 cm
Real Academia de Bellas Artes de
San Fernando, Madrid

standing, alert and well-balanced, ready to move towards or away from his canvas as he paints. The placing of the feet creates a sense of space and underlines the subtle geometry of the picture. Goya's shapely calves and solid thighs are topped by a short jacket, and he wears a narrow-brimmed hat over his long hair. Around the hat are metal candle-holders, and his son explained their use: 'The final touches in order to secure the best effect in a painting would be added at night, under artificial light.' The gaze from the shadowed face is intense and concentrated, alertly observant and calmly analytical.

This portrait could have been painted at any time during the 1790s, and various dates have been proposed. It may well have been done in the same spirit and at much the same time as the '*caprichos*' on tinplate (cat. 32–43), in which Goya proved to himself and to his colleagues that he had lost none of his skill as a result of his illness. It is a portrait of an artist in full command of his powers.

In the tiny self-portrait that he must have given to the Duchess of Alba, Goya also shows himself as an artist, seated before a small canvas and gazing intently into his own – and the spectator's – eyes. Like the little pictures of Cayetana and her *duenna*, painted in 1795 (cat. 64, 65), this is also signed, and could have been done at the same time. However, Goya's 'Romantic' presentation of himself, in half-light against a dark ground, and his extraordinarily intense expression, suggest a connection with the visits he made to the recently widowed Duchess at Sanlúcar in the summer of 1796 and the early months of 1797. The idyll reflected in the pages of the Sanlúcar Album of 1796 (figs. 11, 188, 189) turned to disillusion and bitterness, but in this moving and exquisitely painted image, the strength and sensitivity, and the innate self-confidence and dignity of the all-seeing artist, are revealed.

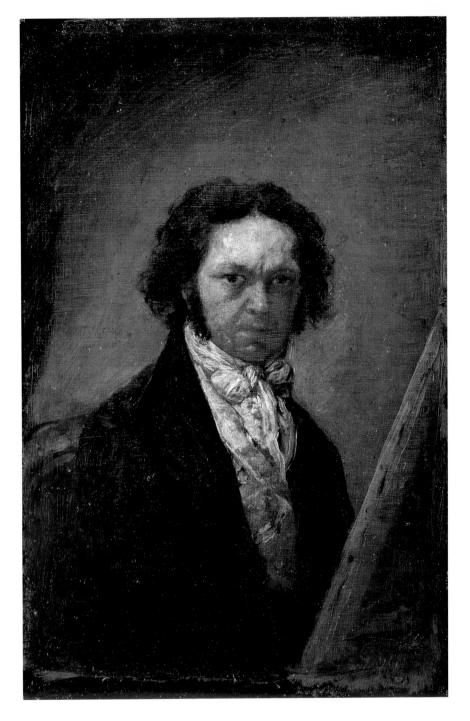

63
Self-portrait, c. 1795–7
oil on canvas, 18 × 12.2 cm
Signed at lower right: *'Goya'*
Gutierrez de Calderón Collection,
Madrid

TWO CAPRICHOS: THE DUCHESS OF ALBA AND 'LA BEATA', 1795

In January 1775, Doña María del Pilar Teresa Cayetana de Silva, later 13th Duchess of Alba, married the gentle, music-loving José María Alvarez de Toledo, Marquess of Villafranca, when he was eighteen and she was still only twelve. Twenty years later Goya painted full-length portraits of the couple, the Duke with his viola and fortepiano and a musical score by Haydn (Museo del Prado, Madrid), and the ravishing Duchess in white and red, accompanied by her little dog. Goya must have visited their palace in the calle del Barquillo in Madrid and seen the childless Duchess with her entourage, and the practical jokes and games for which she was renowned. Still something of a child herself at 33, Cayetana was captured by Goya teasing an old lady's maid known as 'la Beata' for her addiction to prayers. And in a companion to this enchanting canvas, he painted the old lady being tormented by two children, Luis, the little son of the Duchess's major-domo, Tomás de Berganza, and the little '*negrita*', María de la Luz, whom the Duchess virtually adopted and to whom Manuel Quintana addressed a poem. They are tugging at the skirts of 'la Beata', who has dropped her cane and is clinging for support to a man, glimpsed here only as a silhouette, but who is possibly the Abbot Pichurris, who appears with the Duchess in a later drawing (fig. 187).

These intimate little *caprichos* are signed

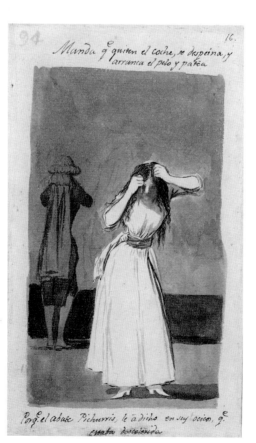

Fig. 187 '*She orders them to send away the coach*', page 94 of the Madrid Album, 1796–7 brush and indian ink, 23.5 × 14.6 cm The Metropolitan Museum of Art, New York

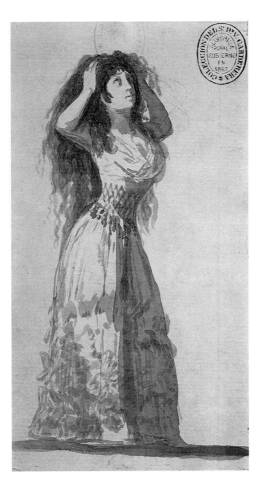

Fig. 188 *The Duchess of Alba Arranging her Hair*, page C of the Sanlúcar Album, 1796 brush and indian ink, 17.1 × 10.1 cm Biblioteca Nacional, Madrid

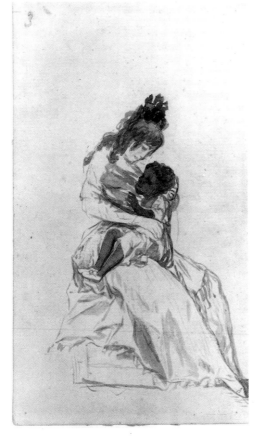

Fig. 189 *The Duchess of Alba with María de la Luz*, page E of the Sanlúcar Album, 1796 brush and indian ink, 17 × 9.9 cm Museo del Prado, Madrid

and dated, and in the one with the children, Goya identified Luis Berganza by name, writing his inscription in the wet paint with the end of his brush or another pointed instrument. The attitudes and expressions of the children and adults are marvellously conveyed (see fig. 55), in a bare setting that surrounds them with the 'magic of the atmosphere'. Swiftly but brilliantly worked, with *graffiti* effects in the Duchess's dress, these little canvases anticipate Goya's drawings in the two albums that he began during his stay with the Duchess at Sanlúcar de Barrameda the following year (figs. 188, 189), and which developed into the etchings of *Los Caprichos*. Here the satire has not yet begun to bite, and the mood is light-hearted and tender, recalling the tones of Goya's letter to Zapater, written when he had already received the commission for the portrait of the Duchess (fig. 8): 'You'd be better off coming to help me paint the Alba woman, who yesterday came to the studio to make me paint her face, and she got her way; I certainly enjoy it more than painting on canvas, and I still have to do a full-length portrait of her.' Two years later he painted another portrait of 'the Alba woman', with the two rings marked with their names and the statement he was perhaps willing her to endorse – 'Only Goya' – in the sand at her feet (fig. 9). It seems to have marked the end of their relationship, and the portrait was never delivered, remaining in the artist's studio as a proud, though perhaps bitter, souvenir of his encounter with Cayetana.

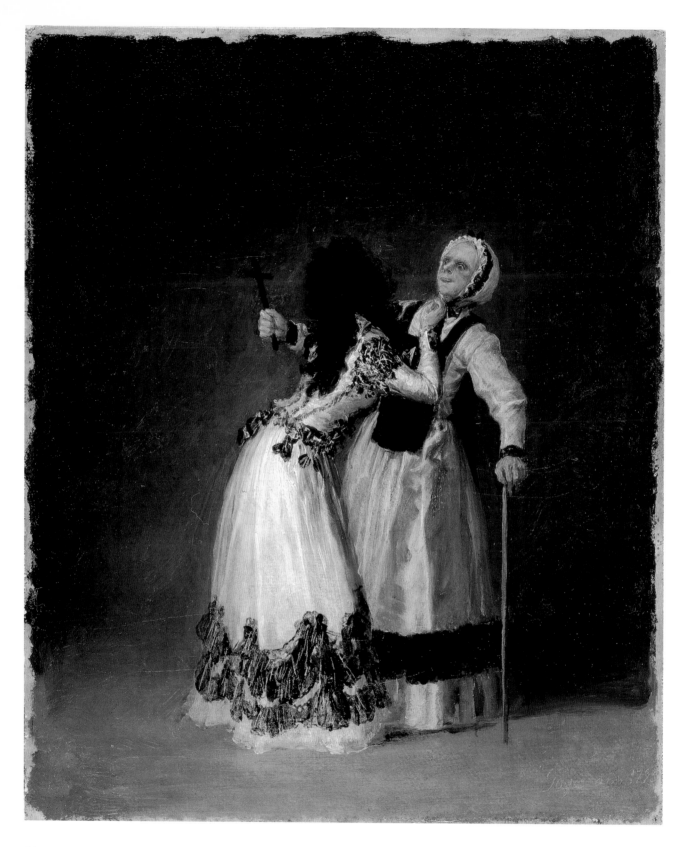

64

The Duchess of Alba and 'La Beata', 1795

oil on canvas, 30.7 × 25.4 cm

Signed and dated at lower right: *'Goya año 1795'*

Museo del Prado, Madrid

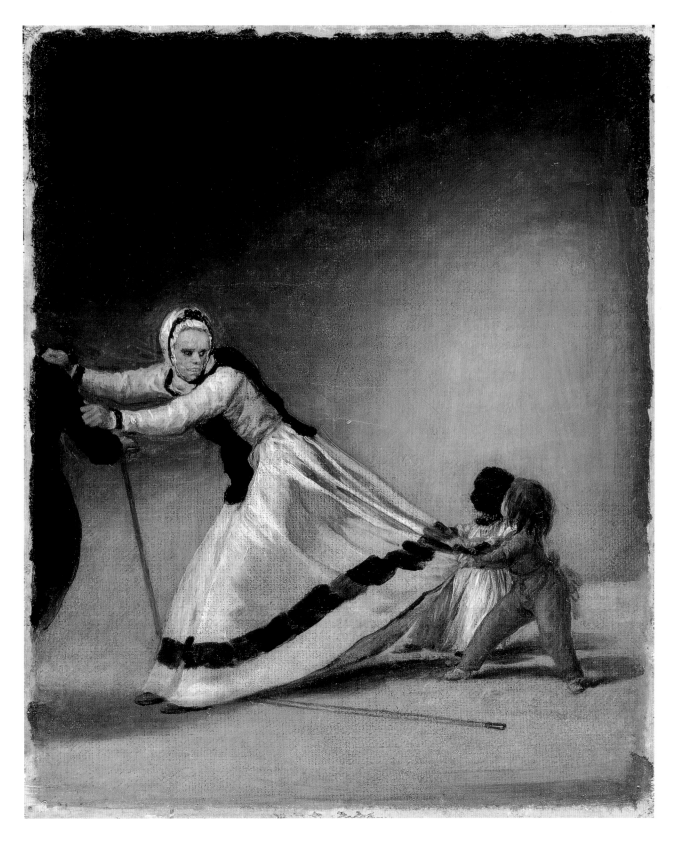

65
'La Beata' with Luis de Berganza and María de la Luz, 1795
oil on canvas, 30.7 × 25.5 cm
Signed, dated and inscribed at lower right: *'Luis Berganza año 1795. Goya'*
Private Collection

PORTRAIT OF 'FRIEND ASENSI', *c.* 1798

When Charles Yriarte saw this small painting in the collection of the Duke of Montpensier, at the Palace of San Telmo in Seville, he noted Goya's inscription near the lower left edge and catalogued it as the 'Portrait of Asensi' in his book on Goya published in 1867. He remarked on the brushes and the bowl of colour on the ground and deduced that it must be the portrait of an artist, 'perhaps in a cathedral or a chapel where scaffolding has been erected for the painting of frescoes'. And since the image obviously anticipates, and was in tune with, the 19th-century Romantic tradition, Yriarte also referred to 'the delicate features and the long hair negligently thrown back to reveal the intelligent brow' that made this for him the picture of 'a man who spends his life thinking about artistic creation'.

He went on to speculate on the identity of the model, wondering whether, in spite of the clearly inscribed name '*Asensi*', it might not be a portrait of Asensio Juliá, a Valencian artist who was one of Goya's assistants at the turn of the century. However, he also suggested that it might be a portrait of Goya himself, however surprising that may seem now, and as such it was catalogued for the celebrated 'Galerie espagnole' of Louis-Philippe, exhibited in Paris from 1838 until the fall of the July Monarchy ten years later. The picture had been acquired in Spain by Baron Taylor for Louis-Philippe's collection of Spanish art, which made an extraordinary impact during the ten years the monarch's gallery was open to the public. The young Edouard Manet almost certainly visited the display, and Goya's little picture anticipates to a remarkable degree Manet's striking small sketches of Berthe Morisot on her visits to Manet's studio in the 1870s.

The image of Asensi suggests a fleeting 'impression' captured by Goya. His friend – whoever he may be – stands in the mysterious setting of the wooden scaffolding through which light filters from the rear and also touches planks on the ground; he catches the figure in a pose that is both calculated, in the firm stance and deliberate placing of arms and feet, and also ephemeral, in the sudden, artful turn of the head. In his dark, blue-trimmed artist's robe and little slippers trimmed with bows, Asensi is placed in an indecipherable setting that could well be the scaffolding in San Antonio de la Florida (see cat. 53, 54), but Goya is only interested in the magic of the atmosphere that surrounds the figure, and in capturing in a purely painterly *capricho* the energy and expressive intensity of the figure.

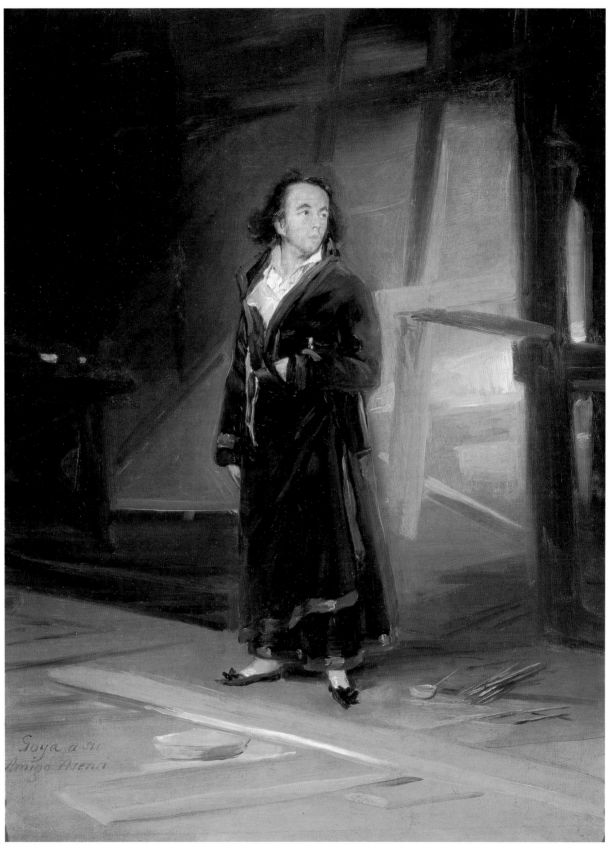

66

'Friend Asensi': A Portrait of Asensio Juliá?, c. 1798
oil on canvas, 54.5 × 41 cm
Signed and inscribed at lower right: *'Goya a su / Amigo Asensi'*
Fundación Colección Thyssen-Bornemisza, Madrid

MINIATURES ON COPPER: JAVIER GOYA AND HIS WIFE'S FAMILY, 1805

'I have a four-year-old son who is considered handsome in Madrid and he has been so ill that I have had no life of my own for all this time. Thank god he is now better.' All Goya's paternal emotion and anxiety is expressed in this letter to Zapater, written on 23 May 1789. He was referring to his last-born child, the only one who does not appear in the Italian Notebook, after the names of the six siblings whose baptisms are recorded (fig. 68) but who all died in childhood. Very little is known about Francisco Javier Goya. In October 1803, when Javier was almost twenty, Goya wrote to the Minister of Finance, Miguel Cayetano Soler, offering the 80 copperplates of *Los Caprichos* and the remainder of the edition published in 1799 'to my Lord, the King, for his Chalcography', adding 'I would only ask His Majesty for some recompense to allow my son Francisco Javier de Goya to be allowed to travel, which he would be able to benefit from greatly'. The response came in a Royal Order to the effect that 'in recompense for this gift it has been decided to grant to Don Francisco Xavier, son of the afore-mentioned Don Francisco de Goya, a bursary of 12,000 *reales* a year, so that by travelling in foreign countries and instructing himself in painting he will distinguish himself like his maternal grandfather [in error for his uncle Francisco Bayeu], and his father, who will take care to direct him towards such an important objective.' However, the pension was stopped when Javier provided no proof of his foreign travel. No doubt as a result of protests from Goya, it was renewed indefinitely by a further Royal Order in 1806.

The previous year, in July 1805, when he was not quite twenty-one, Javier had married the seventeen-year-old Gumersinda de Goicoechea y Galarza. Born in 1788, she was the second of the four daughters of Don Martín Miguel de Goicoechea and Doña Juana Galarza, a wealthy bourgeois couple 'in business in this capital city'. Javier had no occupation, and had been living with his parents and enjoying the annual pensions received from the King (12,000 *reales*) and from the legacy of the Duchess of Alba (3,000 *reales*). On the eve of his marriage, his father signed a legal declaration promising the future couple that 'will keep them in his house, maintaining them and their children … and, in addition, whatever servants they may have to look after them, for as long as the afore-named son and daughter-in-law wish to remain in his company'. A second clause stated 'in the case that for any reason, which is not likely, the afore-mentioned son and daughter-in-law should wish to part from his company and set up house on their own, the consignee will confer on them the sum of 13,055 *reales* in cash annually.… And in addition a house of his property located in this court, Calle de los Reyes, indicated with the number seven on block [*manzana*] five hundred and thirty.…' Furthermore, Goya promised that in respect of the pensions his son already enjoyed, 'he may dispose of them, as may his wife, in order to clothe themselves and for other personal and exceptional expenditure which they may incur'. Was this a clause included to 'cover' his son's and future daughter-in-law's inclination to extravagance, which would be bound to alarm the prudent Goya? The superb, full-length portrait of Javier, known as '*L'homme en gris*' (fig. 48), and that of his elegant young bride, painted that same year, suggest that this may well have been the case.

At all events, 'the case … which is not likely' occurred soon after the wedding, and the

Fig. 190 *Doña Josefa Bayeu*,
inscribed '*Año 1805*'
pen and black chalk,
11.4 × 8.2 cm
Private Collection

Fig. 191 *Doña Juana Galarza*,
inscribed '*Año 1805*'
pen and black chalk,
11.4 × 8.2 cm
Private Collection

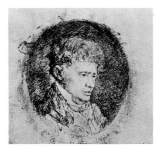

Fig. 192 *Javier Goya*,
signed and dated
'*Por Goya año 1824*'
black chalk, 9 × 8 cm
Private Collection

young couple escaped from the parental home on 1 January 1806, setting up house in the calle de los Reyes, on a comfortable, unearned, annual income of 28,000 *reales*. On the death of his mother, Doña Josefa Bayeu (fig. 190), in 1812, Javier also inherited a half-share of his parents' joint possessions. Apart from producing a single son, Marianito, a year almost to the day after their wedding, Javier and Gumersinda seem to have done little to delight and much to worry the artist, who had constantly to reassure them about his financial position and his intentions, particularly at the end of his life, when he was living with Leocadia Weiss in France. In July 1815, the Swedish envoy in Madrid, Count Jacob Gustaf de La Gardie, paid a visit to Goya's studio and noted his impressions in his diary. He evidently went with someone who filled in the background for him and gave him the current gossip, if not the entire truth, and La Gardie reported that the artist 'was not at home, but we were nevertheless able to see his studio as well as his collection of pictures.... Goya, almost deaf, is threatened by blindness as well, which however does not affect his satirical vein. He is living in strained circumstances, but this too is caused by his curious state of mind and caprices, because one day he suddenly got the idea of writing a letter giving away his whole fortune, which was considerable, to his son and daughter-in-law, the latter of whom it is said behaves badly towards her father-in-law, often denying him even the modest minimum that he needs and craves for a living.'

But if Javier and Gumersinda caused him anxiety and chagrin in later years, on the eve of their wedding in 1805 Goya's happiness must have been intense. Besides the full-length portraits of the young couple, he painted a whole 'family group' of miniature portraits in oil on small copper roundels, and also made a series of drawings, including the one of his wife, Josefa, of whom no miniature is known (fig. 190). The miniatures show the young couple and Gumersinda's parents, Doña Juana

Galarza and Don Martín Miguel de Goicoechea, as well as her three sisters, Manuela, Gerónima and Cesárea, who were twenty, fifteen and twelve years old respectively in 1805, all of them seen wearing their prettiest summer bonnets.

Within the identical circular format, the portraits are composed to produce a sense of variety and to accord with the expression of each sitter. Goya prepared the copper roundels with a thickly applied ground of rich chocolate-brown, and the portraits were swiftly and surely brushed onto the ground used for the darker shadows, enlivened with touches of impasto and very delicate treatment of the hair, and the lace and gauze on the girls dresses. The faces are exquisitely modelled and full of expression: the young couple slightly sulky and pouting, the three sisters sharply and tenderly individualised, and Don Martín, a penetrating and sympathetic character study of great feeling. Inscriptions on the back of the copper support give the names and ages of the two youngest girls, and the whole 'souvenir' group is a delightful and very impressive example of Goya's ability to work in any medium and on any scale.

Javier Goya gave his profession as 'painter' in the wedding register of San Ginés in 1805, but no works have ever been securely attributed to him. Goya seems to have been devoted to him and, even more, to his grandson Marianito, to whom he donated the so-called Quinta del Sordo (House of the Deaf Man) in 1823, but the weak and egoistical Javier (fig. 192) pursued his father to the end, even during his exile in Bordeaux, with purely material questions, and for such an intelligent father his 'painter' son must have been a bitter deception.

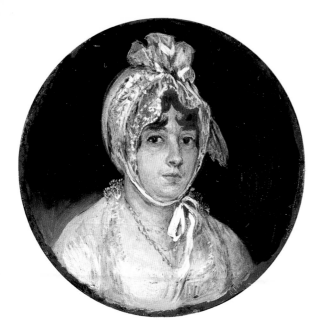

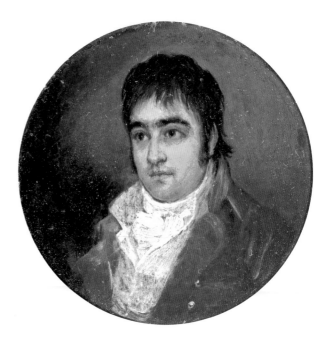

67 *Juana Galarza de Goicoechea*, 1805
copper, 8.1 cm diam.
Museo del Prado, Madrid

68 *Martín Miguel de Goicoechea*, 1805
copper, 8 cm diam.
The Norton Simon Foundation, Pasadena

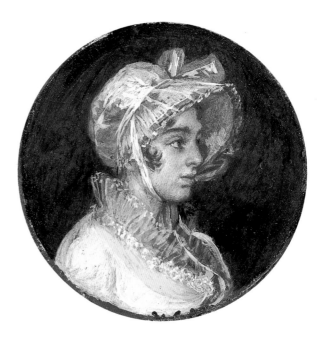

71 *Manuela Goicoechea*, 1805
copper, 8.1 cm diam.
Museo del Prado, Madrid

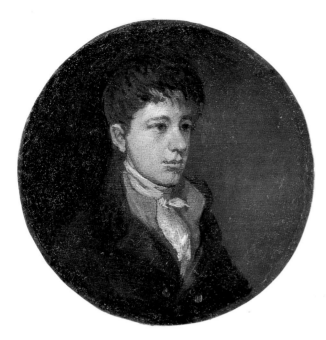

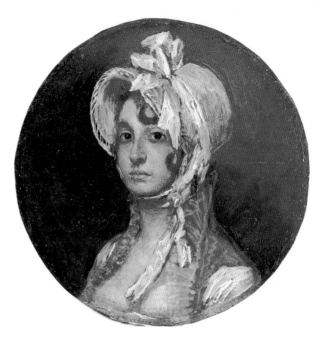

69 *Javier Goya*, 1805
copper, 8 cm diam.
Private Collection

70 *Gumersinda Goicoechea*, 1805
copper, 8 cm diam.
Private Collection

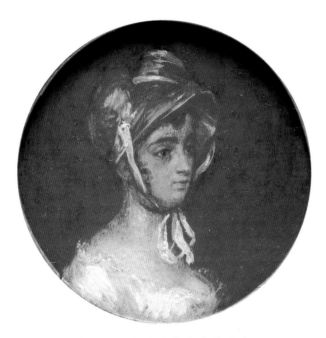

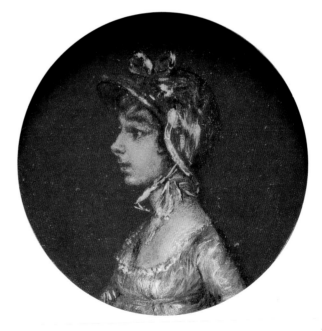

72 *Gerónima Goicoechea*, 1805
copper, 8.9 cm diam.
Inscribed on verso: *'1805/a los 15 años/Geronima/por/Goya'*,
Museum of Art, Rhode Island School of Design, Providence,
Gift of Grenville L. Winthrop

73 *Cesárea Goicoechea*, 1805
copper, 8.9 cm diam.
Inscribed on verso: *'1805/Goya/a los 12 años/ la Cesarea'*,
Museum of Art, Rhode Island School of Design, Providence,
Gift of Mrs Murray S. Danforth

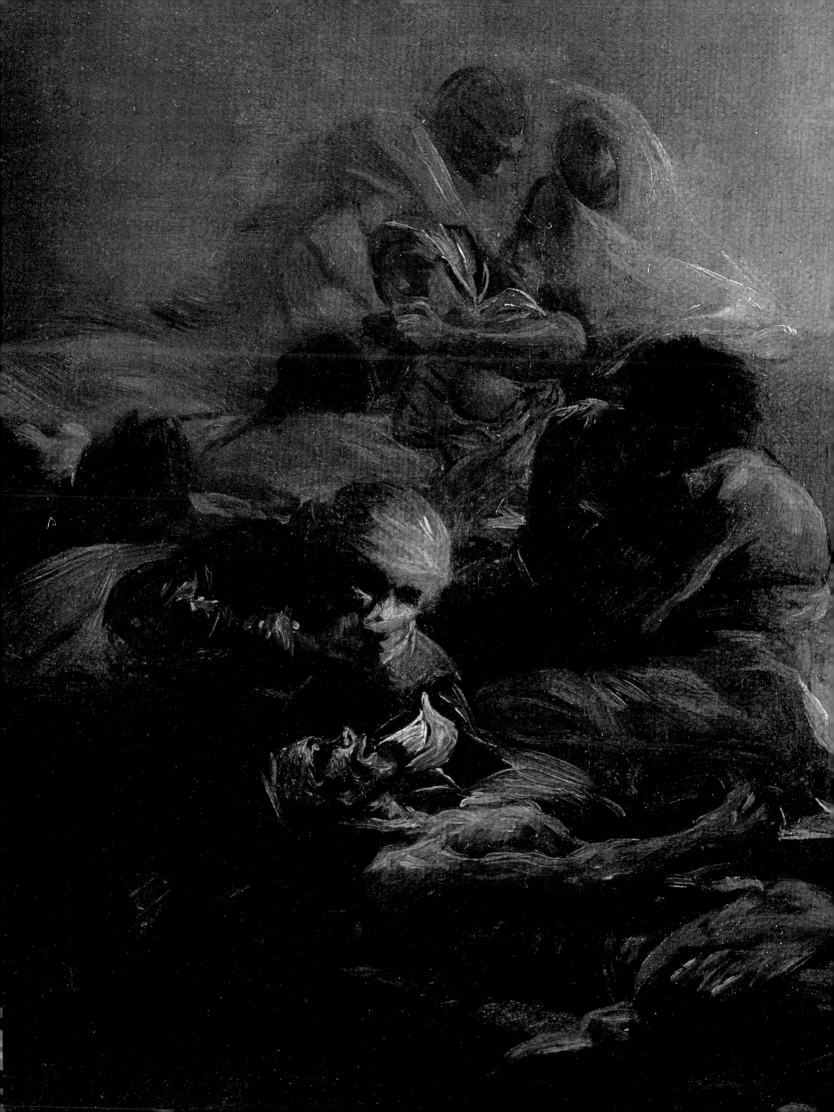

Real Life 'Caprichos'

c. 1798–1808

*F*rom the time of his illness in 1792–3 until the publication of *Los Caprichos* at the beginning of 1799, Goya led a double life. On the one hand, he continued with his official activities as Court Painter, which included the fresco decoration of the church of San Antonio de la Florida (see cat. 53, 54) and a major series of royal portraits, and led in October 1799 to his appointment as First Court Painter. He also continued to play a part in the activities of the Academy of San Fernando, and was appointed to the post of Director of Painting following the death of Francisco Bayeu in 1795, although eighteen months later he resigned because of his deafness, which made teaching too difficult. The 1790s was also a decade in which he painted some of his most splendid portraits of the aristocracy and of ministers and various officials, many of whom were his close personal friends.

At the same time, he continued to explore the kind of art in which '*capricho* and invention' held sway, and after the series of small paintings presented to the Academy in 1794 (cat. 32–43), the two enchanting oil sketches of the Duchess of Alba and her entourage (cat. 64, 65) were followed by the series of brush and ink drawings probably made in the summer of 1796, in the so-called Sanlúcar Album (figs. 188, 189). In a second album Goya multiplied the 'capricious' themes, extending them to include caricature and satire, and then made a new series of drawings in pen and ink which he called *Sueños* (*Dreams*), dating the famous title-page with his self-portrait as '*The Author Dreaming*' in 1797 (fig. 31). These were preparatory drawings for a series of etchings on which he worked until the end of the following year, publishing them in February 1799 as a 'Collection of Prints on Fanciful Themes', and which thereafter were known as *Los Caprichos*.

Goya's etched *Caprichos* were apparently accompanied by pictures on similar themes. Recent cleaning has led to the redating of a number of paintings traditionally associated with the period of the War of Independence, and it now appears possible to trace a more coherent and meaningful development from the early cabinet pictures of 1793–4 to the works executed during the first decade of the 19th century. In all of these Goya continued to exploit the possibilities of '*capricho* and invention' in compositions that are meditations on life and death and the vagaries of human nature, sometimes seen from a satirical point of view (cat. 79), or as an allegorical dream or nightmare (cat. 82, 83), sometimes recorded anecdotally as an actual event (cat. 84–9). Referring to *Los Caprichos* in an article published in 1811, Gregorio González Azaola gave an intelligent view of Goya's art that applies equally to his *capricho* pictures: 'Their delicacy is such that people of the most acute understanding do not usually comprehend at first all the moral meaning of some of them.'

Fig. 193 Detail from *Plague Hospital* (cat. 80)

THE 'CAPRICHOS' OF THE MARQUESS OF LA ROMANA, *c.* 1798–1800

This celebrated series of eight paintings was probably acquired directly from Goya by the Mallorcan art connoisseur Don Juan de Salas, father of Doña Dionisia de Salas y Boxadors, who was married to the 3rd Marquess of La Romana. This famous General died in Portugal in January 1811, during the War of Independence, and when the inventory of his property was drawn up six months later, it included no less than twelve works by Goya, including 'eleven small pictures in gilt frames which are *caprichos* by Goya'. Nothing is known of the fate of the three paintings missing from the set of eleven, and no description of the complete set has ever appeared. The date of the pictures remained a mystery, their subjects were incorrectly described and no attempt was made in the earlier literature to make sense of the sequence of scenes. Celebrated for their originality and beauty, and above all for their dark mystery in the past, their recent cleaning has revealed them as masterpieces executed at the watershed between the 18th and 19th centuries. Although previously considered to be themes of violence connected with the War of Independence, their relationship with the prints of *Los Caprichos* had already been noted, and now proves to be the crucial factor in determining their date.

THE CASTILLO CRIME

The most striking parallel is found in *Caprichos* plate 32 and its preparatory drawing (fig. 195, 196), and the scene of the *Interior of a Prison* (cat. 75). To one of his most beautiful aquatint plates showing a dejected woman seated on the floor of a prison cell, Goya gave the title '*Because she was susceptible*', which has turned out to be deeply ironic. Some contemporary manuscript commentaries on the *Caprichos* identify the woman as 'the wife of Castillo', and in 1978 this 'clue' was itself identified as a reference to the celebrated case of María Vicenta Mendieta who helped her lover to murder her husband and was imprisoned and executed. The murder took place on 9 December 1797, when Goya was already well-advanced with his series of etchings, and quickly became a subject of extraordinary public interest. The trial was held in the early months of 1798, and besides the *Caprichos* print, two of the Romana pictures appear to be related to the 'Castillo Crime', the so-called *Friar's Visit* and the *Interior of a Prison* (cat. 74, 75).

Fig. 194 '*Here comes the Bogeyman*', drawing for pl. 3 of *Los Caprichos*, 1797–8 red chalk, 19.8 × 14 cm Museo del Prado, Madrid

Fig. 195 '*Because she was susceptible*',
drawing for pl. 32 of *Los Caprichos*, 1797–8
sanguine wash over red crayon, 18.8 × 12.8 cm
Museo del Prado, Madrid

Fig. 196 '*Because she was susceptible*',
pl. 32 of *Los Caprichos*, 1797–8
aquatint, 21.8 × 15.2 cm
Museo del Prado, Madrid

María Vicenta was the 32-year-old wife of a wealthy, well-known and respected businessman in Madrid, Francisco de Castillo. Despite his kindness and generosity she quarrelled with her husband, and fell so much in love with her younger cousin, Santiago San Juan, who was only 24, that together they resolved to kill Castillo. The trial took place when Jovellanos was Minister of Grace and Justice, and Goya's friend Juan Meléndez Valdés became counsel for the Crown in February 1798, so the artist was certainly aware of the details of the case. His paintings are allusions, *caprichos* inspired by the events rather than direct reportage, but they include enough elements to justify their identification with the crime.

In the first picture (cat. 74), 'María Vicenta', dressed in fine clothes, is seated on a chair, with her two maids at her feet. She is greeting a bearded 'friar' who stands motionless in profile as she peers up at him, her pose and expression recalling those of the wife who greets her disguised lover in plate 3 of the

Caprichos and its preparatory drawing (fig. 23, 194). San Juan came in through the main door, on a pre-arranged signal, at a quarter past seven on the evening of 9 December, when María Vicenta had just given a potion to her husband, who was in bed with a gum infection. In the painting, the woman's arm and hand are raised to invite the 'friar' to enter, in a gesture that also leads the spectator's eye to a figure on a bed, illuminated by the sudden glow of a fire in the dark alcove behind her. The prosecutor stated that María Vicenta 'saw that her cousin Santiago San Juan was standing masked by the glass panelled door of the room' and that she 'had left open the glass doors which led to the bedroom'. Santiago with 'his face covered by a mask' went into the bedroom and stabbed Castillo eleven times, giving him three mortal wounds to the chest and two to the stomach.

In Goya's painting, the fatal relationship between the motionless figure and the subjugated woman recognising her lover beneath the disguise and inciting him to act, is

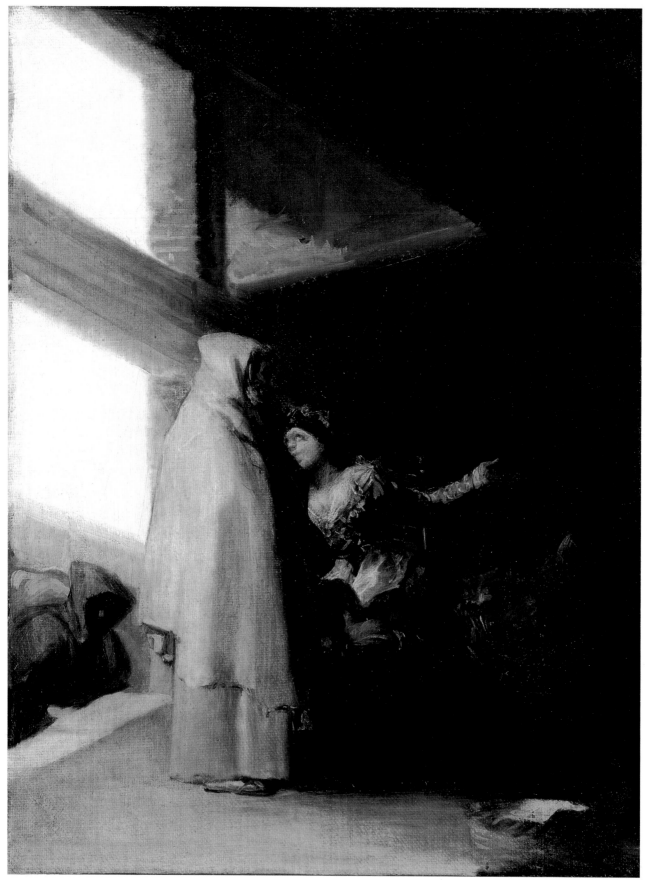

74 *The Friar's Visit (The Castillo Crime I)*, c. 1798–1800
oil on canvas, 41.5 × 31.8 cm
Marqués de la Romana Collection, Madrid

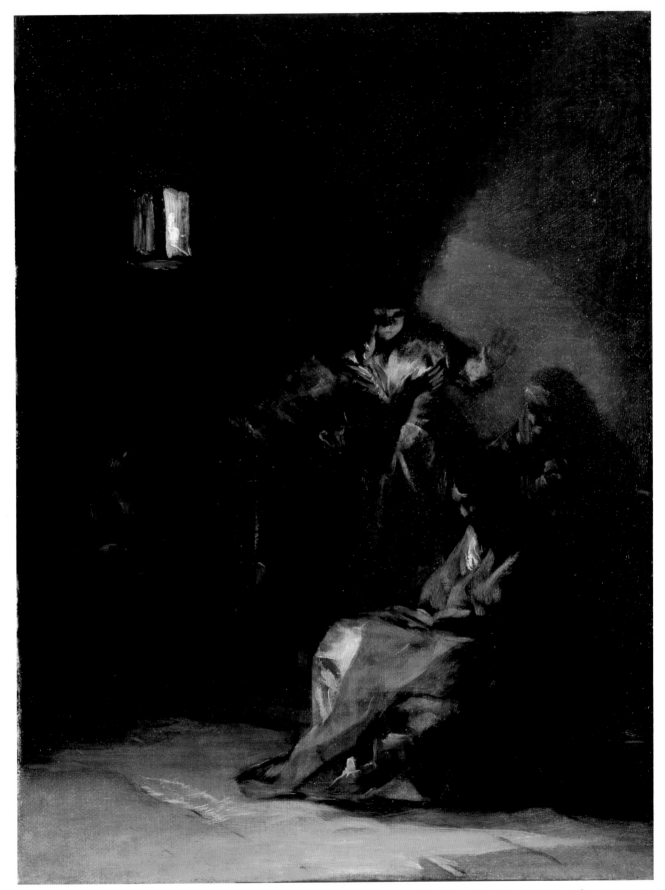

75 *Interior of a Prison (The Castillo Crime II)*, c. 1798–1800
oil on canvas, 41.5 × 31.8 cm
Marqués de la Romana Collection, Madrid

expressed in every line of the irrational but powerfully suggestive architectural elements, as well as in the movements and poses of the women. The eye is led along forceful diagonals, from the light outside (where the repeated figure of the friar suggests San Juan's wait in the street for the signal to enter) to the figure on the bed and the red glow of the fire exactly below his wife's hand, prefiguring the blood that is about to be shed. The mysterious friar, like the statue of the Knight Commander in Goya's witchcraft scene of almost the same date (cat. 48), is not walking, but conveys a sense of implacable movement towards his victim. The relationships of figures and architecture also recall another plate from the *Caprichos*, in which a vivacious and fashionably dressed young woman is flirting with two flying friars (fig. 179).

When the crime was discovered, María Vicenta and her servants were detained for questioning, and after her conviction the murderess was isolated. María Vicenta's mother, in repeated pleas to the King for clemency, referred to the fact that 'the humane treatment due to her sex and condition lasted only a short while; she was transferred to a filthy cell where the most dangerous and violent prisoners are kept, with a pair of fetters and spiked manacles on her hands, which is even more cruel and not permitted for members of the nobility (*hijosdalgo*)', and that she was kept *incomunicada* 'in the cell called the "cricket hole", which is full of insects, with no other bed but the hard floor'. The mother also referred to her daughter's mental state and said that her servants had testified to it. The reports of the case do not give enough details to know whether the scene in the prison is a free interpretation of events or whether it shows María Vicenta, before she was put into solitary confinement, with her visiting maids and two other prisoners.

In the drawing María Vicenta is alone in her cell, with eyes raised and a slightly deranged expression, and in the print her head is bowed in apathetic dejection, with a rat by her side (figs. 195, 196). The painting (cat. 75) shows her in a less sympathetic light, huddled in a blanket, with her hands and feet out of sight. The dark cell is 'lit' by a lantern that seems to throw out no rays of light and barely illuminates the head, breast and hands of the woman seated in the background. Behind the figure of María Vicenta, two girls, caught in the light of an obscured candle, appear to be looking at something in surprise – perhaps the letter of warning that María Vicenta asked one of her servants to deliver to San Juan. If this is the case, then the most powerful source of light in the picture is identified with the evidence that revealed the Truth, that is, the name of the murderer.

The guilty couple were executed in the Plaza Mayor on 23 April 1798, and although the official newspapers of the time carried no 'news' of the event, the *Diario de Madrid* for that day included the second and final instalment of a poem on the evils of crime, and ended with an announcement of a public service in the church of Santa Cruz 'for the souls of the guilty who are being executed on this day'. It is impossible to tell whether the story of the 'Castillo Crime' is complete in this pair of paintings, or whether one or other of the missing three pictures belonged with them.

THE BANDITS' ATTACK

The three other canvases in vertical format form another sequence, this time telling a more straightforward story, one that may also have been inspired by a particularly striking crime. The sequence is clear, and starts with a scene in which bandits are executing the male victims of a hold-up that has evidently taken place in a rocky sierra (cat. 76). The passengers have been robbed and their valuables tied up in the bundle to be seen in the foreground. One man is blindfolded and leans

back with hands clasped, awaiting execution. The legs of another have been stripped bare, and although his face cannot be seen, his outstretched hands express terror and anguish. The victims are threatened and shot at by vicious, mindless men, with a pistol and blunderbuss aimed at point-blank range. The horror and confusion of the scene and the menace of what is to come is perceived by the spectator through the woman. Slender and fragile in her beautiful dress, which provides the only touches of real colour in this otherwise almost monochrome scene, she raises her arms in a despairing gesture, gazing wildly at the hideous, unseeing face of the man about to fire his musket, and threatened by the profusion of figures and guns in the background. The scene is painted in thin, liquid colour, with little touches of impasto and much black outline drawing – a technique developed by Goya in the pages of the Madrid Album and used to great effect in similar themes on facing pages (figs. 197, 198).

In the next scene, women are attacked in their turn (cat. 77). From the rocky scene of the shooting they have been taken to the bandits' cave, where a fire in the foreground (suggesting warmth and comfort) glows within the dark shadows. A slender, shapely nude, like the figure of Truth in Goya's contemporary sketch (cat. 50), is here unveiled not by Time, but by a brutal, expressionless male. This older man stands with his head bowed, pulling at her last remnant of underclothing, while the rest of her clothes are suggested by a flurry of red and blue brushstrokes on the ground and a little, blue pointed slipper. She turns away and shields her face from the darkness in which the unspeakable act will occur, trapped between the look-out at the entrance to the cave and the gun and shovel in the foreground. The two figures stand as if transfixed, forming with the outline of the cave and the angles of the gun and shovel, and the clothes on the ground, a complex pattern of light, shade and line that

Fig. 197 '*Good people, we are the moralists*', page 88 of the Madrid Album, 1796–7 brush and indian ink, 23.7 × 14.7 cm The Hispanic Society of America, New York

Fig. 198 '*The lawyer, this who nobody forgives*', page 89 of the Madrid Album, 1796–7 brush and indian ink, 21.6 × 12.7 cm Private Collection

converges on the act of violation in the background. There, a younger man with an imbecile, gloating expression is casually raping a naked girl, looking round in the direction of his next victim, or else to see how his companion will fare. The girl, barely visible in the shadows beside him, has been pushed back by his groping hand and half reclines with head bowed and hands clasped, the intolerable softness of her open thigh and unresisting leg suggested by the light that filters into the cave. Outside, away from the horror of the shadows, the light is painted so thickly, as always, that its very substance seems to beat against the rocks. The picture is almost a *grisaille*, and so thinly and fluidly painted over the light beige preparation, with its delicate glazes intact, that the visible texture of the canvas increases the sense of vulnerability in the nude.

The final act takes place in a desolate, rocky setting that suggests the underside of a bridge over a steep ravine (cat. 78). Hidden from the road where the coach was attacked, and from which help might have come, one of the bandits kneels over a naked, screaming woman, about to plunge his dagger into her throat and finish her off. The amount of blood on the ground and the broken shovel by the man's feet suggest the violence and brutality of the assault. The woman is already half dead, pinned down with her arm bent under her body, her open mouth and raised thigh indicating a final effort of protest and resistance before the inevitable end. The two are locked in a death struggle that should be a lovers' embrace, and Goya has lovingly depicted the man's curly hair and yellow waistcoat, the transparent folds of his tell-tale shirt-tails and the strength of his muscular right arm, as well as the touches of light on his half-shadowed face and the swelling forms of the woman. At the same time, he used black outlines in the shadows around the figures and, particularly, to emphasise the stomach and groin of the man, recalling the menacing

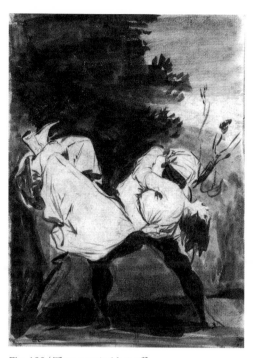

Fig. 199 '*They carried her off*', drawing for pl. 8 of *Los Caprichos*, 1797–8 red wash, 19 × 13.6 cm Museo del Prado, Madrid

shadows in the drawing for one of the most violent plates of the *Caprichos* (fig. 199). In this canvas, too, the background was softly brushed in, with visible changes, until the effect Goya was seeking emerged, and his triptych – if it was so conceived – perfected. In these three violent little pictures, Goya contrasts the vulnerability and liveliness and beauty of women with the mindless brutality of men motivated by greed and lust. The satirical, allegorical element that is so clearly indicated in the pages of the Madrid Album and the prints and drawings of the *Caprichos* (fig. 197–9), is no doubt also present here.

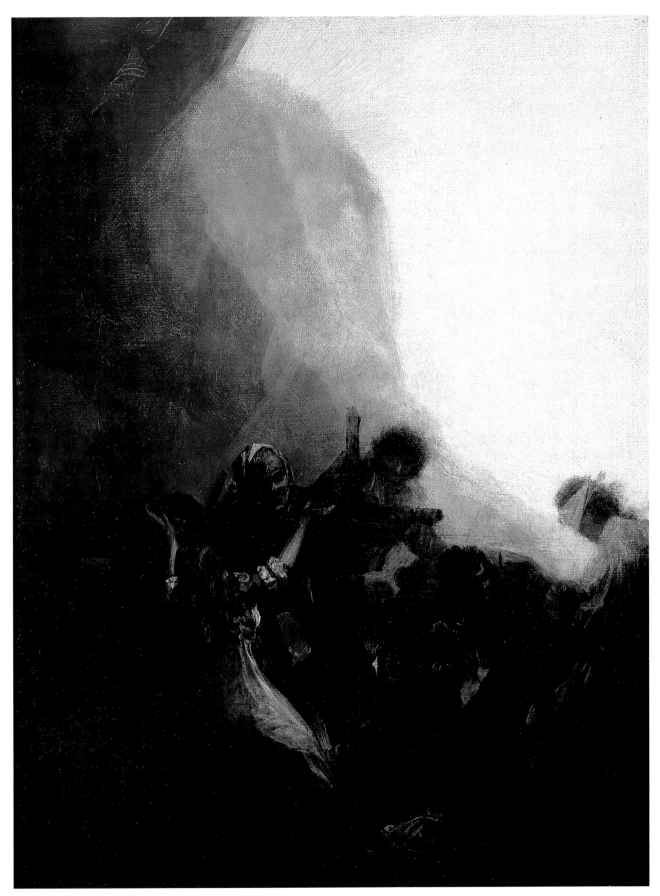

76 Bandits Shooting Male Prisoners (The Bandits' Attack I), c. 1798–1800
oil on canvas, 41.4 × 31.6 cm
Marqués de la Romana Collection, Madrid

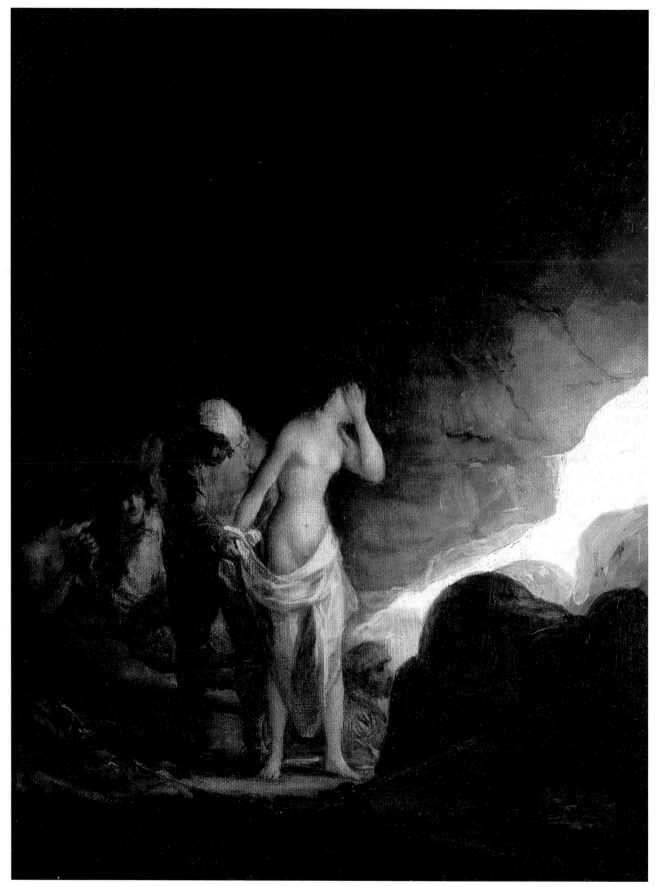

77 *Bandits Stripping and Raping Two Women (The Bandits' Attack II)*, c. 1798–1800
oil on canvas, 41.5 × 31.8 cm
Marqués de la Romana Collection, Madrid

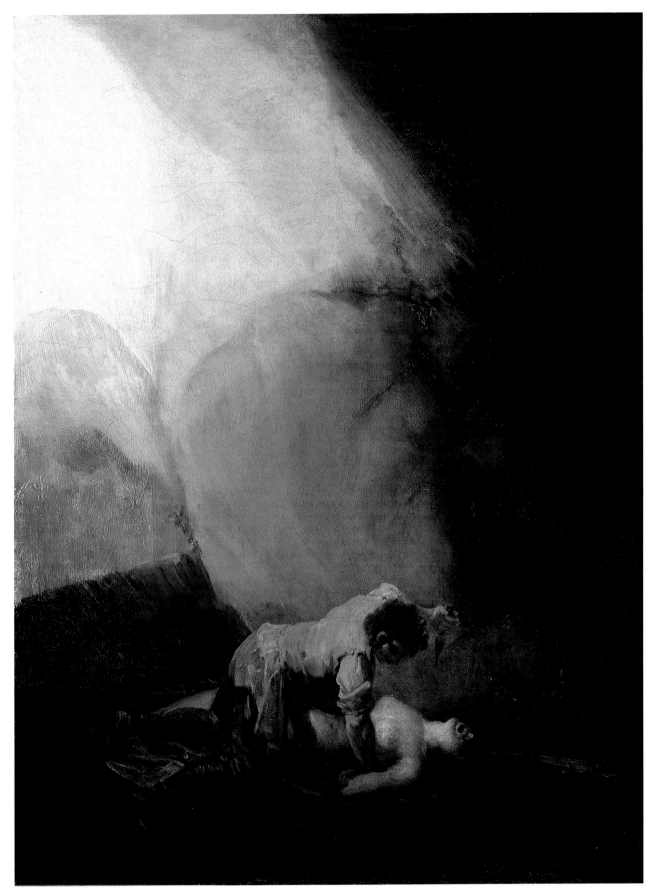

78 *Bandit Murdering a Woman (The Bandits' Attack III)*, c. 1798–1800
oil on canvas, 41.5 × 31.8 cm
Marqués de la Romana Collection, Madrid

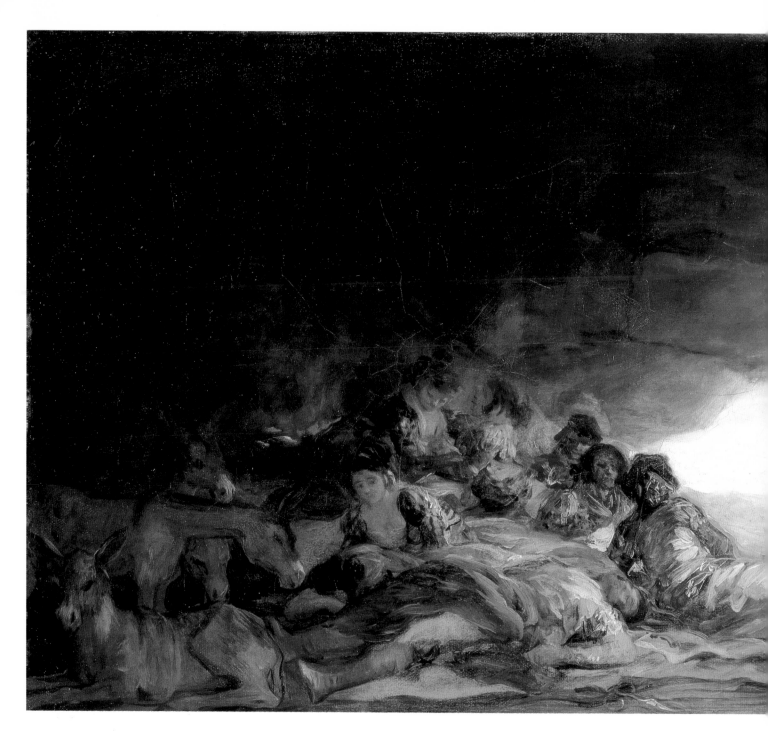

79 *Gypsies Resting in a Cave*, c. 1798–1800
oil on canvas, 33 × 57 cm
Marqués de la Romana Collection, Madrid

THREE SUBJECTS

The three landscape, or wide-format, pictures were painted on an orange rather than a beige-coloured ground that gives them a generally warmer tonality, but their subjects do not appear directly connected. Cleaning of the picture often known as *Vagabonds* or *Gypsies Resting in a Cave* (cat. 79) has revealed not only the beauty of its brushwork and colour but also the subject and its significance. Men, women and asses are seen in the shelter of a cave, where a fire burns at the rear. It is daybreak and a cold light penetrates the cavern in which several reclining men are wrapped in blankets. Those near the entrance are in conversation, while in the foreground a man lies sleeping on his back with a woman face down beside him. From their clothes, the men must be gypsies, and a pair of donkey-shears (revealed during cleaning) placed exactly at the centre of the lower edge confirms their characteristic, seasonal occupation. But the women are not part of their families, as has been suggested; young, comely and alluringly dressed, they are prostitutes who have spent the night with the men.

The girl half raised in the centre looks to her sleeping male companion, who is sprawled unconscious on his back. And the direction of her glance, the line of the shears and the proximity of the donkeys, suggest an allegory like those in the *Caprichos* prints, where prostitutes are seen 'shaving' and 'fleecing' their clients. Goya's magical painting suggests the intimate relationship of men, women and animals, all leading the same life, all bound to and dependent on one other, all exploited and exploiting, summed up in an imaginary scene of 'gypsy donkey-clippers clipped by girls'.

Leaving the cave in the landscape where the light again seems to cling physically to the edge of the rock, Goya penetrates the cavernous spaces of a hospital where people are dying of the plague (cat. 80). Men, women and children, dead and dying, or still alive and trying to

comfort and succour the sick, are crowded into the darkest areas of the gloomy interior. Swiftly and softly brushed figures, defined by the light and delineated with black, are spread across the foreground in an overwhelming display of physical and emotional suffering, made more unbearable by the fact that those who minister to the dying, offering water or the comfort of caring gestures, are obliged to hold their noses against the pestilential stench.

Almost all have turned away from the light that glows at the window, invading and defining the spaces within the vaulted room and binding figures and architectural forms into a harmonious whole. As in the earlier and later scenes of a madhouse (cat. 43, 98), there can be no escape from this doomed world, but two clinging figures are struggling to reach the light that dissolves their forms like those of the angels in Goya's contemporary *Gloria* (cat. 54). Their progress seems to be observed by a man in the foreground who is just able to raise his head, while two other figures, clasped in one other's arms to the left, recall the frescoed dead man in the church of San Antonio de la Florida (fig. 200), but here there are neither saint nor angels to save them. The softness and sensitivity of the brushwork is also seen in the gestures and expressions, where however terrible, pathetic and shocking these may be, nothing is exaggerated: everything is delicately defined or suggested, with a reticence and decency that was still to pervade the more robust and summary treatment of a similar theme in the prints of the *Disasters of War*, some ten or more years later (fig. 201).

The scene of *Shooting in a Military Camp* (cat. 81) is the antithesis of the stillness of death in the hospital. Here, the irruption of bandits into the camp at night causes chaos and fear. Wounded soldiers scream or sink dying to the ground, their faces and uniformed figures minutely described, whereas the bandits, like those in the other shooting scene (cat. 76), are barely defined, faceless executioners whose guns are glimpsed in impossibly

Fig. 200 Detail from *The Miracle of St Antony of Padua*, 1798, fresco, San Antonio de la Florida, Madrid (see fig. 172)

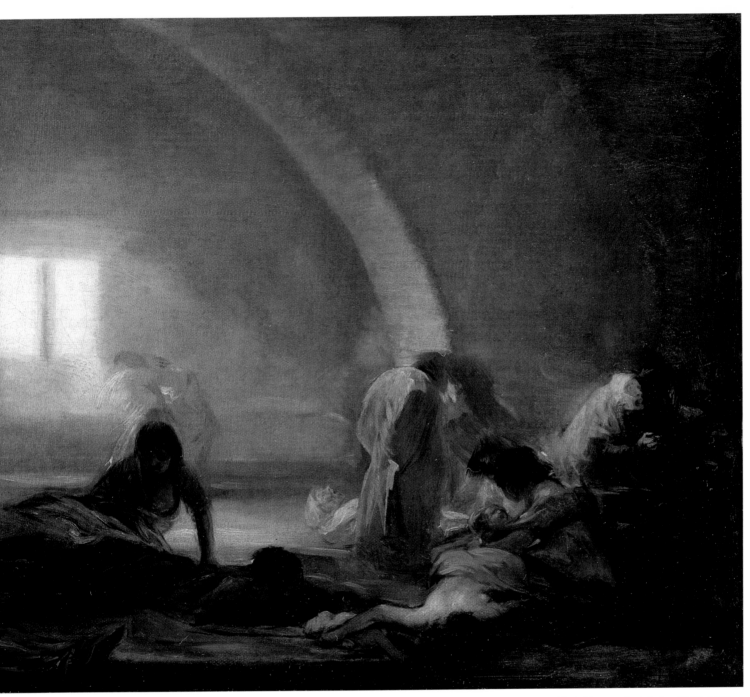

80 *A Plague Hospital*, c. 1798–1800
oil on canvas, 32.5 × 57.3 cm
Marqués de la Romana Collection, Madrid

Fig. 201 '*The sane and the sick*',
pl. 57 of *The Disasters
of War*, c. 1812–15
etching and aquatint,
15.5 × 20.5 cm
Biblioteca Nacional, Madrid

serried ranks, suggesting a menacing horde of armed men. In all the confusion, only the woman with her baby at the centre acts coherently and positively, fleeing in terror but protecting her child, like the mother in one of the earliest scenes of the *Disasters of War* which Goya entitled '*I saw this*' (fig. 202). Is the *Shooting* intended as a scene from 'real life', or is it an allegory like the others in the series? The *caprichos* of the Marquess of La Romana are the key to our understanding of Goya's passage from the 18th century into what is thought of as the modern world.

Fig. 202 '*I saw this*',
pl. 44 of *The Disasters of War, c.* 1810
etching, 16 × 23.5 cm
Biblioteca Nacional, Madrid

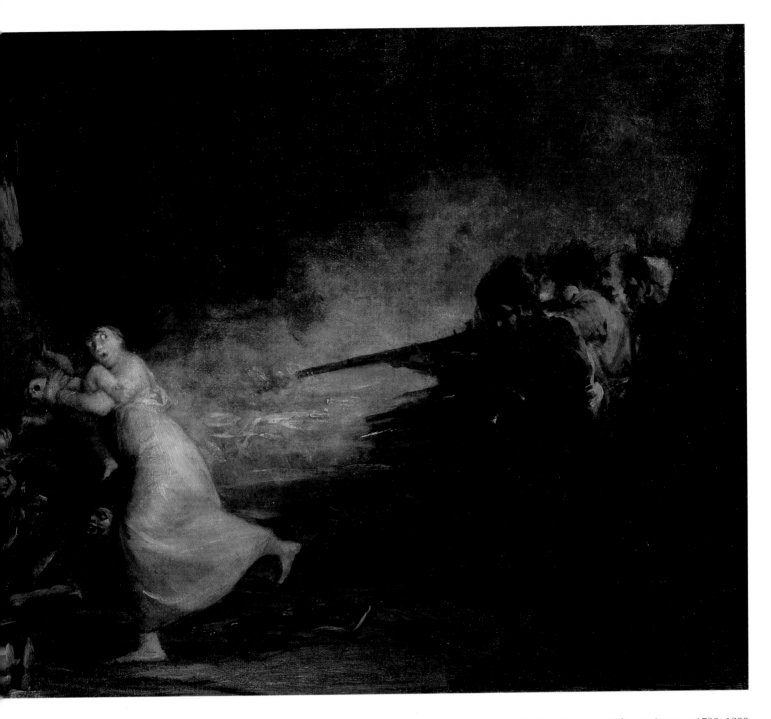

81 *Shooting in a Military Camp*, c. 1798–1800
oil on canvas, 32.6 × 57 cm
Marqués de la Romana Collection, Madrid

CANNIBALS, *c.* 1800–08

This marvellous and terrifying pair of panel paintings has remained together since its acquisition by the French collector Jean Gigoux before 1867. They probably came, directly or indirectly, from Goya's estate, with the curious identification that Yriarte gave in his catalogue, where they are titled '*L'Archevêque de Québec*' ('The Archbishop of Quebec') and '*J'en ai mangé*' ('I have eaten of it'). When it was later realised that the Bishop of Quebec was not made Archbishop until 1819, and died a natural death, the fate of two Jesuit missionaries, Jean de Brebeuf and Gabriel Lallemant, at the hands of the Iroquois in 1649 was proposed as the possible subject of the paintings. The only shred of evidence on which to hang an identification of the two victims are the clothes scattered on the ground (see cat. 82), but these are so freely painted that, apart from the hat and buckled shoe and the suggestion of a blue sash, it is difficult to arrive at a precise definition, although the hat may be that of a Jesuit priest.

A much closer link seems to lie, once again, with Goya's *Caprichos*, in which all manner of obscene rituals connected with witchcraft are found, and where the theme of men eating men is explicitly stated in one of the preparatory *Sueños* drawings, the *Dream* no. 25 – '*Of some men that they were eating us*' – in which greedy friars are seen guzzling their food, while a servant brings in a human head on a platter. The theme was certainly in Goya's mind at the time, since another drawing prepared for the prints shows Saturn eating his sons, and many *Caprichos* plates as well as the *Flying Witches* (cat. 45) in the witchcraft pictures, allude to blood-sucking activities.

The more difficult, and more important, problem is that of dating these panels, which are such brilliant examples of Goya's art that they should serve as a guide to his style. They are close in many ways to the *Caprichos*, and in plate 69, '*Blow*' (fig. 157), the seated figure appears almost as a mirror image of the cannibal staring at the severed head (cat. 83). At the same time, the painting of the scattered clothes is very similar to the way Goya handles the blankets and shoe in the *Gypsies in a Cave* (cat. 79), and the relationship with the pictures in the Romana collection is also seen in the *Plague Hospital* (cat. 80), in the very sensitive treatment of the figures, softly brushed or finely detailed, when compared with the flayed corpse (cat. 82) or the savage seated on the left (cat. 83) in the *Cannibals* pair. Nevertheless, the Besançon pictures are 'rougher', more summary, farther away from the detailed horrors and 'picturesque' settings that characterise even the most violent images in the Romana group. The radical simplification and elimination of all but the most basic background scenery, freely sketched and with large blank areas of sky, as well as the broader handling of the figures and the possibility of certain classical allusions, suggest that these paintings lie somewhere between the Romana group and the four San Fernando panels that must have been painted after the War (cat. 95–8).

The first of the Besançon *Cannibals* shows the corpses of the two victims stripped of their clothes. In a boldly off-centre composition, three savages are preparing the bodies, one of which they are disembowelling on the ground while the other, suspended from a cord, is being flayed. The clothes and shoe to the left and pointed sticks in the foreground direct the eye to the perfectly balanced group of figures actively concentrated on its tasks. Two-thirds of the panel is occupied by empty sky, a sketchy wall of rock and blank ground, but the

Fig. 203 *Piping Marsyas*, 15th-century Italian bronze copy of a lost original, *c.* 300 AD

energy discharged by the figures fills the whole picture space. The savages are painted in precise but impressionistic touches, their forms modelled by the light and described by directional brushstrokes. While the legs of the hanging figure are still smooth and well-defined, with black strokes outlining the thigh and foot, the upper arm and torso have been 'roughened' with cross-strokes and touched with brown-red, to suggest the flayed flesh, bared muscles and blood.

The savage carrying out this fearful task is young and beautiful, with a wild and gleeful expression on his face. He stands braced and alert, in a pose recalling that of the celebrated Antique '*Piping Marsyas*' (fig. 203), and Goya is perhaps alluding here to the innocent savage contrasted with the invading forces of 'civilisation'. The Marsyas allusion, if such it is, would be aptly, if ironically related to the flaying of the victim (since it was Marsyas himself who was flayed after losing his musical contest with Apollo), and may also involve a further allusion to Liberty, with which he was associated by the ancient Greeks.

In the second panel, the savage seated astride a rock is brandishing a dismembered

Fig. 204 *Savages Fighting*, page 57 of Album F, *c.* 1814–20 brush and iron-gall, 20.7 × 14.1 cm Ashmolean Museum, Oxford

hand and head, while a leg and exquisitely detailed rib-cage with blood-red edges are seen on the ground below. To the left, a figure with a primitive but softly brushed head (see fig. 57) sits staring and clasping his legs, while in the background more figures, including a woman seen from behind, are waiting and watching in the shadows. The setting, again, is barely suggested – the diagonal branch of a tree projecting over the rocks, with a fire in the foreground to the right and a distant and sketchily defined hill on the left. This same degree of abstraction is found in the later plates of the *Disasters of War*, where one of the most impressive and terrifying scenes shows dead men and parts of dismembered bodies attached to a blasted tree, like so many superbly carved fragments of Antique sculpture (fig. 205). If these two paintings are another of Goya's allegories on human nature, they suggest the ambiguity of his vision of man as innocent savage or irremediably primitive beast, a vision captured in his drawing of fighting savages or 'Cain Murdering Abel', in a page from one of his albums (fig. 204).

Fig. 205 '*Heroic feat! Against the dead!*', pl. 39 of *The Disasters of War*, *c.* 1812–15 etching and aquatint, 15.7 × 20.8 cm Biblioteca Nacional, Madrid

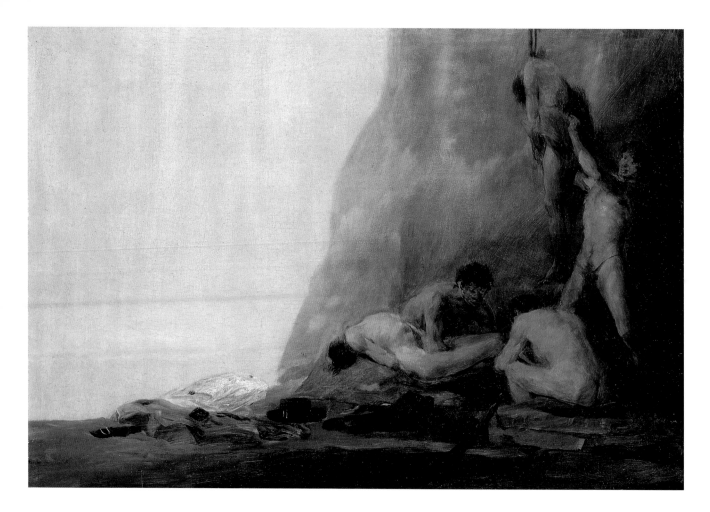

82 *Cannibals Preparing their Victims*, c. 1800–08
oil on panel, 32.8 × 46.9 cm
Musée des Beaux-Arts et d'Archéologie, Besançon

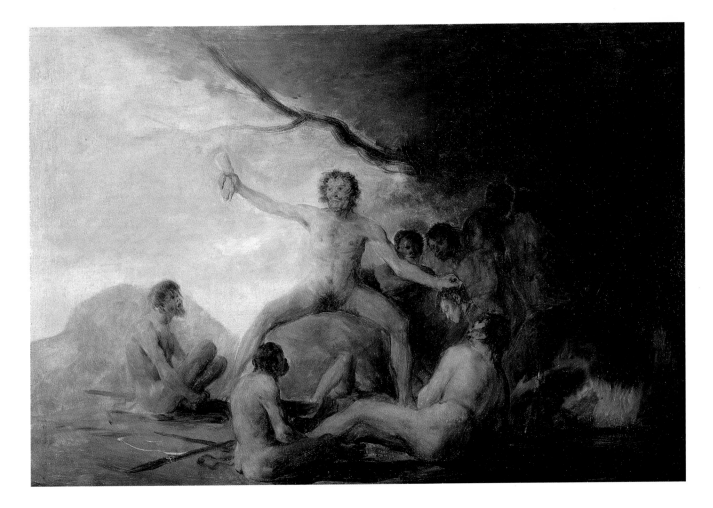

83
Cannibals Contemplating Human Remains, c. 1800–08
oil on panel, 32.7 × 47.2 cm
Musée des Beaux-Arts et d'Archéologie, Besançon

FRIAR PEDRO DE ZALDIVIA AND THE BANDIT 'EL MARAGATO', *c.* 1806

The story of how the terrible bandit Pedro Piñero, alias El Maragato, was captured single handed by the brave Friar Pedro de Zaldivia on 10 June 1806 was an event that caught the imagination of the entire Spanish nation, and was celebrated in poems, prints (fig. 206, 207) and an official publication – and by Francisco de Goya in a set of six paintings. El Maragato had committed many crimes and was condemned to die, but his sentence was commuted to service in the arsenal at Cartagena, where he was sent in 1804. On 28 April 1806 he managed to escape and made his way towards Oropesa, to the west of Toledo, robbing various people of food and money, and acquiring three guns and a horse. On 10 June, at ten in the morning, he reached a house in the Verdugal, where his capture took place. The deed was related in detail in a pamphlet advertised for sale in Madrid in July 1806.

Goya's six pictures are virtually illustrations to this story, and follow its naive presentation and style so closely that their imagery is best understood by reference to the original text. The sequence begins after El Maragato appeared at the house, 'with a shotgun over his arm, and primed ready to fire, leaving two others which he had previously stolen hanging from the tree of his saddle, and surprising those who were in the said house', and 'scaring them with blasphemies and oaths … he locked them all up in the said room.' Afterwards 'he made the guard come out from where he was locked up with the others and ordered him to harness the horse of the second guard which was the one he was looking for, and once done, he hung from the saddle-tree of that horse the two guns formerly on the other one, and without leaving the one he always carried with him, he led the guard back and locked him up with the others. At this point *Padre Fray* Pedro Zaldivia arrived in the vicinity on foot to ask for alms for his convent; when El Maragato heard his steps he came out, raised his gun to a firing position and, aiming at the Father, said to him: "Who are you with, Father?", to which he replied, "No one, I've come alone"; and El Maragato answered, "Well come into this house", and, adjusting his aim to every step the Father took, he led him to the other room and shut him in with the rest. A short while later, remembering that his shoes were in bad condition and that he had seen the second guard with better ones, El Maragato opened the door very carefully and ordered the guard to take off his shoes and give them to him, but the priest, suspecting that handing over the shoes might allow him to surprise the thief and take away his gun, trusting in God and his most Holy Mother and inwardly calling on them for aid, and to St Peter of Alcántara, said: "Brother, I have a pair here which I think will suit you very well"; and as if taking them out of some saddle-packs which he was carrying over his shoulder he began coming out of the room where he was enclosed; when El Maragato saw this he levelled his gun at the right shoulder of the priest in order not to let him come closer, and in this position Friar Pedro pushed out the shoes towards him underneath the gun, and the unwary Maragato also stretched out his left hand in order to take them [cat. 85]; on seeing his chance, the priest vigorously and bravely grabbed the barrel of the shotgun, lowering it towards the floor in case it went off, and with his left hand grasped it near the opening of the barrel, … El Maragato angrily repeated the foul words. He carried on struggling with the priest for quite a while in order to pull the gun from him, threatening to kill him [cat. 86], but, seeing that Friar Pedro was stronger, he released it, saying "I still have two other ones",

Fig. 206 Anonymous engraver, '*The Seizure of Maragato, executed by religious law under the Order of San Pedro Alcantara of the 10th of June ...*', 1806
Biblioteca Nacional, Madrid

and letting go of the gun he jumped towards the horse, from whose saddle the other two weapons were hanging. Then the brave Father Zaldivia turned the gun round to direct its fire towards the evildoer and, as he fired it, a ricochet hit the head of the horse, which took fright and fled. On seeing himself helpless, El Maragato began to run, the priest feared that he would escape and when El Maragato was about eighteen steps away he fired the gun, aiming for the backs of the knees in order not to kill him [cat. 88]; it was loaded with one bullet, two pellets and a handful of shot ... all of which hit him in the right thigh, and being unable to stand upright he fell in a heap on the floor. Friar Pedro ran to him, and with a cord which Providence had placed there he tied up his arms behind his back; when the others saw what was happening they came out with sticks, wanting to hit him [cat. 89], but the priest stopped them, and put the wounded man in the shade as best he could.... El Maragato looked at the priest and said: "Ah, Father! Who would have thought when I threatened you with the gun in order to make you enter the house and you went in with your head and eyes down, that you would betray me like this?" The priest replied, "Alas, my friend, although on the outside I demonstrated humility, on the inside I possessed all the anger of God."'

El Maragato was taken to Madrid and condemned to be hanged, drawn and quartered. The execution took place on 18 August, and excited extraordinary popular interest. Five months later, what remained of 'the head and four quarters of Pedro Piñero', exhibited 'along the roads and in the places where he committed his crimes', were given a Christian burial near the town of Oropesa.

Goya's set of pictures, painted on small wood panels, are directly and swiftly brushed over a warm red ground, with many visible changes in the compositions. In the background to the first two scenes (cat. 84, 85), the open door to the room and the people held captive are visible; in the third scene (cat. 86), the horse's head and one of the rifles attached to its saddle appear; in the fourth (cat. 87), Friar Pedro is seen swinging the gun-butt down on the astonished bandit; the fifth (cat. 88) combines the scene of the horse galloping off with the shooting of El Maragato; the final scene (cat. 89) shows the Friar binding El Maragato with the 'providential' cord, while the cowardly men who had refused to help him earlier on now rush out 'with sticks', attempting to beat him with them.

The changes show Goya working out his compositions as he went along, and a striking example is the visible alteration in the position of El Maragato's left leg in the scene of the shooting (cat. 88): instead of keeping the bandit in the act of running off, as we see the horse is, Goya eliminated the additional diagonal and increased the sense of the bandit's arrested movement as Friar Pedro pulls the trigger. The 'six pictures of El Maragato' were listed among the contents of Goya's studio in 1812, and they were evidently a personal response to the remarkable event that caught both his own and the public imagination. Painted in the manner of the story-telling predella of a traditional altarpiece, with the vigour and naivety of a popular print, Goya's set of small wooden panels recount the miracle of a latter-day saint.

Fig. 207 Anonymous engraver, '*Brave Moments by Friar Pedro Zaldivia against the Prisoner Maragato on the 10th of June*', 1806
Biblioteca Nacional, Madrid

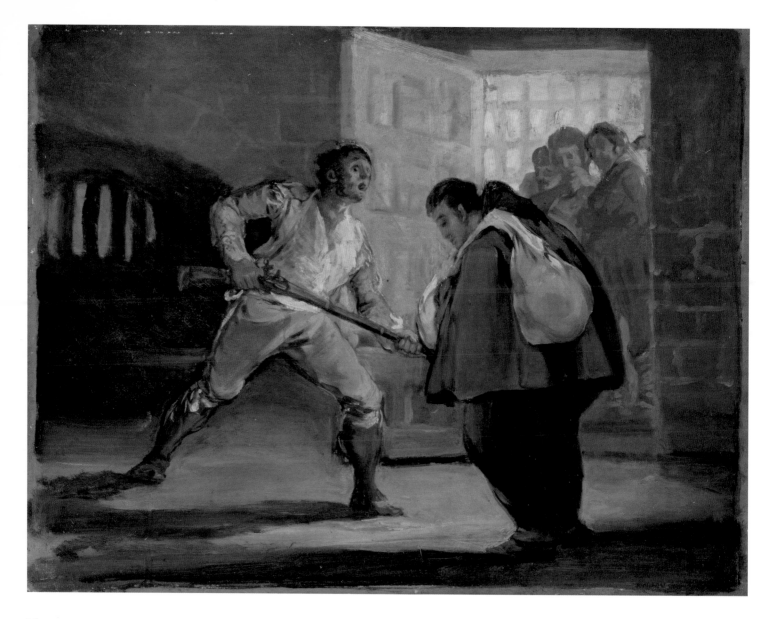

84
El Maragato Threatens Friar Pedro de Zaldivia with his Gun
c. 1806

panel, 29.2 × 38.5 cm
The Art Institute of Chicago, Mr and Mrs Martin A. Ryerson Collection

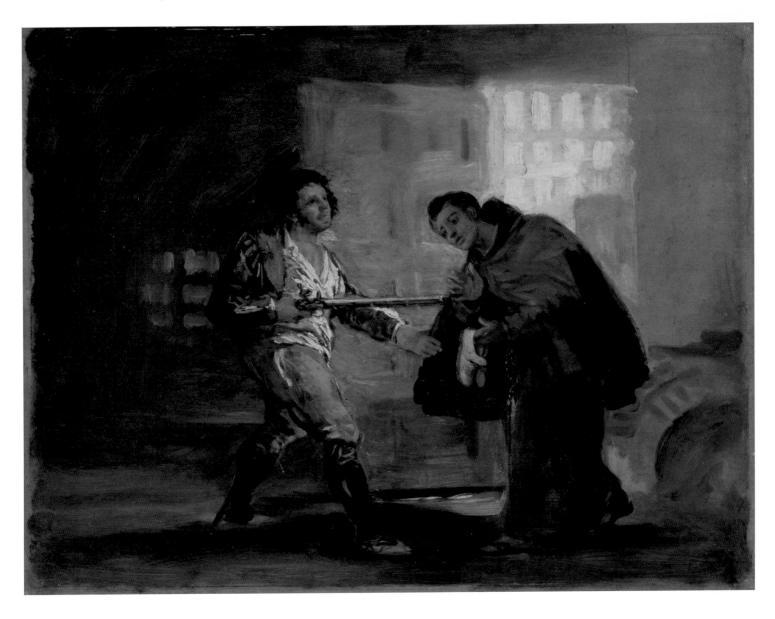

85
Friar Pedro Offers Shoes to El Maragato and prepares to push aside his Gun
c. 1806
panel, 29.2 × 38.5 cm
The Art Institute of Chicago, Mr and Mrs Martin A. Ryerson Collection

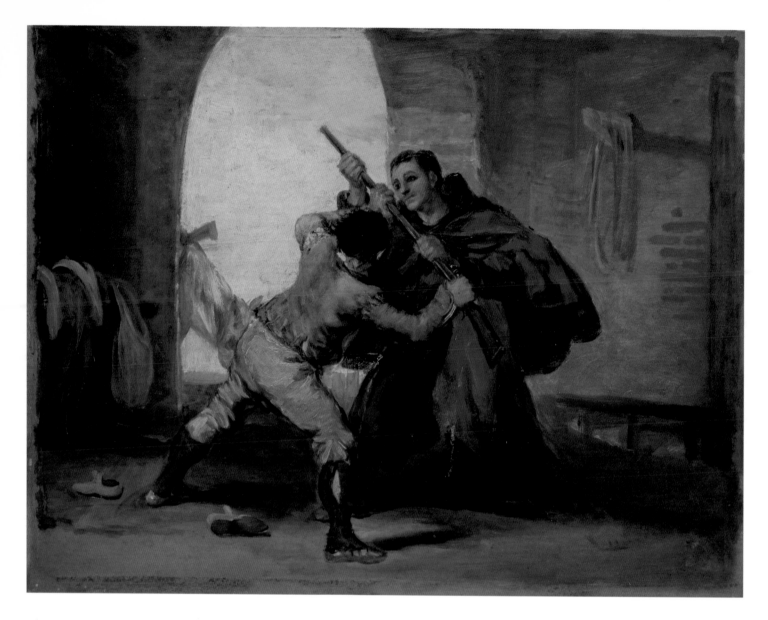

86
Friar Pedro Wrests the Gun from El Maragato
c. 1806
panel, 29.2 × 38.5 cm
The Art Institute of Chicago, Mr and Mrs Martin A. Ryerson Collection

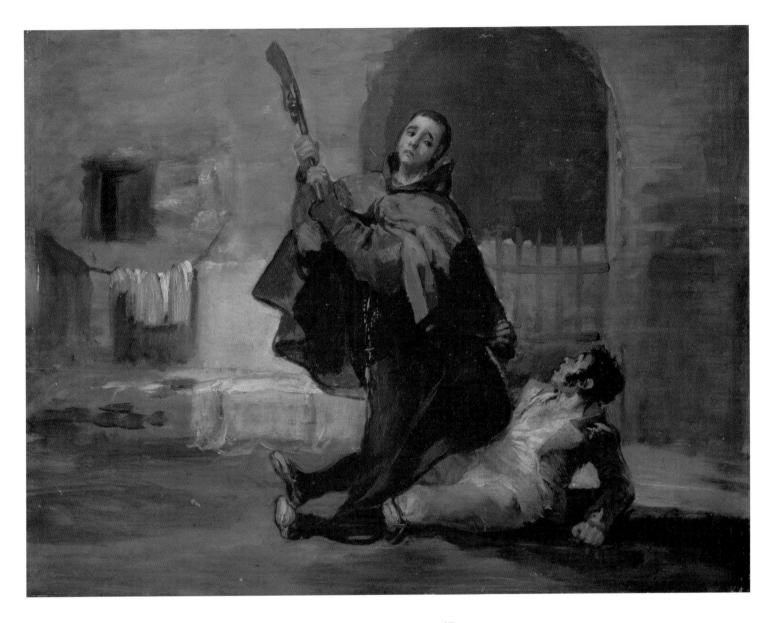

87
Friar Pedro Clubs El Maragato with the Gun-butt
c. 1806
panel, 29.2 × 38.5 cm
The Art Institute of Chicago, Mr and Mrs Martin A. Ryerson Collection

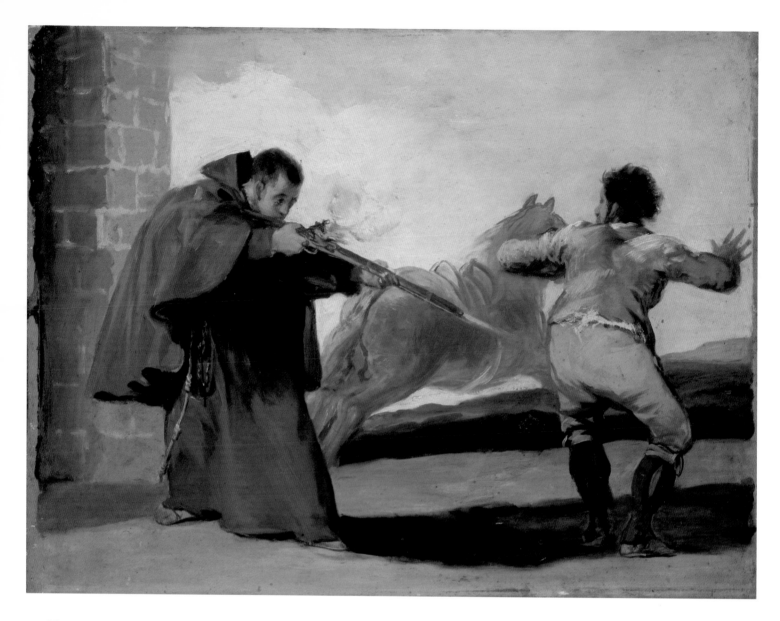

88
Friar Pedro Shoots El Maragato as his Horse Runs off
c. 1806

panel, 29.2 × 38.5 cm
The Art Institute of Chicago, Mr and Mrs Martin A. Ryerson Collection

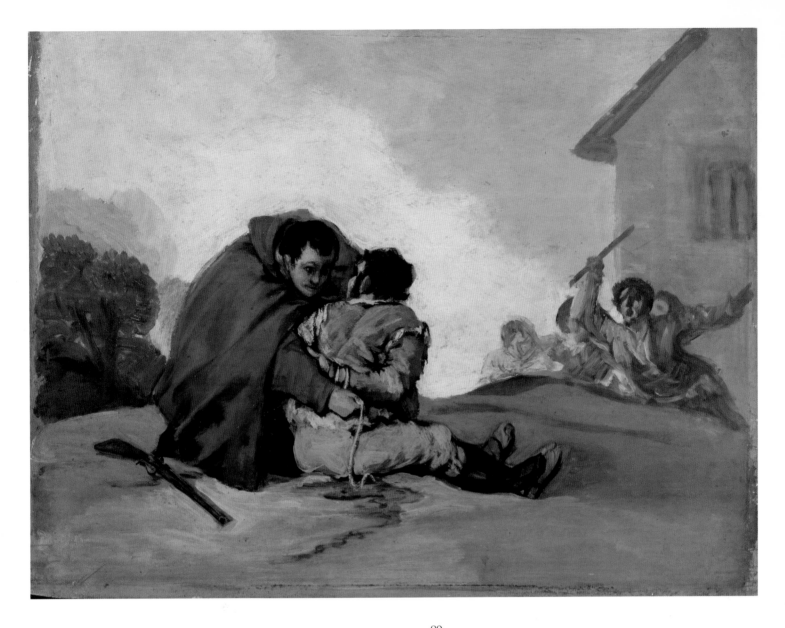

89
Friar Pedro Binds El Maragato with a Rope,
c. 1806
panel, 29.2 × 38.5 cm
The Art Institute of Chicago, Mr and Mrs Martin A. Ryerson Collection

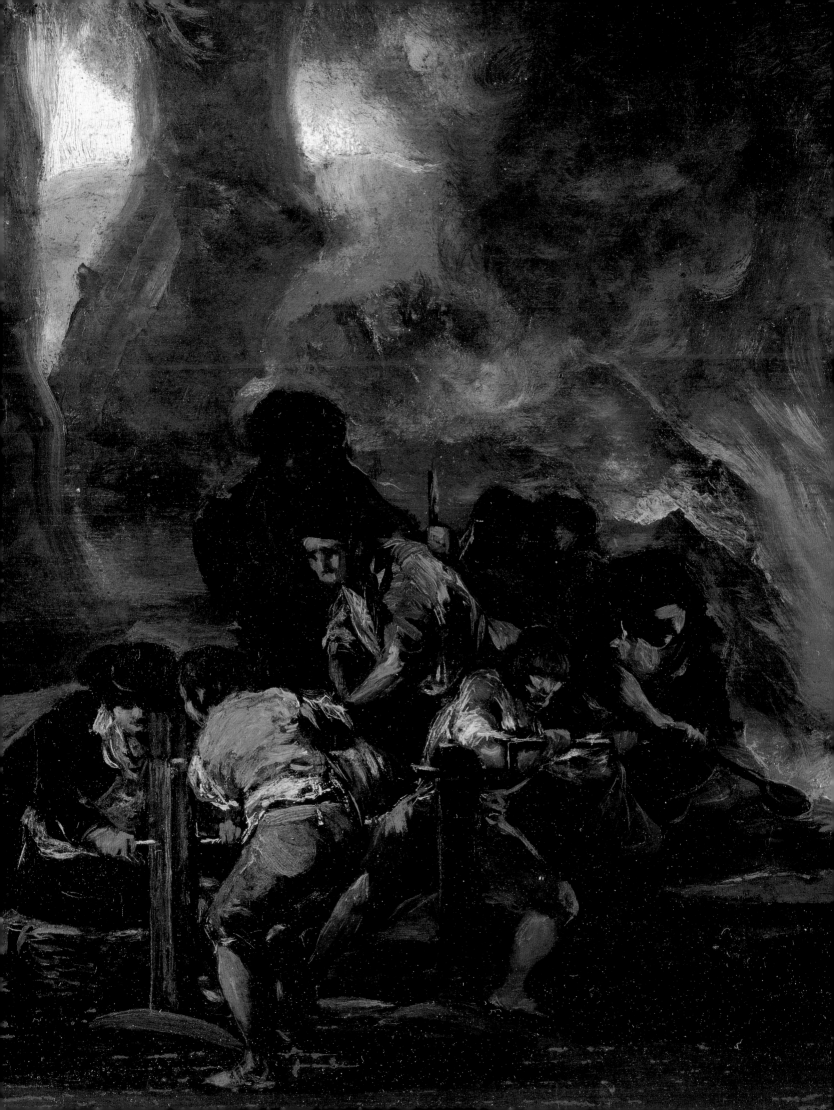

War and Aftermath

1808–1819

*T*he chaotic situation in Spain during the years of the French occupation is reflected in Goya's paintings and the artist's relationship with his official patrons, as well as in the paintings, drawings and prints created to please himself. After the Aranjuez Uprising, the riot in which Godoy was attacked by the populace (see cat. 60) and Carlos IV was obliged to abdicate in favour of the Prince of Asturias, Goya was asked by the Royal Academy of San Fernando to paint a portrait of the new King, Fernando VII; in 1810 the city council commissioned an allegorical picture with a portrait of Joseph Bonaparte that was overpainted, restored and repainted according to the fortunes of the War, and replaced by an inscription '*Constitution*' in 1812 – the period to which another large allegory is related (see cat. 50). In January 1813 Goya informed the city council that 'the allegorical painting is as it was originally, with the portrait of His Majesty [José I], the one which I painted, as when it left my possession'; in 1814 the likeness of Joseph Bonaparte was quickly replaced by that of Fernando VII, and later in the century by the neutral patriotism of the words *'DOS DE MAYO'*, in memory of the heroic uprising of the people of Madrid on 2 May 1808.

In addition to portraits of Joseph Bonaparte (the 'intruder King') and Fernando VII, Goya painted French generals in Napoleon's army, the Duke of Wellington, who led the Spanish patriots to victory, and Palafox, the heroic defender of Saragossa. When the War was over, he also painted his monumental scenes of the *Second of May* and *Third of May 1808*, and at this time if not earlier, the two small scenes connected with the guerillas (cat. 90, 91).

Apart from portraits and the etchings of *The Disasters of War*, Goya's artistic activity during the period 1808–14 is less easy to define. In 1814, during the investigation into the political conduct of all those in royal service under Joseph Bonaparte, one of Goya's friends testified that 'from the entrance of the enemy into this capital he lived shut up in his house and studio, occupied in works of painting and engraving, ceasing to see the majority of the people he formerly dealt with, not only because of the difficulties resulting from his lack of hearing, but much more because of the hatred he professed for the enemy'. His 'hatred for the enemy' was such that he refrained from drawing his salary while the French were in Madrid, 'preferring to sell of his personal treasures rather than serve the said Government', as he himself stated in 1814, and living in the straitened circumstances suggested by the testimony of the Swedish envoy, Count La Gardie, who visited his home the following year.

From the early years of the century until his move to the Quinta on the outskirts of Madrid, in 1819, Goya's activity centred on his own home and studio, where he worked on his series of prints and drawings and the paintings that formed his own collection. Many of these were included in the inventory made in 1812 after the death of his wife (fig. 190), which

Fig. 208 Detail from *Making Shot* (cat. 91)

included the *Knife-grinder* and *Water-carrier* (cat. 92, 93), while other, monumental figure paintings such as the great *Forge* (fig. 14), were no doubt painted after the War. The strength of these works is also found in Goya's few religious paintings from this later period, of which *SS Justa and Rufina* for the magnificent Cathedral sacristy at Seville, together with its preparatory sketch (cat. 94), is a striking example.

The masterpieces of this period are the set of four panels from the Academy of San Fernando. They offer a recapitulation and development of themes that had obsessed Goya since the tinplate pictures of 1793–4 (cat. 32–43) and the prints and drawings of the Madrid Album and *Los Caprichos*, and are a prelude to the Black Paintings that he applied directly to the walls of the Quinta del Sordo (House of the Deaf Man), and to the extraordinary freedom of the last works, painted in Bordeaux.

EVOCATION OF THE WAR OF INDEPENDENCE,
c. 1810–1814

In February 1814 Goya addressed a petition to the Council of the Regency, established the previous month in Madrid, which was headed by Don Luis María de Borbón, the son of his late patron, the Infante Don Luis. In it, the artist expressed 'his burning desire to record for posterity via the paint brush the most outstandng and heroic actions and scenes of our glorious insurrection against the tyrant of Europe'. The Regent gave orders that His Majesty's Court Painter should be enabled to execute this project and that given 'the state of absolute poverty in which he finds himself', he should draw a monthly allowance in addition to the reimbursement of his expenses while working on the paintings. The Order, dated 9 March 1814, was communicated to the Chief Treasurer five days later, and it was probably during the brief period before the return of Fernando VII as absolute monarch in May and the start of the lengthy 'purification' of Court officials that Goya painted his celebrated scenes of the 2nd and 3rd of May 1808, recording the uprising by the people of Madrid in *The Battle against the Mamelukes*, and the subsequent repression in *The Executions on Mount Príncipe Pío* (Museo del Prado, Madrid).

Goya had already 'perpetuated' in etching scenes illustrating the 'fatal consequences of the bloody war in Spain against Buonaparte', that would be published only long after his death as the *Disasters of War* (figs. 201, 202, 205). The earliest prints, for example '*I saw this*' (fig. 202), were made *c*. 1810, and Goya's project to record the resistance of the Spanish people to the hated tyrant was probably inspired by his visit to Saragossa in 1808. On 2 October that year, Goya wrote to the Secretary of the Academy, regretting that he would not be able to be present for the installation of his equestrian portrait of Fernando VII, 'because His Excellency Don Josef Palafox called me to go to Saragossa this week in order to see and examine the ruins of that city, with the intention that I should paint the glories of its inhabitants, something from which I cannot be excused because the glory of my native land interests me so much'. Between the lifting of the first siege in August and the start of the second in December 1808, artists including Fernando Brambila and Juan Galvez recorded the terrible destruction wrought by Napoleon's army, which may already have included the loss of Goya's three altarpieces in the church at Monte Torrero on the outskirts of the city (see cat. 56–8).

Goya was 62 when he travelled across country to Aragon, reportedly arriving in Saragossa at the end of October. During the month before the return of the French army he is said to have painted 'two sketches of the principal ruins, one showing the action of boys dragging French corpses along the calle del Coso during the clash on the 4th of August'. If this is a reliable report, Goya was already planning imaginative, historical works representing 'the most important and heroic actions' of the siege, and giving them the reality of an observed setting. The prints of the *Disasters of War* include a clear reference to the heroism of Agustina of Aragon manning a cannon, in plate 7, and other scenes of devastated landscapes with corpses and wounded soldiers that no doubt reflect what Goya saw on his journeys to and from Saragossa.

The only paintings that apparently illustrate the war against the French in Aragon are two panels showing the *Making of Powder* and *Making of Shot*, identified by inscriptions on paper pasted on the versos as 'factories

established by Don José Mallén in the mountains at Tardienta in Aragon in the years 1811, 1812 and 1813'. Tardienta is in a wild and mountainous area some 50 kilometres to the north of Saragossa, and whether Goya saw such guerilla activities during his visit to Aragon in 1808 or returned there before the end of the War is unknown. From Saragossa he is said to have gone to his birthplace, Fuendetodos, to escape the advancing French army, and it is reported that at some stage, probably after the death of his wife in June 1812, he took it into his head to go to Piedrahita 'with the idea of transferring from there to a free country, and he did not do so because of the requests of his children but because of the notification made to him by order of the Minister of the Police, of the embargo and general confiscation of the property of his entire family if within a fixed term he did not return to this town'.

The identification of José Mallén and his factories reflects a historical reality: Aragon was famous for the quality of its powder from the mid-15th century until well into the 19th, and José Mallén, a shoemaker from Almudévar,

organised a guerilla band and the production of powder and shot in the nearby sierra in 1810. If not witnessed by Goya, these scenes may have caught his imagination through reports or visual evidence. The pictures are painted on very simple, irregular pieces of wood, suggesting the lack of materials available during and immediately after the War, the *Making of Powder* on what looks like cedar wood, perhaps a panel from a door, and the *Making of Shot* on a piece of pine with a coating of light green that may have been on the wood before Goya painted it. Whatever the improvised nature of the supports, the paintings are impressive evocations of the activity of Goya's countrymen in their resistance to the invaders and express 'the hatred which he felt for the enemy, which being his natural way of feeling was increased on the invasion of the Kingdom of Aragon, his native land, whose monumental horror he wished to perpetuate with his brushes', according to the testimony of one of his friends.

In summer landscape settings of great beauty, in which trees and sandy hillocks or distant rocks complement the actions of the

Fig. 209 *Three Gravediggers*,
page 51 of Album F, *c.* 1814–20
brush and iron-gall ink, 20.6 × 14.3 cm
The Metropolitan Museum of Art, New York

figures, groups of men in shirt-sleeves and rope-soled sandals (*alpargatas*) are working with tremendous energy and concentration to prepare the powder and shot for the guerilla fighters. Goya has set out the two scenes as if to provide a practical demonstration of the techniques, and the men's gestures and actions are precisely conveyed, even their expressions are strikingly individualised. In the *Making of Powder*, the men to the left are pounding the mixture of saltpetre, sulphur and carbon to a fine powder in wooden mortars; the sieve in the foreground is for grading the powder, which is then packed into the wooden boxes being handled by the man in white in front of the tree; behind him, a figure in black – perhaps José Mallén – is gesturing in the direction of two men bent under the weight of the boxes as they move off to the right. In the *Making of Shot*, lead is being melted in the blazing hot fire on the right and poured into moulds, from which the shot emerges in a double row. One such row is held by the man on the left, who is about to trim it with a giant pair of shears, and finished piles of shot are neatly stacked before being rounded off by tumbling in the barrel on wooden supports that is being turned by three men in the foreground.

These little scenes are extraordinarily interesting, vivid and varied. Although directly and freely sketched, they are full of precise detail, often drawn with black outlines, and the figures are combined in such a way that their actions and gestures are presented with maximum clarity – like those of the workers in *The Forge*, and the drawing of three men digging (fig. 209) – and at the same time create harmonious compositions full of energetic rhythms that express the urgency of their work. This is contrasted with the peaceful landscape settings where the preparations for the guerilla war are taking place. It is not known when this pair of paintings entered the royal collection, but they may have been painted as a parallel to the large *Second* and *Third of May*, and have been given, or acquired, along with the two commissioned works. They are a splendid homage to Goya's native land and to the courage and loyalty of his countrymen during the war against the French invaders.

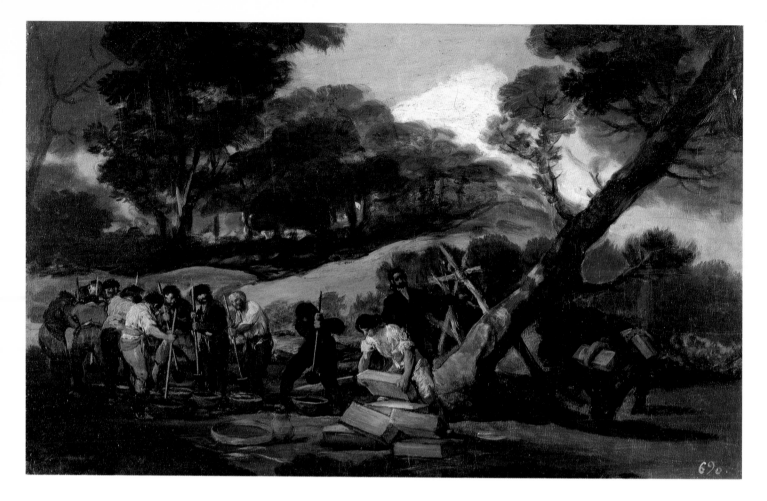

90
Making Powder in the Sierra de Tardienta, c. 1810–14
panel, 32.9 × 52.2 cm
Palace of La Zarzuela, Patrimonio Nacional, Madrid

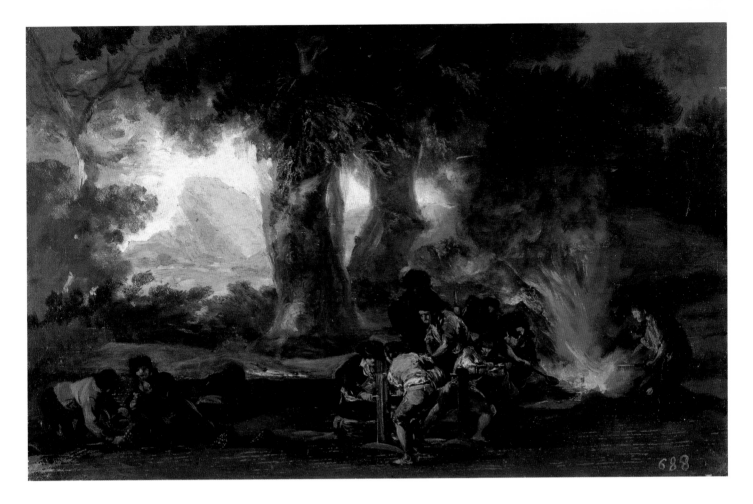

91
Making Shot in the Sierra de Tardienta, c. 1810–14
panel, 33.1 × 51.5 cm
Palace of La Zarzuela, Patrimonio Nacional, Madrid

NATIONAL ALLEGORIES, *c.* 1808–1812

These paintings have always been celebrated for their 'heroic' presentation of the two figures, much smaller than life-size, but monumental and impressive in their effect. They were no doubt painted before 1812, since they are almost certainly identifiable as item 13 in the inventory of paintings in Goya's home drawn up in that year: 'a watercarrier and its companion with the number thirteen at... 300', a valuation that at 150 *reales* each, sets them on the level immediately below the two major paintings of *Majas on a Balcony* (private collection) and *Maja and Celestina* (Bartolomé March Collection, Madrid), valued at 200 *reales* each. Goya evidently prized them highly, and apart from their artistic quality a recent study of the paintings suggests the reason why. They have been convincingly identified not just as representations of particular trades, of the kind illustrated in popular prints, nor as celebrations of working men and women in a 'democratic tradition' of 19th-century realism that anticipates the themes and style of Daumier and Courbet. They are now seen as paintings that combine references to a specific historical moment with a more general symbolic theme, and as a further homage by the Aragonese artist to his countrymen in their heroic struggle against Napoleon's invading army.

During the sieges of Saragossa, both men and women citizens showed extraordinary courage, defending themselves in hand-to-hand fighting with knives, following General Palafox's cry of 'war and the knife' in response to the first French attack. The prints that introduce the *Disasters of War*, which include the image of Agustina of Aragon manning a cannon, show ordinary men and women fighting desperately with lances, rocks and, above all, with knives and jack-knives against the well-armed French. The role of the women is exalted in plate 4, '*Women give courage*', and plate 5, '*And they are like wild beasts*', showing a mother with a baby under her arm, lunging at a soldier and mortally wounding him with a lance. From an active, terrified victim in a scene from the earlier Romana series (cat. 81), the woman here turns the tables on the brutal enemy, while a companion lies wounded with a knife still grasped in her hand.

The knife-grinder was therefore a figure of great significance in the struggle against the French, and Goya represents him bent over his wheel, with the thin stream of water pouring onto its surface and the heat of its friction suggested by touches of red glowing near the hub and right edge. Water-carriers also played an essential role during the siege, bringing refreshments and encouragement to the men in their defended positions, and the way in which both figures were painted by Goya appears to indicate an intensely emotional response to their patriotic symbolism. In both there is a sense of energy and purpose that suggests still deeper layers of meaning, and it cannot be fortuitous that the pose in the *Knife-grinder* is foreshadowed on one of the most beautiful pages of the Italian Notebook. Goya seems to have adapted the energetic but shattered trunk of the Belvedere Torso for his knife-grinder (fig. 66, 210), combining it with the celebrated Antique *Knife-grinder* (fig. 211), with which there is a striking resemblance in the concentrated expression of the two heads.

Goya's knife-grinder works alone at his wheel, against a blank background that gives no suggestion of a setting but creates a sense of the urgent repetition of his gestures and of imminent danger lurking in the shadows. The

Fig. 210 *Belvedere Torso*, Roman copy, 1st century AD, of a Greek original Vatican Museums, Rome

Fig. 211 *The Knife-grinder*, Roman copy of a Greek original Uffizi Gallery, Florence

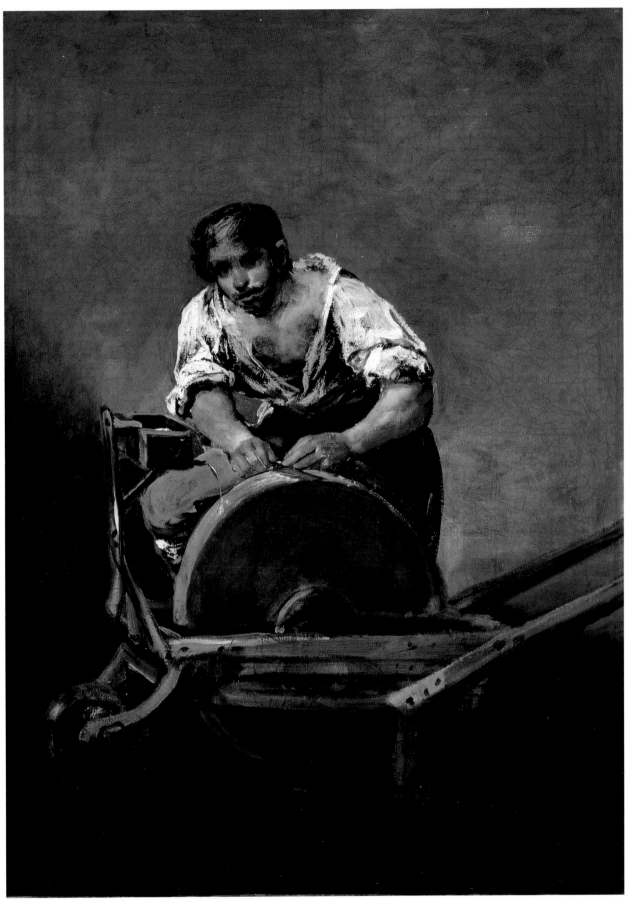

92 *The Knife-grinder*, c. 1808–12
oil on canvas, 68 × 50.5 cm
Szépmüvészeti Múzeum, Budapest

Fig. 212 *The Egg-vendor*,
page 12 of Album C, *c.* 1808–14
brush and indian ink, 20.5 × 13.8 cm
Museo del Prado, Madrid

Fig. 213 '*A pity you aren't interested in something else*',
page 78 of Album C, *c.* 1808–14
brush and iron-gall ink, 20.3 × 14 cm
J. Paul Getty Museum, Malibu

water-carrier also suggests an Antique proto-type, standing like some guardian nymph with her life-giving water. She is set against a dark landscape through which she has evidently walked unafraid, like the *Egg-vendor* (fig. 212), in a splendid drawing, marching across country and pointing straight ahead, unmindful of the men lurking behind rocks on either side of the way. This wash drawing, from the powerful series in the so-called Album C, appears as the antithesis of one on a later page that shows another water-carrier, where Goya's ironic comment suggests a link with the seductive girls in the early tapestry cartoon sketch (cat. 30), rather than with his heroine of the Saragossa siege (fig. 213). Despite her small scale, the *Water-carrier* is a monumental figure intended to be seen from below. As in the early *St Barbara* (cat. 6), a glimpse of the underside of her skirt increases the sense of heroic elevation, as she gazes down at the viewer, and it is not impossible that Goya may have painted both pictures as overdoors for his home in the calle de Valverde. That they were intended for his own collection is suggested by the fact that both make use of previously painted canvases and are executed with a marvellously rough, sketchy finish that is most effective from a certain distance. When Goya, on his return from Saragossa, began to meditate on his series of etchings and to search for an adequate artistic expression of his countrymen's courage, he found it in a fusion of the vivid reality of his recent experience with the timeless images of the Antique world.

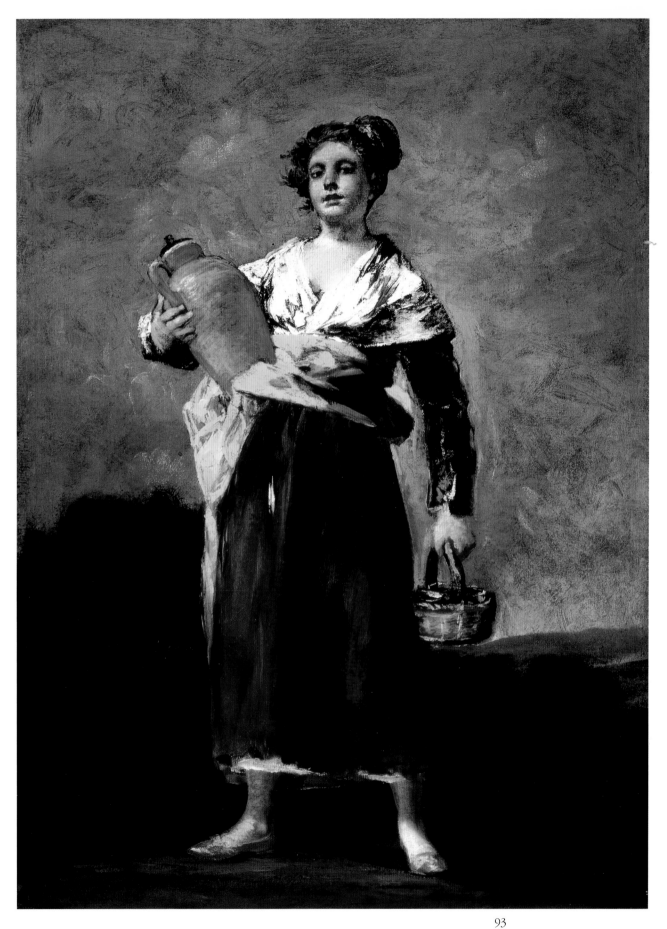

93
The Water-carrier, c. 1808–12
oil on canvas, 68 × 52 cm
Szépmüvészeti Múzeum, Budapest

SACRISTY OF SEVILLE CATHEDRAL, 1817

In September 1817, the eminent art historian Don Juan Agustín Ceán Bermúdez wrote to his friend Tomás de Véri in Mallorca, 'I am currently very busy inspiring Goya: decorum, modesty, devotion, a respectable action, a worthy simple composition containing religious attitudes for a large canvas which the Chapter of Seville Cathedral has requested from me for its Holy Church. . . . The subject is the two martyred saints Justa and Rufina . . . who by their caring devout attitudes and the feelings derived from the virtues they possessed, move people to devotion and to a desire to pray to them, which is the object these pictures should address. You know Goya well enough and will be aware how much effort it took me to inspire such ideas in him, which are so opposed to his character. I gave him instructions in writing in order for him to paint the picture, I made him do three or four sketches, and finally, he is drafting the picture which I hope will end up to my taste.'

Of the 'three or four sketches' for *SS Justa and Rufina*, just one has survived, no doubt the last one, since it is very close to the final composition (fig. 214). In 1817, Goya had turned 70, and Ceán's admonitions and written instructions, and his comments on Goya's character, provide a vivid evocation of his impetuous old friend. The altarpiece was to fill a magnificent Plateresque stone 'frame' in the Sacristy known as 'los Cálices' (fig. 215), and in a celebrated published *Analysis* of Goya's painting, produced to coincide with the work's presentation in the Cathedral, Ceán referred to Goya's careful study of the setting, which it is clear that the artist responded to with intelligence, using the light from the window high on the right wall to enhance the radiance shining down onto the saints.

In the powerful small sketch for the large altarpiece the saints are less harmoniously disposed, and pentimenti, including the shifting of the Giralda tower from the left side to the right, reveal Goya's attention to what Ceán referred to as 'the careful study which must be made in order to achieve exactitude in the outlines', praising the 'gracious proportions and stately attitudes of the two figures' in the altarpiece. He also pointed out, in his much ridiculed but very effective analysis, the similarities with the forms used by Guido Reni, in which a perfect balance was achieved between those drawn from 'ordinary nature and those from Antiquity', and which are illustrated in Goya's beautiful contemporary drawing of the barefoot figure of *Philosophy* (fig. 216).

Fig. 215 Interior view of the sacristy de los Cáliches, Seville Cathedral

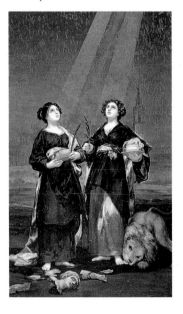

Fig. 214 *SS Justa and Rufina*, 1817 oil on canvas, 309 × 177 cm Sacristy of Seville Cathedral

Fig. 216 *Allegory of Philosophy*, page 28 of Album C, *c.* 1814–17 brush and indian ink, 26.5 × 18.4 cm Private Collection

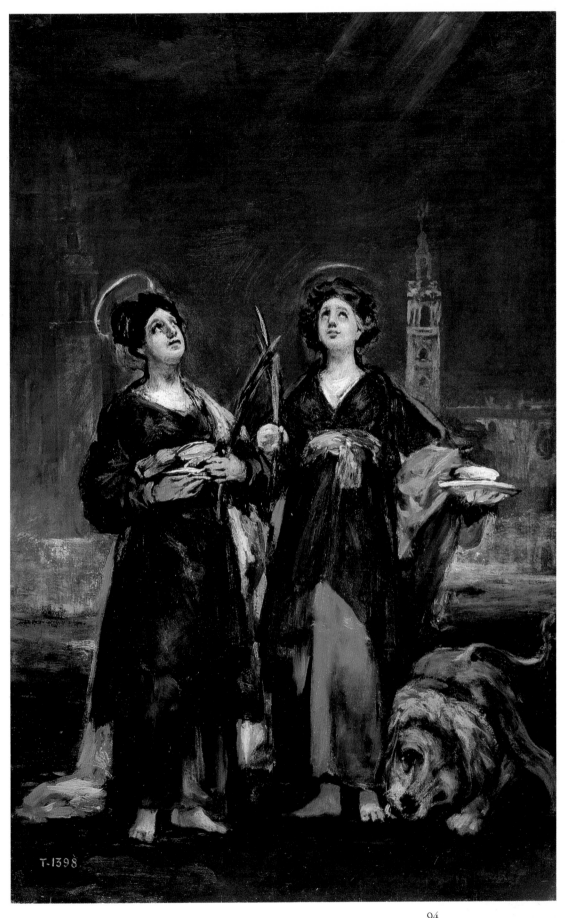

T-1398

94
SS Justa and Rufina, 1817
oil on panel, 45.3 × 30 cm
Museo del Prado, Madrid

FOUR 'CAPRICHOS' IN THE ROYAL ACADEMY OF SAN FERNANDO, *c.* 1815–1819

These four panels, whose celebrity has attained almost mythic proportions, were undoubtedly painted as a series, to be contemplated and considered as a set of *caprichos*. They were bequeathed to the Royal Academy of San Fernando in 1836, less than ten years after Goya's death, accompanied by the no less celebrated *Burial of the Sardine* (whose technical characteristics are distinct from those of the four landscape format panels, and which is not a part of the set). The paintings belonged to Don Manuel García de la Prada, a wealthy businessman whose portrait Goya painted between 1805 and 1810; a French sympathiser (*afrancesado*), like many of Goya's friends, he was Chief Magistrate of the City of Madrid under the Government of occupation, and went into exile on the return of Fernando VII. His pictures went to the Academy after his death in 1839, but it is not known when or from whom he acquired them.

The generally sombre mood and broad technique of the panels suggest that they were painted after the return of Fernando VII, during the period of repression that began, for Goya, with his 'purification' process as a salaried employee of the Court. From November 1814 until April of the following year, he waited to hear whether the testimony of his friends would suffice to clear his name. In the end, he and his son, a royal 'pensioner', thanks to his father's gift of the *Caprichos* plates to Carlos IV in 1803, emerged unscathed in the 'first class', among those whose conduct had not been compromised in any way by their service under the 'intruder King', and whose salaries and pensions were therefore not at risk. It must have been a period of great anxiety for Goya, quite apart from the bitter disillusionment that followed the expulsion of the French and the brief liberal interlude during the Regency in Madrid, which enabled him to paint his great 'scenes of our glorious uprising against the tyrant of Europe'. Now another tyrant was on the throne of Spain, and it must have seemed to Goya that his country had regressed into the Dark Ages.

After the purposeful energy of his paintings of the guerrillas (cat. 90, 91) and the monumental tributes to the events of the 2nd and 3rd of May 1808, the four San Fernando panels represent a return to the subjects that had haunted Goya over twenty years earlier, when he was emerging from the nearly mortal illness that deprived him of his hearing (cat. 32–43). The themes include a bullfight and a madhouse, and two scenes of 'religious practices' in darker tonalities – one showing a procession, the other a trial by the Inquisition. The *Bullfight* is the least threatening of the four scenes, and the easiest to 'read' in terms of its form and content. One of its most remarkable aspects is the freedom of its technique, and comparison with the tinplate paintings of bulls of 1793 (cat. 32–7) affords striking evidence of the distance travelled by Goya in the intervening years.

Fig. 217 *The Celebrated Fernando del Toro, picador* drawing for pl. 27 of *The Tauromaquia*, 1815–16 sanguine wash over red crayon, 18.7 × 31.7 cm Museo del Prado, Madrid

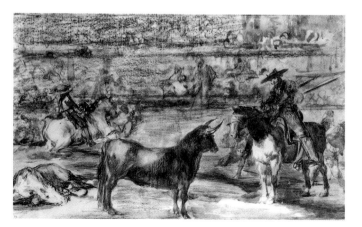

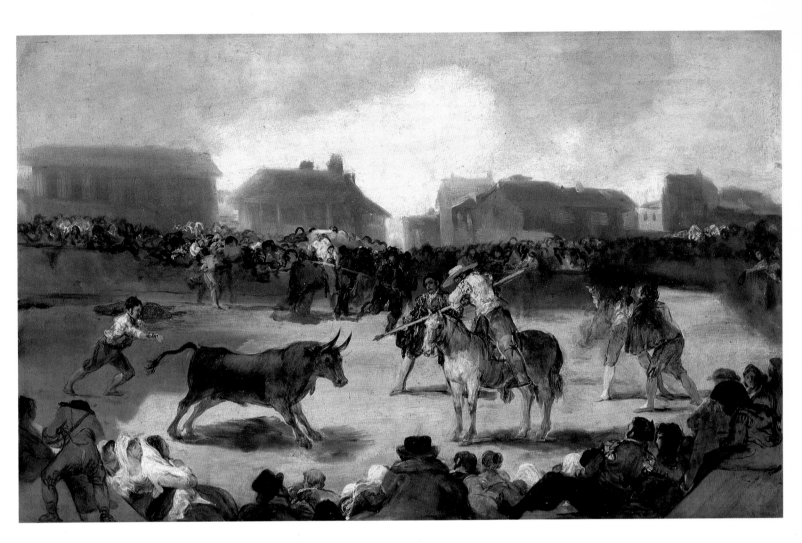

95
Bullfight in a Village, c. 1815–19
oil on panel, 45 × 72 cm
Museo de la Real Academia de Bellas Artes
de San Fernando, Madrid

In October and December 1816 the publication of Goya's *Tauromaquia* prints was announced. He had been working on these bullfighting etchings for at least a year, since the earliest plates are dated 1815, and the painting of a *Bullfight* (cat. 95) is closely related to the prints and their preparatory drawings, particularly those with sanguine wash over red crayon (fig. 217). The panel is worked with thin, transparent washes of diluted oil paint brushed over the reddish ground which is apparent all over the surface and is seen unpainted in many areas and along the edges of the panel. The almost mono-chrome composition, in which the crowd and bullfighters are freely drawn in black, is enlivened by vivid touches of colour or white accents that pull the eye across the picture surface, while the two figures on the right are painted with the thinnest washes of carmine and blue (see fig. 58). The scene takes place in an improvised village bullring, with the crowd packed behind barriers that lead towards the softly brushed houses in the distance. The foreground figures, including women with babies, are sitting on rows of seats that form a semicircular, cradling movement similar to that first encountered in the *Meadow of San Isidro* (cat. 26). All the figures are individu-alised, even those seen from the back, like the broad silhouette of the man in a hat below the horse's head, who acts as a repoussoir and central 'marker' for the whole composition. Only on the extreme right is this 'backs to the spectator' emphasis broken, by a figure who looks directly out at the viewer.

This village entertainment is connected with another street spectacle, the *Procession of Flagellants* (cat. 96), where the images of the Virgin of Solitude, of an *Ecce Homo* and the Crucifixion are carried from the church in the background, preceded by the flagellants wear-ing head-covers (*capilotes*) and conical hats (*corozas*) in the centre, and penitents moving away to the right, bowed under the weight of great crosses and timbers. The procession is

accompanied by black-robed, trumpeting penitents, and women kneel in the foreground as the images pass by, while a great crowd in the background presses forward for a view, the faces astonishingly individualised as they recede into the distance. The amount of information packed into the scene is remark-able when the breadth of Goya's handling is taken into account. He has managed to com-bine a detailed rendering of the naked torsos, of the figures receding into the distance on the right and of the nearer heads in the crowd, with a very sketchy definition of the crowd in the distance and an almost abstract patterning of light and shade on the ground, applying the changing tonalities in patches that vibrate among the figures and on the ground. In 1796 or 1797 Goya made a drawing in the Madrid Album, titling it 'Masquerades of Holy Week in the year 94'. It shows a flagellant with penitents in black, but although the repetition of the theme is no doubt significant, neither the early

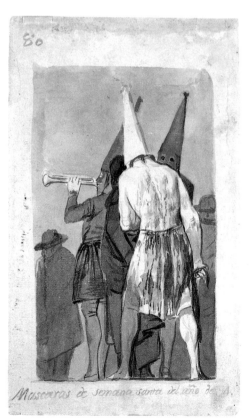

Fig. 218 '*Masquers in the Holy Week of the Year '94*', page 80 of the Madrid Album, 1796–7 brush and indian ink, 23.2 × 14.1 cm The Norton Simon Foundation, Pasadena, California

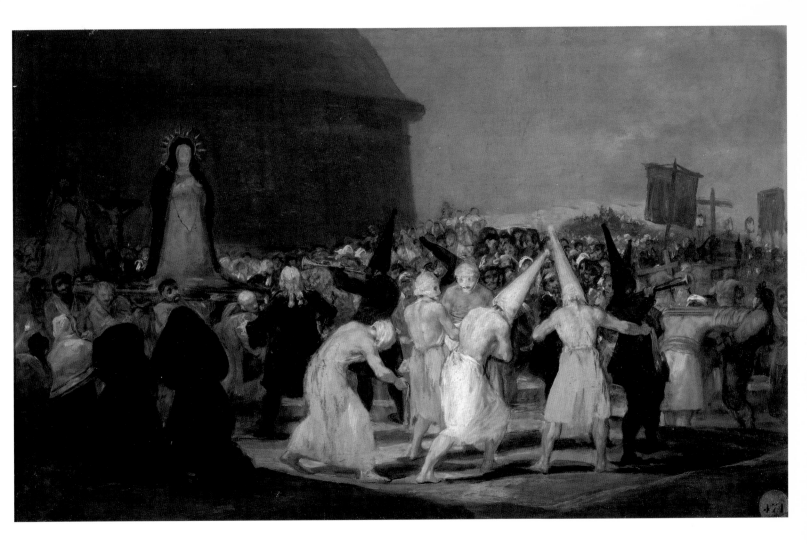

96
Procession of Flagellants, c. 1815–19
oil on panel, 46 × 73 cm
Museo de la Real Academia de Bellas Artes
de San Fernando, Madrid

drawing nor the much later painting reveal Goya's attitude to these religious traditions.

The same is not true of the '*Auto de fe' of the Inquisition* (cat. 97), a theme on which Goya had meditated in the prints of the *Caprichos* and their preparatory drawings (fig. 219) and which he indicted in a series of drawings in Album C (fig. 220). The isolation and helplessness of the prisoner on the platform, and the mindless mouthing of the sentence, are given their ultimate expression in the panel, which shows the scene taking place in a vast hall, columned and vaulted, before an assembled throng of prelates and members of religious orders. The composition is so devised that the eye is led from figure to figure and from group to group: from the bored Chief Magistrate who witnesses the scene on the left, past the gross abbot behind the platform, to the wretched victim whose *coroza* points towards the reader of the sentence; this figure, silhouetted with his book and a flaming torch against the central pillar, is placed directly above the sinister man in black with a gold pectoral cross, who is evidently the Inquisitor in charge of the trial. In a brilliant demonstration of his understanding of body language, Goya shows him with one hand outstretched on the arm of his chair, turning, but without turning his head, to the stilled figure beside him. The Inquisitor is linked, through the gesture of his hand, to the three abject and terrified prisoners sitting together in the foreground. The rising flames on their *corozas* make it clear that they have been condemned to death at the stake.

Goya's own experience of the Holy Office no doubt reinforced his hatred of its workings. Even before the notification of the favourable outcome of his purification in April 1815, another threat had emerged, this time from the Inquisition. In March 1815, the Director-General for Seizures wrote to the Fiscal Inquisitor of the Holy Office to inform him that he held in the Depósito General de Secuestros pictures of a '*desnuda*' and a '*mujer vestida de maja*', both by Goya, to which the Fiscal Inquisitor responded with the chilling declaration that 'having to proceed against painters in

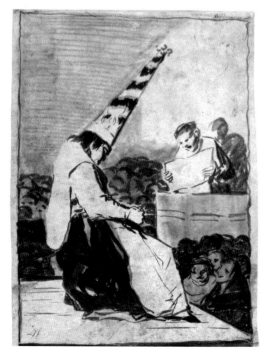

Fig. 219 *Aquellos polvos*, a sketch for an unpublished print of *Los Caprichos*, 1797–8 sanguine wash over red crayon, 20 × 14.6 cm Museo del Prado, Madrid

Fig. 220 '*For carrying tall stories from the Devils of Bayona*', page 86 of Album C, *c.* 1808–14 brush and iron-gall, 20.5 × 14 cm Museo del Prado, Madrid

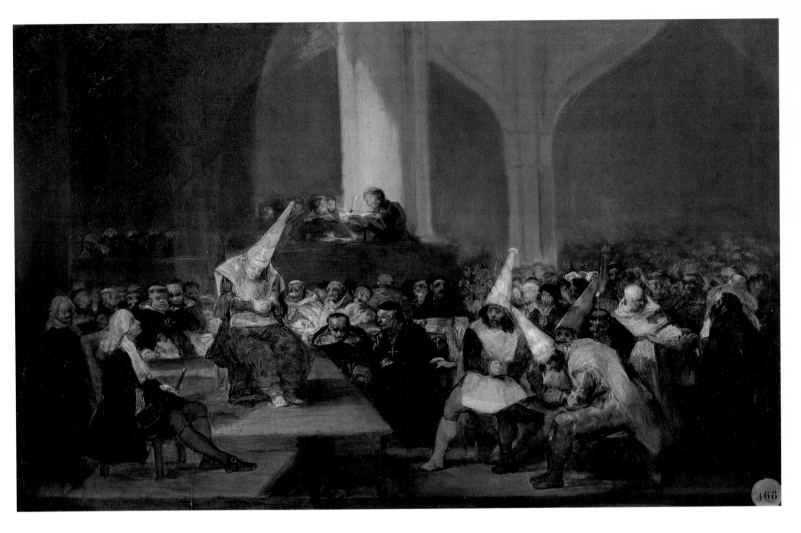

97
'Auto de fe' of the Inquisition, c. 1815–19
oil on panel, 46 × 73 cm
Museo de la Real Academia de Bellas Artes
de San Fernando, Madrid

accordance with rule 11 of the expurgation procedure and given that Don Francisco de Goya is the author of two of the works which have been picked up…one of them represents a naked woman on a bed,…and the other a woman dressed as a *maja* on a bed, it is of the opinion that the said Goya be ordered to appear before this tribunal in order to identify them and state whether they are his work, for what reason he did them, at whose request and what intention guided him'. It is not known to whom this letter, signed by Dr Zorrilla de Velasco of the Secret Chamber of the Court Inquisition, was addressed, or whether Goya was ever required to appear before the Tribunal. The affair was probably suppressed, but a decade later in France he recalled his problems with the Holy Office, not on account of the *Majas* but over publication of his *Caprichos*, telling his friend Joaquín Ferrer that he had given the plates to the King 'and in spite of all that they denounced me to the Holy Office [of the Inquisition]'.

Where the *Auto de fe* offers open criticism of a cruel institution, the *Madhouse* (cat. 98) is an allegory of universal folly embracing the rulers of the world – a king with his sceptre, a pope with his tiara (blessing the spectator), a military commander and a savage chief, a cuckold and a would-be murderer, with other figures representing every kind of folly and vice. As the *Yard with Lunatics* of 1793–4 (cat. 43) suggests, folly in all its forms was a recurring theme in Goya's art, especially in his drawings, where he ironised on those who considered themselves more civilised or wiser than others (fig. 221, 222). The *Madhouse*, some fifteen to twenty years on from the *Yard with Lunatics* and the *Plague Hospital* (cat. 80), demonstrates Goya's ability in his later works to do away with finish and careful draughtsmanship, with pictorial 'effects' other than the direct expression, through the most summary but consummate means, of his dramatic scenes and visions. There are no details, no precisely drawn hands or finely

modelled and outlined figures, and the touch is broader – his eyesight was by now failing; but the impression of fear, suffering, ecstasy and madness, or the energy of figures advancing, commanding, threatening or confronting is achieved through a magisterial, improvised manipulation of paint and the construction of compositions in terms of light and shade and a rigorous but constantly changing internal geometry. In 1819 Goya withdrew to the Quinta across the River and began to paint his visions on the walls of his own home.

Fig. 221 '*These people believe in omens*',
page 33 of Album C,
c. 1808–14
brush and indian ink,
20.5 × 14.1 cm
Museo del Prado, Madrid

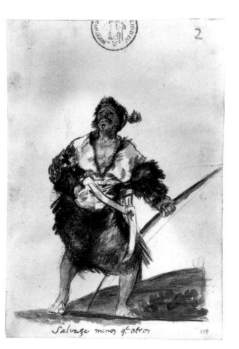

Fig. 222 '*Less savage than others*',
page 2 of Album C,
c. 1808–14
brush and indian ink
Museo del Prado, Madrid

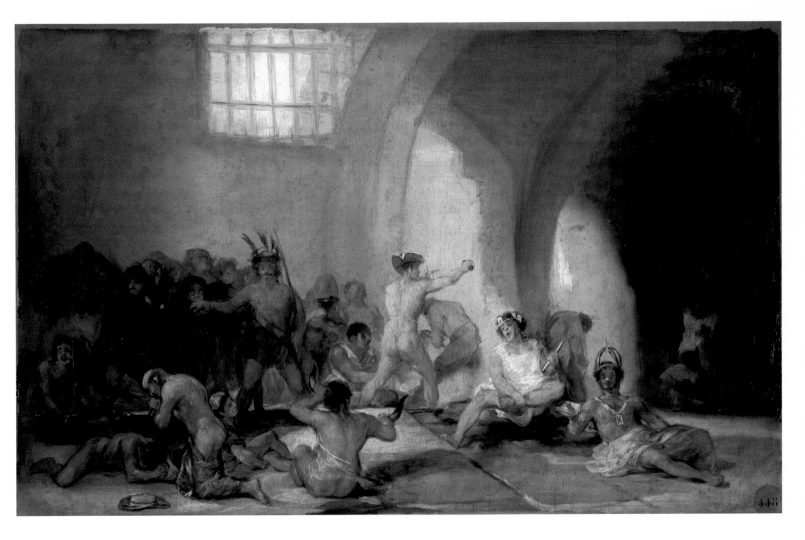

98
The Madhouse, c. 1815–19
oil on panel, 45 × 72 cm
Museo de la Real Academia de Bellas Artes
de San Fernando, Madrid

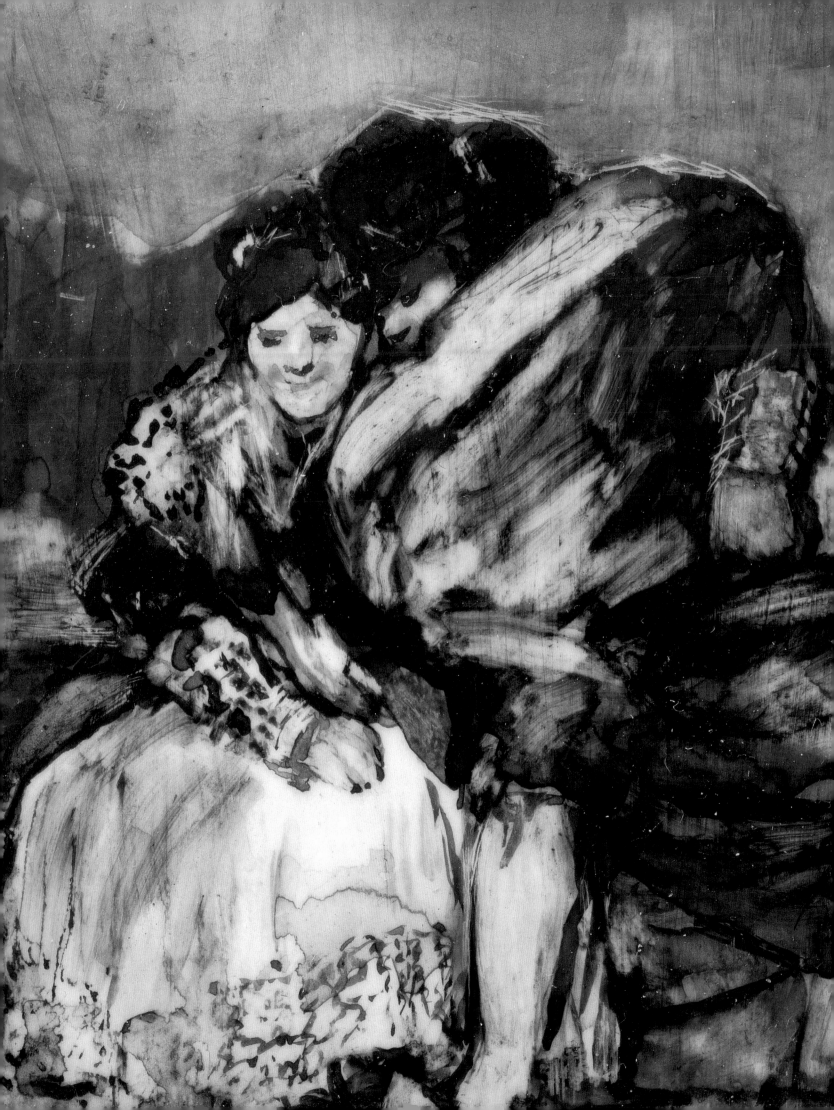

Exile in France

1824–1828

*O*n a symbolic day in 1824 Goya addressed a letter to the King: 'Sir: Don Francisco Goya, Court Painter of His Majesty, with due respect states that his medical advisers have counselled him to take the mineral waters at Plombières in order to diminish the illness and attacks which trouble him at his advanced age; for which reason he begs Your Majesty to grant him royal leave of six months, with full payment of his wages, in order to follow the advice given. Madrid, 2 May 1824.'

This was the start of Goya's withdrawal from the intolerably repressive Spain of Fernando VII to a 'free country', to which he had, in fact, first planned to escape during the French occupation. He had prepared his departure in February of 1824 by legally empowering a representative to collect the salary due to him as Court Painter, and on 30 May the King signed the leave of absence. The movements of émigrés were closely controlled in France, and on 24 June Goya passed through Bayonne, where his passport was exchanged for a temporary visa allowing him to visit Paris 'for consultation with doctors'. But his real goal was Bordeaux, where his old friend Leandro Fernández de Moratín and other exiles from Spain were living, and except for a visit to Paris it was there that he remained until his death.

Thanks to the correspondence of Moratín with Juan Antonio Melón, and of Goya with his son in Madrid, as well as the curious police reports on Goya's activities in Paris, a vivid picture emerges of a stubborn and lively old artist. Of Goya's arrival in Bordeaux, Moratín reported that 'Goya, in fact, arrived deaf, old, clumsy and weak, and without knowing a word of French, and without bringing a servant (which no one needs more than he does), and so happy and wanting to experience life'. He

stayed only three days before setting out again for Paris, where he arrived on 30 June, staying with a relation of his daughter-in-law at 5 rue Marivaux, in the hôtel Favart. The Chief of Police reported to the French Ministry of the Interior that Goya appeared not to mix with his compatriots, that 'he never receives anyone at home' and 'only goes out to visit the monuments and to walk in the public places'. However, Goya must have spent time with Don Joaquín María Ferrer and his wife, painting their portraits and a final *Bullfight* (cat. 112) before returning to Bordeaux with Don Martín Miguel de Goicoechea and members of his family (see cat. 67–73). There he set up home with Doña Leocadia Zorrilla, another relative of his daughter-in-law, with whom he had been living in Spain, and whose daughter Rosario was probably Goya's child.

Moratín reported in September that the artist was installed in good furnished lodgings, adding ten days later 'Goya is here with his Doña Leocadia; I don't notice a great deal of harmony between them'. He spent the winter months painting miniatures on ivory (cat. 99–111), and the following year turned to lithography, producing a number of masterpieces in an extraordinarily original style (cat. 113–18). He continued to work, and Moratín commented in June 1825 that Goya 'is very puffed up and paints like a man possessed without ever wanting to correct anything of what he paints'. And so he went on to the end, painting and, above all, drawing in his final years, recapturing old obsessions and exploring new themes. In one of the last of Moratín's affectionate letters about the artist he noted that 'Goya is well, he amuses himself with sketching, he takes walks, eats, takes a siesta; I think his house is peaceful now'.

Fig. 223 Detail from *A Seated Majo and Maja* (cat. 106)

MINIATURES ON IVORY, 1824–1825

On 20 December 1825 Goya wrote to his friend Joaquín María Ferrer, who had apparently responded negatively to the idea of selling Goya's lithographs in Paris (cat. 115–18) and who had asked whether a new edition of the *Caprichos* could be published. Goya's answer was that this was impossible because the plates had been given to the King more than twenty years before and were in the Royal Chalcography, 'and in spite of all that they denounced me to the Holy Office. Nor would I copy them because I have better things to do nowadays than selling them more effectively. It is true that last winter I painted on ivory and I have a collection of nearly forty exercises, but they are original miniatures which I have never seen the like of before because the whole is made up of points and things which look more like Velázquez's brushwork than that of Men[g]s. You should thank me for these few bad words because I have neither eyesight, pulse, pen or ink, I lack everything and the only thing I have in excess is will-power'.

Apart from the allusion to a large group of miniatures in Goya's letter, there is also a detailed, contemporary description of the way in which he made them. It is contained in the earliest account of Goya's life, written by Laurent Matheron and published in Bordeaux and Paris in 1857 and 1858. Matheron's biography is a highly coloured, romantic tale, until he reaches the final period in France, when his information was based on the first-hand accounts of a young Spanish artist living in Bordeaux, Antonio Brugada. He was an artist who chose to leave Spain in 1823 and he became very close to Goya in his last years. Brugada was clearly fascinated by the old artist's inventiveness and complete mastery of new media, and he gave Matheron detailed technical information and acute aesthetic com-

mentaries on the way Goya worked and the effects he obtained. On the basis of Brugada's explanations, Matheron left the following account of Goya's miniatures:

'His miniatures bore no resemblance to fine Italian miniatures, nor even to those by Isabey.... Goya had never been able to imitate anyone, and he was too old to begin. He blackened the ivory plaque and let fall on it a drop of water which removed part of the black ground as it spread out, tracing random light areas. Goya took advantage of these traces and always turned them into something original and unexpected. These little works were still in the vein of the *Caprichos*; today they would be very much sought after, if the dear man had not wiped off many of them in order to economise on the ivory. Those that remained at his death were, I believe, taken to Madrid by his son.'

Of Goya's 'collection of nearly forty' experimental works in miniature painting on ivory, only a dozen or so are currently located, while another six are known from reproductions. The thin slivers of ivory vary in size from about 5 × 5 cm to 9 × 8.5 cm, and the larger ones tend to be irregular in shape. As far as can be judged from such a small sample, they show a development from more detailed figures, whose heads and hands are clearly defined (cat. 99–102), to broadly brushed forms 'which look more like Velázquez's brushwork than that of Mengs'. As described by Matheron, Goya worked his miniatures from dark to light, lifting off or lightening areas of the lamp-black. He also used a graffiti technique that can be seen in some of his paintings (cat. 64), with free but marvellously precise scratching that uses the translucent white surface of the ivory to add highlights, accent features and give form to the figures, as in the skirts of the *Woman with her Clothes Blowing in the Wind*

Fig. 224 '*A bad night*', pl. 33 of *Los Caprichos*, 1797–8
etching and aquatint, 21.8 × 15.2 cm
Museo del Prado, Madrid

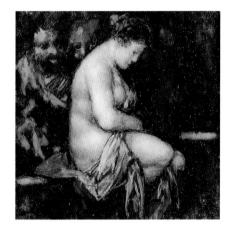

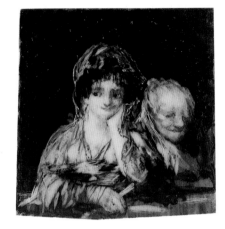

99
Susanna and the Elders, 1824–5
carbon black and watercolour on
ivory, 5.5 × 5.5 cm
S. Sebba Collection

100
Maja and a Celestina, 1824–5
carbon black and watercolour on
ivory, 5.4 × 5.4 cm
Stanley Moss Collection,
Riverdale-on-Hudson, New York

(cat. 105) or over the *majo*'s head and shoulder and on his sleeve in the *Seated Majo and Maja* (cat. 106). Scratching or wiping techniques also created astonishing effects of white eyeballs and teeth (cat. 103, 108). The miniatures are also coloured with watercolour used in thin, transparent washes or more heavily applied, usually blue or red, but sometimes green or yellow. Goya made use of the dark contours that built up at the edges of a patch of watercolour, or added small touches of colour like the green of the leeks (cat. 103) or the red on the *maja*'s cheeks (cat. 106). In one, he uses graphite to 'scribble' the effect of the little dog's fur (cat. 111). And almost always the designs are accented and 'drawn' with black lines that define the forms or create lines of force, adding rhythm and volume, atmosphere and mystery to these extraordinary little works. They are clearly related to Goya's drawings and lithographs of these years, and also to the Black Paintings in his abandoned Quinta (fig. 15), and the artist returns again in them to all his earlier themes, seen in the images of *Los Caprichos* (fig. 19–23, 224) and in the first pictures in which he combined realism and fantasy in his own uniquely original and inventive way (cat. 38–43).

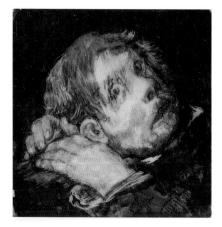

101
Head of a Man, 1824–5
carbon black and watercolour
on ivory, 5.5 × 5.5 cm
Stanley Moss Collection,
Riverdale-on-Hudson, New York

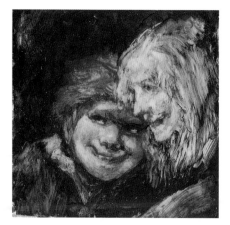

102
*Heads of a Child and an Old
Woman*, 1824–5
carbon black and watercolour
on ivory, 5.5 × 5.5 cm
Stanley Moss Collection,
Riverdale-on-Hudson

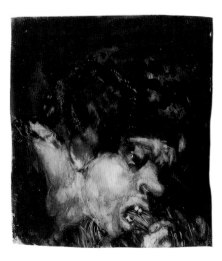

103
Man Eating Leeks, 1824–5
carbon black and watercolour
on ivory, 6.2 × 5.6 cm
Kupferstich-Kabinett, Dresden

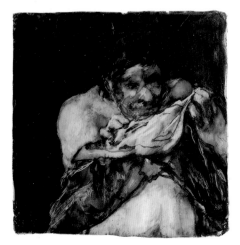

104
Man Looking for Fleas in his Shirt,
1824–5
carbon black and watercolour
on ivory, 6 × 5.9 cm
Museum of Fine Arts, Boston,
M.M. Karolik Fund

105
*Woman with her Clothes
Blowing in the Wind*, 1824–5
carbon black and watercolour
on ivory, 9 × 9.5 cm
Private Collection

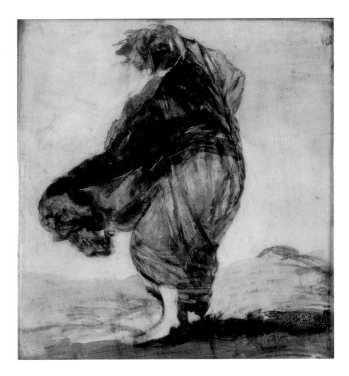

106
A Seated Majo and Maja,
1824–5
carbon black and watercolour
on ivory, 9 × 8.5 cm
Nationalmuseum, Stockholm

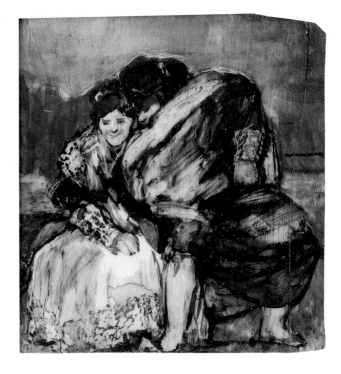

107
*Two Children Looking at a
Book*, 1824–5
carbon black and watercolour
on ivory, 5.2 × 5.3 cm
Museum of Art, Rhode Island
School of Design, Providence, Rhode Island,
Gift of Mrs Gustave Radeke

108
*Monk Talking to an Old
Woman*, 1824–5
carbon black and watercolour
on ivory, 5.7 × 5.4 cm
Princeton University Art Museum,
Princeton, New Jersey,
Fowler McCormick Fund

109
Boy Frightened by a Man,
1824–5
carbon black and watercolour
on ivory, 5.9 × 6 cm
Museum of Fine Arts, Boston,
Gift of Eleanor A. Sayre

110
*Young Woman, Half-naked,
Leaning against a Rock*, 1824–5

carbon black and watercolour
on ivory, 8.8 × 8.6 cm
Museum of Fine Arts, Boston,
Ernest Wadworth Longfellow Fund

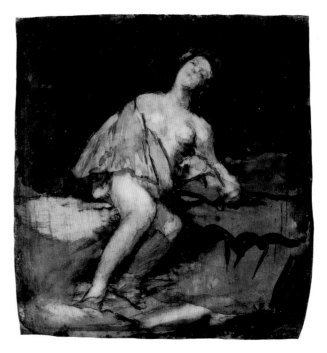

111
*Man Picking Fleas from a Little
Dog*, 1824–5

carbon black, watercolour and
graphite on ivory, 8.9 × 8.5 cm
Kupferstich-Kabinett, Dresden

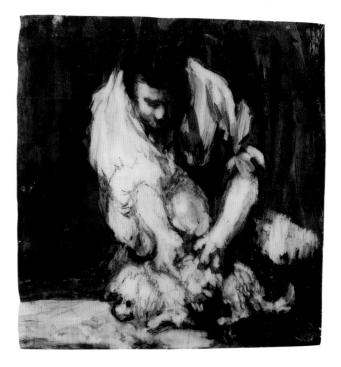

BULLFIGHT, 1824

This celebrated work has emerged like a ghost from the past, having remained virtually unseen between its first exhibition in Madrid in 1900 and its reappearance 90 years later and subsequent acquisition by the J. Paul Getty Museum. This is therefore its first major public appearance, and an initial opportunity to study the painting in context. The inscription added by Joaquín María Ferrer on the back of the original canvas recorded that it was 'Painted in Paris in July 1824 by Don Francisco Goya'. This means that it was painted at the same time as the portraits of Ferrer and his wife, when Goya was staying in Paris in the summer of 1824. He arrived there on 30 June and was back in Bordeaux by 20 September, and there appears to be no reason to doubt the accuracy of Ferrer's inscription, stating that the *Bullfight* was executed in July. There is no record of where Goya actually painted the Ferrer portraits and the bullfight picture – whether Ferrer and his wife came to the hôtel Favart where he was staying – or whether he made any other paintings at this time in Paris.

On his return to Bordeaux, Goya painted some further portraits, but his activity was principally devoted to graphic work of various kinds and his experiments with miniatures (cat. 99–111). In many of these late works of imagination, Goya took up earlier themes, expressing them with extraordinary technical freedom. The theme of the bullfight was the first to which he had turned in the period of his illness and convalescence in 1793 (cat. 32–7), and it was the subject of a major series of etchings, published in 1816, and of one of his most celebrated paintings dating from a slightly later period (cat. 95). In France, Goya explored once again the 'various episodes and actions in the art of fighting bulls' in this painting and in the lithographs made in Bordeaux (cat. 113–18).

In 1828 Goya had turned 78, and his style at this period in Bordeaux was inevitably marked by his age and infirmities. The *Bullfight* of 1824 reduces its elements to essentials: the complex settings of the earlier bullrings have gone, the background is simply a wash of black and grey, suggesting the barrier and the crowd. All of the old artist's interest is concentrated on the foreground drama, the confrontation between the brutal energy of the bullfighters and the calm, uncomprehending innocence of their victims, both the horses and the bull. The picador on his badly wounded horse urges the creature forward with reins raised, a cruel spur gleaming near the exposed entrails, but the horse stands motionless, as does the bull, while the horde of *chulos* agitate their capes and incite the unoffending animal to charge again. Black lines add tension and movement to the figures in this powerful, awkward painting, still half-obscured by an ancient yellow varnish. There is nothing with which to compare it, except earlier paintings, drawings and prints (fig. 217), and the bullfight lithographs to which it is so closely related (cat. 113–18). Comparison with the late lithographs, particularly the *Bulls of Bordeaux*, and with the remarkable technique of the miniatures is undoubtedly the key to an understanding of Goya's late painting style.

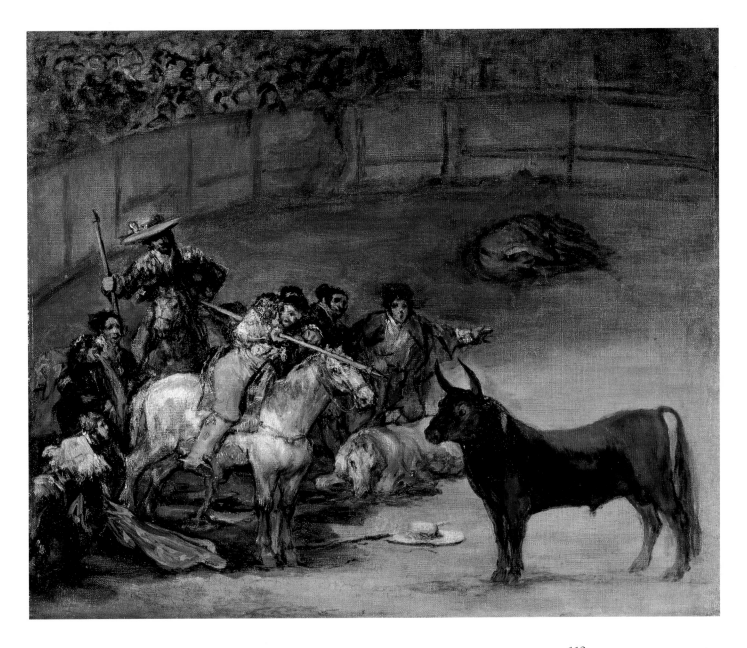

112
Bullfight: Suerte de vara, 1824
oil on canvas, 50 × 61 cm
Collection of the J. Paul Getty
Museum, Malibu, California

LITHOGRAPHS: THE 'BULLS OF BORDEAUX', 1824–1825

Goya had made his first experiments with the new art of lithography in Madrid in 1819, in the lithographic workshop just opened by José María Cardano. He met Cardano again on his visit to Paris in the summer of 1824, and this may have stimulated his interest in the technique and the idea of exploiting the popularity of prints. In his old age, Goya was clearly anxious about his financial situation, and in a letter to his son about an investment he wrote that 'the same fate may befall me as Titian, to live to 99 and have no other source of income'. He looked for ways to supplement his salary from the Spanish Court (and was anxious about the extensions of his leave of absence), and he may even have imagined that he would be able to sell his miniatures (cat. 99–111).

On 6 December 1825 he wrote a letter to his friend Ferrer in Paris, to say that he was sending him 'a trial lithograph which represents a bullfight with young bulls so that you and our friend Cardano can see it, and if some of them are thought worthy of being sent I'll send whatever ones you want; I am putting this note with the print and having no news I beg you again to tell me because I have done three in the same size and on a bullfight theme', adding at the bottom of the page 'I live at Rue Croix Blanche 10 / and if we die, would they be kind enough to bury us'. His next letter dated 20 December, expresses his disappointment at Ferrer's response: 'I take note and agree with what you say about the bullfight prints, but as I thought that they should be seen by artistically aware people of whom there are many in that great court, as well as the large number of people who will have already seen them, without counting the number of Spaniards, I thought it would be easy to give them to a print dealer without saying my name and do so at

low cost' and goes on to describe his miniature painting.

The printing of 100 impressions of the set of four lithographs was registered in Bordeaux on 17 and 29 November and 23 December, and half the edition had already been printed before Goya wrote to Ferrer. It was printed and registered by Gaulon, a calligrapher and lithographer established in Bordeaux, of whom Goya made a superb lithographic portrait (fig. 225). It was Gaulon who helped him to grasp the full possibilities of the new medium, and the various works created by Goya on lithographic stone in the course of a year, between his return to Bordeaux from Paris and the publication of the *Bulls* in the winter of 1825, are among the great masterpieces of graphic art.

As with his miniatures, Goya adopted unusual and original methods in making his lithographs. The testimony of Antonio Bru-

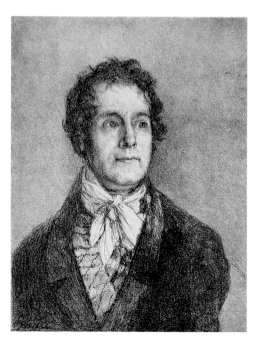

Fig. 225 *Gaulon*, 1824–5
lithograph, 27 × 21 cm
Davison Art Center,
Wesleyan University,
Middletown, Connecticut

gada, relayed by Matheron, is again of great interest: 'The artist worked at his lithographs on his easel, the stone placed like a canvas. He handled the crayons like paint brushes, and never sharpened them. He remained standing, walking backwards and forwards from moment to moment to judge the effect. He usually covered the whole stone with a uniform, grey tint, and then removed the areas that were to be light with a scraper: here a head, a figure; there a horse, a bull. The crayon was then brought back into play to reinforce the shadows and accents, or to indicate figures and give them a sense of movement.... People might laugh if I said that Goya's lithographs were all executed with a magnifying glass. The fact is that it was not in order to do detailed work, but his eyesight was failing'.

A unique proof of the dramatic *Picador Drawing a Bull in Open Country* (cat. 113) makes use of detailed drawing in the dead man on the ground and the expressive figures on the distant rock. Another unique proof (cat. 114) appears to be a rejected composition for the published set of four *Bulls of Bordeaux.* The scene is one of extraordinary confusion, with dead and dying horses and men, and a picador charging the bull that has run amok and is being attacked with lances while another *torero* hangs onto its tail. Both of these prints are close in many ways to the painting of the *Bullfight* (cat. 112), particularly if it is recalled that the compositions drawn by Goya on the lithographic stone appear reversed when printed.

The four *Bulls of Bordeaux* (cat. 115–18), which Goya hoped he might be able to sell cheaply and anonymously in Paris print-shops, are among the finest lithographic works ever made. On one set of proofs (Biblioteca Nacional, Madrid), the numbers I to IV are inscribed in pencil, and the first is lettered in Spanish: 'Don Francisco Goya y Lucientes, First Court Painter to the King of Spain and Director of the Royal Academy of San Fernando, invented and lithographed these four

prints in Bordeaux in 1826 at the age of 80'. The prints are presented here in the sequence indicated, and the first scene shows Mariano Ceballos, a Mexican Indian, riding a wild bull and about to spear another. Goya took the theme from plate 24 of his earlier *Tauromaquia* etchings, but transformed the composition into a whirling, circular movement of men and beasts that fills the bullring with movement (cat. 115). The second is again a *suerte de vara*, with a picador caught on the horns of a massive bull (cat. 116). The other print with a descriptive – and possibly ironic – lithographed title, '*Spanish Entertainment*', is another of Goya's circular compositions, this time illustrating the popular appeal of the bullfight for amateurs and its moments of danger and comedy (cat. 117). The fourth, and final, scene is the *Divided Ring*, in which Goya establishes dynamic groupings of men and beasts around the diagonal thrust of the central division, with the matador poised and smiling in the foreground (cat. 118), recalling the cannibal with his victim in an earlier painting (cat. 82).

All four of these extraordinary scenes were drawn, scraped and scratched into the stone, with numerous pentimenti, and are enlivened and strengthened with characteristic zigzag lines. They express the impulsive energy of the old man of whom Moratín wrote in October 1825, 'Goya says he has fought bulls in his time, and that with a sword in his hand he is afraid of no one. In two months he will be 80'. Perhaps the bullfight most perfectly expresses the duality of Goya's perception of the world as it appears in his art: energy and violence, but also balance and harmony; the splendour of life and the inevitability of death.

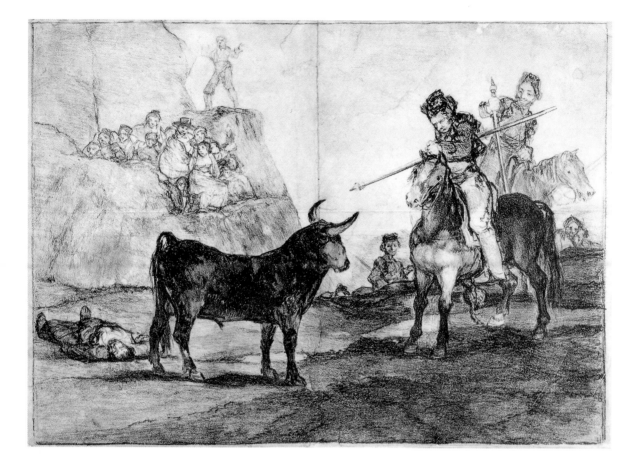

113
Picador Drawing a Bull in Open Country, 1824–5
lithograph, 25 × 35.5 cm
Kupferstichkabinett, Berlin

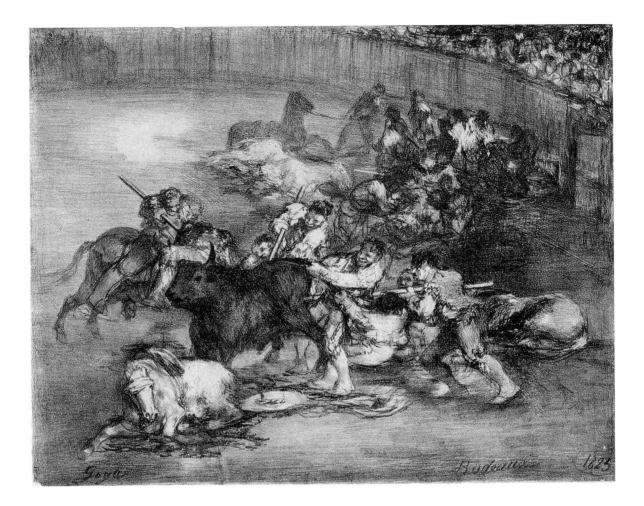

114
Bullfight, 1825
lithograph, 31 × 41.5 cm
Signed and dated: '*Goya Bodeaux* [sic] *1825*'
Musée des Beaux-Arts, Bordeaux

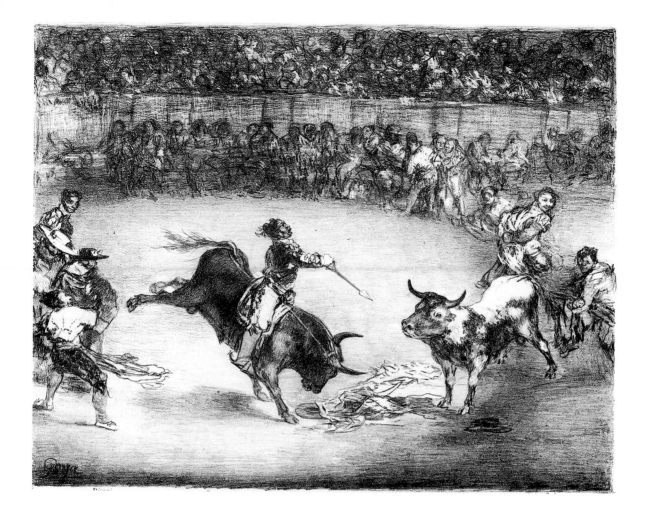

115

'The Celebrated American, Mariano Ceballos'

lithograph, 30.5 × 40 cm
Signed at lower left: *Goya*
Inscribed below: '*El famoso Americano, Mariano Ceballos*'
The British Museum, London/Art Institute of Chicago

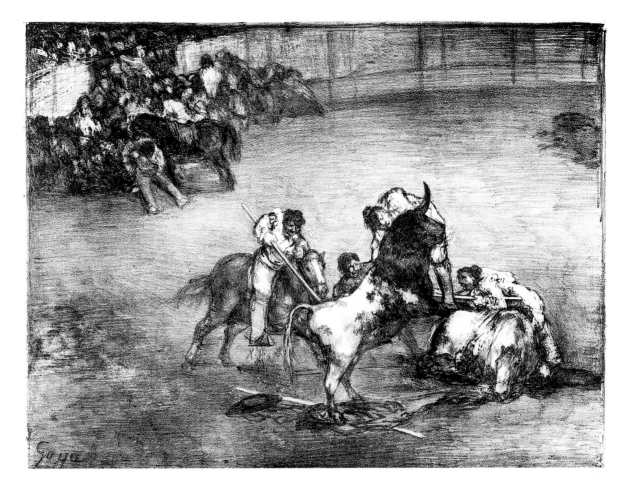

116
Bravo toro
lithograph, 30.5 × 41 cm
Signed at lower left: '*Goya*'
The British Museum, London/Art Institute of Chicago

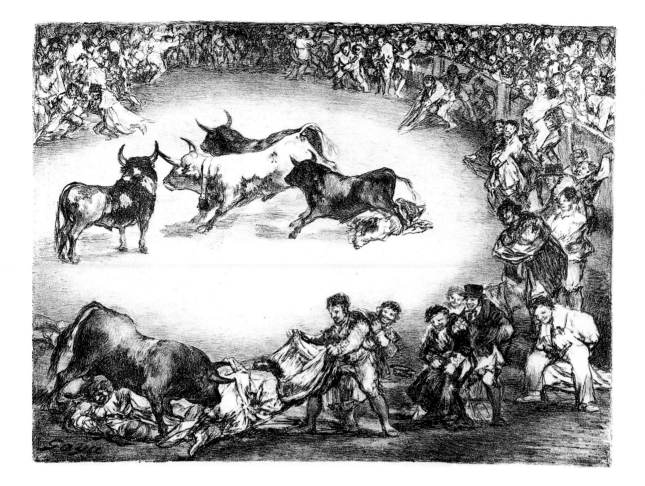

117
'Spanish Entertainment'
lithograph, 30 × 41 cm
Signed at lower left '*Goya*'
Inscribed below: '*Dibersión de España*'
The British Museum, London/Art Institute of Chicago

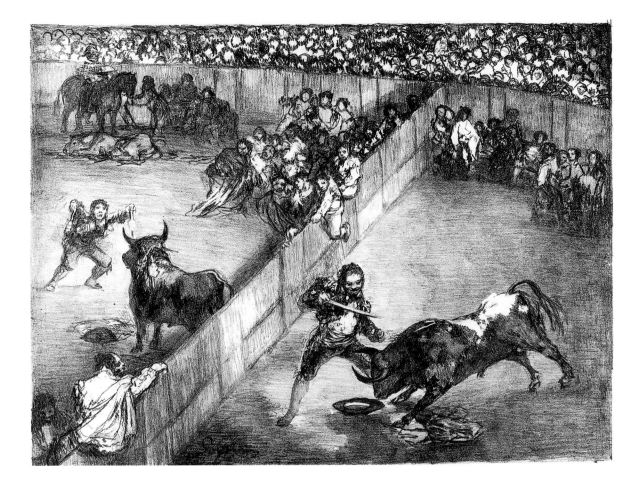

118
The Divided Ring
lithograph, 30 × 41.5 cm
Signed at lower edge: '*Goya*'
The British Museum, London/Art Institute of Chicago

CATALOGUE OF WORKS

USING THE CATALOGUE
OF WORKS

The following section is a revised version of the one to be found in the Spanish edition of the catalogue. Its organisation is in accord with that of the main, illustrated text (pp. 91–339).

Titles and dates
These reflect the latest research into early source material and are based on contemporary documents; some, therefore, will be found to differ from those given in previous publications.

Technique, support and dimensions
Apart from the miniatures on ivory (cat. 99–111) and the lithographs (cat. 113–19), all works are paintings in oils, and only the support is mentioned: canvas, panel (wood), tinplate, or copper.

Dimensions are given in centimetres, height before width, and are those of the original support.

In the majority of cases, dimensions and other technical information have been confirmed by direct examination of the works.

References
The principal references cited are G–W = Gassier and Wilson, 1970; Gud. = Gudiol, 1970/1984 (citing both editions); DeA = De Angelis, 1974; H = Harris, 1964; and D = Delteil, 1922. Full details for these publications are given in the Bibliography.

Exhibitions
These are cited, with the lender's name, where this helps to confirm the work's provenance. (The list of Exhibitions follows the Bibliography.)

Italy and Spain: The Early Years, c. 1770–1773

THE ITALIAN NOTEBOOK, *c.* 1770–1785
(pp. 92–7; fig. 38, 60–69, 72, 75, 81, 84, 86, 102, 148)

The Notebook, acquired by the Museo del Prado in 1993, has been published in facsimile and will appear in a further, fully annotated edition in 1994.

For information on Goya's early years, see the following:
Autobiographical and biographical notes for Goya's art training under José Luzán in Saragossa, and for the visit to Italy: Prado catalogue, 1828, pp. 67–8; Calleja, 1924, p. 60; Beroqui, 1927; Harris, E., 1969, pp. 24–7. Art training in Madrid with Francisco Bayeu: Arnaiz–Montero, 1986, p. 46.
Competitions at the Academia de San Fernando 1763, 1766: Sánchez Cantón, 1928, pp. 11–13; Gudiol, 1970, pp. 19–20; Arnaiz, 1987, pp. 32–4.
Baptism of Goya's first child in Saragossa (recorded in the Italian Notebook, see fig. 68): San Miguel de los Navarros, Saragossa, vol. IX, of the 'bautizados desde 1771 hasta 1788', fol. 54r: '[on 29 August 1774] bauticè un niño que nacio el mismo dia, hijo de Francisco Goya y de Josepha Bayeu naturales de Zaragoza, … que al presente habitan en esta Parroquia.... por nombre Antonio Juan Ramón Carlos. Fue su Padrino Don Carlos Salas Parroquiano, de San Felipe …'.

Of the numerous undocumented works of art that have been attributed to Goya in earlier publications as well as in recent years, the *Hannibal* (cat. 1) and three religious paintings (cat. 4–6) – attributions supported by the evidence contained in the Italian Notebook – and a further painting that accords with the others in style and technique (cat. 3), are included in this and the following section, in order that they may serve for comparison with other works.

THE PARMA ACADEMY COMPETITION, 1771

1 *Hannibal the Conqueror, Viewing Italy for the First Time from the Alps,* 1771
canvas, 30.6 × 38.5 cm (stretcher with additional canvas, 33.2 × 40.8 cm)
Private collection, Madrid

REFERENCES
G–W –; Gud. –/–; DeA – (painting identified and published by Arnaiz and Buendía in 1984).

PROVENANCE
Unknown collection, Saragossa; Garmendía-Herrero, Vilanova de Ordicia; private collection (acquired in 1984).

DOCUMENTS
Competition picture: Copertini, 1928; Sánchez Cantón, 1931; Hyatt Mayor, 1955; Gassier–Wilson, 1970/71, p. 382, Appx III; Pellegri, 1988, p. 95.

EXHIBITIONS
Saragossa, 1986 (17); Madrid, 1988 (52); Venice, 1989 (3); Saragossa, 1992 (2).

BIBLIOGRAPHY
Ripa (1618), 1986, p. 254; Copertini, 1928; Sambricio, 1946, pp. 19–23; Glendinning, 1977, p. 32, 1983, p. 45; Wilson-Bareau, 1981, p. 13; Arnaiz–Buendía, 1984; Pellegri, 1988; Baticle, 1992, pp. 46–8; Mangiante, 1992, pp. 26–8.

The sketch is painted on a canvas with a pronounced weave, prepared with a red ground that is left uncovered in the shadows and other secondary areas. It has been enlarged and fixed to a new stretcher, with added strips at the top (1 cm), on the right (2 cm) and at the bottom edges (1–1.5 cm), which the present frame conceals in order to restore the visual effect of the original format (as seen here in the reproduction). The painting's appearance is affected by the heavy relining, carried out before 1984, which flattened the paint surface and its vivid impasto touches, and over-emphasised the texture of the canvas. The previous heavy restoration and retouching gave rise to doubts about the authenticity of *Hannibal* when it was first shown at exhibitions, but with a recent restoration, in 1993, much of its original quality has been recovered. The principal area of the composition is in good condition, with very few losses. Technical examination of the canvas failed to reveal any trace of a supposed signature in an area of cracks and repainted damage close to the added strip at the bottom of the canvas.

The documents concerning Goya's relationship with Kuntz have yet to be published in full and compared with the evidence of the Italian Notebook, but since Kuntz was a friend of Mengs, a more detailed account of the society in which Goya moved in Rome should emerge, as well as a more precise assessment of his relationship with the Aragonese circle that included the Pignatelli family in Rome and Juan Martín de Goicoechea, whose name appears in the Notebook, in Saragossa.

The picture by Paolo Borroni, with the device '*Montes fregit aceto*', that won the Parma competition is now in Parma's Galleria Nazionale and measures 89 × 126 cm (Pellegri, 1988, p. 95, repr.), as against the prescribed 88 × 142 cm. Apart from the fact that strong Bourbon connections with Parma existed, Goya's decision to enter the competition may have been strongly motivated by the theme itself, which was linked to the history of his own country: Hannibal's campaigns in Spain were directed from Cartagena ('New Carthage'), in the province of Valencia. His siege and conquest of pro-Roman Saguntum to the north led to the outbreak of the Second Punic War in 218 BC, and Hannibal at once prepared for his march to Italy, with the conquest of Rome itself his goal. Marching north from Spain with a vast army, he successfully crossed the Alps, though with his forces very much depleted and only one of the 40 elephants with which he had set out.

In addition to the Antique sculptures here illustrated (fig. 71, 73), see also Bober–Rubinstein, 1986, 158i, iii, and 170B, for Trajanic battles, with commanders and figures of Victory, and a crouching barbarian, on the Arch of Constantine, Rome.

Paintings on Religious Themes, 1771–1775

Apart from the paintings on the doors of the reliquary in Fuendetodos, traditionally attributed to Goya when a very young artist, which were destroyed in 1937 (fig. 50, 51), discussion of Goya's early religious paintings has to be based mainly on a study of his monumental paintings on the vault of the Little Choir (*Coreto*) in El Pilar and the walls of the church in the Charterhouse of Aula Dei (the latter accessible with difficulty, but only to male visitors). Major restoration of Goya's fresco and murals has been carried out in recent years by Teresa Grasa Jordán and Carlos Barboza Vargas, who have published detailed accounts of Goya's technique and the condition in which they found the various works (the Aula Dei murals were replaced wholly or in part by the French academic painters Paul and Amédée Buffet in 1902–3).

The Aula Dei paintings, in particular, are crucial for an appreciation of Goya's style in these early years (prior to his arrival in Madrid), and further study and adequate reproductions of the paintings are now a priority.

BIBLIOGRAPHY

Goya's letter of 22 November 1772: *Regina Martirum. Goya*, 1982, p. 141, no. 13.
Charterhouse of Aula Dei: *La Cartuja de Aula Dei de Zaragoza*, 1986, pp. 395–475; see the 'Informe de la restauración …', pp. 476–81.

LITTLE CHOIR ('CORETO') OF THE BASILICA OF EL PILAR, SARAGOSSA, 1771–1772

2 *The Gloria*, 1771–2

canvas, 76 × 151 cm
inscribed on verso in large letters '*Goya*'
Private Collection, Barcelona

REFERENCES

G–W 31; Gud. 24/22; DeA 27.

PROVENANCE

Condes de Sobradiel, Saragossa; by marriage to María del Pilar Alcibar-Jáuregui, Saragossa (inventory 1867); Condes de Sobradiel, Saragossa (to 1908); Rosa Cavero y Alcibar-Jáuregui, and Sancho de Castro, Saragossa; José Gudiol Ricart, Barcelona; thence by descent.

DOCUMENTS

El Pilar Archive, 'Actas Juntas de Nueva Fábrica', in *Regina Martirum. Goya*, 1982, p. 138, nos. 1–3.

EXHIBITIONS

Saragossa, 1908 (41: Conde de Sobradiel); Madrid, 1949 (145: Sancho de Castro); The Hague/Paris, 1970 (1); Milan, 1978 (29); Saragossa, 1986 (24); Saragossa, 1992 (4).

CATALOGUE

Morales y Marín, 1990, p. 58 (15). Although the sketch was exhibited in Saragossa in 1908, it was not included in an *œuvre* catalogue until 1970.

BIBLIOGRAPHY

Tormo, 1909, p. 283; Galindo, 1928; Stolz Viciano, 1942, p. 344; Sánchez Cantón, 1951, p. 14; Lafuente Ferrari, 1955, pp. 120, 136; Gudiol, 1965; Torralba Soriano, 1971, pp. 219–20; Gassier, 1975, pp. 26–9, nos. 1, 2; Torralba Soriano, 1977, p. 11; *Gazette des Beaux-Arts*, XCIII, 1979, p. 9, no. 41, repr.; Barboza–Grasa, 1982, pp. 29–30; *Acquisitions du Cabinet des Dessins, 1973–1983*, exh. cat., Musée du Louvre, Paris, 1984, no. 156; Gallego–Domingo, 1987, pp. 46–7, 92–5; Grasa–Barboza, 1989, pp. 56–8; Morales y Marín, 1990, pp. 60–6; Barboza–Grasa, 1992, p. 87.

The unlined canvas was prepared with a black ground that shows through the craquelure and gives vibrancy to the golden tones of the heavens (as in many of Murillo's *glorias*). The composition was painted within the brown and black border that imitates the gilded stucco relief around the ceiling of the *coreto* (fig. 37; see also *Regina Martirum. Goya*, 1982, repr. pp. 28–9), and which resembles the dark, decorative surround on the two lunette-shaped sketches by Antonio González Velázquez for the earlier frescoes in El Pilar (Gállego–Domingo, 1987, repr. pp. 82–3). The overpainted figures seen in the x-ray (fig. 78) show through the present paint surface, most clearly at lower centre where the left leg of a large angel lies across the decorative border and is now half-obscured by a cloud. Since a corresponding area of disturbance is also visible on the vault of the *Coreto* and the architrave above the window, it is possible that a painted or stucco figure was intended to link the frescoed heavens with the tangible reality of the architecture of the church.

The sketch was cleaned in 1993, and this has augmented the transparency and liveliness of the colours, but above all it has increased the sense of depth and revealed the delicacy of Goya's technique.

On the stretcher is the label of the 1908 Saragossa exhibition, with the name of the 'Conde de Sobradiel'. Morales y Marín (1990, p. 58) rectified the information concerning the picture's provenance but did not record its inclusion in the 1908 exhibition.

In October 1771, the Council of Castile had pronounced in favour of El Pilar in a case involving substantial funds witheld from it since 1725 by the city of Valencia. Don Ramón de Pignatelli informed the Building Committee of the favourable outcome, and Goya's commission for the *Coreto* followed shortly afterwards.

SCENE FROM THE LIFE OF CHRIST, *c.* 1771–1775

3 *The Baptism of Christ*, *c.* 1771–5

canvas, 45.4 × 39.4 cm
Madrid, Conde de Orgaz

REFERENCES

G–W 174; Gud. 114/120; DeA 147.

PROVENANCE

Juan Martín de Goicoechea, Saragossa; Condes de Sobradiel, Saragossa; thence by descent.

EXHIBITIONS

Saragossa, 1986 (38); Venice, 1989 (12).

CATALOGUE

Morales y Marín, 1990, p. 112 (46).

The *Baptism of Christ* was painted over an existing picture, and the x-ray image shows traces of the earlier composition, with small figures, apparently by another hand, on the left side of the inverted canvas. The canvas is unlined and may be on its original stretcher. The work was restored and cleaned in 1993, and the picture has recovered much of its original transparency and volume.

TWO DEVOTIONAL PICTURES, *c.* 1771–1775

The two paintings share a common origin and provenance.

PROVENANCE

Gracia Lucientes (mother of the artist), Saragossa; by inheritance to Francisca Lucientes (by 1926); acquired by the Museo de Zaragoza (1927).

DOCUMENTS

'Junta ordinaria celebrada el 11 de Abril de 1926', MS, Museo Provincial de Bellas Artes, Saragossa; 'Crónica del Museo', *Boletín del Museo de Bellas Artes de Zaragoza*, December 1927, p. 38.

4 *The Virgin of the Pillar*, *c.* 1771–5

canvas, 56 × 42.5 cm
Saragossa, Museo de Zaragoza (9261)

REFERENCES

G–W 172; Gud. 112/118; DeA 66.

EXHIBITIONS
Saragossa, 1928 (462); Madrid, 1961 (ex-cat. 121); Saragossa, 1986 (33); Venice, 1989 (10); Saragossa, 1992 (5).

CATALOGUE
Morales y Marín, 1990, p. 114 (47).

BIBLIOGRAPHY
D. Fúster, 'Informe técnico y tratamiento', in *Catálogo de obras restauradas 1982–1986*, ICRBC, Ministry of Culture, Madrid, 1989, pp. 56–7, no. 35.

The canvas was prepared with a red ground.
The reproduction in the 1989 exhibition catalogue shows the canvas before restoration which was carried out in the Institute of Conservation and Restoration, Madrid, in 1982. The very strong craquelure and cupping of the paint layers was also a characteristic of other early canvases by Goya (see Gudiol, illustrations 187/–, 188/–, 189/128, 191/130, 398/167). This condition resulted in many paint losses, and the heads of the two cherubim at upper centre are largely reconstructed. The flattened paint surface has lost the transparency and sense of depth that have been recovered in the sketch for the *Gloria* (cat. 2) and the very similar *Baptism of Christ* (cat. 3).

5 *The Death of St Francis Xavier,*
c. 1771–5
canvas, 56.5 × 42.2 cm
Saragossa, Museo de Zaragoza (9259)

REFERENCES
G–W 173; Gud. 113/119; DeA 65.

EXHIBITIONS
Madrid, 1961 (ex-cat. 122); Saragossa, 1986 (34); Venice, 1989 (11).

CATALOGUE
Morales y Marín, 1990, p. 116 (48).

This painting, which presented similar defects to other early works (cat. 3, 4), was cleaned and restored in 1986. Its surface is seriously abraded and much of its quality has been lost. The relined canvas has a red ground that Goya used in many areas of the painting.

A SAINT AND MARTYR, *c.* 1771–1775

6 *St Barbara, c.* 1771–5
canvas, 97.2 × 78.5 cm
Private Collection

REFERENCES
G–W 162; Gud. 102/96; DeA 56.

PROVENANCE
Juan Molina, Madrid (by 1932); E. Bernaldo de Quirós, Madrid; Torelló, Barcelona (acquired 1956).

EXHIBITION
Madrid, 1932 (3: Juan Molina).

CATALOGUE
Morales y Marín, 1990, p. 132 (56).

BIBLIOGRAPHY
Lafuente Ferrari, 1947, p. 355.

Cleaned in 1993, the painting is in generally excellent condition and has regained its transparency. It was painted on a red ground, which shows through in many areas. The canvas was relined in an earlier restoration.
Exhibited in 1932, the painting was otherwise unknown, except through black and white photographs. It is reproduced here in colour for the first time.

The Royal Tapestry Factory of Santa Barbara, 1776–1778

DINING-ROOM OF THE PRINCE AND PRINCESS OF ASTURIAS, PALACE OF EL PARDO, 1777

7 *A Brawl at the Cock Inn,* 1777
canvas, 41.9 × 67.3 cm
inscribed over the inn door: '*MESON DEL GALLO*'
Private Collection

REFERENCES
G–W 77; Gud. 64/58; DeA 71.

PROVENANCE
Charles Yriarte, Paris (by 1867); (Vente Yriarte, Hôtel Drouot, Paris, 26 December 1898, lot 9); Wertheimer, Paris.

EXHIBITIONS
Syracuse/Milwaukee, 1957 (30/37); Martigny, 1982 (1); Rotterdam/Brunswick, 1983–4 (79).

CATALOGUES
Yriarte, 1867, p. 149 (Yriarte); Viñaza, 1887, p. 292 (CIII); von Loga, 1903/21 (576); Mayer, 1923 (702); Desparmet Fitz-Gerald, 1928–50 (140); Sambricio, 1946 (12a); Arnaiz, 1987 (16B).

BIBLIOGRAPHY
Yriarte, 1867, p. 99, repr.; Cruzada Villaamil, 1870, p. 114, no. III; Sambricio, 1946, pp. 97–8, docs. 33–6; Held, 1971, pp. 35–40; Tomlinson, 1989, pp. 40–6, 1993, pp. 61–8.

The canvas was prepared with a rich, dark red ground that is characteristic of the early tapestry cartoons. As the only surviving example from this period, it is not surprising that it has suffered considerably, and it was probably restored when Yriarte acquired the painting towards the mid-19th century. The areas most affected are the sky in the upper left and, more particularly, the upper-right areas and a strip some 2 to 3.5 cm deep along the lower edge. The central group of figures is generally well preserved, and gives a particularly vivid impression of Goya's ability to combine broad and detailed handling, while the delicate colours and brushwork on the carriage and the more distant group to the left contrast with the strong *contre-jour* effects in the foreground.
The picture, cleaned in 1993 to remove a thick coating of yellowed varnish that is apparent in all previous reproductions, has now regained much of its original luminosity and cool tonality, as well as its impression of space and recession. It is interesting to compare this picture with the engraving published by Yriarte in 1867, although the latter should not be taken as an entirely accurate reproduction of the original work as it appeared at that date.

Paintings on Religious Themes, 1780–1788

CUPOLA OF THE BASILICA OF EL PILAR, SARAGOSSA, 1780–1782

The two sketches have remained together since they were painted, and share a common provenance.

PROVENANCE

Francisco Bayeu, Madrid; Léonard Chopinot, Madrid (before 1800); by inheritance Angela Sulpice y Chopinot, Madrid; acquired by El Pilar Chapter, Saragossa (1805: see Gallego–Domingo, 1987, pp. 68–9).

DOCUMENTS

Goya and the Building Committee: Viñaza, 1887, pp. 159–77 (Eng. trans. in Symmons, 1988, Appx I, pp. 186–91); Galindo, 1928; *Diplomatario*, 1981, pp. 206–36, nos. 5, 17, 35, 47; pp. 412–26, nos. XXIII, XXVII–XXX; *Cartas a Zapater*, 1982, nos. 4, 14, 20; *Regina Martirum. Goya*, 1982, pp. 138–65; Gallego–Domingo, 1987, pp. 68–9.

BIBLIOGRAPHY

Beruete, II, 1917, pp. 25–6; Sánchez Cantón, 1951, p. 23; Lafuente Ferrari, 1955, pp. 123–3, 136; Barboza-Grasa, 1982, pp. 73–84; Arnaiz, 1987, pp. 117–27; Tomlinson, 1989, pp. 126–7, 1993, pp. 168–9; Glendinning, 1992 (*Aragón*), pp. 85–99; Glendinning, 1992 (*Retratos*), p. 56.

8 *Queen of Martyrs,* [Sketch with the Virgin], 1780

canvas, 85 × 165 cm
Saragossa, El Pilar, Museo Pilarista

REFERENCES

G–W 178; Gud. 117/110; DeA 105.

EXHIBITIONS

Saragossa, 1908 (26); Madrid, 1949 (137); Bordeaux, 1959 (150); Paris, 1961–2 (15); Bordeaux/Paris/Madrid, 1979–80 (14/2); Saragossa, 1992 (8).

CATALOGUES

Viñaza, 1887, pp. 194–5 (II, n.); Von Loga, 1903/21 (5); Mayer, 1924 (9a); Desparmet Fitz-Gerald, 1928–50 (52); Morales y Marín, 1990, p. 139 (58).

9 *Queen of Martyrs* [Sketch with the Banner], 1780

canvas, 85 × 165 cm
inscribed on the banner: '*REGINA MARTIRUM*'
Saragossa, El Pilar, Museo Pilarista

REFERENCES

G–W 179; Gud. 118/111; DeA 106.

EXHIBITIONS

Saragossa, 1908 (27); Madrid, 1949 (137); Bordeaux, 1959 (150); Paris, 1961–62 (16); The Hague/Paris, 1970 (4/3); Bordeaux/Paris/Madrid, 1979–80 (15/–); Saragossa, 1992 (9).

CATALOGUES

Viñaza, 1887, pp. 194–5 (II, n.); von Loga, 1903/1921 (5); Mayer, 1924 (9b); Desparmet Fitz-Gerald, 1928–50 (52); Morales y Marín, 1990, p. 139 (59).

The sketches are on canvases prepared with a rich red ground. Cat. 9 appears to be on a coarser canvas with a dryer ground; also, it is less fully worked than Cat. 8 and makes greater use of the red preparation.

For a comparative study of the sketches and the fresco, see Barboza and Grasa, 1982, pp. 73–84. It is regrettable that while recent cleaning of Goya's cupola has revealed the astonishing freedom and assurance of his fresco painting, both in conception and execution, all the ceilings and cupolas by other artists remain blackened by time and extensively damaged, and their combined decorative effect in the church by Ventura Rodríguez cannot be assessed.

CHURCH OF SAN PEDRO, URREA DE GAÉN (TERUEL), 1782–1783

10 *Appearance of the Virgin of the Pillar to St James,* 1782–3

canvas, 46.7 × 33 cm
inscribed on a label on the stretcher: '*Boceto de D.ⁿFran.ᶜᵒ Goya, restaurado en 1867. 1.500*'
Private Collection

REFERENCES

G–W 194; Gud. 280/170; DeA 144.

PROVENANCE

Juan Eugenio Hartzenbusch, Madrid; María Ubón López, Madrid (1883); Purificación Capdevilla Moyano, Madrid (c. 1920); Luis García Rodríguez, Valladolid (by 1951).

DOCUMENTS

Ponz, XV, 1788, pp. 186–7/1947, p. 1375; *Diplomatario*, 1981, p. 249, no. 70; *Cartas a Zapater*, 1982, pp. 104–5, no. 46.

CATALOGUE

Morales y Marín, 1990, p. 172 (70).

BIBLIOGRAPHY

Sketch: Lozoya, 1951, pp. 8–9 (García Rodríguez). Church and altarpiece: Sánchez Cantón, 1946, pp. 288–9; Torralba Soriano 1971, p. 224; Sebastián López, 1974, pp. 453–4; M. García Guatas, 'Contribución a la obra del arquitecto Agustín Sanz (1724–1801)', *Seminario de Arte Aragonés*, XXIX–XXX, 1979, pp. 59–66; J. Laborda Yneva, *Maestros de obras y arquitectos del período ilustrado en Zaragoza*, Saragossa, 1989, pp. 290–98; Morales y Marín, 1992, p. 312, no. 5.

Exhibited for the first time, this oil sketch (restored and cleaned in 1993, apparently the only time since the restoration of 1867) is very freely painted over a light beige preparation that covers a warm reddish ground. There are areas of vigorous graphite under-drawing. The sketch was published by Lozoya in 1951, and is here reproduced in colour for the first time.

Ponz described the church of San Pedro at Urrea de Gaén in 1788: references to Hijar and its ducal palace and church are followed by Urrea de Gaén, also the property of the Duke of Hijar, whose coat of arms appears, with the date 1782, above the entrance: 'Its handsome, circular Church was funded by the same Señor and supervised by Don Augustín Sanz. The paintings for the main and side altars were done in Madrid: the one representing St Peter Martyr is by Ramón Bayeu, that of St Blaise by Don Francisco Goya, and the St Augustine by Don Joseph Castillo'. No painting of 'St Blaise' by Goya is known, and Ponz makes no mention of Goya's *Apparition of the Virgin of the Pillar*. It is possible that Ponz restricted his description to the main- and side-altars, and omitted Goya's *Virgin of the Pillar*, perhaps the less recent work.

The interior of the church (fig. 101), whose plans were submitted by Sanz to the Academy of San Fernando in 1775, is elliptical, based on Italian Baroque forms interpreted in Ventura Rodríguez's uncomplicated, neoclassical style. Its four altars are surmounted by an elegant cupola with *œil-de-bœuf* windows around the dome, and with the high altar and two domed chapels leading off the central space.

The existing photographs of Goya's destroyed altarpiece (G–W 192; Gud. 281/171; DeA 145) reveal considerable changes, apart from the reversal of the composition. In the large painting, the Virgin places a hand on her breast, rather than pointing at the Saint, who is seen in stricter profile. The running figure has been eliminated, and a group of disciples is glimpsed in the background, in front of the River Ebro spanned by a great stone bridge, an arch of which appears behind the Saint. The preparatory drawing for the final composition is in white chalk on (faded) blue paper (Prado 2: G–W 193; Gassier, 1975, no. 12).

SAN FRANCISCO EL GRANDE, MADRID, 1781–1784

Two sketches have survived, but have not been exhibited or studied since the first quarter of this century.

The complex history of the San Francisco el Grande commission is presented here with the known documentation. Goya's original title, in his letter to Floridablanca, referring to '*San Bernardino de Siena predicando ante Renato Rey de Sicilia*', was altered to '*… el Rey Alfonso de Aragón*'.

DOCUMENTS

Goya's letters to Zapater: *Diplomatario*, 1981, pp. 236–8, nos. 48, 49, 51, pp. 245–6, nos. 63, 64; *Cartas a Zapater*, 1982, pp. 64–6, nos. 21, 22, p. 91, no. 37. Goya's letters to Floridablanca, 22 September 1781 (original manuscript destroyed 1939): Lafuente Ferrari, 1946, pp. 314–15; Lafuente Ferrari, 1947, p. 321; *Diplomatario*, 1981, p. 238, no. 52; 25 April 1785: *Diplomatario*, 1981, p. 263, no. 96. Church and altarpieces: Ponz, v, 1776, 1782, 1793, pp. 105–6/ed. 1947, pp. 440–41; *Memorial literario …*, vi, April 1785 (in Viñaza, 1887, p. 42, n. 2; see also Rodríguez Moñino, 1981, p. 300, no. 14); J.M. de Eguren, 'San Francisco el Grande', *Semanario Pintoresco Español*, 19 December 1847, pp. 401–4 (see fig. 103); Mesonero Romanos, 1844, p. 184; Mesonero Romanos, 1861, pp. 171–3; Tormo, 1927, pp. 83–95; García Barriuso, 1975, pp. 286–302, 423–5.

BIBLIOGRAPHY

Beruete, ii, 1917, pp. 22–6; Sánchez Cantón, 1946 (*Revista*), p. 287; Lafuente Ferrari, 1946, pp. 308–23; Sánchez Cantón, 1951, pp. 25–6; Tomlinson, 1989, pp. 127–31, 134, 143–4; Tomlinson, 1992, pp. 28–38, 1993, pp. 43–53.

11 *St Bernardino of Siena Preaching before King Alfonso of Aragon, or Renato, King of Sicily* [First sketch], 1781

canvas, 62 × 31 cm
Madrid, Private Collection

REFERENCES

G–W 187; Gud. 135/125; DeA 120.

PROVENANCE

Martín Zapater, Saragossa(?); Marqués de la Torrecilla, Madrid (by 1867); Conde de Villagonzalo, Madrid; thence by descent.

EXHIBITION

Royal Academy, London, 1920–21 (107: Torrecilla).

CATALOGUES

Yriarte 1867, p. 136 (Torrecilla); Viñaza 1887, p. 202 (vi, n.); von Loga, 1903/21 (179); Mayer, 1924 (37); Desparmet Fitz-Gerald, 1928–50 (63); Morales y Marín, 1990, p. 149 (61).

12 *St Bernardino of Siena Preaching before King Alfonso of Aragon* [Second sketch], 1781

canvas, 62 × 33 cm
Madrid, Private Collection

REFERENCES

G–W 186; Gud. 136/126; DeA 121.

PROVENANCE

Marqués de la Torrecilla, Madrid (by 1867); Conde de Villagonzalo, Madrid; thence by descent.

EXHIBITION

Madrid, 1900 (53: Torrecilla).

CATALOGUES

Yriarte, 1867, p. 136 (Torrecilla); Viñaza, 1887, p. 202 (vi, n.); von Loga, 1903/21 (29); Mayer, 1924 (36); Desparmet Fitz-Gerald, 1928–50 (64); Morales y Marín, 1990, p. 152 (62).

The fully documented history of the convent and church of San Francisco el Grande (García Barriuso, 1975) provides the background to the commissioning of the seven altarpieces: High-altar (Francisco Bayeu, *Appearance of Christ and the Virgin to St Francis – 'La Porciuncula'*); Gospel (left side): first chapel (Mariano Maella, *Immaculate Conception*), second chapel (Gregorio Ferro, *St Joseph and the Christ Child*), third chapel (Antonio González Velázquez, *St Bonaventura Witnessing the Removal of the Relics of St Antony of Padua*); Epistle (right side): first chapel (Joseph Castillo, *The Meeting of SS Francis and Dominic on the Steps of St Peter's in Rome*), second chapel (Andrés de la Calleja, *St Antony of Padua Kissing the Foot of the Christ Child*), third chapel (Francisco Goya, *St Bernardino of Siena Preaching before Alfonso, King of Aragon*); description from the *Memorial …* of 1785 (also in Viñaza, 1887, pp. 42–4). Following the major renovation of the interior in 1885–6, and the decoration of the six chapels in different 'period' styles – Baroque, Byzantine, Plateresque, Spanish Renaissance, Italian Renaissance and *Mudéjar* – with additional paintings and frescoes by contemporary artists, the six original altarpieces were re-grouped in the two chapels on either side of the entrance, and Bayeu's *Porciuncula* was removed from the high-altar and hung elsewhere.

The principal stages of Goya's work on the altarpiece (see Lafuente 1946 for the fullest account, and Tomlinson 1992 for the most recent) were as follows:

20 July 1781: Floridablanca advised Goya of the royal order to paint an altarpiece, on the theme of St Bernardino of Siena, but without specifying the precise subject.

25 July: Goya to Zapater about the 'competition' for the San Francisco altarpieces.

August: Goya was working on '*los borroncillos*' and '*el borrón*'.

22 September: Goya's letter to Floridablanca (see p. 134), also asking to be advised 'if I have to hand over

the said sketch here, or if I have to send it to that Royal Residence [*Real Sitio*]'. A further, undated, letter implies that sketches by all seven artists were presented to Floridablanca, but royal approval could not be given until the Court returned to Madrid in December.

23 December: Floridablanca's order for payments, 'on account', of 6,000 *reales*, to the three unsalaried artists, Castillo, Ferro and Goya (Viñaza, 1887, pp. 180–1).

15 January 1783: Goya announces the sending of an early sketch, '*muy el borrón*', to Zapater. This may be the earlier of the two sketches catalogued here, and cannot refer to the larger picture – almost identical with the altarpiece in composition – said to have come from Zapater's collection, and exhibited in Saragossa in 1928 (G–W 185, Gud. 137/127, DeA 123; see Lafuente Ferrari, 1947, p. 323).

Goya's early sketch is described in the exhibition catalogue for London, 1920–21, no. 107: 'the Saint is preaching, dressed in dark brown', and the King is 'wearing a purple cloak', while 'against tonalities of a dark wine colour, mauve and greyish blue, vibrate the tints of intense yellow and blue of the short cloaks of the noblemen standing at each extremity of the foreground'.

Lafuente noted a possible source in the *Année Chrétienne* of Father Croisset for the original subject of Goya's painting, and attributed the substitution of Alfonso V of Aragon for 'Renato, King of Sicily', (or René of Anjou), in Goya's letter to Floridablanca, to a realisation that the Aragonese and Angevin monarchs were in dispute over the realm of Naples when St Bernardino was preaching, and that the altarpiece was being painted for Carlos III, a descendant of Alfonso V, who was also born in Naples.

Lafuente also noted Goya's debt to the *St Francis Regis Preaching*, by Michel-Ange Houasse, then in the Church of the Noviciado (Museo del Prado 4196), see fig. 104; for a possible source for the final figure of St Bernardino with the crucifix, see fig. 117.

11 January 1783: All the paintings are installed in the Church, but covered up.

12 October 1784: Goya's account for expenses (García Barriuso, 1975, pp. 301–2, repr.), and the announcement to Zapater on 13 October: 'I am putting the final touches to my painting'.

6 December: the Church is consecrated.

25 April 1785: Goya, Ferro and Castillo petition Floridablanca for financial compensation for their work, 'having spent two years working on sketches, studies and the execution of the said paintings'.

21 June: A marginal note, probably by Floridablanca, on a letter by Ponz supporting the artists' petition, authorises further payment of 4,000 *reales* to each artist, with the comment that 'the paintings were not very good, although the works by these artists are the least bad'.

24 June: Order for payment, addressed to the 'Directores generales de Correos', despatched from Aranjuez (Viñaza, 1887, p. 181).

COLLEGE OF CALATRAVA, SALAMANCA,
1783–1784

13 *The Immaculate Conception,*
1783–4

canvas, 80.2 × 41.1 cm

Inscribed on wood from the original stretcher:
'*Original de Goya procede de la Galeria del Excmo*
Sr. D. Gaspar Jovellanos / Me la regalo Dn. Acisclo
Fernández Vallín preceptor que fue de mi hijo
Felipe'

Madrid, Museo del Prado (3260)

REFERENCES

G–W [188], Gud., –/146; DeA –.

PROVENANCE

Gaspar Melchor de Jovellanos (by August 1800);
Acisclo Fernández Vallín; Eulalia García Rivero
(acquired by the Prado in 1891).

DOCUMENTS

Goya's letters: A.H.N. Ordenes Militares, Calatrava,
Leg. 3651, no. 56 (see Saltillo, 1954, pp. 6–7);
Diplomatario, 1981, pp. 255–6, no. 84; *Cartas a*
Zapater, 1982, pp. 119–20, no. 57.
Jovellanos's letters: *Diplomatario*, 1981, p. 431, no.
XXXIV; Jovellanos, *Obras completas*, V, 1990, p. 159,
no. 2091; p. 545, no. 170 *bis.*
Church and altarpieces: Ponz, XII, 1783/1788, pp.
236–7/1947, p. 1098; Cruzada Villaamil, 1870, p. 42, n.
1; Gómez Centurión, 1913–14 (see vol. LXIII, 1913, pp.
20–21); Saltillo, 1954; Salas, 1977.

CATALOGUE

Morales y Marín, 1990, p. 174 (71), p. 319 (12): both
entries refer to the same work.

BIBLIOGRAPHY

Cruzada Villaamil, 1870, pp. 42–3; Viñaza, 1887, p.
205; Marcos Vallaure, 1987; Tomlinson, 1989, pp.
142–3; Morales y Marín, 1990, pp. 315–20.

The sketch of the *Immaculate Conception*, unlined
and in near-perfect condition (cleaned in 1993), is
thinly painted over a beige preparation that covers a
red ground, with very free graphite underdrawing.
Fragments of the original stretcher with the inscrip-
tion in pen and ink are incorporated in the present
stretcher.

In 1780, it was decided that the College of the
Military Order of Calatrava in Salamanca should be
stripped of its unfinished, and ornate (*churrigueres-*
que), decorative elements and remodelled. In June
1782 the Royal Academy in Madrid endorsed a
decision that Pedro Arnal should design three stone
altarpieces for the chapel. The designs were
approved in April 1783, and Goya was commissioned
to make four paintings on specified subjects. His
report of 10 October 1784 describes the finished
paintings and gives their sizes: the *Immaculate*
Conception, whose doctrine the knights of Calatrava

were sworn to uphold, 'three feet (*pies*) high and half
as wide' (3.60 × 1.80 m.), *St Raymond of Fitero*, the
founder of the Order of Calatrava, 'three rods (*varas*)
high by two wide' (2.50 × 1.65 m.), and *St Benedict*,
whose Cistercian rule was followed by the Order, and
St Bernard, 'three rods long and one and three-
quarters wide' (2.50 × 1.45 m.) each. Goya added that
'so that they can go rolled up, the stretchers on which
they are mounted can be dismantled' (fig. 108).

Jovellanos expressed his satisfaction to the Council
in a note added below Goya's (A.H.N., see Docu-
ments, above), and also in a letter to Goya dated the
following day, recommending payment of 20,000
reales for the four works; a copy of his letter was sent
by Goya to Zapater on 13 October (Prado MS 19). By
late 1786, the stone and marble mouldings and altars
had still not been completed, and the chapel was not
inaugurated until the feast of St James, 25 July 1790. In
April of that year, Jovellanos as Visitor, and the Rector
and Secretary of the College, prepared a report on the
state of the chapel, in which the altarpieces and the
paintings are described.

The sketch belonged to Jovellanos, who men-
tioned it in two letters, and it is known, from the
inscription on the stretcher, to have passed to Don
Acisclo Fernández Vallín, a noted pedagogue and
mathematician from Asturias, who donated it to the
mother of one of his pupils. She sold it to the Prado in
1891; it was published by Xavier de Salas in 1977, and
was included in the catalogue of exhibited works
from 1985.

SAN ANTONIO DEL PRADO, MADRID, 1784–1785

14 *The Annunciation, 1784–5*

canvas, 42 × 26 cm

Boston, Museum of Fine Arts, William Francis
Warden Fund (1988.218)

REFERENCES

G–W 235; Gud. 166/151; DeA 178.

PROVENANCE

Eduardo Lucas Moreno, Madrid; Marqués de Casa
Torres, Madrid; (Wildenstein, London); private
collection, Barcelona; (Christie's, London, 29 June
1979, lot 73); (Christie's, London, 11 Dec. 1981, lot
67); S.J. Abate, Jr, Boston; acquired by the Museum of
Fine Arts in 1988.

DOCUMENTS

'Descripción del retablo nuevamente construido en la

Iglesia de S. Antonio del Prado', *Memorial literario*
..., VII, February 1786, pp. 215–8 (extract in *Incun-*
ables goyescos, 1981, p. 300, no. 15).

EXHIBITIONS

Vienna, 1908 (18: Casa Torres); Berlin, 1908 (2);
Bordeaux, 1951 (8); London, 1962 (46); London,
1963–4 (56); The Hague/Paris, 1970 (6b); Madrid/
Boston/New York, 1988–9 (7).

CATALOGUES

Mayer, 1924 (18); Morales y Marín, 1990, p. 180 (73).

BIBLIOGRAPHY

Ponz, V, 1776, pp. 296–7, 1947, pp. 492–3; Cavestany,
1928; Sánchez Cantón, 1946 (*Revista*), p. 290; Mor-
ales y Marín, 1990, pp. 176–9; Tomlinson, 1992, p. 29,
1993, p. 44.

The canvas has a reddish ground covered by a light
beige preparation. The composition was sketched in
graphite on the preparation and then freely brushed
in. The painted area extends to the drawn lines that
limit the composition, leaving the preparation –
which is uncovered in many places within the picture
– visible all round the edges.

Ponz's guide to Madrid (1776) describes the
paintings in the unrestored church of the Capuchin
priests of the Prado, which included works by Pereda
and Palomino in the main altarpiece, and by Luca
Giordano in the side altars. The *Memorial literario*
gives a detailed description of the new altarpiece
crowned by Goya's *Annunciation* (the other compo-
nent parts of the *retablo* have not been identified),
and describes the solemn inauguration on 8
December 1785 (although the later edition of Ponz's
guide makes no reference to the changes in the
church).

Goya's altarpiece, restored and cleaned in 1993, is
here reproduced in colour (fig. 42).

Nothing is known of the early provenance of the
sketch, before its appearance in the late 19th century
or early 20th century in the Lucas Moreno collection,
Madrid. It differs so greatly from the finished altar-
piece that its status as a preparatory sketch has been
doubted (Morales y Marín, 1990). However, the
parallel lines carefully drawn to mark the arched top
of the composition leave no doubt that it corres-
ponds with the format of the painting for the vaulted
church of San Antonio del Prado. In the sketch, the
height of the painted area is 38.1 to 39 or 38.8 to
39.5 cm, taking each of the parallel lines from the
lower to the higher point of the arch; in the large
painting, the corresponding points are at 287 cm and
300.5 cm from the lower edge. Similarly, the relative
proportions and positions of the figures in both
paintings make it clear that the one served as the basis
for the other. (Rita Albertson in Boston and Enrique
Quintana in Madrid supplied the material basis for
these observations.)

ROYAL CONVENT OF SANTA ANA, VALLADOLID, 1787

15 *The Death of St Joseph*, 1787

canvas, 54.5 × 41.1 cm

Flint (Michigan), Flint Institute of Arts, Gift of Mr and Mrs William L. Richards through the Viola E. Bray Charitable Trust (67.19)

REFERENCES

G–W 237; Gud. 245/233; DeA 213.

PROVENANCE

Aureliano de Beruete, Madrid (by 1908); Otto Gerstenberg, Berlin (acquired from Beruete's widow, 1929); (Peter Nathan, Zurich); acquired Flint Institute of Arts, 1967.

DOCUMENTS

Alcocer, 1926, pp. 35–7, docs 7–9; Sambricio, 1946, p. LXXXII, docs 94, 109; *Diplomatario*, 1981, p. 284, no. 133; *Cartas a Zapater*, 1982, pp. 173–34, no. 97.

EXHIBITIONS

Vienna, 1908 (15: Beruete); Berlin, 1908 (1); Madrid, 1928 (78/11: Beruete); London, 1963–4 (65); Paris, 1979 (9); Dallas, 1982–3 (1.3); Madrid/Boston/New York, 1988–9 (14).

BIBLIOGRAPHY

Bosarte, 1804 (ed. 1978, p. 150); Alcocer, 1926, pp. 5–13; Agapito Garcia, 1928, pp. 200–6; Sánchez Cantón, 1946, p. 292; Sánchez Cantón, 1951, pp. 32–3; Morales y Marín, 1979, p. 141, nos. 16–18; M. Pajes Merriman, *Giuseppe Maria Crespi*, Milan, 1980, p. 249, nos. 48–50; *Diplomatario*, 1981, p.241, no. 56; *Cartas a Zapater*, 1982, p. 79, no. 29; J.J. Martín Gonzalez y J. de la Plaza Santiago, *Catálogo monumental. Monumentos religiosos de la cuidad de Valladolid*, Valladolid, 1987, p. 14; Tomlinson, 1989, pp. 148–50; Morales y Marín, 1990, pp. 183–93.

The sketch is lightly brushed onto a canvas with a light beige preparation, and shows extensive, very free, graphite underdrawing.

The differences in composition between the sketch and the altarpiece (fig. 111) have led to doubts about the relationship of the sketch to the painting in Valladolid. However, as in other cases (cat. 10, 14), it is probable that only Goya's first *borrón* has survived, and that one or more further sketches have been lost. Following the suggestion, in April 1787, that Goya and Ramón Bayeu should paint the altarpieces as part of their duties as Painters to the King (Alcocer, doc. 8), a bill for materials from Goya's supplier indicates that 'three primed canvases for sketches' were supplied to him on 7 May, and that on 1 June he was charged, among other items, for '22 rods of blue crimson Holland Cloth to make a tunic and cloak' and for payment 'to the tailor for the confection of each of them' (Sambricio, doc. 109). This suggests that Goya

made studies from draped models or mannequins for Joseph and Mary, as he probably did for all the figures in the large paintings, besides studies for at least the more strongly characterised heads. The paintings in Valladolid are presently in a dull, sunken condition, and the colours have lost their vibrancy, but they are still very impressive. All three were exhibited in Saragossa in 1992 (14–16, catalogued in the wrong order, and with the reproduction of no. 3 in error for no. 16).

Various sources have been cited for Goya's *Death of St Joseph* (summarised by Morales y Marín, 1990, p. 191). The most striking comparison appears to be the painting by Crespi of the same subject (Hermitage Museum, St Petersburg), of which there is a fine copy in Bologna. Since Goya's sketch would reflect a reversed image of the composition, he probably knew the picture from an engraving.

The three paintings commissioned from Ramón Bayeu for the convent in Valladolid face those by Goya, across the floor of the church (see fig. 113). As with the sketches and frescoes for El Pilar (cat. 8, 9), the contrast of styles is striking. In Ramón's altarpieces, the expressions and gestures of the Virgin and saints, surrounded by billowing clouds and little flying angels, appear conventional and unconvincing, and there is no overall unity either of composition or of light.

Isidoro Bosarte, in his *Viaje artístico* published in 1804, under the heading '*Otras pinturas públicas modernas*' referred to the paintings 'in the new church of Santa Ana', citing those by 'Don Francisco Goya, one of his Majesty's two present First Court Painters', and those by Don Ramón Bayeu, with the prudent comment that 'the well-deserved fame of these two accomplished modern artists obviates the necessity to laud each of them individually'.

CHAPEL OF ST FRANCIS BORGIA, VALENCIA CATHEDRAL, 1787–1788

The sketches have remained together since they were painted, and were probably inherited by one of the Osuna children, whose mother commissioned the altarpieces for the Cathedral.

PROVENANCE

Marqués de Santa Cruz, Madrid (by 1846).

DOCUMENTS

Goya's invoice, note of payment (AHN, Osuna): Beruete, II, 1917, p. 33; *Diplomatario*, 1981, p. 441, no. LI (in error, as Valencia Cathedral Archive).

EXHIBITIONS

Madrid, 1846 (4, 6: Santa Cruz); Madrid, 1928 (20/11,

21/13); London, 1963–4 (66, 67); Bordeaux/Paris/Madrid, 1979–80 (18, 19); Madrid, 1983 (11, 12).

BIBLIOGRAPHY

P. de Ribadeneyra, 'Vida del P. Francisco de Borja', *Historias de la Contrarreforma*, Madrid (1592), ed. E. Rey, S.I., Madrid, 1945, pp. 680–81, 811–15; Zapater y Gómez, 1859, p. 39, 1863, p. 40; Yriarte, 1867, pp. 66–7; J.M. Solá and F. Cervós, *El Palacio ducal de Gandía*, Barcelona, 1904; J. Sanchís y Sivera, *La Catedral de Valencia*, Valencia, 1909, pp. 270–76, 523–4; Sánchez Cantón, 1946, pp. 292–94; Sánchez Cantón, 1951, pp. 41–42; Nordström, 1962, pp. 59–75, 1989, pp. 75–93; *Incunables goyescos*, 1981, p. 303, no. 26; Morales y Marín, 1990, pp. 198–208; Morales y Marín, 1991, pp. 81–2.

16 *St Francis Borgia Taking Leave of his Family*, 1787–8

canvas, 38 × 29.3 cm

Madrid, Marchioness de Santa Cruz

REFERENCES

G–W 241; Gud. 257/240; DeA 255.

CATALOGUES

Yriarte, 1867, p. 134 (Santa Cruz); Viñaza, 1887, p. 201 (IV, n.); von Loga, 1903/21 (38); Mayer, 1924 (44); Desparmet Fitz-Gerald, 1928–50 (81); Morales y Marín, 1990, p. 200 (80).

17 *St Francis Borgia Attending a Dying Impenitent*, 1787–8

canvas, 38 × 29.3 cm

Madrid, Marquesa de Santa Cruz

REFERENCES

G–W 244; Gud. 259/242; DeA 227.

CATALOGUES

Yriarte, 1867, p. 134 (Santa Cruz); Viñaza, 1887, p. 201 (IV, n.); von Loga, 1903/21 (40); Mayer, 1924 (46); Desparmet Fitz-Gerald, 1928–50 (83); Morales y Marín, 1990, p. 204 (82).

The two sketches are painted on fairly coarse canvases, their original size rigorously respected when they were lined in an earlier restoration. The ground is seen in many places where the rich reddish tone was used as an essential element in the painting.

The colour is brushed on freely, and forms are 'drawn' with fluid black pigment. Cleaned in 1993, the pictures are in excellent condition.

No documents have been published, apart from Goya's account, dated Madrid, 16 October 1788, and the record of its payment, debited to the Gandía estate, on 22 May 1789. Since Maella's altarpiece is known to have been painted in Valencia, during a leave of absence in the summer of 1787 (Morales y Marín, 1991), Goya's paintings for the side walls in the chapel could have been commissioned at the same time, or after completion of Maella's picture. No official leave of absence has been recorded at this time, so it is possible that he worked on both paintings in Madrid, using drawings or engravings of the ducal palace at Gandía and the chapel in the Cathedral at Valencia.

It has been pointed out that the wide ruffs, in both the drawing and the sketch for the leave-taking scene, were an anachronism since they did not come into fashion until the late 16th century, and were modified by Goya in the large painting (see exh. cat. 1928). Yriarte's story that the dying impenitent was painted naked, and that his draperies were added by another hand, is a romantic fantasy contradicted by the preparatory drawing and sketch. However, the striking nude torso recalls the figure of St Sebastian in the Pilar fresco and its sketch (cat. 9), and anticipates the straining figures in the *Shipwreck* (cat. 41) of 1793–4, and many authors have pointed to the relationship between Goya's figure and the classicising nudes or semi-nudes in similar scenes by David, Greuze and other later 18th-century French artists (see Nordström, 1962, p. 72).

Besides these currently fashionable Neoclassical compositions of which Goya must have been aware, at least through engravings, it is possible that the effect of his painting and to some extent its composition may also have been inspired, especially in its earliest form, by Houasse's *Appearance of St Francis*, then in the Temple of the Noviciado in Madrid (fig. 117), as suggested by Sánchez Cantón (1946, *Revista*, p. 294; see also the exhibition catalogue *Miguel-Ángel Houasse*, Museo Municipal, Madrid, 1981, no. 6).

The figures in the leave-taking appear to have been painted from life studies, perhaps made from the studio models used for *St Bernardino of Siena* (fig. 105), or from the Countess Duchess's entourage.

Zapater y Gómez, in notes first published in 1850 and in a definitive edition in 1859, recorded the sketch for the 'Leave-taking' in the collection of the Marqués de Santa Cruz, and for another subject ('*asunto*') in the life of the Saint, in the collection of the late Francisco Acebal y Arratia. Yriarte saw both works in the Santa Cruz collection before 1867.

Morales y Marín (1990, pp. 198–9, no. 79) publishes what appears to be a later copy of the 'Leave-taking' sketch. Other copies have also been seen in recent years.

Allegory and Genre: Tapestry Cartoons, 1784–1792

A MYTHOLOGICAL ALLEGORY, 1784

18 *Hercules and Omphale,* 1784

canvas, 81 × 64 cm
signed and dated on the sword blade: '*FRANCISCO DE GOYA AÑO 1784*'
Private Collection

REFERENCES
G–W 198; Gud. 158/147; DeA 173.

PROVENANCE
Marqués de la Torrecilla, Madrid (Mayer, 1923); Duque of San Pedro de Galatino, Madrid (by 1928); Marqués de Valdeolmos, Madrid (to 1983).

EXHIBITIONS
Madrid, 1928 (3/73: San Pedro de Galatino).

CATALOGUES
Mayer, 1924 (70); Desparmet Fitz-Gerald, 1928–50 (66).

BIBLIOGRAPHY
Calleja, 1924, pl. 232 (Torrecilla, photo Moreno); Graves, 1985, II; Arnaiz–Montero, 1986, p. 53; Wilson-Bareau, 1992, pp. 259–61.

The painting, unseen except for its appearance in the 1928 exhibition, remained with the heirs of the Marqués de la Torrecilla until recently. Cleaned in 1983, it is in almost perfect condition, unlined (though not on its original stretcher), and with its impasto intact. The red ground is apparent everywhere, and underlies the very thinly and freely brushed, dark-brown background.

Since the early provenance of the painting is unknown, the title by which it is known may not reflect the original identification of the subject. The prominence of Goya's signature and the date suggest that the painting was made for a friend or patron with whom the artist was on close terms, but it may even have been painted for his own collection. In the inventory of 1812, item 16 is listed as *El Congreso de los Dioses* (*The Congress of the Gods*), with the high valuation of 200 *reales*, which could apply to such a finished picture.

The facial type of the women is very similar to that of the Virgin of the *Immaculate Conception* of the same year (cat. 13), and recalls the classic, oval features of María Teresa de Vallabriga. On the family of the Infante Don Luis, see Arnaiz–Montero, 1986. The pet dog is of the same breed as that in the portrait of young Vicente Osorio of *c.* 1786–8 (G–W, no. 231; exh. cat. Martigny, 1982, no. 4).

TAPESTRY CARTOONS, 1786–1792

DINING-ROOM OF THE PRINCE AND PRINCESS OF ASTURIAS, PALACE OF EL PARDO, 1786–1787

Six principal cartoon sketches for tapestries to decorate a dining-room at El Pardo. They were subsequently sold to the Duke and Duchess of Osuna, in 1798, and their history is the same until the Osuna auction in 1896.

PROVENANCE
Duque de Osuna, La Alameda (1798); Osuna sale, Madrid, 1896; thereafter, see provenance notes for each work.

DOCUMENTS
Cruzada Villaamil, 1870; Sambricio, 1946, pp. LI–LXXXI, docs. 78–107 (29 August 1783 – 1 May 1787); Yebes, 1955, p. 43; Gassier–Wilson, 1970, Appx V; *Diplomatario*, 1981, pp. 273–6, nos. 113–8; *Cartas a Zapater*, pp. 156–60, nos. 83–6; Arnaiz, 1987, pp. 221–23, docs XII–XIV.

BIBLIOGRAPHY
Nordström, 1962, pp. 29–58, 1989, pp. 40–74; Pita Andrade, 1979, pp. 237–8; Agueda, 1984, pp. 41–6; Arnaiz, 1987, pp. 137–52, 176–84; Tomlinson, 1989, pp. 156–79, 1993, pp. 204–31.

The sketches are on canvases that do not appear in Goya's Palace accounts and were probably prepared in his own studio. Over the characteristic red ground is a beige preparation, on which the designs are sketched out in graphite. The extraordinarily free underdrawing is conclusive evidence that these are all sketches, rather than later reductions, painted from the cartoons, even though the Duke of Osuna's note authorising payment of Goya's account (dated 6 May 1798) referred to these among 'various paintings which he has made for the study of Her Excellency my wife'.

The sketches correspond with the six principal panels of this decorative series, and besides the corresponding cartoons, a narrow corner panel, four rectangular overdoors and two narrow, rectangular overwindow panels are known or identified from a tapestry.

Any evaluation of the differences between the preparatory oil studies and final cartoons must take into account the fact that while the very small sketches are all in near-perfect condition, the magnificent, painterly qualities of the damaged and much repainted cartoons remain largely obscured, pending their future restoration.

Agueda (1984, p. 45) provides a diagram showing the hypothetical disposition of the tapestries in the dining-room, which is reproduced here (fig. 124).

Documents cited by Cruzada Villaamil, 1870 (CV) and Sambricio, 1946 (S), concerning the weaving of the tapestries may provide information relevant to the completion of the cartoons:

Spring	woven 1788 (cv)
	measured 13 August 1788 (s)
Summer	woven 1788–9 (cv), A. Puñadas
	measured 30 March 1790 (s)
Woman and Two	woven 1788 (cv), A. Puñadas
Children	measured 3 April 1794 (s)
Autumn	woven 1789 (cv), E. Candamo
	measured 8 May 1789 (s)
Winter	woven 1793 (cv)
	measured 30 March 1790 (s)
Mason	woven 1788–9 (cv), A. Puñadas
	no tapestry recorded (s)

The original documents in the Palace archive have not been checked for this publication.

19 *Spring* or *The Flower Girl*, 1786

canvas, 34.2 × 23.9 cm
Private Collection

REFERENCES

G–W 256; Gud. 214/202; DeA 194.

PROVENANCE

Duque de Osuna, La Alameda (1798); Felipe Falcó y Osorio, 8th Duke of Montellano (bought Osuna sale 1896); private collection.

EXHIBITIONS

Madrid, 1896 (75); Madrid, 1928 (9/76); Madrid, 1949 (106); Munich, 1958 (57); Bordeaux, 1959 (151); Paris, 1961–2 (28); Madrid, 1965 (n/n); Madrid, 1983 (18); Lugano, 1986 (9).

CATALOGUES

Yriarte, 1867, p. 143; Viñaza, 1887, p. 282 (XL); von Loga, 1903/21 (88); Beruete, II, 1917 (103); Mayer, 1925 (93); Sambricio, 1946 (40a); Desparmet Fitz-Gerald, 1928–50 (146); Arnaiz, 1987 (44B).

BIBLIOGRAPHY

Cruzada Villaamil, 1870, p. 137, no. XXXI; Sentenach, 1895, pp. 196–9; Tormo, 1902, p. 207; Sambricio, 1946, p. 142; Nordström, 1962, pp. 31–6; Tomlinson, 1989, 158–9, 1993, pp. 207–11.

The title '*La florera*' (*The Flower Girl*) is that given to the tapestry cartoon by Cruzada Villaamil on its discovery in 1869 and published in his catalogue in 1870. For some reason it appeared as *Las floreras* on its first inclusion in the catalogue of the Museo del Prado, in 1899 (*Catalogue illustré des tableaux du Musée du Prado à Madrid. Ecoles espagnoles*, Madrid, 1899).

20 *Summer* or *Harvesting*, 1786

canvas, 33.5 × 79.5 cm
Madrid, Museo Lázaro Galdiano (M. 2510)

REFERENCES

G–W 257; Gud. 216/204; DeA 196.

PROVENANCE

Duque de Osuna, La Alameda (1798); Richard Traumann, Madrid (bought Osuna sale 1896); José Lázaro, Madrid (by 1926).

EXHIBITIONS

Madrid, 1896 (76); Granada, 1955 (90); Madrid, 1961 (LI); Paris, 1961–2 (29); The Hague/Paris, 1970 (7); Brussels, 1985 (10); Lugano, 1986 (10, not exhibited).

CATALOGUES

Yriarte, 1867, p. 143; Viñaza, 1886, p. 282 (XXXIX); Von Loga, 1903/21 (90); Beruete, II, 1917 (100); Mayer, 1924 (95); Sambricio, 1946 (41a); Desparmet Fitz-Gerald, 1928–50 (147); Arnaiz, 1987 (45B).

BIBLIOGRAPHY

Cruzada Villaamil, 1870, p. 138, no. XXXII; Sambricio, 1946, p. 144; Camón Aznar, 1952, p. 7; Nordström, 1962, pp. 37–42; Tomlinson, 1989, pp. 163–5, 1993, pp. 214–16.

21 *Autumn* or *The Grape Harvest*, 1786

canvas, 33.8 × 24 cm
Williamstown, Massachusetts, Sterling and Francine Clark Art Institute (R.S.C. 1939)

REFERENCES

G–W 258; Gud. 218/206; DeA 198.

PROVENANCE

Duque de Osuna, La Alameda (1798); Baron Alquier (Ambassador to Joseph Bonaparte in Spain, before 1813?); by descent to Baron Alquier, Nantes; (Knoedler & Co, New York); R. Sterling Clark, Upperville, Virginia (acquired 1939); Sterling and Francine Clark Art Institute (1955).

EXHIBITION

Dallas, 1982–3 (4).

CATALOGUES

Yriarte, 1867, p. 143, n. (as with Goupil, Paris); Viñaza, 1887, p. 283 (XLI: Goupil, Paris, 1866); Sambricio, 1946 (42a: citing Yriarte); Arnaiz, 1987 (46 B-I).

BIBLIOGRAPHY

Cruzada Villaamil, 1870, p. 139, no. XXXIII; Sambricio, 1946, p. 145; Nordström, 1962, pp. 42–8; Tomlinson, 1989, pp. 159–63, 1993, pp. 211–14.

The sketch (relined and cleaned in 1980) is characterised by very lively brushwork and visible evidence of much graphite underdrawing.

The existence of the original sketch in the collection of Baron Alquier remained unknown until its sale in 1939. Yriarte noted its absence from La Alameda in his catalogue (1867), but identified it with a sketch then offered for sale by Goupil in Paris. Desparmet Fitz-Gerald (1928–50) conflated the two, preceding Goupil's ownership by that of Angel Tadei, Madrid (148), and Arnaiz (1987) lists it as a separate but unseen canvas (46 B-II).

It is possible that the model for the dark-haired child in his fashionable romper-suit was the young son of the Count and Countess of Altamira, Manuel Osorio, whose portrait with bird and cats Goya painted at this time (Metropolitan Museum of Art, New York).

22 *Winter* or *The Snowstorm*, 1786

canvas, 31.7 × 33 cm
Chicago, Art Institute of Chicago, Bequest of Verde C. Graff (1990.558)

REFERENCES

G–W 259; Gud. 220/208; DeA 215.

PROVENANCE

Duque de Osuna, La Alameda (1798); Cerbera, Madrid (acquired Osuna sale 1896); Desparmet Fitz-Gerald, Paris (acquired c. 1910); Demotte, Paris; (E. & A. Silberman, New York, by 1936); Everett D. Graff, Chicago (acquired 1942); Mrs Verde C. Graff; on loan to the Art Institute (from 1977); bequest to Art Institute 1990.

EXHIBITIONS

Madrid, 1896 (74); Chicago, 1941 (12: Silberman); Toledo, Ohio, 1941 (85); New York, 1950 (4); The Hague/Paris, 1970 (8).

CATALOGUES

Yriarte, 1867, p. 143; Viñaza, 1887, p. 282 (XXXVIII); von Loga, 1903/21 (93); Beruete, II, 1917 (102); Mayer, 1924 (98); Sambricio, 1946 (43a); Desparmet Fitz-Gerald, 1928–50 (153); Arnaiz, 1987 (47 B).

BIBLIOGRAPHY

Cruzada Villaamil, 1870, p. 141, no. XXXVI; Nordström, 1962, pp. 48–50; Madrid/Boston/New York, 1988–9, no. 10; Tomlinson, 1989, pp. 165–8, 1993, pp. 216–18.

Yriarte, mistranslated by Viñaza, gave a curiously inaccurate description of this sketch, and even the Osuna sale catalogue referred to 'two men walking . . . leading laden donkeys'.

23 *A Woman and Two Children by a Fountain,* 1786
canvas, 35.4 × 18.4 cm
Madrid, Private Collection

REFERENCES
G–W 261; Gud. 222/216; DeA 219.

PROVENANCE
Duque de Osuna, La Alameda (1798?); Lafora, Madrid (acquired Osuna sale 1896); Duque de Valencia, Madrid; Mercedes de Borbón, Madrid; Carlos Borbón, Madrid; Alonso Ferrer, Madrid; (P. & D. Colnaghi, London, 1960); priv. coll., Hertfordshire, G.-B.; (E.V. Thaw, New York, 1987).

DOCUMENTS
3 January 1794 description of a tapestry in the 'Libro de Medidas': '*representa una muger y dos Muchachos que van por agua a la fuente*' (Sambricio, 1946, p. 256).
1834 Inventory of cartoons in the Tapestry Factory: '*una muger con unos chicos que van por agua*' (Sambricio, 1946, doc. 279, p. CLXXIV).
1867 description of the sketch (see below under Catalogues: Yriarte).
1869–70 description of the cartoon: '*Los pobres*': A poor woman numb with cold standing by a fountain and accompanied by two boys, is waiting for the pitcher to fill with water from the spout. Background is a landscape covered in snow' (Cruzada Villaamil, 1870, pp. 50–1, 140–1, no. XXXV).
1896 Osuna exhibition and sale of the sketch (see below under Exhibitions).

CATALOGUES
Yriarte, 1867, p. 145 (*Une femme et deux enfants à la fontaine*); Viñaza, 1887, p. 281 (XXX: *Una mujer y dos niños junto a una fuente*); Von Loga, 1903/21 (558); Beruete, II, 1917 (101); Mayer, 1924 (681); Desparmet Fitz-Gerald, 1928–50 (149); Sambricio, 1946 (45a); Arnaiz, 1987 (49B).

EXHIBITIONS
Madrid, 1896 (81: *Una mujer y dos niños junto a una fuente*); Madrid, 1908 (3661); The Hague/Paris, 1970 (9).

BIBLIOGRAPHY
Cruzada Villaamil, 1870, p. 140, no. XXXV; Nordström, 1962, pp. 50–54, figs. 21, 23 (Viladomat's *Allegory*); Agueda, 1984, p. 44; Tomlinson, 1989, pp. 175, 179, 1993, pp. 228, 231.

This subject is not accounted for in the order of payment, dated 26 April 1799, for Goya's cartoon sketches invoiced to the Osunas on 6 May 1798, and it may have been received as a gift from the artist or acquired without documentation at a later date. See also cat. 24, 27.

24 *The Drunken Mason,* 1786
canvas, 34.9 × 15.3 cm
Madrid, Museo del Prado (2783)

REFERENCES
G–W 260; Gud. 224/212; DeA 202.

PROVENANCE
Duque de Osuna, La Alameda (1798?); Pedro Fernández-Durán, Madrid (acquired Osuna sale 1896); bequest to the Museo del Prado (1930).

EXHIBITIONS
Madrid, 1896 (82); Madrid, 1972 (796); Hamburg, 1981 (284); Rotterdam/Brunswick, 1983–4 (81).

CATALOGUES
Yriarte, 1867, p. 145; Viñaza, 1887, p. 282 (XXXI); von Loga, 1903/21 (579); Beruete, II, 1917 (99); Mayer, 1924 (705); Sambricio, 1946 (44a); Desparmet Fitz-Gerald, 1928–50 (145); Arnaiz, 1987 (48B).

BIBLIOGRAPHY
Cruzada Villaamil, 1870, p. 140, no. XXXIV; Sambricio, 1946, p. 147; Nordström, 1962, pp. 55–6; Helman, 1963, pp. 30–33, 217–8; Held, 1971, p. 58; Young, 1973, p. 45; Madrid/Boston/New York, 1988–9, no. 13; Tomlinson, 1989, pp. 175–9, 1993, pp. 228–31.

This subject is not accounted for in the order of payment for Goya's cartoon sketches to the Osunas on 26 April 1799 (see cat. 23).

The work was restored and cleaned in 1993, and is in an excellent state of conservation.

BEDCHAMBER OF THE INFANTAS, EL PARDO, 1788

PROVENANCE
Duque de Osuna, La Alameda (1798); Osuna sale, Madrid (1896); thereafter see Provenance notes for the individual works.

DOCUMENTS
Invoices for materials supplied: 7 February–30 April 1788: Sambricio, 1946, pp. LXXXIII–V, docs. 111–14; *Diplomatario*, 1981, pp. 290–91 (145); Arnaiz, 1987, pp. 224–5, docs. XV, XVI (MS invoices).
Goya's letter to Zapater 31 May 1788: *Diplomatario*, 1981, p. 289 (143); *Cartas a Zapater*, 1982, pp. 182–24 (104).
Goya's invoice for sketches 6 May 1798 and the Duke of Osuna's payment order 26 April 1799: Sentenach, 1895, p. 199; Sambricio, 1946, p. CXXVII, doc. 192; Gassier–Wilson, 1970, Appx V, pp. 383–4; *Diplomatario*, 1981, pp. 469–70 (XCIV).

BIBLIOGRAPHY
Sambricio, 1946, pp. 154–7; Held, 1971, pp. 53–62, 142–5 (Castillo: 243–53); Arnaiz, 1987, pp. 153–8, 176–8; Tomlinson, 1989, pp. 179–86, 1993, pp. 231–9.

The sketches are all painted in a similar technique, with very free graphite underdrawing on the beige preparation applied over a reddish ground. The underdrawing in all the paintings, including *Blind Man's Buff* from which the only cartoon was executed, indicates that these are all preparatory sketches, rather than later, independent paintings, as some have held.

The room for which Goya was to make cartoons is specified in the accounts for 'a hundred rods [*varas*] of St Jorge cloth for the tapestries for the bedchamber of the Most Serene Infantas', and the carpenter's account for the stretchers: 'one stretcher for the paintings for the tapestries which are to hang in the bedchamber of the Most Serene Infantas in El Pardo'. The 100 *varas* (over 80 metres) of canvas were purchased on 7 February 1788, and on 10 April the carpenter delivered the stretchers for the cartoons, including the one for the *Meadow of San Isidro*, which was never used but measured over 7.5 metres wide.

The designs for the Bedchamber were devised for the three daughters of the Prince and Princess of Asturias, of whom the second, María Amalia, was born in 1779 and died in 1798, four years after her marriage to her uncle the Infante Antonio Pascual; not having attained her majority at the time of her death, she is sometimes omitted from the Bourbon genealogies.

25 *The Hermitage of San Isidro,* 1788
canvas, 42 × 44 cm
Madrid, Museo del Prado (2783)

REFERENCES
G–W 273; Gud. 253/246; DeA 247.

PROVENANCE
Duque de Osuna, La Alameda (1798); Pedro Fernández Durán, Madrid (bought Osuna sale 1896); by bequest to Museo del Prado, 1930.

EXHIBITIONS
Madrid, 1896 (79); Mexico City, 1978 (33); Bordeaux/Paris/Madrid, 1979–80 (20/16); Madrid, 1992–3 (50).

CATALOGUES

Yriarte, 1867, p. 143; Viñaza, 1887, p. 281 (XXVII); von Loga, 1903/21 (470); Mayer, 1924 (582); Sambricio, 1946 (54); Desparmet Fitz-Gerald, 1928–50 (168); Arnáiz, 1987 (59B).

BIBLIOGRAPHY

Sánchez Cantón, 1951, p. 40; Salas, 1979, p. 23; Arnáiz, 1987, pp. 177–9, 306 (59D: drawing); Tomlinson, 1989, pp. 180–2, 1993, pp. 232–4.
For José del Castillo: Held, 1971, pp. 133, 142, no. 243; exh. cat. Madrid (Municipal), 1992–3, no. 46.

The painting, restored and cleaned in 1993, is in good condition, unlined and on its original stretcher.

The sketch was probably one of the 'two rustic subjects' sold by Goya to the Osunas in 1798.

26 The Meadow of San Isidro, 1788

canvas, 41.9 × 90.8 cm
Madrid, Museo del Prado (750)

REFERENCES

G–W 272; Gud. 252/245; DeA 246.

PROVENANCE

Duque de Osuna, La Alameda (1798); Museo del Prado (bought Osuna sale, 1896).

EXHIBITIONS

Madrid, 1896 (66); Bordeaux/Paris/Madrid, 1979–80 (21/17); Leningrad/Moscow, 1980 (28); Madrid/Boston/New York, 1988–9, (16), Madrid (Municipal), 1992–3 (51).

CATALOGUES

Yriarte, 1867, p. 143; Viñaza, 1886, p. 280 (XXVI); von Loga, 1903/21 (469); Beruete, II, 1917 (119); Mayer, 1925 (581); Desparmet Fitz-Gerald, 1928–50 (166); Sambricio, 1946 (53); Arnáiz, 1987 (58B).

BIBLIOGRAPHY

Sánchez Cantón, 1951, p. 39; Salas, 1979, pp. 169; Arnáiz, 1987, pp. 177, 303–5; Tomlinson, 1989, pp. 180–2, 1993, pp. 232–4.
For Joli: J. Urrea, *La pintura italiana en el siglo XVIII*, Valladolid, 1977, pp. 151–6.
For Castillo: see cat. 25, Bibliography: Held, 1971.

The painting, restored in 1987, is in good condition, unlined and on its original stretcher.

The sketch was invoiced by Goya to the Osunas on 6 May 1798, and listed in the Duke's order for payment dated 26 April 1799 as '*la Pradera de San Ysidro*'.

A preparatory drawing (not in G–W) was published by Salas, 1979, from an old photograph.

27 The Picnic, 1788

canvas, 41.3 × 25.8 cm
London, The Trustees of the National Gallery (1471)

REFERENCES

G–W 274; Gud. 254/247; DeA 248.

PROVENANCE

Duque de Osuna, La Alameda (1798); National Gallery, London (bought Osuna sale, 1896).

EXHIBITIONS

Madrid, 1896 (78); London, 1947 (8); London, 1981 (66).

CATALOGUES

Yriarte, 1867, p. 144; Viñaza, 1887, p. 281 (XXIX); von Loga, 1903/21 (451); Beruete, II, 1917 (122); Mayer, 1924 (563); Sambricio, 1946 (56); Desparmet Fitz-Gerald, 1928–50 (163); Arnaiz, 1987 (61B).

BIBLIOGRAPHY

Cruzada Villaamil, 1870, p. 111 (I); MacLaren–Braham, 1970, pp. 9–11, no. 1471; Arnaiz, 1987, pp. 177, 303–5; Tomlinson, 1989, pp. 184–5, 1993, p. 237.

The painting was lined and cleaned on its acquisition in 1896, and now shows an additional lining canvas strip round all four edges (new stretcher measurement). The work was restored and cleaned in 1987. Infra-red photography shows up strong brush drawing in black on the central figure's breeches, similar to that seen in the 1793–4 tinplate paintings and many of Goya's later series (cat. 32–43, 74–81).

This miniature-like 'sketch' is related in size and technique to the others in the series, and its proportions correspond with those of the third stretcher on the carpenter's list (12.5 × 8 *pies*), giving it a cartoon size of 347.5 × 222.5 cm.

Arnaiz has suggested that this is the sketch for *Autumn* (cat. 21) that was missing from the Osuna collection by 1867, in spite of the fact that its dimensions do not correspond with those of the earlier series.

Tomlinson (1989, 1993) rejects this work as a sketch for the tapestry series intended for the children's bedchamber, on grounds of its impropriety, and suggests that it may have been painted to accompany the seven works sold by Goya to the Osunas in 1798.

28 Blind Man's Buff, 1788

canvas, 41 × 44 cm
Madrid, Museo del Prado (2781)

REFERENCES

G–W 275; Gud. 255/248; DeA 234.

PROVENANCE

Duque de Osuna, La Alameda; Pedro Fernández Durán, Madrid (bought Osuna sale, 1896); by bequest to Museo del Prado (1930).

EXHIBITIONS

Madrid, 1986 (80); Mexico City, 1978 (32); Leningrad/Moscow, 1980; Hamburg, 1980–81 (286); Munich, 1982 (19).

CATALOGUES

Yriarte, 1867, p. 143–4; Cruzada Villaamil, 1870, p. 146 (XLIV); Viñaza, 1887, p. 281 (XXVIII, following Yriarte); von Loga, 1903/21 (457); Beruete, II, 1917 (106); Mayer, 1924 (569); Sambricio, 1946 (55a); Desparmet Fitz-Gerald, 1928–50 (157); Arnáiz, 1987 (45B).

BIBLIOGRAPHY

Cruzada Villamil, 1870; Sánchez Cantón, 1951, p. 39; Bozal, 1983, pp. 86–90; Tomlinson, 1989, pp. 183–4, 1993, pp. 235–7.

The painting was restored and cleaned in 1993 and, like the other sketches in the Prado (cat. 25, 26), is in good condition, unlined and on its original stretcher.

The sketch has the same characteristics, in size and technique, as all the others and must have been prepared for this series, although the cartoon has evidently been cut down and corresponds in format with neither the sketch nor the stretcher in the carpenter's list, nor with the tapestry that was woven from the cartoon by 19 July 1790 (see Sambricio, and Arnaiz, 1987, p. 308, no. 60T). Like cat. 25, it was probably one of the 'two rustic subjects' sold to the Osunas in 1798.

29 The Cat at Bay, 1788

canvas, 42 × 15.5 cm
Private Collection

REFERENCES

G–W–; Gud. 233/221; DeA–.

PROVENANCE

Hulot, Paris (Vente Hulot, Hôtel Drouot, Paris, 9 May 1892, lot 135; Camille Groult, Paris (bought Hulot sale); (Vente Groult, Galerie Charpentier, Paris, 21 March 1952, lot. 78); Jorge Ortiz Linares (bought Groult sale); thence by descent.

CATALOGUES

Desparmet Fitz-Gerald, 1928–50 (144); Arnaiz, 1987 (57B, attributed to Ramón Bayeu).

BIBLIOGRAPHY

Arnaiz, 1987, p. 193.

Thinly painted on a beige preparation on the unlined canvas, the sketch corresponds in its proportions and

technique with the others in this series.

The expressions of the laughing men are very similar to those of the two carrying the drunken mason in the preceding series of tapestry cartoon sketches (cat. 24). The dog recalls the one in a lost of cartoon of 1780 (Gassier–Wilson, no. 134). See Tomlinson, 1989, pp. 156–7, 1993, pp. 204–5, for her views on the *Fighting Cats* cartoon (fig. 135).

THE KING'S STUDY ('DESPACHO DEL REY'), EL ESCORIAL, 1791–1792

The two surviving sketches for the series of cartoons for tapestries for the palace apartments at San Lorenzo, El Escorial.

DOCUMENTS

Subject-matter ('*asumptos de cosas campestres y jocosas*'), 'rustic and light-hearted subject-matter': Sambricio, 1946, doc. 129.
Goya's delay: idem, docs. 131–44.

BIBLIOGRAPHY

Sambricio, 1946, pp. 170–1; Chan, 1985; Arnaiz, 1987, pp. 157–71, 194–5; Tomlinson, 1989, pp. 187–210, 1993, pp. 261–70; Baticle, 1992, pp. 170–4.

Both the known sketches for this series of cartoons are painted on a thick, irregularly woven canvas, primed with a reddish ground that is visible through the thinner paint layers and is left unpainted round all four edges. Both show chalk or graphite underdrawing, and evidence of considerable pentimenti in the course of work.

The tapestries woven from this series of cartoons were completed and measured between December 1792 (*The Stilts*) and March 1793 (*The Wedding*), with *The Straw Manikin* measured on 14 May and *Girls with Water-jars* on 30 July 1793.

30 *Girls with Water-jars*, 1791
canvas, 34.4 × 21.5 cm
Madrid, Paloma Mac-Crohon Garay Collection

REFERENCES

G–W 295; Gud. 296/267; DeA 253.

PROVENANCE

Javier Goya, Madrid?; Mariano Goya, Madrid?; Francisco de Acebal y Arratia, Madrid; Luis Mac-Crohon, Madrid (by 1928).

EXHIBITIONS

Madrid, 1928 (10/83: Mac-Crohon); Madrid, 1949 (102); Madrid, 1983 (19).

CATALOGUES

Sambricio, 1946 (57a); Desparmet Fitz-Gerald, 1928–50 (38); Arnaiz, 1987 (63B).

BIBLIOGRAPHY

Cruzada Villaamil, 1870, p. 142, no. XXXVIII; Haraszti-Takács, 1975, pp. 118–19; Bozal, 1983, p. 79.

The painting, cleaned in 1993 and in good condition, shows the red ground uncovered to a width of 7 mm from the canvas edges.

The large '*X.13*' on the back of the picture appears to identify it as part of the inventory of 1812, although the *Knife-grinder* and *Water-carrier* now in Budapest (cat. 92, 93) are generally supposed to be the two paintings listed under this number (Gassier–Wilson, 1970, p. 381, Appx I, no. 13). Since it appears that Goya's son or grandson may have substituted other works for those listed in the inventory but already sold, the sketch may be an example of this practice.

31 *The Straw Manikin*, 1791
canvas, 35.6 × 23.2 cm
Los Angeles, Armand Hammer Museum of Art and Cultural Center, The Armand Hammer Collection (90.36)

REFERENCES

G–W 296; Gud. 300/271; DeA 255.

PROVENANCE

Juan Lafora, Madrid (by 1928); Beatriz Sánchez de la Fuente de Lafora, Madrid (in 1949); (Tomás Harris Ltd, London); (Knoedler/Pinakos Inc., New York, acquired 1953); Henry R. Luce, New York (acquired 1955); Armand Hammer, Los Angeles.

EXHIBITIONS

Madrid, 1949 (109: Sánchez de la Fuente de Lafora); New Haven, Conn., 1956 (29); USA (circulating exhibition), 1969–74; Mexico City, 1977 (35).

CATALOGUES

Sambricio, 1946 (58a); Arnaiz, 1987 (64B-a).

BIBLIOGRAPHY

Cruzada Villaamil, 1870, p. 145, no. XLII; Lafora, 1928–29, p. 361; Chan, 1985; Tomlinson, 1989, pp. 207–8, 1993, pp. 266–7.

An almost identical version of the present sketch, lacking pentimenti and other characteristics of the original, is probably a later replica or copy: G–W 297, Gud. 301/272; DeA 255; Arnaiz, 1987, 64B-b.

Cabinet Pictures: 'Capricho and Invention', 1793–1794

BULLS AND BULLFIGHTING, 1793
'CAPRICHOS' AND INVENTIONS, 1793–1794

These two groups of paintings forming Goya's 'set of cabinet pictures' are identified with the eleven pictures on 'various themes of national pastimes' known to have been presented to the San Fernando Academy on 5 January 1794, and the twelfth (cat. 43) completed after 7 January. They are also assumed to be included in the group of 'fourteen sketches on panel which represent various scenes of bullfights, shipwrecks, robberies, fires, a fire at night, etc. [by] Goya' that appears in an extensive list of paintings from the estate of Doña Angela Sulpice Chopinot. The paintings were selected by the Court Painter Jacinto Gómez on behalf of Manuel Godoy, the Prince of the Peace, and they included the sketches by Francisco and Ramón Bayeu and Goya for the frescoes in El Pilar (cat. 8, 9).

The date of Angela Sulpice Chopinot's death is unknown, but the sketches for El Pilar were acquired by the Cabildo in August 1805, and the list must therefore have been made before this date. Many of the paintings in the Chopinot estate had been acquired by Léonard Chopinot from the estate of Francisco Bayeu who died 4 August 1795, exactly one month before Godoy was made Prince of the Peace. Jacinto Gómez was one of Francisco Bayeu's executors and also the person who drew up the list of pictures for Godoy, suggesting a connection between these various events, and Chopinot may originally have acquired Goya's paintings at the same time as those from the Bayeu estate, with a view to selling them to Godoy.

That Goya had fallen ill and been taken from Seville to Cadiz before 5 January 1793 (the date of Sebastián Martínez's 'first' letter to Zapater) appeared proved by Zapater's letter published by Gimeno with the date 19 January, and led to the view that his friends made arrangements to cover his departure from Madrid, before the granting of a leave of absence on an unspecified date in January. However, Nigel Glendinning has suggested (oral communication, December 1993) that the date of 19 January (*enero*) might be a misreading or printer's error for March (*marzo*), in which case his relapse in Seville would have occurred during convalescence after his illness in Madrid. Camellas López (1988) published the correct date, but without commenting on the earlier error. Examination of Zapater's *borrador* (draft), for which we are indebted to Ignacio Calvo, has confirmed the date of March 1793.

Goya's illness – the symptoms suggest to some a kind of stroke allied perhaps to acute meningitis, while others have seen it as a particular manifestation of syphilis – has recently been identified as the cumulative effect of lead poisoning that had already affected Goya at various times (Rodríguez Torres, 1994). The manifestation occurred in late 1792 and more severly in March 1793. It has also been connected with Goya's involvement in political events in France and Spain (Baticle, 1988–9, pp. 207–8).

PROVENANCE

Léonard Chopinot, Madrid (before 1800?); Angela Sulpice Chopinot, Madrid (before 1805); thereafter, see individual catalogue entries.

DOCUMENTS

Goya's illness: Gimeno, 1917; Sambricio, 1946, docs. 157–77; *Diplomatario*, 1981, pp. 453–8, nos. LXVI–LXXV; *Cartas a Zapater*, 1982, pp. 210–20, nos. 123–9; Camellas López, 1988, pp. 12–13.
Goya–Iriarte correspondence (British Museum, London, MSS Egerton 585, ff. 74–6): Calleja, 1924, pp. 53–4; Gassier–Wilson, 1970, pp. 108, 110, repr., 382, Appx IV; *Diplomatario*, 1981, pp. 314–6, nos. 188–90. Chopinot inventory (Biblioteca Nacional, Madrid, MS 20065/10): Salas, 1968–9, p. 30.

BIBLIOGRAPHY

Saltillo, 1952, pp. 23–33, 68–80, doc. 8; Salas, 1968; Glendinning, 1977, pp. 46–7; 1982, pp. 60–61; Pemán, 1978; Glendinning, 1981, pp. 244–5; Baticle, 1988–9, pp. lix–lx; Tomlinson, 1989, pp. 211–7, 1993, pp. 271–90; Baticle, 1992, pp. 191–213; Pemán Medina, 1992; Glendinning, 1992 (Aragón), pp. 137–8; Glendinning, 1992 (*Retratos*), pp. 24–33, 56–7; Rodríguez Torres, 1993 (pp. 43–6).

The twelve paintings catalogued here are all painted on thin metal sheets plated with almost pure tin. The rectangular shapes were scissor-cut and are slightly uneven. Most of the sheets are 'free' – only two (cat. 34, 43) have been applied to panel or cradled – and are warped and bent. It appears that the reddish-beige preparation was thickly applied, usually with vertical brushstrokes, over a very thin red ground.

Many of the plates have one or more numbers on the verso. Their significance is at present unclear, but the numbers are indicated in the individual catalogue entries.

BULLS AND BULLFIGHTING, 1793

Eight scenes on tinplate relating to bullfighting are known, including the six catalogued here and two others on another type of tinplate, with a different preparation and in a different style (G–W 320, 324),

that may have been added to the series after the completion of the set of twelve paintings in January 1794. This could account for the total of fourteen pictures listed in the Chopinot inventory.

All the bullfight paintings were said by Desparmet Fitz-Gerald, without citing a source, to have belonged to Ceán Bermúdez (died 1829). Yriarte, in 1867, noted that the two owned by Paul Lefort (cat. 32, 35) came from the family of Ceán Bermúdez; the others had not yet been acquired by the Marqués de la Torrecilla, according to his catalogue.

BIBLIOGRAPHY

Calleja, 1924, pl. 306–9; Cossío, (1947), 1980, I, pp. 512–4; Lafuente Ferrari, (1947), 1980, pp. 751–9; Martínez Novillo, 1988, pp. 52–5; Baticle, 1992, pp. 211–3.

32 *Sorting the Bulls, or Bulls in the Watercourse,* 1793
tinplate, 42.6 × 32 cm
verso numbers: 5 and *9*
Private Collection

REFERENCES

G–W 317; Gud. –/299; DeA 269.

PROVENANCE

Léonard Chopinot, Madrid (before 1800?); Angela Sulpice Chopinot, Madrid (before 1805); Juan Agustín Ceán Bermúdez, Seville/Madrid (?); Paul Lefort, Paris (by 1859); Carlin, Paris; (Vente Carlin, Hôtel Drouot, Paris, 29 April 1872, lot 15); C.G. de Candamo, Paris (bought Carlin sale); (Vente Candamo, Galerie Charpentier, Paris, 14–15 December 1933, lot 35, pl. VIII); Thierry Delanoue, Paris (bought Candamo sale); thence by descent.

EXHIBITION

Paris, 1961–2 (12).

CATALOGUES

Yriarte, 1867, p. 149 (Lefort); Viñaza, 1887, p. 292 (CII); von Loga, 1903/21 (534); Mayer, 1924 (654a); Desparmet Fitz-Gerald, 1928–50 (137).

BIBLIOGRAPHY

Lefort (1859), p. 3, repr.; Salas, 1968–9, p. 30; exh. cat. Arles/Madrid, 1990, p. 31/52, repr.

The painting, cleaned in 1993, is in an excellent state of conservation.

33 *Banderillas in the Countryside,* 1793
tinplate, 43.1 × 32 cm
verso number: *11*
Oviedo, Masaveu Collection

REFERENCES

G–W 319; Gud. 274/301; DeA 271.

PROVENANCE

Léonard Chopinot, Madrid (before 1800?); Angela Sulpice Chopinot, Madrid (before 1805); Juan Agustín Ceán Bermúdez, Seville/Madrid(?); Marqués de la Torrecilla, Madrid (after 1867); Pedro Masaveu, Oviedo (acquired by 1961?).

EXHIBITIONS

Paris, 1961–2 (11); Madrid, 1989 (35); Arles/Madrid, 1990 (3/4).

CATALOGUES

Mayer, 1924 (667d); Desparmet Fitz-Gerald, 1928–50 (132).

The painting, cleaned in 1993, is in very good condition.

34 *Bull Held by a Cord,* 1793
tinplate, 42.9 × 31.6 cm
Private Collection

REFERENCES

G–W 318; Gud. 273/300; DeA 270.

PROVENANCE

Léonard Chopinot, Madrid (before 1800)?; Angela Sulpice Chopinot, Madrid (before 1805); Juan Agustín Ceán Bermúdez, Seville/Madrid(?); Marqués de la Torrecilla, Madrid (after 1867); private collection, Madrid; (J.-F. Sedlmajer, Geneva, acquired 1990).

EXHIBITIONS

Paris, 1961–2 (12); Arles/Madrid, 1990 (2/0).

CATALOGUES

Mayer, 1924 (667a); Desparmet Fitz-Gerald, 1928–50 (130).

BIBLIOGRAPHY

exh. cat. Arles/Madrid, 1990, p. 54, repr.

The tinplate, apparently in good condition but showing yellowed varnish, is backed by a panel and it was not possible to inspect the verso for numbers.

35 *Death of a Picador*, 1793

tinplate, 43 × 31.9 cm
verso numbers: *3* and *2*
London, British Rail Pension Trustee Co.

REFERENCES

G–W 322; Gud. 277/304; DeA 274.

PROVENANCE

Léonard Chopinot, Madrid (before 1800?); Angela Sulpice Chopinot, Madrid (before 1805); Juan Agustín Ceán Bermúdez, Seville/Madrid(?); Paul Lefort, Paris (by 1859); Carlin, Paris; (Vente Carlin, Hôtel Drouot, Paris, 29 April 1872, lot 16); C.G. de Candamo, Paris (bought Carlin sale); (Vente Candamo, Galerie Charpentier, Paris, 14–15 December 1933, lot 34, pl. VII); Cotnareanu, New York (bought Candamo sale); Coty, New York/Paris; (Brame & Lorenceau, Paris); acquired British Rail Pension Fund 1977.

EXHIBITIONS

Paris, 1874 (821); Bordeaux, 1951 (2); Arles/Madrid, 1990 (6/7).

CATALOGUES

Yriarte, 1867, p. 149 (Lefort); Viñaza, 1887, p. 292 (CI); von Loga, 1903/21 (539); Mayer, 1924 (660); Desparmet Fitz-Gerald, 1928–50 (136).

BIBLIOGRAPHY

Lefort (1869), p. 5 repr., p. 12; Glendinning, 1992 (*Retratos*), p. 33.

36 *Pass with the Cape*, 1793

tinplate, 43.1 × 32 cm
verso number: *2*
Madrid, Conde de Villagonzalo

REFERENCES

G–W 321; Gud. 276/303; DeA 273.

PROVENANCE

Léonard Chopinot, Madrid (before 1800?); Angela Sulpice Chopinot, Madrid (before 1805); Juan Agustín Ceán Bermúdez, Seville/Madrid(?); Marqués de la Torrecilla, Madrid (after 1867); Marqesa de Valdeolmos, Madrid (inherited 1925).

EXHIBITIONS

Madrid, 1984 (3); Arles/Madrid, 1990 (5/6).

CATALOGUES

Mayer, 1924 (667c); Desparmet Fitz-Gerald, 1928–50 (133).

37 *Matador Killing the Bull*, 1793

tinplate, 43 × 31.9 cm
verso number: *9*
Casilda-Ghisla Guerrero Burgos y Fernández de Córdoba

REFERENCES

G–W 323; Gud. 278/305; DeA 275.

PROVENANCE

Léonard Chopinot, Madrid (before 1800?); Angela Sulpice Chopinot, Madrid (before 1805); Juan Agustín Ceán Bermúdez, Seville/Madrid(?); Marqués de la Torrecilla, Madrid (after 1867); Duquesa de Cardona, Madrid (by 1961).

EXHIBITIONS

Paris, 1961–62 ([13], omitted in error from the catalogue); Bordeaux, 1985 (13); Arles/Madrid, 1990 (00/8).

CATALOGUES

Mayer, 1924 (667e); Desparmet Fitz-Gerald, 1928–50 (134).

BIBLIOGRAPHY

exh. cat. Arles/Madrid, 1990, p. 42.

The painting was cleaned in 1993. The precisely painted architectural construction underlying the figures is less apparent here than in the other bullring scenes (cat. 35, 36).

'CAPRICHOS' AND INVENTIONS, 1793–1794

The technical characteristics of these six paintings are the same as those of the scenes with bulls (cat. 32–37), emphasising the underlying unity of the series in spite of stylistic differences.

38 *The Strolling Players*, 1793–4

tinplate, 42.5 × 31.7 cm
inscribed lower left: '*ALEG[ORIA] MEN[ANDREA]*'
verso numbers: *5, 8, 15* (?)
Madrid, Museo del Prado (3045)

REFERENCES

G–W 325; Gud. 344/307; DeA 344.

PROVENANCE

Léonard Chopinot, Madrid (before 1800?); Angela Sulpice Chopinot, Madrid (before 1805); Conde de Adanero, Madrid (by 1867); Conde de Castro Serna, Madrid; Vizcondes de Roda, Madrid; Ramón Jordán de Urries, Madrid (by 1961); acquired for Museo del Prado, 1962.

EXHIBITIONS

Madrid, 1900 (172 supplement, as *Juegos malabares*); Granada, 1955 (101: San Clemente); Madrid, 1961. (LXIII); Madrid, 1969, p. 27 (3045); Madrid, Palacio de Exposiciones y Congresos, *Exposición histórica del teatro*, 1970.

CATALOGUES

Yriarte, 1867, p. 138 (Adanero); Viñaza, 1887, p. 295 (CXVII: Castro Serna); von Loga, 1903/21 (477); Mayer, 1924 (588); Desparmet Fitz-Gerald, 1928–50 (128).

BIBLIOGRAPHY

Arnaiz, 1987, pp. 198–9; Tomlinson, 1989, pp. 217–8, 1993, pp. 24–5.

Unusually in this series, the ground was applied horizontally across the tinplate. Furthermore, infrared reflectography reveals much vigorous graphite underdrawing, also apparent to the eye, which is not a characteristic of the other paintings in the series and suggests a close relationship with the tapestry cartoon sketches.

Cleaned in 1993, the work is in very good condition. This and two other works (cat. 39, 40) are in identical gilt frames (probably dating from the mid–19th century), which were copied for all the other pictures from this series in the exhibition.

39 *Fire at Night*, 1793–4

tinplate, 43.2 × 32 cm
verso numbers: *4, 7*
BANCO INVERSION-AGEPASA, Madrid

REFERENCES

G–W 329; Gud. 345/312; DeA 281.

PROVENANCE

Léonard Chopinot, Madrid (before 1800?); Angela Sulpice Chopinot, Madrid (before 1805); Conde de Adanero, Madrid (by 1867); Conde de of Castro Serna, Madrid (by 1900); Conde de Campo Giro, Madrid; Flor Milicua, Bilbao; José Várez Fisa, San Sebastian (by 1970).

DOCUMENTS

Chopinot inventory (see above, p. 358): '*yncendios, un fuego de noche*'.

40 *Attack by Robbers,* 1793–4

tinplate, 42.7 × 31.7 cm
verso numbers: *3, 4*
BANCO INVERSION-AGEPASA, Madrid

REFERENCES

G–W 327; Gud. 347/311; DeA 278.

PROVENANCE

Léonard Chopinot, Madrid (before 1800?); Angela Sulpice Chopinot, Madrid (before 1805); Count of Adanero, Madrid (by 1867); Conde de Castro Serna, Madrid (by 1900); Marqués Conde de Adanero, Madrid??.

DOCUMENTS

Chopinot inventory (see above, p. 358): '*asalto de ladrones*'.

EXHIBITIONS

Madrid, 1900 (173 supplement: Castro Serna); Madrid, 1961 (LVII).

CATALOGUES

Yriarte, 1867, p. 138 (Adanero); Viñaza, 1887, p. 295 (CXIX); von Loga, 1903/21 (490); Mayer, 1924 (601); Desparmet Fitz-Gerald, 1928–50 (127).

BIBLIOGRAPHY

Glendinning, 1982, p. 64; Bozal, 1987, p. 124.

41 *Shipwreck,* 1793–4

tinplate, 43 × 31.8 cm
verso numbers: *1, 10*
Private Collection

REFERENCES

G–W 328; Gud. 346/310; DeA 280.

PROVENANCE

Léonard Chopinot, Madrid (before 1800?); Angela Sulpice Chopinot, Madrid (before 1805); Count of Adanero, Madrid; Conde de Castro Serna, Madrid (by 1900); Marqués de Oquendo, Madrid (by inheritance, by 1961).

DOCUMENTS

Chopinot inventory (see above, p. 358): '*naufragios*'.

EXHIBITIONS

Madrid, 1900 (174 supplement: Castro Serna); Madrid, 1928 (58/87: Oquendo); Madrid, 1983 (21: Plácido Arango Arias); Lugano, 1986 (19); Saragossa, 1992 (22).

CATALOGUES

von Loga, 1903/21 (565); Mayer, 1924 (688); Desparmet Fitz-Gerald, 1928–50 (126).

BIBLIOGRAPHY

Tormo, 1902, p. 221; Sariñena, 1928, p. 92; Salas, 1950, pp. 337–46; Sánchez Cantón, 1951, p. 115; Gállego, 1981, pp. 32–3; Wolf, 1987, p. 233; Agueda, 1991, pp. 171–4.

42 *Interior of a Prison,* 1793–4

tinplate, 42.9 × 31.7 cm
verso number: *2* (?)
Barnard Castle, Co. Durham, The Bowes Museum (29)

REFERENCES

G–W 929; Gud. 470/313; DeA 532.

PROVENANCE

Léonard Chopinot, Madrid (before 1800?); Angela Sulpice Chopinot, Madrid (before 1805); Conde de Quinto, Madrid (by 1846; *c.* 1860 to Paris); sold by his widow, Paris, 1862 (Gogué cat. 48); acquired John Bowes for Barnard Castle, 1862.

EXHIBITIONS

Madrid, 1846 (50: Quinto); London, 1901 (60); London, 1947 (10); New York, 1950 (38); London, 1959 (44); London, 1962 (50); Paris, 1961–2 (57); London, 1962 (206); Great Britain, 1962–3 (50); London, 1963–4 (102); Bordeaux/Paris/Madrid, 1979–80 (24/20); London, 1981 (73); Madrid/Boston/New York, 1988–89 (71).

CATALOGUES

von Loga, 1903/21 (433); Mayer, 1924 (544); Desparmet Fitz-Gerald, 1928–50 (207).

BIBLIOGRAPHY

E. Harris, 1953, pp. 22–3; Soria, 1961; Young, 1988, pp. 78–9; Crossling, 1993, pp. 32–3.

The back of the tinplate was affected at one time by oxidisation and has been cleaned up, with burnishing in several places. There is therefore probably no chance that written numbers would have survived, but what looks like an engraved number *2* appears at upper left.

43 *Yard with Lunatics,* 1793–4

tinplate, 43.5 × 32.4 cm
Dallas, Meadows Museum, Southern Methodist University, Algur H. Meadows Collection (67.01)

REFERENCES

G–W 330; Gud. 343/309; DeA 282.

PROVENANCE

Léonard Chopinot, Madrid (before 1800?); Angela Sulpice Chopinot, Madrid (before 1805); Conde de Quinto, Madrid (by 1846; *c.* 1860 to Paris); sold by his widow, Paris 1862 (Gogué cat. 49); E.G. de Knyff, Paris; (Vente de Knyff, Hôtel Drouot, Paris, 20 April 1876, lot 37.); Edmond Picard, Brussels; (Vente Picard, Brussels, 26 March 1904, lot 41); priv. coll., Paris; (sale Hôtel Drouot, Paris, 30 December 1922, lot 10); (Wildenstein & Co., New York); acquired Meadows Museum (1967).

DOCUMENTS

Goya–Iriarte correspondence (see p. 358): Calleja, 1924, pp. 53–4; Gassier–Wilson, 1970, pp. 110 (repr.), 382, Appx IV; *Diplomatario,* 1981, p. 315, no. 189.

EXHIBITIONS

Madrid, 1846 (51: Quinto); The Hague/Paris, 1970 (15/13); Dallas, 1982–3 (6); Madrid/Boston/New York, 1988–9 (21).

CATALOGUE

Mayer, 1924 (695).

BIBLIOGRAPHY

Desparmet Fitz-Gerald, 1967; Jordan, 1974, pp. 56–8, 110–11; Glendinning, 1977, p. 47, 1982, pp. 60–61.

Witchcraft and Allegory, 1797–1799

SIX WITCHCRAFT SUBJECTS, 1797–1798

Although the Duke of Osuna's order for payment implies that the witchcraft pictures were painted specifically for La Alameda, there is no indication of the room in which they were hung, whereas the seven pictures invoiced by Goya one month earlier – the sketches for tapestry cartoons, painted in 1786–8 (cat. 19–28) – were noted by the Duke as having been painted for his wife's study (*gabinete*).

The Osunas acquired the country property at La Alameda on 18 October 1783, and four towers were added in 1787, converting the house into a small palace. That same year, Goya delivered the seven large canvases that were set into the walls of one of the rooms (G–W 248–55; figs. 45, 46), while the tapestry cartoon sketches and witchcraft pictures were acquired ten years later.

Goya exhibited two portraits and 'six bizarre *caprichos*' at the San Fernando Academy in 1799, and it seems not unlikely that the Osunas would have lent their set of witchcraft pictures, perhaps to stimulate interest in the etchings of *Los Caprichos* that had been published earlier that year. It is, however, possible that these '*caprichos*' were from another series of pictures (see cat. 74–77).

All the witchcraft scenes are painted on a reddish-beige ground, in a much broader, freer technique than the paintings on tinplate (cat. 32–43).

PROVENANCE
Duques de Osuna, La Alameda (1798); (Osuna sale, Madrid, 1896, lots 83–8); thereafter, see Provenance notes for each work.

DOCUMENTS
Goya's account and its payment: Herrero, 1941; Yebes, 1955, p. 42; Gassier–Wilson, 1970, pp. 383–4, Appx v.

EXHIBITIONS
Madrid, Real Academia de San Fernando, 1799(?); Madrid, 1896 (83–8); and see individual entries below.

CATALOGUES
Yriarte, 1867, pp. 144–5 (Alameda de Osuna, Library); Viñaza, 1887, p. 282 (xxxii–vii); and see individual entries below.

BIBLIOGRAPHY
Yriarte, 1867, pp. 83–6; Camón Aznar, 1952, pp. 660–61; Nordström, 1962, pp. 153–71, 1989, pp. 184–205; Helman, 1963, pp. 177–94, 1983, pp. 169–84; Glendinning, 1981, pp. 239–40; *Diplomatario*, 1981, pp. 252–53, no. 77 (as February 1784); *Cartas a Zapater*,

1982, pp. 210–11, no. 123 (as *c.* 1792); Baticle, 1986, pp. 6–7; Helman, 1987; Tomlinson, 1992, pp. 48–9, 1993, pp. 64–6.

44 *The Witches' Kitchen*, 1797–98
canvas, 45 × 32 cm
Private Collection

REFERENCES
G–W 662; Gud. 361/354; DeA 340.

PROVENANCE
Duques de Osuna, La Alameda (1798); (Osuna sale, Madrid, 1896, lot 85); Gustave Bauer, Madrid (bought Osuna sale); Felix Boix, Madrid; Eduardo Pani, Mexico City (by 1940).

EXHIBITION
Madrid, 1896 (85).

CATALOGUES
Desparmet Fitz-Gerald, 1928–50 (171); von Loga, 1903/21 (439); Mayer, 1924 (549).

BIBLIOGRAPHY
Calleja 1924, pl. 314; Nordström, 1962, pp. 170–71, 1989, pp. 203–4.

The painting left Europe before the Second World War and was not found, as hoped, in time for of this catalogue printing.

45 *Flying Witches*, 1797–8
canvas, 43 × 30.5 cm
Jaime Ortiz-Patiño Collection

REFERENCES
G–W 659; Gud. 360/353; DeA 338.

PROVENANCE
Duques de Osuna, La Alameda (1798); (Osuna sale, Madrid, 1896, lot 83); Sota, Bilbao; Ministerio de la Gobernación, Madrid (on deposit from 1960s); (sale Sotheby–Peel, Madrid, 19 December 1985, lot 11, bought Ortiz-Patiño).

EXHIBITIONS
Madrid, 1896 (83); Lugano, 1986 (24); Japan, 1987 (35); Paris, 1987–8 (104); Madrid/Boston/New York, 1988–9 (27).

CATALOGUES
von Loga, 1903/21 (441); Mayer, 1924 (550); Desparmet Fitz-Gerald, 1928–50 (169).

BIBLIOGRAPHY
Beruete, ii, 1917, p. 180; Calleja, 1924, pl. 319; Herrero, 1941, p. 176; Nordström, 1962, pp. 168–70, 1989, pp. 201–3; Helman, 1987, pp. 196–205; Baticle, 1986.

46 *The Witches' Sabbath*, 1797–8
canvas, 43.3 × 30.5 cm
Madrid, Museo Lázaro Galdiano (M.2004)

REFERENCES
G–W 660; Gud. 356/349; DeA 339.

PROVENANCE
Duques de Osuna, La Alameda (1798); (Osuna sale, Madrid, 1896, lot 84); Duque de Tovar, Madrid (by 1928); José Lázaro Galdiano, Madrid (acquired after 1928).

EXHIBITIONS
Madrid, 1896 (84); Madrid, 1928 (34/61: Tovar); Granada, 1955 (90); Stockholm, 1959–60 (143); Madrid, 1961 (ii); London, 1963–4 (79); The Hague/Paris, 1970 (27); Lugano, 1986 (25, not exhibited); Paris, 1987 (103); Madrid/Boston/New York, 1988–9 (26).

CATALOGUES
von Loga, 1903/21 (438); Mayer, 1924 (548); Desparmet Fitz-Gerald, 1928–50 (170).

BIBLIOGRAPHY
Calleja, 1924, pl. 326; Camón Aznar, 1952, p. 7; Nordström, 1962, pp. 160–4/1989, pp. 193–7.

47 *The Spell*, 1797–8
canvas, 43.5 × 30.5 cm
Madrid, Museo Lázaro Galdiano (M.2016)

REFERENCES
GW 661; Gud. 358/351; DeA 341.

PROVENANCE
Duques de Osuna, La Alameda (1798); (Osuna sale, Madrid, 1896, buyer unknown); Duque de Tovar, Madrid (by 1928); José Lázaro Galdiano, Madrid (after 1928).

EXHIBITIONS
Madrid, 1896 (86); Madrid, 1928 (62/35: Tovar); Bordeaux, 1957 (67).

CATALOGUES
von Loga, 1903/21 (440); Mayer, 1924 (552); Desparmet Fitz-Gerald, 1928–50 (172).

BIBLIOGRAPHY
Calleja, 1924, pl. 327; Camón Aznar, 1952, p. 7; Nordström, 1962, pp. 164–8, 1989, pp. 197–201.

REFERENCES
G–W 663; Gud. 359/352; DeA 343.

PROVENANCE
Duques de Osuna, La Alameda (1798); (Osuna sale, Madrid, 1896, lot 88); National Gallery, London (acquired Osuna sale).

EXHIBITIONS
Madrid, 1896 (88); London, 1947 (9); London, 1963–4 (uncatalogued); London, 1981 (67); Madrid/Boston/New York, 1988–9 (25).

BIBLIOGRAPHY
Beruete, II, 1917, pp. 99–101; Nordström, 1962, pp. 154–8, 1989, pp. 185–90; MacLaren–Braham, 1970, pp. 11–12, no. 1472.

The work is painted on a fairly coarse canvas, and the evidence of the x-ray image and an old photograph (Museum conservation files) suggests that it was a cut piece, not fixed to a stretcher until it was relined. It is therefore very similar to the two paintings of the Duchess of Alba and 'la Beata' (cat. 64, 65), still on their original pieces of loose canvas, which appears almost identical to this one in weave. The light-beige ground is also very similar in all three. The dimensions of the original, irregularly cut canvas are 41.2/3 × 31.5 (top)/32.3 (bottom) cm, and those of the lining canvas and new stretcher 41.6 × 32.6 cm (information kindly supplied by Rita Albertson, Museum of Fine Arts, Boston).

48 *A Scene from 'The Stone Guest',* 1797–8

canvas, 45 × 32 cm
Location unknown

REFERENCES
G–W 664; Gud. 357/359; DeA 342.

PROVENANCE
Duques de Osuna, La Alameda (1798); (Osuna sale, 1986, lot 87, buyer unknown).

EXHIBITION
Madrid, 1896 (87).

CATALOGUES
von Loga, 1903/21 (445); Mayer, 1924 (558); Desparmet Fitz-Gerald, 1928–50 (173).

BIBLIOGRAPHY
Beruete, II, 1917, p. 166; Calleja, 1924, pl. 318; Nordström, 1962, 1989, pp. 190–93; Glendinning, 1992 (*Retratos*), p. 33.

The picture, known from a Laurent photograph that shows it in apparently fragile condition, has not been seen since the date of the Osuna sale, where its buyer was unrecorded.

Zamora's play, *There is no time limit which does not expire, nor debt which has not been repaid, and the Stone Guest*, was a rewrite of Molina's *Trickster from Seville*, and the picture is also known by the latter, title.

ALLEGORY ON TIME, TRUTH AND HISTORY, c. 1797–1799

50 *Time, Truth and History,* c. 1797–9

canvas, 41.3 × 32.3 cm
(new stretcher: 41.6 × 32.6 cm)
Boston, Museum of Fine Arts, Gift of Mrs. Horatio Greenough Curtis in Memory of Horatio Greenough Curtis (27.1330)

REFERENCES
G–W 696; Gud. 482/442; DeA 332.

PROVENANCE
Juan Carnicero, Madrid (gift from Goya); Alejandro de Coupigny, Madrid (by 1875); Horatio G. Curtis (bought by R. W. Curtis in Madrid 1918); gift of Mrs H. G. Curtis to the museum (1927).

EXHIBITIONS
Madrid, 1900 (42: Navas); Boston, 19?? (40); Chicago, 1941 (59); New York, 1950 (13); London, 1963–4 (83); Boston-Ottawa, 1974–5 (76); Stockholm, 1980 (4); Hamburg, 1980–1 (291); Madrid, 1982–3 (2); Madrid/Boston-New York, 1988–9 (28).

CATALOGUES
Viñaza, 1887, p. 288 (LII); von Loga, 1903/21 (80); Mayer, 1924 (87); Desparmet Fitz-Gerald, 1928–50 (86).

BIBLIOGRAPHY
'El grabador al aguafuerte', *Colección de obras originales y copias de las selectas de autores españoles*, Madrid, 1875, II, pl. 21 (A. de Coupigny); Sánchez Cantón, 1945, pp. 303–4; Soria, 1948, p. 199; Nordström, 1962, pp. 105–6, 1989, pp. 127–39; Sayre, 1979.

49 *Scene from 'The Forcibly Bewitched',* 1797–8

canvas, 42.5 × 30.8 cm
inscribed lower right: '*LAM/PARA/ DESCO/MUNAL*'
London, The Trustees of the National Gallery (1472)

Paintings on Religious Themes, 1796–1800

BIBLIOGRAPHY
Goya's convalescence: Angulo Iñiguez, 1944; Sambricio, 1946, doc. 177; Buendía–Peña, 1989, p. 307.

ORATORY OF THE SANTA CUEVA, CADIZ
c. 1796–1797

Since no detailed contemporary description of the Oratory exists, Torralba (1983, Saragossa) has questioned whether the paintings are now in the positions they originally occupied, and has suggested that the inscriptions above the scenes may be later additions, made after the order of the paintings was changed. It is true that the mediocre paintings flanking Goya's *Last Supper* present an unhappy contrast with his work, and Torralba's theory that Goya planned his pictures to be seen as a group of three, with the miracles of the *Wedding Guest* to the left and the *Loaves and Fishes* to the right of *The Last Supper*, which was, and still is placed above the entrance door, is a tempting one, and may be true to the extent that Goya himself saw them as a triptych. However, it is equally reasonable to suppose that the Goyas were interspersed with the other two paintings in order to create a more harmonious whole. What remains unexplained is the decision to divide the paintings unequally between the three artists.

BIBLIOGRAPHY
Pelayo Quintero, 1928; Ezquerra del Bayo, 1928; Pemán y Pemartín, 1928; Sánchez Cantón, 1946 (*Revista*), pp. 295–6; Sánchez Cantón, 1951, pp. 60–61; Lafuente Ferrari, 1955, p. 124; Taylor, 1964; Guerrero Lovillo, 1971; Pemán, 1978, p. 58; Torralba Soriano, 1983 (Saragossa); Torralba Soriano, 1983 (Huesca); Sebastián López, 1987; Morales y Marín, 1990, pp. 238–49; Glendinning, 1992 (*Retratos*), pp. 34–6.

51 *The Last Supper, c.* 1796–7
canvas, 25 × 42 cm
Private Collection

REFERENCES
G–W 712; Gud. 365/340; DeA 309.

PROVENANCE
Cecilia Balaguer, widow of Gimeno, Saragossa (by 1928); Kleinberger, Paris (by 1932); (sale Palais Galliéra, Paris, 25 Nov. 1971); private collection (bought Galliéra sale).

DOCUMENTS
Poussin source: *Galerie de S.A.S. Monseigneur le duc d'Orléans,* Paris, 1786, II, no. 62; Pemán Medina, 1992, pp. 309, 316, no. 140.

EXHIBITION
Saragossa, 1928 (17: Balaguer).

CATALOGUES
Desparmet Fitz-Gerald, 1928–50 (535s, n.); Morales y Marín, 1990, p. 246 (101).

The sketch, not examined directly or included in the exhibition in Madrid, is reproduced here for the first time in colour, and shows Goya's characteristic red ground.

52 *The Miracle of the Loaves and Fishes, c.* 1796–7
canvas, 24.4 × 38.7 cm
Location unknown

REFERENCES
G–W 710; Gud. 363/338; DeA 307.

PROVENANCE
Iruretagoyena, Seville; Jimeno y Fernández Vizarra, Madrid; (sale Auktion Lempertz, Cologne, 27–28 November 1935, lot 146: buyer unknown).

CATALOGUES
Desparmet Fitz-Gerald, 1928–50 (534s, n.); Morales y Marín, 1990, p. 241 (99).

Enriqueta Harris kindly provided a black and white photograph of this painting, which has remained untraced since the Lempertz auction in 1935.

SAN ANTONIO DE LA FLORIDA, MADRID, 1798

Details of the site and its various hermitages are given by Tormo (1927, pp. 718–28), with additional information and corrections by Lafuente Ferrari (1955, pp. 13–16).

Church decorations in Madrid studied by Goya in relation to these frescoes would have included San Placido (Moratín, 1968, p. 203; Baticle, 1992, p. 249); Nuestra Señora de Atocha (Tovar Martín, 1975, p. 115; Gallego–Domingo, 1987, p. 29).

The account from Goya's colours supplier (Sambricio, 1946, doc. 191) includes remarkably large quantities of pigments, paint brushes and paper, and it has been calculated that the fine quality paper supplied would have been sufficient and may indeed have been used for the printing of the edition of the *Caprichos* etchings that was issued for sale in February of the following year. Jovellanos, who was probably responsible for the San Antonio commission, was also involved in Goya's project for the *Caprichos,* in which the first satire following the author's self-portrait is a quotation from one of his poems (figs. 21, 186).

Of the portraits cited in the text (p. 232), that of *Jovellanos* is in the Museo del Prado, *Saavedra* in the Courtauld Institute Galleries, London, and *Guillemardet* in the Musée du Louvre, Paris (G–W 675–7).

DOCUMENTS
Croisset/Isla, 1852, II, pp. 506–7; Viñaza, 1887, pp. 196–8; Beruete, II, 1917, pp. 80–1; López Rey, 1944, pp. 231–4; Sambricio, 1946, p. CXXVI, doc. 191; Lafuente Ferrari, 1955, pp. 142–3; Moratín, 1968, pp. 203, 210.

BIBLIOGRAPHY
Viñaza, 1887, pp. 195–9; Tormo, 1902, p. 213; Beruete, II, 1917, pp. 74–84; Calleja, 1924, pl. 206, 207; López Rey, 1944; Rothe, 1944; Herrán de las Pozas, 1946; López Rey, 1947, pp. 37–60; Sánchez Cantón, 1951, pp. 63–6; Lafuente Ferrari, 1955; Morales y Marín, 1990, pp. 212–14.

The two sketches have remained together and share a common provenance and exhibition history. Their early provenance is not known.

53 *Miracle of St Antony of Padua,* 1798
canvas, 26 × 38 cm
Madrid, L. Maldonado

REFERENCES
G–W 718; Gud. 380/360; DeA 346.

54 *Adoration of the Trinity,* 1798
canvas, 26.6 × 37.7 cm
Madrid, L. Maldonado

REFERENCES
G–W 723; Gud. 395/375; DeA 360.

Both works:

PROVENANCE
Conde de Villagonzalo (by 1900); thence by descent.

CATALOGUES
von Loga, 1903/21 (7, 8); Mayer, 1924 (10, 13); Desparmet Fitz-Gerald, 1928–50 (88, 90); Morales y Marín, 1990, pp. 215–7 (85, 86).

EXHIBITIONS
Madrid, 1900 (87, 88: Villagonzalo); Madrid, 1928 (40/57, 41/59); Madrid, 1949 (103, 104); Madrid, 1983 (27, 28); Lugano, 1986 (27, 28); Venice, 1989 (28, 29); Saragossa, 1992 (27, 28).

Both canvases, relined long ago, have a beige preparation over a reddish ground. The works were restored and cleaned in 1993.

SACRISTY OF TOLEDO CATHEDRAL, 1798

The first record of a work commissioned from Goya for the Cathedral at Toledo occurs in a letter to Zapater, dated 2 July 1788. He apologised for not painting the picture ordered by his friend, adding 'the same thing had happened to the Archbishop of Toledo who commissioned a painting from me for his Church and I have not even been able to do the preliminary sketch yet'.

On 2 October 1787, Francisco Bayeu was paid for the latest of his many frescoes in the Cathedral cloister, and it is possible that he arranged for a commission for his brother-in-law, as he evidently did for his brother Ramón (Zarco del Valle, 1914, p. 408, doc. 859; p. 417, doc. 876), although no other painting by Goya for the Cathedral is known.

On 6 January 1799, the Academy was shown the *Prendimiento* altarpiece (G–W 736, Gud. 398/378, DeA 363) 'and praised its effectiveness, fine taste in colouring, draftsmanship and technique, which further, enhance the reputation of Señor Goya' (Sánchez Cantón, 1928, p. 17).

The picture is documented in the Cathedral archives by the payment on 10 February 1799 of 15,000 *reales* for the painting, and further sums for the crate and its transport to Toledo (Nicolau, 1991, p. 133: Archivo de Obras y Fábrica, Toledo Cathedral, *Libro de 1798*, fol. 141) and by the payment, on 28 June 1800, of 10,340 *reales* to 'the Court Painter of His Majesty, Don Francisco Ramos, resident in Madrid, for the painting of the prayer in the garden, which he has painted for the altar, which will be made out of marble, for the large sacristy, as a complement to the one painted by Don Francisco Goya, also Court Painter' (Zarco del Valle, 1914, p. 421, doc. 881; Nicolau, 1991, p. 133).

Another document records that on 18 May 1798, 'the *maestro mayor* (building supervisor) Ignacio Haan was paid for two drawings on paper for the design and execution of the altarpieces in the large sacristy', presumably the architectural drawings for the main altar for the Greco and the design for the two identical side-altars (Zarco del Valle, 1914, p. 420).

In the side-altars, the paintings are framed by bands of dark-green marble veined with white and gilded on the carved edges, and a wider surround of pale-brownish, striated marble that fills the rest of the recess; the altar table below is mainly of white marble with red marble inserts, and with gilt bronze swags and a cross. Goya must have visited the Sacristy to study the position his picture was to occupy in the room and its relation to the Greco altarpiece. And he very probably saw the drawings for the altars which were evidently not constructed until after his and Ramos's paintings had been completed. A payment of 22 July 1803 to the sculptor Mariano Savatierra indicates that the main altar for the Greco had not yet been completed.

Yriarte (1867, pp. 64–5) described the painting in the sacristy, and the lack of light which made the execution of Bocourt's drawing for the engraved reproduction very difficult. He also quoted Théophile Gautier's reference to the painting in his *Voyage en Espagne*, and referred to the Rembrandtesque qualities of the work.

The dimensions of the altarpiece, which are wrong in all the catalogues, are approximately 265 × 140 cm, and are therefore in proportion to those of the painted image in the sketch.

DOCUMENTS
Goya's letter: *Diplomatario*, 1981, p. 291, no. 146; *Cartas a Zapater*, 1982, pp. 184–8, no. 105.
Presentation in the Academy: Sánchez Cantón, 1928, p. 17; Sánchez Cantón, 1951, p. 66.
Cathedral archive: Zarco del Valle, 1914, pp. 420–1, docs 879–82; Nicolau Castro, 1991, pp. 131–3.

BIBLIOGRAPHY
Yriarte, 1867, pp. 64–5; Sánchez Cantón, 1928, p. 17; Desparmet Fitz-Gerald, 1928–50, no. 80; López Rey, 1981; Wilson-Bareau, 1992, see pp. 164, 182; Morales y Marín, 1990.

55 *The Taking of Christ*, 1798
canvas, 40.2 × 23.1 cm (dimensions of the painted image: 38 × 21 cm)
Madrid, Museo del Prado (3113)

REFERENCES
G–W 737; Gud. 397/377; DeA 362.

PROVENANCE
Luis Rotondo, Madrid (by 1867); Condes de Sobradiel; by inheritance to Rosa Cavero (acquired Museo del Prado 1966).

EXHIBITIONS
The Hague/Paris, 1970 (25); Hamburg, 1980–81 (293); Munich-Vienna, 1982 (18); Madrid/Boston-New York, 1988–9 (29).

CATALOGUES
Yriarte, 1867, p. 137 (Rotondo); von Loga, 1903/21 (16); Mayer, 1924 (22); Desparmet Fitz-Gerald, 1928–50 (80 n.); Morales y Marín, 1990, p. 254 (105).

BIBLIOGRAPHY
Morales y Marín, 1990, pp. 256–8.

The sketch is painted on a canvas prepared with a very dark ground overlaid with beige, as in the *Self-portrait* of *c.* 1795–7 (cat. 63). The green-painted border surrounding the image, probably intended to simulate the effect of the green marble around the painting in the Sacristy, is now partly wrapped over the edges of the stretcher with the lining canvas, suggesting that like other canvases (cat. 16, 17, 50, 64, 65) it may not have been on a stretcher when painted. This makes it more likely that it was a first idea, rather than a finished presentation sketch. The painting, restored and cleaned in 1993, is in excellent condition.

CHURCH OF SAN FERNANDO, MONTE TORRERO, SARAGOSSA, *c.* 1798–1800

The church, for the workers employed by the Canal Imperial de Aragon, was built to plans by Tiburcio del Caso, a follower of Ventura Rodríguez, between 1796 and 1799, although a dispute over the ecclesiastical jurisdiction of the church delayed its consecration until 30 May 1802.

In his diary entry for 7 April 1801, Jovellanos misidentified the scene over the main altar, but confirmed the placing of the paintings in the side chapels: 'The principal painting represents Saint [blank] like a pendulum in the air, as if protecting King James of Aragon for the conquest of Valencia [sic]. The monarch looks in wonder while a youth offers him a crown, and around him are some of his soldiers who very effectively make up the scene: On the Gospel side is St Elizabeth curing a sick woman's wound, and on the Epistle side is St Hermengild in prison, being shackled.'

Del Caso's report of 3 December 1813 on the damage to the church gives a graphic insight into the destruction caused in and around Saragossa during the two sieges of the city: 'On the outside too it has suffered a great deal, as much from the bombs and grenades which rained on it from the cupola, towers and roof as from the damage caused by the troops.'

The three sketches belonged to Francisco Zapater y Gómez, the nephew of Goya's friend Don Martín, who may have been involved in some way in the commission from the board of the Canal de Aragón.

DOCUMENTS

Canal Imperial archive: A. Lasierra, 'Nuevos cuadros de Goya', *Aragón*, 1928, p. 123; Giménez Ruiz et al., 1983, Appx, pp. 29–46.
Jovellanos's diary: Tenth Diary, Itinerary XVIII, in *Obras publicadas e inéditas de D. Gaspar Melchor de Jovellanos* (vol. IV, p. 57), *B.A.E.*, vol. 86, 1956.

BIBLIOGRAPHY

Church and lost paintings: Viñaza, 1887, p. 208–09, nos. XXIV–XXVI; Sánchez Cantón, 1946, pp. 300–1; Junquera, 1955, p. 186; Pardo Canalis, 1968; Laborda Yneva, 1989, pp. 322–7; J. Domínguez Lasierra, 'La Iglesia de San Fernando de Torrero', *Aragón turístico y monumental*, 51, 1977, pp. 2–3; Giménez Ruiz et al., 1983; Morales y Marín, 1990, p. 259.
Sketches: Calleja, 1924, pl. 212–4.

56 *The Apparition of St Isidore to St Ferdinand, c. 1798–1800*
canvas, 46.5 × 31 cm
Buenos Aires, Museo Nacional de Bellas Artes (2563)

REFERENCES

G–W 739; Gud. 459/434; DeA 391.

PROVENANCE

Martín Zapater, Saragossa (?); Francisco Zapater y Gómez, Saragossa; Pablo Bosch, Madrid; Antonio Cánovas y Vallejo, Madrid (by 1900); Albert Porlitz, Paris; (Porlitz sale, Hôtel Drouot, Paris, 17 Nov. 1910, lot 25); (George Bernheim, Paris); (Pedro Artal, bought Bernheim 26 Dec. 1910, for José Artal); (José Artal, Buenos Aires); acquired Museo Nacional de Bellas Artes 1911.

EXHIBITIONS

Madrid, 1900 (98: Cánovas); Buenos Aires, 1928 (17); Buenos Aires, 1934 (488); Buenos Aires, 1939 (46); Buenos Aires, 1966 (53); Buenos Aires, 1967 (69); Saragossa, 1992 (33).

CATALOGUES

Viñaza, 1887, p. 299 (CXXXVII); von Loga, 1903/21

(48); Mayer, 1924 (56); Desparmet Fitz-Gerald, 1928–50 (104); Morales y Marín, 1990, p. 264 (108).

Angel Navarro kindly supplied information concerning the provenance of this painting.

57 *St Elizabeth Tending a Sick Woman, c. 1798–1800*
canvas, 33 × 23 cm
Madrid, Museo Lázaro Galdiano (2021)

REFERENCES

G–W 738; Gud. 460/435; DeA 389.

PROVENANCE

Martín Zapater, Saragossa (?); Francisco Zapater y Gómez, Saragossa (to 1887 or later); Clemente Velasco, Madrid (by 1900); José Lázaro Galdiano, Madrid (after 1928).

EXHIBITIONS

Madrid, 1900 (70: Velasco); Madrid, 1928 (32/90: Velasco); Saragossa, 1992 (34).

CATALOGUES

Viñaza, 1887, p. 299 (CXXXVIII: Zapater y Gómez); von Loga, 1903/21 (35); Mayer, 1924 (41); Desparmet Fitz-Gerald, 1928–50 (100); Morales y Marín, 1990, p. 267 (109).

The very similar *grisaille* composition, painted for the Royal Palace in 1816–17, was first published by Junquera in 1955.

58 *St Hermengild in Prison, c. 1798–1800*
canvas, 33 × 23 cm
Madrid, Museo Lázaro Galdiano (2017)

REFERENCES

G–W 740; Gud. 461/436; DeA 393.

PROVENANCE

Martín Zapater, Saragossa (?); Francisco Zapater y Gómez, Saragossa; Clemente Velasco, Madrid (by 1900); José Lázaro Galdiano, Madrid (after 1928).

EXHIBITIONS

Madrid, 1900 (31: Velasco); Madrid, 1928 (31/87: Velasco); Venice, 1989 (31); Saragossa, 1992 (32).

CATALOGUES

Viñaza, 1887, p. 299 (CXXXIX: Zapater y Gómez); von Loga, 1903/21 (41); Mayer, 1924 (49); Desparmet Fitz-Gerald, 1928–50 (101); Morales y Marín, 1990, p. 261 (107).

Portraits, 1783–1805

EQUESTRIAN PORTRAIT OF MARÍA TERESA DE VALLABRIGA, 1783

59 *María Teresa de Vallabriga on Horseback, 1783*
canvas, 82.5 × 61.7 cm
Florence, Galleria degli Uffizi (9485)

REFERENCES

G–W –; Gud. –/141; DeA 166a.

PROVENANCE

Infante Don Luis de Borbón, Arenas de San Pedro; by descent to Carlota, Duquesa de Sueca, Boadilla del Monte; Luis Ruspoli, Marqués de Boadilla del Monte, Florence (1904); Paolo Ruspoli, Rome; acquired Uffizi 1974.

DOCUMENTS

Goya's letters: *Diplomatario*, 1981, pp. 250, 254–6, nos. 72, 81, 84; *Cartas a Zapater*, 1982, pp. 107–10, 116–17, 119–22, nos. 49, 55, 57.
Estate of Infante Don Luis, 1797 (A.H.P., Madrid, Protocolo no. 20,822, fᵒ 645 v, 815 v): Arnaiz–Montero, 1986, p. 49, n. 35.
Boadilla inventories (1826 and c. 1847–56, no. 118): Gassier, 1979, p. 20, nn. 50, 51.

CATALOGUES

Sketch: Desparmet Fitz-Gerald, 1928–50 (314: Ruspoli, Florence); Uffizi, 1983, vol. II, p. 283; *Gli Uffizi*, Florence; *The Uffizi. Guide to the Collections*, Florence, 1986, p. 173.
Lost painting: Viñaza, 1887, p. 231 (XLV); von Loga, 1903/21 (152); Mayer, 1924 (183): Gudiol, 1970 (155).

BIBLIOGRAPHY

Angulo Iñiguez, 1940; Gassier–Wilson, 1970, pp. 60–61; Gassier, 1979; Gassier, 1983; Arnaiz–Montero, 1986; Agueda, 1987, pp. 44–45; Tomlinson, 1989, p. 139, 1993, pp. 179–82.

This picture was not included in the Madrid exhibition.

EQUESTRIAN PORTRAITS: A 'GARROCHISTA', c. 1791–1792, AND GODOY, 1794

All Goya's equestrian portraits require further investigation, both documentary and technological, following the publications that have revealed problems of overpainting and identification of the sitters in recent years.

60 *Equestrian Portrait, known as 'A Garrochista'*, *c.* 1791–92 (repainted *c.* 1808)

canvas, 57 × 46.8 cm
Museo del Prado (744)

REFERENCES

G–W 255; Gud. 242/230; DeA 312.

PROVENANCE

Royal Palace, Madrid; Real Museo del Prado (August 1819).

DOCUMENTS

'Inventario de las pinturas que existían en este Real Palacio de Madrid, 1814' (Palace archive: typescript, Museo del Prado); '*Lista de los cuadros ... del Real Palacio*', Madrazo, 1945, pp. 249–51, no. 75: 'A picador on horseback, with a lance, unframed', Prado catalogue 1821, p. 22, no. 316: 'A Picador on horseback'; *Noticia de los Cuadros ... en la Galería del Museo del Rey ...*, 1828, p. 80, no. 320: 'Portrait of a Bullfighters on horseback'.

EXHIBITIONS

Paris, 1961–2 (39); Tokyo–Kyoto, 1971–2 (13b); Barcelona, 1977 (32); Buenos Aires, 1980 (p. 136); Belgrade, 1981 (18); Arles/Madrid, 1990 (9/11).

CATALOGUES

Yriarte, 1867, p. 130; Viñaza, 1887 (55); von Loga, 1903/21 (372); Mayer, 1924 (665); Desparmet Fitz-Gerald, 1928–50 (167).

BIBLIOGRAPHY

Braham, 1966; Salas, 1969; Agueda, 1987; Pérez Sánchez, 1987, p. 308; Tomlinson, 1992, pp. 93–8, 1993, pp. 121–6.

Goya's original equestrian portrait was executed on a reddish ground, and the principal area to have escaped repainting is the distant landscape on the left. The x-ray was published by Agueda (1987, figs. 12, 13). However, it was not until the picture was cleaned and examined in 1993 that the extent of the repainting became clear, and also the fact that it could not have been done by Goya.

A small 'window' opened in the heavily repainted sky on the right (and visible in the reproduction) has revealed a light, almost translucent grey underneath, and since the bulls are partly painted over the heavy grey repaint that covers Goya's landscape on the right, they too were added in keeping with the new subject of the picture. The heavy repainting of the figure makes use of some of Goya's underlying impasto, and the blue and white ribbon of the Order of Carlos III over Godoy's chest – seen in (cat. 61) – was incorporated into the *garrochista*'s shirt; similarly, the formal coat with its trimmings is visible in relief under the repainted breeches and saddle-blanket. The horse's silhouette was considerably altered, and the belly was lowered from the line of the rider's foot.

The alterations to the outlines and heavy-handed repainting of the whole picture has virtually eliminated the effect seen in the x-ray, that of the figure lifted up and projected against an intensely luminous background.

A painting of 'A picador on horseback, with a lance' is first recorded among the pictures transferred from the Royal Palace to the Royal Museum, in a list (without artists' names) signed by the Keeper Luis Eusebi on 5 August 1819. It does not appear in the available transcription of the palace inventory of 1814, but since it was unframed when transferred to the Prado, it was probably among the groups of paintings referred to as 'impossible to identify' or 'lacking useful information'. The similarity of the titles in the 'list of works delivered' and the first catalogue in which the picture appeared, in 1821, confirms the identification with this work.

61 *Equestrian Portrait of Don Manuel Godoy, Duke of Alcudia*, 1794

canvas, 55.7 × 44.4 cm
Private Collection

REFERENCES

G–W 344; Gud. 332/319; DeA 297.

PROVENANCE

Javier Goya, Madrid (?); Marqués de Guirior, Malaga; (Arnold Seligman, Paris/New York); (Wildenstein, New York, acquired by 1937); Meadows Museum, Southern Methodist University, Dallas (acquired 1967; de-accessioned 1986).

DOCUMENTS

Diplomatario, 1981, pp. 320–21, no. 200; *Cartas a Zapater*, 1982, pp. 225–8, no. 135; V. de Cadenas y Vicent, *Extracto de los expedientes de la Orden de Carlos III. 1771–1847*, Madrid, 1983, v, p. 157, no. 1051.

EXHIBITIONS

San Francisco, 1937 (11: Wildenstein); (see Jordan, 1974, no. 25, for exh. to 1962); Dallas, 1982–83 (7); New York, Wildenstein, *The Winds of Revolution*, November 1989 – January 1990 (91).

CATALOGUES

Viñaza, 1887, pp. 232–3 (XLVII: citing Goya's letter); von Loga, 1903/21 (225); Mayer, 1924 (279); Desparmet Fitz-Gerald, 1920–58 (556s: as a presumed portrait of the Duke of Osuna).

BIBLIOGRAPHY

Sánchez Cantón, 1916, p. 211; Salas, 1969, pp. 223–5; Jordan, 1974, pp. 112–13; Glendinning, 1977, p. 66, 1982, p. 80; Rose de Viejo, 1978; Glendinning, 1981, p. 246; Agueda, 1987, p. 45, nos. 20–2; Braham, 1988; Symmons, 1988, pp. 117–18; Baticle, 1992, pp. 216–17; Tomlinson, 1992, pp. 104–7, 1993, pp. 136–9.

The red ground shows through in a number of areas, and was used as a middle tone in the landscape. Abrasion and subsequent restoration altered the appearance of the horse's tail, which is unlike either the *Garrochista*'s partly overpainted tail (cat. 60) or, more pertinently, those of Goya's other equestrian portraits and his etchings after Velázquez (cat. 59). See the reproduction in the exh. cat. San Francisco, 1937. The picture appears to have remained untouched for many years, and cleaning in 1993 disposed of the 'pale yellow sky' (due to old, very yellowed varnish) and the 'white sun that rises behind Godoy's head' (a relatively recent cleaning test), so that the symbolic significance of the portrait now requires revision (see Tomlinson, 1992, p. 106, 1993, p. 138). The restoration and cleaning carried out in 1993 have also recovered an overpainted area of Godoy's shoulder and back, giving the figure much greater solidity and weight.

The pigtailed wig worn by Godoy in both equestrian portraits is also seen in a slightly earlier portrait by Antonio Carnicero (Madrid, Museo Municipal, I.N. 3415). Godoy was appointed Captain General on 23 May 1793; Goya's letter is dated 1794; and on 25 March 1795 the uniform of the Bodyguards was modified to include ' collar and lapels of red cloth' ('*cuello y solapas de paño rojo*'), which are absent in the portrait here. Jesúsmaría Alía Plana kindly provided full documentation from his forthcoming thesis on the uniforms and on Godoy's military appointments.

The date of 1794 for Goya's letter inscribed 'London 2 August 1800' (fig. 7), is confirmed by the fact that Godoy was made Duke of Alcudia in April 1792 and Prince of the Peace in 1795, that Francisco Bayeu, referred to as absent in Saragossa (see Morales y Marín, 1979, p. 41, n. 137), died on 4 August 1795, and that Goya's first portrait of the Duchess of Alba is signed and dated 1795 (see cat. 64 and 65, and fig. 8).

SELF-PORTRAITS, *c.* 1794–1797

62 *Self-portrait in the Studio, c.* 1794–5

canvas, 42 × 28 cm
Madrid, Real Academia de Bellas Artes de San
Fernando (1166)

REFERENCES
G–W 331; Gud. 96/107; DeA 286.

PROVENANCE
Madrid, Conde de Villagonzalo (by 1900); thence by
descent; acquired by the San Fernando Academy
1978.

EXHIBITIONS
Madrid, 1900 (86: Villagonzalo); London, 1920–1
(106); Madrid, 1928 (25/54); Madrid, 1983 (22);
Lugano, 1986 (20); Madrid/Boston-New York, 1988–
9 (18); Madrid, 1992–3 R.A. *Retratos* (60).

CATALOGUES
von Loga, 1903/21 (233); Mayer, 1924 (293); Despar-
met Fitz-Gerald, 1928–50 (352).

BIBLIOGRAPHY
Beruete, I, 1916, p. 24; Beroqui, 1927; Ezquerra del
Bayo, 1928, p. 310; Sánchez Cantón, 1930, p. 37;
Sánchez Cantón, 1951, pp. 45–6, 148; Helman, 1963,
p. 24, 1983, p. 27; Gállego, 1978; Glendinning, 1992
(*Retratos*), pp. 109–10.

The canvas, which has a light beige preparation, is of
fairly coarse weave, like those of cat. 64 and cat. 65.
The very narrow margins and lack of cusping suggest
that, like those pictures, it may also have been a cut
piece of canvas, unattached to a stretcher.

63 *Self-portrait, c.* 1795–7

canvas, 18 × 12.2 cm
signed lower right: '*Goya*'
Madrid, Gutierrez de Calderón Collection

REFERENCES
G–W 665; Gud. 338/314; DeA 302.

PROVENANCE
Duquesa de Alba, Madrid; by inheritance Tomás de
Berganza, Madrid (1802); by descent Luis Berganza,
Carmen Berganza de Martín, Pilar Martín Berganza,
Antonio Martín; (sold Edmund Peel & Asociados,
Madrid, 31 October 1989, lot 20); (Caylus, Madrid).

EXHIBITIONS
Madrid, 1900 (101: Berganza de Martín); Madrid,
1991 (7); Madrid (Ayuntamiento), 1992 (41); Madrid,
1992 Caylus (31); Madrid, 1992–3 R.A. *Retratos* (62,
not exhibited).

CATALOGUES
von Loga, 1903/21 (239); Mayer, 1924 (300) – see text
note below.

BIBLIOGRAPHY
Ezquerra del Bayo, 1928, pp. 280–81.

Apart from von Loga and Mayer, all other references,
including Gassier–Wilson, Gudiol and De Angelis,
attribute this painting to the collection of Alejandro
Pidal, in which a version of Goya's original portrait
existed. This other version, not considered auto-
graph, is reproduced in Calvert, 1908, pl. 116, Calleja,
1924, pl. 4, Mayer, 1924 (299), pl. 4.

This tiny canvas, which has remained unlined, was
given a black ground, and then a light reddish
preparation, freely applied, that does not reach to the
edges all round. The very thinly brushed, blue-ish
background, comparable with those in cat. 64 and
cat. 65, was added last and partly covers the hair. The
head is painted with very thin, transparent glazes, and
uneven cleaning or slight abrasion has disturbed the
modelling of the brow. The tiny touches of brilliant
red in the cravat (originally more numerous), and the
blues on the shirt are handled with the delicacy of a
miniature, but also with extraordinary freedom and
assurance.

TWO 'CAPRICHOS': THE DUCHESS OF ALBA AND
'LA BEATA', 1795

A pair of small paintings, both signed and dated 1795,
that were no doubt a gift from Goya to the Duchess.
They passed to Tomás de Berganza, the father of the
little boy (cat. 65), and by descent in the same family
until 1985, together with the small self-portrait (cat.
63).

Each picture was originally catalogued as a *capri-
cho*, and it was not until Mayer's catalogue of 1923–5
that the title was changed to include a reference to the
so-called *dueña*, who according to Ezquerra del Bayo
(1928, p. 190) was an elderly ladies' maid, Doña
Rafaela Luisa Velázquez.

PROVENANCE
Duquesa de Alba, Madrid; Tomás de Berganza,
Madrid; by descent to Luis Berganza, Carmen Ber-
ganza de Martín, Madrid (by 1900); thence by descent
(see cat. 63).
64: (sold Sotheby's, Madrid, 27 February 1985, lot 35);
acquired Museo del Prado;
65: acquired by a private collector.

BIBLIOGRAPHY
Calleja, 1924, pl. 335; Ezquerra del Bayo, 1928, pp.
188–95, 280–81; Glendinning, 1981, p. 240; *Diploma-
tario*, 1981, pp. 320–21, no. 200; *Cartas a Zapater*,

1982, pp. 225–8, no. 135; Baticle, 1987; Baticle, 1992,
pp. 225–6; Glendinning, 1992 (*Retratos*), pp. 104,
121–3.

64 *The Duchess of Alba and 'La Beata',*
1795

canvas, 30.7 × 25.4 cm
signed and dated lower right: '*Goya año 1795*'
Madrid, Museo del Prado (7020)

REFERENCES
G–W 352; Gud. 368/342; DeA 294.

EXHIBITIONS
Madrid, 1900 (102: Berganza de Martín); Paris, 1987–
8 (101); Saragossa, 1992 (23).

CATALOGUES
Mayer, 1924 (699); Desparmet Fitz-Gerald, 1928–50
(180).

65 *'La Beata' with Luis de Berganza*
and María de la Luz, 1795

canvas, 30.7 × 25.5 cm
signed, dated and inscribed lower right: '*Luis Ber-
ganza año 1795. Goya.*'
Madrid, Private Collection

REFERENCES
G–W 353; Gud. 367/343; DeA 295.

EXHIBITION
Madrid, 1900 (103: Berganza de Martín).

CATALOGUES
Mayer, 1924 (700); Desparmet Fitz-Gerald, 1928–50
(181).

The paintings are on fairly coarse canvas apparently
cut from a larger piece (there are traces of a black
chalk line on cat. 64, along the top edge), and have
never been fixed to a stretcher, as may also have been
the case with cat. 16, 17, 50, 62 and 74–81. The figures
were sketched first, directly on the light beige ground
that is visible all round the edges, and is overlaid by a
dark layer that stops short of the signature and date;
the very thinly washed blue-grey tone over the
background was added around and between the
figures. The black 'apron' or bag that hangs from the
old lady's shoulders in cat. 65 was added by Goya to
separate the figures and emphasise their three-
dimensional forms. The paintings, restored and
cleaned in 1993, are unlined and in very good
condition.

PORTRAIT OF 'FRIEND ASENSI', *c.* 1798

66 *'Friend Asensi': A Portrait of Asensio Juliá?, c.* 1798

canvas, 54.5 × 41 cm

signed and inscribed at lower right: '*Goya a su / Amigo Asensi*'

Madrid, Fundación Colección Thyssen-Bornemisza

REFERENCES

G–W 682; Gud. 378/359; DeA 345.

PROVENANCE

Unknown collection; acquired by Baron Taylor in Spain; Galerie espagnole of Louis-Philippe, Paris (1838–48); (sold Christie & Manson, London, 13–21 May 1853, lot 446); (acquired Durlacher, London); Duque de Montpensier, Palacio de San Telmo, Seville (by 1867); Infante Don Antonio de Orléans, Sanlúcar de Barrameda; Comtesse de Paris, Paris; (Durand-Ruel, Paris, 1911); Arthur Sachs, Paris (by 1928); (sold Sotheby's, London, 24 March 1971, lot 17); Thyssen-Bornemisza Collection, Lugano/Madrid (from 1992); Fundación Colección Thyssen-Bornemisza (acquired by Spanish state, 1993).

DOCUMENTS

See Baticle-Marinas, 1981, pp. 89–90, no. 108.

EXHIBITIONS

Paris, Galerie Espagnole, 1838–48 (108); New York, 1928 (5: Sachs); Paris, 1938 (9); Paris, 1961–2 (54); The Hague/Paris, 1970 (20); USA, 1979–81 (53); Paris, 1982 (54); USSR, 1983–84 (34); Madrid, 1987–8 (47); London, 1988 (22); Stuttgart, 1988–9 (25); Saragossa, 1992 (29); Madrid, 1992–3 R.A. *Retratos* (58).

CATALOGUES

Yriarte, 1867, p. 146 (Seville, SAR, the Duke of Montpensier); Viñaza, 1887, p. 260 (CX); von Loga, 1903/21 (263); Mayer, 1924 (117); Desparmet Fitz-Gerald, 1928–50 (382).

BIBLIOGRAPHY

Yriarte, 1867, p. 77, repr.; Asensio Julia: Boix, 1931; Lafuente Ferrari, 1947, pp. 152, 362–3; R. Gil Salinas, 'Asensio Juliá (1748–1832): Rasgos biográficos', *Archivo de Arte Valenciano*, LXVII, 1986, pp. 79–82; 'Asensio Juliá y Goya', *Goya*, no. 198, 1986, pp. 348–54; *Asensio Juliá. El deixable de Goya*, Valencia, 1990; 'Nuevos aportaciones sobre el pintor Asensio Juliá Alvarrach', *Archivo de Arte Valenciano*, LXXII, 1991, pp. 59–61; Pitta Andrade, 1992, p. 592, no. 166, Glendinning, 1992 (*Retratos*), pp. 144–5.

The identification of the sitter, first proposed by Yriarte, remains unproved in the absence of other likenesses of Asensio Juliá (the portrait in Williamstown [G–W 902], to which Yriarte also referred, being of doubtful authenticity and largely repainted). It has been suggested that the person represented may be the engraver Manuel Monfort y Asensi, but his portrait by Vicente López (Real Academia de San Carlos, Museo San Pío, Valencia) appears to exclude this possibility (see the reproduction in the exh. cat. *El Mon de Goya i López en el Museu Sant Pius V*, Generalitat Valenciana. Sant Pius V, Valencia, 1992, no. 20).

MINIATURES ON COPPER: JAVIER GOYA AND HIS WIFE'S FAMILY, 1805

For references in the text on pp. 266–7 and below, the following sources were used:

Goya on Javier as a child: *Diplomatario*, 1981, p. 296, no. 155; *Cartas a Zapater*, 1982, p. 192, no. 110.

Javier as an artist: Sánchez Cantón, 1916, pp. 207–8; Sambricio, 1946, docs. 219–21; Saltillo, 1952, p. 67, doc. 6. The 1803 pension was still being paid to Javier Goya in 1846: Sánchez Cantón, *op. cit.*, p. 208, n. 2.

Javier's painting in the Quinta del Sordo: Yriarte, 1867, p. 141; Gassier–Wilson, 1970, p. 384, Appx VI.

The Goicoechea family: Lafuente Ferrari, 1947, pp. 289–91; Saltillo, 1952, pp. 35–42.

Goya's relationship with his son and daughter-in-law: Sánchez Cantón, 1946 (*Archivo*), pp. 99–101; Lafuente Ferrari, 1947, pp. 291–4; Bjurström, 1962; Glendinning, 1977, pp. 53–4, 1982, p. 68; Baticle, 1992, pp. 411–12.

These seven miniatures, painted in oils on copper roundels, were dispersed at an early date and have never been studied together. Two of them (cat. 72, 73) are slightly larger than the others and have partly illegible inscriptions on the verso, with dates that have been read as *1805* (72) and *1806* (73). However, they must all have been painted at the same time, probably before rather than after the wedding in July 1805. They may all have passed to Alejandro Pidal, who is known to have owned two of them (cat. 67, 68). The portrait drawings (G–W 840–43; figs. 190, 191) are catalogued in Gassier, 1975, pp. 527–31, nos. 354–57.

Yriarte reported that according to Mariano Goya, a painting by his father on the walls of the Quinta del Sordo had already been removed and was in the Salamanca collection by the time Yriarte saw the house with Goya's Black Paintings *in situ*. After his father's death, Javier began to dispose of the paintings which had already been allotted to him in 1812 and to which were added the pictures painted by Goya during the following fifteen years, as well as his life's work in drawings and prints. Eight major masterpieces, including the *Portrait of the Duchess of Alba* (fig. 9), the paintings known as *Les Jeunes* and *Les Vieilles* (G–W 961, 962, Musée de Lille), the *Majas on a balcony* (G–W 959, priv. coll.) and *The Forge* (G–W

965, fig. 14) were acquired from Javier by Baron Taylor for Louis-Philippe's collection for 15,500 *reales* in August 1836, and Javier probably sold the paintings now in the San Fernando Academy to Manuel García de la Prada not long after Goya's death (cat. 95–98).

It seems likely that Goya's son, repeatedly referred to as an 'artist', did at least some painting and that his work was in the style of his father and based on his paintings and drawings, as a substitute for any inspiration and original 'invention' of his own, which Javier clearly lacked. Whether he was always scrupulous in identifying and distinguishing his own work from that of his illustrious father is a question that remains to be answered.

The miniatures are painted on a dark reddish ground so thickly applied to the copper that the brushstrokes are raised and clearly visible, as is the case with the series of paintings on tinplate (cat. 32–43). The portraits are handled with great delicacy, and the fluid paint is drawn across the ridges of the red preparation without always filling the interstices.

Due to the confusion in ealier publications over the identity of the sitters, the principal bibliographical references are here grouped together.

BIBLIOGRAPHY

Tormo, 1902, p. 218, n. 2; Calleja, 1924, pl. 4; Mayer, 1924, p. 40; Lafuente Ferrari, 1947, pp. 37–8, 347; Soria, 1949; Pita Andrade, 1980.

67 *Juana Galarza de Goicoechea,* 1805

copper, 8.1 cm diameter

Madrid, Museo del Prado (4194)

REFERENCES

G–W 849; Gud. 502/464; DeA 441.

PROVENANCE

Alejandro Pidal, Madrid (by 1900); Amparo Pidal y Bernaldo de Quirós, Madrid (1913–75); Liniers y Pidal, Madrid (1975–78); acquired Museo del Prado, July 1978.

EXHIBITIONS

Madrid, 1900 (64: Pidal); Madrid, 1981 (11).

CATALOGUE

Mayer, 1924 (286).

Cleaned in 1993, this, the best preserved of the miniatures, is in very good condition, with its glazes intact.

68 *Martín Miguel de Goicoechea*, 1805
copper, 8 cm diameter
Pasadena (California), The Norton Simon Foundation (F.1978.3.P)

REFERENCES
G–W 850; Gud. 503/465; DeA 442.

PROVENANCE
Alejandro Pidal, Madrid (by 1900); Clemente Altarriba, Paris; (Galerie René Drouet/Sylvie Blatas, Paris); acquired Norton Simon Foundation 1978.

EXHIBITIONS
Madrid, 1900 (65: Pidal); New York, *The Grand Gallery at the Metropolitan Museum of Art*, C.I.N.O.A., 19 October 1974 – 4 January 1975 (37).

69 *Javier Goya*, 1805
copper, 8 cm diameter
Private Collection

REFERENCES
G–W 844; Gud. 00/469; DeA 436.

PROVENANCE
Alejandro Pidal, Madrid (?); Salas Bosch, Barcelona; Goupil Collection, Paris; by inheritance Cléry, Paris; (Cléry sale, Hôtel Drouot, Paris, 31 May 1933, lot 6); Bergerat, Paris; (sold Palais des Congrés, Versailles, 19 December 1979, lot 20).

EXHIBITION
Paris, 1970 (17).

70 *Gumersinda Goicoechea*, 1805
copper, 8 cm diameter
Private collection

REFERENCES
G–W 845; Gud.–/470; DeA 437.

PROVENANCE
Alejandro Pidal, Madrid (?); Salas Bosch, Barcelona; Goupil Collection, Paris; by inheritance Cléry, Paris; (Cléry sale, Hôtel Drouot, Paris, 31 May 1933, no. 7); Bergerat, Paris; (sold Palais des Congrés, Versailles, 19 December 1979, lot. 20).

EXHIBITION
Paris, 1970 (18).

71 *Manuela Goicoechea*, 1805
copper, 8.1 cm diameter
Madrid, Museo del Prado (7461)

REFERENCES
G–W 846; Gud. 506/468; DeA 440.

PROVENANCE
Alejandro Pidal, Madrid (?); Eduardo Bosch, Barcelona (by 1913); Salas Bosch, Barcelona; Xavier de Salas, Madrid; heirs of de Salas; acquired by Museo del Prado 1989.

EXHIBITIONS
Madrid, 1913 (161, as *Gumersinda*); London, 1963–64 (92, as *Gumersinda*); Madrid, 1987 (44).

BIBLIOGRAPHY
Boletin del Museo del Prado, x, 1989, p. 123.

72 *Gerónima Goicoechea*, 1805
copper, 8.9 cm diameter
inscribed on verso: '*1805/a los 15 años/Geronima/por/Goya*'
Providence, Rhode Island School of Design, Museum of Art, Gift of Greville L. Winthrop (34.1366)

REFERENCES
G–W 847; Gud. 504/467; DeA 438.

PROVENANCE
Alejandro Pidal, Madrid (?); (Olivia Carstairs, New York); (acquired Knoedler, New York, 1931); Martin Birnbaum (1933); Gift to the Museum of Grenville L. Winthrop (1934).

EXHIBITION
Paris, 1979 (192).

BIBLIOGRAPHY
Rosenfeld, 1991, p. 231, 83.

73 *Cesárea Goicoechea*, 1805
copper, 8.9 cm diameter
inscribed on verso: '*1805/Goya/a los 12 años/la Cesarea*'
Providence, Rhode Island School of Design, Museum of Art, Gift of Mrs Murray S. Danforth (34.1365)

REFERENCES
G–W 848; Gud. 505/466; DeA 439.

PROVENANCE
As cat. 72; Gift to the Museum of Mrs Murray S. Danforth (1934).

BIBLIOGRAPHY
As cat. 72, no. [P84].

The date on the verso of this portrait has been read, since Mayer published it in 1932 with cat. 72, as *1806*. However, the last figure, which is almost lost, is better interpreted as the numeral *5*.

Real Life 'Caprichos',
c. 1798–1808

For references in the text on p. 271, the following sources were used:

Portraits and personalities: Glendinning, 1992 (*Retratos*).

Los Caprichos: Wilson-Bareau, 1992.

González Azaola: E. Harris, 1964; Glendinning, 1977, pp. 59–61, 1982, pp. 73–5.

THE 'CAPRICHOS' OF THE MARQUESS OF LA ROMANA, *c.* 1798–1800

These eight canvases have remained together since they were painted, and share a common provenance. As far as is known, they were first mentioned as a group of 'eleven small pictures in gilt frames which constitute Goya's *caprichos*' in the inventory 'of the estate and property of Señor Don Pedro Caro y Sureda Maza de Lizana, Marquis of la Romana' (died 23 January 1811), drawn up in Palma, Mallorca, and dated 17 June 1811 (Crespí de Valldaura archive). It is not known what became of the missing three pictures whose subjects have never been recorded, but Nigel Glendinning has suggested (oral communication 1994) that *once* (eleven) could be a mistranscription in the MS. document cited of *ocho* (eight).

The same inventory also includes 'another picture with a gilt frame two and a half spans heigh by two spans in width representing a *capricho* and is a work by Goya'. The dimensions given are the equivalent of 53 × 42 cm, and this picture has not so far been identified. We are indebted to Don Gonzalo Crespí de Valldaura, Conde de Orgaz, for making the manuscript inventory available, and it will be included in Nigel Glendinning's forthcoming article in *The Burlington Magazine* (February 1994).

The descriptions of the paintings published by Yriarte in 1867 suggest that they were already difficult to see, and they have been much admired but little studied. All eight were among paintings sold (or bought in) at the Hôtel Drouot, in Paris, on behalf of the picture dealer and *expert*, Etienne Haro, on 13 May 1870, lots 33–41 (the ninth painting was probably G–W 354). They were adjudicated to Demeter(?), according to the *procès verbal* (kindly communicated by Claudie Ressort and Carmen Armiñan, at the Musée du Louvre), and the circumstances of this sale of the *Collection du prince T*[atischeff] require further research.

The eight canvases were exhibited, apparently for the first time, in Madrid in 1900, and again in 1908, 1913 and 1928. Two of them were included in an exhibition of Spanish painting held at the Royal Academy of Arts in London in 1920, and since the 1928 exhibition only three paintings have been seen, in two exhibitions held in the 1980s.

The cleaning of the eight canvases in 1993 revealed details that make it possible to date the series with confidence and arrive at a clearer understanding of the paintings' significance. The eight paintings (from the original set of eleven?) fall into three principal groups: two and three pictures of vertical format, and three apparently isolated subjects in the larger, landscape format.

PROVENANCE

Juan de Salas, Palma de Mallorca; Pedro Caro, 3rd Marqués de la Romana, Palma de Mallorca (before 1811, seen by Yriarte 1867); (sale Hôtel Drouot, Paris, 13 May 1870, nos. 34–41, sold/bought in (?)December); Marqués de la Romana, Madrid (in 1900); thence by descent.

EXHIBITIONS

all eight paintings: Madrid, 1900 (55–62); Madrid, 1908 (2906–08, 2910–14); Madrid, 1913 (*passim*, unspecified: *boceto*); Madrid, 1928 (1, 3, 5, 12, 34, 36, 39, 41, 62–69).

BIBLIOGRAPHY

Ariany *et al.* 1920, pp. 11, 57, n.1; Glendinning, 1983, p. 33; Glendinning, 1992 (*Aragón*), p. 157, n. 45; Glendinning, 1992 (*Retratos*), p. 56, n. 122.

The five upright canvases were prepared with a light beige ground. The very thin paint layers were applied directly and the x-ray images are almost blank and show no traces of lead white pigment. Cleaning revealed some small areas of old damage, particularly over the foreground on cat. 78, but in general the paintings were found to be in almost perfect condition beneath layers of yellowed varnish and grime, with their glazes and impasto intact.

All the canvases were lined at an unknown date. In the groups of both the vertical and horizontal format, Goya left the ground showing as an uneven border around all four edges, and the cut canvases lie along the edges of the stretchers. Since no nail holes or traces of cusping are visible and there was no attempt to fold the blank, unpainted canvas over the edge of the stretcher, it is possible that like other paintings (cat. 64, 65) these were not originally attached to a stretcher and were simply framed as flat pieces of canvas.

THE CASTILLO CRIME, I AND II

DOCUMENTS

A.H.N., Madrid: Consejos, Legajo 9344, No. 8; *Diario de Madrid*, 22 and 23 April 1798, pp. 445–6, 449–50, 452.

BIBLIOGRAPHY

Glendinning, 1978.

74 *The Friar's Visit (The Castillo Crime I), c.* 1798–1800

canvas, 41.5 × 31.8 cm
Madrid, Marqués de la Romana Collection

REFERENCES

G–W 914; Gud. 351/332; DeA 488.

CATALOGUES

Yriarte, 1867, p. 148; Viñaza, 1887, p. 290 (LXI); von Loga, 1903/21 (428); Mayer, 1924 (539); Desparmet Fitz-Gerald, 1928–50 (209).

75 *Interior of a Prison (The Castillo Crime II), c.* 1798–1800

canvas, 41.5 × 31.8 cm
Madrid, Marqués de la Romana

REFERENCES

G–W 915; Gud. 352/333; DeA 492.

CATALOGUES

Yriarte, 1867, p. 148; Viñaza, 1887, p. 290 (LIX); von Loga, 1903/21 (434); Mayer, 1924 (606); Desparmet Fitz-Gerald, 1928–50 (206).

THE BANDITS' ATTACK, I–III

It is possible that this group of paintings, similar to a sequence of *aleluyas* as seen in the 'Maragato' series (cat. 84–89, figs. 206, 207), was also inspired by a particularly bold and brutal attack on a stage-coach. An engraving by Marcos Téllez, dateable to the end of the 1790s, shows a similarly dramatic scene of 'Highway robbers' (*Salteadores de caminos*, Biblioteca Nacional, Madrid, 38061; information kindly provided by Doña Elena Santiago).

76 *Bandits Shooting their Prisoners (The Bandits' Attack I), c. 1798–1800*
canvas, 41.4 × 31.6 cm
Madrid, Marqués de la Romana

REFERENCES
G–W 918; Gud. 349/330; DeA 491.

EXHIBITIONS
See above; Brussels, 1985 (27).

CATALOGUES
Yriarte, 1867, p. 148; Viñaza, 1887, p. 290 (LXIII); von Loga, 1903/21 (493); Mayer, 1924 (604); Desparmet Fitz-Gerald, 1928–50 (194).

77 *A Bandit Stripping a Woman (The Bandits' Attack II), c. 1798–1800*
canvas, 41.5 × 31.8 cm
Madrid, Marqués de la Romana

REFERENCES
G–W 916; Gud. 348/329; DeA 489.

EXHIBITIONS
See above; Brussels, 1985 (28); Madrid, 1987 (46).

CATALOGUES
Yriarte, 1867, p. 148; Viñaza, 1887, p. 290 (LXII); von Loga, 1903/21 (494); Mayer, 1924 (605); Desparmet Fitz-Gerald, 1928–50 (197).

78 *A Bandit Murdering a Woman (The Bandits' Attack III), c. 1798–1800*
canvas, 41.5 × 31.8 cm
Madrid, Marqués de la Romana

REFERENCES
G–W 917; Gud. 350/331; DeA 490.

CATALOGUES
Yriarte, 1867, p. 148; Viñaza, 1887, p. 290 (LX); von Loga, 1903/21 (496); Mayer, 1924 (607); Desparmet Fitz-Gerald, 1928–50 (196).

THREE SUBJECTS

These three horizontal canvases are of a different, slightly denser weave than the five of vertical format, and they were prepared with a light orange-red ground that shows through the thin paint layers in all three.

79 *Gypsies Resting in a Cave, c. 1798–1800*
canvas, 33 × 57 cm
Madrid, Marqués de la Romana

REFERENCES
G–W 920; Gud. 354/335; DeA 494.

EXHIBITIONS
See above; London, 1920 (122).

CATALOGUES
Yriarte, 1867, p. 148; Viñaza, 1887, p. 290 (LVIII); von Loga, 1903/21 (492); Mayer, 1924 (603); Desparmet Fitz-Gerald, 1928–50 (193).

Although none of the *Caprichos* prints is directly related to this painting, it may be of significance that all the themes identified in the picture (p. 283) appear in a sequence of three of them: pl. 35 *Le descañona* ('*She is shaving him*') shows a prostitute shaving a man, pl.36 *Mala noche* ('*A bad night*') is a night scene with prostitutes out in the open (fig. 212), and pl. 37 *Si sabrá mas el discipulo?* ('*What if the pupil knows more?*') is the first of the sequence of asses, showing 'asinine pupils', very similar to the donkeys in the cave, with their equally asinine teacher.

80 *A Plague Hospital, c. 1798–1800*
canvas, 32.5 × 57.3 cm
Madrid, Marqués de la Romana

REFERENCES
G–W 919; Gud. 353/334; DeA 493.

EXHIBITIONS
See above; London, 1920 (121).

CATALOGUES
Yriarte, 1867, p. 148; Viñaza, 1887, p. 290 (LVII); von Loga, 1903/21 (569); Mayer, 1924 (692); Desparmet Fitz-Gerald, 1928–50 (192).

This is one of the most perfectly preserved of any of Goya's paintings and shows his technique at its most subtle and skilful: a combination of very thin, translucent washes of paint over the warm red ground, with discreet touches of colour, and much use of black outline drawing with the point of the brush, as well as dragged and feathered strokes that describe some of the broader, softer forms. On the wall to the right, Goya traced or suppressed the outline of an arch moving upwards towards the right by dabbing the thin paint layer with his fingers.

81 *Shooting in a Military Camp, c. 1798–1800*
canvas, 32.6 × 57 cm
Madrid, Marqués de la Romana

REFERENCES
G–W 921; Gud. 355/336; DeA 495.

EXHIBITIONS
see above; Madrid, 1987 (45).

CATALOGUES
Yriarte, 1867, p. 148; Viñaza, 1887, p. 290 (LVI); von Loga, 1903/21 (495); Mayer, 1924 (606); Desparmet Fitz-Gerald, 1928–50 (222).

CANNIBALS, *c. 1800–1808*

The two panels were apparently first catalogued by Yriarte in Gigoux's collection (by 1867), but without giving details of any kind and listing them simply as *L'Archevêque de Québec* (The Archbishop of Quebec) and *J'en ai mangé* (I have eaten of it), followed by two of the four small paintings on tinplate whose attribution to Goya remains doubtful (G–W 1657a–d). Sánchez Cantón (1951) gave details concerning the Bishop of Quebec and proposed Brebeuf and Lallement as the possible models, although many other Jesuits were killed by the Iroquois at that time. Barrio-Garay (1987) reproduced two prints showing the martydom of the Jesuits.

For sources of Goya's imagery, see Gassier, 1973, p. 435, 487, no. 323 (Album F 57); 1975, p. 94, no. 57 (*Sueño* no. 25) and p. 176, no. 139 (Saturn devouring his sons).

For Antique sources, see Bober–Rubinstein, 1986, nos. 30, 32 (Marsyas).

The panels, probably acquired from Javier Goya, have remained together and share a brief provenance. They were catalogued as on copper, and under various numbers, by von Loga (313, 498, 581, 582) and Mayer (395, 609, 706, 707).

PROVENANCE

Jean Gigoux, Paris (by 1867); Gigoux bequest to the Musée de Besançon (1896).

EXHIBITIONS

For the exhibition history to 1963, see London, 1963–4 (103, 104); The Hague/Paris, 1970 (23, 24); Washington/Cleveland/Paris, 1975–7 (290, 291).

BIBLIOGRAPHY

Sánchez Cantón, 1951, p. 115; Barrio-Garay, 1987, pp. 81–2; M. Pinette and F. Soulier-François, *De Bellini à Bonnard: Chefs d'œuvre de la peinture du Musée des Beaux-Arts et d'Archéologie de Besançon*, Paris, 1992, p. 158.

82 *Cannibals Preparing their Victims,* *c.* 1800–08

panel, 32.8 × 46.9 cm
Besançon, Musée des Beaux-Arts et d'Archéologie (896.1.176)

REFERENCES

G–W 922; Gud. 475/591; DeA 408.

CATALOGUES

Yriarte, 1867, p. 151 (Gigoux, Paris); Desparmet Fitz-Gerald, 1928–50 (249).

83 *Cannibals Contemplating Human Remains, c.* 1800–08

panel, 32.7 × 47.2 cm
Besançon, Musée des Beaux-Arts et d'Archéologie (896.1.177)

REFERENCES

G–W 923; Gud. 476/592; DeA 409.

CATALOGUES

Yriarte, 1867, p. 151 (Gigoux, Paris); Desparmet Fitz-Gerald, 1928–50 (250).

The paintings are on thick panels, analysed as pine, probably of the *pin pignon* type, prepared with a 3 cm wide bevel on the verso that tapers from a total panel thickness of about 1.8 cm to 1.2 cm at the bevelled edge. The panels were prepared with a warm red ground that extends around the edges and over the whole of the verso, and was covered by a grey preparation.

FRIAR PEDRO DE ZALDIVIA AND THE BANDIT 'EL MARAGATO', *c.* 1806

Apart from the eight (out of eleven) canvases of the Marquess de la Romana (cat. 74–81), this is the only extended series of Goya's pictures to have remained intact since the works were painted. It is not known when the dealer Lafitte acquired them in Madrid. The receipted invoice from Julius Böhler to Martin A. Ryerson, dated 22 July 1911, gives the provenance of the six pictures as 'from the collections Lafitte and Marqués de Villatoya, Madrid' (Art Institute of Chicago archives).

84 *El Maragato Threatens Friar Pedro de Zaldivia with his Gun*

85 *Friar Pedro Offers Shoes to El Maragato and prepares to push aside his Gun*

86 *Friar Pedro Wrests the Gun from El Maragato*

87 *Friar Pedro Clubs El Maragato with the Gun-butt*

88 *Friar Pedro Shoots El Maragato as his Horse runs off*

89 *Friar Pedro Binds El Maragato with a Rope*

all *c.* 1806
panels, 29.2 × 38.5 cm each
The Art Institute of Chicago, Mr and Mrs Martin A. Ryerson Collection (1933.1071–76)

REFERENCES

G–W 864–9; Gud. 511–6/504–9; DeA 456–61

PROVENANCE

Javier Goya, Madrid (1812); Marqués de Villatoya, Madrid(?); (Lafitte, Madrid, before 1861); (Vente Lafitte, Hôtel Drouot, Paris, 7 March 1861, lot 34, unsold); (Lafitte, Madrid); (Julius Böhler, Munich, 1911); Martin A. Ryerson, Chicago (1911); bequest to The Art Institute, 1933.

DOCUMENTS

1812 Inventory: 'Six pictures of El Maragato, indicated with the number eight at . . . 700 [reales]', see Sánchez Cantón, 1946 (*Archivo*), p. 86; Gassier–Wilson, 1970, p. 381, Appx I The escape and capture of El Maragato: '*Noticia exacta de todo lo executado por Pedro Piñero, alias el* Maragato, *desde que se escapó de presidio, hasta que fue preso y herido por el Padre Fray Pedro de Zaldivia Religioso lego de la Orden de S. Pedro de Alcántara*' [Madrid, 1806], reprinted in Malaga (copies in The Hispanic Society of America, New York; British Library, London): Domergue, 1987, p. 183, Appx II.

EXHIBITIONS

(complete series): New York, 1928 (7–12); Chicago, 1933 and 1934, *Century*, The Art Institute of Chicago (166a–f); New York, 1934, M. Knoedler & Co. (16–21); Columbus, Ohio, 1936, Columbus Gallery of Fine Arts; Chicago, 1941 (71–5). Toledo, Ohio, 1941, Museum of Art; New York, 1950 (29–34); New York, 1955, Metropolitan Museum of Art (suppl. ex-cat. 178–83, *Goya Drawings and Prints*).
Cat. 84 and 88: The Hague/Paris, 1970 (33, 34).

CATALOGUES

von Loga, 1903/21 (485); Mayer, 1924 (597a–f); Desparmet Fitz-Gerald, 1928–50 (215–50).

BIBLIOGRAPHY

Calleja, 1924, pl. 284–9 (heirs of Lafitte, Paris) Hilton, 1946; Sánchez Cantón, 1951, p. 81; Sherman Font, 1958; Bozal, 1983, pp. 150–54; Domergue, 1987.

The series is painted on panels (now cradled) prepared with a red ground that shows through in many areas. The handling is very free, with thin washes alternating with areas of impasted paint, and innumerable pentimenti are visible. Every scene has a different setting, even the first two that occur in the same place, and as in the Romana pictures (cat. 74–81), they were devised and transformed in the course of work to suit the final arrangement of the figures.

War and Aftermath, 1808–1819

BIBLIOGRAPHY

For references in the text on pp. 301–2, the following sources were used:
Allegory of the City of Madrid (Ayuntamiento, Madrid): see exh. cat. Madrid, 1982–3; *Diplomatario*, 1981, pp. 367–68, nos. 237, 238; Madrid, 1988 (Municipal), p. 266; A.E. Peréz Sánchez and J.L. Diez García, *Catalogo de las pinturas del Museo Municipal de Madrid*, Madrid, 1990, pp. 125–8.
Portrait of Palafox (Museo del Prado, Madrid): *Diplomatario*, 1981, pp. 371–2, no. 245.

EVOCATION OF THE WAR OF INDEPENDENCE, *c.* 1810–1814

The account of Goya's commissions and of his conduct during the period of the French occupation, as well as his visit to Saragossa in 1808, is drawn from letters, documents and records in Sentenach (1919–23), 1919, p. 207; Lafuente Ferrari, 1946 (see also p. 50, n. 21); Sambricio, 1946, doc. 225–47; *Diplomatario*, 1981, pp. 361–74.

It is presumed that these two small panels entered the Royal Collection at the same time as Goya's history paintings of the *Second …* and *Third of May 1808*. They have not been identified in the Palace inventories made at the time of the transfer of paintings to the Real Museo del Prado in 1819 (see cat. 60).

PROVENANCE

Royal Collection: Casino del Príncipe, El Escorial (by 1857); Palacio Real, Madrid; Palacio de la Zarzuela.

EXHIBITIONS

Madrid, 1900 (3, 4: Casa Real); Madrid, 1928 (78/29, 79/32); Geneva, 1939 (34, 35); Madrid, 1946 (280, 282); Venice, 1952 (26, 25); Basle, 1953 (27, 28); Madrid, 1961 (55, 54); Madrid, 1983 (43, 44); Brussels, 1985 (32, 33); Madrid, 1988–9 (262, 263). Cat. 91: Stockholm, 1959–60 (157) Paris, 1987–8 (236).

BIBLIOGRAPHY

V. Polero y Toledo, *Catálogo de los cuadros del Real Monasterio de San Lorenzo, llamado del Escorial*, Madrid, 1857 (688, 690). Sánchez Cantón, 1951, p. 94; Borderías Bescós, 1967, pp. 157–99, Hamburg exh. cat. 1980–81; Pérez Sánchez, 1970, pp. 40–41, 44; Baticle, 1992, pp. 317–65 *passim.*

90 *Making Powder in the Sierra de Tardienta, c.* 1810–14
panel, 32.9 × 52.2 cm
Madrid, Patrimonio Nacional, Palace of La Zarzuela

REFERENCES

G–W 980; Gud. 618/594; DeA 549.

CATALOGUES

Yriarte, 1867, p. 145 (L'Escurial. Casa del Príncipe); Viñaza, 1887, p. 283 (XLII); von Loga, 1903/21 (74); Mayer, 1924 (81); Desparmet Fitz-Gerald, 1928–50 (227).

91 *Making Shot in the Sierra de Tardienta, c.* 1810–14
panel, 33.1 × 51.5 cm
Madrid, Patrimonio Nacional, Palace of La Zarzuela

REFERENCES

G–W 981; Gud. 619/595; DeA 550.

CATALOGUES

Yriarte, 1867, p. 145 (L'Escurial. Casa del Príncipe); Viñaza, 1887, p. 283 (XLIII); von Loga, 1903/21 (73); Mayer, 1924 (80); Desparmet Fitz-Gerald, 1928–50 (228).

The paintings are on pieces of reused wood: cat. 90 is on a pine panel, 5 mm in thickness, covered by a light-green ground(?), except for a strip 7 mm wide along the lower edge; cat. 91 is on a red (cedar?) wood panel, 32.2 to 32.9 cm in height with an irregular lower edge, whose thickness varies considerably. In this panel, a layer of white appears to have been applied directly to the wood, and then a dark layer before the final light reddish-ochre that served as the preparation for Goya's painting. The paintings were restored and cleaned in 1993.

The numbers painted in the lower right corners of the panels are the same as those used in the catalogue of 1857. The labels on the backs of the panels are lettered in pen and ink: '*Numero 1 / Fabrica de pólvora establecida por D. Josef Mallen / en la Sierra de Tardienta / en Aragon / en los años de 1811, 12 y 13*', and '*Numero 2 / Fábrica de balas de fusil / establecida …* [idem]'.

NATIONAL ALLEGORIES, *c.* 1808–1812

The complex provenance of the paintings was discussed, though hardly clarified by Haraszti-Takács, 1975. If Prince Alois Wenzel Kaunitz acquired the pair in Madrid before 1820 (the date of his sale in Vienna), and most probably *c.* 1815–16, as suggested in her article, he would have bought them from Javier Goya, to whom they legally belonged. It is usually thought that all the paintings remained in Goya's home until his move to the Quinta in 1819, but is not impossible that he may have disposed of works on Javier's behalf. On the other hand, there is no proof of the date of acquisition by Kaunitz.

PROVENANCE

Javier Goya (1812); Prince Alois Wenzel Kaunitz, Madrid (acquired *c.* 1815–16?); (Kaunitz sale, Vienna, 1820, lots 69, 70); Esterházy, Hungary; acquired National Picture Gallery 1871; to Szépművészeti Múzeum 1907.

DOCUMENTS

1812 Inventory, no. 13: Sánchez Cantón, 1946 (*Archivo*); Gassier–Wilson, p. 381, Appx I, no. 13.

EXHIBITIONS

London, 1936–4 (99, 100); Munich-Vienna, 1982 (25, 26); Madrid/Boston-New York, 1988–9 (67, 68).

BIBLIOGRAPHY

Beruete, II, 1917, pp. 131–3; Klingender, 1948, pp. 209–10; Pigler, 1967, p. 267, no. 760, 763; Haraszti-Takács, 1975, pp. 113–20; Garas, 1988, p. 90; Budapest Museum catalogue, 1991, p. 153.

92 *The Knife-grinder, c.* 1808–12
canvas, 68 × 50.5 cm
Budapest, Szépművészeti Múzeum (316)

REFERENCES

G–W 964; Gud. 580/559; DeA 482.

CATALOGUE

von Loga, 1903/21 (530); Mayer, 1924 (648); Desparmet Fitz-Gerald, 1928–50 (248).

93 *The Water-carrier, c.* 1808–12
canvas, 68 × 52 cm
Budapest, Szépművészeti Múzeum (313)

REFERENCES

G–W 963; Gud. 579/557; DeA 481.

CATALOGUES

von Loga, 1903/21 (554); Mayer, 1924 (677); Desparmet Fitz-Gerald, 1928–50 (240 n.).

x-radiographs show that the two paintings were executed on canvases previously painted with decorative flower compositions. Their technique, which has not been studied in detail, suggests a date closer to 1812 than to 1808.

Moreno de las Heras, in her notice in the 1988–9 exhibition catalogue, proposed the interpretation of the figures as symbols of the Saragossan resistance. The further identification, suggested here, with Antique prototypes raises the possibility, of which Goya may or may not have been aware, of a connection with the theme of the flayed Marsyas, with whom the Antique figure of the *Knife-grinder* is associated, and therefore with Goya's *Cannibals* of some years earlier (cat. 82). See Haskell–Penny, 1981, nos. 11, 82; Bober–Rubinstein, 1986, nos. 33, 132. For the type of water-nymph that may be associated with Goya's *Water-carrier*, see Bober–Rubinstein, 1986, no. 63.

SACRISTY OF SEVILLE CATHEDRAL, 1817

94 *SS Justa and Rufina*, 1817
panel, 45.3 × 30 cm
Madrid, Museo del Prado (2650)

REFERENCES
G–W 1570; Gud. 653/633; DeA 609.

PROVENANCE
Pablo Bosch, Madrid; bequest to Prado, 1915.

DOCUMENTS
Ceán Bermúdez–Tomás Verí correspondence: Ariany 1920, p. 109.
Ceán's analysis: Ceán Bermúdez, 1817; Glendinning, 1977, pp. 56, 287–90, Appx I, 1982, pp. 70, 294–7, Appx I.

EXHIBITION
Tokyo-Kyoto, 1971–2 (44).

CATALOGUES
von Loga, 1903/21 (50); Mayer, 1924 (59); Desparmet Fitz-Gerald, 1928–50 (98); Morales y Marín, 1990, p. 280 (114).

BIBLIOGRAPHY
Yriarte, 1867, p. 67; Viñaza, 1887, pp. 206–7; Beruete, II, 1917, pp. 134–6; Ariany *et al.* 1920, pp. 109–20; Calleja, 1924, pl. 209; Sánchez Ventura, 1928, p. 151; González Palencia, 1946; Sánchez Cantón, 1946 (*Revista*), p. 277ff.: Sánchez Cantón, 1951, pp. 113–14; Guerrero Lovillo, 1971, pp. 216–7; Salas, 1974.

The panel of red cedar, 7 mm thick, is covered with a very thin, light-red ground that reveals the grain of the wood. The work was cleaned in 1993 and found to be in good condition.

The altarpiece in the Sacristía de los Calices is signed and dated '*Francisco de Goya y Lucientes. Cesar-/ augustano y primer Pintor de cámara / del Rey. Madrid año de 1817*', and was painted in Madrid after a period of study in Seville, when Goya certainly looked at Murillo's celebrated painting of the same subject, part of the altarpiece (*retablo*) in the Capuchin church, now in the Museum of Fine Arts in Seville.

FOUR 'CAPRICHOS' IN THE ROYAL ACADEMY OF SAN FERNANDO, *c.* 1815–1819

The four panels have been tentatively identified with the inventory of 1828. If this is correct, they were presumably acquired from Javier Goya, together with the *Burial of the Sardine* (G–W 970), not long before they were bequeathed by García de la Prada to the 'Real Academia de Nobles Artes de San Fernando'. They are described as follows in his will: 'Five pictures on panel, the four of horizontal format representing one, an *auto de fe* of the Inquisition; another, a procession of penitents, or flagellants; another, a madhouse; another, a bullfight; and another, which is larger, Masqueraders performing, all by the celebrated Court Painter don Francisco Goya, and much lauded by professional artists.' The titles in the will are those used in this catalogue.

PROVENANCE
Javier Goya (by 1828); Manuel García de la Prada, Madrid (before 1836); Royal Academy of San Fernando (bequeathed 17 January 1836; received 22 December 1839).

DOCUMENTS
1828 Inventory (no. 5 '*Quatro cuadritos fiestas y costumbres*'): Desparmet Fitz-Gerald, 1928–50, I, p. 53, n.1; Gassier–Wilson, 1970, p. 381, Appx II.
Garcia de la Prada's will: A.H.P.M., 23964, 17 January 1836 (Martín Santín y Vázquez).
San Fernando Academy archives: 'Juntas ordinarias', Sig. 3/90, 26 January 1840 (see also Sig. C.F.1/9).

BIBLIOGRAPHY
López Rey, 1945, pp. 137–41, no. 95; Pemán, 1962, pp. 408–10; Glendinning, 1983, p. 28; *El libro de la Academia*, 1991, pp. 278–80; Tomlinson, 1992, pp. 162–4, 1993, pp. 212–14.

95 *Bullfight in a Village*, *c.* 1815–19
panel, 45 × 72 cm
Madrid, Royal Academy of San Fernando (675)

REFERENCES
G–W 969; Gud. 465/501; DeA 559.

EXHIBITIONS
Madrid, 1900 (14); Arles/Madrid, 1990 (–/13).

CATALOGUES
Yriarte, 1867, p. 131; Viñaza, 1887, p. 284 (XLV); von Loga, 1903/21 (537); Mayer, 1924 (658); Desparmet Fitz-Gerald, 1928–50 (247).

96 *Procession of Flagellants*, *c.* 1815–19
panel, 46 × 73 cm
Madrid, Royal Academy of San Fernando (674)

REFERENCES
G–W 967; Gud. 463/499; DeA 556.

EXHIBITION
Madrid, 1900 (13).

CATALOGUES
Yriarte, 1867, p. 131; Viñaza, 1887, p. 285 (XLVII); von Loga, 1903/21 (424); Mayer, 1924 (534); Desparmet Fitz-Gerald, 1928–50 (214).

97 *'Auto de fe' of the Inquisition*, *c.* 1815–19
panel, 46 × 73 cm
Madrid, Royal Academy of San Fernando (673)

REFERENCES
G–W 966; Gud. 462/498; DeA 557.

EXHIBITION
Madrid, 1900 (12).

CATALOGUES
Yriarte, 1867, p. 131; Viñaza, 1887, p. 283 (XLIV); von Loga, 1903/21 (431); Mayer, 1924 (543); Desparmet Fitz-Gerald, 1928–50 (212).

98 *The Madhouse*, *c.* 1815–19
panel, 45 × 72 cm
Madrid, Royal Academy of San Fernando (672)

REFERENCES
G–W 968; Gud. 464/500; DeA 558.

EXHIBITIONS
Madrid, 1900 (11); Lugano, 1986 (39).

CATALOGUES
Yriarte, 1867, p. 131; Viñaza, 1887, p. 286 (XLVIII); von Loga, 1903/21 (570); Mayer, 1923 (693); Desparmet Fitz-Gerald, 1928–50 (202).

The panels were prepared with a reddish ground that is apparent in many places and forms an unpainted border around the images. The works are at present affected by uneven, yellowed varnish, but are in an excellent state of conservation.

Exile in France, 1824–1828

Accounts of Goya's years in Spain are found in Núñez de Arenas, 1950; Sayre, 1966, 1971.
Particular references are taken from the following sources:
Palace documents and correspondence: Sambricio, 1946, doc. 251 (and see docs. 252–74).
Goya–Ferrer correspondence: Calleja, 1924, pp. 54–5; Sayre, 1966, pp. 112–14.
Moratín–Melon correspondence: Moratín, 1867–8, III; Beruete, I, 1916, p. 145.

MINIATURES ON IVORY, 1824–1825

The most important study of Goya's late miniatures was published by Eleanor A. Sayre in the *Boston Museum Bulletin* in 1966 (with a French translation in the 1979 Paris exh. cat.). Since then, a number of unlocated miniatures have come to light, and all those known to the author are included here, in order to give as complete a representation as possible of these tiny, fragile works whose loan to exhibitions is often refused on conservation grounds. Six of them (cat. 99–103, 106) were included in the exhibition in Madrid. Difficult of access, and rarely reproduced, they demand to be more widely known, and are very important for an understanding of Goya's late painting style.

DOCUMENTS
Calleja, 1924, p. 55, letter III; Sayre, 1966, Appx I, pp. 113, letter III; *Diplomatario*, 1981, pp. 389–90, no. 273.

BIBLIOGRAPHY
Matheron, 1858, ch.XI, 1890, pp. 97–8; Soria, 1949; Sayre, 1966; Salas, 1973; 1979/81 (647).

99 *Susanna and the Elders*, 1824–5
carbon black and watercolour on ivory, 5.5 × 5.5 cm
S. Sebba Collection

REFERENCES
G–W 1682; Gud. 746/716; DeA 673.

PROVENANCE
Edward Habich, Kassel; (Habich sale, Gutekunst, Stuttgart, 27–28 April 1889, lot 303); priv. coll., New York; (sale, Sotheby, London, 24 June 1964, lot 25); (acquired Alfred Brod Gallery, London); S. Sebba (by 1966).

EXHIBITION
London, 1964 (Alfred Brod Gallery, *25th Exhibition of Old Master Paintings*, no. 1).

CATALOGUES
Mayer, 1924 (16a); Soria, 1949 (2); Sayre, 1966 (10).

100 *Maja and a Celestina*, 1824–5
carbon black and watercolour on ivory, 5.4 × 5.4 cm
Riverdale-on-Hudson, New York, Stanley Moss Collection

REFERENCES
G–W 1676; Gud. 747/717; DeA 666.

PROVENANCE
Luis de Portilla, Madrid; (Portilla sale, Madrid, 16 February 1880 and following days, lot 189); Sir Kenneth (subsequently Lord) Clark, London (by 1963) ; (sold Sotheby's, New York, 30 May 1991, lot 83).

EXHIBITIONS
London, 1963–4 (123); Paris, 1970 (20); Paris, 1979 (193).

CATALOGUES
Soria, 1949 (16); Sayre, 1966 (3).

101 *Head of a Man*, 1824–5
carbon black and watercolour on ivory, 5.5 × 5.5 cm
Riverdale-on-Hudson, New York, Stanley Moss Collection

REFERENCES
G–W –; Gud. –/727; DeA 679.

PROVENANCE
Juan de Muguiro, Bordeaux.

BIBLIOGRAPHY
Salas, 1973, p. 170, fig. 4.

102 *Heads of a Child and an Old Woman*, 1824–5
carbon black and watercolour on ivory, 5.5 × 5.5 cm
Riverdale-on-Hudson, New York, Stanley Moss Collection

REFERENCES
G–W –; Gud. –/726; DeA 687.

PROVENANCE
Juan de Muguiro, Bordeaux.

BIBLIOGRAPHY
Salas, 1973, p. 170, fig. 3.

103 *Man Eating Leeks,* 1824–5
carbon black and watercolour on ivory, 6.2 × 5.6 cm
Dresden, Kupferstich–Kabinett (C.1899–41)

REFERENCES
G–W 1686; Gud. 753/723; DeA 677.

PROVENANCE
Edward Habich, Kassel; (Habich sale, Gutekunst, Stuttgart, 27–28 April 1899, lot 307); acquired Dresden Kupferstich-Kabinett.

EXHIBITIONS
Paris, 1979 (195); Madrid/London/Chicago, 1993–94 (exh. Madrid only).

BIBLIOGRAPHY
von Loga, 1903/21 (224); Sayre, 1966 (14).

104 *Man Looking for Fleas in his Shirt,* 1824–5
carbon black and watercolour on ivory, 6 × 5.9 cm
Boston, Museum of Fine Arts, M.M. Karolik Fund (1973.733)

REFERENCES
G–W 1679; Gud. 759/726; DeA 669.

PROVENANCE
Luis de Portilla; (Portilla sale, Madrid, 16 February 1880 and following days, lot 192); Warwick, Paris; Schidloff, Paris; Baron von Schlumberger, Vienna; (Tomás Harris, London, by 1938); (Durlacher Bros, New York, by 1941); Mr and Mrs Vincent Price, Los Angeles (by 1956); acquired by Boston Museum of Fine Arts, 1973.

EXHIBITIONS
London, 1938 (25: Tomás Harris); Chicago, 1941 (156: Durlacher Bros.); New Haven, Yale University Art Gallery, *Pictures Collected by Yale Alumni,* 1956 (33: Vincent Price); Los Angeles, UCLA, The Art Galleries, Dickson Art Center, *Spanish Masters,* 1960 (23).

CATALOGUES
Soria, 1949 (6); Sayre, 1966 (6).

105 *Woman with her Clothes Blowing in the Wind,* 1824–5
carbon black and watercolour on ivory, 9 × 9.5 cm
Private Collection

REFERENCES
G–W 1690; Gud. 742/712; DeA 682.

PROVENANCE
Priv. coll., Paris; (sale Hôtel Drouot, Paris, 22 February 1937, lot 56–1); (Tomás Harris, London, by 1938); (Durlacher Bros, New York, by 1941); Mr and Mrs R. Kirk Askew, Jr., New York; thence by descent.

EXHIBITIONS
London, 1938 (28); Chicago, 1941 (147: Durlacher); Los Angeles, UCLA, The Art Galleries, Dickson Art Center, *Spanish Masters,* 1941 (5); Los Angeles, [as 1941], 1960 (21); London, 1963–64 (122); Boston, *Prized Possessions: European Paintings from Private Collections,* 1992 (62).

CATALOGUES
Soria, 1949 (7); Sayre, 1966 (20).

106 *A Seated Majo and Maja,* 1824–5
carbon black and watercolour on ivory, 9 × 8.5 cm
Stockholm, Nationalmuseum (NMB 1879)

REFERENCES
G–W 1689; Gud. 738/708; DeA 681.

PROVENANCE
Sir William Stirling-Maxwell, Keir (?); Archibald Stirling, Keir; Hon. Mrs Stirling, Keir; (sale Sotheby, London, 3 July 1963, lot 63); acquired by Nationalmuseum 1900.

EXHIBITIONS
London, 1928, p. 81 (15); London, 1938 (26); Paris, 1979 (196).

CATALOGUES
Soria, 1949 (9); Sayre, 1966 (19).

107 *Two Children Looking at a Book,* 1824–5
carbon black and watercolour on ivory, 5.2 × 5.3 cm
Providence, Rhode Island School of Design, Museum of Art, Gift of Mrs Gustave Redeke (21.129)

REFERENCES
G–W 1687; Gud. 749/719; DeA 678.

PROVENANCE
Edward Habich, Kassel; (Habich sale, Gutekunst, Stuttgart, 27–28 April 1899, lot 308); Dr Gustav Radeke; gift to Rhode Island School of Design 1921.

EXHIBITIONS
Indianapolis, John Herron Museum of Art, *El Greco to Goya,* 1963 (38); Boston/Ottawa, 1974–75 (255).

CATALOGUES
Soria, 1949 (10); Sayre, 1966 (15).

108 *Monk Talking to an old Woman,* 1824–5
carbon black and watercolour on ivory, 5.7 × 5.4 cm
Princeton, New Jersey, Princeton University, The Art Museum, Fowler McCormick Fund (Y1985–6)

REFERENCES
G–W 1685; Gud. 748/718; DeA 676.

PROVENANCE
Edward Habich, Kassel; (Habich sale, Gutekunst, Stuttgart, 27–28 April 1899, lot 306); William Rothenstein, London (by 1900); John Quinn, New York (by 1913); (Quinn sale, American Art Galleries, New York, 9–12 February 1927, lot 29); P. Lorillard, New York; Mrs E. John Heidsieck, New York; (Heidsieck sale, Parke–Bernet, New York, 12–13 February 1943, lot 278); Mrs Robert Maisel, New York; (Richard L. Feigen, New York, 1984); acquired Princeton Art Museum, 1985.

EXHIBITIONS
1913, New York (Armory Show), *International Exhibition of Modern Art* (588: Quinn).

CATALOGUES
Lafond, 1902 (61); Mayer, 1924 (542); Soria, 1949 (5); Sayre, 1966 (13).

BIBLIOGRAPHY
W. Rothenstein, *Goya,* London, 1900, p. 25, pl. 12/ New York, 1901, p. 37, pl. 12; von Loga, 1903/21, p. 224; F. Watson, *John Quinn... Collection of Paintings,* Huntington, New York, 1926, p. 26; exh. cat. *1913 Armory Show,* Munson–Williams–Proctor Institute, Utica, 1963, p. 191; J. Zilcer, *The Noble Buyer: John Quinn,* exh. cat., Hirschorn Museum, Washington, DC, 1978, p. 161; *Record of the Art Museum, Princeton University,* ill. p. 99, and *Selections from The Art Museum,* ill. p. 99, both Princeton, 1986.

109 *Boy Frightened by a Man,* 1824–5
carbon black and watercolour on ivory, 5.9 × 6 cm
Boston, Museum of Fine Arts, Gift of Eleanor A. Sayre (1992.326)

REFERENCES
G–W 1693; Gud. 755/725; DeA 685.

PROVENANCE
Priv. coll., France; (sale Hôtel Drouot, Paris, 22 February 1937, lot 56–4); England, priv. coll. (by 1970); Eleanor A. Sayre, Cambridge, Mass.; Gift to Boston Museum of Fine Arts, 1992.

CATALOGUES
Soria, 1949 (11); Sayre, 1966 (23).

110 *Young Woman, Half-naked, Leaning Against Rocks,* 1824–5

carbon black and watercolour on ivory, 8.8 × 8.6 cm
Boston, Museum of Fine Arts, Ernest Wadsworth Longfellow Fund (63.1081)

REFERENCES
G–W 1688; Gud. 739/709; DeA 680.

PROVENANCE
Sir William Stirling-Maxwell, Keir (?); Archibald Stirling, Keir; Hon. Mrs Stirling, Keir; (sold Sotheby, London, 3 July 1963, lot 64); acquired Boston Museum of Fine Arts 1964.

EXHIBITIONS
London, 1928 (11); London, 1938 (27).

CATALOGUES
Soria, 1949 (8); Sayre, 1966 (18).

111 *Man Picking Fleas from a Little Dog,* 1824–5

carbon black, watercolour and graphite on ivory, 8.9 × 8.5 cm
Dresden, Kupferstich-Kabinett (C.1899-40)

REFERENCES
G–W 1683; Gud. 740/710; DeA 674.

PROVENANCE
Edward Habich, Kassel; (Habich sale, Gutekunst, Stuttgart, 27–28 April 1899, lot 304); acquired Dresden Kupferstich-Kabinett.

EXHIBITIONS
Los Angeles, 1941 (21); Paris, 1979 (194); Prado/London/Chicago, 1993–4 (exh. London only).

CATALOGUES
Lafond, 1902, p. 155 (59); Mayer, 1924 (646a); Soria, 1949 (3); Sayre, 1966 (11).

BULLFIGHT, 1824

112 *Bullfight: Suerte de vara,* 1824

canvas, 50 × 61 cm
inscribed on the back of the original canvas '*Pintado en Paris en Julio de 1824/Por/D^r. Fran.^{co} Goya/JMF*' (copied on the lining canvas)
Malibu, California, Collection of the J. Paul Getty Museum (93.PA.1)

REFERENCES
G–W 1672; Gud. 734/704; DeA 660.

PROVENANCE
Joaquín María Ferrer, Paris; by descent to Marqués de Baroja, Madrid (by 1900); by inheritance to Marquesa de la Gándara, Rome (by 1970)/Switzerland; (sold Sotheby, London, 9 December 1992, lot 84); acquired for J. Paul Getty Museum.

EXHIBITIONS
Madrid, 1900 (119: Baroja); Bordeaux, 1951 (59: Baroja); Arles/Madrid, 1990 (48).

CATALOGUES
von Loga, 1903/21 (543); Mayer, 1924 (664); Desparmet Fitz-Gerald, 1928–50 (274).

BIBLIOGRAPHY
Calleja, 1924, pl. 302; Salas, 1964 (*Burlington*), pp. 37–8; exh. cat. (Arles)/Madrid, 1990, pp. 134–5.

The canvas, apparently relined in 1959, has a thin, white-ish ground that appears to be covered by a dark preparation in some areas. The picture was examined at the Courtauld Institute of Art, London, prior to the 1992 sale, and has since been lightly cleaned, partially reducing the thickness of the yellowed varnish.

LITHOGRAPHS, 1824–1825

DOCUMENTS
Matheron, 1858, ch. XI/1890, pp. 98–9; Lafond, 1907, p. 242.

113 *Picador Drawing a Bull in Open Country,* 1824–5

lithograph, 25 × 35.5 cm (unique proof)
Berlin, Kupferstichkabinett (801.1906)

REFERENCES
G–W 1705; H 278; D 275.

114 *Bullfight,* 1825

lithograph, 31 × 41.5 cm (unique proof)
signed and dated '*Goya Bodeaux* [sic] *1825*'
Bordeaux, Musée des Beaux-Arts

REFERENCES
G–W 1706; H 287; D –.

PROVENANCE
Laurent Matheron, Paris; acquired Ville de Bordeaux, 1898.

EXHIBITIONS
Amsterdam, 1970–71 (157).

THE 'BULLS OF BORDEAUX', 1824–1825

DOCUMENTS
Calleja, 1924, pp. 54–5, nos. II, III; Sayre, 1966, pp. 113–14, Letters II, III; *Diplomatario*, 1981, pp. 389–90, nos. 272, 273.

The four lithographs in the Biblioteca Nacional, Madrid (the set included in the exhibition shown at the Museo del Prado), are numbered I to IV in graphite, in the order catalogued here, and the first has a long inscription (see p. 333).

115 '*The Celebrated American, Mariano Ceballos*' [I], 1825

lithograph, 30.5 × 40 cm
signed at lower left: '*Goya*'; inscribed below: '*El famoso Americano, Mariano Ceballos*'

REFERENCES
G–W 1707; H 283; D 286.

116 *Bravo toro* [II], 1825

lithograph, 30.5 × 41 cm
signed at lower left: '*Goya*'

REFERENCES
G–W 1708; H 284; D 287.

117 *'Spanish Entertainment'* [III], 1825
lithograph, 30 × 41 cm
signed at lower left: '*Goya*'; inscribed below: '*Diber-
sión de España*'

REFERENCES
G–W 1709; H 285; D 287.

118 *The Divided Ring* [IV], 1825
lithograph, 30 × 41.5 cm
signed at lower edge: '*Goya*'

REFERENCES
G–W 1710; H 286; D 289.

For the lithographs exhibited at the Royal Academy:
London, The British Museum (1975.10.25.426–29,
Harris Collection). For the lithographs exhibited at
Chicago: The Art Institute of Chicago, The Clarence
Buckingham Collection (1936.166–69).

BIBLIOGRAPHY

A slash (/) between names and numbers indicates a change of language and/or numbering.

AGAPITO GARCÍA, A., 'Algo sobre Goya y su tiempo. Apéndice. Los lienzos de Goya, de Valladolid', *Boletín del Museo Provincial de Bellas Artes*, Valladolid, 1928, pp. 187–214.

ÁGUEDA, M. and SALAS, X. DE, see [GOYA, F. de]. *Cartas a Martín Zapater*.

ÁGUEDA, M., 'Novedades en torno a una serie de cartones de Goya', *Boletín del Museo del Prado*, V, 1984, pp. 41–6.

ÁGUEDA, M., 'Los retratos ecuestres de Goya', in *Goya. Nuevas visiones*, 1987, pp. 39–59.

ÁGUEDA, M., 'Goya y Bernardin de Saint-Pierre', *Cuadernos de Arte e Iconografía*, Acts of the colloquia on Iconography, Fundación Universitaria Española, Seminar on Art, 'Marqués de Lozoya', IV, 1991, pp. 167–74.

ALCOCER, M., 'Real Monasterio de San Joaquín y Sta. Ana, de Valladolid', *Boletín de la Comisión Provincial de Monumentos Históricos y Artísticos de Valladolid*, 3, 1926, pp. 5–44.

ALÍA PLANA, J. M., 'Imágenes y textos para el estudio de los uniformes militares españoles en el arte de la Ilustración' (doctoral thesis in preparation).

ANGULO ÍÑIGUEZ, D., 'La familia del Infante Don Luis pintada por Goya', *Archivo Español de Arte*, XIII, 1940, pp. 49–58.

ANGULO ÍÑIGUEZ, D., 'Un testimonio mejicano de la sordera de Goya', *Archivo Español de Arte*, XVII, 1944, pp. 391–2.

ANSON NAVARRO, A, *El pintor y profesor José Luzán Martínez (1710–1785)*, Saragossa, 1986.

ARAUJO SÁNCHEZ, C., *Goya*, Madrid, 1896.

ARCO, R. DEL, 'Pinturas de Goya (inéditas) en el Palacio de los Condes de Sobradiel, de Zaragoza', *Boletín de la Sociedad Española de Excursiones*, XXIII, 1915, pp. 124–31.

ARIANY and LA CENIA, MARQUESSES OF, *Cuadros notables de Mallorca. Principales colecciones que existen en la isla de Mallorca*, Collection of Don Tomás de Verí, Madrid, [1920].

ARNAIZ, J. M., *Francisco de Goya. Cartones y tapices*, Madrid, 1987.

ARNAIZ, J. M. and BUENDÍA, J.R., 'Aportaciones al Goya Joven', *Archivo Español de Arte*, LVII, 1984, pp. 169–76.

ARNAIZ, J. M. and MONTERO, A., 'Goya y el Infante Don Luis', *Antiquaria*, IX, 1986, pp. 45–55.

BARBOZA, C. and GRASA, T., 'Un año de restauración en la cúpula de Regina Martyrum', in *Regina Martirum. Goya*, 1982, pp. 55–93.

BARBOZA, C. and GRASA, T., 'La Gloria. Pintura al fresco en el Coreto de la Basílica del Pilar de Zaragoza. Francisco de Goya. 1772', in *Goya*, exh. cat. Seville, 1992, pp. 85–99.

BARRIO-GARAY, J. L., 'Antropofagia y hematofagia en la iconografía de Goya', in *Goya. Nuevas Visiones*, 1987, pp. 73–89.

BATICLE, J. and MARINAS, C., *La Galerie espagnole de Louis-Philippe au Louvre. 1838–1848*, Paris, 1981.

BATICLE, J., 'Goya and the link with France at the end of the old regime', in exh. cat. Madrid/Boston/New York, 1988–9, pp. 55–72/l–lxiii.

BATICLE, J., *Goya*, Paris, 1992

BEROQUI, P., 'Una biografía de Goya escrita por su hijo', *Archivo Español de Arte y Arqueología*, III, 1927, pp.

99–100 (Eng. trans. in E. Harris, 1969, pp. 23–24).

BERTAUX, E., *Exposición Retrospectiva de Arte.1908*, exh. cat., Saragossa, Madrid, 1910.

BERUETE Y MORET, A. de, *Goya pintor de retratos*, I, Madrid, 1916.

BERUETE Y MORET, A. de, *Goya, composiciones y figuras*, II, Madrid, 1917.

BERUETE Y MORET, A. de, *Goya grabador*, III, Madrid, 1918.

BJURSTRÖM, P., 'Jacob Gustaf de la Gardie och Goya', *Meddelander från Nationalmuseum* (Stockholm), 86, 1962, pp. 77–81.

BLANC, C., *et al. Histoire des Peintres de toutes les écoles. Ecole Espagnole*, Paris, 1869.

BOBER, P. P. and RUBINSTEIN, R., *Renaissance Artists & Antique Sculpture. A Handbook of Sources*, Oxford and New York, 1986.

BOIX, F., 'Un discípulo e imitador de Goya, Asensi Juliá (El Pescadoret)', *Arte Español*, X, 1931, pp. 138–41.

BORDERÍAS BESCÓS, A., 'Nota sobre un cuadro de Goya: José Mallén de Almudévar, posible cabecilla de los "Guerrilleros que fabricaban pólvora en la Sierra de Tardienta"', *Archivo Español de Arte*, XL, 1967, pp. 157–9.

BOSARTE, I., 'Viaje a Segovia, Valladolid y Burgos', *Viage artístico á varios pueblos de España*, I, (Madrid, 1804), ed. A. E. Pérez Sánchez, Madrid, 1978.

BOZAL, V., *Imagen de Goya*, Madrid, 1983.

BRAHAM, A., 'Goya's Equestrian Portrait of the Duke of Wellington', *The Burlington Magazine*, CVIII, 1966, pp. 618–21.

BRAHAM, A., 'Wellington y Goya', in exh. cat. Madrid, 1988 (*Wellington*), pp. 145–63.

BUENDÍA, J. R. and PEÑA, R., 'Goya académico', in *El Arte en tiempo de Carlos III, IV Jornadas de Arte*, Madrid, 1989, pp. 303–10.

BUENDÍA, J. R., *Goya*, Madrid, 1990.

BUENO PAZ, J., 'Datos documentales sobre los hijos de Goya', *Arte Español*, 1947, pp. 57–63.

CADENAS y VICENT, V. DE, *Extracto de los expedientes de la Orden de Carlos 3º. 1771–1847*, V, Madrid, 1983.

CALLEJA, see [GOYA, F. de] *Colección de … reproducciones …*, 1924.

CAMÓN AZNAR, J., 'Cuadros de Goya en el Museo Lázaro Galdiano', *Seminario de Arte Aragonés*, IV, 1952, pp. 5–14.

CANELLAS LÓPEZ, A. see [GOYA, F. de], 1981.

CANELLAS LÓPEZ, A., 'Goya y un borrador de cartas de Martín Zapater', *Boletín Camón Aznar*, XXXI–II, 1988, pp. 7–13.

CARDERERA, V. de, 'Biografía de don Francisco de Goya', *El Artista*, II, 1835, pp. 253–5 (reprinted in Lafuente Ferrari, 1947, pp. 302–5; Eng. trans. in E. Harris, 1969, pp. 24–7).

CARDERERA, V. de, 'Goya', *Semanario Pintoresco Español*, 120, 1838 (reprinted in Lafuente Ferrari, 1947, pp. 305–8, and in Eng. trans. and original Spanish in Glendinning, 1977, App. II, pp. 291–4/1982, App. II, pp. 298–301).

CARO BAROJA, J., *Ensayo sobre la literatura del cordel*, Barcelona, (1969), 1988.

Cartas a Zapater, see [GOYA, F. de], 1982.

CAVESTANY, J., 'La Anunciación (cuadro inédito de Goya)', *Arte Español*, IX, 1928, pp. 351–5.

CEÁN BERMÚDEZ, J. A., 'Análisis de un cuadro que pintó don

Francisco de Goya para la catedral de Sevilla', *Crónica científica y literaria*, 73, 9 December 1817 (reprinted Seville, 1817; in facsimile in *Boletín de la Real Academia de la Historia* – see González Palencia, 1946; in Eng. trans. and original Spanish in Glendinning, 1977, App. I, pp. 287–90/1977, App. I, pp. 294–7).

CHAN, V., 'Goya's Tapestry Cartoon of the Straw Manikin: A Life of Games and a Game of Life', *Arts Magazine*, 60, 1985, pp. 50–8.

COPERTINI, G., 'Note sul Goya', off-print from *Annuario per l'anno scolastico 1926–1927 del R. Liceo Gimnasio 'Gian Domenico Romagnosi'*, VI, Parma, 1928, pp. 1–14.

COSSÍO, J. M., *Los toros: Tratado técnico e histórico*, 7th edn., Madrid, 1980.

CROISSET, PÈRE, *L'Année chrétienne*, Lyon, 1712; Sp. trans. by Padre J. F. de Isla, Madrid (1748), 1852.

CROSSLING, B., *European Paintings from The Bowes Museum*, exh. cat. London, 1993.

CRUZADA VILLAAMIL, G., *Los tapices de Goya*, Madrid, 1870.

DE ANGELIS, R., ed. *L'opera pittorica completa di Goya*, Milan, 1974/*Tout l'œuvre peint de Goya*, Paris, 1976

DELTEIL, L., 'Francisco Goya', *Le Peintre graveur illustré*, XIV, XV, Paris, 1922.

DESPARMET FITZ-GERALD, X., *L'œuvre peinte de Goya. Catalogue raisonné*, Paris, 1928–50.

Diplomatario, see [GOYA].

DOMERGUE, L., 'Un bandolero frente a la justicia, la literatura y el arte', *Actas del I Symposium del Seminario de Ilustración Aragonesa*, Saragossa, 1987, pp. 169–87.

DOMINGUEZ BORDONA, J., 'Noticia de pinturas elegidas por orden de Godoy', *Archivo Español de Arte y Arqueología*, XII, 1936, p. 272.

EL LIBRO DE LA ACADEMIA, ed. J. M. Pita Andrade, Madrid, 1991.

EZQUERRA DEL BAYO, J., *La Duquesa de Alba y Goya*, Madrid, 1928.

FERNÁNDEZ de MORATÍN, L. – see MORATÍN

Francisco de Goya. Cartas a Martín Zapater, ed. M. Agueda and X. de Salas, Madrid, 1982.

FRAUQUE, J. and VILLANUEVA ETCHEVERRIA, R., *Goya y Burdeos (1824–1828)*, trilingual edn, Saragossa, 1982.

GALINDO, P., 'Goya pintando en el Pilar. Efemérides de su labor', *Aragón*, XXXI, 1928, pp. 152–8.

GÁLLEGO, J., *En torno a Goya*, Saragossa, 1978.

GÁLLEGO, J., 'Carlos III y Goya', in *El Arte en tiempo de Carlos III, IV Jornadas de Arte*, Madrid, 1989, pp. 331–6.

GALLEGO, J. and DOMINGO, T., *Los bocetos y las pinturas murales del Pilar*, Caja de Ahorros de la Inmaculada, Saragossa, 1987.

GARAS, K., *The Budapest Museum of Fine Arts*, Budapest, 1988.

GARCÍA BARRIUSO, P., *San Francisco el Grande de Madrid. Aportación documental para su historia*, Madrid, 1975.

GASSIER, P. and WILSON, J., *Vie et œuvre de Francisco de Goya*, Fribourg, 1970 (English edn., London and New York, 1971; reprinted New York, 1981), (Spanish edn., Barcelona, 1974).

GASSIER, P., *Les dessins de Goya. Les Albums*, Fribourg, 1973.

GASSIER, P., *Les dessins de Goya*, II, Fribourg, 1975.

GASSIER, P., 'Les portraits peints par Goya pour l'Infant Don Luis de Borbón à Arenas de San Pedro', *Revue de l'Art*, 43, 1979, pp. 9–22.

GASSIER, P., 'Goya, Pintor del Infante D. Luis de Borbón', in exh. cat. *Goya en las colecciones madrileñas*, Madrid, 1983, pp. 15–19.

GASSIER, P., BARBOZA, C. and GRASA, T., *Goya. El Coreto de la Basílica del Pilar de Zaragoza*, Saragossa, 1992.

GAYA NUÑO, J. A., *La pintura española fuera de España (Historia y catálogo)*, Madrid, 1958.

GIMÉNEZ RUIZ, NACHON GONZÁLEZ, DIAZ CUETARA, *La iglesia de San Fernando, de Torrero*, Monumentos de Aragón, 8, Saragossa, 1983.

GIMENO, H., 'Cartas de Martín Zapater, referentes a D. Francisco Goya y Lucientes', *Boletín del Museo Provincial de Bellas Artes de Zaragossa*, I, 1917, pp. 21–2.

GLENDINNING, N., 'The Monk and the Soldier in plate 58 of Goya's Caprichos', *Journal of the Warburg and Courtauld Institutes*, XXIV, 1961, pp. 115–20.

GLENDINNING, N., 'Goya and England in the Nineteenth Century', *The Burlington Magazine*, CVI, 1964, pp. 4–14.

GLENDINNING, N., *Goya and his Critics*, New Haven and London, 1977/*Goya y sus críticos*, Madrid, 1982.

GLENDINNING, N., 'Goya on Women in the Caprichos: The Case of Castillo's Wife', *Apollo*, CVII, 1978, pp. 130–4.

GLENDINNING, N., 'Goya's Patrons', *Apollo*, CXIV, 1981, pp. 236–47.

GLENDINNING, N., 'La fortuna de Goya', in exh. cat. *Goya en las colecciones madrileñas*, Madrid, 1983, pp. 21–47.

GLENDINNING, N., 'Nineteenth-century Editions of Goya's Etchings: New details of their Sales Statistics', *Print Quarterly*, VI, 1989, pp. 394–403.

GLENDINNING, N., *Goya. La década de los Caprichos. Retratos 1792–1804*, (Real Academia de Bellas Artes de San Fernando), Madrid, 1992.

GLENDINNING, N., 'Recuerdos y angustias en las pinturas de Goya, 1793–1794', in *Goya*, Pabellón de Aragón, Saragossa, 1992, pp. 133–58.

GLENDINNING, N., see RODRÍGUEZ MOÑINO, 1981.

GÓMEZ CENTURIÓN, J., 'Informes. Jovellanos y los colegios de las órdenes militares en la Universidad de Salamanca', *Boletín de la Real Academia de la Historia*, 1913–14, LXII, pp. 5–38 and 497–528; LXIII, pp. 5–66 and 281–326; LXIV, pp. 5–49.

[GOYA, F. DE], *Cartas a Martín Zapater*, ed. M. Agueda and X. de Salas, Madrid, 1982.

[GOYA, F. DE], *Colección de Cuatrocientas cuarenta y nueve reproducciones de Cuadros, Dibujos y Aguafuertes de Don Francisco de Goya, Precedidos de un Epistolario del gran pintor y de las Noticias Biográficas publicadas por Don Francisco Zapater y Gómez en 186[8]*, (Saturnino Calleja), Madrid, 1924.

[GOYA, F. DE], *Diplomatario de Francisco de Goya*, ed. A. Canellas López, Saragossa, 1981.

GOYA. NUEVAS VISIONES. Homenaje a Enrique Lafuente Ferrari, ed. I. García de la Rasilla and F. Calvo Serraller, Madrid, 1987.

GRASA, T. and BAROBOZA, C., 'Goya muralista. Itinerario attraverso la pittura murale e il restauro', in exh. cat. Venice, 1989, pp. 45–63.

GRAVES, R., *The Greek Myths*, 2 vols [paperback ed.], London (1955), 1960/*Los Mitos Griegos*, 2 vols., Madrid, 1985.

GUDIOL, J., 'La primera gran obra de goya', *Coloquio*, XXXV, 1965, pp. 19–23.

GUDIOL, J., *Goya 1746–1828. Biografi, estudio analítico y catálogo de sus pinturas*, Barcelona, 1970/4 vols, Barcelona, 1984.

GUERRERO LOVILLO, J., 'Goya en Andalucía', 100, *Goya*, 1971, pp. 211–17.

HARASZTI-TAKÁCS, M., 'Scènes de genre de Goya à la vente de la collection Kaunitz en 1820', *Bulletin du Musée Hongrois des Beaux-Arts*, 44, 1975, pp. 107–21.

HARRIS, E., 'Spanish Pictures from the Bowes Museum', *The Burlington Magazine*, XCV, 1953, pp. 22–4.

HARRIS, E., 'A contemporary review of Goya's "Caprichos",' *The Burlington Magazine*, CVI, 1964, pp. 38–43.

HARRIS, E., *Goya*, London, 1969.

HARRIS, T., *Goya. Engravings and Lithographs*, 2 vols, Oxford, 1964.

HASKELL, F. and PENNY, N., *Taste and the Antique. The Lure of Classical Sculpture 1500–1900*, New Haven and London, 1981; *El gusto y el arte de la Antigüedad. El atractivo de la escultura clásica (1500–1900)*, Madrid, 1990.

HELD, J., *Farbe und Licht in Goyas Malerei*, Berlin, 1964.

HELD, J., *Die Genrebilder der Madrider Teppichmanufaktur und die Anfänge Goyas*, Berlin, 1971.

HELMAN, E., 'Algunos sueños y brujas de Goya', in *Goya. Nuevas Visiones*. Madrid, 1987, pp. 197–205.

HEMPEL-LIPSCHUTZ, I., 'Théophile Gautier y su "Quimera retrospectiva" captada en la obra pictórica de goya', in *Goya. Nuevas Visiones*. Madrid, 1987, pp. 207–25.

HERRÁN DE LAS POZAS, A., *Pinturas y dibujos coleccionados por Agustín Herrán de las Pozas, Goya 1746–1946*, Bilbao, 1946.

HERRERO, M., 'Un autógrafo de Goya', *Archivo Español de Arte*, XIV, 1941, pp. 176–7.

HILTON, R., 'Margato y el ocaso del bandolerismo español', *Hispanic Institute in The United States*, New York, 1946.

HYATT MAYOR. A., 'Goya's Hannibal Crossing the Alps', *The Burlington Magazine*, XCVII, 1955, pp. 295–6.

JORDAN, W. B., *The Meadows Museum. A visitor's Guide to the Colletion*, Dallas, 1974.

JORNADAS, *Goya. Jornadas en torno al estado de la cuestión de los estudios sobre Goya*, Universidad Autónoma de Madrid, Madrid, 1993.

JUNQUERA, P., 'Un lienzo inédito de Goya en el Palacio de Oriente', *Archivo Español de Arte*, XXII, 1959, pp. 185–92.

KLINGENDER, F., *Goya in the democratic tradition*, London, 1948, New York 1968.

LAFOND, P., *Goya*, Paris, 1902.

LAFOND, P., 'Les dernières années de Goya en France', *Gazette des Beaux-Arts*, XXXVII, 1907, pp. 114–31, 241–57.

LAFORA, J., 'Goya. Estudio biográfico-crítico', *Arte Español*, 1928–9, pp. 359–72.

LAFUENTE FERRARI, E., 'Sobre el cuadro de San Francisco El Grande y las ideas estéticas de Goya', *Revista de Ideas Estéticas*, IV, 1946, pp. 307–37.

LAFUENTE FERRARI, E., *Antecedentes, Coincidencias e influencias del arte de Goya*, Madrid, 1947.

LAFUENTE FERRARI, E., *Goya. Les fresques de San Antonio de la Florida à Madrid*, Lausanne, 1955.

LAFUENTE FERRARI, E., 'Los toros en las artes plásticas'. *Cossío*, 1980, pp. 735–1032.

LASIERRA, A., 'Nuevos cuadros de Goya', *Aragón*, April 1928, p. 123.

LICHT, F., *Goya: The Origins of the Modern Temper in Art*, New York, 1979; London, 1980; New York, 1983.

LONGHI, R., 'Il Goya romano e la cultura di via condotti', *Paragone*, V, 1954, pp. 28–39.

LÓPEZ REY, J., 'A Contribution to the Study of Goya's art. The San Antonio de la Florida Frescoes', *Gazette des Beaux-Arts*, 1944, XXV, pp. 231–48.

LÓPEZ REY, J., 'Goya and the World Around Him', *Gazette des Beaux-Arts*, XXVIII, 1945, pp. 129–50.

LÓPEZ REY, J., 'Goya's *The Taking of Christ*. Challenge and Achievement', *Apollo*, CXIV, 1981, pp. 252–4.

LOZOYA, MARQUESS OF, 'Dos Goyas inéditos de tema religioso', *Archivo Español de Arte*, XXIV, 1951, pp. 5–10.

MACLAREN, N. and BRAHAM, A., *The Spanish School, National Gallery Catalogues*, London, 1970.

MANGIANTE, P. E., *Goya e l'Italia*, Rome, 1992.

MARCOS VALLAURE, E., 'El propietario del boceto de la *Inmaculada* de Goya (Prado, nº 3260)', *Boletín del Museo del Prado*, 24, 1987, pp. 182–3.

MARIANO, M. DE, *Historia del Museo del Prado. 1818–1868*, Madrid, 1945.

MARTINEZ NOVILLO, A., *Le peintre et la tauromachie*, Paris, 1988.

MATHERON, L., *Goya*, Bordeaux, 1857; Paris, 1858; Madrid, 1890.

MAYER, A. L., *Francisco de Goya.*, Munich, 1923; London, 1924; Madrid 1925.

MAYER, A. L., 'Zu Goya', *Pantheon The Cicerone*, IX April 1932, pp. 113–16.

MEMORIAL, Memorial Litterario, instructivo y curioso de la corte de Madrid, Madrid, 1785, 1786, pp. 215–18.

MESONERO ROMANOS, R. de, *Manual histórico-topográfico administrativo y artístico de Madrid*, Madrid, 1844.

MESONERO ROMANOS, R. de, *El antiguo Madrid. Paseos históricos-anecdóticos por las calles y casas de esta villa*, Madrid, 1861.

MILICUA, J., 'Anotaciones al Goya joven', *Paragone*, V, 1954, pp. 5–28.

MORALES Y MARÍN, J. L., *Los Bayeu*, Saragossa, 1979.

MORALES Y MARÍN, J. L., 'Los pintores de la Ilustracion', in exh. cat. Madrid, 1988.

MORALES Y MARÍN, J. L., *Goya pintor religioso*, Saragossa, 1990.

MORALES Y MARÍN, J. L., *Mariano Salvador Maella*, Madrid, 1991.

MORATÍN, LEANDRO FERNÁNDEZ DE, *Diario (Mayo 1780–Marzo 1808)*, ed. R. and M. Andioc, Madrid, 1968.

NICOLAU CASTRO, J., *Escultura toledana del siglo XVIII*, Instituto Provincial de Investigaciones y Estudios Toledanos, Diputación Provincial de Toledo, Toledo, 1991.

NORDSTRÖM, F., *Goya, Saturn and Melancholy. Studies in the Art of Goya*, Stockholm, Uppsala, 1962; Spanish trans., Madrid, 1989.

NÚÑEZ DE ARENAS, M., 'Manojo de noticias. La suerte de Goya en Francia', *Bulletin Hispanique*, 3, 1950, pp. 229–73.

Osuna Sale, see SENTENACH, 1896.

PARDO CANALÍS, E., 'La Iglesia zaragozana de San Fernando y las pinturas de Goya', *Goya*, 84, 1968, pp. 358–65.

PELAYO QUINTERO, 'Goya en Cádiz', *La Esfera*, 745, 1928.

PELLEGRI, M. ed., *Concorsi dell'Accademia Reale di Belle Arti di Parma dal 1757 al 1796*, Parma, 1988.

PEMÁN, C., 'Ter Borch y España', *Goya*, 47, 1962, pp. 408–10.

PEMÁN, M., 'La colección artística de bon Sebastián Martínez, el amigo de Goya, en Cadiz', *Archivo*

Español de Arte, LI, 1978, pp. 53–62.

PEMÁN MEDINA, M., 'Estampas y libros que vio Goya en Casa de Sebastián Martínez', *Archivo Español de Arte*, LXVM, 1992, pp. 303–20.

PEMÁN Y PEMARTÍN, C., *Los goyas de Cádiz*, Cadiz, 1928.

PÉREZ SÁNCHEZ, A. E., 'Colecciones del Patrimonio Nacional. Pinturas. Goya', in *Reales Sitios*, 25, 1970, pp. 37–44.

PÉREZ SÁNCHEZ, A. E., 'Goya en el Prado. Historia de una colección singular', in *Goya. Nuevas Visiones*. Madrid, 1987.

PIGLER, A., *Katalog Der Galerie Alter Meister*, Budapest, 1967.

PITA ANDRADE, J. M., 'Observaciones en torno a los cartones para tapices', *Goya*, 148–50, 1979, pp. 232–9.

PITA ANDRADE, J. M., 'Una miniatura de Goya', Boletín del Museo del Prado, I, 1980, pp. 12–16.

PITA ANDRADE, J. M. and BOROBIA GUERRERO, M., *Maestros antiguos del Museo Thyssen-Bornemisza*, Madrid, 1992.

PONZ, A., *Viaje de España* (1772–1794), ed. Casto María del Rivero, Madrid, 1947 facsimile, 1972.

PRADO CATALOGUE, *Catálogo de los cuadros que existen colocados en el Real Museo del Prado*, Madrid, 1821.

PRADO CATALOGUE, *Noticia de los cuadros que se hallan colocados en la galería del Museo del Rey Nuestro Señor sito en el Prado de esta corte*, Madrid, 1828.

PRADO CATALOGUE, *Catalogue illustré des tableaux du Museé du Prado à Madrid. Ecoles Espagnoles*, Madrid, 1899.

REGINA MARTIRUM. GOYA, see TORRA, E. *et al.*, Saragossa, 1982.

RIPA, C., *Nova Iconología*, Padua, 1618 (ed. Turin, 1986).

RODRÍGUEZ MOÑINO, A., 'Incunables goyescos', ed. N. GLENN-DINNING, *Bulletin of Hispanic Studies*, LVIII, 1981, pp. 293–312.

RODRÍGUEZ TORRES, M. T., *Goya, Saturno y el Saturnismo. Su enfermedad*, Madrid, 1993.

ROSE DE VIEJO, I., 'La celebrada caída de nuestro coloso. Destrucciones espontáneas de retratos de Manuel Godoy por el populacho', *Academia*, 1978, pp. 199–226.

ROSE DE VIEJO, I., 'Goya's allegories and the sphinxes: Commerce, Agriculture, Industry and Science in situ', *The Burlington Magazine*, CXXVI, 1984, pp. 34–9.

ROSENFELD, D. ed., *European Painting and Sculpture, ca. 1770-1937 in the Museum of Art. Rhode Island School of Design*, Providence, Rhode Island, 1991.

ROTHE, H., *Las pinturas del Panteón de Goya. Ermita de San Antonio de La Florida*, Barcelona, 1944.

SALAS, X. DE, 'Miscelánea goyesca', *Archivo Español de Arte*, XXIII, 1950, pp. 335–46.

SALAS, X. DE, 'A group of Bullfightings Scenes by Goya', *The Burlington Magazine*, CVI, 1964, pp. 37–8.

SALAS, X. DE, 'Sur les tableaux de Goya qui appartinrent à son fils', *Gazette Des Beaux Arts*, 1964, LXXXI, pp. 169–72.

SALAS, X. DE, 'Precisiones sobre la pintura de Goya', *Archivo Español de Arte*, XLI, 1968, pp. 1–16.

SALAS, X. DE, 'Inventario. Pinturas elegidas para el Príncipe de la Paz, entre las dejadas por la viuda Chopinot', *Arte Español*, XXVI, 1968/69, pp. 29–33.

SALAS, X. DE, 'Sobre un retrato ecuestre de Godoy', *Archivo Español de Arte*, XLII, 1969, pp. 217–33.

SALAS, X. DE, 'Sur deux miniatures de Goya récemment retrouvées', *Gazette des Beaux Arts*, 1973, LXXXI, pp. 169–72.

SALAS, X. DE, 'Dos notas, a dos pinturas de Goya, de tema religioso', *Archivo Español de Arte*, XLVII, 1974, pp. 383–96.

SALAS, X. DE, 'Un boceto de Goya para la Inmaculada del colegio de Calatrava', *Archivo Español de Arte*, L, 1977, pp. 1–8.

SALAS, X. DE, 'Une miniature et deux dessins inédits de Goya', *Gazette des Beaux Arts*, 1979, pp. 167–71.

SALTILLO, MARQUES DEL, *Miscelánea madrileña, histórica y artística. Goya en Madrid, su familia y allegados, (1746-1856)*, Madrid, 1952.

SALTILLO, MARQUES DEL, 'Las pinturas de Goya en el Colegio de Calatrava de Salamanca (1780–1790)', *Seminario de Arte Aragonés*, 1954, pp. 5–9.

SAMBRICIO, V. DE, *Tapices de Goya*, Madrid, 1946.

SÁNCHEZ CANTÓN, F. J., 'Los pintores de Cámara de los Reyes de España. Los pintores de los Borbones', *Boletín de la Sociedad Española de Excursiones*, 1916, pp. 202–20.

SÁNCHEZ CANTÓN, F. J., 'Goya en la Academia', *Discursos. Primer Centenario de Goya*, Madrid, 1928, pp. 11–23.

SÁNCHEZ CANTÓN, F. J., *Goya*, Paris, 1930.

SÁNCHEZ CANTON, F. J., 'La estancia de Goya en Italia', *Archivo Español de Arte y Arqueología*, VII, 1931, pp. 182–4.

SÁNCHEZ CANTÓN, F. J., 'La elaboración de un cuadro de Goya', *Archivo Español de Arte*, XVIII, 1945, pp. 301–7.

SÁNCHEZ CANTÓN, F. J., 'Cómo vivía Goya. I – El inventario de sus bienes. II – Leyenda e historia de la Quinta del Sordo', *Archivo Español de Arte*, XIX, 1946, pp. 73–109.

SÁNCHEZ CANTÓN, F. J., 'Goya, Pintor religioso: Precedentes italianos y franceses', *Revista de Ideas Estéticas*, IV, 1946, pp. 277–318.

SÁNCHEZ CANTÓN, F. J., *Vida y obras de Goya*, Madrid, 1951.

SÁNCHEZ VENTURA, R., 'Santas Justa y Rufina', *Aragón*, 1928, p. 151.

SAYRE, E. A., 'Goya's Bordeaux miniatures', *Boston Museum Bulletín*, LXIV, 1966, pp. 84–123; French translation, exh. cat. *Goya. 1746-1828. Peintures-Dessins-Gravures*, Paris, 1979.

SAYRE, E. A., *Late Caprichos of Goya*, New York, 1971.

SAYRE, E. A. *et al.*, *The Changing Image: Prints by Francisco Goya*, Museum of Fine Arts, Boston, 1974.

SAYRE, E. A., 'Goya. A moment in Time', in *National-museum Bulletin*, III, 1979, pp. 28–49. 'Goya. Un momento en el Tiempo', in exh. cat. *Goya y la Constitución de 1812*, Museo Municipal, Madrid, 1982–3, pp. 55–69.

SEBASTIÁN LÓPEZ, S., *Inventario artístico de Teruel y su provincia*, Madrid, 1974.

SEBASTIÁN LÓPEZ, S., 'El programa iconográfico de la Santa Cueva de Cádiz', in *Goya. Nuevas Visiones.*, Madrid, 1987, pp. 374–85.

SENTENACH, N., 'Nuevos datos sobre Goya y sus obras', *Historia y Arte*, I, 1895, pp. 196–9.

SENTENACH, N., *Catálogo de los cuadros, esculturas, grabados y otros objetos artísticos de la antigua Casa Ducal de Osuna*, exh. and auction cat. Madrid, 1896.

SENTENACH, N., 'Notas sobre la exposición de Goya', *La España Moderna*, 138, 1900, pp. 34–53.

SENTENACH, N., 'Fondos selectos del archivo de la Real Academia de Bellas Artes de San Fernando', *Boletín de la Real Academia de Bellas Artes de San Fernando*, (1919–23), 1919, pp. 205–11.

SHERMAN FONT, E., 'Goya's source for the Maragato series',

Gazette des Beaux-Arts, 1958, LII, pp. 289–304.

SORIA, M. S., 'Goya's Allegories of Fact and Fiction', *The Burlington Magazine*, July, 1948.

SORIA, M. S., 'Las miniaturas y retratos-miniaturas de Goya', *Cobalto* (Barcelona), XLIX:2, 1949, pp. 1–4.

SORIA, M. S., 'Spanish paintings in The Bowes Museum', *The Connoisseur*, 1961, pp. 30–7.

STOLZ VICIANO, R., 'Las pinturas al fresco del Templo del Pilar', *Aragón*, 1942.

SUTTON, D., 'Goya: Apostle of Reason', *Apollo*, LXXIX, 1964, pp. 67–72.

SYMMONS, S., *Goya: In Pursuit of Patronage*, London, 1988.

TAYLOR, R., 'Goya's Paintings in the Santa Cueva at Cadiz', *Apollo*, LXXIX, 1964, pp. 60–6.

TOMLINSON, J. A., *Francisco de Goya. The tapestry cartoons and early career at the Court of Madrid*, Cambridge, 1989. *Francisco de Goya. Los cartones para tapices y los comienzos de su camera en la corte de Madrid*, Madrid, 1993.

TOMLINSON, J. A., *Goya in the Twilight of Enlightenment*, New Haven and London, 1992. *Goya en el crepúsculo del siglo de las luces*, Madrid, 1993.

TORMO Y MONZO, E., 'Las pinturas de Goya y su clasificación y distribución cronológicas', *Varios Estudios de Artes y Letras*, Madrid, 1902, I, Estudio nº 2, pp. 199–233.

TORMO Y MONZO, E., 'La pintura aragonesa cuatrocentista y la Retrospectiva de la Exposición de Zaragoza', *Boletín de la Sociedad Española de Excursiones*, XVII, 1909, pp. 277–84.

TORMO Y MONZO, E., *Las iglesias del Antiguo Madrid*, Madrid, 1927.

TORRA, E., TORRALBA, F., BARBOZA, C., GRASA, T. and DOMINGO, T., *Regina Martirum, Goya.*, Banco Zaragozano, Saragossa, 1982.

TORRALBA SORIANO, F., 'Notas sobre algunas obras de la juventud de Goya en Aragón', *Goya*, 100, 1971, pp. 218–25.

TORRALBA SORIANO, F., *Goya en la Santa Cueva*, Saragossa, 1983.

TORRALBA SORIANO, F., 'Problemática y cronología de las pinturas de Goya en la Santa Cueva', in *III Coloquio de arte aragonés. El arte Barroco en Aragón*, Huesca, 1983, pp. 443–7.

TOVAR MARTÍN, V., *Arquitectos madrileños de la segunda mitad del siglo XVII*, Madrid, 1975.

VIÑAZA, Count de la, *Goya. Su tiempo, su vida, sus obras*, Madrid, 1887.

VARIOUS AUTHORS, *Goya. Nuevas Visiones. Homenaje a Enrique Lafuente Ferrari*, Madrid, 1987.

VARIOUS AUTHORS, *El libro de la Academia*, Royal Academy of San Fernando, Madrid, 1991.

WILSON, J., see GASSIER, P. and WILSON, J.

WILSON-BAREAU, J., *Goya's Prints. The Tomás Harris Collection in the British Museum*, London, 1981.

WILSON-BAREAU, J., *Goya. La década de los Caprichos. Dibujos y aguafuertes*, exh. cat. Madrid, 1992.

WOLF, R., *Francisco Goya and the interest in British Art and Aesthetics in late Eighteenth-Century Spain*, Ann Arbor, Michigan, 1987.

WOOD, N. J. and LEE, C. K., *Master Paintings in The Art Institute of Chicago*, Chicago, 1988.

YEBES, COUNTESS OF, *La Condesa-Duquesa de Benavente. Una vida en unas cartas*, Madrid, 1955.

YOUNG, E., *Catalogue of spanish paintings in The Bowes Museum*, Barnard Castle, Durham, 1988.

YRIARTE, CH., *Goya, sa biographe, les fresques, les toiles, les*

tapisseries, les eaux-fortes et le catalogue de l'œuvre, Paris, 1867.

ZAPATER Y GÓMEZ, F., *Apuntes históricos-biográficos acerca de la Escuela Aragonesa de pintura*, Madrid, (1859), 1863.

ZAPATER Y GÓMEZ, F., *Goya, noticias biográficas*, Saragossa, 1868, reprinted in [GOYA, F. de] *Colección....*, Madrid, 1924, pp. 17–49.

ZARCO DEL VALLE, M., *Datos documentales para la historia del arte español.* II, *Documentos de la catedral de Toledo*, Madrid 1916.

EXHIBITIONS

A slash (/) between names and numbers indicates a change of language and/or numbering.

1846

MADRID: *Catálogo de las obras de pintura, escultura y arquitectura presentadas a exposición en junio de 1846, y ejecutadas por los profesores existentes y los que han fallecido en este siglo*, Liceo Artístico y Literario, Madrid (reprinted in Lafuente Ferrari, 1947, pp. 339–46).

1874

PARIS: *Exposition de peintures au profit des Alsaciens-Lorrains*, Palais-Bourbon, Paris.

1896

MADRID: *Catálogo de los cuadros...de la antigua Casa Ducal de Osuna*, Palacio de la Industria y de las Artes, Madrid.

1900

MADRID: *Catálogo de las obras de Goya*, Ministerio de Instrucción Pública y Bellas Artes, Madrid.

1901

LONDON: *Descriptive and biographical Catalogue of the Exhibition of Works by Spanish Painters*, Art Gallery of the Corporation of London.

1908

BERLIN: *X. Ausstellung: Francisco de Goya*, Paul Cassirer, Berlin.

SARAGOSSA: *Exposición Retrospectiva de Arte*. Real Junta del Centenario de los Sitios de 1808–1809, Saragossa.

VIENNA: *Francisco José de Goya y Lucientes 1746–1828*, Galerie Miethke, Vienna.

1912

BOSTON: *Spanish Masters*, Copley Society, Boston.

1913

MADRID: *Exposición de pinturas españolas de la 1ª mitad del siglo XIX*, Sociedad Española de Amigos de Arte, Madrid (n.d.).

1920–1921

LONDON: *Exhibition of Spanish Paintings at The Royal Academy*, illustrated catalogue, Royal Academy of Arts, London.

1928

BUENOS AIRES: *Exposición del Centenario de Goya*, Museo Nacional de Bellas Artes, Buenos Aires.

LONDON: *Exhibition of Spanish Art, Including Pictures, Drawings, and Engravings by Goya*, Burlington Fine Arts Club, London.

MADRID: *Centenario de Goya. Exposición de pinturas* and *Catálogo ilustrado de la exposición de pinturas de Goya*, Museo del Prado, Madrid.

SARAGOSSA: *Exposición de obras de Goya y de objetos que recuerdan las manufacturas artísticas de su época*, Museo de Bellas Artes, Saragossa.

1930

NEW YORK: *Spanish Paintings from Greco to Goya*, Metropolitan Museum of Art, New York.

1932

MADRID: *Antecedentes, coincidencias e influencias del arte de Goya*, Sociedad Española de Amigos del Arte, Madrid (reprinted in Lafuente Ferrari, 1947, pp. 349–69).

1934

BUENOS AIRES: *Arte Religioso Retrospectivo*, Congreso Eucarístico Internacional de Bellas Artes, Buenos Aires.

1937

SAN FRANCISCO: *Paintings, Drawings and Prints by Francisco Goya (1746–1828)*, California Palace of the Legion of Honor, San Francisco.

1938

LONDON: *From Greco to Goya*, Tomás Harris. The Spanish Art Gallery, London.

PARIS: *Peintures de Goya des Collections de France*, Musée de l'Orangerie, Paris.

1939

BUENOS AIRES: *De los Primitivos a Rosales*, Amigos del Arte, Buenos Aires.

GENEVA: *Les Chefs d'oeuvre du Musée du Prado*, Geneva.

1941

CHICAGO: *Paintings, Drawings, Prints: The Art of Goya*, The Art Institute of Chicago.

TOLEDO, OHIO: *Spanish Paintings*, Toledo Museum of Art, Ohio.

1943

MADRID: *Autorretratos de pintores españoles 1800–1943*, Museo Nacional de Arte Moderno, Madrid.

1946

MADRID: *Exposición conmemorativa del Centenario de Goya*, Palacio de Oriente, Madrid.

1947

LONDON: *An Exhibition of Spanish Paintings*, (The Arts Council), National Gallery, London.

1949

MADRID: *Bocetos y estudios para pinturas y esculturas*, Asociación de Amigos del Arte, Madrid.

1950

NEW YORK: *A Loan Exhibition of Goya, for the benefit of the Institute of Fine Arts, New York University*, Wildenstein & Co. New York.

1951

BORDEAUX: *Goya (1746–1828)*, Musée des Beaux-Arts, Bordeaux.

MADRID: *Goya*, Museo del Prado, Madrid.

1952

VENICE: *Exposición del Pabellón Español de la Exposición Bienal De Venecia*, Venice.

1953

BASLE: *Goya. Gemälde. Zeichnungen. Graphik. Tapisserien*, Kunsthalle, Basle.

1955

GRANADA: *Exposición Goya*. Palacio de Carlos V, Granada.

NEW YORK: Supplement to *Goya: Drawings and Prints* (Smithsonian Institution touring exhibition), Metropolitan Museum of Art, New York.

1956

NEW HAVEN: *Pictures collected by Yale Alumni*, Yale University Art Gallery, New Haven, Conn.

1957

BORDEAUX: *Bosch, Goya et le fantastique*, Musée des Beaux-Arts, Bordeaux.

SYRACUSE-MILWAUKEE: *An Exhibition of Spanish Painting*, Museum of Fine Arts, Syracuse; Art Institute, Milwaukee.

1959

LONDON: *The Romantic Movement*, Tate Gallery, London.

1959–1960

ROTTERDAM/ESSEN: *Collection Thyssen-Bornemisza*, Boymans–van Beuningen Museum, Rotterdam, 1959–60; Sammlung Thyssen-Bornemisza, Folkwang Museum, Essen.

STOCKHOLM: *Stora Spanska Mästare*, Nationalmuseum, Stockholm.

1961

MADRID: *Exposición Francisco de Goya*, Casón del Buen Retiro, Madrid.

1961–1962

PARIS: *Francisco Goya y Lucientes. 1746–1828*, Musée Jacquemart-André, Paris.

1962

LONDON: *Primitives to Picasso*, Royal Academy of Arts, London.

1962–1963

GREAT BRITAIN: *Pictures from the Bowes Museum*, (Arts Council touring exhibition).

1963–1964

LONDON: *Goya and his Times*, Royal Academy of Arts, London.

1966

BUENOS AIRES: *De los Primitivos a Goya*, Museo Nacional de Bellas Artes, Buenos Aires.

1967

BUENOS AIRES: *Encuentros y Coincidencias en el Arte*, Museo Nacional de Bellas Artes, Buenos Aires.

1969
MADRID: *Principales adquisiciones 1958–1968*, Museo del Prado, Madrid.

1969–1974
U.S.A: *The Armand Hammer Collection*, (touring exhibition).

1970
THE HAGUE/PARIS: *Goya*, Mauritshuis, The Hague; Orangerie des Tuileries, Paris.

PARIS: Goya: *Dessins, Gravures, Lithographies*, Galerie Huguette Berès, Paris.

1971–1972
TOKYO–KYOTO: *El Arte de Goya: Exposición extraordinaria de Goya en Japón*, National Museum of Western Art, Tokyo; Municipal Museum, Kyoto.

1974–1975
BOSTON/OTTAWA: *The Changing Image: Prints by Francisco Goya*, Museum of Fine Arts, Boston; The National Gallery of Canada, Ottawa.

1975–1977
WASHINGTON–CLEVELAND/PARIS: *The European Vision of America*, National Gallery of Art, Washington, DC; The Cleveland Museum of Art, Ohio; *L'Amérique vue par l'Europe*, Grand Palais, Paris.

1976
WASHINGTON D.C.: *Goya in the Prado*, National Gallery of Art, Washington D.C.

1977
BARCELONA: *Goya*, Palacio de Pedralbes, Barcelona.

MEXICO CITY: *The Armand Hammer Collection*, Palacio de Bellas Artes de Mexico, Mexico City.

1978
MILAN: *Goya*, Milan.

MEXICO CITY: *Del Greco a Goya*, Mexico City.

1979
PARIS: *Goya 1746–1828. Peintures–Dessins–Gravures*, Centre Culturel du Marais, Paris.

1979–1980
BORDEAUX–PARIS/MADRID: *L'Art européen à la Cour d'Espagne an XVIIIᵉ siècle*, Galerie des Beaux-Arts, Bordeaux; Graud Palais, Paris; *El Arte europeo en la Corte de España durante el siglo XVIII*, Museo de Prado, Madrid.

1979–1981
USA: *Old Master Paintings from the Collection of Baron Thyssen-Bornemisza*, (touring exhibition).

1980
BUENOS AIRES: *Panorama de la Pintura Española desde los Reyes Católicos a Goya*, Palacio del Concejo Deliberante, Buenos Aires.

LENINGRAD/MOSCOW: *Spanish Masterpieces of the 16th–19th centuries*, The Hermitage, Leningrad; Pushkin Museum, Moscow.

STOCKHOLM: *Goya's 'Spanien, Tiden och Historien'*, Nationalmuseum, Stockholm.

1980–1981
HAMBURG: *Goya. Das Zeitalter der Revolutioner 1789–1830*, Kunsthalle, Hamburg.

1981
BELGRADE: *Exposición de Arte Español*, Belgrade.

LONDON: *El Greco to Goya: The Taste for Spanish Paintings in Britain and Ireland*, National Gallery, London.

MADRID: *Museo del Prado. Adquisiciones de 1978 a 1981*, Casón del Buen Retiro, Madrid.

1982
MARTIGNY: *Goya dans les collections suisses*, Fondation Pierre Gianadda, Martigny.

MUNICH–VIENNA: *Von Greco bis Goya: Vier Jahrhunderte Spanische Malerei*, Haus der Kunst, Munich; Künstlerhaus, Vienna.

PARIS: *Collection Thyssen-Bornemisza: Maîtres Anciens*, Musée du Petit Palais, Paris.

1982–1983
DALLAS: *Goya and the Art of his Time*, Meadows Museum, Southern Methodist University, Dallas, Texas.

MADRID: *Goya la Constitución de 1812*, Museo Municipal, Madrid.

1983
MADRID: *Goya en las colecciones madrileñas*, Museo del Prado, Madrid.

1983-1984
ROTTERDAM–BRUNSWICK: *Schilderkunst uit de eerste hand. Olieverfschetsen van Tintoretto tot Goya; Malerei aus erster Hand. Ölskizzen von Tintoretto bis Goya*, Museum Boymans–van Beuningen, Rotterdam; Herzog-Anton-Ulrich Museum, Brunswick.

USSR: *Master Paintings from the Thyssen-Bornemisza Collection*, Pushkin Museum, Moscow, The Hermitage, Leningrad; State Museum of Fine Arts, Kiev.

1985
BRUSSELS: *Goya*, (Europalia 85/Spain), Musées Royaux des Beaux-Arts de Belgique, Brussels.

1986
SARAGOSSA: *Goya Joven (1746–1776) y su entorno*, Museo e Instituto 'Camón Aznar', Saragossa.

LUGANO: *Goya nelle collezioni private di Spagna*, Collezione Thyssen-Bornemisza, Villa Favorita, Lugano.

1987
JAPAN: *Spanish Paintings of the 18th & 19th Century: Goya and his Times*, (touring exhibition).

MADRID: *Tesoros de las colecciones particulares madrileñas: Pintura desde el siglo XV a Goya*, Royal Academy of San Fernando, Madrid.

PARIS: *De Greco à Picasso: Cinq Siècles D'Art Espagnol*, Musée du Petit Palais, Paris.

1988
LONDON: *Old Master Paintings from the Thyssen-Bornemisza Collection*, Royal Academy of Arts, London.

MADRID: *Los pintores de la Ilustración*, Centro Cultural del Conde Duque, Madrid.

MADRID: *La alianza de dos monarquís: Wellington en España*, Museo Municipal, Madrid.

1988–1989
MADRID–BARCELONA: *Carlos III y la Ilustración*, Palacio de Velázquez, Madrid; Palacio de Pedralbes, Barcelona.

MADRID/BOSTON–NEW YORK: *Goya y el Espíritu de la Ilustración*, Palacio de Villahermosa, Museo del Prado. Madrid; *Goya and the Spirit of Enlightenment*, Museum of Fine Arts, Boston; Metropolitan Museum of Art, New York.

STUTTGART: *Meisterwerke der Sammlung Thyssen-Bornemisza*, Staatsgalerie, Stuttgart.

1989
LONDON: *Painting in Spain during the later eighteenth century*, National Gallery, London.

MADRID: *Obras maestras de la colección Masaveu*, Palacio de Villahermosa (Museo del Prado), Madrid.

VENICE: *Goya 1746–1828*, Galleria Internazionale d'Arte Moderna di Ca' Pesaro, Venice..

1990
ARLES/MADRID: *Goya. Toros y toreros*, Espace Van Gogh, Arles; Royal Academy of San Fernando, Madrid.

1991
MADRID: *El Autorretrato en la Pintura Española. De Goya a Picasso*, Fundación Cultural Mapfre Vida, Madrid.

MILAN: *Da Goya a Picasso. La pittura spagnola dell'Ottocento*, Palazzo Reale, Milan.

1992
MADRID: *El gusto español*, Galería Caylus, Madrid.

MADRID: *Retratos de Madrid, Villa y Corte*, Centro Cultural de la Villa, Madrid.

SARAGOSSA: *Goya*, La Lonja, Saragossa.

SEVILLE: *Goya*, Aragon Pavilion, Exposición Universal, Seville.

1992–1993
MADRID: *Goya. La década de los Caprichos. Retratos; Dibujos y aguafuertes*, Royal Academy of San Fernando, Madrid.

MADRID: *Madrid pintado. La imagen de Madrid a través de la pintura*, Museo Municipal, Madrid.

1993
LONDON: *European Paintings from The Bowes Museum*, National Gallery, London.

Comparative Table of numbers used in this catalogue and those in
P. Gassier and J. Wilson, *Vie et œuvre de Francisco de Goya*, Freiburg, 1970, and
J. Gudiol, *Goya, 1746–1828; Biographie, étude analytique et catalogue de ses peintures*, Barcelona, 1970; 2nd edn. Barcelona, 1984.

G–W. 1970	CAT.	G–W. 1970	CAT.	GUDIOL 1970	CAT.	GUDIOL 1970	CAT.	GUDIOL 1984	CAT.	GUDIOL 1984	CAT.
31	2	723	54	24	2	360	45	22	2	338	52
77	7	737	55	64	7	361	44	58	7	340	51
162	6	738	57	96	62	363	52	96	6	342	64
172	4	739	56	102	6	365	51	107	62	343	65
173	5	740	58	112	4	367	65	110	8	349	46
174	3	844	69	113	5	368	64	111	9	350	48
178	8	845	70	114	3	378	66	118	4	351	47
179	9	846	71	117	8	380	53	119	5	352	49
186	12	847	72	118	9	395	54	120	3	353	45
187	11	848	73	135	11	397	55	125	11	354	44
[188]	13	849	67	136	12	459	56	126	12	359	66
194	10	850	68	[155]	59	460	57	141	59	360	53
198	18	864	84	158	18	461	58	146	13	375	54
235	14	865	85	166	14	462	97	147	18	377	55
237	15	866	86	214	19	463	96	151	14	434	56
241	16	867	87	216	20	464	98	170	10	435	57
244	17	868	88	218	21	465	95	202	19	436	58
255	60	869	89	220	22	470	42	204	20	442	50
257	19	914	74	222	23	475	82	206	21	464	67
257	20	915	75	224	24	476	83	208	22	465	68
258	21	916	77	233	29	482	50	212	24	466	73
259	22	917	78	242	60	502	67	216	23	467	72
260	24	918	76	245	15	503	68	221	29	468	71
261	23	919	80	252	26	504	72	230	60	469	69
272	26	920	79	253	25	505	73	233	15	470	70
273	25	921	81	254	27	506	71	240	16	498	97
274	27	922	82	255	28	511	84	242	17	499	96
275	28	923	83	257	16	512	85	245	26	500	98
295	30	929	42	259	17	513	86	246	25	501	95
296	31	963	93	273	34	514	87	247	27	504	84
317	32	964	92	274	33	515	88	248	28	505	85
318	34	966	97	276	36	516	89	267	30	506	86
319	33	967	96	277	35	579	93	271	31	507	87
321	36	968	98	278	37	580	92	299	32	508	88
322	35	969	95	280	10	618	90	300	34	509	89
323	37	980	90	296	30	619	91	301	33	557	93
325	38	981	91	300	31	653	94	303	36	559	92
327	40	1570	94	332	61	734	112	304	35	591	82
328	41	1672	112	338	63	738	106	305	37	592	83
329	39	1676	100	343	43	739	110	307	38	594	90
330	43	1679	104	344	38	740	111	309	43	595	91
331	62	1682	99	345	39	742	105	310	41	633	94
344	61	1683	111	346	41	746	99	311	40	704	112
352	64	1685	108	347	40	747	100	312	39	708	106
353	65	1686	103	348	77	748	108	313	42	709	110
659	45	1687	107	349	76	749	107	314	61	710	111
660	46	1688	110	350	78	753	103	319	61	712	105
661	47	1689	106	351	74	755	109	329	77	716	99
662	44	1690	105	352	75	759	104	330	76	717	100
663	49	1693	109	353	80	—	1	331	78	718	108
664	48	1705	113	354	79	—	13	332	74	719	107
665	63	1706	114	355	81	—	32	333	75	720	104
682	66	1707	116	356	46	—	69	334	80	723	103
696	50	1708	117	357	48	—	70	335	79	725	109
710	52	1709	115	358	47	—	101	336	81	726	102
712	51	1710	118	359	49	—	102			727	101
718	53	—	1							—	1
		—	29								
		—	59								
		—	101								
		—	102								

PHOTOGRAPHIC CREDITS

COLOUR

Tomás Antelo, Madrid cat. 20, 46, 47, 57, 58
Archivo Barboza-Grasa, Saragossa fig. 37
Archivo Scala, Florence cat. 59
Archivo del Instituto de Conservación y Restauración de Bienes Culturales, Madrid cat. 52
Archivo Mas, Barcelona cat. 48
Archivo Moreno, Madrid cat. 44
Archivo Oronoz, Madrid fig. 5, 8, 36
The Art Institute, Chicago cat. 22, 84, 85, 86, 87, 88, 89
Douglas Baz, London cat. 105
British Rail Pension Trustee Co., London cat. 35
Cathy Carver, Providence cat. 72, 73, 106
Collection of The J. Paul Getty Museum, Malibu cat. 112
Joaquín Cortés, Madrid cat. 1, 2, 3, 4, 5, 6, 7, 8, 9, 10, 13, 16, 17, 19, 24, 25, 26, 28, 29, 30, 32, 33, 34, 36, 37, 38, 39, 40, 41, 45, 51, 55, 60, 61, 63, 64, 65, 67, 71, 74, 75, 76, 77, 78, 79, 80, 81, 90, 91, 94; fig. 42, 61–9, 72
Flint Institute of Arts, Flint cat. 15
The Frick Collection, New York fig. 14
Patrick Goetlen cat. 34
Paula Goldman, Los Angeles cat. 31
The Hispanic Society of America, New York fig. 9
José Loren, Madrid cat. 23, 66
Carlos Manso, Madrid cat. 11, 12, 53, 54, 95, 96, 97, 98; figs. 1, 4, 12, 13, 15, 18, 26, 27, 39, 43
Meadows Museum, Dallas cat. 43
The Metropolitan Museum of Art, New York fig. 2
Musée d'Agen fig. 6
Musée des Beaux-Arts et d'Archéologie, Besançon cat. 82, 83
Musée des Beaux-Arts, Bordeaux cat. 114
Museo Nacional de Bellas Artes, Buenos Aires cat. 56
Museum of Fine Arts, Boston cat. 14, 50, 104, 109
Nationalmuseum, Stockholm cat. 99
The Norton Simon Foundation, Pasadena cat. 68
Princeton University Art Museum, Princeton cat. 111
The Royal Academy of Arts, London cat. 103
Staatliche Kunstsammlungen, Dresden cat. 102, 110
Sterling and Francine Clark Art Institute, Williamstown cat. 21
Szépmüvészti Muzéum, Budapest cat. 92, 93
The Trustees of the National Gallery, London cat. 27, 42, 49

BLACK AND WHITE

Tomás Antelo, Madrid fig. 34
Archivo Barboza-Grasa, Saragossa fig. 88, 97, 98, 99
Archive Bulloz, Paris, fig. 48
Archivo Mas, Barcelona fig. 79, 156, 165, 168, 169, 171, 173, 200
Archivo Oronoz, Madrid fig. 28, 105, 115, 116, 119, 133
Luis Arenas, Seville fig. 215
Biblioteca Nacional, Madrid fig. 11, 30, 85, 92, 144, 145, 150, 151, 166, 182, 188, 201, 202, 205, 206, 207, 217
British Library, London fig. 141, 147
British Museum, London cat. 115, 116, 117, 118
Santos Cid, Valladolid fig. 107
Collection of The J. Paul Getty Museum, Malibu fig. 213
Joaquín Cortés, Madrid fig. 17, 60, 61, 75, 101, 102, 174, 175, 178
Davison Art Center, Middletown fig. 225
Editions Office du Livre, Lausanne fig. 29, 106, 216
Carlos Manso, Madrid fig. 7, 10, 19–23, 31, 32, 33, 38, 44, 78, 84, 86, 91, 102, 104, 112, 114, 117, 118, 121, 125, 126, 127, 128, 129, 131, 134, 135, 136, 138, 139, 148, 152, 156, 157, 158, 159, 160, 161, 163, 176, 177, 179, 180, 185, 186, 189, 194, 195, 196, 199, 212, 219, 220, 221, 222
Agustín Martínez, Madrid fig. 95, 103, 108, 170, 198
The Metropolitan Museum of Art, New York fig. 187, 209
The Norton Simon Foundation, Pasadena fig. 218
Patrimonio Nacional, Madrid fig. 90, 109
Réunion des Musées Nationaux, Paris fig. 80